PHOTOGRAPHIC LAB HANDBOOK

PHOTOGRAPHIC LAB HANDBOOK

Photographic
LAB HAND BOOK

JOHN S. CARROLL

Fifth Edition

AMPHOTO
American Photographic Book Publishing Co., Inc.
New York, New York

1970 First Edition
1974 Second Edition
1976 Third Edition
1977 Fourth Edition
1979 Fifth Edition

Library of Congress Catalog Card No. 74-84030

AMPHOTO ISBN: 0-8174-2486-5 (hardbound)
AMPHOTO ISBN: 0-8174-2158-0 (softbound)
PRENTICE-HALL ISBN: 0-13-665422-3 (hardbound)

Manufactured in the United States of America

10 9 8 7 6 5 4 3 2

TABLE OF CONTENTS

This page is being reserved
for future expansion.

INTRODUCTION

This volume, the first completely new photographic data book in more than 25 years, is offered to the photographic community to fill a long-felt need. The idea of a master data service is, itself, not new — several are offered, most by manufacturers of photographic products.

The problem is simply that the average photographer does not limit himself to the products of one manufacturer, and when he has to refer to data sheets, and pamphlets issued by the various manufacturers, he finds himself in at least one dilemma. Namely, the format used by different manufacturers differs, and data is offered in a variety of forms, arrangements, and even, in some cases, using different systems of measurement. Film speeds are given in ASA by American manufacturers; foreign makers use BSI, DIN, and sometimes others. Developer formulas make up to quarts, liters, and in some cases, British Imperial pints.

So, then, the first purpose of this volume is to standardize the presentation of photographic information; to make it completely comparable. This is not entirely new, either; it has been done before, with varying degrees of success.

More important, in terms of purpose, is to be sure that the information offered is in such form as to make it easiest to refer to. A book which over-classifies is as bad as one which is insufficiently classified. It should not be necessary to turn pages a dozen times while looking up information on a given make or type of film. One should not have to refer to one section of the book to find the speed of a film, another section for filter factors, a third for flash guide numbers, and a fourth for developing data. This approach may be useful in an encyclopedia, but not in a workbook for practical photographers.

Thus the first and most important difference between this book and all others is that the basic information required by the photographer for any and all sensitized materials is conveniently grouped, mostly in tabular form, using just a single page for each film, plate or paper. If, for instance, you wish to find out how to work with Kodak Plus-X Sheet Film, you will find a data page devoted to this one film; on this page you will find its film speed (ASA), the recommended safelight for loading and processing, a table of filter factors, a table of flash guide numbers, a table of guide numbers for electronic flash, and a table giving the developers recommended.

7

Manufacturer sections, as such, are neither used nor required. The second section, logically, is devoted entirely to black-and-white films, which includes both sheet, roll films, and 35 mm films.

The third section, arranged in much the same manner covers all the commonly used color films, mainly of American manufacture. Although it might be of some value to the curious to read the data for such minor foreign products as Telcolor, Orwocolor, and so on, we feel that this book is intended for the serious worker, amateur and professional, who wants useful useable information. There is little use in cluttering pages with data about products which can't be bought anyway.

Again, the fourth section is arranged in much the same order; it contains data on all commonly used photographic papers for black and white photography, and a standardized format has been devised so that everything you need to know to use a given paper will be found on a single data page.

As we mentioned previously, each data page contains processing recommendations for that particular film, plate or paper. But these recommendations are only for time of development for one or more recommended formulas. The broad subject of processing is covered in the following two sections.

The section on processing black-and-white films opens with a general formulary; it contains formulas for mixing developers, stop baths, fixing baths, and incidental formulas such as intensifiers, reducers, toners, and so on. This formulary has been very strictly edited; the huge proliferation of published formulas could result in this section running into hundreds of pages, most of them devoted to material of very dubious utility.

The fact is that there has been a very notable change in the entire philosophy of black-and-white photography in recent years. It is now generally appreciated that image characteristics are mostly "built-in" to an emulsion; most of them are almost unaffected by variations in the composition of a developer. With this appreciation, the entire subject of "fine-grain" processing, so popular only a few years ago, has now ceased to have any meaning or even interest. If you want fine grain, you must use a fine grained film; the developer composition has next to no influence on graininess. However—and this is important—the *use* of the developer does have some effect on grain; generally the higher the contrast of the developed image, the grainier, and likewise, the higher the density, the grainier. It is this reasoning that leads to current recommendations for low-gamma processing combined with minimum exposure. The former keeps the contrast down, the latter minimizes density, and a soft, thin negative has the finest grain structure possible with a given emulsion.

Actually, the huge number of negative developer formulas available never did serve any really useful purpose. It has become more and more evident in recent years that this multiplicity of formulas was really only a large number of variations on combinations of a few basic chemicals. The only function of a negative developer is to reduce the exposed grains of silver halide to a metallic silver image, and these hundreds of formulas merely represent many different ways of arriving at the identical end result. If a developer is chosen according to purpose and format, it is obvious that one or two developers for miniature films, a couple for roll films, and two or three for sheet films are all that is really necessary—the remainder merely make for confusion.

On the other hand, there is ample justification for a variety of developers for black and white papers. Variation in formula in the case of papers *can* have the effect of producing a variety of effects, mostly connected with the image tone or color of the silver deposit. On the other hand, paper emulsions always

develop to maximum contrast and there is almost no way in which variation of a developer formula can change the contrast of the final image.

Nonetheless, the number of useful formulas is still limited, and furthermore, there are few photographers today who will waste the time required to mix a developer from its basic ingredients. Many of them merely buy the packaged versions of the same developers—thus the familiar Kodak D-76 Developer is available in packaged form, and all that is required is to mix it with water. Many other numbered formulas are likewise available in ready mixed form. In addition, all the major manufacturers have trademarked developers for which the formulas are not available; examples are GAF's Hyfinol, Kodak's Polydol and Microdol-X, Agfa's Rodinal, and Dupont's 16-D.

Some photographers prefer to use packaged developers made by firms which do not manufacture films, and certain of these products are very popular indeed. For this reason, we have chosen a representative selection of such packaged developers and have given practically complete instructions for their use in this section.

One thing which the reader will find absent in this section is the subject of gamma and contrast index. The reasons for this significant omission are given below, under the appropriate heading.

Corresponding to the section on Black and White Processing is the following section on Color Processing; here, however, no formulas are given since none are available. Instead, we show, in highly condensed form, the recommended procedure for processing those color films and color printing materials, in the appropriate kits supplied by the respective manufacturer. This is necessitated by the fact that color films are still the subjects of patents. Since no two of them can be alike, it follows that each color film or printing medium can be processed only in its appropriate developers. Attempts at processing a color film of one manufacturer in the formulas of another will result only in total failure, and for this reason, no general procedures can be given at this time. With the instructions for the processing of color printing materials will be found some general data on the making of color prints, by reversal from transparency materials, and by straight printing from color negatives. Such processes as trichrome carbro, wash-off relief, etc. are substantially obsolete, and there is no good reason to include such material in an up-to-date manual; all of these antiquated processes are therefore omitted.

Up to this point, the book has been devoted to products and how to use them. The remaining three sections differ in that they contain more general information, useful to photographers in their work, but not necessarily referring to any specific product.

The section on Motion Pictures and Slides covers mainly the mechanical details, often needed and somehow difficult to find when needed. The size and shapes of the actual film formats — image areas, as photographed and projected, for 8mm, Super 8, 16mm, and 35mm, as well as for 2 x 2 and full size slides, are given followed by projection tables for all these different formats. Data on screens and their use, audience arrangements, etc. are given. There is a special discussion on standards for single frame filmstrips; these are widely used in education and industry.

The section on Optics contains, as might be expected, the usual tables and formulas for the use of lenses, calculation of relative aperture and effective aperture, and the use of supplementary lenses for closeup work. However, this section is entirely new in one respect; it contains a discussion of elementary lens design, which leads into lens aberrations, their evaluation and relative

importance. There is a short discussion of computer-designed lenses and the significance of computer design to the working photographer. Reference is made to resolving power, the newer concept of acutance, and methods of lens testing.

The following section is a general data section, containing information which is less directly related to photography, but of considerable value to the working photographer. This includes tables of weights and measures, metric conversions, thermometer scales, specific gravities, and other general information.

Photographic tables in this section include several for flashlamp exposures, a table of film speed conversions, and others. General discussions are included covering such matters as reflected-light, incident-light, and spot-type exposure meters, and the special problem of the built-in exposure meter. There are also tables of filters, darkroom safelights, color temperatures of light sources, and other useful information.

The following section is one on Graphic Arts Materials; like the sections on black-and-white, color, and motion-picture films, it is largely composed of data pages for the particular types of films and papers used in the photomechanical trades. The purpose of this, however, is not to supply data for the use of engravers and lithographers; the presence of this section recognizes that the creative photographer, in his search for exotic effects, often makes use of materials not originally intended for general photography. Therefore, the materials listed, and the data supplied for them, are those which the general photographer would find most useful, and information on their use in photo-mechanical fields (such as, for instance, exposures through halftone screens) is kept to the minimum.

This section concludes with some directions for the carrying out of procedures having considerable creative potential; equidensity production with Agfacontour film, the making of Tone-Line positives, and the use of color proofing materials for special types of prints, are covered at some length.

The final section of the book is a general alphabetical index, covering the entire contents of the volume. This is a big thing, and would be bigger if we cross-indexed in the manner of many other books. The size and bulk of this index is kept to the minimum by indexing each item only once, as far as possible—that is, for example, a single listing for "Films, black-and-white," followed by all black-and-white films in alphabetic order. No separate indexing is used for the individual films, otherwise; this would not only hugely increase the bulk of the index, it would actually make things harder to find. The book having also been repaged consecutively, no further section references are required, and there are no longer any sectional indexes.

Gamma And Contrast Index

For many years, a great deal of emphasis was placed on gamma as a measure of development contrast, and some of the discussion of the subject tended to generate more heat than light. Photographers tended to use gamma in many incorrect ways; often as a measure of negative contrast, or in various attempts to relate the subject contrast, negative contrast, and paper exposure scale into one homogeneous "system". Many such systems have been proposed, few have survived.

The reasons for the failure of these various systems are various, and we should like to clear up the numerous misconceptions which led to some proposals, as well as to evaluate those which show some promise. We cannot, in the limited space available here, explain the fundamentals of sensitometry or do any more than to define gamma as "the slope of the straight line portion (correct exposure portion) of the characteristic curve." For further explanation

of this definition, the reader is referred to any good basic textbook on photography. The following discussion is aimed at the advanced photographer who has some grasp of sensitometry, and who is curious to know why the whole subject of gamma has been de-emphasized in this book.

In general, the entire problem of tone reproduction in the black-and-white photograph is simply an attempt to reproduce the entire scale of brightnesses in the original subject as a series of tones from white, through various grays, to black, on a piece of photographic paper. In the early days of photography, this ideal was attained, if at all, more by accident than by design.

With the introduction of the electronic exposure meter in the 1930s, means became available by which the average photographer could easily measure the brightnesses of the various elements of a given scene. It was found that there was a wide variation in range in given scenes—some having very bright highlight areas and deep blacks in shadow, could have a scale of 100 to 1 in terms of measured brightness. More normal scenes ran about 30 to 1, and some "flat" scenes ran as little as 10 to 1 in brightness range.

Most negative films used in black-and-white photography are easily capable of accommodating subject matter with a 100:1 brightness range. The problem is in getting this range of tones onto the printing paper.

So-called "Normal" or No. 2 papers have a Scale Index of 1.30 which implies a 20:1 exposure range. Extra Soft, or No. 0 papers have a Scale Index of about 1.70, which corresponds to a range of about 50:1; likewise "Extra Hard" or No. 5 papers have a Scale Index of 0.70 or about 5:1.

Some papers, made mainly for amateur photographers, are available in the full range of 6 exposure scale values from No. 0 to No. 5. On the other hand, the papers made for professional use, portrait photography, etc. are often available in a single grade only, generally No. 2 with a scale of no more than 20:1. Obviously, those intending to print their negatives on the latter types of paper are required to make all their negatives to a single range of transmissions, in which the lightest part of the negative transmits no more than 20 times the light which passes through the densest part.

In portrait photography, this is easy enough—the subject can be illuminated by separate light units in such a manner as to establish almost any density range desired in the final negative. In outdoor work, and in other areas where there is little or no control over the illumination or subject matter, the problem is different—another means must be found to control the printing range of the negative.

It was, then, in the 1930s, that certain advanced photographers began to investigate the matter of contrast control in negative processing to better fit the negative to the printing paper. Now, since "gamma" is defined as the slope of the straightline portion of the characteristic curve of the film, it appeared that gamma would be a useful measure of the relation between subject brightness and negative transmission—that is, it would be possible to fit the negative of any reasonable subject matter to any given paper, with mathematical precision, by proper control of negative development.

As an example (and a highly simplified one): it was believed that if a negative were developed to a gamma of 1.0, then the scale of the subject would be exactly reproduced in the negative—that is, a subject having 30:1 brightness range would result in a negative having, likewise a 30:1 scale. Thus, it was said, all you had to do, if you had a 30:1 scene and wanted to print the negative on a 20:1 paper, would be to develop the negative to a gamma of 0.66, and the job would be done.

The system is deceptively simple and speciously logical. In point of fact, it did work to some extent, simply because any system works better than no system at all. In the motion picture industry, where strict control of negative gamma had been enforced for some time because of the problems associated with photographic sound tracks, the photographers found that they could, indeed, measure the various brightnesses in the scene, adjust them with lighting, reflectors, or screens, and predict fairly well the appearance of the final screen image.

But the motion picture industry had both the sensitometric equipment and know-how to measure gamma precisely, and the automated developing equipment to maintain a desired gamma within narrow limits from day to day. This point was overlooked by the mass of still photographers who tried in various ways to adopt gamma control in their daily work. These latter tried to control their development in various free-hand ways, without measuring equipment; they demanded of the film manufacturer (and of the publishers of various data books) that information be provided as to the exact gammas obtainable with various film and developer combinations, at various processing times. Such information was duly provided, with appropriate disclaimers for the inevitable inaccuracies; it was used, unfortunately, by many photographers uncritically and without regard for the exceptions which had been duly pointed out.

Let us look at some of the reasons why the system of predicting the final print from the brightness range of the original and the negative gamma, did not work.

To begin with, the fact that a given subject may have a brightness range of, say 30:1 does not mean that the image at the film plane of the camera will have the same range; in point of fact it seldom if ever does. The problem is that a certain amount of light is scattered by the glasses of the lens; furthermore, some of the excess image which spills over the film and strikes the walls of the camera is reflected in random directions and some of this light ends up on the surface of the film. This effect is summed up under the name of "camera flare" and can be very serious indeed.

It takes only a very small amount of flare light to degrade the contrast of an image quite seriously. As an example, let us take a typical subject—arbitrarily, let us say that the shadows are receiving one unit of light, the highlights 30 units. That is, the subject has a brightness range of 30:1. But suppose that as a result of internal reflections in lens and camera, 1 unit of light is added, uniformly over the entire image. The result of adding 1 unit of light over the image is to increase the shadow illumination: $1 + 1 = 2$. Likewise adding 1 unit of light to the highlight, we have $30 + 1 = 31$. But now, our image instead of having a range of 1:30 has a range of 2:31 or only 1:15½. In short only 1 unit of flare light has cut the contrast of the image almost in half!

So, then, if we assumed a subject brightness range of 30:1 and developed the negative to a gamma of .66, to fit it to a 20:1 paper, we would find our negative actually has a range of a bit more than 10:1. It would be far too flat for printing on this paper, and in fact, we should have developed it to a gamma of a bit more than 1.3 to make it print properly on a Number 2 paper. This is, admittedly, an extreme case, but one which occurred often enough in practice to cast some doubt on the validity of the whole method. The only reason the situation was not even worse than this was that there were two other sources of error, and they tended in some cases to cancel each other.

One source of error, and probably the biggest, was simply that the average photographer did not really know what gamma he was developing to. True, he

did have various complicated charts, diagrams, etc. all of which purported to tell him that if he developed Brand X film in Brand Y developer for 7 minutes at 68 F, his negative would have exactly .65 gamma.

Actually, it was nearly certain that no matter how carefully he followed these directions, he would get some other gamma, and the error was likely to be a very large one. First of all, gamma is very sensitive to the conditions of development; variations in agitation alone can account for large differences in the contrast of the final negative. Then, too, the temperature control of an ordinary developer tank in the average darkroom is a pretty freehand sort of thing, nor can most low priced thermometers be depended on for accuracy much better than ± 2 or 3 degrees. Then, too, there are variations in development rate from one batch of film to another, while chemical mixing, the alkalinity of the water used, and other factors all have their influences.

All things considered, even with the big, thermostatically controlled developing machines used in the motion picture industry, a gamma specification of .65 means only that the negative is likely to be developed somewhere between .63 and .67—in short the second decimal place is quite uncertain. Without such advanced equipment, it is doubtful that gamma .70 is likely to mean much more than a range of from .6 to .8 and such variation is sufficient to make the whole subject of negative control by variation of gamma meaningless.

One more point, commonly overlooked but of great importance, is that the term "gamma" means only the slope of the straightline portion of the characteristic curve. In earlier photography, exposures were commonly kept quite full to secure ample shadow detail, and the films of that period had rather short toe sections anyway. Today's films, on the contrary, usually have a long, sweeping toe; in addition, the photographer is encouraged to keep his exposure to the minimum to avoid graininess. This results in a large part of the image tones being recorded on the toe of the curve, where gamma is meaningless.

Recently, a new concept, that of "Contrast Index", has been introduced to provide a means of measuring the range of an image when it had been exposed using a large part of the toe of the characteristic curve. While this concept is a useful one, and certainly does give a better picture of the effective contrast of given negatives, it is not, apparently, any more controllable by normal darkroom procedures than is gamma.

Some eminent photographic teachers have been espousing a system in which the brightness range of the subject is expressed in terms of a few discrete steps of brightness; the student is then expected to run tests with his own camera, exposure meter and processing equipment, to determine a few developing times which will compensate for subjects differing by one, two or three steps in overall scale. Inasmuch as this system depends on individual calibration of equipment and method, it is workable—it automatically compensates for camera flare, thermometer errors, variations in agitation, etc. The concept of gamma or Contrast Index does not even enter into this system, and it thus avoids the pitfall of attempting to control with mathematical exactness a process which is far from exact.

However, there is some doubt as to whether even this simplified method of negative control is either necessary or desirable. While all this experimenting has been going on, two major changes have taken place in photography, and these seem to have eliminated both the need for and the possibility of exact negative control.

Take possibility first. All systems of matching negative to subject and paper obviously depend upon being able to develop each negative individually,

to the optimum gamma required. This was simple enough, if laborious, when most professional and advanced amateur photography was done on sheet film. However, today's photographers are swinging over, more and more, to roll film, especially in the 120 and 220 sizes, and as soon as you have a dozen or two dozen negatives on a roll, the chance of doing anything about negative contrast in the development process is gone.

As for the need for such control: modern printing is being done, more and more, on variable contrast papers, that is, papers whose exposure scale is varied by the simple use of a color filter over the enlarger lens. Where former professional papers were made in only one or two degrees of contrast, and amateur papers in a maximum of six, we now have papers whose exposure scale can be varied within extreme limits, to as fine a degree as one would wish — if adjacent filters produce too large a difference in contrast for the desired print effect, it is easily possible to split the difference by giving part of the exposure through each filter.

What this is leading to is simply this—since it is now a simple matter to fit the paper to the negative, there is no longer any real need to try to fit the negative to the paper. This situation was, of course, true even in the earlier days, at least with papers which came in from 3 to 5 contrast degrees. However, photographers often claimed that graded papers had noticeably different image tone, poor highlight contrast, or inferior tone separation, in certain grades and not in others. Thus, they often restricted themselves to one or two out of the available 5 or 6 grades, and this was used as a reason to continue attempting to fit the negative to the existing papers.

This problem does not hold in the case of the variable contrast papers. The mixture of color sensitive emulsions used in these papers is, of course, a constant—no matter what filter is used, the image tone will be the same. Tone separation, highlight or shadow contrast remain fairly constant in these papers, too, regardless of which filter or filters are in use.

This does not mean that we may be careless with processing, and trust to using different grades of paper, or different filtration of variable contrast papers to cover our carelessness. What it does mean, though, is that futile attempts to relate some printed gamma values to the contrast of the negative actually attained, can now be abandoned. And in line with this reasoning, this book will not attempt to predict gamma or Contrast Index values that will be attained by a photographer using any recommended formula and processing time.

Nonetheless, it is still necessary to be meticulous in processing. Having found a developer and time of development that produces a print which is satisfactory, on a given grade of paper with given equipment, the photographer should make every effort to maintain these conditions. In this way, the adjustment permitted by the use of modern printing materials can be used as a "tolerance" to cover *unavoidable* variables, such as subject matter with unorthodox illumination ratios, or off-average distribution of light and dark.

The fact is, most modern photographers are using roll film or 35mm. With as many as 36 different negatives on a single roll, processing control for subject matter is out of the question. But if the photographer does establish processing conditions under which the majority of his negatives will print on #2 or #3 paper or the corresponding filters, then he has #0 or #1 paper to handle the occasional negative which is excessively contrasty, due to a wide range subject or contrasty lighting. And he has #4 and #5 paper to brighten up the occasional negative which is lacking in contrast due to subject matter or lighting.

References

The foregoing discussion of gamma and contrast index is not intended to give an understanding of either of these two matters; it is intended only to explain certain matters of editorial policy in this book. This being a working handbook, most matters of theory, either elementary or advanced, are out of place, and cannot be covered.

For those who wish to understand the workings of the process, as well as how to do it, there are many excellent books available; most of those in the following list are available either from your dealer or from the publishers of this book. A few may be out of print; often these can be referred to at your local library. We omit from this list, all the excellent Data Books published by Kodak and other film manufacturers; these are available from almost all dealers and are highly recommended. They are not listed here only because we have no way of knowing when these appear on the market or when they are discontinued; your dealer can show them to you, when available.

We cannot, of course, list all the books available; the mention of a book herein does not mean that others are not equally good or useful. The restriction is one of space only.

General Photography

Daniels, Dan. *Photography from A to Z.* Amphoto
Feininger, Andreas. *Total Picture Control.* Amphoto
Feininger, Andreas. *The Complete Photographer.* Prentice-Hall
Feininger, Andreas. *The Creative Photographer.* Prentice-Hall
Feininger, Andreas. *Successful Photography.* Prentice-Hall
Keppler, Herbert. *How To Make Better Pictures In Your Home.* Amphoto
Miller, Thomas, and Brummitt, Wyatt. *This is Photography.* Doubleday
Stroebel, Leslie. *View Camera Techniques.* (Amphoto-Focal) Hastings

Photographic Chemistry

Glafkides, Pierre. *Photographic Chemistry.* (2 volumes) Fountain Press
Mason, L. F. A. *Photographic Processing Chemistry.* Focal-Pitman
Neblette, C. B. *Photography, Its Materials and Processes.* Van Nostrand

Color Photography

Bomback, Edward S. *Encyclopedia of Color Photography.* Fountain Press
Coote, Jack A. *Color Prints.* Amphoto
Engdahl, David A. *Color Printing, Materials, Processes,*
Color Control, Amphoto
Hunt, R. W. G. *Reproduction of Color,* Fountain Press
Spencer, D. A. *Color Photography in Practice.* Focal-Pitman
Thompson, S. Leslie. *Color Films.* Amphoto-Focal

Processing

Croy, O. R. *The Complete Art of Printing and Enlarging.* Amphoto-Focal
Jacobson, C. I. *Developing: The Technique of the Negative.* Amphoto-Focal
Jacobson, C. I. *Enlarging: The Technique of the Positive.* Amphoto-Focal

Jacobs, Lou Jr. *How to Use Variable Contrast Papers* Amphoto
Lootens, J. G. *Lootens on Photographic Enlarging and*
Print Quality Amphoto

Exposure

Berg, W. F. *Exposure* Amphoto-Focal
Dunn, J. F. *Exposure Manual* Fountain Press

Optics

Conrady, A. E. *Optics and Optical Design* Dover
Cox, Arthur *Optics* Amphoto-Focal
Cox, Arthur *A System of Optical Design* Focal-Pitman
Hardy, Arthur C. and Perrin, Fred F. *The Principles of Optics* McGraw-Hill

Reference

Focal Encyclopedia of Photography Focal-Pitman
Horder, Alan *Ilford Manual of Photography* Ilford
Langford, M. J. *Basic Photography* Amphoto-Focal
Lobel, L. and DuBois, E. M. *Basic Sensitometry* Amphoto-Focal

Availability of Products

In general, this book provides information on the use only of those products which are generally available through the normal channels of trade—most if not all of them will be available at any well-stocked photographic supply shop. A few products which have to be specially ordered may be listed where they are of sufficient interest, but by and large, we intend to avoid such items.

One point must be made very clear, however. The listing of a product in this book does not in any way guarantee that it is available at any given time. New products come on the market without advance notice, and by the same token, products are withdrawn when demand no longer justifies stocking, or when new and improved products take their place.

It is for this reason that we have established an editorial policy for this book. By and large, the greater number of photographic products are fairly staple; they come and go very slowly, simply because they meet the needs of a majority of photographers. Listings and data for these products, therefore, comprise the greater part of the contents of this volume. Likewise, there are a few products of smaller, independent firms, which maintain their popularity from year to year; such products must be, and are listed.

On the other hand, many items appear on the market that can only be described as "speculative." Most of them are products of small companies, inexperienced in the field and with inadequate marketing and distribution. Some of these find favor with a few photographers, but most people are unable to find them. Such products come and go, generally before they have even been heard of by most persons, and it would be irresponsible for us to clutter the book with data on products that cannot be bought. We are in no way prejudiced against new products, nor of goods by new manufacturers, but our first duty is to keep this book from growing rapidly obsolete.

On the other hand, one will find certain items listed which were once available but have been discontinued. These have been retained, simply because many photographers buy materials in large quantities, and often have stocks of some items long after they have been discontinued.

For this reason, as mentioned above, it is not intended that this book be used as a catalog or an index of availability of photographic materials. For such information, we suggest you ask your local dealer; he maintains up to date catalog files and can tell you immediately. If your dealer does not have such information, we suggest you write the manufacturer directly. Do not write us on such matters; we only have to forward your letter to the manufacturer in question and this merely delays your receipt of an answer.

By the same token, we request that you do not write to us when in need of information concerning photographic hardware—cameras, lenses, projectors, enlargers, etc. We keep no files on this type of material, and as before, we suggest your best source of information is your dealer; if he cannot help you, write the manufacturer or importer.

Acknowledgments

Though not individually identified in the following pages, all data, tables, and diagrams from Kodak copyrighted publications have been reproduced by specific permission of the Eastman Kodak Company for each item. We tender our sincere appreciation for this courtesy.

Other material in these pages was supplied through the courtesy of the following manufacturers, whose assistance is likewise highly appreciated.

Acufine, Inc.
 439-447 East Illinois Avenue, Chicago, Ill. 60611

American National Standards Institute, Inc.
 1430 Broadway, New York, N. Y. 10018

Agfa-Gevaert, Inc.
 275 North Street, Teterboro, N. J. 07608

DuPont Corp., Photo Products Div.
 1007 Market Street, Wilmington, Del.

Eastman Kodak Company
 Rochester, N. Y. 14650

Edwal Scientific Products
 12120 So. Peoria Street, Chicago, Ill.

Ethol, Inc.
 1808 N. Damen Avenue, Chicago, Ill. 60647

F-R Corporation
 6171 Interstate Circle, Cincinnati, Ohio 45242

Fuji Photo Film, U. S. A.
 350-5th Avenue, New York, N. Y. 10011

GAF Corporation
 140 West 51st Street, New York, N. Y. 10020

General Electric Co., Lamp Division
 Nela Park, Cleveland, Ohio 44112

H & W Company
 Box 332, St. Johnsbury, Vt. 05819

Ilford, Inc.
 West 70 Century Road, P. O. Box 288, Paramus, N. J. 07652

Polaroid Corporation
 549 Technology Square, Cambridge, Mass. 02139

Sylvania Photolamps Division
 730-3rd Avenue, New York, N. Y. 10017

Unicolor-KMS Industries
 P. O. Box 306, Dexter, Mich. 48130

This page is being reserved
for future expansion.

INTRODUCTION TO "BLACK & WHITE FILMS"

In this section, we offer data pages for practically all the black and white films currently available on the American market.

The aim of this section is to avoid unnecessary page turning; if you are going to take a picture and you are using any one of the films in this section, you will find on a single page, all you need to know about that film at that time. Safelight information is given first, for those who have to load film holders, as well as for processing.

ASA Speeds: The next and most important piece of data is the ASA Speed of the film. In all cases, this speed (or speeds in the case of films having more than one) is the manufacturer's recommendation. It may differ from speeds given by other sources, and some judgment may be required to decide which to use. In general, though, the manufacturer's recommended speed is the best starting point when using a film for the first time. We say starting point because many workers find that these speeds occasionally need modification. This is not due to any error in the original listing, nor to any misrepresentation of the film speed by the manufacturer. It is due, almost entirely, to variations in individual equipment, and to the effect of processing on the speed of films

Equipment variations are several. Exposure meters, by and large, unless damaged or defective, are usually the most precise members of the chain from negative to print. It is seldom that a new or well kept meter will give a wrong reading, properly used. The exception, perhaps is the case of the Cadmium Sulfide type meters, which may start to show an error as the battery runs down. The cure is simply to replace the battery.

Lens apertures and shutter speeds are the real offenders in equipment errors. Few lenses are very accurately marked for lens stops, and shutter speeds are at best only approximate. It is, of course, possible that these errors may be in opposite directions so they would tend to cancel each other out. This occurs, but rarely. More often the effects add up and a number of small errors produce a serious discrepancy. If the recommended film speed consistently gives

under- or overexposure, simply use a lower or higher film speed setting for your work with that particular equipment. We must emphasize again, that this does not mean that the actual speed of the film has changed at all; it simply means that your equipment requires a different speed number to operate correctly.

Daylight Exposure: The next piece of information given is the daylight exposure; this is simply a rough guide to the approximate exposure for an average scene in normal sunlight. The main value of this information is in the comparison of various films to determine which to use for a given situation. This exposure recommendation comes, in some cases from the film manufacturer; in others it has been estimated by the following rule of thumb:

$$1/ASA \text{ speed at } f/16.$$

Thus, if a film has an ASA rating of 200, the daylight exposure will be 1/200 sec at $f/16$. If it is ASA 400, then the exposure will be 1/400 second at $f/16$. This will not always agree with the manufacturer's recommendation, but the discrepancy will seldom be more than 1/2 lens stop, which is well within the latitude of black and white films. The whole thing is only an approximation anyway, since it is based on "average" sunlight and "average" subject matter, and it should be used mainly as an emergency procedure.

For other light and subject situations, the following adjustments should be made:

Bright sun on beach or snow	: 1 stop smaller
Cloudy bright, no shadows	: 2 stops larger
Open shade, no sun, but lighted by open sky	: 3 stops larger
Heavy overcast	: 3 stops larger

Filter Factors: The next information given is a series of filter factors for the most commonly used filters. Wratten designations are given, and refer to filters of that make in the case of Kodak films. However, other filter manufacturers have adopted the same numbers for their line of filters, and for most noncritical work, they may be considered interchangeable.

For critical work, of course, filters should be calibrated by test. In any case, it is important to remember that all filters have some "leakage"—they do not cut off sharply at any color, and the result will be in the case of overexposure, that the effect of the filter will be much less pronounced. The opposite case, underexposure, tends to exaggerate the effect of a filter. In some extreme cases, where a dark sky effect is required and a red filter not available, a deep yellow filter with a stop or more of underexposure will often give the desired result.

This, again, ties in with the matter of equipment errors mentioned above under *film speeds*. If your equipment causes you consistently to underexpose, then of course, the filter factors given will also lead to underexposure and exaggerated effects. If you are consistently overexposing, you will find filter effects much less pronounced.

If you like the effects you have been obtaining on normal negatives with your present exposure setup, then to get the desired filter results, you may have to increase or decrease the filter factor from that given in the table. On the other hand, failure to secure the desired result from filters may indicate the necessity of changing, not the filter factor, but the film speed setting in use. Either way, of course, the result is the same—reduce or increase exposure to attain the desired result.

Flash Exposure Guide Numbers: The tables given in these pages come from various sources. In the case of Kodak and GAF films, they are the recommendations of the film manufacturer. In the case of other brands of film, they have been taken from published tables by the manufacturers of flash lamps.

This latter procedure is quite valid; it is reasonable to believe that if one film of, say, ASA 100 speed is correctly exposed with a given flashlamp at a given guide number, all other films of the same ASA speed should likewise produce correct exposures under the same conditions.

This is, in fact, quite true. Nonetheless, there are noticeable variations between the recommendations of the various film manufacturers and flashlamp manufacturers. These variations are not due to any difference of opinion as to what is a correct exposure; they are due almost entirely to variations in equipment, particularly to the reflector in which the lamps are used.

It is not generally realized that reflectors have a huge effect on the amount of light reaching the subject, and differences between reflectors can, in some cases, be enormous. Consider that a bare flashlamp emits light through a complete 360° circle. Now, a simple reflector picking up half this light and reflecting it forward into 180° of a circle, will double the amount of light on the subject, reducing the exposure by one full lens stop. This is equivalent to changing a guide number, from, say, 100 to 140. This is by no means all. 180° of light is still more than is needed for all but extreme wide angle shots, and so reflectors can be made more efficient yet. The average angle of view with most normal lenses being about 45°, we can consider that a reflector that can concentrate all the light of the lamp into a 45° angle will give a "gain" over bare bulb of as much as 8 times—a difference in exposure of *3 full stops!* Even more efficient reflectors are possible, but their angle of illumination may be useful only for telephoto photography.

For this reason, the tables herein specify the reflector type to be used with each lamp, and other reflectors may result in quite large difference in results. Probably the only really consistent reflector is the flashcube since this is built-in to the lamp; however, at this time, we are not giving any recommendations for flashcube exposures because these are currently used mainly for color films with automated miniature cameras. However, if and when their use is recommended for black and white films, we shall update this material in a Supplement.

Note that in the case of Kodak, and one or two other manufacturers, that current recommendations call for the use of *blue* flashlamps with black-and-white films. Originally, blue flashlamps were designed for use with daylight type color films, for flash-fill exposures, and for occasional indoor use. Improved blue coatings have now made it possible to use blue lamps for all indoor photography with color films; to simplify matters and avoid having to stock two different types of each lamp, it was decided that blue lamps could just as well be used with black and white films also.

There is a positive benefit to this recommendation. Indoor photographs with clear flashlamps often produce a somewhat "overcorrected" effect—skin tones and lips appearing much too light in the black and white print. For full correction of this effect, of course, an X-1 filter should be used, with the appropriate factor. But a good approximate correction is accomplished simply by using blue flashlamps with no other filter at all; what we get then is pretty much the same as a daylight rendition.

For the moment, though, you will find that the recommendations for use of blue flashlamps are only in connection with roll and 35mm miniature films.

It is assumed that professionals who use sheet films may need more light for larger area coverage, and clear lamps are preferred. Hence, data for sheet films still call for clear flashlamps.

Electronic Flash Guide Numbers: Again, these guide numbers are, in most cases, those recommended by the manufacturers of the film in question. Where, however, we did not have authentic recommendations of this kind, we simply used the guide numbers given for some other film of the same ASA rating. As previously mentioned, this is perfectly valid, since that is the whole purpose of the ASA speed rating system anyway.

Note carefully, though, that these figures are given for units rated by output in either Beam Candlepower-seconds or Effective Candlepower-seconds. Since this is a measure of the actual light being projected on the subject, it includes the factor of reflector efficiency and no compensation need be made—that is, any unit having, say, 700 BCPS will produce exactly the same result as any other unit of the same rating. There will, of course, be variations in the area covered, since a given light output can be attained by high wattage and a relatively soft reflector, or lower wattage and a "hot" reflector.

Processing Information: The final data given on each page is the time and temperature information for development of the film in question, in the developers recommended by the manufacturer. As mentioned in the introduction, the data given here is for negatives of average printing contrast, and specific gammas or Contrast Index figures are not given or needed. In general, it will be found that these recommendations produce a degree of contrast suited to the major uses of the particular films. Thus development of roll and miniature films is to a lower contrast, since these films are usually printed on condenser enlargers. Sheet films are developed to a higher contrast, to suit them to diffusion enlargers or contact printers.

Naturally, it is expected that these data will be used for a starting point; it is simply not possible to provide data suitable for all the possible uses, equipment, and personal tastes of various photographers. The negatives produced by these recommended times, in the absence of gross errors such as an inaccurate thermometer, careless chemical mixing, or sloppy timing, will be easily printable with the normal range of papers.

One or two films call for special processing, by reversal, for instance. In this case, a note is made of the fact and instructions will be found in the section on Black and White Processing.

Also, for those photographers who do not wish to use the recommended developers, data on processing various films in such popular developers as Ethol UFG, Acufine, and the FR and Edwal developers, will also be found in the section on black-and-white processing.

Motion Picture Films

Many motion picture films carry the same names as popular still films. However, they are not necessarily the same in emulsion characteristics; in addition, the data required for the use of a film in motion picture work are different from those needed for still photography.

For this reason, and to prevent any possibility of confusing the still and cine versions of a given film, all data pages for motion picture films have been placed in Section 7: Motion Pictures & Slides. In addition, these data pages have all been given a special heading to distinguish them from the corresponding pages for still camera films.

CODE NOTCHES FOR KODAK BLACK-AND-WHITE SHEET FILMS

Kodak sheet films carry distinctive notches in the edge of the film; their purpose is, first, to identify the type of film in hand, and second, to indicate the emulsion position. When the notch is in the upper righthand corner of the film, the emulsion side is facing you.

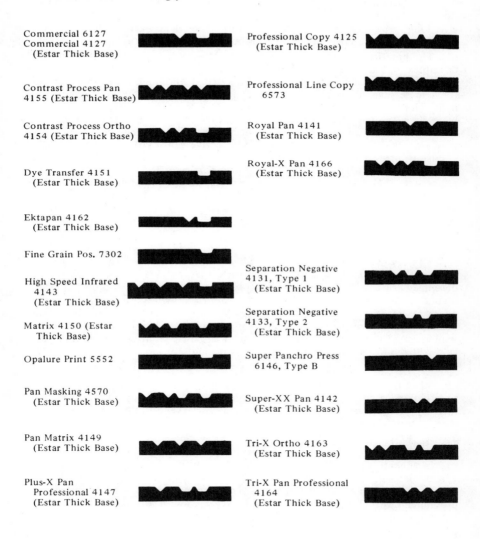

Commercial 6127
Commercial 4127
 (Estar Thick Base)

Contrast Process Pan
4155 (Estar Thick Base)

Contrast Process Ortho
4154 (Estar Thick Base)

Dye Transfer 4151
 (Estar Thick Base)

Ektapan 4162
 (Estar Thick Base)

Fine Grain Pos. 7302

High Speed Infrared
 4143
 (Estar Thick Base)

Matrix 4150 (Estar
 Thick Base)

Opalure Print 5552

Pan Masking 4570
 (Estar Thick Base)

Pan Matrix 4149
 (Estar Thick Base)

Plus-X Pan
 Professional 4147
 (Estar Thick Base)

Professional Copy 4125
 (Estar Thick Base)

Professional Line Copy
 6573

Royal Pan 4141
 (Estar Thick Base)

Royal-X Pan 4166
 (Estar Thick Base)

Separation Negative
4131, Type 1
 (Estar Thick Base)

Separation Negative
4133, Type 2
 (Estar Thick Base)

Super Panchro Press
 6146, Type B

Super-XX Pan 4142
 (Estar Thick Base)

Tri-X Ortho 4163
 (Estar Thick Base)

Tri-X Pan Professional
 4164
 (Estar Thick Base)

RECIPROCITY-LAW FAILURE WITH BLACK-AND-WHITE FILMS

All photographic emulsions are subject to an effect known as reciprocity-law failure. The term "failure" in this instance does not imply a shortcoming of the material, but merely that the law of reciprocity (Exposure = Intensity × Time) does not hold for photosensitive materials under certain conditions of exposure to light. Although the reciprocity effect is insignificant in most ordinary applications of black-and-white photography, some lighting conditions require abnormally long or abnormally short exposures. The effect can then be seen as underexposure, a change in contrast, or both.

The practical aspects of the reciprocity effect are explained in the following examples: one unit of light falling on an emulsion for 100 seconds does not have the same photographic effect as 100 units of light falling on the same emulsion for one second, although these two exposures represent the same amount of light. The longer exposure would yield an underexposed negative. On the other hand, an extremely powerful light falling on the same emulsion for a correspondingly short time—say 100,000 units of light for 1/1000 second—might also result in lower density. In other words, the effective sensitivity of a photographic emulsion varies with the illumination level and the exposure time. Furthermore, each emulsion has its greatest response at a particular level of illumination. On either side of this level, the response decreases until a situation is reached where extra exposure is needed to obtain normal density in the negative. Just where in the range of light intensity the greatest response occurs can be determined, within certain limits, when the emulsion is designed.

The Low-Intensity Effect

The low-intensity effect occurs when a film is exposed to a low level of illumination for a time much longer than that for which the emulsion was designed. For example, suppose the exposure calculated for a studio setup is one second at $f/8$. If the lens aperture is stopped down to $f/32$, the calculated exposure becomes 16 seconds, but a negative exposed for this longer time would probably be underexposed because of the reciprocity effect. If the exposure time is increased to compensate, the contrast of the image will be increased; in turn, this will require a reduction in development and still more exposure to yield a normal negative.

Since the low-intensity effect is compounded by every increase in exposure time beyond a certain level, always increase exposure by opening the lens aperture, by using a faster film, or by increasing the level of illumination, whenever these alternatives are possible.

The High-Intensity Effect

In general, the high-intensity effect occurs with exposure times shorter than 1/1000 second. Its effect can be seen as a reduction in the highest densities of a negative and can be compensated by an increase in developing time. With exposures much shorter than 1/1000 second, however, as with some types of electronic flash equipment, extra exposure may be needed as well.

Reciprocity Effect Adjustments

Because batch-to-batch variations in reciprocity characteristics of certain films are nearly as great as the differences between the reciprocity failures of different film types, it is not worth while to give adjustments for each individual type of film. Instead, the following two tables provide a starting point for adjustment of reciprocity failure for the Kodak films listed. The photographer should use these recommendations as a midpoint in bracketing his exposures

when lighting conditions are such that reciprocity failure may be encountered. These recommendations and the considerable exposure latitude of black-and-white films will usually yield a printable negative.

Since variations in negative quality caused by reciprocity effects may be difficult to isolate from those caused by the more common variables that exist in a photographic system, be sure that exposure, developing time, developer temperature, and developer activity are all under control.

TABLE I: RECIPROCITY COMPENSATION FOR KODAK PANCHROMATIC FILMS

ROLL AND 35mm FILMS	SHEET FILMS
Kodak Panatomic-X	*Kodak Ektapan 4162
Kodak Plus-X Pan	Kodak Plus-X Pan Professional 2147
Kodak Tri-X Pan	Kodak Plus-X Pan Professional 4147
Kodak Royal-X Pan	Kodak Plus-X Portrait 5067
Kodak Plus-X Pan Professional	Kodak Royal Pan 4141
Kodak Tri-X Pan Professional	Kodak Royal-X Pan 4166
	Kodak Super-XX Pan 4142
	Kodak Tri-X Pan Professional 4164

If indicated exposure time is (seconds)	Use		And in either case use this development adjustment
	Either this lens aperture adjustment	Or this exposure time adjustment (seconds)	
1/1000	None	None	10% more
1/100	None	None	None
1/10	None	None	None
1	1 stop more	2	10% less
10	2 stops more	50	20% less
100	3 stops more	1200	30% less

*Kodak Ektapan Film 4162 does not require a development time adjustment for exposures of 1/1000 second.

TABLE 2: RECIPROCITY COMPENSATION FOR KODAK BLUE-SENSITIVE FILMS

SHEET FILMS
Kodak Commercial 4127
Kodak Commercial 6127

If indicated exposure time is (seconds)	Use		And in either case use this development adjustment
	Either this lens aperture adjustment	Or this exposure time adjustment (seconds)	
1/1000	None	None	10% more
1/100	None	None	None
1/10	None	None	10% less
1	None	None	20% less
10	½ stop more	15	30% less
100	1 stop more	300	40% less

BLACK-AND-WHITE STILL-CAMERA FILMS

FILM NAME AND FORMAT	COLOR SENSITIVITY	FILM SPEED	DESCRIPTION OR USE
DU PONT			
Cronar Data Recording 35mm Film	Panchromatic		Negative or reversal instrumentation film
FUJI			
Fujipan K (126)	Panchromatic	125	Medium-speed amateur film
Neopan SSS (35mm, 127, and 120 roll)	Panchromatic	200	Fast amateur film
ILFORD			
Commercial Ortho sheet film	Orthochromatic	D-80, T-40	Commercial and copying film
FP-4 35mm, roll, and sheet film	Panchromatic	125	Medium-speed general purpose film
HP-5 35mm, roll, and sheet film	Panchromatic	400	Fast film for news, sports, available-light
Pan-F 35mm film	Panchromatic	50	Slow, very fine-grain film for big prints
KODAK			
Commercial sheet film	Blue-sensitive	D-50, T-16	Slow film for commercial use and copying
Contrast Process Ortho sheet film	Orthochromatic	T-50	Slow ortho film for line copying, high contrast
Contrast Process Pan sheet film	Panchromatic	T-80	Slow pan film for line copying, high contrast
Direct Positive Pan film, 35mm	Panchromatic	D-80, T-64	Reversal film for black-and-white transparencies
Ektapan sheet film	Panchromatic	100	Medium-speed, general-purpose sheet film
High Contrast Copy Film, 35mm	Panchromatic	T-64	Ultra-fine-grain film for microcopying
High Speed Infrared 35mm and sheet film	Infrared	D-80, T-200	Infrared film
Panatomic-X 35mm and roll film	Panchromatic	32	Slow, fine-grain film for big prints
Plus-X Pan, Plus-X Pan Professional, Plus-X Pan Portrait, 35mm, roll, sheet film	Panchromatic	125	Medium-speed, general purpose film
Professional Copy sheet film	Orthochromatic	T-12	Slow, special-purpose copying film
Professional Line Copy sheet film	Orthochromatic	T-3	High-contrast, slow, line copying film
Panchromatic Film 2484 (35mm)	Panchromatic	1000–3200	Ultra-speed instrumentation film
RAR Film 2479	Panchromatic	400	Fast pan film for instrumentation
RAR Film 2496	Panchromatic	80	Slow film, for rapid access processing
RAR Film 2498 and 5498	Panchromatic	250	Medium-speed film for rapid access processing
Recording Film 2475	Panchromatic	1000–3200	Ultra-speed instrumentation film
Recording Film 2485	Panchromatic	800–8000	Ultra-speed instrumentation film
Royal-X Pan roll and sheet film	Panchromatic	1250	Fast available-light film

FILM NAME AND FORMAT	COLOR SENSITIVITY	FILM SPEED	DESCRIPTION OR USE
KODAK (Concluded)			
Royal Pan sheet film	Panchromatic	400	Fast commercial and news film
Super Panchro Press Type B sheet film	Panchromatic	250	Medium-speed commercial and news film
Super-Speed Direct Positive Paper	Orthochromatic	20–25	Direct positive paper for coin operated cameras
Super-XX Panchromatic sheet film	Panchromatic	200	Medium-fast general purpose film
Tri-X Ortho sheet film	Orthochromatic	D-320, T-200	Medium-fast commercial and portrait film
Tri-X Pan sheet film	Panchromatic	320	Fast pan portrait film
Tri-X Pan Professional roll film	Panchromatic	320	Fast pan roll film for press work
Tri-X Pan 35mm film	Panchromatic	400	Fast film for miniature cameras
Verichrome Pan roll film	Panchromatic	125	Medium speed amateur and snapshot film
POLAROID			
Film Packet Type 52	Panchromatic	400	Normal speed film for outdoor use
Film Packet Type 55 P/N and Pack No. 665	Panchromatic	75	Slow film producing usable negative and print
Film Packet Type 57 and Pack No. 107	Panchromatic	3000	Ultra-speed available-light film
Film Packet Type 51	Blue-sensitive	D-200, T-64	High contrast material for line copying
Film Pack No. 664	Panchromatic	500	Long-scale black-and-white print film
Film Pack No. 667	Panchromatic	2500	Ultra-speed, coaterless, black-and-white print film
VTE FILMS			
H & W Control VTE Panchromatic film	Panchromatic	80	Medium-speed, ultra-fine-grain, high-resolution film
H & W Control VTE Ultra Pan Film	Panchromatic	25	Slow, ultra-fine-grain, high-resolution film

DUPONT CRONAR DATA RECORDING FILM (35mm)

Safelight: *Total darkness required.* A Safelight Filter Series 3 (dark green), in a suitable safelight lamp with a 15-watt bulb can be used for a few seconds *only*, at 4 feet, after development is half completed.

Speed: Negative: ASA Daylight 160, Tungsten 125
Reversal: ASA Daylight 320, Tungsten 250

Daylight Exposure: *(See Introduction to this section)* 1/200 sec. at *f*/16

Color Sensitivity: Panchromatic

Filter Factors: Increase normal exposure by filter factor given below:

Kodak Wratten Filter	No. 6 (K1)	No. 8 (K2)	No. 15 (G)	No. 11 (X1)	No. 29 (F)	No. 25 (A)	No. 58 (B)	No. 47 (C5)	Pola-Screen
Daylight	—	—	—	—	—	8	6	10	2.5
Photoflood or high-efficiency tungsten	—	—	—	—	—	—	—	—	2.5

*For correct gray-tone rendering of colored objects.

Flash Exposure Guide Numbers: To get f-number, divide guide number by flash-to-subject distance in feet, taken to a point midway between nearest and farthest details of interest. In small white rooms, use one stop smaller.

Synchronization: X or F			M			Focal-Plane	
Shutter Speed	M2B‡	M3B‡, M5B‡ 5B§, 25B§	AG-1B†	Flash Cube		Shutter Speed	6B§ 26B§
Open. 1/25	170	240	130	90		1/50	180
1/50	—	220	130	90		1/100	120
1/100	—	190	110	70		1/250	90
1/200	—	150	90	55		1/500	60
1/400	—	110	70	45			

Bowl-Shaped Polished Reflector Sizes: †2-inch; ‡3-inch; §4- to 5-inch; ‖6- to 7-inch. If shallow cylindrical reflectors are used, divide these guide numbers by two.
Note: At 1/25 second, cameras having X or F synchronization can use any of the flashbulbs listed under M synchronization.
Caution: Since bulbs may shatter when flashed, the use of a flashguard over the reflector is recommended. *Do not flash bulbs in an explosive atmosphere.*

Electronic Flash Guide Numbers: This table is intended as a starting point in determining the correct guide number. The table is for use with equipment rated in beam candlepower-seconds (BCPS) or effective candlepower-seconds (ECPS). Divide the appropriate guide number by the flash-to-subject distance in feet to determine the f-number for average subjects.

Output of Unit (BCPS or ECPS)	350	500	700	1000	1400	2000	2800	4000	5600	8000
Guide Number for Trial	55	65	75	90	110	130	150	180	210	250

Develop at approximate times and temperatures given below:

Developer	Developing Times (in Minutes)									
	Small Tank*					Large Tank †				
	65 F	68 F	70 F	72 F	75 F	65 F	68 F	70 F	72 F	75 F
Dupont 6D	—	4½	—	—	—	—	—	—	—	—
Kodak D-19	—	1½	—	—	—	—	—	—	—	—
Kodak D-76	—	4½	—	—	—	—	—	—	—	—

*Agitation at 30-second intervals during development.
†Agitation at 1-minute intervals during development.
‡For greatest sharpness (see developer instructions).
§Dilution A is a 1:15 dilution of the developer concentrate; Dilution B is a 1:31 dilution of the developer concentrate.

FUJIPAN K FILM (126)

Safelight: *Total darkness required.* A Safelight Filter Series 3 (dark green), in a suitable safelight lamp with a 15-watt bulb can be used for a few seconds *only*, at 4 feet, after development is half completed.

Speed: ASA 125

Daylight Exposure: *(See Introduction to this section)* 1/125 sec. at $f/16$

Color Sensitivity: Panchromatic

Filter Factors: Increase normal exposure by filter factor given below:

Kodak Wratten Filter	No. 6 (K1)	No. 8 (K2)	No. 15 (G)	No. 11 (X1)	No. 29 (F)	No. 25 (A)	No. 58 (B)	No. 47 (C5)	Pola-Screen
Daylight	1.5	2*	3	4	—	8	—	—	2.5
Photoflood or high-efficiency tungsten	1.3	1.5	2	3*	—	6	—	—	2.5

*For correct gray-tone rendering of colored objects.

Flash Exposure Guide Numbers: To get f-number, divide guide number by flash-to-subject distance in feet, taken to a point midway between nearest and farthest details of interest. In small white rooms, use one stop smaller.

Synchronization: X or F			M		Focal-Plane	6B§
Shutter Speed	Flash Cube	M3B‡, M5B‡ 5B§, 25B§	AG-1B†	AG-3B†	Shutter Speed	26B§
Open, 1/25	80	220	110	140	1/50	160
1/50	80	200	110	140	1/100	110
1/100	60	160	95	110	1/250	80
1/200	50	130	80	90	1/500	55
1/400	40	100	60	70		

Bowl-Shaped Polished Reflector Sizes: †2-inch; ‡3-inch; §4- to 5-inch; ‖6- to 7-inch. If shallow cylindrical reflectors are used, divide these guide numbers by two.
Note: At 1/25 second, cameras having X or F synchronization can use any of the flashbulbs listed under M synchronization.
Caution: Since bulbs may shatter when flashed, the use of a flashguard over the reflector is recommended. *Do not flash bulbs in an explosive atmosphere.*

Electronic Flash Guide Numbers: This table is intended as a starting point in determining the correct guide number. The table is for use with equipment rated in beam candlepower-seconds (BCPS) or effective candlepower-seconds (ECPS). Divide the appropriate guide number by the flash-to-subject distance in feet to determine the f-number for average subjects.

Output of Unit (BCPS or ECPS)	350	500	700	1000	1400	2000	2800	4000	5600	8000
Guide Number for Trial	45	55	65	80	95	110	130	160	190	220

Develop at approximate times and temperatures given below:

Developer	Developing Times (in Minutes)									
	Small Tank*					Large Tank †				
	65 F	68 F	70 F	72 F	75 F	65 F	68 F	70 F	72 F	75 F
Fujidol	—	7	—	—	—	—	—	—	—	—
Fuji Minidol	—	—	—	—	—	—	7½	—	—	—
Fuji Microfine	—	10	—	—	—	—	—	—	—	—
Fuji Finedol	—	—	—	—	—	—	10½	—	—	—
Kodak D-76	8½	7½	7	6½	6	9½	8½	8	7½	6½

*Agitation at 30-second intervals during development.
†Agitation at 1-minute intervals during development.
‡For greatest sharpness (see developer instructions).
§Dilution A is a 1:15 dilution of the developer concentrate; Dilution B is a 1:31 dilution of the developer concentrate.

FUJI NEOPAN SSS FILM (135 Cartridge)

Safelight: *Total darkness required.* A Safelight Filter Series 3 (dark green), in a suitable safelight lamp with a 15-watt bulb can be used for a few seconds *only*, at 4 feet, after development is half completed.

Speed: ASA 200

Daylight Exposure: *(See Introduction to this section)* 1/200 sec. at *f*/16

Color Sensitivity: Panchromatic

Filter Factors: Increase normal exposure by filter factor given below:

Kodak Wratten Filter	No. 6 (K1)	No. 8 (K2)	No. 15 (G)	No. 11 (X1)	No. 29 (F)	No. 25 (A)	No. 58 (B)	No. 47 (C5)	Pola-Screen
Daylight	1.5	2*	3	4	—	8	—	—	2.5
Photoflood or high-efficiency tungsten	1.3	1.5	2	3*	—	6	—	—	2.5

*For correct gray-tone rendering of colored objects.

Flash Exposure Guide Numbers: To get f-number, divide guide number by flash-to-subject distance in feet, taken to a point midway between nearest and farthest details of interest. In small white rooms, use one stop smaller.

Synchronization: X or F			M			Focal-Plane	
Shutter Speed	Flash Cube	M3B‡, M5B‡ 5B§, 25B§	AG-1B†	AG-3B†		Shutter Speed	6B§ 26B§
Open, 1/25	130	280	160	—		1/50	220
1/50	90	240	125	—		1/100	140
1/100	75	230	—	—		1/250	100
1/200	60	200	—	—		1/500	70
1/400	40	160	—	—			

Bowl-Shaped Polished Reflector Sizes: †2-inch; ‡3-inch; §4- to 5-inch; ‖6- to 7-inch. If shallow cylindrical reflectors are used, divide these guide numbers by two.
Note: At 1/25 second, cameras having X or F synchronization can use any of the flashbulbs listed under M synchronization.

Caution: Since bulbs may shatter when flashed, the use of a flashguard over the reflector is recommended. *Do not flash bulbs in an explosive atmosphere.*

Electronic Flash Guide Numbers: This table is intended as a starting point in determining the correct guide number. The table is for use with equipment rated in beam candlepower-seconds (BCPS) or effective candlepower-seconds (ECPS). Divide the appropriate guide number by the flash-to-subject distance in feet to determine the f-number for average subjects.

Output of Unit (BCPS or ECPS)	350	500	700	1000	1400	2000	2800	4000	5600	8000
Guide Number for Trial	60	70	85	100	120	140	170	200	240	280

Develop at approximate times and temperatures given below:

Developer	Developing Times (in Minutes)									
	Small Tank*					Large Tank †				
	65 F	68 F	70 F	72 F	75 F	65 F	68 F	70 F	72 F	75 F
Fujidol	—	8	—	—	—	—	—	—	—	—
Fuji Minidol	—	—	—	—	—	—	8	—	—	—
Fuji Microfine	—	12	—	—	—	—	—	—	—	—
Fuji Finedol	—	—	—	—	—	—	12	—	—	—
Fuji Pandol	9	7	6	5½	5	—	—	—	—	—
Kodak D-76	9	8	7½	7	6	10	9	8½	8	7

*Agitation at 30-second intervals during development.
†Agitation at 1-minute intervals during development.
‡For greatest sharpness (see developer instructions).
§Dilution A is a 1:15 dilution of the developer concentrate; Dilution B is a 1:31 dilution of the developer concentrate.

FUJI NEOPAN SSS FILM (120 & 127 Rolls)

Safelight: *Total darkness required.* A Safelight Filter Series 3 (dark green), in a suitable safelight lamp with a 15-watt bulb can be used for a few seconds *only,* at 4 feet, after development is half completed.

Speed: ASA 200

Daylight Exposure: *(See Introduction to this section)* 1/200 sec. at f/16

Color Sensitivity: Panchromatic

Filter Factors: Increase normal exposure by filter factor given below:

Kodak Wratten Filter	No. 6 (K1)	No. 8 (K2)	No. 15 (G)	No. 11 (X1)	No. 29 (F)	No. 25 (A)	No. 58 (B)	No. 47 (C5)	Pola-Screen
Daylight	1.5	2*	3	4	—	8	—	—	2.5
Photoflood or high-efficiency tungsten	1.3	1.5	2	3*	—	6	—	—	2.5

*For correct gray-tone rendering of colored objects.

Flash Exposure Guide Numbers: To get f-number, divide guide number by flash-to-subject distance in feet, taken to a point midway between nearest and farthest details of interest. In small white rooms, use one stop smaller.

Synchronization: X or F		M			Focal-Plane Shutter Speed	6B§ 26B§
Shutter Speed	Flash Cube	M3B‡, M5B‡ 5B§, 25B§	AG-1B†	AG-3B†		
Open, 1/25	130	280	160	—	1/50	220
1/50	90	240	125	—	1/100	140
1/100	75	230	—	—	1/250	100
1/200	60	200	—	—	1/500	70
1/400	40	160	—	—		

Bowl-Shaped Polished Reflector Sizes: †2-inch; ‡3-inch; §4- to 5-inch; ‖6- to 7-inch. If shallow cylindrical reflectors are used, divide these guide numbers by two.
Note: At 1/25 second, cameras having X or F synchronization can use any of the flashbulbs listed under M synchronization.

Caution: Since bulbs may shatter when flashed, the use of a flashguard over the reflector is recommended. *Do not flash bulbs in an explosive atmosphere.*

Electronic Flash Guide Numbers: This table is intended as a starting point in determining the correct guide number. The table is for use with equipment rated in beam candlepower-seconds (BCPS) or effective candlepower-seconds (ECPS). Divide the appropriate guide number by the flash-to-subject distance in feet to determine the f-number for average subjects.

Output of Unit (BCPS or ECPS)	350	500	700	1000	1400	2000	2800	4000	5600	8000
Guide Number for Trial	60	70	85	100	120	140	170	200	240	280

Develop at approximate times and temperatures given below:

Developer	Developing Times (in Minutes)									
	Small Tank*					Large Tank †				
	65 F	68 F	70 F	72 F	75 F	65 F	68 F	70 F	72 F	75 F
Fujidol	—	8	—	—	—	—	—	—	—	—
Fuji Minidol	—	—	—	—	—	10	8	7½	7	6
Fuji Microfine	13	11	9½	8½	7	—	—	—	—	—
Fuji Finedol	—	—	—	—	—	—	11	—	—	—
Fuji Pandol	—	7	—	—	—	—	—	—	—	—
Kodak D-76	9	8	7½	7	6	10	9	8½	8	7

*Agitation at 30-second intervals during development.
†Agitation at 1-minute intervals during development.

H & W CONTROL VTE PANCHROMATIC FILM
(35mm and 120 Roll Film)

Safelight: *Total darkness required.* A Safelight Filter Series 3 (dark green), in a suitable safelight lamp with a 15-watt bulb can be used for a few seconds *only*, at 4 feet, after development is half completed.

Speed: ASA 80

Daylight Exposure: *(See Introduction to this section)* 1/100 sec. at *f*/12.5

Color Sensitivity: Panchromatic

Filter Factors: Increase normal exposure by filter factor given below:

Kodak Wratten Filter	No. 6 (K1)	No. 8 (K2)	No. 15 (G)	No. 11 (X1)	No. 29 (F)	No. 25 (A)	No. 58 (B)	No. 47 (C5)	Pola-Screen
Daylight Photoflood or high-efficiency tungsten				NOT GIVEN					

*For correct gray-tone rendering of colored objects.

Flash Exposure Guide Numbers: To get *f*/number, divide guide number by flash-to-subject distance in feet, taken to a point midway between nearest and farthest details of interest. In small white rooms, use one stop smaller.

Synchronization:	X or F		M			Focal-Plane	6§
Shutter Speed	AG-1† M2‡	M3‡, M5‡ 5§, 25§	11‖ 40‖	2‖ 22‖		Shutter Speed	26§
Open. 1/25	120	230	240	340		1/50	165
1/50	100	200	200	320		1/100	120
1/100	—	160	170	250		1/250	85
1/200	—	105	110	190		1/500	60
1/400	—	—	—	—		—	—

Bowl-Shaped Polished Reflector Sizes: †2-inch; ‡3-inch; §4- to 5-inch; ‖6- to 7-inch. If shallow cylindrical reflectors are used, divide these guide numbers by two.
Note: At 1/25 second, cameras having X or F synchronization can use any of the flashbulbs listed under M synchronization.

Caution: Since bulbs may shatter when flashed, the use of a flashguard over the reflector is recommended. *Do not flash bulbs in an explosive atmosphere.*

Electronic Flash Guide Numbers: This table is intended as a starting point in determining the correct guide number. The table is for use with equipment rated in beam candlepower-seconds (BCPS) or effective candlepower-seconds (ECPS). Divide the appropriate guide number by the flash-to-subject distance in feet to determine the *f*/number for average subjects.

Output of Unit (BCPS or ECPS)	350	500	700	1000	1400	2000	2800	4000	5600	8000
Guide Number for Trial	40	45	55	65	80	90	110	130	160	180

Develop at approximate times and temperatures given below:

Developer	Developing Times (in Minutes)									
	Continuous Agitation (Tray)					Intermittent Agitation (Tank)*				
	65 F	68 F	70 F	72 F	75 F	65 F	68 F	70 F	72 F	75 F
H & W Control	—	—	—	—	—	15	14	13½	13	12

*Agitation at 30-second intervals during development.
†Development times of less than 5 minutes in a tank may produce poor uniformity and should be avoided.

H & W CONTROL VTE ULTRA PAN FILM (35 MM)

Safelight: *Total darkness required.* A Safelight Filter Series 3 (dark green), in a suitable safelight lamp with a 15-watt bulb can be used for a few seconds *only,* at 4 feet, after development is half completed.

Speed: ASA 25

Daylight Exposure: *(See Introduction to this section)* 1/25 sec. at *f*/16

Color Sensitivity: Panchromatic

Filter Factors: Increase normal exposure by filter factor given below:

Kodak Wratten Filter	No. 6 (K1)	No. 8 (K2)	No. 15 (G)	No. 11 (X1)	No. 29 (F)	No. 25 (A)	No. 58 (B)	No. 47 (C5)	Pola-Screen
Daylight Photoflood or high-efficiency tungsten					NOT GIVEN				

*For correct gray-tone rendering of colored objects.

Flash Exposure Guide Numbers: To get *f*/number, divide guide number by flash-to-subject distance in feet, taken to a point midway between nearest and farthest details of interest. In small white rooms, use one stop smaller.

Synchronization: X or F		M			Focal-Plane	6§
Shutter Speed	AG-1† M2‡	M3‡, M5‡ 5§, 25§	11‖ 40‖	2‖ 22‖	Shutter Speed	26§
Open. 1/25	70	130	160	220	1/50	130
1/50	55	120	130	170	1/100	70
1/100	48	100	120	160	1/250	50
1/200	34	90	80	130	1/500	34
1/400	28	70	65	100		

Bowl-Shaped Polished Reflector Sizes: †2-inch; ‡3-inch; §4- to 5-inch; ‖6- to 7-inch. If shallow cylindrical reflectors are used, divide these guide numbers by two.
Note: At 1/25 second, cameras having X or F synchronization can use any of the flashbulbs listed under M synchronization.

Caution: Since bulbs may shatter when flashed, the use of a flashguard over the reflector is recommended. *Do not flash bulbs in an explosive atmosphere.*

Electronic Flash Guide Numbers: This table is intended as a starting point in determining the correct guide number. The table is for use with equipment rated in beam candlepower-seconds (BCPS) or effective candlepower-seconds (ECPS). Divide the appropriate guide number by the flash-to-subject distance in feet to determine the *f*/number for average subjects.

Output of Unit (BCPS or ECPS)	350	500	700	1000	1400	2000	2800	4000	5600	8000
Guide Number for Trial	20	24	30	35	40	50	60	70	85	100

Develop at approximate times and temperatures given below:

Developer	Developing Times (in Minutes)									
	Continuous Agitation (Tray)					Intermittent Agitation (Tank)*				
	65 F	68 F	70 F	72 F	75 F	65 F	68 F	70 F	72 F	75 F
H & W Control diluted 10.5 ml in 8 oz.	—	—	—	—	—	—	12	—	11	10½

*Agitation at 30-second intervals during development.
†Development times of less than 5 minutes in a tank may produce poor uniformity and should be avoided.

ILFORD COMMERCIAL ORTHO SHEET FILM

Safelight: A Safelight Filter Series 2 (red) in a suitable safelight lamp with a 15-watt bulb can be used at 4 feet.

Speed: ASA 80 Daylight, 40 Tungsten

Daylight Exposure: *(See Introduction to this section)* 1/100 sec. at f/12.5

Color Sensitivity: Orthochromatic

Filter Factors: Increase normal exposure by filter factor given below:

Kodak Wratten Filter	No. 6 (K1)	No. 8 (K2)	No. 15 (G)	No. 11 (X1)	No. 29 (F)	No. 25 (A)	No. 58 (B)	No. 47 (C5)	Pola- Screen
Daylight	—	—	—	—	—	—	—	—	2.5
Photoflood or high- efficiency tungsten	—	—	—	—	—	—	—	—	2.5

*For correct gray-tone rendering of colored objects.

Flash Exposure Guide Numbers: To get f/number, divide guide number by flash-to-subject distance in feet, taken to a point midway between nearest and farthest details of interest. In small white rooms, use one stop smaller.

Synchronization: X or F				M	Focal-Plane Shutter Speed	6§ 26§
Shutter Speed	AG-1† M2‡	M3‡, M5‡ 5§, 25§	11‖ 40‖	2‖ 22‖		
Open. 1/25	90	170	200	280	1/50	120
1/50	70	150	170	220	1/100	85
1/100	60	130	150	200	1/250	60
1/200	44	110	100	160	1/500	45
1/400	36	90	80	130	—	—

Bowl-Shaped Polished Reflector Sizes: †2-inch; ‡3-inch; §4- to 5-inch; ‖6- to 7-inch. If shallow cylindrical reflectors are used, divide these guide numbers by two.
Note: At 1/25 second, cameras having X or F synchronization can use any of the flashbulbs listed under M synchronization.

Caution: Since bulbs may shatter when flashed, the use of a flashguard over the reflector is recommended. *Do not flash bulbs in an explosive atmosphere.*

Electronic Flash Guide Numbers: This table is intended as a starting point in determining the correct guide number. The table is for use with equipment rated in beam candlepower-seconds (BCPS) or effective candlepower-seconds (ECPS). Divide the appropriate guide number by the flash-to-subject distance in feet to determine the f/number for average subjects.

Output of Unit (BCPS or ECPS)	350	500	700	1000	1400	2000	2800	4000	5600	8000
Guide Number for Trial	40	45	55	65	80	90	110	130	160	180

Develop at approximate times and temperatures given below:

Developer	Developing Times (in Minutes)									
	Continuous Agitation (Tray)					Intermittent Agitation (Tank)*				
	65 F	68 F	70 F	72 F	75 F	65 F	68 F	70 F	72 F	75 F
ID-2 (1:2)	6	5	4½	4	3½	—	—	—	—	—
ID-11	—	—	—	—	—	12	10	9	8	7
Bromophen	—	3¾	—	—	—	—	7½	—	—	—
Kodak D-76	—	—	—	—	—	12	10	9	8	7

*Agitation at 30-second intervals during development.
†Development times of less than 5 minutes in a tank may produce poor uniformity and should be avoided.

ILFORD FP-4 ROLL, 126 CARTRIDGE, AND 35MM FILM

Safelight: *Total darkness required.* A Safelight Filter Series 3 (dark green), in a suitable safelight lamp with a 15-watt bulb can be used for a few seconds *only,* at 4 feet, after development is half completed.

Speed: ASA 125

Daylight Exposure: *(See Introduction to this section)* 1/125 sec. at f/16

Color Sensitivity: Panchromatic

Filter Factors: Increase normal exposure by filter factor given below:

Wratten Filter Ilford Filter	No. 86B 104	No. 9 109	No. 15 —	No. 11 402	No. 22 202	No. 25 204	No. 58 404	No. 47 304	Pola- Screen
Daylight	1.5	2	—	3.5	5	6	6	7	2.5
Photoflood or high- efficiency tungsten	1.3	1.5	—	4*	2.2	4	6	13	2.5

*For correct gray-tone rendering of colored objects.

Flash Exposure Guide Numbers: To get f-number, divide guide number by flash-to-subject distance in feet, taken to a point midway between nearest and farthest details of interest. In small white rooms, use one stop smaller.

Synchronization			M			Focal-Plane	6B§
Shutter Speed	Flash Cube	M3B‡, M5B‡ 5B§, 25B§	AG-1B†	AG-3B†		Shutter Speed	26B§
Open. 1/25	80	220	110	140		1/50	160
1/50	80	200	110	140		1/100	110
1/100	60	160	95	110		1/250	80
1/200	50	130	80	90		1/500	55
1/400	40	100	60	70			

Bowl-shaped Polished Reflector Sizes: †2-inch; ‡3-inch; §4- to 5-inch. If shallow cylindrical reflectors are used, divide these guide numbers by two.
Note: At 1/25 second, cameras having X or F synchronization can use any of the flashbulbs listed under M synchronization.

Caution: Since bulbs may shatter when flashed, the use of a flashguard over the reflector is recommended. *Do not flash bulbs in an explosive atmosphere.*

Electronic Flash Guide Numbers: This table is intended as a starting point in determining the correct guide number. The table is for use with equipment rated in beam candlepower-seconds (BCPS) or effective candlepower-seconds (ECPS). Divide the appropriate guide number by the flash-to-subject distance in feet to determine the f-number for average subjects.

Output of Unit (BCPS or ECPS)	350	500	700	1000	1400	2000	2800	4000	5600	8000
Guide Number for Trial	45	55	65	80	95	110	130	160	190	220

Develop at approximate times and temperatures given below:

Developer	Developing Times (in Minutes)									
	Small Tank*					Large Tank †				
	65 F	68 F	70 F	72 F	75 F	65 F	68 F	70 F	72 F	75 F
Ilford ID-11	7½	6	5½	5	4½	—	—	—	—	—
‡Ilford Microphen	6½	5½	5	4½	3¾	—	—	—	—	—
§Ilford Perceptol	9	8	7	6½	5½	—	—	—	—	—
Kodak D-76	7½	6	5½	5	4½	—	—	—	—	—
§Kodak Microdol-X	9	8	7	6½	5½	—	—	—	—	—

*Agitation at 30-second intervals during development.
†Agitation at 1-minute intervals during development.
‡Expose at ASA 200.
§Expose at ASA 64.

ILFORD HP-5 ROLL & 35MM FILM

Safelight: *Total darkness required.* A Safelight Filter Series 3 (dark green), in a suitable safelight lamp with a 15-watt bulb can be used for a few seconds *only*, at 4 feet, after development is half completed.

Speed: ASA 400

Daylight Exposure: *(See Introduction to this section)* 1/250 sec. at *f*/16.

Color Sensitivity: Panchromatic

Filter Factors: Increase normal exposure by filter factor given below:

Wratten Filter Ilford Filter	No. 86B 104	No. 9 109	No. 15 —	No. 11 402	No. 22 202	No. 25 204	No. 58 404	No. 47 304	Pola- Screen
Daylight	1.5	2	—	3.5	5	6	6	7	2.5
Photoflood or high- efficiency tungsten	1.3	1.5	—	4*	2.2	4	6	13	2.5

*For correct gray-tone rendering of colored objects.

Flash Exposure Guide Numbers: To get f-number, divide guide number by flash-to-subject distance in feet, taken to a point midway between nearest and farthest details of interest. In small white rooms, use one stop smaller.

Synchronization		M				Focal-Plane	6B§
Shutter Speed	Flash Cube	M3B‡, M5B‡ 5B§, 25B§	AG-1B†	AG-3B†		Shutter Speed	26B§
Open. 1/25	140	400	200	250		1/50	240
1/50	130	350	200	250		1/100	140
1/100	110	290	170	200		1/250	135
1/200	90	240	140	160		1/500	100
1/400	75	170	110	120			

Bowl-Shaped Polished Reflector Sizes: †2-inch; ‡3-inch; §4- to 5-inch; ‖6- to 7-inch. If shallow cylindrical reflectors are used, divide these guide numbers by two.
Note: At 1/25 second, cameras having X or F synchronization can use any of the flashbulbs listed under M synchronization.

Caution: Since bulbs may shatter when flashed, the use of a flashguard over the reflector is recommended. *Do not flash bulbs in an explosive atmosphere.*

Electronic Flash Guide Numbers: This table is intended as a starting point in determining the correct guide number. The table is for use with equipment rated in beam candlepower-seconds (BCPS) or effective candlepower-seconds (ECPS). Divide the appropriate guide number by the flash-to-subject distance in feet to determine the f-number for average subjects.

Output of Unit (BCPS or ECPS)	350	500	700	1000	1400	2000	2800	4000	5600	8000
Guide Number for Trial	85	100	120	140	170	200	240	280	340	400

Develop at approximate times and temperatures given below:

	Developing Times (in Minutes)									
Developer	Small Tank*					Large Tank †				
	65 F	68 F	70 F	72 F	75 F	65 F	68 F	70 F	72 F	75 F
Ilford ID-11	7½	7	5½	5	4½	—	—	—	—	—
‡Ilford Microphen	7	6	5	4½	4	—	—	—	—	—
§Ilford Perceptol	12	11	10	9	8	—	—	—	—	—
Kodak D-76	7½	7	5½	5	4½	—	—	—	—	—
§Kodak Microdol-X	12	11	10	9	8	—	—	—	—	—

*Agitation at 30-second intervals during development.
†Agitation at 1-minute intervals during development.
‡Expose at ASA 500.
§ Expose at ASA 200.

ILFORD PAN F 35MM FILM

Safelight: *Total darkness required.* A Safelight Filter Series 3 (dark green), in a suitable safelight lamp with a 15-watt bulb can be used for a few seconds *only,* at 4 feet, after development is half completed.

Speed: ASA 50

Daylight Exposure: *(See Introduction to this section)* 1/50 sec. at *f*/16

Color Sensitivity: Panchromatic

Filter Factors: Increase normal exposure by filter factor given below:

Wratten Filter Ilford Filter	No. 86B 104	No. 9 109	No. 15 —	No. 11 402	No. 22 202	No. 25 204	No. 58 404	No. 47 304	Pola- Screen
Daylight	1.5	2	—	3.5	5	6	6	7	2.5
Photoflood or high- efficiency tungsten	1.3	1.5	—	4	2.2	4	6	13	2.5

*For correct gray-tone rendering of colored objects.

Flash Exposure Guide Numbers: To get f-number, divide guide number by flash-to-subject distance in feet, taken to a point midway between nearest and farthest details of interest. In small white rooms, use one stop smaller.

Synchronization		M			Focal-Plane	6B§
Shutter Speed	Flash Cube	M3B‡, M5B‡ 5B§, 25B§	AG-1B†	AG-3B†	Shutter Speed	26B§
Open. 1/25	55	150	80	100	1/50	110
1/50	55	140	80	100	1/100	80
1/100	45	120	70	80	1/250	55
1/200	36	95	55	65	1/500	38
1/400	28	70	45	50	—	—

Bowl-Shaped Polished Reflector Sizes: †2-inch; ‡3-inch; §4- to 5-inch; ‖6- to 7-inch. If shallow cylindrical reflectors are used, divide these guide numbers by two.
Note: At 1/25 second, cameras having X or F synchronization can use any of the flashbulbs listed under M synchronization.

Caution: Since bulbs may shatter when flashed, the use of a flashguard over the reflector is recommended. *Do not flash bulbs in an explosive atmosphere.*

Electronic Flash Guide Numbers: This table is intended as a starting point in determining the correct guide number. The table is for use with equipment rated in beam candlepower-seconds (BCPS) or effective candlepower-seconds (ECPS). Divide the appropriate guide number by the flash-to-subject distance in feet to determine the f-number for average subjects.

Output of Unit (BCPS or ECPS)	350	500	700	1000	1400	2000	2800	4000	5600	8000
Guide Number for Trial	30	35	40	45	55	65	80	90	110	130

Develop at approximate times and temperatures given below:

Developer	Developing Times (in Minutes)									
	Small Tank*					Large Tank †				
	65 F	68 F	70 F	72 F	75 F	65 F	68 F	70 F	72 F	75 F
Ilford ID-11	6½	5½	5	4½	3¾	—	—	—	—	—
‡Ilford Microphen	—	3	—	—	—	—	—	—	—	—
§Ilford Perceptol	9½	8½	7½	6½	5½	—	—	—	—	—
Kodak D-76	6½	5½	5	4½	3¾	—	—	—	—	—
§Kodak Microdol-X	9½	8½	7½	6½	5½	—	—	—	—	—

*Agitation at 30-second intervals during development.
†Agitation at 1-minute intervals during development.
‡Expose at ASA 80.
§Expose at ASA 25.

Safelight: A Safelight Filter Series 1 (red), in a suitable safelight lamp with a 15-watt bulb can be used at 4 feet.

Speed: ASA Daylight 50 — Tungsten 8

Daylight Exposure: *(See Introduction to this section)* 1/50 sec. at *f*/16

Color Sensitivity: Blue only

Filter Factors: Increase normal exposure by filter factor given below:

Kodak Wratten Filter	No. 6 (K1)	No. 8 (K2)	No. 15 (G)	No. 11 (X1)	No. 29 (F)	No. 25 (A)	No. 58 (B)	No. 47 (C5)	Pola-Screen
Daylight	—	—	—	—	—	—	—	—	2.5
Photoflood or high-efficiency tungsten	—	—	—	—	—	—	—	—	2.5

*For correct gray-tone rendering of colored objects.

Flash Exposure Guide Numbers: To get f-number, divide guide number by flash-to-subject distance in feet, taken to a point midway between nearest and farthest details of interest. In small white rooms, use one stop smaller.

Synchronization		M			Focal-Plane	6B§
Shutter Speed	Flash Cube	M3B‡, M5B‡ 5B§, 25B§	AG-1B†	AG-3B†	Shutter Speed	26B§
Open. 1/25	40	110	60	—	1/50	80
1/50	38	100	60	—	1/100	55
1/100	32	80	50	—	1/250	38
1/200	26	65	40	—	1/500	28
1/400	20	50	30	—		

Bowl-Shaped Polished Reflector Sizes: †2-inch; ‡3-inch; §4- to 5-inch; ‖6- to 7-inch. If shallow cylindrical reflectors are used, divide these guide numbers by two.
Note: At 1/25 second, cameras having X or F synchronization can use any of the flashbulbs listed under M synchronization.

Caution: Since bulbs may shatter when flashed, the use of a flashguard over the reflector is recommended. *Do not flash bulbs in an explosive atmosphere.*

Electronic Flash Guide Numbers: This table is intended as a starting point in determining the correct guide number. The table is for use with equipment rated in beam candlepower-seconds (BCPS) or effective candlepower-seconds (ECPS). Divide the appropriate guide number by the flash-to-subject distance in feet to determine the f-number for average subjects.

Output of Unit (BCPS or ECPS)	350	500	700	1000	1400	2000	2800	4000	5600	8000
Guide Number for Trial	24	28	32	40	50	55	65	80	95	110

Develop at approximate times and temperatures given below:

	Developing Times (in Minutes)									
Developer	Small Tank*					Large Tank †				
	65 F	68 F	70 F	72 F	75 F	65 F	68 F	70 F	72 F	75 F
DK-50	2½	2	2	1¾	1¾	—	—	—	—	—
§HC-110 (Dilution B)	2¾	2¼	2¼	2	1¾	—	—	—	—	—
Polydol	4½	4	3¾	3½	3¼	—	—	—	—	—
D-11	9	8	7	6½	5½	—	—	—	—	—

*Agitation at 30-second intervals during development.
†Agitation at 1-minute intervals during development.
‡For greatest sharpness (see developer instructions).
§Dilution A is a 1:15 dilution of the developer concentrate; Dilution B is a 1:31 dilution of the developer concentrate.

KODAK CONTRAST PROCESS ORTHO SHEET FILM

Safelight: A safelight filter Series 1 (red), in a suitable safelight lamp with a 15-watt bulb can be used at 4 feet.

Speed: ASA 50 Tungsten; 100 White Flame Arc

Daylight Exposure: *(See Introduction to this section)* Not used

Color Sensitivity: Orthochromatic

Filter Factors: Increase normal exposure by filter factor given below:

Kodak Wratten Filter	No. 6 (K1)	No. 8 (K2)	No. 15 (G)	No. 11 (X1)	No. 29 (F)	No. 25 (A)	No. 58 (B)	No. 47 (C5)	Pola-Screen
White Flame Arc	2.0	3.0	6.0	—	—	—	6.0	6.0	2.5
Photoflood or high-efficiency tungsten	1.5	2.0	3.0	—	—	—	4.0	8.0	2.5

*For correct gray-tone rendering of colored objects.

Flash Exposure Guide Numbers: To get f-number, divide guide number by flash-to-subject distance in feet, taken to a point midway between nearest and farthest details of interest. In small white rooms, use one stop smaller.

Synchronization: X or F			M			Focal-Plane Shutter Speed	2A‖ 31‖
Shutter Speed	AG-1† M2‡	M3‡ M5‡ 5§ 25§	11‖ 40‖	2‖ 22‖			
Open. 1/25 1/50 1/100 1/200 1/400		NOT USED				1/50 1/100 1/250 1/500	NOT USED

Bowl-Shaped Polished Reflector Sizes: †2-inch; ‡3-inch; §4- to 5-inch; ‖6- to 7-inch. If shallow cylindrical reflectors are used, divide these guide numbers by two.
Note: At 1/25 second, cameras having X or F synchronization can use any of the flashbulbs listed under M synchronization.
Caution: Since bulbs may shatter when flashed, the use of a flashguard over the reflector is recommended. *Do not flash bulbs in an explosive atmosphere.*

Electronic Flash Guide Numbers: This table is intended as a starting point in determining the correct guide number. The table is for use with equipment rated in beam candlepower-seconds (BCPS) or effective candlepower-seconds (ECPS). Divide the appropriate guide number by the flash-to-subject distance in feet to determine the f-number for average subjects.

Output of Unit (BCPS or ECPS)	350	500	700	1000	1400	2000	2800	4000	5600	8000
Guide Number for Trial					NOT RECOMMENDED					

Develop at approximate times and temperatures given below:

Developer	Developing Times (in Minutes)									
	Continuous Agitation (Tray)					Intermittent Agitation (Tank)*				
	65 F	68 F	70 F	72 F	75 F	65 F	68 F	70 F	72 F	75 F
D-11	4¾	4	3½	3¼	2¾	6	5	4½	4	3
D-8 (2:1)	—	2	—	—	—	—	—	—	—	—

*Agitation at 1-minute intervals during development.
†Development times of less than 5 minutes in a tank may produce poor uniformity and should be avoided.

KODAK CONTRAST PROCESS PANCHROMATIC SHEET FILM

Safelight: *Total darkness required.* A safelight filter Series 3 (dark green), in a suitable safelight lamp with a 15-watt bulb can be used for a few seconds *only*, at 4 feet, after development is half completed.

Speed: ASA 80 Tungsten; 100 White Flame Arc

Daylight Exposure: *(See Introduction to this section)* Not Used

Color Sensitivity: Panchromatic

Filter Factors: Increase normal exposure by filter factor given below:

Kodak Wratten Filter	No. 6 (K1)	No. 8 (K2)	No. 15 (G)	No. 11 (X1)	No. 29 (F)	No. 25 (A)	No. 58 (B)	No. 47 (C5)	Pola-Screen
White Flame Arc	—	2.0	3.0	—	32.0	10.0	10.0	10.0	2.5
Photoflood or high-efficiency tungsten	—	1.5	1.5	—	10.0	5.0	6.0	16.0	2.5

*For correct gray-tone rendering of colored objects.

Flash Exposure Guide Numbers: To get f-number, divide guide number by flash-to-subject distance in feet, taken to a point midway between nearest and farthest details of interest. In small white rooms, use one stop smaller.

Synchronization: X or F				M	Focal-Plane Shutter Speed	2A‖ 31‖
Shutter Speed	AG-1† M2‡	M3‡ M5‡ 5§ 25§	11‖ 40‖	2‖ 22‖		
Open. 1/25 1/50 1/100 1/200 1/400		NOT USED			1/50 1/100 1/250 1/500	NOT USED

Bowl-Shaped Polished Reflector Sizes: †2-inch; ‡3-inch; §4- to 5-inch; ‖6- to 7-inch. If shallow cylindrical reflectors are used, divide these guide numbers by two.
Note: At 1/25 second, cameras having X or F synchronization can use any of the flashbulbs listed under M synchronization.

Caution: Since bulbs may shatter when flashed, the use of a flashguard over the reflector is recommended. *Do not flash bulbs in an explosive atmosphere.*

Electronic Flash Guide Numbers: This table is intended as a starting point in determining the correct guide number. The table is for use with equipment rated in beam candlepower-seconds (BCPS) or effective candlepower-seconds (ECPS). Divide the appropriate guide number by the flash-to-subject distance in feet to determine the f-number for average subjects.

Output of Unit (BCPS or ECPS)	350	500	700	1000	1400	2000	2800	4000	5600	8000
Guide Number for Trial					NOT USED					

Develop at approximate times and temperatures given below:

Developer	Developing Times (in Minutes)									
	Continuous Agitation (Tray)					Intermittent Agitation (Tank)*				
	65 F	68 F	70 F	72 F	75 F	65 F	68 F	70 F	72 F	75 F
D-11	4¾	4	3½	3¼	2¾	6	5	4½	4	3¼
D-8 (2:1)	—	2	—	—	—	—	—	—	—	—

*Agitation at 1-minute intervals during development.
†Development times of less than 5 minutes in a tank may produce poor uniformity and should be avoided.

KODAK DIRECT POSITIVE PANCHROMATIC FILM

Safelight: *Total darkness required.* A safelight filter Series 3 (dark green), in a suitable safelight lamp with a 15-watt bulb can be used for a few seconds *only*, at 4 feet, after development is half completed.

Speed: ASA 80 Daylight, 64 Tungsten

Daylight Exposure: *(See Introduction to this section)* 1/200 sec. at f/9

Color Sensitivity: Panchromatic

Filter Factors: Increase normal exposure by filter factor given below:

Kodak Wratten Filter	No. 6 (K1)	No. 8 (K2)	No. 15 (G)	No. 11 (X1)	No. 29 (F)	No. 25 (A)	No. 58 (B)	No. 47 (C5)	Pola-Screen
Daylight	—	2.0*	2.5	4.0	—	10.0	5.0	8.0	2.5
Photoflood or high-efficiency tungsten	—	1.5	2.0	3.0*	—	5.0	5.0	16.0	2.5

*For correct gray-tone rendering of colored objects.

Flash Exposure Guide Numbers: To get f-number, divide guide number by flash-to-subject distance in feet, taken to a point midway between nearest and farthest details of interest. In small white rooms, use one stop smaller.

Shutter Speed	M2B‡	M3B‡, M5B‡ 5B§, 25B§	AG-1B†	AG-3B†	Focal-Plane Shutter Speed	6B§ 26B§
Open. 1/25	120	180	90	110	1/50	130
1/50	—	160	90	110	1/100	90
1/100	—	130	75	90	1/250	60
1/200	—	105	65	75	1/500	—
1/400	—	—	—	—		

(Synchronization: X or F for first columns; M for AG columns)

Bowl-Shaped Polished Reflector Sizes: †2-inch; ‡3-inch; §4- to 5-inch; ‖6- to 7-inch. If shallow cylindrical reflectors are used, divide these guide numbers by two.
Note: At 1/25 second, cameras having X or F synchronization can use any of the flashbulbs listed under M synchronization.
Caution: Since bulbs may shatter when flashed, the use of a flashguard over the reflector is recommended. *Do not flash bulbs in an explosive atmosphere.*

Electronic Flash Guide Numbers: This table is intended as a starting point in determining the correct guide number. The table is for use with equipment rated in beam candlepower-seconds (BCPS) or effective candlepower-seconds (ECPS). Divide the appropriate guide number by the flash-to-subject distance in feet to determine the f-number for average subjects.

Output of Unit (BCPS or ECPS)	350	500	700	1000	1400	2000	2800	4000	5600	8000
Guide Number for Trial	40	50	60	70	80	100	120	140	160	200

Develop at approximate times and temperatures given below:

Developer	Developing Times (in Minutes)									
	Small Tank*					Large Tank †				
	65 F	68 F	70 F	72 F	75 F	65 F	68 F	70 F	72 F	75 F

Processed in Kodak Direct Positive Film Developing Outfit by reversal process.
See Section 5.

*Agitation at 30-second intervals during development.
†Agitation at 1-minute intervals during development.
‡For greatest sharpness (see developer instructions).
§Dilution A is a 1:15 dilution of the developer concentrate; Dilution B is a 1:31 dilution of the developer concentrate.

KODAK EKTAPAN SHEET FILM 4162

Safelight: *Total darkness required.* A Safelight Filter Series 3 (dark green), in a suitable safelight lamp with a 15-watt bulb can be used for a few seconds *only,* at 4 feet development is half completed.

Speed: ASA 100

Daylight Exposure: *(See Introduction to this section)* 1/100 sec. at $f/16$

Color Sensitivity: Panchromatic

Filter Factors: Increase normal exposure by filter factor given below:

Kodak Wratten Filter	No. 6 (K1)	No. 8 (K2)	No. 15 (G)	No. 11 (X1)	No. 29 (F)	No. 25 (A)	No. 58 (B)	No. 47 (C5)	Pola- Screen
Daylight	1.5	2*	3	4	16	8	8	5	2.5
Photoflood or high- efficiency tungsten	1.5	1.5	2	3*	8	4	8	10	2.5

*For correct gray-tone rendering of colored objects.

Flash Exposure Guide Numbers: To get $f/$number, divide guide number by flash-to-subejct distance in feet, taken to a point midway between nearest and farthest details of interest. In small white rooms, use one stop smaller.

Synchronization: X or F			M		Focal-Plane Shutter Speed	6§ 26§
Shutter Speed	AG-1† M2‡	M3‡, M5‡ 5§, 25§	11‖ 40‖	2‖ 22‖		
Open. 1/25	170	250	260	320	1/50	190
1/50	—	220	240	310	1/100	130
1/100	—	190	210	260	1/250	95
1/200	—	150	160	200	1/500	65
1/400	—	110	120	150		

Bowl-Shaped Polished Reflector Sizes: †2-inch; ‡3-inch; §4- to 5-inch; ‖6- to 7-inch. If shallow cylindrical reflectors are used, divide these guide numbers by two.
Note: At 1/25 second, cameras having X or F synchronization can use any of the flashbulbs listed under M synchronization.
Caution: Since bulbs may shatter when flashed, the use of a flashguard over the reflector is recommended. *Do not flash bulbs in an explosive atmosphere.*

Electronic Flash Guide Numbers: This table is intended as a starting point in determining the correct guide number. The table is for use with equipment rated in beam candlepower-seconds (BCPS) or effective candlepower-seconds (ECPS). Divide the appropriate guide number by the flash-to-subject distance in feet to determine the $f/$number for average subjects.

Output of Unit (BCPS or ECPS)	350	500	700	1000	1400	2000	2800	4000	5600	8000
Guide Number for Trial	40	50	60	70	85	100	120	140	170	200

Develop at approximate times and temperatures given below:

Developer	Developing Times (in Minutes)									
	Continuous Agitation (Tray)					Intermittent Agitation (Tank)*				
	65 F	68 F	70 F	72 F	75 F	65 F	68 F	70 F	72 F	75 F
HC-110 (Dilution A)	3¼	3	2¾	2½	2¼	4†	3¾†	3¼†	3†	2¾†
HC-110 (Dilution B)	5	4½	4¼	4	3½	7	6	5½	5	4¼†
Polydol	9½	8	7	6	5	12	10	9	8	7
DK-50 (1:1)	5	4½	4¼	4	3½	7	6	5½	5	4¼†
D-76	9	8	7	6½	5½	11	10	9	8½	7½
Microdol-X	12	10	9½	8	7	16	13	12	10	9

*Agitation at 1-minute intervals during development.
†Development times of less than 5 minutes in a tank may produce poor uniformity and should be avoided.

KODAK HIGH CONTRAST COPY FILM 5069

Safelight: *Total darkness required.* A safelight filter Series 3 (dark green), in a suitable safelight lamp with a 15-watt bulb can be used for a few seconds *only*, at 4 feet, after development is half completed.

Speed: ASA 64 Tungsten

Daylight Exposure: *(See Introduction to this section)* Not used.

Color Sensitivity: Panchromatic

Filter Factors: Increase normal exposure by filter factor given below:

Kodak Wratten Filter	No. 6 (K1)	No. 8 (K2)	No. 15 (G)	No. 11 (X1)	No. 29 (F)	No. 25 (A)	No. 58 (B)	No. 47 (C5)	Pola- Screen
Daylight	—	—	—	—	—	—	—	—	2.5
Photoflood or high- efficiency tungsten	—	1.2	1.5	—	—	8.0	—	—	2.5

*For correct gray-tone rendering of colored objects.

Flash Exposure Guide Numbers: To get f-number, divide guide number by flash-to-subject distance in feet, taken to a point midway between nearest and farthest details of interest. In small white rooms, use one stop smaller.

Synchronization: X or F			M		Focal-Plane Shutter Speed	6B§ 26B§
Shutter Speed	M2B‡	M3B‡, M5B‡ 5B§, 25B§	AG-1B†	AG-3B†		
Open. 1/25 1/50 1/100 1/200 1/400		NOT USED			1/50 1/100 1/250 1/500	NOT USED

Bowl-Shaped Polished Reflector Sizes: †2-inch; ‡3-inch; §4- to 5-inch; ||6- to 7-inch. If shallow cylindrical reflectors are used, divide these guide numbers by two.
Note: At 1/25 second, cameras having X or F synchronization can use any of the flashbulbs listed under M synchronization.

Caution: Since bulbs may shatter when flashed, the use of a flashguard over the reflector is recommended. *Do not flash bulbs in an explosive atmosphere.*

Electronic Flash Guide Numbers: This table is intended as a starting point in determining the correct guide number. The table is for use with equipment rated in beam candlepower-seconds (BCPS) or effective candlepower-seconds (ECPS). Divide the appropriate guide number by the flash-to-subject distance in feet to determine the f-number for average subjects.

Output of Unit (BCPS or ECPS)	350	500	700	1000	1400	2000	2800	4000	5600	8000
Guide Number for Trial					NOT USED					

Develop at approximate times and temperatures given below:

Developer	Developing Times (in Minutes)									
	Small Tank*					Large Tank †				
	65 F	68 F	70 F	72 F	75 F	65 F	68 F	70 F	72 F	75 F
D-19	7	6	5	4½	4	—	—	—	—	—

*Agitation at 30-second intervals during development.
†Agitation at 1-minute intervals during development.
‡For greatest sharpness (see developer instructions).
§Dilution A is a 1:15 dilution of the developer concentrate; Dilution B is a 1:31 dilution of the developer concentrate.
Note: Do not use developers containing silver halide solvents, such as thiocyanates, or thiosulfates.

KODAK HIGH SPEED INFRARED FILM 2481 (HIE 135-20)

Safelight: Total darkness required.

Speed: ASA (See table below.)

Kodak Wratten Filter	Exposure Index (Development in Kodak Developer D-76)	
	Daylight	Tungsten
No. 25 (A), No. 29, No. 70, and No. 89B	50	125
No. 87 or No. 88A	25	64
No. 87C	10	25
No filter	80	200

Color Sensitivity: Infrared

Flash Exposure Guide Numbers: To get f/number, divide guide number by flash-to-subject distance in feet, taken to a point midway between nearest and farthest details of interest. In small white rooms, use one stop smaller.

Synchronization: X or F			M		Focal-Plane	6§
Shutter Speed	AG-1† M2‡	M3‡, M5‡ 5§, 25§	11‖ 40‖	2‖ 22‖	Shutter Speed	26§
Open. 1/25	190	290	—	—	1/50	210
1/50	—	250	—	—	1/100	150
1/100	—	210	—	—	1/250	105
1/200	—	170	—	—	1/500	75
1/400	—	120	—	—	1/1000	50

With Kodak Wratten Filter No. 25, 29, 70, or 89B.

Bowl-Shaped Polished Reflector Sizes: †2-inch; ‡3-inch; §4- to 5-inch; ‖6- to 7-inch. If shallow cylindrical reflectors are used, divide these guide numbers by two.
Note: At 1/25 second, cameras having X or F synchronization can use any of the flashbulbs listed under M synchronization.

Caution: Since bulbs may shatter when flashed, the use of a flashguard over the reflector is recommended. *Do not flash bulbs in an explosive atmosphere.*

Electronic Flash Guide Numbers: This table is intended as a starting point in determining the correct guide number. The table is for use with equipment rated in beam candlepower-seconds (BCPS) or effective candlepower-seconds (ECPS). Divide the appropriate guide number by the flash-to-subject distance in feet to determine the f/number for average subjects. *Use Filter No. 87.*

Output of Unit (BCPS or ECPS)	350	500	700	1000	1400	2000	2800	4000	5600	8000
Guide Number for Trial	35	40	45	55	65	80	95	110	130	160

Develop at approximate times and temperatures given below:

Developer	Developing Times (in Minutes)									
	Continuous Agitation (Tray)					Intermittent Agitation (Tank)*				
	65 F	68 F	70 F	72 F	75 F	65 F	68 F	70 F	72 F	75 F
Kodak D-19	—	—	—	—	—	8	7	6½	6	5½
Kodak D-76	—	—	—	—	—	12	10	9	8½	7½
Kodak Microdol-X	—	—	—	—	—	15	13	11	10	9

*Agitation at 30-second intervals during development.
†Development times of less than 5 minutes in a tank may produce poor uniformity and should be avoided.

KODAK HIGH SPEED INFRARED SHEET FILM 4143

Safelight: *Total darkness required.* A safelight filter Series 7 (green), in a suitable safelight lamp with a 15-watt bulb can be used at 4 feet.

Speed: ASA (see table below)

Color Sensitivity: Infrared

Filter	SPEEDS	
	Daylight	Tungsten
None	80	200
Wratten 25, 29, 70, or 89B	50	125
Wratten 87 or 88A	25	64
Wratten 87C	10	25

Flash Exposure Guide Numbers: To get f-number, divide guide number by flash-to-subject distance in feet, taken to a point midway between nearest and farthest details of interest. In small white rooms, use one stop smaller.

Synchronization: X or F		M			Focal-Plane	6§
Shutter Speed	AG-1† M2‡	M3‡ M5‡ 5§ 25§	11‖ 40‖	2‖ 22‖	Shutter Speed	26§
Open, 1/25	200	300	370	450	1/50	250
1/50	—	280	330	400	1/100	200
1/100	—	240	290	350	1/250	130
1/200	—	180	220	260	1/500	100

All above with No. 25, 29, 70, or 89B Filter over lens

Bowl-Shaped Polished Reflector Sizes: †2-inch; ‡3-inch; §4- to 5-inch; ‖6- to 7-inch. If shallow cylindrical reflectors are used, divide these guide numbers by two.
Note: At 1/25 second, cameras having X or F synchronization can use any of the flashbulbs listed under M synchronization.

Caution: Since bulbs may shatter when flashed, the use of a flashguard over the reflector is recommended. *Do not flash bulbs in an explosive atmosphere.*

Electronic Flash Guide Numbers: This table is intended as a starting point in determining the correct guide number. The table is for use with equipment rated in beam candlepower-seconds (BCPS) or effective candlepower-seconds (ECPS). Divide the appropriate guide number by the flash-to-subject distance in feet to determine the f-number for average subjects. *Use Filter No. 87.*

Output of Unit (BCPS or ECPS)	350	500	700	1000	1400	2000	2800	4000	5600	8000
Guide Number for Trial	35	40	45	55	65	80	95	110	130	160

Develop at approximate times and temperatures given below:

Developer	Developing Times (in Minutes)									
	Continuous Agitation (Tray)					Intermittent Agitation (Tank)*				
	65 F	68 F	70 F	72 F	75 F	65 F	68 F	70 F	72 F	75 F
D-76 (Pictorial)	9	8	7½	7	6	12	10	9	8	7½
Microdol-X (Pictorial)	13	11	10	9	8	16	14	12	10	9
DK-50 (High Contrast)	11	9½	8	7	6½	14	12	10	9	8
D-19 (Max. Contrast)	13	11	10	9	8	16	14	12	10	9

*Agitation at 1-minute intervals during development.
†Development times of less than 5 minutes in a tank may produce poor uniformity and should be avoided.

KODAK PANATOMIC-X 35MM FILM AND PANATOMIC-X PROFESSIONAL FILM 6040 (120 roll film)

Safelight: *Total darkness required.* A safelight filter Series 3 (dark green), in a suitable safelight lamp with a 15-watt bulb can be used for a few seconds *only*, at 4 feet, after development is half completed.

Speed: ASA 32

Daylight Exposure: *(See Introduction to this section)* 1/100 sec. at *f*/8

Color Sensitivity: Panchromatic

Filter Factors: Increase normal exposure by filter factor given below:

Kodak Wratten Filter	No. 6 (K1)	No. 8 (K2)	No. 15 (G)	No. 11 (X1)	No. 29 (F)	No. 25 (A)	No. 58 (B)	No. 47 (C5)	Pola-Screen
Daylight	1.5	2.0*	2.5	4.0	—	8.0	6.0	8.0	2.5
Photoflood or high-efficiency tungsten	1.5	1.5	1.5	4.0*	—	5.0	6.0	16.0	2.5

*For correct gray-tone rendering of colored objects.

Flash Exposure Guide Numbers: To get f-number, divide guide number by flash-to-subject distance in feet, taken to a point midway between nearest and farthest details of interest. In small white rooms, use one stop smaller.

Synchronization: X or F					Focal-Plane	6B§ 26B§
Shutter Speed	M2B‡	M3B‡, M5B‡ 5B§, 25B§	AG-1B†	Flash Cube	Shutter Speed	
Open. 1/25	75	110	60	40	1/50	80
1/50	—	100	60	38	1/100	55
1/100	—	80	50	32	1/250	35
1/200	—	60	40	26	1/500	28
1/400	—	50	30	20		

Bowl-Shaped Polished Reflector Sizes: †2-inch; ‡3-inch; §4- to 5-inch; ‖6- to 7-inch. If shallow cylindrical reflectors are used, divide these guide numbers by two.
Note: At 1/25 second, cameras having X or F synchronization can use any of the flashbulbs listed under M synchronization.
Caution: Since bulbs may shatter when flashed, the use of a flashguard over the reflector is recommended. *Do not flash bulbs in an explosive atmosphere.*

Electronic Flash Guide Numbers: This table is intended as a starting point in determining the correct guide number. The table is for use with equipment rated in beam candlepower-seconds (BCPS) or effective candlepower-seconds (ECPS). Divide the appropriate guide number by the flash-to-subject distance in feet to determine the f-number for average subjects.

Output of Unit (BCPS or ECPS)	350	500	700	1000	1400	2000	2800	4000	5600	8000
Guide Number for Trial	24	28	32	40	50	55	65	80	95	110

Develop at approximate times and temperatures given below:

	Developing Times (in Minutes)									
Developer	Small Tank*					Large Tank †				
	65 F	68 F	70 F	72 F	75 F	65 F	68 F	70 F	72 F	75 F
D-76	8	7	6½	6	5	9	8	7½	7	6
DC-76 (1:1)	11	9	8	7	6	12	10	9	8	7
Microdol-X	11	9	8	7	6	12	10	9	8	7
‡Microdol-X (1:3)	—	—	13	12	11	—	—	15	14	13
Polydol	8	7	6	5	4½	9	8	7	6	5
§HC-110 (Dil. A)	3	2¾	2½	2¼	2	3½	3	2¾	2½	2¼
§HC-110 (Dil. B)	5	4½	4	3¾	3½	6	5	4½	4¼	3¾

*Agitation at 30-second intervals during development.
†Agitation at 1-minute intervals during development.
‡For greatest sharpness (see developer instructions).
§Dilution A is a 1:15 dilution of the developer concentrate; Dilution B is a 1:31 dilution of the developer concentrate.

KODAK PANATOMIC-X (FX-135) 35mm FILM
FOR BLACK-AND-WHITE TRANSPARENCIES

While Kodak Direct Positive Panchromatic Film is designed especially to produce projection transparencies, those requiring only an occasional few slides can use Panatomic-X 35mm Film and process it by reversal. Speeds differ from those attained with negative processing and the directions below should be followed.

Speed: ASA 80 Daylight; 64 Tungsten

Daylight Exposure: *(See Introduction to this section)* 1/100 sec. at *f*/12.5

Color Sensitivity: Panchromatic

Filter Factors: Increase normal exposure by filter factor given below:

Kodak Wratten Filter	No. 6 (K1)	No. 8 (K2)	No. 15 (G)	No. 11 (X1)	No. 29 (F)	No. 25 (A)	No. 58 (B)	No. 47 (C5)	Pola-Screen
Daylight	1.5	2.0*	2.5	4.0	—	8.0	6.0	8.0	2.5
Photoflood or high-efficiency tungsten	1.5	1.5	1.5	4.0*	—	5.0	6.0	16.0	2.5

*For correct gray-tone rendering of colored objects.

Flash Exposure Guide Numbers: To get f-number, divide guide number by flash-to-subject distance in feet, taken to a point midway between nearest and farthest details of interest. In small white rooms, use one stop smaller.

Shutter Speed	Synchronization: X or F			M		Focal-Plane Shutter Speed	6B§ 26B§
	M2B‡	M3B‡, M5B‡ 5B§, 25B§	AG-1B†	AG-3B†			
Open, 1/25	130	200	130	—		1/50	160
1/50	—	170	—	—		1/100	100
1/100	—	150	—	—		1/250	60
1/200	—	120	—	—		1/500	45
1/400	—	—	—	—			

Bowl-Shaped Polished Reflector Sizes: †2-inch; ‡3-inch; §4- to 5-inch; ‖6- to 7-inch. If shallow cylindrical reflectors are used, divide these guide numbers by two.
Note: At 1/25 second, cameras having X or F synchronization can use any of the flashbulbs listed under M synchronization.
Caution: Since bulbs may shatter when flashed, the use of a flashguard over the reflector is recommended. *Do not flash bulbs in an explosive atmosphere.*

Electronic Flash Guide Numbers: This table is intended as a starting point in determining the correct guide number. The table is for use with equipment rated in beam candlepower-seconds (BCPS) or effective candlepower-seconds (ECPS). Divide the appropriate guide number by the flash-to-subject distance in feet to determine the f-number for average subjects.

Output of Unit (BCPS or ECPS)	350	500	700	1000	1400	2000	2800	4000	5600	8000
Guide Number for Trial	35	45	55	65	75	90	110	130	150	180

Copying Radiographs: Kodak Panatomic-X Film can be used for copying radiographs by the method outlined in Journal Reprint M3-24, *Copying Radiographs,* available from the Radiography Markets Division of Eastman Kodak Company. When using an x-ray illuminator fitted with two 15-watt T-8 Daylight Fluorescent Lamps or one 32-watt T-10 Daylight Circline Lamp, try a basic exposure of 2 seconds at *f*/22. Many "average" radiographs will not require a pre-exposure as is recommended in the above publication. However, if the radiograph has detail in very dense areas as well as in light areas, a pre-exposure of 1/200 second at *f*/22 is recommended.

When Panatomic-X Film is used in this manner, the ordinary room illumination should be turned off and the work carried on under subdued lighting. If this is not done, light reflected from the surface of the radiograph is likely to affect the exposure and lead to copies that are grayish and "washed out."

Processing: For processing No. 135 Kodak Panatomic-X Film in the Kodak Direct Positive Film Developing Outfit, the following temperature and times (in minutes) are recommended:

	Minutes at 68 F (20 C)
First Developer	
Reel and trough	6
Large spiral reels	6
Small spiral reels	8
Kodak Day-Load Tank or other non-invertible tanks	8
Rack and tank	9
Wash (running water)	2 to 5*
Bleach	1
Clear	2
Redeveloper	8
Rinse	1
Fix	5
Wash	as required†

*Two minutes with good agitation in running water is sufficient.

†Washing time can be reduced by using Kodak Hypo Clearing Agent.

Except for the times in the first developer and the final wash, the details of the procedure are identical to the instructions packaged with the Direct Positive Film Developing Outfit, sold by dealers in Kodak Products.

Agitation

Small Spiral Reels: Agitate by moving the reel up and down (keeping it immersed) and at the same time rotating it back and forth half a turn. With each solution, the agitation should be continuous for the first 30 seconds, then for 5 seconds every minute thereafter.

NOTE: With some tanks, it is possible to obtain satisfactory results with the cover on, by following the agitation procedure as directed in the instructions for the tank. It is more convenient, however, to use the "cover-off" method.

Reel and Trough: Rotate the reel at a moderate rate, reversing the direction of rotation at 1-minute intervals.

Kodak Day-Load Tank, or other Non-Invertible Tanks: Use the instructions that come with the tank.

Rack and Tank: Immerse the film and agitate it for 5 seconds. Thereafter, at 1-minute intervals, lift the rack out completely, drain it a few seconds, and reimmerse it.

Safelight: Handle this film in total darkness until the bleaching has been completed. For the remaining operations, use a Kodak Safelight Filter OA (greenish-yellow) with a 15-watt bulb. The safelight should be no closer to the film than 4 feet.

Safelight: *Total darkness required.* A Safelight Filter Series 3 (dark green), in a suitable safelight lamp with a 15-watt bulb can be used for a few seconds *only,* at 4 feet, after development is half completed.

Speed: ASA 125

Daylight Exposure: *(See Introduction to this section)* 1/100 sec. at $f/16$

Color Sensitivity: Panchromatic

Filter Factors: Increase normal exposure by filter factor given below:

Kodak Wratten Filter	No. 6 (K1)	No. 8 (K2)	No. 15 (G)	No. 11 (X1)	No. 29 (F)	No. 25 (A)	No. 58 (B)	No. 47 (C5)	Pola-Screen
Daylight	1.5	2.0*	2.5	4.0	25.0	8.0	6.0	6.0	2.5
Photoflood or high-efficiency tungsten	1.5	1.5	1.5	4.0*	12.0	5.0	6.0	12.0	2.5

*For correct gray-tone rendering of colored objects.

Flash Exposure Guide Numbers: To get $f/$number, divide guide number by flash-to-subject distance in feet, taken to a point midway between nearest and farthest details of interest. In small white rooms, use one stop smaller.

Synchronization: X or F			M		Focal-Plane	6§
Shutter Speed	AG-1† M2‡	M3‡, M5‡ 5§, 25§	11‖ 40‖	2‖ 22‖	Shutter Speed	26§
Open. 1/25	190	280	240	360	1/50	210
1/50	—	250	270	340	1/100	150
1/100	—	210	230	290	1/250	105
1/200	—	170	180	220	1/500	75
1/400	—	120	130	170		

Bowl-Shaped Polished Reflector Sizes: †2-inch; ‡3-inch; §4- to 5-inch; ‖6- to 7-inch. If shallow cylindrical reflectors are used, divide these guide numbers by two.
Note: At 1/25 second, cameras having X or F synchronization can use any of the flashbulbs listed under M synchronization.

Caution: Since bulbs may shatter when flashed, the use of a flashguard over the reflector is recommended. *Do not flash bulbs in an explosive atmosphere.*

Electronic Flash Guide Numbers: This table is intended as a starting point in determining the correct guide number. The table is for use with equipment rated in beam candlepower-seconds (BCPS) or effective candlepower-seconds (ECPS). Divide the appropriate guide number by the flash-to-subject distance in feet to determine the $f/$number for average subjects.

Output of Unit (BCPS or ECPS)	350	500	700	1000	1400	2000	2800	4000	5600	8000
Guide Number for Trial	45	55	65	80	90	110	130	160	180	220

Develop at approximate times and temperatures given below:

	Developing Times (in Minutes)									
Developer	Continuous Agitation (Tray)					Intermittent Agitation (Tank)*				
	65 F	68 F	70 F	72 F	75 F	65 F	68 F	70 F	72 F	75 F
Polydol	7	6	5½	5	4½	9	8	7½	7	6
HC-110 (Dil. B)	6	5	4¾	4½	4	8	7	6½	6	5½
DK-50 (1:1)	5	4½	4¼	4	3½	6½	6	5¾	5½	5
D-76	7	6	5½	5	4½	9	8	7½	7	6
Microdol-X	9	8	7½	7	6	11	10	9½	9	8

*Agitation at 1-minute intervals during development.
NOTE: Do not use developers containing silver halide solvents, such as thiocyanates or thiosulfates.

Forms Available: Sheet films; 35mm, 70mm and 3½-inch long rolls.

KODAK PLUS-X PAN, PLUS-X PAN PROFESSIONAL, AND PLUS-X PORTRAIT 5068 ROLL AND 35MM FILMS

Safelight: *Total darkness required.* A Safelight Filter Series 3 (dark green), in a suitable safelight lamp with a 15-watt bulb can be used for a few seconds *only*, at 4 feet, after development is half completed.

Speed: ASA 125

Daylight Exposure: *(See Introduction to this section)* 1/125 sec. at $f/16$.

Color Sensitivity: Panchromatic

Filter Factors: Increase normal exposure by filter factor given below:

Kodak Wratten Filter	No. 6 (K1)	No. 8 (K2)	No. 15 (G)	No. 11 (X1)	No. 29 (F)	No. 25 (A)	No. 58 (B)	No. 47 (C5)	Pola-Screen
Daylight	1.5	2.0*	2.5	4.0	25.0	8.0	6.0	6.0	2.5
Photoflood or high-efficiency tungsten	1.5	1.5	1.5	4.0*	12.0	5.0	6.0	12.0	2.5

*For correct gray-tone rendering of colored objects.

Flash Exposure Guide Numbers: To get f-number, divide guide number by flash-to-subject distance in feet, taken to a point midway between nearest and farthest details of interest. In small white rooms, use one stop smaller.

Shutter Speed	Synchronization: X or F M2B‡	M3B‡, M5B‡ 5B§, 25B§	M AG-1B†	Flash Cube	Focal-Plane Shutter Speed	6B§ 26B§
Open. 1/25	150	220	110	110	1/50	160
1/50	—	200	110	80	1/100	110
1/100	—	170	95	60	1/250	80
1/200	—	130	80	50	1/500	55
1/400	—	100	60	40	1/1000	38

Bowl-Shaped Polished Reflector Sizes: †2-inch; ‡3-inch; §4- to 5-inch; ‖6- to 7-inch. If shallow cylindrical reflectors are used, divide these guide numbers by two.
Note: At 1/25 second, cameras having X or F synchronization can use any of the flashbulbs listed under M synchronization.

Electronic Flash Guide Numbers: This table is intended as a starting point in determining the correct guide number. The table is for use with equipment rated in beam candlepower-seconds (BCPS) or effective candlepower-seconds (ECPS). Divide the appropriate guide number by the flash-to-subject distance in feet to determine the f-number for average subjects.

Output of Unit (BCPS or ECPS)	350	500	700	1000	1400	2000	2800	4000	5600	8000
Guide Number for Trial	45	55	65	80	90	110	130	160	180	220

Develop at approximate times and temperatures given below:

Developer	Developing Times (in Minutes) Small Tank*					Large Tank †				
	65 F	68 F	70 F	72 F	75 F	65 F	68 F	70 F	72 F	75 F
§HC-110 (Dil. B)	6	5	4½	4	3½	6½	5½	5	4¾	4
Polydol	6½	5½	4¾	4¼	3¼	7½	6	6½	4¾	3¾
D-76	6½	5½	5	4½	3¾	7½	6½	6	5½	4½
D-76 (1:1)	8	7	6½	6	5½	10	9	8	7½	7
‡Microdol-X	8	7	6½	6	5½	10	9	8	7½	7
Microdol-X (1:3)	—	—	11	10	9½	—	—	14	13	11

*Agitation at 30-second intervals during development.
†Agitation at 1-minute intervals during development.
‡For greatest sharpness (see developer instructions).
§Dilution A is a 1:15 dilution of the developer concentrate; Dilution B is a 1:31 dilution of the developer concentrate.

Forms Available: Roll films 120, 220, 110, and 135. *Plus-X Portrait 5068:* 70mm long rolls.

KODAK PROFESSIONAL COPY SHEET FILM 4125
(ESTAR THICK BASE)

Safelight: A safelight filter Series 2 (dark red) in a suitable safelight lamp with a 15-watt bulb can be used at 4 feet.

Daylight Exposure: *(See introduction to this section)* Not used.

Color Sensitivity: Orthochromatic.

Speed: ASA 25 (white-flame arc), 12 (tungsten and quartz-iodine), 25 (pulsed xenon arc).

These speeds are for use with meters marked for ASA speeds; they are recommended for trial exposures in copying. To obtain a trial exposure, take a reflected-light meter reading from the gray (18% reflectance) side of the Kodak Neutral Test Card at the copyboard. If the white (90% reflectance) side of the card is used, multiply the indicated exposure by 5.

In copying, extra exposure is needed to compensate for a long bellows extension.

To make an accurate reproduction from a continuous-tone original:

1. Copy a paper gray scale together with the original.
2. Choose a paper from the table below.
3. Make a series of test negatives at different exposures.
4. Develop the test negatives as indicated by the table.
5. With a densitometer, read the density of the steps in the negative gray scale that correspond with those marked 0.00 and 1.60 in the paper gray scale. Select the negative whose aim densities are closest to those indicated by the table.
6. If the densities in the negative gray scale fail to read within the indicated tolerances, first adjust exposure until the shadow density matches that given in the table. Then, if necessary, adjust developing time until the highlight density also matches that in the table.

Aim Densities for Facsimile Reproduction

When you use this Kodak paper	Develop Kodak Professional Copy Film in this Kodak Developer at 68 F (20 C)	For these development times		To obtain these densities in the copy negative gray scale	
		Tray— continuous agitation	Tray— intermittent agitation	Shadow	Highlight
Ektamatic SC*	HC-110 (Dilution E)	4¾ min	6½ min	0.37±.02	1.48±.05
Polycontrast F*	HC-110 (Dilution E)	4½ min	6 min	0.30±.02	1.30±.05
Ektalure G	HC-110 (Dilution E)	3¾ min	4¾ min	0.24±.02	1.12±.05
Azo F†	HC-110 (Dilution B)	3½ min	4¼ min	0.38±.02	1.52±.05

* Kodak Polycontrast filter PC 2.

† Contrast grade 1.

KODAK PROFESSIONAL LINE COPY SHEET FILM 6573

Safelight: A safelight filter Series 1A (light red), in a suitable safelight lamp with a 15-watt bulb can be used at 4 feet.

Color Sensitivity: Orthochromatic

Speed: ASA Tungsten 16

This speed is recommended for use with meters marked for ASA speeds.

These settings are recommended for trial exposures in copying; they apply to incident-light meters directly and to reflected-light meters used with the gray (18% reflectance) side of the Kodak Neutral Test Card at the copyboard. If the white (90% reflectance) side of the test card is used, multiply the calculated exposure by 5.

Allow for the change in effective aperture due to extended bellows. To find the correct exposure for use in copying, multiply the indicated exposure time by the appropriate factor based on the percentage of reduction or enlargement from the original copy. A few typical factors are given below; to determine others, use the "Effective Aperture Computer" in the *Kodak Master Photoguide.*

Reproduction size (percentage of original size)	25%	50%	100% (same size)	150%	200%	300%
Multiply calculated exposure by	1.6	2.2	4.0	6.5	9.0	16.0

Caution: To prevent pinholes and spots, be sure the film and copyboard glass are clean and free of dust. Also, because of the increase in highlight contrast, uneven illumination of the copyboard will be more noticeable; therefore, use a meter to check the uniformity of illumination.

Example of Exposure: For making same-size reproductions, use two RFL-2 photoflood lamps at an angle of 45° and 4½ feet from the center of the copy. Expose approximately 14 seconds at f/11, with a Kodak Wratten Neutral Density Filter No. 96 (0.60).

Develop at approximate times and temperatures given below:

	Developing Times (in Minutes)									
	Continuous Agitation (Tray)					Intermittent Agitation (Tank)*				
	65 F	68 F	70 F	72 F	75 F	65 F	68 F	70 F	72 F	75 F
Kodak D-11	—	2	—	—	—	—	—	—	—	—

*Agitation at 1-minute intervals during development.

KODAK 2475 RECORDING FILM (ESTAR-AH BASE)
16MM AND 35MM

Safelight: *Total darkness required.* A Safelight Filter Series 3 (dark green), in a suitable safelight lamp with a 15-watt bulb can be used for a few seconds *only,* at 4 feet, after development is half completed.

Speed: ASA 1000 (Developed in DK-50, 5 min. at 68 F. With low contrast subjects. ASA 3200 can be used, develop 8 min. at 68 F.)

Daylight Exposure: *(See Introduction to this section)* 1/1000 sec. at *f*/16

Color Sensitivity: Panchromatic with extended red sensitivity

Filter Factors: Increase normal exposure by filter factor given below:

Kodak Wratten Filter	No. 6 (K1)	No. 8 (K2)	No. 15 (G)	No. 11 (X1)	No. 29 (F)	No. 25 (A)	No. 58 (B)	No. 47 (C5)	Pola- Screen
Daylight	1.5	2*	2	6	—	3	10	6	2.5
Photoflood or high- efficiency tungsten	1.2	1.2	1.5	6*	—	2	12	16	3

*For correct gray-tone rendering of colored objects.

Flash Exposure Guide Numbers: To get *f*/number, divide guide number by flash-to-subject distance in feet, taken to a point midway between nearest and farthest details of interest. In small white rooms, use one stop smaller.

Synchronization: X or F			M		Focal-Plane Shutter Speed	6§ 26§
Shutter Speed	AG-1† M2‡	M3‡, M5‡ 5§, 25§	11‖ 40‖	2‖ 22‖		
Open. 1/25	480	950	1100	1600	1/50	580
1/50	—	850	950	1200	1/100	420
1/100	—	750	850	1100	1/250	300
1/200	—	600	550	850	1/500	210
1/400	—	480	440	750		

Bowl-Shaped Polished Reflector Sizes: †2-inch; ‡3-inch; §4- to 5-inch; ‖6- to 7-inch. If shallow cylindrical reflectors are used, divide these guide numbers by two.
Note: At 1/25 second, cameras having X or F synchronization can use any of the flashbulbs listed under M synchronization.

Caution: Since bulbs may shatter when flashed, the use of a flashguard over the reflector is recommended. *Do not flash bulbs in an explosive atmosphere.*

Electronic Flash Guide Numbers: This table is intended as a starting point in determining the correct guide number. The table is for use with equipment rated in beam candlepower-seconds (BCPS) or effective candlepower-seconds (ECPS). Divide the appropriate guide number by the flash-to-subject distance in feet to determine the *f*/number for average subjects.

Output of Unit (BCPS or ECPS)	350	500	700	1000	1400	2000	2800	4000	5600	8000
Guide Number for Trial	150	180	210	250	300	350	420	500	600	700

Develop at approximate times and temperatures given below:

Developer	Developing Times (in Minutes)									
	Continuous Agitation (Tray)					Intermittent Agitation (Tank)*				
	65 F	68 F	70 F	72 F	75 F	65 F	68 F	70 F	72 F	75 F
DK-50 (ASA 1000)	—	5	—	—	3¾	—	6	—	—	4†
DK-50 (ASA 3200)	—	8	—	—	5½	—	9	—	—	6½
D-19	—	8	—	—	5	—	—	—	—	—
HC-110, Dil. A (Normal Subjects)	—	4	—	—	2¾	—	4½	—	—	3†
HC-110, Dil. A (Low- contrast Subjects)	—	7	—	—	4½	—	8	—	—	5
HC-110 Dil. B (Normal Subjects)	—	8	—	—	5	—	9	—	—	6
HC-110, Dil. B (Low- contrast Subjects)	—	13	—	—	9	—	15	—	—	10

*Agitation at 30-second intervals during development.
†Development times of less than 5 minutes in a tank may produce poor uniformity and should be avoided.

KODAK 2479 RAR FILM (ESTAR BASE) 16MM, 35MM AND 70MM.

Safelight: *Total darkness required.* A Safelight Filter Series 3 (dark green), in a suitable safelight lamp with a 15-watt bulb can be used for a few seconds *only,* at 4 feet, after development is half completed.

Speed: ASA 400

Daylight Exposure: *(See Introduction to this section)* 1/400 sec. at *f*/16

Color Sensitivity: Panchromatic with extended red sensitivity.

Filter Factors: Increase normal exposure by filter factor given below:

Kodak Wratten Filter	No. 6 (K1)	No. 8 (K2)	No. 15 (G)	No. 11 (X1)	No. 29 (F)	No. 25 (A)	No. 58 (B)	No. 47 (C5)	Pola-Screen
Daylight	1.5	2*	2	6	—	3	10	6	2.5
Photoflood or high-efficiency tungsten	1.2	1.2	1.5	6*	—	2	12	16	3

*For correct gray-tone rendering of colored objects.

Flash Exposure Guide Numbers: To get *f*/number, divide guide number by flash-to-subject distance in feet, taken to a point midway between nearest and farthest details of interest. In small white rooms, use one stop smaller.

Synchronization: X or F				M	Focal-Plane Shutter Speed	6§ 26§
Shutter Speed	AG-1† M2‡	M3‡, M5‡ 5§, 25§	11‖ 40‖	2‖ 22‖		
Open. 1/25	340	500	500	650	1/50	370
1/50	—	450	475	600	1/100	270
1/100	—	340	425	525	1/250	190
1/200	—	300	310	390	1/500	130
1/400	—	220	240	300		

Bowl-Shaped Polished Reflector Sizes: †2-inch; ‡3-inch; §4- to 5-inch; ‖6- to 7-inch. If shallow cylindrical reflectors are used, divide these guide numbers by two.
Note: At 1/25 second, cameras having X or F synchronization can use any of the flashbulbs listed under M synchronization.

Caution: Since bulbs may shatter when flashed, the use of a flashguard over the reflector is recommended. *Do not flash bulbs in an explosive atmosphere.*

Electronic Flash Guide Numbers: This table is intended as a starting point in determining the correct guide number. The table is for use with equipment rated in beam candlepower-seconds (BCPS) or effective candlepower-seconds (ECPS). Divide the appropriate guide number by the flash-to-subject distance in feet to determine the *f*/number for average subjects.

Output of Unit (BCPS or ECPS)	350	500	700	1000	1400	2000	2800	4000	5600	8000
Guide Number for Trial	85	100	120	140	170	200	240	280	340	400

Develop at approximate times and temperatures given below:

Developer	Developing Times (in Minutes)									
	Continuous Agitation (Tray)					Intermittent Agitation (Tank)*				
	65 F	68 F	70 F	72 F	75 F	65 F	68 F	70 F	72 F	75 F
D-19	—	8	—	—	5	—	—	—	—	—
‡D-76	—	10	—	—	7	—	—	—	—	—
§D-76	—	7	—	—	5	—	—	—	—	—

*Agitation at 30-second intervals during development.
†Development times of less than 5 minutes in a tank may produce poor uniformity and should be avoided.
‡For gamma 1.0
§For gamma 0.7

KODAK 2484 PAN FILM (ESTAR-AH BASE) 16MM AND 35MM.

Safelight: *Total darkness required.* A Safelight Filter Series 3 (dark green), in a suitable safelight lamp with a 15-watt bulb can be used for a few seconds *only,* at 4 feet, after development is half completed.

Speed: ASA 3200 (for low contrast scenes, high contrast development)
1000 (for normal scenes, low contrast development)

Daylight Exposure: *(See Introduction to this section)* 1/1000 sec. at *f*/16 to *f*/25

Color Sensitivity: Panchromatic

Filter Factors: Increase normal exposure by filter factor given below:

Kodak Wratten Filter	No. 6 (K1)	No. 8 (K2)	No. 15 (G)	No. 11 (X1)	No. 29 (F)	No. 25 (A)	No. 58 (B)	No. 47 (C5)	Pola- Screen
Daylight	1.5	2*	2	6	—	3	10	6	2.5
Photoflood or high-efficiency tungsten	1.2	1.2	1.5	6*	—	2	12	16	3

*For correct gray-tone rendering of colored objects.

Flash Exposure Guide Numbers: To get *f*/number, divide guide number by flash-to-subject distance in feet, taken to a point midway between nearest and farthest details of interest. In small white rooms, use one stop smaller.

Synchronization: X or F			M			Focal-Plane Shutter Speed	6§ 26§
Shutter Speed	AG-1† M2‡	M3‡, M5‡ 5§, 25§	11‖ 40‖	2‖ 22‖			
Open. 1/25	700	1400	1600	2200		1/50	1040
1/50	—	1200	1400	1800		1/100	760
1/100	—	1000	1200	1600		1/250	540
1/200	—	880	800	1300		1/500	380
1/400	—	720	640	1000			

Bowl-Shaped Polished Reflector Sizes: †2-inch; ‡3-inch; §4- to 5-inch; ‖6- to 7-inch. If shallow cylindrical reflectors are used, divide these guide numbers by two.
Note: At 1/25 second, cameras having X or F synchronization can use any of the flashbulbs listed under M synchronization.

Caution: Since bulbs may shatter when flashed, the use of a flashguard over the reflector is recommended. *Do not flash bulbs in an explosive atmosphere.*

Electronic Flash Guide Numbers: This table is intended as a starting point in determining the correct guide number. The table is for use with equipment rated in beam candlepower-seconds (BCPS) or effective candlepower-seconds (ECPS). Divide the appropriate guide number by the flash-to-subject distance in feet to determine the *f*/number for average subjects.

Output of Unit (BCPS or ECPS)	350	500	700	1000	1400	2000	2800	4000	5600	8000
Guide Number for Trial	180	220	260	320	360	440	520	640	720	880

Develop at approximate times and temperatures given below:

	Developing Times (in Minutes)									
Developer	Continuous Agitation (Tray)					Intermittent Agitation (Tank)*				
	65 F	68 F	70 F	72 F	75 F	65 F	68 F	70 F	72 F	75 F

Kodak D-76: for ASA 800 develop 10 min. at 68 F.
Kodak D-76: for ASA 1000 develop 3 min. at 95 F.
Kodak D-76: for ASA 2000 develop 15 min. at 68 F.
Kodak D-76: for ASA 3200 develop 4 min. at 95 F.
Kodak D-19: for ASA 2000 develop 4 min. at 68 F.
Kodak D-19: for ASA 3200 develop 1¼ min. at 95 F.

*Agitation at 30-second intervals during development.
†Development times of less than 5 minutes in a tank may produce poor uniformity and should be avoided.

KODAK 2485 HIGH SPEED RECORDING FILM (ESTAR-AH BASE)

Safelight: *Total darkness required.* A Safelight Filter Series 3 (dark green), in a suitable safelight lamp with a 15-watt bulb can be used for a few seconds *only,* at 4 feet, after development is half completed.

Speed: ASA 800 for normal photography, average scenes. ASA 5000—8000 depending upon processing conditions, for low-contrast, available-light subjects.

Daylight Exposure: *(See Introduction to this section)* 1/1000 sec at f/16

Color Sensitivity: Panchromatic, with extended red sensitivity

Filter Factors: Increase normal exposure by filter factor given below:

Kodak Wratten Filter	No. 6 (K1)	No. 8 (K2)	No. 15 (G)	No. 11 (X1)	No. 29 (F)	No. 25 (A)	No. 58 (B)	No. 47 (C5)	Pola-Screen
Daylight	1.5	2*	2	6	—	3	10	6	2.5
Photoflood or high-efficiency tungsten	1.2	1.2	1.5	6*	—	2	12	16	3

*For correct gray-tone rendering of colored objects.

Flash Exposure Guide Numbers: To get f/number, divide guide number by flash-to-subject distance in feet, taken to a point midway between nearest and farthest details of interest. In small white rooms, use one stop smaller.

	Synchronization: X or F		M			Focal-Plane	
Shutter Speed	AG-1† M2‡	M3‡, M5‡ 5§, 25§	11‖ 40‖	2‖ 22‖		Shutter Speed	6§ 26§
Open. 1/25	—	950	—	1900		1/50	660
1/50	—	850	—	1700		1/100	480
1/100	—	750	—	1500		1/250	340
1/200	—	600	—	1200		1/500	240
1/400	—	450	—	1000			

Bowl-Shaped Polished Reflector Sizes: †2-inch; ‡3-inch; §4- to 5-inch; ‖6- to 7-inch. If shallow cylindrical reflectors are used, divide these guide numbers by two.

Note: At 1/25 second, cameras having X or F synchronization can use any of the flashbulbs listed under M synchronization.

Caution: Since bulbs may shatter when flashed, the use of a flashguard over the reflector is recommended. *Do not flash bulbs in an explosive atmosphere.*

Electronic Flash Guide Numbers: This table is intended as a starting point in determining the correct guide number. The table is for use with equipment rated in beam candlepower-seconds (BCPS) or effective candlepower-seconds (ECPS). Divide the appropriate guide number by the flash-to-subject distance in feet to determine the f/number for average subjects.

Output of Unit (BCPS or ECPS)	350	500	700	1000	1400	2000	2800	4000	5600	8000
Guide Number for Trial	150	180	210	250	300	350	420	500	600	700

Develop at approximate times and temperatures given below:

	Developing Times (in Minutes)									
Developer	Continuous Agitation (Tray)					Intermittent Agitation (Tank)*				
	65 F	68 F	70 F	72 F	75 F	65 F	68 F	70 F	72 F	75 F

Kodak 857 (for ASA 800) 1½ min. at 95 F (4 min. at 75 F)
Kodak 857 (for ASA 6500) 2½ min. at 95 F
Kodak 857 (for ASA 8000) 3½ min. at 95 F
Kodak D-19 (for ASA 5000) 2½ min. at 95 F (12 min. at 75 F)

*Agitation at 30-second intervals during development.
†Development times of less than 5 minutes in a tank may produce poor uniformity and should be avoided.

KODAK 2496 RAR FILM (ESTAR-AH BASE) 16MM AND 35MM.

Safelight: *Total darkness required.* A Safelight Filter Series 3 (dark green), in a suitable safelight lamp with a 15-watt bulb can be used for a few seconds *only,* at 4 feet, after development is half completed.

Speed: ASA 80

Daylight Exposure: *(See Introduction to this section)* 1/100 sec. at f/12.5

Color Sensitivity: Panchromatic with extended red sensitivity.

Filter Factors: Increase normal exposure by filter factor given below:

Kodak Wratten Filter	No. 6 (K1)	No. 8 (K2)	No. 15 (G)	No. 11 (X1)	No. 29 (F)	No. 25 (A)	No. 58 (B)	No. 47 (C5)	Pola- Screen
Daylight	1.5	2*	2	6	—	3	10	6	2.5
Photoflood or high- efficiency tungsten	1.2	1.2	1.5	6*	—	2	12	16	3

*For correct gray-tone rendering of colored objects.

Flash Exposure Guide Numbers: To get f/number, divide guide number by flash-to-subject distance in feet, taken to a point midway between nearest and farthest details of interest. In small white rooms, use one stop smaller.

Synchronization: X or F		M			Focal-Plane Shutter Speed	6§ 26§
Shutter Speed	AG-1† M2‡	M3‡, M5‡ 5§, 25§	11‖ 40‖	2‖ 22‖		
Open. 1/25	120	230	240	340	1/50	165
1/50	100	200	200	320	1/100	120
1/100	—	160	170	250	1/250	85
1/200	—	105	110	190	1/500	60
1/400	—	—	—	—		

Bowl-Shaped Polished Reflector Sizes: †2-inch; ‡3-inch; §4- to 5-inch; ‖6- to 7-inch. If shallow cylindrical reflectors are used, divide these guide numbers by two.
Note: At 1/25 second, cameras having X or F synchronization can use any of the flashbulbs listed under M synchronization.

Caution: Since bulbs may shatter when flashed, the use of a flashguard over the reflector is recommended. *Do not flash bulbs in an explosive atmosphere.*

Electronic Flash Guide Numbers: This table is intended as a starting point in determining the correct guide number. The table is for use with equipment rated in beam candlepower-seconds (BCPS) or effective candlepower-seconds (ECPS). Divide the appropriate guide number by the flash-to-subject distance in feet to determine the f/number for average subjects.

Output of Unit (BCPS or ECPS)	350	500	700	1000	1400	2000	2800	4000	5600	8000
Guide Number for Trial	40	45	55	65	80	90	110	130	160	180

Develop at approximate times and temperatures given below:

	Developing Times (in Minutes)									
Developer	Continuous Agitation (Tray)					Intermittent Agitation (Tank)*				
	65 F	68 F	70 F	72 F	75 F	65 F	68 F	70 F	72 F	75 F
Kodak D-19	—	8	—	—	5	—	—	—	—	—
Kodak D-76‡	—	6	—	—	4½	—	—	—	—	—
Kodak D-76§	—	12	—	—	9	—	—	—	—	—

*Agitation at 30-second intervals during development.
†Development times of less than 5 minutes in a tank may produce poor uniformity and should be avoided.
‡For gamma 1.0
§For gamma 1.6

KODAK 2498 RAR FILM (ESTAR-AH BASE) 16-, 35-, 70mm AND 5-INCH ROLLS AND 5498 RAR FILM 16- AND 70mm

Safelight: *Total darkness required.* A Safelight Filter Series 3 (dark green), in a suitable safelight lamp with a 15-watt bulb can be used for a few seconds *only,* at 4 feet, after development is half completed.

Speed: ASA 250 (for low-contrast processing in D-76)

Daylight Exposure: *(See Introduction to this section)* 1/250 sec. at $f/16$.

Color Sensitivity: Panchromatic, with extended red sensitivity

Filter Factors: Increase normal exposure by filter factor given below:

Kodak Wratten Filter	No. 6 (K1)	No. 8 (K2)	No. 15 (G)	No. 11 (X1)	No. 29 (F)	No. 25 (A)	No. 58 (B)	No. 47 (C5)	Pola-Screen
Daylight	1.5	2*	2	6	—	3	10	6	2.5
Photoflood or high-efficiency tungsten	1.2	1.2	1.5	6*	—	2	12	16	3

*For correct gray-tone rendering of colored objects.

Flash Exposure Guide Numbers: To get f/number, divide guide number by flash-to-subject distance in feet, taken to a point midway between nearest and farthest details of interest. In small white rooms, use one stop smaller.

Shutter Speed	Synchronization: X or F AG-1† M2‡	M3‡, M5‡ 5§, 25§	11‖ 40‖	M 2‖ 22‖	Focal-Plane Shutter Speed	6§ 26§
Open. 1/25	240	480	550	800	1/50	290
1/50	—	420	480	600	1/100	210
1/100	—	360	420	550	1/250	150
1/200	—	320	280	460	1/500	105
1/400	—	240	220	360		

Bowl-Shaped Polished Reflector Sizes: †2-inch; ‡3-inch; §4- to 5-inch; ‖6- to 7-inch. If shallow cylindrical reflectors are used, divide these guide numbers by two.
Note: At 1/25 second, cameras having X or F synchronization can use any of the flashbulbs listed under M synchronization.

Caution: Since bulbs may shatter when flashed, the use of a flashguard over the reflector is recommended. *Do not flash bulbs in an explosive atmosphere.*

Electronic Flash Guide Numbers: This table is intended as a starting point in determining the correct guide number. The table is for use with equipment rated in beam candlepower-seconds (BCPS) or effective candlepower-seconds (ECPS). Divide the appropriate guide number by the flash-to-subject distance in feet to determine the f/number for average subjects.

Output of Unit (BCPS or ECPS)	350	500	700	1000	1400	2000	2800	4000	5600	8000
Guide Number for Trial	65	80	95	110	130	160	190	220	260	320

Develop at approximate times and temperatures given below:

Developer	Developing Times (in Minutes)									
	Continuous Agitation (Tray)					Intermittent Agitation (Tank)*				
	65 F	68 F	70 F	72 F	75 F	65 F	68 F	70 F	72 F	75 F
Kodak D-76 (use 3 min. at 95 F)	—	8								
Kodak D-19 (use 1½ min. at 95 F)	—	8								
Kodak 448 Monobath (¾ to 1 min. at 95 F 2498 RAR film only)										
Kodak Reversal Process may also be used with these films.										

*Agitation at 30-second intervals during development.
†Development times of less than 5 minutes in a tank may produce poor uniformity and should be avoided.

Note: Kodak Developer DK-20 and other developers containing silver halide solvents, such as thiocyanates or thiosulfates, should not be used as they may form a scum on the surface of the film.

KODAK PROFESSIONAL DIRECT DUPLICATING FILM SO-015
(ESTAR THICK BASE)

Safelight: Use a safelight filter No. 1A (light red) in a suitable safelight lamp, with a 15-watt bulb at not less than 4 feet.

Color Sensitivity: Orthochromatic

Meter Settings

White Flame Arc	Tungsten or Quartz-Iodine	Pulsed Xenon

FOR CONTACT PRINTING

Use and Exposure: This film produces negatives directly from original negatives (or will make a positive from a positive.) Reversal processing is not required; the film is simply developed directly in an ordinary negative developer.

As an example of an exposure for trial, using a tungsten light source producing 3 footcandles at the exposure plane, expose for 40 seconds. This light level is attainable with many enlargers and in this case the film can be used to make enlarged duplicate negatives without need for an intermediate positive. Since the film works oppositely to normal negative emulsions, if adjustment of exposure is required, it is necessary to give more exposure to produce a lighter image, less exposure for a denser image.

Some adjustment of contrast is possible in development, and the times of development given below may be increased for a higher contrast copy, or decreased for lower contrast.

Develop at 68 F (20 C) for approximate times given below:

Developer*	Development Times (minutes)			Development Range† (minutes)
	Halftone Negative	Agitation	Line Negative	
Kodak DK-50	7	1-minute	—	—
Kodak D-72 or Kodak Dektol (1:1)	2	Continuous	—	—

*Available in ready-to-mix form in several package sizes.
†Within this range of development times, satisfactory results can usually be obtained.

KODAK ROYAL PAN FILM 4141 (ESTAR THICK BASE)

Safelight: *Total darkness required.* A Safelight Filter Series 3 (dark green), in a suitable safelight lamp with a 15-watt bulb can be used for a few seconds *only,* at 4 feet, after development is half completed.

Speed: ASA 400

Daylight Exposure: *(See Introduction to this section)* 1/400 sec. at $f/16$

Color Sensitivity: Panchromatic

Filter Factors: Increase normal exposure by filter factor given below:

Kodak Wratten Filter	No. 6 (K1)	No. 8 (K2)	No. 15 (G)	No. 11 (X1)	No. 29 (F)	No. 25 (A)	No. 58 (B)	No. 47 (C5)	Pola-Screen
Daylight	1.5	2.0*	3.0	4.0	25.0	8.0	8.0	6.0	2.5
Photoflood or high-efficiency tungsten	1.5	1.5	2.0	3.0*	12.0	5.0	6.0	12.0	2.5

*For correct gray-tone rendering of colored objects.

Flash Exposure Guide Numbers: To get $f/$number, divide guide number by flash-to-subject distance in feet, taken to a point midway between nearest and farthest details of interest. In small white rooms, use one stop smaller.

Synchronization: X or F		M			Focal-Plane	6B§
Shutter Speed	Flash Cube	M3B‡, M5B‡ 5B§, 25B§	AG-1B†	M2B‡	Shutter Speed	26B§
Open, 1/25	200	400	200	250	1/50	290
1/50	130	350	200	—	1/100	190
1/100	110	290	170	—	1/250	135
1/200	90	240	140	—	1/500	100
1/400	70	170	110	—		

Bowl-Shaped Polished Reflector Sizes: †2-inch; ‡3-inch; §4- to 5-inch; ‖6- to 7-inch. If shallow cylindrical reflectors are used, divide these guide numbers by two.

Note: At 1/25 second, cameras having X or F synchronization can use any of the flashbulbs listed under M synchronization.

Caution: Since bulbs may shatter when flashed, the use of a flashguard over the reflector is recommended. *Do not flash bulbs in an explosive atmosphere.*

Electronic Flash Guide Numbers: This table is intended as a starting point in determining the correct guide number. The table is for use with equipment rated in beam candlepower-seconds (BCPS) or effective candlepower-seconds (ECPS). Divide the appropriate guide number by the flash-to-subject distance in feet to determine the $f/$number for average subjects.

Output of Unit (BCPS or ECPS)	350	500	700	1000	1400	2000	2800	4000	5600	8000
Guide Number for Trial	85	100	120	140	170	200	240	280	340	400

Develop at approximate times and temperatures given below:

Developer	Developing Times (in Minutes)									
	Continuous Agitation (Tray)					Intermittent Agitation (Tank)*				
	65 F	68 F	70 F	72 F	75 F	65 F	68 F	70 F	72 F	75 F
Polydol	7	6	5½	5	4½	9	8	7½	7	6
HC-110 (Dil A)	3½	3	2¾	2½	2¼	4	3¾	3¼	3	2¾
HC-110 (Dil B)	7	6	5½	5	4½	9	8	7½	7	6
DK-50	4½	4	4	3¾	3½	5½	5	4¾	4½	4¼
DK-50 (1:1)	7	6	5½	5	4½	9	8	7½	7	6
D-76	9	8	7½	7	6	11	10	9½	9	8
Microdol-X	10	9	8½	8	7	12	11	10½	10	9

*Agitation at 1-minute intervals during development.

Forms Available: Sheets and 3½-inch long rolls.

KODAK ROYAL-X PAN FILM 4166 (ESTAR THICK BASE)

Safelight: *Total darkness required.*

Speed: ASA 1250

Daylight Exposure: *(See Introduction to this section)* 1/400 sec. at ƒ/32.

Color Sensitivity: Panchromatic

Filter Factors: Increase normal exposure by filter factor given below:

Kodak Wratten Filter	No. 6 (K1)	No. 8 (K2)	No. 15 (G)	No. 11 (X1)	No. 29 (F)	No. 25 (A)	No. 58 (B)	No. 47 (C5)	Pola-Screen
Daylight	—	2.0	2.5	—	—	8.0	8.0	6.0	2.5
Photoflood or high-efficiency tungsten	—	2.0	2.5	—	—	5.0	8.0	12.0	2.5

*For correct gray-tone rendering of colored objects.

Flash Exposure Guide Numbers: To get ƒ/number, divide guide number by flash-to-subject distance in feet, taken to a point midway between nearest and farthest details of interest. In small white rooms, use one stop smaller.

	Synchronization: X or F			M	Focal-Plane	
Shutter Speed	AG-1† M2‡	M3‡, M5‡ 5§, 25§	11‖ 40‖	2‖ 22‖	Shutter Speed	6§ 26§
Open. 1/25	480	950	1100	1600	1/50	950
1/50	400	850	950	1200	1/100	480
1/100	340	750	850	1100	1/250	360
1/200	240	600	550	850	1/500	240
1/400	200	480	440	750		

Bowl-Shaped Polished Reflector Sizes: †2-inch; ‡3-inch; §4- to 5-inch; ‖6- to 7-inch. If shallow cylindrical reflectors are used, divide these guide numbers by two.
Note: At 1/25 second, cameras having X or F synchronization can use any of the flashbulbs listed under M synchronization.

Caution: Since bulbs may shatter when flashed, the use of a flashguard over the reflector is recommended. *Do not flash bulbs in an explosive atmosphere.*

Electronic Flash Guide Numbers: This table is intended as a starting point in determining the correct guide number. The table is for use with equipment rated in beam candlepower-seconds (BCPS) or effective candlepower-seconds (ECPS). Divide the appropriate guide number by the flash-to-subject distance in feet to determine the ƒ/number for average subjects.

Output of Unit (BCPS or ECPS)	350	500	700	1000	1400	2000	2800	4000	5600	8000
Guide Number for Trial	150	180	210	250	300	350	420	500	600	700

Develop at approximate times and temperatures given below:

Developer	Developing Times (in Minutes)									
	Continuous Agitation (Tray)					Intermittent Agitation (Tank)*				
	65 F	68 F	70 F	72 F	75 F	65 F	68 F	70 F	72 F	75 F
HC-110 (Dil A)	5	4½	4½	4	3½	7	6	5½	5	4½
HC-110 (Dil B)	8½	8	7½	7	6½	11	10	9	8½	7½
DK-60a	4½	4	3¾	3½	3	6	5	4½	4	3½
DK-50	4¾	4½	4¼	4¼	4	6½	6	5½	5½	5
Polydol	7½	6½	6	5½	4½	9½	8½	8	7½	6½

*Agitation at 1-minute intervals during development.

Forms Available: Sheets and 3½-inch long rolls.

KODAK ROYAL-X PAN ROLL FILM

Safelight: *Total darkness required.*

Speed: ASA 1250

Daylight Exposure: *(See Introduction to this section)* 1/400 sec. at *f*/32.

Color Sensitivity: Panchromatic

Filter Factors: Increase normal exposure by filter factor given below:

Kodak Wratten Filter	No. 6 (K1)	No. 8 (K2)	No. 15 (G)	No. 11 (X1)	No. 29 (F)	No. 25 (A)	No. 58 (B)	No. 47 (C5)	Pola-Screen
Daylight	1.5	2.0*	2.5	4.0	—	8.0	8.0	6.0	2.5
Photoflood or high-efficiency tungsten	1.5	1.5	2.0	4.0*	—	5.0	8.0	12.0	2.5

*For correct gray-tone rendering of colored objects.

Flash Exposure Guide Numbers: To get *f*/number, divide guide number by flash-to-subject distance in feet, taken to a point midway between nearest and farthest details of interest. In small white rooms, use one stop smaller.

Synchronization: X or F			M			Focal-Plane	
Shutter Speed	Flash Cube	M3B‡, M5B‡ 5B§, 25B§	AG-1B†	M2B‡		Shutter Speed	6B§ 26B§
Open, 1/25	—	750	440	500		1/50	—
1/50	—	650	360	—		1/100	—
1/100	—	600	—	—		1/250	—
1/200	—	500	—	—		1/500	—
1/400	—	400	—	—			

Bowl-Shaped Polished Reflector Sizes: †2-inch; ‡3-inch; §4- to 5-inch; ‖6- to 7-inch. If shallow cylindrical reflectors are used, divide these guide numbers by two.
Note: At 1/25 second, cameras having X or F synchronization can use any of the flashbulbs listed under M synchronization.

Caution: Since bulbs may shatter when flashed, the use of a flashguard over the reflector is recommended. *Do not flash bulbs in an explosive atmosphere.*

Electronic Flash Guide Numbers: This table is intended as a starting point in determining the correct guide number. The table is for use with equipment rated in beam candlepower-seconds (BCPS) or effective candlepower-seconds (ECPS). Divide the appropriate guide number by the flash-to-subject distance in feet to determine the *f*/number for average subjects.

Output of Unit (BCPS or ECPS)	350	500	700	1000	1400	2000	2800	4000	5600	8000
Guide Number for Trial	150	180	210	250	300	350	420	500	600	700

Develop at approximate times and temperatures given below:

Developer	Developing Times (in Minutes)									
	Small Tank*					Large Tank †				
	65 F	68 F	70 F	72 F	75 F	65 F	68 F	70 F	72 F	75 F
DK-50	5½	5	4¾	4¾	4½	—	—	—	—	—
DK-60a	5	4½	4¼	—	—	—	—	—	—	—
Polydol	8	7	6½	6	5	—	—	—	—	—
§HC-110 (Dil. A)	6	5	4¾	4½	4¼	—	—	—	—	—
§HC-110 (Dil. B)	10	9	8	7½	6½	—	—	—	—	—

*Agitation at 30-second intervals during development.
†Agitation at 1-minute intervals during development.
§Dilution A is a 1:15 dilution of the developer concentrate; Dilution B is a 1:31 dilution of the developer concentrate.

Forms Available: 120 Roll films.

KODAK SUPER PANCHRO-PRESS TYPE B SHEET FILM

Safelight: *Total darkness required.* A Safelight Filter Series 3 (dark green), in a suitable safelight lamp with a 15-watt bulb can be used for a few seconds *only,* at 4 feet, after development is half completed.

Speed: ASA 250

Daylight Exposure: *(See Introduction to this section)* 1/250 sec. at $f/16$

Color Sensitivity: Panchromatic

Filter Factors: Increase normal exposure by filter factor given below:

Kodak Wratten Filter	No. 6 (K1)	No. 8 (K2)	No. 15 (G)	No. 11 (X1)	No. 29 (F)	No. 25 (A)	No. 58 (B)	No. 47 (C5)	Pola- Screen
Daylight	1.5	2.0*	3.0	4.0	16.0	8.0	8.0	5.0	2.5
Photoflood or high-efficiency tungsten	1.5	1.5	2.0	3.0*	8.0	4.0	8.0	10.0	2.5

*For correct gray-tone rendering of colored objects.

Flash Exposure Guide Numbers: To get $f/$number, divide guide number by flash-to-subject distance in feet, taken to a point midway between nearest and farthest details of interest. In small white rooms, use one stop smaller.

Synchronization: X or F			M		Focal-Plane	6§
Shutter Speed	AG-1† M2‡	M3‡, M5‡ 5§, 25§	11‖ 40‖	2‖ 22‖	Shutter Speed	26§
Open. 1/25	260	400	400	500	1/50	290
1/50	—	350	380	475	1/100	210
1/100	—	300	330	425	1/250	150
1/200	—	230	250	310	1/500	105
1/400	—	180	190	230		

Bowl-Shaped Polished Reflector Sizes: †2-inch; ‡3-inch; §4- to 5-inch; ‖6- to 7-inch. If shallow cylindrical reflectors are used, divide these guide numbers by two.
Note: At 1/25 second, cameras having X or F synchronization can use any of the flashbulbs listed under M synchronization.

Caution: Since bulbs may shatter when flashed, the use of a flashguard over the reflector is recommended. *Do not flash bulbs in an explosive atmosphere.*

Electronic Flash Guide Numbers: This table is intended as a starting point in determining the correct guide number. The table is for use with equipment rated in beam candlepower-seconds (BCPS) or effective candlepower-seconds (ECPS). Divide the appropriate guide number by the flash-to-subject distance in feet to determine the $f/$number for average subjects.

Output of Unit (BCPS or ECPS)	350	500	700	1000	1400	2000	2800	4000	5600	8000
Guide Number for Trial	65	80	95	110	130	160	190	220	260	320

Develop at approximate times and temperatures given below:

Developer	Developing Times (in Minutes)									
	Continuous Agitation (Tray)					Intermittent Agitation (Tank)*				
	65 F	68 F	70 F	72 F	75 F	65 F	68 F	70 F	72 F	75 F
Polydol	11	9	8	7	6	13	11	10	9	8
HC-110 (Dil A)	4½	4	3¾	3½	3	6	5	4½	4¼	3½
HC-110 (Dil B)	7	6	5½	5	4½	9	8	7½	7	6
DK-50	4¾	4½	4½	4¼	4	6½	6	5¾	5½	5
DK-50 (1:1)	9	8	7½	7	6	11	10	9½	9	8
D-76	11	10	9½	9	8	14	13	12	11	10

*Agitation at 1-minute intervals during development.
†Development times of less than 5 minutes in a tank may produce poor uniformity and should be avoided.

KODAK SUPER SPEED DIRECT POSITIVE PAPER

Safelight: A Safelight Filter Series 2 (dark red), in a suitable safelight lamp with a 15-watt bulb can be used at 4 feet.

Speed: ASA PROCESS 1: Daylight 25; Tungsten 12
 PROCESS 2: Daylight 20; Tungsten 10

Daylight Exposure: *(See Introduction to this section)* 1/100 sec. at *f*/8

Color Sensitivity: Orthochromatic

Filter Factors: Increase normal exposure by filter factor given below:

Kodak Wratten Filter	No. 6 (K1)	No. 8 (K2)	No. 15 (G)	No. 11 (X1)	No. 29 (F)	No. 25 (A)	No. 58 (B)	No. 47 (C5)	Pola- Screen
Daylight Photoflood or high-efficiency tungsten				NOT USED					

*For correct gray-tone rendering of colored objects.

Flash Exposure Guide Numbers: To get *f*/number, divide guide number by flash-to-subject distance in feet, taken to a point midway between nearest and farthest details of interest. In small white rooms, use one stop smaller.

Synchronization: X or F			M		Focal-Plane Shutter Speed	6§ 26§
Shutter Speed	AG-1† M2‡	M3‡, M5‡ 5§, 25§	11‖ 40‖	2‖ 22‖		
Open. 1/25	—	110	130	—	1/50	95
1/50	—	110	130	—	1/100	65
1/100	—	85	95	—	1/250	50
1/200	—	62	69	—	1/550	35
1/400	—	39	44	—		

Bowl-Shaped Polished Reflector Sizes: †2-inch; ‡3-inch; §4- to 5-inch; ‖6- to 7-inch. If shallow cylindrical reflectors are used, divide these guide numbers by two.
Note: At 1/25 second, cameras having X or F synchronization can use any of the flashbulbs listed under M synchronization.

Caution: Since bulbs may shatter when flashed, the use of a flashguard over the reflector is recommended. *Do not flash bulbs in an explosive atmosphere.*

Electronic Flash Guide Numbers: This table is intended as a starting point in determining the correct guide number. The table is for use with equipment rated in beam candlepower-seconds (BCPS) or effective candlepower-seconds (ECPS). Divide the appropriate guide number by the flash-to-subject distance in feet to determine the *f*/number for average subjects.

Output of Unit (BCPS or ECPS)	350	500	700	1000	1400	2000	2800	4000	5600	8000
Process 1	18	22	26	32	35	45	55	65	75	90
Process 2	17	20	24	28	32	40	50	55	65	80

Develop at approximate times and temperatures given below:

Developer	Developing Times (in Minutes)									
	Continuous Agitation (Tray)					Intermittent Agitation (Tank)*				
	65 F	68 F	70 F	72 F	75 F	65 F	68 F	70 F	72 F	75 F

Reversal processing; see Section BPR.

*Agitation at 1-minute intervals during development.
†Development times of less than 5 minutes in a tank may produce poor uniformity and should be avoided.

KODAK SUPER-XX PAN SHEET FILM

Safelight: *Total darkness required.* A safelight filter Series 3 (dark green), in a suitable safelight lamp with a 15-watt bulb can be used for a few seconds *only*, at 4 feet, after development is half completed.

Speed: ASA 200

Daylight Exposure: *(See Introduction to this section)* 1/150 sec. at f/16

Color Sensitivity: Panchromatic

Filter Factors: Increase normal exposure by filter factor given below:

Kodak Wratten Filter	No. 6 (K1)	No. 8 (K2)	No. 15 (G)	No. 11 (X1)	No. 29 (F)	No. 25 (A)	No. 58 (B)	No. 47 (C5)	Pola-Screen
Daylight	1.5	2.0*	3.0	4.0	16.0	8.0	8.0	5.0	2.5
Photoflood or high-efficiency tungsten	1.5	1.5	2.0	3.0*	8.0	4.0	8.0	10.0	2.5

*For correct gray-tone rendering of colored objects.

Flash Exposure Guide Numbers: To get f-number, divide guide number by flash-to-subject distance in feet, taken to a point midway between nearest and farthest details of interest. In small white rooms, use one stop smaller.

Synchronization: X or F			M			Focal-Plane	6§
Shutter Speed	AG-1† M2‡	M3‡ M5‡ 5§ 25§	11‖ 40‖	2‖ 22‖		Shutter Speed	26§
Open. 1/25	220	340	400	500		1/50	260
1/50	—	300	360	450		1/100	190
1/100	—	260	350	380		1/250	135
1/200	—	200	250	300		1/500	95
1/400	—	150	190	220			

Bowl-Shaped Polished Reflector Sizes: †2-inch; ‡3-inch; §4- to 5-inch; ‖6- to 7-inch. If shallow cylindrical reflectors are used, divide these guide numbers by two.
Note: At 1/25 second, cameras having X or F synchronization can use any of the flashbulbs listed under M synchronization.
Caution: Since bulbs may shatter when flashed, the use of a flashguard over the reflector is recommended. *Do not flash bulbs in an explosive atmosphere.*

Electronic Flash Guide Numbers: This table is intended as a starting point in determining the correct guide number. The table is for use with equipment rated in beam candlepower-seconds (BCPS) or effective candlepower-seconds (ECPS). Divide the appropriate guide number by the flash-to-subject distance in feet to determine the f-number for average subjects.

Output of Unit (BCPS or ECPS)	350	500	700	1000	1400	2000	2800	4000	5600	8000
Guide Number for Trial	60	70	85	100	120	140	170	200	240	280

Develop at approximate times and temperatures given below:

	Developing Times (in Minutes)									
Developer	Continuous Agitation (Tray)					Intermittent Agitation (Tank)*				
	65 F	68 F	70 F	72 F	75 F	65 F	68 F	70 F	72 F	75 F
Polydol	11	9	8	7	6	13	11	10	9	8
HC-110 (Dil A)	4½	4	3¾	3½	3	6	5	4½	4¼	3½
HC-110 (Dil B)	8	7	6½	6	5	11	9	8	7	6
DK-60a	4½	4	3¾	3½	3	6	5	4½	4¼	3½
DK-50	5½	5	4¾	4½	4	8	7	6½	6	5
DK-50 (1:1)	9	8	7½	7	6	11	10	9½	9	8

*Agitation at 1-minute intervals during development.
†Development times of less than 5 minutes in a tank may produce poor uniformity and should be avoided.

KODAK TRI-X ORTHO SHEET FILM

Safelight: *Total darkness required.* A safelight filter Series 2 (dark red), in a suitable safelight lamp with a 15-watt bulb can be used at 4 feet.

Speed: ASA 320 Daylight—200 Tungsten

Daylight Exposure: *(See Introduction to this section)* 1/250 sec. at f/16

Color Sensitivity: Orthochromatic

Filter Factors: Increase normal exposure by filter factor given below:

Kodak Wratten Filter	No. 6 (K1)	No. 8 (K2)	No. 15 (G)	No. 11 (X1)	No. 29 (F)	No. 25 (A)	No. 58 (B)	No. 47 (C5)	Pola-Screen
Daylight	2.0	2.0	3.0	—	—	—	6.0	5.0	2.5
Photoflood or high-efficiency tungsten	1.5	2.0	3.0	—	—	—	5.0	8.0	2.5

*For correct gray-tone rendering of colored objects.

Flash Exposure Guide Numbers: To get f-number, divide guide number by flash-to-subject distance in feet, taken to a point midway between nearest and farthest details of interest. In small white rooms, use one stop smaller.

Synchronization: X or F				M	Focal-Plane Shutter Speed	6§ 26§
Shutter Speed	AG-1† M2‡	M3‡ M5‡ 5§ 25§	11‖ 40‖	2‖ 22‖		
Open. 1/25	240	350	360	450	1/50	260
1/50	—	320	340	425	1/100	190
1/100	—	260	290	370	1/250	135
1/200	—	210	220	280	1/500	95
1/400	—	160	170	210		

Bowl-Shaped Polished Reflector Sizes: †2-inch; ‡3-inch; §4- to 5-inch; ‖6- to 7-inch. If shallow cylindrical reflectors are used, divide these guide numbers by two.
Note: At 1/25 second, cameras having X or F synchronization can use any of the flashbulbs listed under M synchronization.

Caution: Since bulbs may shatter when flashed, the use of a flashguard over the reflector is recommended. *Do not flash bulbs in an explosive atmosphere.*

Electronic Flash Guide Numbers: This table is intended as a starting point in determining the correct guide number. The table is for use with equipment rated in beam candlepower-seconds (BCPS) or effective candlepower-seconds (ECPS). Divide the appropriate guide number by the flash-to-subject distance in feet to determine the f-number for average subjects.

Output of Unit (BCPS or ECPS)	350	500	700	1000	1400	2000	2800	4000	5600	8000
Guide Number for Trial	75	90	110	130	150	180	210	250	300	360

Develop at approximate times and temperatures given below:

Developer	Developing Times (in Minutes)									
	Continuous Agitation (Tray)					Intermittent Agitation (Tank)*				
	65 F	68 F	70 F	72 F	75 F	65 F	68 F	70 F	72 F	75 F
Polydol	7	6	5½	5	4½	9	8	7½	7	6
HC-110 (Dil B)	5	4½	4¼	4	3¼	7	6	5½	5	—
DK-50 (1:1)	4¾	4½	—	4¼	4	6½	6	5¾	5½	5
D-76	8	7	6½	6	5	10	9	8½	8	7
Microdol-X	9	8	7½	7	6	11	10	9½	9	8

*Agitation at 1-minute intervals during development.
†Development times of less than 5 minutes in a tank may produce poor uniformity and should be avoided.
Note: Kodak Developer DK-20 and other developers containing silver halide solvents, such as thiocyanates or thiosulfates, should not be used as they may form a scum on the surface of the film.

KODAK TRI-X PAN SHEET FILM

Safelight: *Total darkness required.* A safelight filter Series 3 (dark green), in a suitable safelight lamp with a 15-watt bulb can be used for a few seconds *only*, at 4 feet, after development is half completed.

Speed: ASA 320

Daylight Exposure: *(See Introduction to this section)* 1/250 sec. at f/16

Color Sensitivity: Panchromatic

Filter Factors: Increase normal exposure by filter factor given below:

Kodak Wratten Filter	No. 6 (K1)	No. 8 (K2)	No. 15 (G)	No. 11 (X1)	No. 29 (F)	No. 25 (A)	No. 58 (B)	No. 47 (C5)	Pola-Screen
Daylight	1.5	2.0*	2.5	4.0	16.0	8.0	8.0	6.0	2.5
Photoflood or high-efficiency tungsten	1.5	1.5	2.0	4.0*	10.0	5.0	8.0	10.0	2.5

*For correct gray-tone rendering of colored objects.

Flash Exposure Guide Numbers: To get f-number, divide guide number by flash-to-subject distance in feet, taken to a point midway between nearest and farthest details of interest. In small white rooms, use one stop smaller.

Synchronization:	X or F		M			Focal-Plane	6§
Shutter Speed	AG-1† M2‡	M3‡ M5‡ 5§ 25§	11‖ 40‖	2‖ 22‖		Shutter Speed	26§
Open. 1/25	310	450	450	575		1/50	330
1/50	—	400	425	525		1/100	240
1/100	—	330	370	475		1/250	170
1/200	—	260	280	350		1/500	120
1/400	—	200	210	260			

Bowl-Shaped Polished Reflector Sizes: †2-inch; ‡3-inch; §4- to 5-inch; ‖6- to 7-inch. If shallow cylindrical reflectors are used, divide these guide numbers by two.
Note: At 1/25 second, cameras having X or F synchronization can use any of the flashbulbs listed under M synchronization.

Caution: Since bulbs may shatter when flashed, the use of a flashguard over the reflector is recommended. *Do not flash bulbs in an explosive atmosphere.*

Electronic Flash Guide Numbers: This table is intended as a starting point in determining the correct guide number. The table is for use with equipment rated in beam candlepower-seconds (BCPS) or effective candlepower-seconds (ECPS). Divide the appropriate guide number by the flash-to-subject distance in feet to determine the f-number for average subjects.

Output of Unit (BCPS or ECPS)	350	500	700	1000	1400	2000	2800	4000	5600	8000
Guide Number for Trial	75	90	110	130	150	180	210	250	300	360

Develop at approximate times and temperatures given below:

	Developing Times (in Minutes)									
Developer	Continuous Agitation (Tray)					Intermittent Agitation (Tank)*				
	65 F	68 F	70 F	72 F	75 F	65 F	68 F	70 F	72 F	75 F
Polydol	7	6	5½	5	4½	9	8	7½	7	6
HC-110 (Dil A)	3¼	2¾	2½	2¼	2	3¾	3¼	3	2¾	2½
HC-110 (Dil B)	5	4½	4¼	4	3¼	7	6	5½	5	4½
DK-50 (1:1)	4¾	4½	4½	4¼	4	6½	6	5¾	5½	5
D-76	8½	7	6½	6	5	10	9	8½	8	7
Microdol-X	9	8	7½	7	6	11	10	9½	9	8

*Agitation at 1-minute intervals during development.
†Development times of less than 5 minutes in a tank may produce poor uniformity and should be avoided.
Note: Kodak Developer DK-20 and other developers containing silver halide solvents, such as thiocyanates or thiosulfates, should not be used as they may form a scum on the surface of the film.

KODAK TRI-X PAN 35MM FILM

Safelight: *Total darkness required.* A safelight filter Series 3 (dark green), in a suitable safelight lamp with a 15-watt bulb can be used for a few seconds *only*, at 4 feet, after development is half completed.

Speed: ASA 400

Daylight Exposure: *(See Introduction to this section)* 1/200 sec. at f/22

Color Sensitivity: Panchromatic

Filter Factors: Increase normal exposure by filter factor given below:

Kodak Wratten Filter	No. 6 (K1)	No. 8 (K2)	No. 15 (G)	No. 11 (X1)	No. 29 (F)	No. 25 (A)	No. 58 (B)	No. 47 (C5)	Pola-Screen
Daylight	1.5	2.0*	2.5	4.0	—	8.0	6.0	6.0	2.5
Photoflood or high-efficiency tungsten	1.5	1.5	1.5	3.0*	—	5.0	6.0	12.0	2.5

*For correct gray-tone rendering of colored objects.

Flash Exposure Guide Numbers: To get f-number, divide guide number by flash-to-subject distance in feet, taken to a point midway between nearest and farthest details of interest. In small white rooms, use one stop smaller.

Synchronization: X or F			M			Focal-Plane	6B§
Shutter Speed	M2B‡	M3B‡, M5B‡ 5B§, 25B§	AG-1B†	AG-3B†		Shutter Speed	26B§
Open. 1/25	270	400	200	250		1/50	290
1/50	—	350	200	250		1/100	140
1/100	—	290	170	200		1/250	135
1/200	—	240	140	160		1/500	100
1/400	—	170	110	120			

Bowl-Shaped Polished Reflector Sizes: †2-inch; ‡3-inch; §4- to 5-inch; ‖6- to 7-inch. If shallow cylindrical reflectors are used, divide these guide numbers by two.
Note: At 1/25 second, cameras having X or F synchronization can use any of the flashbulbs listed under M synchronization.
Caution: Since bulbs may shatter when flashed, the use of a flashguard over the reflector is recommended. *Do not flash bulbs in an explosive atmosphere.*

Electronic Flash Guide Numbers: This table is intended as a starting point in determining the correct guide number. The table is for use with equipment rated in beam candlepower-seconds (BCPS) or effective candlepower-seconds (ECPS). Divide the appropriate guide number by the flash-to-subject distance in feet to determine the f-number for average subjects.

Output of Unit (BCPS or ECPS)	350	500	700	1000	1400	2000	2800	4000	5600	8000
Guide Number for Trial	85	100	120	140	170	200	240	280	340	400

Develop at approximate times and temperatures given below:

Developer	Developing Times (in Minutes)									
	Small Tank*					Large Tank †				
	65 F	68 F	70 F	72 F	75 F	65 F	68 F	70 F	72 F	75 F
D-76	10	8	7	6	5	11	9	8	7	6
D-76 (1:1)	13	11	10	9	8	15	13	11	10	9
Microdol-X	13	11	10	9	8	15	13	11	10	9
‡Microdol-X (1:3)	—	—	17	16	15	—	—	19	18	17
DK-50 (1:1)	5½	5	—	4¾	4½	6½	6	5¾	5½	5
Polydol	9	8	7½	7	6	10	9	8½	8	7
§HC-110 (Dil. A)	4¼	3¾	3½	3	2¾	4¾	4¼	3¾	3½	3
§HC-110 (Dil. B)	6	5	4½	4	3½	7	6	5	4½	3¾
Agfa Rodinal (1:100)	—	—	—	—	17½	—	—	—	—	—

*Agitation at 30-second intervals during development.
†Agitation at 1-minute intervals during development.
‡For greatest sharpness (see developer instructions).
§Dilution A is a 1:15 dilution of the developer concentrate; Dilution B is a 1:31 dilution of the developer concentrate.

KODAK TRI-X PAN PROFESSIONAL ROLL FILM (120)

Safelight: *Total darkness required.* A safelight filter Series 3 (dark green), in a suitable safelight lamp with a 15-watt bulb can be used for a few seconds *only*, at 4 feet, after development is half completed.

Speed: ASA 320

Daylight Exposure: *(See Introduction to this section)* 1/250 sec. at f/16

Color Sensitivity: Panchromatic

Filter Factors: Increase normal exposure by filter factor given below:

Kodak Wratten Filter	No. 6 (K1)	No. 8 (K2)	No. 15 (G)	No. 11 (X1)	No. 29 (F)	No. 25 (A)	No. 58 (B)	No. 47 (C5)	Pola-Screen
Daylight	1.5	2.0*	2.5	4.0	16.0	8.0	8.0	6.0	2.5
Photoflood or high-efficiency tungsten	1.5	1.5	2.0	4.0*	10.0	5.0	8.0	10.0	2.5

*For correct gray-tone rendering of colored objects.

Flash Exposure Guide Numbers: To get f-number, divide guide number by flash-to-subject distance in feet, taken to a point midway between nearest and farthest details of interest. In small white rooms, use one stop smaller.

Synchronization: X or F			M			Focal-Plane Shutter Speed	6B§ 26B§
Shutter Speed	M2B‡	M3B‡, M5B‡ 5B§, 25B§	AG-1B†	AG-3B†			
Open. 1/25	240	350	180	220		1/50	260
1/50	—	310	180	220		1/100	170
1/100	—	260	150	180		1/250	120
1/200	—	210	130	150		1/500	90
1/400	—	160	100	110			

Bowl-Shaped Polished Reflector Sizes: †2-inch; ‡3-inch; §4- to 5-inch; ‖6- to 7-inch. If shallow cylindrical reflectors are used, divide these guide numbers by two.
Note: At 1/25 second, cameras having X or F synchronization can use any of the flashbulbs listed under M synchronization.

Caution: Since bulbs may shatter when flashed, the use of a flashguard over the reflector is recommended. *Do not flash bulbs in an explosive atmosphere.*

Electronic Flash Guide Numbers: This table is intended as a starting point in determining the correct guide number. The table is for use with equipment rated in beam candlepower-seconds (BCPS) or effective candlepower-seconds (ECPS). Divide the appropriate guide number by the flash-to-subject distance in feet to determine the f-number for average subjects.

Output of Unit (BCPS or ECPS)	350	500	700	1000	1400	2000	2800	4000	5600	8000
Guide Number for Trial	75	90	110	130	150	180	210	250	300	360

Develop at approximate times and temperatures given below:

	Developing Times (in Minutes)									
Developer	Small Tank*					Large Tank †				
	65 F	68 F	70 F	72 F	75 F	65 F	68 F	70 F	72 F	75 F
D-76	9	8	7½	7	6	10	9	8½	8	7
Microdol-X	10	9	8½	8	7	11	10	9½	9	8
DK-50 (1:1)	5½	5	—	4¾	4½	6½	6	5¾	5½	5
Polydol	8	7	6½	6	5	9	8	7½	7	6
§HC-110 (Dil. A)	3¼	3	2¾	2½	2¼	3¾	3¼	3	2¾	2½
§HC-110 (Dil. B)	6	5	4¾	4½	4	7	6	5½	5	4½

*Agitation at 30-second intervals during development.
†Agitation at 1-minute intervals during development.
‡For greatest sharpness (see developer instructions).
§Dilution A is a 1:15 dilution of the developer concentrate; Dilution B is a 1:31 dilution of the developer concentrate.

Note: Do not use developers containing silver halide solvents, such as thiocyanates, or thiosulfates.

KODAK VERICHROME PAN ROLL FILM (110, 120, 126, 127, 616 and 620)

Safelight: *Total darkness required.* A safelight filter Series 3 (dark green), in a suitable safelight lamp with a 15-watt bulb can be used for a few seconds *only*, at 4 feet, after development is half completed.

Speed: ASA 125

Daylight Exposure: *(See Introduction to this section)* 1/200 sec. at f/11

Color Sensitivity: Panchromatic

Filter Factors: Increase normal exposure by filter factor given below:

Kodak Wratten Filter	No. 6 (K1)	No. 8 (K2)	No. 15 (G)	No. 11 (X1)	No. 29 (F)	No. 25 (A)	No. 58 (B)	No. 47 (C5)	Pola-Screen
Daylight	1.5	2.0*	2.5	4.0	—	8.0	6.0	6.0	2.5
Photoflood or high-efficiency tungsten	1.5	1.5	1.5	4.0*	—	5.0	6.0	12.0	2.5

*For correct gray-tone rendering of colored objects.

Flash Exposure Guide Numbers: To get f-number, divide guide number by flash-to-subject distance in feet, taken to a point midway between nearest and farthest details of interest. In small white rooms, use one stop smaller.

Synchronization: X or F		M				Focal-Plane Shutter Speed	6B§ 26B§
Shutter Speed	M2B‡	M3B‡, M5B‡ 5B§, 25B§	AG-1B†	AG-3B†			
Open. 1/25	150	220	110	140		1/50	160
1/50	—	200	110	140		1/100	110
1/100	—	160	95	110		1/250	80
1/200	—	130	80	90		1/500	55
1/400	—	100	60	70			

Bowl-Shaped Polished Reflector Sizes: †2-inch; ‡3-inch; §4- to 5-inch; ‖6- to 7-inch. If shallow cylindrical reflectors are used, divide these guide numbers by two.
Note: At 1/25 second, cameras having X or F synchronization can use any of the flashbulbs listed under M synchronization.
Caution: Since bulbs may shatter when flashed, the use of a flashguard over the reflector is recommended. *Do not flash bulbs in an explosive atmosphere.*

Electronic Flash Guide Numbers: This table is intended as a starting point in determining the correct guide number. The table is for use with equipment rated in beam candlepower-seconds (BCPS) or effective candlepower-seconds (ECPS). Divide the appropriate guide number by the flash-to-subject distance in feet to determine the f-number for average subjects.

Output of Unit (BCPS or ECPS)	350	500	700	1000	1400	2000	2800	4000	5600	8000
Guide Number for Trial	45	55	65	80	95	110	130	160	190	220

Develop at approximate times and temperatures given below:

Developer	Developing Times (in Minutes)									
	Small Tank*					Large Tank †				
	65 F	68 F	70 F	72 F	75 F	65 F	68 F	70 F	72 F	75 F
D-76	8	7	6½	6	5	9	8	7½	7	6
D-76 (1:1)	11	9	8	7	6	12	10	9	8	7
Microdol-X	11	9	8	7	6	12	10	9	8	7
‡Microdol-X (1:3)	—	—	12	11	10	—	—	13	12	11
Polydol	12	10	9	8	7	13	11	10	9	8
§HC-110 (Dil. A)	4¼	3¾	3½	3	2¾	4¾	4¼	3¾	3½	3
§HC-110 (Dil. B)	9	8	7½	7	6	10	9	8½	8	7

*Agitation at 30-second intervals during development.
†Agitation at 1-minute intervals during development.
‡For greatest sharpness (see developer instructions).
§Dilution A is a 1:15 dilution of the developer concentrate; Dilution B is a 1:31 dilution of the developer concentrate.

POLAROID PACKET TYPE 51

This film is intended for use with any camera or photo-recording instrument which takes a Polaroid 4 x 5 Land film holder No. 545 or No. 500. It is a high-contrast film, producing positive prints, and is intended mainly for line reproduction in black and white, without intermediate gray tones.

Color Sensitivity: Type 51 film is sensitive to blue light only.

Recommended Meter Settings: 320 ASA for daylight
125 ASA for Tungsten

Exposure Latitude: As with all high-contrast films, the exposure latitude of Type 51 film is limited, and determination of optimum exposure under varying conditions is to a large extent dependent upon experimentation. The lighting conditions, the degree of whiteness of the paper of the original, and the color of the artwork or printing in the original, all influence the determination of exposure.

Contrast: The film is intended to yield blacks and whites only, with no intermediate gray tones.

Print Resolution: 28–32 lines per millimeter.

Processing Times:

70 F (21 C)	15–20 minutes for line work
	10 minutes for haltones
50–60 F (10–15 C)	20–25 minutes, line work only

Print Judgment:

If you got a good black on gray	*Increase exposure.*
If you got a grayish black on white	*Decrease exposure.*

Care of Prints: Black and white prints must be coated as soon as possible (within one hour) to protect them from scratches and fading. Use the coaters supplied with the film. Use 6 to 8 overlapping strokes and cover the entire print, including the borders. Keep the freshly coated prints separate from each other for a few minutes, until they are thoroughly dry. Keep the coater fluid away from furniture, clothing, etc.

Storage of Prints: For best protection, store prints in the transparent sleeves or envelopes sold for negatives and color transparencies. Never write on the back of the picture area.

Storage of Unexposed Films: Store it in a dry, cool place. Do not break the foil wrapping until just before the film is to be used. If you do not use all the film at one time, insert the remaining packets into the polyethylene bag provided with the film. Fold over the top of the bag, to seal it.

Store the film in a refrigerator, whenever possible. Do this only so long as the film is sealed in its original foil wrapper or in the polyethylene bag. Remove from the refrigerator at least two hours before use (24 hours, if the film was in the deep freeze), to allow the film to reach room temperature. To avoid condensation, do not break the seal until the two-hour period has elapsed.

Always keep unwrapped film packages in a closed box. To guard against light leakage, protect the film from strong light until just before it is to be used.

POLAROID FILM PACKET TYPE 52

Speed: ASA 400

Daylight Exposure: *(See Introduction to this section)* 1/200 sec. at f/22

Color Sensitivity: Panchromatic

Filter Factors: Increase normal exposure by filter factor given below:

Kodak Wratten Filter	No. 6 (K1)	No. 8 (K2)	No. 15 (G)	No. 11 (X1)	No. 29 (F)	No. 25 (A)	No. 58 (B)	No. 47 (C5)	Pola- Screen
Daylight	2.0	2.0	3.0	4.0	16.0	8.0	8.0	8.0	4.0
Photoflood or high- efficiency tungsten	—	—	—	—	—	—	—	—	—

*For correct gray-tone rendering of colored objects.

Flash Exposure Guide Numbers: To get f-number, divide guide number by flash-to-subject distance in feet, taken to a point midway between nearest and farthest details of interest. In small white rooms, use one stop smaller.

Synchronization: X or F				M	Focal-Plane	6 §
Shutter Speed	AG-1† M2‡	M3‡ M5‡ 5§ 25§	11‖ 40‖	2‖ 22‖	Shutter Speed	26 §
Open. 1/25	—	550	800	1100	1/50	370
1/50	—	500	650	900	1/100	270
1/100	—	444	650	800	1/500	190
1/200	—	—	—	—	1/500	130
1/400	—	—	—	—		

Bowl-Shaped Polished Reflector Sizes: †2-inch; ‡3-inch; §4- to 5-inch; ‖6- to 7-inch. If shallow cylindrical reflectors are used, divide these guide numbers by two.
Note: At 1/25 second, cameras having X or F synchronization can use any of the flashbulbs listed under M synchronization.
Caution: Since bulbs may shatter when flashed, the use of a flashguard over the reflector is recommended. *Do not flash bulbs in an explosive atmosphere.*

Electronic Flash Guide Numbers: This table is intended as a starting point in determining the correct guide number. The table is for use with equipment rated in beam candlepower-seconds (BCPS) or effective candlepower-seconds (ECPS). Divide the appropriate guide number by the flash-to-subject distance in feet to determine the f-number for average subjects.

Output of Unit (BCPS or ECPS)	350	500	700	1000	1400	2000	2800	4000	5600	8000
Guide Number for Trial	85	100	120	140	170	200	240	280	340	400

Develop at approximate times and temperatures given below:

Developer	Developing Times (in Minutes)									
	Continuous Agitation (Tray)					Intermittent Agitation (Tank)*				
	65 F	68 F	70 F	72 F	75 F	65 F	68 F	70 F	72 F	75 F

Development time begins when packet is pulled from holder. Develop for 15 seconds above 65 F. At 50 F, develop about 50 seconds; at 40 F, develop about 90 seconds.

POLAROID PACKET TYPE 55P/N & FILM PACK TYPE 665

Speed: Type 55 P/N ASA 50
Type 665 ASA 75

Daylight Exposure: *(See Introduction to this section)* 1/100 sec. at f/11

Color Sensitivity: Panchromatic

Filter Factors: Increase normal exposure by filter factor given below:

Kodak Wratten Filter	No. 6 (K1)	No. 8 (K2)	No. 15 (G)	No. 11 (X1)	No. 29 (F)	No. 25 (A)	No. 58 (B)	No. 47 (C5)	Pola-Screen
Daylight	—	2.0	—	4.0	—	16.0	8.0	8.0	4.0
Photoflood or high-efficiency tungsten	—	—	—	—	—	—	—	—	4.0

*For correct gray-tone rendering of colored objects.

Flash Exposure Guide Numbers: To get f-number, divide guide number by flash-to-subject distance in feet, taken to a point midway between nearest and farthest details of interest. In small white rooms, use one stop smaller.

Synchronization: X or F					Focal-Plane	6 §
Shutter Speed	AG-1† M2‡	M3‡ M5‡ 5§ 25§	11‖ 40‖	2‖ 22‖	Shutter Speed	26 §
Open. 1/25	110	180	210	250	1/50	130
1/50	100	150	180	220	1/100	95
1/100	—	130	160	180	1/250	70
1/200	—	100	120	150	1/500	50
1/400	—	—	—	—		

Bowl-Shaped Polished Reflector Sizes: †2-inch; ‡3-inch; §4- to 5-inch; ‖6- to 7-inch. If shallow cylindrical reflectors are used, divide these guide numbers by two.
Note: At 1/25 second, cameras having X or F synchronization can use any of the flashbulbs listed under M synchronization.
Caution: Since bulbs may shatter when flashed, the use of a flashguard over the reflector is recommended. *Do not flash bulbs in an explosive atmosphere.*

Electronic Flash Guide Numbers: This table is intended as a starting point in determining the correct guide number. The table is for use with equipment rated in beam candlepower-seconds (BCPS) or effective candlepower-seconds (ECPS). Divide the appropriate guide number by the flash-to-subject distance in feet to determine the f-number for average subjects.

Output of Unit (BCPS or ECPS)	350	500	700	1000	1400	2000	2800	4000	5600	8000
Guide Number for Trial	30	35	40	50	60	70	85	100	120	140

Develop at approximate times and temperatures given below:

Developer	Developing Times (in Minutes)									
	Continuous Agitation (Tray)					Intermittent Agitation (Tank)*				
	65 F	68 F	70 F	72 F	75 F	65 F	68 F	70 F	72 F	75 F

Development begins when packet is pulled from holder. Development time is 20 seconds at 55 to 90 F. At 50 F develop 60-90 seconds .See section 5 for instructions for preserving negative.

POLAROID PACKET TYPE 57, FILM PACKS TYPES 107 AND 667

Speed: Type 57: ASA 3000
Types 107 and 667: ASA 2500
Daylight Exposure: *(See Introduction to this section)* 1/1000 sec. at f/32

Color Sensitivity: Panchromatic

Filter Factors: Increase normal exposure by filter factor given below:

Kodak Wratten Filter	No. 6 (K1)	No. 8 (K2)	No. 15 (G)	No. 11 (X1)	No. 29 (F)	No. 25 (A)	No. 58 (B)	No. 47 (C5)	Pola- Screen
Daylight	2.0	2.0	3.0	4.0	16.0	8.0	8.0	8.0	4.0
Photoflood or high- efficiency tungsten	—	—	—	—	—	—	—	—	—

*For correct gray-tone rendering of colored objects.

Flash Exposure Guide Numbers: To get f-number, divide guide number by flash-to-subject distance in feet, taken to a point midway between nearest and farthest details of interest. In small white rooms, use one stop smaller.

| | Synchronization: X or F | | M | | | Focal-Plane | 6§ |
Shutter Speed	AG-1† M2‡	M3‡ M5‡ 5§ 25§	11‖ 40‖	2‖ 22‖		Shutter Speed	26§
Open. 1/25	720	1400	1600	2200		1/50	1100
1/50	560	1200	1400	1800		1/100	760
1/100	480	1000	1200	1600		1/250	540
1/200	360	880	800	1300		1/500	380
1/400	280	720	640	1000			

Bowl-Shaped Polished Reflector Sizes: †2-inch; ‡3-inch; §4- to 5-inch; ‖6- to 7-inch. If shallow cylindrical reflectors are used, divide these guide numbers by two.
Note: At 1/25 second, cameras having X or F synchronization can use any of the flashbulbs listed under M synchronization.
Caution: Since bulbs may shatter when flashed, the use of a flashguard over the reflector is recommended. *Do not flash bulbs in an explosive atmosphere.*

Electronic Flash Guide Numbers: This table is intended as a starting point in determining the correct guide number. The table is for use with equipment rated in beam candlepower-seconds (BCPS) or effective candlepower-seconds (ECPS). Divide the appropriate guide number by the flash-to-subject distance in feet to determine the f-number for average subjects.

Output of Unit (BCPS or ECPS)	350	500	700	1000	1400	2000	2800	4000	5600	8000
Guide Number for Trial	220	260	300	360	420	520	600	720	860	1020

Develop at approximate times and temperatures given below:

| | Developing Times (in Minutes) | | | | | | | | | |
| Developer | Continuous Agitation (Tray) | | | | | Intermittent Agitation (Tank)* | | | | |
	65 F	68 F	70 F	72 F	75 F	65 F	68 F	70 F	72 F	75 F

Development time begins when packet is pulled from holder. Develop Types 57 and 107 for 15 seconds at 65 F and above; develop Type 667 for 30 seconds at 65 F and above. For lower temperatures, see instruction sheet packed with films.

Important Note: Aside from the difference in speed (ASA 3000 vs ASA 2500) Film Packet Type 667 differs in that prints made with this film, unlike those made with Types 57 and 107, *do not need coating after development!*

POLAROID FILM PACK TYPE 664

Speed: ASA 500

Daylight Exposure: *(See Introduction to this section)* 1/250 sec. at *f*/22.

Color Sensitivity: Panchromatic

Filter Factors: Increase normal exposure by filter factor given below:

Kodak Wratten Filter	No. 6 (K1)	No. 8 (K2)	No. 15 (G)	No. 11 (X1)	No. 29 (F)	No. 25 (A)	No. 58 (B)	No. 47 (C5)	Pola-Screen
Daylight Photoflood or high-efficiency tungsten	2.0	2.0	3.0	4.0	16.0	8.0	8.0	8.0	4.0

*For correct gray-tone rendering of colored objects.

Flash Exposure Guide Numbers: To get *f*/number, divide guide number by flash-to-subject distance in feet, taken to a point midway between nearest and farthest details of interest. In small white rooms, use one stop smaller.

Synchronization: X or F			M		Focal-Plane Shutter Speed	6§ 26§
Shutter Speed	AG-1† M2‡	M3‡, M5‡ 5§, 25§	11‖ 40‖	2‖ 22‖		
Open. 1/25	320	610	610	910	1/50	470
1/50	255	510	540	770	1/100	340
1/100	—	425	450	670	1/250	215
1/200	—	330	350	550	1/500	—
1/400	—	—	—	—		

Bowl-Shaped Polished Reflector Sizes: †2-inch; ‡3-inch; §4- to 5-inch; ‖6- to 7-inch. If shallow cylindrical reflectors are used, divide these guide numbers by two.
Note: At 1/25 second, cameras having X or F synchronization can use any of the flashbulbs listed under M synchronization.

Caution: Since bulbs may shatter when flashed, the use of a flashguard over the reflector is recommended. *Do not flash bulbs in an explosive atmosphere.*

Electronic Flash Guide Numbers: This table is intended as a starting point in determining the correct guide number. The table is for use with equipment rated in beam candlepower-seconds (BCPS) or effective candlepower-seconds (ECPS). Divide the appropriate guide number by the flash-to-subject distance in feet to determine the *f*/number for average subjects.

Output of Unit (BCPS or ECPS)	350	500	700	1000	1400	2000	2800	4000	5600	8000
Guide Number for Trial	95	110	135	160	190	220	270	320	380	440

Develop at approximate times and temperatures given below:

Developer	Developing Times (in Minutes)									
	Continuous Agitation (Tray)					Intermittent Agitation (Tank)*				
	65 F	68 F	70 F	72 F	75 F	65 F	68 F	70 F	72 F	75 F

Development begins when the paper tab (yellow) is pulled. Develop Type 664 for 30 seconds at 65 F and above (18 C and above). For processing at lower temperatures, see instruction sheet packed with film.

This page is being reserved
for future expansion.

INTRODUCTION TO "COLOR FILMS"

Color photography, as it is presently practiced, is based on a three-color theory first propounded by Thomas Young in 1802. In essence, this theory states that color is a sensation, not a substance, and as far as the viewer is concerned, the sensation produced by any given color can be matched by a proper mixture of three fundamental colors called *primaries*. Of course, artists had known for many years that colors could be matched and mixed; where Young's theory differed was in that he postulated the existence of three light-sensitive receptors in the optical apparatus of the human being.

This theory led to a huge number of proposals for photographic color systems; from the simple photographing of a stationary subject, using a single camera, three filters, and three successive exposures, to numerous ingenious optical systems for exposing three plates at one exposure and to various means of putting the three records on a single film. All of these will be found described at great length in various books on the history of color photography and will not be further discussed here.

The practical photographer has today abandoned all of these more or less cumbersome methods of producing color photographs in favor of the one simple system—the three-layered color film, now available in a variety of types, all of which work on one basic principle. In these films, there are three separate emulsion layers, coated one over the other on a single base. Each emulsion is sensitized to one region of the spectrum, and each, after processing, is converted in one way or another to a colored image in one of the primary colors. The combination of the three-colored images produces a full-color picture containing, to a first approximation, all the colors of the original subject.

To grasp some of the problems involved in the practical application of the modern color film, it is well to understand a little of the theory underlying its operation. In general, this is divided into two parts: color analysis, the separation of the subject colors into their component parts; and color synthesis, the combination of three dye images into a color image reproducing the original subject colors.

Color Analysis

In the basic system of three-color photography, three color-separation negatives are made by the exposure of three films, each through a different

filter. Each filter transmits approximately one-third of the visible spectrum. For the purposes of this discussion, it may be accepted that the visible spectrum extends from 400nm to 700nm* and is broadly divided into three main regions: 400–500nm is the "blue" region, 500–600nm is the "green" region, and 600–700nm is the "red" region. However, it is not necessary, in the case of three-layer color films, to use filters to accomplish the color analysis. Instead, the emulsions for the three layers are differentially sensitized to cover the three major regions of the spectrum.

A normal, unsensitized silver bromide emulsion is sensitive only to ultraviolet, violet, and blue, and covers almost exactly the same range (400–500nm) as the typical blue separation filter.

Silver emulsions are sensitized to other spectral regions by adding dyes to the silver bromide-gelatin mixture. Dyes are known which will sensitize to green, to red, and to other spectral regions as in the case of infrared films. The usual panchromatic film is sensitized with a mixture of two dyes, one of which sensitizes to green (500–600nm) and the other, to red (600–700nm). In the case of color films, these dyes are used individually, one for the green-sensitized layer and the other for the red. Again, the sensitization area is very similar to the pass-bands of the usual green and red filters, respectively.

There is one important difference, however: in sensitizing these two layers to green and red, the original sensitivity to blue light is not removed nor even diminished. Thus, means must be taken to prevent any blue light from reaching these layers, and this is done by the coating of a yellow filter layer, just under the top, or blue-sensitive, layer. This yellow filter dye is destroyed during the processing of the film, so that no trace of it remains in the finished color transparency.

Ordinarily, no filter layer is needed between the green-sensitive and red-sensitive layers; however, some manufacturers do coat a magenta filter between these two layers. This serves as a "trimmer" filter to minimize overlapping of the sensitivities of the two coatings and also as an antihalation layer for the upper two coatings. Where no filter is used between these two coatings, a clear gelatin separation layer is often coated, to minimize interaction between the two layers during processing.

The finished color film usually contains other layers, such as an anti-abrasion overcoat and an antihalation backing layer, but these are not pertinent to this discussion and will not be further discussed.

What is important is this—we must not assume that the three layers divide the spectrum into three neat and distinct parts; this is neither necessary nor desirable. The sensitivity of each layer begins and ends gradually, not abruptly. It is possible to choose some dyes which sensitize to narrow regions of the spectrum, and others which have a considerably broader sensitization band. In the case of a color film for use in a camera, dyes are chosen that will provide some overlap in sensitivity between the adjacent layers; this is essential for the reproduction of certain mixed colors. On the other hand, special-purpose color films made for copying, duplicating, print films, and so on are sensitized with narrow-band sensitizers which leave definite gaps between the three spectral bands of these particular films.

This division of the spectrum into three broad and overlapping bands for color analysis has one inevitable consequence which may not be evident at first. The eye can see a great variety of colors within each section of the spectrum—for instance, the area between 400nm and 500nm contains shades of color from

* nm—*nanometer,* one billionth of a meter. This unit was formerly known as the *millimicron.*

deep violet through pure blues to blue-greens. However, this band of colors will be recorded in one and only one layer of the color film and will be reproduced by precisely the same dyestuffs; hence all these colors will be represented by a single blue color in the finished transparency. Obviously, then, it is impossible to photograph an actual spectrum on a three-layer color film. Attempting to do so will result in a picture containing five bands of color, uniform in hue and varying only in brightness within each band. There will be three broad bands—red, green, and blue in color—and two narrow stripes where the spectral sensitivities of the layers overlap; there will be a cyan stripe at the overlap of blue and green, and a yellow stripe at the overlap of green and red.

This failing of three-color processes is of little practical importance. Pure spectral colors are seldom found in nature, except in the case of rainbows, and since most natural colors are mixtures of all three primaries, their reproduction is not too difficult. There is one important implication, however, of this inability to reproduce certain colors lying entirely in specified areas of the spectrum: a color film cannot be used either for precise color matching or for the measurement and specification of color. Color films are intended only to produce visually pleasing color photographs, nothing more.

Practical Color Films

There is more to the making of a practical color film than merely mixing three batches of color-sensitive emulsion and coating them in layers on a substratum. One essential characteristic of any three-layer system is that the characteristic curves of the three emulsion layers must match as closely as possible. If this is not accomplished, it will not be possible to reproduce colors uniformly throughout the range of the film, and a given color will appear different in hue depending upon whether it was exposed at a high or a low level. This effect is most noticeable in the reproduction of grays, which will tend to take on a tint at one end of the scale or the other and even more important, in subtle, grayed-down colors such as flesh tints, upon which the acceptability of the average color photograph usually depends.

There are various ways of accomplishing this curve matching; one is to use a single batch of emulsion for all three layers, dividing it into three parts and using one "as is," sensitizing the other two to green and red respectively. However, this is not always feasible, since there are other considerations in the choice of emulsion layer types, and to balance a given emulsion to a certain type of illuminant, it may be necessary to make one layer much faster than the others. In such a case, different means are used to secure curve matching.

When layers of such different sensitization are used, though, other problems arise. One of the most important is the result of reciprocity law failure. A minor matter in black-and-white photography, reciprocity law failure can be quite serious in the case of color film, especially when the characteristics of the three layers are not alike. The effect usually shows up in the case of very long exposures, where color balance may shift sharply to red or blue, depending upon which layer has the most marked reciprocity failure.

Most current color films perform satisfactorily within the usual range of exposures—say, from about ten seconds to about 1/1000 sec. For longer or shorter exposures, there will be some departure from correct color balance, and in any case, additional exposure above the calculated amount will usually be needed. Color filters can sometimes be used to correct the effect of reciprocity failure; however, in the case of such films as Kodak Ektacolor Type L, the manufacturer warns that exposures shorter than 1/10 sec. or longer than 60 seconds will produce color errors that cannot be corrected. Obviously, such films must be used according to the manufacturer's instructions, and in

cases where exposures fall outside the acceptable range, the photographer should either add or subtract light or use a different film. A more extended discussion of this point will be found in the following pages.

Color Films and Illumination

Up to this point, we have tacitly assumed that the three layers of a color film should be equal in speed, granted of course that the loss of light in passing through the layers is very small. This, however, cannot be the case, simply because we know that there is a wide variation in the energy content of the light we call "white." Even daylight varies a good deal in color, from very white at high noon to definitely red at sunrise and sunset.

For this reason, the relative sensitivities of the three layers of a color film will have to be adjusted so that equal densities result from the exposure of a white object, when this exposure is made to light of a given color quality. Obviously, we cannot make color films for every possible nuance of light, and a choice must be made. Currently, therefore, color films are available for three major types of illuminant—daylight, Photoflood lamps, and 3200 K lamps. This latter lamp designation came about as a result of early attempts to relate all light sources to a system of "color temperatures;" the concept still has some use and will be discussed at greater length below, but meanwhile, let us take a "3200 K" lamp to be merely a definite type of commercially available lamp and nothing more.

In the case of "daylight"-type films, the sensitivity of the blue layer is adjusted with respect to that of the red, in order to secure curve matching when the film is exposed to average daylight, which is considered to be a mixture of sunlight and skylight. For the two tungsten-type films, the relationship has been altered to increase the sensitivity of the blue layer with respect to that of the red. This compensates for the lower blue content of artificial light sources. Obviously, this adjustment can also be made by the use of filters, and conversion filters are available which are used to change the balance of one type of film for the other type of illuminant. In the case of artificial light films, the filters used are in the Wratten #85 series, salmon pink in color, which absorb very little useful light. Very often, the speed of a given tungsten-type film, with a #85 filter in daylight is almost exactly the same as its basic tungsten speed. On the other hand, using daylight-type films with artificial light requires a filter of the Wratten #80 series, a deep blue in color, which absorbs a good deal of the light to which the film is most sensitive. The result is a very large loss in emulsion speed when a daylight-type film is used in artificial light.

One other problem arises from the inherent sensitivities of the separate emulsion layers. All silver bromide emulsions have some sensitivity to ultraviolet rays as well as to the visible spectrum. This presents no problem as far as the red- and green-sensitive layers are concerned, since the yellow filter layer which removes the visible blue light also eliminates all ultraviolet. However, this leaves the top, blue-sensitive layer affected by ultraviolet as well as visible light, and if compensation were not made, the resulting pictures would be excessively blue. However, since most of the ultraviolet light is eliminated by absorption by the glass of the lens, the remainder can be taken care of simply by considering it as part of the blue light and reducing the sensitivity of the blue-sensitive emulsion sufficiently to restore the balance for average or normal daylight. However, at high altitudes and in shaded areas open to clear sky but not direct sunlight, some excess ultraviolet light is still present. The usual remedy is a filter such as the Kodak Wratten #1A or "Skylight" Filter.

The problem is practically nonexistent in the case of color films balanced for tungsten light, because this illuminant has very little ultraviolet emission in

any case. When these tungsten-type films are used in daylight with a conversion filter, all the ultraviolet is removed by the conversion filter. Thus, it is never necessary to add a skylight filter to a conversion filter, and in addition, there will necessarily be some difference in rendition between daylight-type films and tungsten-type films used in daylight with a conversion filter.

Color Temperature

Different light sources have different energy distributions, and this necessarily affects the rendition of colors on various color films. In the case of color negative films, a small variation in color balance can be compensated for in the making of the positive print, by adjustment of the color of the printing light, with filters or other means. However, this is possible only as long as none of the three emulsion layers of the negative has been either over or underexposed. Thus, if a normal daylight-balanced negative film is exposed in ordinary room illumination without filter compensation, the chances are that the blue-sensitive layer will be grossly underexposed, and much of the detail in this layer will lie on the toe of its characteristic curve. Or, conversely, the green- and red-sensitive layers may be so far overexposed that the detail therein will lie mainly on the shoulder of their curves. Either way, it will be impossible to secure curve matching in the three images, and no kind or quantity of filtering can correct a negative which is unbalanced in this manner.

For this reason, all but the smallest corrections for illuminant color must be made in the original exposure, in the case of color negative films, and as far as reversal color films are concerned, *all* corrections must be made at this stage. To do this requires that the photographer know the energy distribution of the light source in use, and the type of illuminant for which the film is balanced.

One could, of course, specify the energy distribution of a light source in terms of its red, green, and blue content, but such a three-figured specification would be difficult to use in a practical way. Another possibility is to use a two-figure specification, considering green as the constant color and specifying the relative amounts of red and blue as a simple ratio. This has been done in the case of certain color meters and is workable in some cases but not in all. Obviously, it will be effective where the green content of the light is, in fact, constant and only the red and blue ratio varies. This is actually the case with incandescent lamps; it is most emphatically *not* the case with daylight and fluorescent light, so these meters are mainly useful for incandescent light exposures.

For some years it was believed that the most useful measure of the energy distribution of a light source was its *color temperature*. The definition of color temperature is simply that temperature to which a theoretical black body must be raised for the color of the light emitted by that black body to match the color of the light we are trying to measure.

This is a simple enough concept. Everyone is familiar with the fact that if you heat an iron bar, it starts to glow, first dull red, then bright red, then orange, yellow, white, and finally blue-white at its melting temperature. Thus, we find no difficulty comparing the color of the light from, say, an incandescent lamp with that of a glowing poker and specifying its color temperature as being low, medium, or high, in terms of the temperature of the poker. Of course, we can use any convenient temperature scale—Fahrenheit, Celsius, or Kelvin. In practice, the Kelvin scale is used, for reasons which we need not go into here.

But we must call attention here to the fact that we originally specified the standard, or basis, of the system to be a "black body," and this is really the

key to the entire concept. The black body is a theoretical object which is defined as being a perfect radiator and a perfect absorber. That is, whatever light is emitted by the black body is generated entirely by the heating of that body; none of it is reflected from other sources, hence there is nothing to distort the shape of its energy distribution curve.

Such a black body does not exist except in theory. The nearest approximation to it would be a black box with a hole in one side, in which the radiation from the hole would be essentially black body radiation. However, no practical light source matches this concept, although the incandescent lamp is not far from it; the actual temperature of an incandescent filament at a color temperature of 3200 K (Kelvin) is only about 100 degrees lower.

The incandescent lamp filament is known, actually, as a *"gray body" emitter*—that is, whereas it has some reflectance, this reflectance is uniform throughout the spectrum or substantially so. Thus, its energy distribution remains the same as that of a black body, only its absolute temperature being different. For practical purposes, we are not particularly concerned with the actual temperature of the filament, and so by proper design, we can specify a given incandescent lamp as being "3200 K" or "3400 K" and it will have the same effect, visually, as a black body at those temperatures.

Except for incandescent lamps and to some extent, flashlamps and electronic flashtubes, color temperature is not an accurate measure of the energy distribution of the source. From the basic theory of color photography, we have learned that it is possible to match a given spectral color by any one of many pairs of other colors, and it is likewise possible to match a so-called white light with a great many triplets of color. Thus, it is possible to make a fluorescent lamp which has a light output visually matching that of a 3200 K incandescent lamp, but the proportions of red, green, and blue in its output are far different from those of the incandescent lamp it purports to match. And, most important, its light will have an entirely different effect on color film supposedly balanced for light of 3200 K color temperature. What this means, we repeat, is that a color film marked "for 3200 K lamps" is balanced for just that light source—incandescent lamps marked "3200 K." It is not balanced for any and all light sources having a visual equivalent color temperature of 3200 K.

This same applies to daylight; figures such as 5600 K or 6500 K which have been assigned to daylight are actually meaningless. Normal daylight consists of a mixture of sunlight and blue skylight, and color films marked "For Daylight" are not balanced for a particular color temperature at all. As has been previously pointed out, they are adjusted for an average mixture of skylight, sunlight, and a certain amount of ultraviolet radiation.

Thus, the fallacy in the use of color temperature as a means of specifying illumination for color photography is simply this: color temperature is a psycho-physical concept. When we say that a light source has a color temperature of 3200 K, we mean nothing more than that its color matches, visually, that of the light from a black body having that particular temperature. In short, it is tied to the color response of the human eye and has no precise relationship to the color response of any other receptor such as a color film.

It is true that a specification exists for the energy distribution of a black body at certain temperatures; this is in the form of a graph of the output at all wavelengths from 400nm to 700nm. Only those light sources which have the same curve shape, strictly, can be specified in terms of their equivalent black body temperatures. Others are mere visual matches and cannot be assumed to have the same effect on a color film as they have on the eye.

Thus, the value of color temperature in practical photography is rather limited. It is of some value to professional photographers in the studio, working with incandescent lamps whose color output varies somewhat with the fluctuations in supply voltage. Correction for this effect can, of course, be made either with filters or by adjusting the voltage of the supply. Interestingly enough, the electronic flashlamp has an energy distribution somewhat similar to that of a black body at about 6500-7000 K and can be treated with filters to adjust its output to match either daylight or tungsten-type color films.

There are mathematical problems in this type of correction, however; a filter which adjusts color temperature in a step of 100 K at 3200 K will not have the same effect at some other color temperature. This problem is overcome by the use of a different unit—the *micro-reciprocal degree,* or *mired.* A fuller discussion of this unit and filter tables for its use will be found in the miscellaneous section.

Summing up: when a color film is marked "For Daylight," it simply means that the film is balanced for normal outdoor photography, and the light is considered an average mixture of sunlight and skylight. Films marked "For Photoflood Lamps" are intended for use with photoflood lamps, and films marked "For 3200 K Lamps" are intended for use with incandescent lamps branded by the manufacturer "3200 K"—*not,* we repeat, for any and all light sources purporting to have a color temperature of 3200 K. Changes, conversions, and small corrections of color balance are done with filters.

Filters for Color Films

Color film emulsions are made in only three basic types—for daylight, for photoflood, and for 3200 K lamps. However, there are a number of other light sources in common use. The older flashlamps with aluminum filling have an equivalent visual color temperature of 3800 K, and if used with either of the artificial light type of films mentioned, will result in pictures having a noticeably blue cast. The newer flashlamps, such as the AG-1, M3, and M5, use a zirconium filling, and their color temperature is even higher, approximating 4200 K. These will, of course, produce even bluer results.

By the same token, daylight is noticeably variable, and the average daylight for which the film is normally balanced is that which occurs between about 10 A.M. and 4 P.M. and refers to subjects in the clear, so that they receive a mixture of both sunlight and skylight. Subjects in shade, illuminated only by skylight and reflected light but not reached by direct sunlight, will be much too blue. On the other hand, even subjects in the open, photographed early in the morning or late in the afternoon, will be reddish.

These and other variations to be discussed are outside the scope of the emulsion maker's art and are left to the individual photographer for correction with filters. Since most photographers use the Kodak filters, and in any case, most equivalent filters of other makers use the same nomenclature, we shall principally discuss the various filters below, made by Kodak. These are made in four classes.

1. Kodak Color Compensating Filters. These are available in six colors (red, green, blue, cyan, magenta, and yellow) and a variety of densities in each color. Their use is mainly for adjusting color-balance variations between batches of color films; they are also useful for changing the color quality of certain light sources that cannot be corrected by means of the usual Light Balancing Filters, such as fluorescent light.

2. Kodak Light Balancing Filters. These filters are designed specifically to make adjustments of color temperature, mainly with incandescent and photoflash

illumination. Their transmissions are carefully adjusted to maintain the proper energy distribution of the transmitted light, so that it can reasonably be described as having a certain color temperature. These filters are used for such corrections as adjusting photoflood lamp illumination to a 3200 K balance or for lowering the 3800 K or 4200 K level of photoflash lamps to either 3200 K or 3400 K. Conversely, they can be used to raise color temperatures, when that is required; thus, there are two basic series of these filters.

3. Kodak Conversion Filters. These are similar to Kodak Light Balancing Filters but are designed to produce larger changes in color temperature. They are used mainly for conversion from "daylight" to "tungsten" balance and vice versa.

4. Kodak Color Printing Filters. These are similar to the types discussed above, but are made in larger sizes of a less expensive material and are not intended to be used over the lens of a camera or other equipment. They can be used in the light source of a printer or enlarger or over the reflector of certain types of lamp. They are not normally used for color photography; they will be discussed at greater length in the section on color processing.

Filtering for Fluorescent Illumination. Since fluorescent light does not have the normal energy distribution described by color temperature, it cannot be corrected for color photography in the normal manner. However, there are occasions when color photographs must be made using fluorescent lamps as the main source of illumination: for example, architectural interiors by existing room light. In such a case, a fairly satisfactory result can be obtained by the use of a combination of color compensating filters, in such a way as to bring the three layers of the film to a nominally correct balance. However, such a correction is likely to work for one make of color film and not for another. This is due to minor differences in color sensitization of the three film layers, and for this reason, each manufacturer publishes separate directions for this particular correction.

Filters for Kodak Color Films & Fluorescent Light

KODAK Film Type	Type of Fluorescent Lamp†					
	Daylight	White	Warm White	Warm White Deluxe	Cool White	Cool White Deluxe
Daylight Type and Type S	40M + 30Y + 1 stop	20C + 30M + 1 stop	40C + 40M + 1⅓ stop	60C + 30M + 1⅔ stop	30M + ⅔ stop	30C + 20M + 1 stop
Type B and Type L	85B‡ + 30M + 10Y + 1 stop	40M + 40Y + 1 stop	30M + 20Y + 1 stop	10Y + ⅓ stop	50M + 60Y + 1⅓ stop	10M + 30Y + ⅔ stop
Type A	85§ + 30M +10Y + 1 stop	40M + 30Y + 1 stop	30M + 10Y + 1 stop	No Filter None	50M + 50Y + 1⅓ stop	10M + 20Y + ⅔ stop
KODA-COLOR-X	40M + 30Y + 1 stop	20C + 30M + 1 stop	40C + 40M + 1⅓ stop	60C + 30M + 1⅔ stop	30M + ⅔ stop	30C + 20M + 1 stop

Increase a meter-indicated exposure by the amount indicated in the table to compensate for light absorbed by the filters recommended. If this makes the exposure time longer than that for which the film is designed, refer to the table on page 90 for further filter and exposure-time adjustments that must be added to these lamp-quality corrections.
†When it is difficult or impossible to gain access to fluorescent lamps in order to identify type, ask the maintenance man.
‡Kodak Wratten Filter No. 85B
§Kodak Wratten Filter No. 85

Because of the relatively low level of fluorescent illumination and the increased exposure required by filters over the camera lens, the exposure time may be longer than that for which a color film is designed. In this case, a further exposure adjustment as well as additional filter adjustment, may be necessary. Exposure times longer than those given in the table on page 90 are not recommended, since they may result in color-balance errors that cannot be corrected by filters. Exposure times shorter than 1/60 second are also not recommended, because the brightness and color of fluorescent lamps vary during each a-c cycle (1/60 second for common 60-cycle current).

From the table on page 90, obtain the necessary exposure increase and filter adjustment and add them to the exposure and filters determined from the table on the preceding page. No more than three CC filters should be used over the camera lens if definition is of major importance. To simplify the filter pack, translate all filters into the subtractive colors (magenta, cyan, and yellow), eliminate the neutral density, and use the simplest possible number of filters over the camera lens. The simplest pack is found by performing the following operations:

1. Convert additive colors to subtractive colors, thus:

 20 R = 20M + 20Y; 20G = 20Y + 20C; 20B = 20M + 20C

2. Add filters of the same color normally:

 20M + 10M = 30M; 20Y − 10Y = 10Y

3. Eliminate neutral density by removing equal amounts of all three subtractive colors:

 10C + 20M + 20Y = 10M + 10Y + 0.10 neutral density, which has been removed.

Kodak Light Balancing Filters. These filters are intended to adjust the quality of the illumination in terms of color temperature and therefore can be used only with sources to which the term "color temperature" can be applied—that is, incandescent lamps and photoflood lamps. This being the case, the filter color is necessarily based on the characteristics of the light source, not of the film in question and is, in fact, substantially independent of film type. Thus, the following filters will produce pretty much the same effect regardless of the make of the color film in use.

It must be clearly understood here that the color temperature shift given in this table is characteristic of the filter at that particular color temperature level. A filter that will raise color temperature 200 K at 3200 K—that is, one that will transform 3200 K to 3400 K—will not necessarily transform a light source of 4200 K to 4400 K. Thus the filters specified are intended to be used at the levels given in the table.

KODAK LIGHT BALANCING FILTERS

Color	WRATTEN Number	Exposure Increase in Stops*	Color Temperature of Source		Mired Interval
			Converted to 3200 K	Converted to 3400 K	
Bluish	82C + 82C	1 1/3	2490 K	2610 K	−89
	82C + 82B	1 1/3	2570 K	2700 K	−77
	82C + 82A	1	2650 K	2780 K	−65
	82C + 82	1	2720 K	2870 K	−55
	82C	2/3	2800 K	2950 K	−45
	82B	2/3	2900 K	3060 K	−32
	82A	1/3	3000 K	3180 K	−21
	82	1/3	3100 K	3290 K	−10
No Filter Necessary			3200 K	3400 K	—
Yellowish	81	1/3	3300 K	3510 K	9
	81A	1/3	3400 K	3630 K	18
	81B	1/3	3500 K	3740 K	27
	81C	1/3	3600 K	3850 K	35
	81D	2/3	3700 K	3970 K	42
	81EF	2/3	3850 K	4140 K	52

*These values are approximate. For critical work, they should be checked by practical test, especially if more than one filter is used.

that will transform 3200 K to 3400 K—will not necessarily transform a light source of 4200 K to 4400 K. Thus the filters specified are intended to be used at the levels given in the table.

However, there are times when a filter must be used at some other level than that for which it was designed, and the corrected shift must be found. For this purpose, an alternative unit, the micro-reciprocal degree (*mired,* pronounced my-red), is used. The color shift value of a given filter, measured in mireds, is the same regardless of the color temperature level used. To obtain the mired equivalent of a given color temperature, one merely divides the temperature in question into 1,000,000. Mired shifts are found by a rather more complicated procedure, explained in the miscellaneous section: to avoid this calculation, mired shift values for the various filters are given in the table above. Some filter manufacturers use a different unit, the *decamired* (pronounced dekka-my-red) which is equal to ten mireds. Since color temperature correction is rather inexact at best, these larger steps are probably accurate enough for practical work.

Kodak Conversion Filters. The Light Balancing Filters in the table above are intended only for relatively small changes in color temperature. They should not be combined for larger shifts except in those cases listed in the table. Furthermore, since daylight cannot be specified in terms of color temperature, these filters cannot be used for changes from daylight to tungsten balance and so forth.

For such conversions, there are two series of Kodak Conversion Filters available. The #80 series, which are blue in color, are used to expose daylight-balanced films by tungsten or clear flashlamps. The #85 series, which are salmon-pink in color, are used to expose artificial-light films in daylight. These filters, as made by Kodak, are also recommended by other American manufacturers and in many cases will work with foreign made color films also. In the latter case, a few tests will establish whether the recommended filter will work in such a case or whether some minor adjustment may be required, such as using an 80 A instead of an 80 B filter and so on.

To Convert	Use KODAK Filter No.	Filter Color	Exposure Increase in Stops*
3200 K to Daylight (5500 K)	80A	Blue	2
3400 K to Daylight (5500 K)	80B	Blue	1 2/3
3800 K† to Daylight (5500 K)	80C	Blue	1
4200 K‡ to Daylight (5500 K)	80D	Blue	1/3
Daylight (5500 K) to 3800 K	85C	Orange	1/3
Daylight (5500 K) to 3400 K	85	Orange	2/3
Daylight (5500 K) to 3200 K	85B	Orange	2/3

*For critical work, check these values by practical test.
†Aluminum-filled clear flashbulbs, such as M2, 5, and 25.
‡Zirconium-filled clear flashbulbs, such as AG-1, M3, and M5.

For exact film speed corrections required with these filters and various films, see the film data pages in the latter part of this section. Filter corrections needed for fluorescent illumination will be found on page 84.

Ultraviolet Absorbers. Pictures in open shade on heavily overcast days or at high altitudes often show a strong bluish cast which was not visible to the eye when the picture was taken. This is due to excess ultraviolet light. Such pictures can be improved by the use of a filter which absorbs ultraviolet only, without having any noticeable effect on the visible light. These filters are usually either colorless or faintly pink or yellow; a typical example is the Kodak Wratten Filter #1A (Skylight Filter). Similar filters are offered by other manufacturers and work in substantially the same manner. These filters should be used only with daylight-type films; they are not needed when tungsten-type films are being exposed in daylight with a conversion filter, since the latter also absorbs all the ultraviolet. With negative color films, compensation can also be made in printing.

Flashlamp Exposure. The normal flashlamp approximates a gray-body emitter, with a color temperature somewhat higher than that of the incandescent lamp. Aluminum filled flashlamps burn at about 3800 K, whereas the miniature lamps (AG-1, M3, M5) burn at 4200 K. Correction for the bluish results is only approximate, however, since there is some change in color during the burning of the lamp and the deposit of the products of combustion on the inside of the glass bulb. For this reason, the usual recommendation is for the use of the Light Balancing Filter 81C, regardless of which type of lamp is used.

Blue-coated flashlamps were originally designed only as a secondary light source, for supplementing daylight in interior views or for fill-in flash outdoors. Improved filter coatings on these lamps now make them satisfactory as the sole light source in interior photography as well as for the uses formerly recommended. Although there is some difference in blue lamps, depending upon the type of filling, no additional filtering is used or recommended when these lamps are used with any daylight balanced color film. However, the individual can use a Light Balancing Filter of either the yellowish or bluish series if he finds his results consistently too blue or too red, respectively.

When one is making pictures indoors and no blue flashlamps are available, daylight-type color films can be exposed with clear flashlamps, by the use of the appropriate conversion filter. Some compensation is made in this case for the type of flashlamp being used. For zirconium filled lamps, AG-1, M3, and M5, use the Kodak Conversion Filter Wratten #80D; for all other types of lamps, use the #80C filter.

Fill-in Flash Outdoors. Blue flashlamps are most often used as a shadow illumination source in outdoor photography. The apparent problem of balancing the flash and sunlight exposure is simpler than it may appear at first. In fact,

with most color films, it makes little difference what type of flashlamp is used; the exposure remains fairly constant regardless of the type of lamp.

The reason is that the flashlamp is being used merely to provide supplementary illumination for the shadows; its effect on the overall illumination of the scene is not very great. This can be understood if we imagine a normal outdoor portrait with about 200 candles per square foot luminance in the highlight areas of the face. In such a scene, the deep shadows will probably have a brightness of perhaps ten candles per square foot. Now, if we add as much as 20 candles per square foot, we have raised the shadow brightness to 30 candles, while increasing the highlights to 220 candles, and it is obvious that a change of highlight brightness from 200 to 220 candles per square foot will not even be noticed in the final picture. Yet we have, in this example, reduced the lighting ratio of the scene from 20:1 to about 7:1 by the use of the flashlamp. Thus, the choice of the flashlamp has little effect on overall exposure and can be used mainly to determine the amount of contrast reduction desired.

The method of calculating exposure for such synchro-sunlight flash exposures depends upon the fact that the sunlight exposure is more or less a constant factor, whereas the flash contribution depends upon the size of the flashlamp and the distance from the flash to the subject.

As a simple example, let us assume we are photographing a normal outdoor scene with Kodachrome 64 Film. The normal outdoor exposure in sunlight for an average subject with this film is 1/100 sec. at $f/11$. Now, we intend to use a #5B lamp for fill-in light, and reference to the published tables shows that the normal guide number for this lamp at 1/100 sec. is 120. Then, for equal shadow and highlight illumination, we would simply take the $f/11$ already determined and divide the guide number 120 by 11; the result is that we would use the flash approximately 11 feet from the subject. This, as mentioned, will give fairly full shadow illumination; however, since illumination falls off as the square of the distance, increasing the flash-to-subject distance by two or three feet would be ample to reduce the ratio to a just barely noticeable fill-in.

Assume now that we wish to use a shorter working distance. This will call for a smaller lens aperture, obviously, so we first find the daylight exposure. If the recommended exposure for Kodachrome 64 Film is 1/100 sec. at $f/11$, then it will be 1/25 sec. at $f/22$. Now, the guide number for the #5B lamp at 1/25 sec. is 150; dividing this by 22, we get about 7½ feet as our new lamp-to-subject distance. This, again, depends upon the balance of highlight to shadow desired; we can assume the useful range to be from 7½ to 9 feet on the average.

Consider this latter situation again but this time choosing a smaller lamp, such as the M3B, which has a guide number of 100 for 1/25 sec. Dividing this by 22 gives a bit less than five feet as a distance, and again we may assume a working range of from five to eight feet for practical purposes. Thus, the change from the lamp with a guide number of 150 to one having 2/3 that value, shortens the working distance by only about two feet.

Evidently, the question of which lamp to use for flash fill is not very important; it has only a small effect on the flash-to-subject distance and none at all on the basic exposure. The only problem arises when a given composition is required and the resultant camera-to-subject distance is not the one desired for the proper fill-in light ratio. The solution, of course, is to put the flash unit on an extension wire and remove it from the camera. In this way, the exact flash-to-subject distance can be chosen, independently of the distance from camera to subject. Where this is not possible, some workers tone down the flash by placing a thin handkerchief over the lamp reflector. In any case, it is essential to make test exposures with the lamp and shutter speed usually used, and to keep notes of the results obtained.

There cannot be any one recommended distance for fill-in flash, simply because the amount of fill-in exposure is a matter of personal taste. Therefore, in the data sheets in this section, only an approximate recommendation is given. That is, the reader will find, for example, that an exposure of 1/25 sec. at $f/22$ is recommended with the subject at eight to ten feet, and no particular lamp is specified. The photographer, by making a few tests, will find that a given lamp will provide the desired degree of fill using this recommendation, and he can then use this lamp for all future work. Or he can choose any lamp he prefers and adjust his distances accordingly.

Electronic Flash Illumination. The electronic flashlamp has a color quality closely approximating daylight, and in most cases can be used with daylight-type color films without compensation. A few units, especially the larger professional packs with quartz tubes, tend to have somewhat higher ultraviolet emission than would be the case with daylight, and the results obtained with these units sometimes have a bluish cast. A very pale yellow or amber filter is all that is needed to compensate for this effect; in most cases, a light balancing filter #81B will be ample. For critical work, allow $1/3$ $f/$stop additional exposure with this filter.

Electronic flashlamps can also be used in daylight for flash fill-in. The method of determining the flash-to-subject distance is exactly the same as that given above; one simply determines the exposure for the daylight part of the scene first, then divides the guide number of the unit by the chosen $f/$stop, to secure the flash-to-subject distance. However, because of the high speed of the electronic flash, its guide number is not affected by the shutter speed. Thus, we have a wider choice of flash-to-subject distances, since we can change the $f/$stop used by the choice of an appropriate shutter speed, while leaving the flash unit guide number unchanged.

Reciprocity Law Failure with Color Film. The phenomenon of reciprocity failure is a well-known one. Although theory indicates that one unit of illumination falling on a given film for 100 seconds should produce the same effect as 100 units falling on that film for one second, in practice this does not work out. When films are exposed either for very long times at low light levels or for very short times (shorter than about 1/5000 sec.) at high light levels use of the calculated exposure will result in underexposure. In some cases, additional exposure up to several times the indicated base exposure is required to compensate for the loss of speed due to reciprocity failure.

In the case of black-and-white films, the effect is simply to require additional exposure under the given circumstances. Most reciprocity failure in black-and-white film is marginal; it is often covered by the latitude of the film. With color films the effect is more serious because in some cases, in addition to an overall speed loss, the effect is also to cause a shift in color balance due to one layer having a greater reciprocity failure than the others. In one case, that of Kodak Vericolor II Film, Type L, the effect is so serious that users are warned not to expose outside the recommended range: the color errors resulting from exposures either too long or too short are incapable of being corrected by filters in either taking or printing.

Thus, the effect of reciprocity failure obviously depends upon the individual film characteristics. For instance, Kodacolor II shows no failure at short exposure times to at least 1/1000 sec. For long exposures exceeding two minutes, it requires fully 2½ stops of additional exposure, or about 6 times the metered exposure. In addition, it shows some color shift, and requires filtering for proper color rendition. The table on the following page gives exposure corrections and filtration for currently available Kodak color films for various exposure times.

EXPOSURE* AND FILTER COMPENSATION FOR
THE RECIPROCITY CHARACTERISTICS OF **KODAK** COLOR FILMS

	Exposure Time (Seconds)						
	1/10000†	1/1000†	1/100	1/10	1	10	100
Kodacolor II	None No filter				+½ stop No filter	+1½ stops CC10C	+2½ stops CC10C + CC10G
Kodacolor 400	None No filter				+½ stop No filter	+1 stop No filter	+2 stops No filter
Vericolor II Professional, Type S	None No filter			Not Recommended			
Vericolor II Professional, Type L	Not Recommended		See film instructions for speed values for exposures of 1/50 thru 60 seconds				
Ektachrome 64 Prof (Daylight) rolls and 6117 sheet films Ektachrome 64 Day	+½ stop No filter	None No filter			+1 stop CC15B	+1½ stops CC20B	N.R.
Ektachrome 50 Prof (Tungsten)‡ rolls	—	+½ stop CC10G	None No filter		+1 stop CC20B	N. R.	
Ektachrome 200 Professional and Ektachrome 200 (Daylight type)	+½ stop No filter	None No filter			+½ stop CC10R	Not Recommended	
Ektachrome 160 Professional and Ektachrome 160 (Tungsten type)	—	None No filter			+½ stop CC10R	+1 stop CC15R	N.R.
Ektachrome Infrared	—	None No filter		+ 1 stop CC20B	Not Recommended		
Kodachrome 40 5070 (Type A)	None No filter				+½ stop No filter	+1 stop No filter§	N.R.
Kodachrome 25 (Daylight)	None No filter				+1 stop CC10M	+1½ stops CC10M	+2½ stops CC10M
Kodachrome 64 (Daylight)	None No filter				+1 stop CC10R	Not Recommended	

*The exposure increase, in lens stops, includes the adjustment required by any filter(s) suggested,

†Short exposure times and the color quality of some electronic flash units may cause a bluish color balance on some daylight-type films. If your results are consistently bluish, use a CP10Y or CP20Y filter over the flash unit or a CC10Y or CC20Y filter over the camera lens. Give 1/3 stop more exposure unless your flash unit makes automatic allowance for a filter over the flash tube.

‡For 6118 sheet film, see supplementary data sheet packaged with the film.

§For 5 seconds. 10-11-78

Notes: The data for each film are based on average emulsions and are rounded to the nearest ½ stop. They apply only to the type of illumination for which that film is balanced, and assume normal recommended processing. The data should be used as guides only. The adjustments are subject to change due to normal manufacturing variations or subsequent film storage conditions after the film leaves the factory.

Color Synthesis

Up to this point, we have discussed color films in terms of exposure and the manner in which they record the colors of nature as part images in three emulsions sensitized to red, green, and blue, respectively. Now, we must consider how, in turn, these part images are transformed into a colored picture approximating the colors of the original subject.

Assume for the moment that we are using separate films and filters dividing the spectrum into three parts as in a color film. Then the negative taken through the blue filter will show all blue objects as high densities, and the print from this negative will be very light or white where blue existed in the original subject. Obviously, then, the *densities* of the print must represent the colors which the blue filter did *not* transmit, namely green and red, and thus the print from this negative must be made in a color which does transmit green and red. Such a color is yellow to the eye, and this establishes the blue filter image as the yellow printer.

In the same manner, the green filter image must be printed in the colors which the green filter does not transmit, namely red and blue, and this establishes the green filter image as the magenta printer. And by the same reasoning, the red filter image must be printed in cyan (a blue-green color).

In multilayer color films, the method is exactly the same. The blue-sensitive top layer is transformed in processing into a yellow dye image, the green-sensitive midlayer to a magenta dye image, and the red-sensitive bottom layer to a cyan dye image. If the film has been developed by reversal to a positive image, then the result will be a positive transparency in the colors of the original subject.

If, on the other hand, the same film is developed to a negative, the result will be a negative image in which all the colors of the subject are represented by their complementaries. Blue skies will be yellow, red lips will be blue-green, and green foliage will be magenta. If we then take this colored negative and print it on another piece of the same film, we should reason that the result would be a positive image in the correct colors. In theory, this is absolutely true; in practice, there are certain difficulties which must be overcome.

These difficulties stem from two sources; to understand them, let us return to the positive color transparency for the moment. To the eye, this is a fairly faithful reproduction of the original subject matter, and it would seem easy enough to produce a copy of this colored image by photographing it on another piece of the same kind of film. When this is attempted, though, the colors of the first transparency are barely approximated in the second; there are large color shifts and loss of saturation.

One reason for this difficulty is simply that in trying to rephotograph a color transparency, we are *not* actually photographing a subject containing all the colors of nature. Our subject in this case is merely a picture composed of three superimposed images, one in each of the colors yellow, magenta, and cyan. In one way, this would simplify the problem, if we could possibly arrange it so that each part-image is copied in a single layer of the copy film—that is, if we could do a layer-by-layer transfer.

However, the sensitivities of the layers of a normal color film overlap to some degree. This is intentionally done to improve the rendition of mixed colors in nature, but it precludes the possibility of using such a film for a color duplicating medium. In the overlap regions, colors appearing on only one layer of the original appear in two of the duplicate, resulting in a strong desaturation of such colors.

If this were the only problem, however, copying of colored images would be easy enough. It is possible to use filters to eliminate the overlapping sensitivities of the emulsion layers, or films intended only for copying could be made with special sensitizers that cover narrower bands and do not overlap. In fact, the emulsions of current duplicating and color print films are sensitized in just this manner.

However, there is a second and more intractable problem in copying color photographs. Up to this point, we have assumed that the dyes used in forming the images—yellow, magenta, and cyan—each have the spectral transmission implied by their appearance. That is, we assume that the yellow dye absorbs all the blue, while transmitting red and green freely; likewise, we assume that magenta absorbs all the green, transmitting red and blue freely; and that cyan absorbs all the red, transmitting blue and green freely. Unfortunately, only the yellow dye has anywhere near the desired characteristics. The magenta dyes known so far tend to lack density in the green, while they absorb some blue, which they should transmit freely. The very best cyan dyes available absorb some of the blue and green, both of which should be transmitted freely, and in addition, transmit a good deal of red, which should be completely absorbed.

If then, we try to copy an image produced in such imperfect dyes on another color film, even one spectrally sensitized to the narrow bands intended to limit reproduction to a layer-by-layer copy, we find that the colors of the copy are still degraded. The unwanted absorption of the cyan and magenta dyes that should be transmitting freely results in these images being represented to some extent in layers other than their own. This has the effect of adding the complementary color to a given hue, in effect producing black or gray.

Thus, the multilayer color film which produces such sparkling colorful transparencies from original subject matter is a poor reproduction medium for other color transparencies. Transparencies are being reproduced, however, by other methods, both photographically and photomechanically. The photomechanical method, of course, makes use of a combination of hand work and photographic masking methods. Photographic copies can be made of color transparencies by the use of masking methods, and excellent results are obtained at the expense of considerable extra labor.

The theory and practice of masking is too complex to be covered in the limited space available here, but in effect what masking amounts to is to produce additional images representing the unwanted densities of the dyes. These images are in negative form when used with a positive transparency; thus, in effect, they add the unwanted density wherever it is *not* present in the original. Thus, they combine inversely with the unwanted densities of the image to form a uniform overall density covering the entire image area. The end result, then, is to neutralize the unwanted absorptions of the dyes, and the only cost is the addition of some gray density overall, which merely serves to increase the exposure required in copying. In copying transparencies, these added complementary densities are produced on separate films and are placed in register with the original while copying. Masking could be built into a transparency film, but this would spoil the appearance of the image for direct viewing or projection.

However, negative color films have greater latitude in certain areas than transparency films. Since a negative image is not intended for direct viewing and since the complementary color rendition is going to be unfamiliar to the untrained eye, there is no need for the dyes in these films to have the same visual appearance as those needed to produce a color transparency for direct viewing. Thus, dyes for color negative films can be chosen for their printing quality rather than for their appearance, and this alone can make a noticeable

improvement. Some European color films are made in this manner, and they produce color prints which are quite satisfactory for noncritical uses. Even these dyes are imperfect, however, and to offset the inevitable degradation of the color by added gray, the negatives are developed to a fairly high contrast to secure sufficient saturation of color. Likewise, the printing paper must also be fairly contrasty to secure bright enough colors, and the result of the two high contrast media is to produce rather hard, harsh results.

Masking adds a negative image to the positive or conversely, a positive image to a color negative. Either way, the result is to lower the contrast of the image, without, however, decreasing color saturation. Thus, even without considering the improvement in color by the use of multiple masks, the benefit of reduced contrast without loss of saturation makes the use of masks highly valuable. When the mask serves both purposes, color correction and reduced contrast, the beneficial effects are so great that one could say that the masked color negative film is what made the use of color negatives by professional photographers possible.

The masking system used in Kodacolor II and Kodak Vericolor II Films is based on the use of a set of color couplers which are themselves colored to begin with. For instance, since the cyan dye has some unwanted density in the blue and green, the color coupler in this layer is reddish in hue, and this color is adjusted to be as nearly as possible equal to the unwanted blue and green density of the cyan dye. When this layer is developed, cyan dye is produced to form the image, and the red color is destroyed in proportion to the amount of cyan dye formed. Thus, the more cyan dye formed in this layer, the less red dye is present, and the result is to balance out the unwanted blue and green density of the cyan dye completely.

In the magenta layer, the same principle is followed, but here the masking dye coupler is yellow in color, since it is correcting for unwanted blue density only. Again, the yellow color is discharged in proportion to the amount of magenta dye formed, so that the net result is simply an overall blue density which does not affect the image quality at all; it merely increases the printing exposure of the negative.

The remaining layer which forms the yellow image does not need masking, since most yellow dyes are fairly efficient and contain little unwanted density. So the color negative carries three image colors—magenta, cyan, and yellow—and it contains colored couplers which are yellow and red in color, respectively. The visual effect of the masking layers is to give the negative a strong orange overall cast which makes it difficult to judge visually, but its printing quality is greatly improved.

The foregoing description of the masking method is, of course, schematic; those who wish to study this problem at greater length are referred to such advanced textbooks as *Principles of Color Photography* by Evans, Hanson, and Brewer. (John Wiley, New York)

It should be obvious, though, that the choice of colored couplers can be carried to any desired degree, even to the point of overcorrection, so that compensation can be made for both the dyes in the negative material and also for color errors in the original subject matter as well. This makes it possible to devise such color negative materials as internegative color films, which are designed to make copy negatives from color transparencies. Subsequent prints are then made from the internegative, and results of excellent quality are obtained by this process. Further information on this subject will be found in the section on color processing.

Processing Color Films. Color films currently manufactured fall into two broad classes. In the first class are those having silver bromide emulsions, sensitized respectively to blue, green, and red as described, but with no other components in the film itself. These films must be processed by various complex differential methods, since the correct dye must be formed in the layers by the color developer; obviously, a different color developer must be used for each layer, and each layer must be color-developed separately. Such selective processing requires special machinery and intricate processing control methods for its accomplishment. Such films as Kodachrome 25, Kodachrome 64, and certain home movie films are made this way, and processing can only be done by the manufacturer or by authorized laboratories having the special equipment required. They cannot be processed by the user in normal darkroom equipment.

The second class of color films contains all of those in which color couplers are incorporated in the emulsion layers. These color couplers are chosen so that a single properly formulated color developer will form the proper color in each layer during the course of a single color development step. Because of patent problems, the developers required for color films of different manufacturers are different, and it is not possible at this time to specify a single color developer that will work with all brands of films. Some of the chemicals used in these color developers are fairly difficult to come by; many of them are manufactured by the film maker. Thus, formulas for processing color films are not usually published, and the photographer is offered packaged chemicals, both for the individual baths and in kits containing everything needed to process the film. No special equipment is required.

One reason that these built-in coupler films differ from each other lies in the handling of a peripheral problem. It should be obvious that coupler chemicals wandering from one layer to another must be avoided at all cost; otherwise pure colors cannot be obtained. In some cases, this end is gained by the use of a coupler chemical which is a long-chain carbon compound; the great molecular weight of this chain tends to immobilize it in the gelatin, without, however, making it insoluble in water, which would prevent its reaction with the color developer. In other cases, a simpler coupler is used, dispersed in a special water-permeable plastic binder material, which is mixed with the gelatin of the emulsion layer. This binder must be transparent, and it must have roughly the same refractive index as the gelatin. Otherwise it would make the emulsion layers more or less opaque. This can be accomplished wet or dry but apparently not both, hence the binder is chosen to be transparent when dry. In the wet state, changes in the refractive index cause this binder layer to appear cloudy or opalescent, and this effect is very noticeable during the processing of such films.

In the data sheets at the end of this section, a short note is given for each film indicating the basic type of processing required. Further information will be found in the section on color processing.

Storage of Color Films. Color films are more adversely affected by improper storage conditions than are black-and-white materials. This is because deterioration of a black-and-white film usually results only in a change in speed or some fog. In the case of color films, these same effects may occur, but to a different extent in each layer, so that the change may be a loss of speed, a loss of color balance, color fog, or all three. Excess moisture may, in addition, cause other defects such as color mottle, and in severe cases, sticking of the film to itself or to the backing paper.

Protection from humidity is in many cases more important than protection from heat. Original film packages are usually well enough sealed to prevent much damage from moisture; the exception is in the case of moving picture

films which are usually supplied in taped cans. The tape is not completely equivalent to a hermetic seal, and some moisture will get into such cans; it is well in humid areas to provide a special dry storage area for motion picture materials.

Protection from heat is important mainly in areas where temperatures are consistently above 75 F, especially when films are to be stored in quantity for long periods. Refrigeration is the best method for storing materials to be kept more than about four weeks and up to a few months. An ordinary household refrigerator is a satisfactory storage cabinet; the temperature should be kept below 55 F for the best short-term storing qualities.

It was formerly believed that films should not be frozen in storage or stored at below freezing temperatures. More recent research shows that sub-zero storage is not only not harmful but that it actually arrests the changes in the film emulsion almost completely. Films can be stored in a frozen state for long periods, in some cases for several years. It is usually considered that this delays deterioration so completely that one can consider that aging of the film effectively begins when it is removed from frozen storage—not from the date of manufacture.

No matter how carefully films are stored, deterioration does begin as soon as the film is removed from storage. This continues after exposure, too. Therefore, when conditions are not optimum, films should not be removed from storage until needed, and they should be processed as soon after exposure as possible.

However, film cannot be used immediately upon removal from refrigerated or frozen storage. If the film package is opened in a moist atmosphere, moisture will condense on the film surfaces and cause damage. Film packages must be allowed to warm up to room temperature before the seal is broken. The following table gives some warm-up times for packages which must come to ambient temperature from refrigerated storage and from frozen storage (a 25 F and 100 F temperature rise, respectively).

| | Warm-up Time (Hours) | |
Type of Film Package	For 25 F rise	For 100 F rise
Roll film and 828	½	1
35mm and 126	1	1½
10 sheet box	1	1½
50 sheet box	2	3
8mm or 16mm motion picture	1	1½
35mm motion picture	3	5

These times are suggested for single packages standing on edge or end so that air can circulate around them. If a number of packages are stacked flat on top of one another, warm-up times may be much longer.

Other Harmful Influences. Films not in tightly sealed containers or in cans sealed only with tape, must be kept away from various industrial gases, motor exhausts, the vapor of paradichlorobenzene (moth repellent), formaldehyde, various solvents, cleaners, paint thinners, turpentine, and the various mildew preventives, most of which contain paraformaldehyde. The currently popular fumigant for termite control is acrylonitrile, which also has severe damaging effects on film emulsions. If film in taped cans must be stored in places where it is subject to such influences, they should be enclosed in tightly sealed outer containers, such as screw-top cans or jars.

Radiation from X-ray machines, radium, and other radioactive materials is also extremely harmful to films; in areas where such radioactive materials or radiation-producing machines are present, film requires considerable protection. For example, films stored 25 feet from 100 milligrams of radium require that the radium be shielded with 3½ inches of lead.

Protection of Films after Opening Package. Once the package is opened, the films are no longer protected from heat, humidity, or harmful gases. Films should be exposed and processed as quickly as possible after the package is opened, especially in areas of high temperature and humidity or in industrial environments where harmful pollutants prevail in the atmosphere.

If film must be kept for appreciable periods after exposure and before processing, it should be kept in cool dry storage. Where this is not possible, the film should be placed in a closed container along with a moisture absorber. The simplest and most effective device of this sort is the Davison Silica Gel Air Dryer, which is a perforated metal container holding about 1½ oz. of silica gel. The container also has a colored indicator, which is blue when the unit is dry and ready for use and pink as moisture is absorbed; this pink color is a signal that the unit needs to be regenerated.

These units last indefinitely and can be used over and over again by reactivating them in a vented oven or over an open fire. They should be heated to 300–400 F for about ½ hour for the small units. Larger quantities of silica gel require longer reactivating times. Allow the heated silica gel to cool in a closed metal container; then if the desiccant is not to be used immediately, seal the container.

Film to be shipped to commercial laboratories for processing should not be delayed for drying; instead it should be packed with the drying units in a sealed can and shipped at once. The jarring which packages receive in transit will spill loose silica gel and cause dusting, hence bulk silica gel should not be used, only the packaged drying units.

COLOR FILMS FOR STILL PHOTOGRAPHY

FILM	TYPE	SPEED	PROCESSING	SIZES AVAILABLE*
AGFA				
Agfachrome CT-18	Daylight Transparency	D-50, T-25†	Mfg	35mm, Rapid, 126, 127, sheet
Agfacolor CNS	Daylight negative	D-80, T-25†	Mfg or user	35mm
Agfacolor CNS-400	Daylight negative	D-400	C-41	See note 1
FUJI				
Fujicolor F-II	Daylight negative	D-100, T25†	Mfg or user	35mm, 126, 120
Fujicolor 400	Daylight negative	D-400	Mfg or user	See note 1
Fujichrome R-100	Daylight transparency	D-100, T-25†	Mfg or user	35mm
KODAK				
Ektachrome-64 & Prof.	Daylight transparency	D-64	User, E-6	See note 1
Ektachrome-50 Professional	Tungsten Transparency	T-50	User, E-6	See note 1
Ektachrome-200 & Prof.	Daylight transparency	D-200, T-50†	User, E-6	See note 1
Ektachrome-160 & Prof.	Tungsten transparency	D-100†, T-160	User, E-6	See note 1
Ektachrome-400	Daylight transparency	D-400	User, E-6	See note 1
Kodachrome-25, Daylight	Daylight transparency	D-25, T-8†	Mfg.	35mm
Kodachrome-40 Type A	Tungsten transparency	D-25†, T-40	Mfg.	35mm
Kodachrome-64	Daylight transparency	D-64, T-20†	Mfg.	35mm
Kodacolor II	Daylight negative	D-80	Mfg or user	110, 120, 126, 127, 135
Kodacolor-400	Daylight negative	D-400	Mfg or user	110, 120, 135
Vericolor Commercial	Daylight negative	D-80	User, C-41	See note 1
Vericolor II Type L	Tungsten negative	T-100	User, C-41	Sheet films, 120 roll
Vericolor II Type S	Daylight negative	D-100	User, C-41	120, 220, 620. 135, sheet films, long rolls
Vericolor ID Copy	Daylight negative	D-80, T-16†	User, C-41	Long rolls, sheet films
Photomicrography Color Film	Daylight transparency	D-16, T-4†	User, E-4	35mm long rolls, sheet films
POLAROID				
Polacolor	Daylight print film	D-75	In camera	38, 48, 58, 88, 108, 668

* Availability is subject to change without notice, depending upon current demand; see your dealer.
† With appropriate filter, see film instructions
NOTE 1: New film, marketing arrangements not complete when this edition went to press. See your
dealer for latest information on availability.

AGFACHROME-64 AND CT-18 COLOR FILMS

Type of Film: Color transparency film for daylight.

Film Speed and Filters: The number given after each light source is based on a USA Standard and is for use with meters and cameras marked for "ASA" speeds.

Light Source	Speed	With Filter such as:
Daylight	50	None
Photoflood	25	80B

Note: Exposure times 1/10 second or longer may require an increase in exposure to compensate for the reciprocity characteristics of this film. See introduction to this section.

Daylight Exposure Table: Lens openings with shutter at 1/100 sec.

Bright or Hazy Sun on Light Sand or Snow	Bright or Hazy Sun (Distinct Shadows)†	Cloudy Bright (No Shadows)	Heavy Overcast	Open Shade*
f/16	f/11	f/8	f/5.6	f/5.6

*Subject shaded from sun but lighted by a large area of clear, unobstructed sky.
†For backlighted closeup subjects, use 2 stops larger.

Fill-in Flash: Blue flashbulbs are helpful in lightening the harsh shadows usually found in making close-ups in bright sunlight. A typical exposure is 1/25 sec. at f/22 with the subject 8 to 10 feet away. See introduction to this section, also.

Flash Exposure Guide Numbers: Use *blue flashbulbs* without a filter. With zirconium-filled clear flashbulbs (AG-1, M3 and M5), use a Kodak No. 80D Filter over camera lens. With all other clear flashbulbs, use a No. 80C Filter. Divide guide number by flash-to-subject distance in feet to determine the f/number for average subjects.

Synchronization: X or F		M				Focal-plane	6B§ 26B§
Shutter Speed	M2B‡	Flash Cube	AG-1B†	AG-3B†	M3B§, M5B§ 5B§, 25B§	Shutter Speed	
Open. 1/25	85	—	85	—	110	1/50	85
1/50	—	—	—	—	100	1/100	52
1/100	—	—	—··	—	90	1/250	32
1/200	—	—	—	—	70	1/500	—
1/400	—	—	—	—	—		

Bowl shaped polished reflector sizes: †2-inch; ‡3-inch; §4 to 5-inch. If shallow cylindrical reflectors are used, divide these guide numbers by 2.
Caution: Since bulbs may shatter when flashed, the use of a flashguard over the reflector is recommended. *Do not flash bulbs in an explosive atmosphere.*

Electronic Flash Guide Numbers: This table is intended as a starting point in determining the correct guide number. It is for use with equipment rated in beam candlepower-seconds (BCPS) or effective candlepower-seconds (ECPS). Divide the appropriate guide number by the flash-to-subject distance in feet to determine the f/number for average subjects.

Output of Unit (BCPS or ECPS)	350	500	700	1000	1400	2000	2800	4000	5600	8000
Guide Number For Trial	36	45	50	60	72	85	100	125	145	180

Processing: Processing and mounting into standard cardboard frames is included in the purchase price; a special mailer is packaged with each roll of film.

AGFACOLOR CNS COLOR PRINT FILM

Type of Film: Color negative film for daylight.

Film Speed and Filters: The number given after each light source is based on a USA Standard and is for use with meters and cameras marked for "ASA" speeds.

Light Source	Speed	With Filter such as:
Daylight	80	—
Photoflood (3400 K)	25	80B
Tungsten (3200 K)	—	—

Note: Exposure times 1/10 second or longer may require an increase in exposure to compensate for the reciprocity characteristics of this film. See introduction to this section.

Daylight Exposure Table: Lens openings with shutter at 1/100–1/125 second.

Bright or Hazy Sun on Light Sand or Snow	Bright or Hazy Sun (Distinct Shadows)†	Cloudy Bright (No Shadows)	Heavy Overcast	Open Shade*
f/16	f/11	f/5.6	f/4	f/4

*Subject shaded from sun but lighted by a large area of clear, unobstructed sky.
†For backlighted closeup subjects, use 2 stops larger.

Fill-in Flash: Blue flashbulbs are helpful in lightening the harsh shadows usually found in making close-ups in bright sunlight. A typical exposure is 1/25 sec. at f/22 with the subject 8 to 10 feet away.

Flash Exposure Guide Numbers: Use *blue flashbulbs* without a filter. With zirconium-filled clear flashbulbs (AG-1, M3 and M5), use a Kodak No. 80D Filter over camera lens. With all other clear flashbulbs, use a No. 80C Filter. Divide guide number by flash-to-subject distance in feet to determine the f/number for average subjects.

Synchronization: X or F			M			Focal-plane	6B§
Shutter Speed	M2B‡	Flash Cube	AG-1B†	AG-3B†	M3B‡, M5B‡ 5B§, 25B§	Shutter Speed	26B§
Open. 1/25	100	60	100	110	180	1/50	130
1/50	—	60	90	110	160	1/100	90
1/100	—	50	75	90	130	1/250	60
1/200	—	40	65	75	105	1/500	—
1/400	—	—	—	—	—		

Bowl shaped polished reflector sizes: †2-inch; ‡3-inch; §4 to 5-inch. If shallow cylindrical reflectors are used, divide these guide numbers by 2.
Caution: Since bulbs may shatter when flashed, the use of a flashguard over the reflector is recommended. *Do not flash bulbs in an explosive atmosphere.*

Electronic Flash Guide Numbers: This table is intended as a starting point in determining the correct guide number. It is for use with equipment rated in beam candlepower-seconds (BCPS) or effective candlepower-seconds (ECPS). Divide the appropriate guide number by the flash-to-subject distance in feet to determine the f/number for average subjects.

Output of Unit (BCPS or ECPS)	350	500	700	1000	1400	2000	2800	4000	5600	8000
Guide Number For Trial	32	40	45	55	65	80	95	110	130	160

Processing: By manufacturer or franchised laboratory; also by user, with Agfacolor processing chemicals.

Color prints from Agfacolor CNS negatives may be made on Agfacolor paper (MCN-111). Color transparencies may be made on Agfacolor Positive Film M. Black-and-white prints are not usually satisfactory.

AGFACOLOR CNS-400 NEGATIVE FILM

Type of Film: Color negative film for daylight.

Film Speed: ASA 400 for daylight.

Processing: Agfacolor Process 70 (compatible with Kodak Process C-41.)

Note: This is tentative, unofficial data only; at the time this edition went to press this film was not yet available on the American market and no marketing plans have been announced. The film is presently available in Europe in 110 and 135 sizes. For those who may pick some up on their travels, it is likely that exposure tables, flash guide numbers, and other data for similar color films of ASA 400 rating, will provide a starting point for personal tests.

FUJICOLOR F-II FILM (110, 120, 126, and 135)

Type of Film: Color negative film for daylight.

Film Speed and Filters: The number given after each light source is based on a USA Standard and is for use with meters and cameras marked for "ASA" speeds.

Light Source	Speed	With Filter such as:
Daylight	100	None
Photoflood (3400 K)	—	—
Tungsten (3200 K)	32*	LBB-12** or Wratten 80A

*Speed includes the exposure factor of the light balancing filter
**Fuji Light Balancing Filter

Daylight Exposure Table: Lens openings with shutter at 1/100–1/125 sec.

Bright or Hazy Sun on Light Sand or Snow	Bright or Hazy Sun (Distinct Shadows)†	Cloudy Bright (No Shadows)	Heavy Overcast	Open Shade*
f/16	f/11	f/5.6	f/4	f/4

*Subject shaded from sun but lighted by a large area of clear, unobstructed sky.
†For backlighted closeup subjects, use 2 stops larger.

Fill-in Flash: Blue flashbulbs are helpful in lightening the harsh shadows usually found in making close-ups in bright sunlight. A typical exposure is 1/25 sec. at f/22 with the subject 8 to 10 feet away.

Flash Exposure Guide Numbers: Use *blue flashbulbs* without a filter. With zirconium-filled clear flashbulbs (AG-1, M3 and M5), use a Kodak No. 80D Filter over camera lens. With all other clear flashbulbs, use a No. 80C Filter. Divide guide number by flash-to-subject distance in feet to determine the f/number for average subjects.

Synchronization: X or F			M			Focal-plane	6B§
Shutter Speed	M2B‡	Flash Cube	AG-1B†	AG-3B†	M3B‡, M5B‡ 5B§, 25B§	Shutter Speed	26B§
Open, 1/25	105	100	90	—	185	1/50	125
1/50	—	70	65	—	160	1/100	90
1/100	—	60	50	—	140	1/250	65
1/200	—	45	43	—	110	1/500	45
1/400	—	40	33	—	85		

Bowl shaped polished reflector sizes: †2-inch; ‡3-inch; §4 to 5-inch. If shallow cylindrical reflectors are used, divide these guide numbers by 2.

Caution: Since bulbs may shatter when flashed, the use of a flashguard over the reflector is recommended. *Do not flash bulbs in an explosive atmosphere.*

Electronic Flash Guide Numbers: This table is intended as a starting point in determining the correct guide number. It is for use with equipment rated in beam candlepower-seconds (BCPS) or effective candlepower-seconds (ECPS). Divide the appropriate guide number by the flash-to-subject distance in feet to determine the f/number for average subjects.

Output of Unit (BCPS or ECPS)	350	500	700	1000	1400	2000	2800	4000	5600	8000
Guide Number For Trial	40	50	60	70	85	100	120	140	170	200

Processing: The film price does not include processing. For processing and printing, the film should be sent to a Fuji-authorized laboratory or other laboratory offering such service, or it may be processed by the user with Fujicolor F-II Processing Chemicals, Process CN-16, or in Kodak Process C-41 chemicals.

FUJICOLOR F-II 400 FILM (110, 120, 135)

Type of Film: Color negative film for daylight.

Film Speed and Filters: The number given after each light source is based on a USA Standard and is for use with meters and cameras marked for "ASA" speeds.

Light Source	Speed	With Filter such as:
Daylight	400	None
Photoflood (3400 K)	125	80 B
Tungsten (3200 K)	—	80 A

Note: Exposure times 1/10 second or longer may require an increase in exposure to compensate for the reciprocity characteristics of this film. See introduction to this section.

Daylight Exposure Table: Lens openings with shutter at 1/400—1/500 sec.

Bright or Hazy Sun on Light Sand or Snow	Bright or Hazy Sun (Distinct Shadows)†	Cloudy Bright (No Shadows)	Heavy Overcast	Open Shade*
f/22	f/16	f/8	f/5.6	f/5.6

*Subject shaded from sun but lighted by a large area of clear, unobstructed sky.
†For backlighted closeup subjects, use 2 stops larger.

Flash Exposure Guide Numbers: Use *blue flashbulbs* without a filter. With zirconium-filled clear flashbulbs (AG-1, M3 and M5), use a Kodak No. 80D Filter over camera lens. With all other clear flashbulbs, use a No. 80C Filter. Divide guide number by flash-to-subject distance in feet to determine the f/number for average subjects.

Synchronization			M			Focal-Plane Shutter Speed	6B§ 26B§
Shutter Speed	Flash Cube	M3B‡, M5B‡ 5B§, 25B§	AG-1B†	AG-3B†			
Open. 1/25	140	400	200	250		1/50	240
1/50	130	350	200	250		1/100	140
1/100	110	290	170	200		1/250	135
1/200	90	240	140	160		1/500	100
1/400	75	170	110	120			

Bowl-Shaped Polished Reflector Sizes: †2-inch; ‡3-inch; §4- to 5-inch; ‖6- to 7-inch. If shallow cylindrical reflectors are used, divide these guide numbers by two.
Note: At 1/25 second, cameras having X or F synchronization can use any of the flashbulbs listed under M synchronization.

Caution: Since bulbs may shatter when flashed, the use of a flashguard over the reflector is recommended. *Do not flash bulbs in an explosive atmosphere.*

Electronic Flash Guide Numbers: This table is intended as a starting point in determining the correct guide number. The table is for use with equipment rated in beam candlepower-seconds (BCPS) or effective candlepower-seconds (ECPS). Divide the appropriate guide number by the flash-to-subject distance in feet to determine the f-number for average subjects.

Output of Unit (BCPS or ECPS)	350	500	700	1000	1400	2000	2800	4000	5600	8000
Guide Number for Trial	85	100	120	140	170	200	240	280	340	400

Processing: The price of the film does not include processing. This film may be processed by the user, using Fujicolor Negative Film Processing Chemicals Process CN-16. It may also be sent to any authorized Fujicolor laboratory or to any commercial laboratory which has processing facilities for Fujicolor Negative films. It is completely compatible with Process C-41 (and the Flexicolor chemicals) and may be processed in these solutions, by the user or at any commercial laboratory offering this service.

FUJICHROME R-100 FILM (135 Roll)

Type of Film: Color transparency film for daylight.

Film Speed and Filters: The number given after each light source is based on a USA Standard and is for use with meters and cameras marked for "ASA" speeds.

Light Source	Speed	With Filter such as:
Daylight	100	None
Photoflood (3400 K)	—	—
Tungsten (3200 K)	25	80A

Note: Exposure times 1/10 second or longer may require an increase in exposure to compensate for the reciprocity characteristics of this film. See introduction to this section.

Daylight Exposure Table: Lens openings with shutter at 1/100–1/125 sec.

Bright or Hazy Sun on Light Sand or Snow	Bright or Hazy Sun (Distinct Shadows)†	Cloudy Bright (No Shadows)	Heavy Overcast	Open Shade*
f/16	f/11	f/5.6	f/4	f/4

*Subject shaded from sun but lighted by a large area of clear, unobstructed sky.
†For backlighted closeup subjects, use 2 stops larger.

Fill-in Flash: Blue flashbulbs are helpful in lightening the harsh shadows usually found in making close-ups in bright sunlight. A typical exposure is 1/25 sec. at f/22 with the subject 8 to 10 feet away.

Flash Exposure Guide Numbers: Use *blue flashbulbs* without a filter. With zirconium-filled clear flashbulbs (AG-1, M3 and M5), use a Kodak No. 80D Filter over camera lens. With all other clear flashbulbs, use a No. 80C Filter. Divide guide number by flash-to-subject distance in feet to determine the f/number for average subjects.

Synchronization: X or F		M				Focal-plane	6B§
Shutter Speed	M2B‡	Flash Cube	AG-1B†	AG-3B†	M3B‡, M5B‡ 5B§, 25B§	Shutter Speed	26B§
Open. 1/25	—	80	110	140	220	1/50	160
1/50	—	80	110	140	200	1/100	110
1/100	—	60	95	110	160	1/250	80
1/200	—	50	80	90	130	1/500	55
1/400	—	40	60	70	100		

Bowl shaped polished reflector sizes: †2-inch; ‡3-inch; §4 to 5-inch. If shallow cylindrical reflectors are used, divide these guide numbers by 2.

Caution: Since bulbs may shatter when flashed, the use of a flashguard over the reflector is recommended. Do not flash bulbs in an explosive atmosphere.

Electronic Flash Guide Numbers: This table is intended as a starting point in determining the correct guide number. It is for use with equipment rated in beam candlepower-seconds (BCPS) or effective candlepower-seconds (ECPS). Divide the appropriate guide number by the flash-to-subject distance in feet to determine the f/number for average subjects.

Output of Unit (BCPS or ECPS)	350	500	700	1000	1400	2000	2800	4000	5600	8000
Guide Number For Trial	40	50	60	70	85	100	120	140	170	200

Processing: This film may be processed by the user with Fujichrome Film Processing Chemicals or Kodak Ektachrome Process E-4. Commercial processing is available from Fuji-authorized laboratories and others.

KODAK EKTACHROME-64 & EKTACHROME-64 PROF. FILMS

Type of Film: Color transparency film for daylight.

Film Speed and Filters: The number given after each light source is based on a USA Standard and is for use with meters and cameras marked for "ASA" speeds.

Light Source	Speed	With Filter such as:
Daylight	64	NONE
Photoflood (3400 K)	20	80 B
Tungsten (3200 K)	16	80 A

Note: Exposure times 1/10 second or longer may require an increase in exposure to compensate for the reciprocity characteristics of this film. See introduction to this section.

Daylight Exposure Table: Lens openings with shutter at 1/100–1/125 sec.

Bright or Hazy Sun on Light Sand or Snow	Bright or Hazy Sun (Distinct Shadows)†	Cloudy Bright (No Shadows)	Heavy Overcast	Open Shade*
f/16	f/11	f/5.6	f/4	f/4

*Subject shaded from sun but lighted by a large area of clear, unobstructed sky.
†For backlighted closeup subjects, use 2 stops larger.

Fill-in Flash: Blue flashbulbs are helpful in lightening the harsh shadows usually found in making close-ups in bright sunlight. A typical exposure is 1/25 sec. at f/22 with the subject 8 to 10 feet away. See introduction to this section, also.

Flash Exposure Guide Numbers: Use *blue flashbulbs* without a filter. With zirconium-filled clear flashbulbs (AG-1, M3 and M5), use a Kodak No. 80D Filter over camera lens. With all other clear flashbulbs, use a No. 80C Filter. Divide guide number by flash-to-subject distance in feet to determine the f/number for average subjects.

Synchronization: X or F			M			Focal-plane	6B§
Shutter Speed	M2B‡	Flash Cube	AG-1B†	AG-3B†	M3B‡, M5B‡ 5B§, 25B§	Shutter Speed	26B§
Open. 1/25	105	55	80	100	150	1/50	110
1/50	—	55	80	100	140	1/100	80
1/100	—	45	70	80	120	1/250	55
1/200	—	36	55	65	95	1/500	38
1/400	—	28	45	50	70	—	—

Bowl shaped polished reflector sizes: †2-inch; ‡3-inch; §4 to 5-inch. If shallow cylindrical reflectors are used, divide these guide numbers by 2.

Caution: Since bulbs may shatter when flashed, the use of a flashguard over the reflector is recommended. *Do not flash bulbs in an explosive atmosphere.*

Electronic Flash Guide Numbers: This table is intended as a starting point in determining the correct guide number. It is for use with equipment rated in beam candlepower-seconds (BCPS) or effective candlepower-seconds (ECPS). Divide the appropriate guide number by the flash-to-subject distance in feet to determine the f/number for average subjects.

Output of Unit (BCPS or ECPS)	350	500	700	1000	1400	2000	2800	4000	5600	8000
Guide Number For Trial	32	40	45	55	65	80	95	110	130	160

Processing: This film is processed by Kodak on orders through dealers, also by independent laboratories. It may be processed by the user, with the Kodak Ektachrome Chemicals, Process E-6.

KODAK EKTACHROME-50 PROFESSIONAL FILM

Type of Film: Color transparency film for tungsten illumination.

Film Speed and Filters: The number given after each light source is based on a USA Standard and is for use with meters and cameras marked for "ASA" speeds.

Light Source	Speed	With Filter such as:
Photoflood Lamps	50	None (½ sec. exposure)
3200 K Lamps	40	81A (½ sec. exposure)
Daylight	40	85B (½ sec. exposure)

Note: Exposure times longer than 1/10 second may require an increase in exposure to compensate for the reciprocity characteristics of this film. See introduction to this section.

Reflector-Type Lamp Exposure Table: Based on the use of the types of lamp listed below. In the case of 3200 K lamps, some increase in exposure may be required after about 10 hours of burning: with Photoflood types, ½ stop increase is required after 1 hour, and 1 full stop increase is needed after 2 hours of use.

Lens Opening at ½ second exposure			f/16	f/11	f/8	f/5.6	f/4
Lamp to subject Distance in feet:	EAL Lamps (GE)	Main Light	5½	7½	10½	15	20
		Fill-in Light	7½	10½	15	20	30
	R-32 Lamps (Sylvania)	Main Light	6½	9	13	18	26
		Fill-in Light	9	13	18	26	35

Flash Exposure Guide Numbers: To get *f*/number, divide guide number by flash-to-subject distance in feet, taken to a point midway between nearest and farthest details of interest. In small white rooms, use one stop smaller. *Use filter No. 81C.*

Synchronization:	X or F		M			Focal-Plane	6§
Shutter Speed	AG-1†	M3†, M5‡ 5§, 25§	11‖ 40‖	M2‡		Shutter Speed	26§
Open. 1/25	95	140	150	100		1/50	105
1/50	—	130	130	—		1/100	80
1/100	—	120	120	—		1/250	55
1/200	—	90	90	—		1/500	38
1/400	—	70	70	—			

Bowl-Shaped Polished Reflector Sizes: †2-inch; ‡3-inch, §4 to 5-inch; ‖6 to 7 inch. If shallow cylindrical reflectors are used, divide these guide numbers by two.

Note: At 1/25 second, cameras having X or F synchronization can use any of the flashbulbs listed under M synchronization.

Caution: Since bulbs may shatter when flashed, the use of a flashguard over the reflector is recommended. *Do not flash bulbs in an explosive atmosphere.*

Electronic Flash Guide Numbers: This table is intended as a starting point in determining the correct guide number. The table is for use with equipment rated in beam candlepower-seconds (BCPS) or effective candlepower-seconds (ECPS). Divide the appropriate guide number by the flash-to-subject distance in feet to determine the *f*/number for average subjects.

Output of Unit (BCPS or ECPS)	350	500	700	1000	1400	2000	2800	4000	5600	8000
Guide Number For Trial					NOT RECOMMENDED					

Processing: Processed by Kodak and other laboratories on orders placed through dealers. Some laboratories, including Kodak, also provide direct mail service; purchase special mailing device from your dealer. This film may also be processed by the user, with Kodak Ektachrome Chemicals, Process E-6.

KODAK EKTACHROME-200 & EKTACHROME-200 PROF. FILMS

Type of Film: Color transparency film for daylight.

Film Speed and Filters: The number given after each light source is based on a USA Standard and is for use with meters and cameras marked for "ASA" speeds.

Light Source	Speed	With Filter such as:
Daylight	200	None
Photoflood Lamps	64	80B
32003 K Lamps	50	80A

Note: Exposure times 1/10 second or longer may require an increase in exposure to compensate for the reciprocity characteristics of this film. See introduction to this section.

Daylight Exposure Table: Lens openings with shutter at 1/200 or 1/250 sec.

Bright or Hazy Sun on Light Sand or Snow	Bright or Hazy Sun (Distinct Shadows)†	Cloudy Bright (No Shadows)	Heavy Overcast	Open Shade*
f/22	f/16	f/8	f/5.6	f/5.6

*Subject shaded from sun but lighted by a large area of clear, unobstructed sky.
†For backlighted closeup subjects, use 2 stops larger.

Fill-in Flash: Blue flashbulbs are helpful in lightening the harsh shadows usually found in making close-ups in bright sunlight. A typical exposure is 1/100 sec. at f/22 with the subject 8 to 10 feet away. See introduction to this section, also.

Flash Exposure Guide Numbers: Use *blue flashbulbs* without a filter. With zirconium-filled clear flashbulbs (AG-1, M3 and M5), use a Kodak No. 80D Filter over camera lens. With all other clear flashbulbs, use a No. 80C Filter. Divide guide number by flash-to-subject distance in feet to determine the f/number for average subjects.

Synchronization: X or F		M			Focal-Plane	
Shutter Speed	Flash Cube	M3B‡, M5B‡ 5B§, 25B§	AG-1B†	AG-3B†	Shutter Speed	6B§ 26B§
Open, 1/25	130	280	160	—	1/50	220
1/50	90	240	125	—	1/100	140
1/100	75	230	—	—	1/250	100
1/200	60	200	—	—	1/500	70
1/400	40	160	—	—		

Bowl-Shaped Polished Reflector Sizes: †2-inch; ‡3-inch; §4- to 5-inch; ‖6- to 7-inch. If shallow cylindrical reflectors are used, divide these guide numbers by two.
Note: At 1/25 second, cameras having X or F synchronization can use any of the flashbulbs listed under M synchronization.
Caution: Since bulbs may shatter when flashed, the use of a flashguard over the reflector is recommended. *Do not flash bulbs in an explosive atmosphere.*

Electronic Flash Guide Numbers: This table is intended as a starting point in determining the correct guide number. The table is for use with equipment rated in beam candlepower-seconds (BCPS) or effective candlepower-seconds (ECPS). Divide the appropriate guide number by the flash-to-subject distance in feet to determine the f-number for average subjects.

Output of Unit (BCPS or ECPS)	350	500	700	1000	1400	2000	2800	4000	5600	8000
Guide Number for Trial	60	70	85	100	120	140	170	200	240	280

Processing: Processed by Kodak and other laboratories on orders placed through dealers. Some laboratories including Kodak, also provide direct mail services; purchase special mailing device from your dealer. This film can also be processed by the user, all chemicals for preparing a complete set of processing solutions are in the Kodak Ektachrome Film Processing Kit, Process E-6.

KODAK EKTACHROME-160 & EKTACHROME-160 PROF. FILMS

Type of Film: Color transparency film for 3200 K illumination.

Film Speed and Filters: The number given after each light source is based on a USA Standard and is for use with meters and cameras marked for "ASA" speeds.

Light Source	Speed	With Filter such as:
3200 K Lamps	160	None
Photoflood Lamps	125	81A
Daylight	100	85B

Note: Exposure times longer than 1/10 second may require an increase in exposure to compensate for the reciprocity characteristics of this film. See introduction to this section.

Reflector-Type Lamp Exposure Table: Based on the use of the types of lamp listed below. In the case of 3200 K lamps, some increase in exposure may be required after about 10 hours of burning: with Photoflood types, ½ stop increase is required after 1 hour, and 1 full stop increase is needed after 2 hours of use.

	Lens Opening at 1/50 or 1/60 Second		f/5.6	f/4	f/2.8	f/2
Lamp-to-Subject Distance in feet	EAL Lamps (GE)	Main Light	5½	8	11	16
		Fill-in Light	8	11	16	22
	R-32 Lamps (Sylvania)	Main Light	6½	10	13½	20
		Fill-in Light	10	13½	20	28

Flash Exposure Guide Numbers: To get f/number, divide guide number by flash-to-subject distance in feet, taken to a point midway between nearest and farthest details of interest. In small white rooms, use one stop smaller. *With Filter No. 81C.*

Synchronization: X or F			M			Focal-Plane	6§
Shutter Speed	AG-1†	M3†, M5‡ 5§, 25§	11‖ 40‖	M2‡		Shutter Speed	26§
Open 1/25	190	280	290	200		1/50	215
1/50	—	250	270	—		1/100	145
1/100	—	215	240	—		1/250	105
1/200	—	170	180	—		1/500	75
1/400	—	125	135	—			

Bowl-Shaped Polished Reflector Sizes: †2-inch; ‡3-inch, §4 to 5-inch; ‖6 to 7 inch. If shallow cylindrical reflectors are used, divide these guide numbers by two.
Note: At 1/25 second, cameras having X or F synchronization can use any of the flashbulbs listed under M synchronization.
Caution: Since bulbs may shatter when flashed, the use of a flashguard over the reflector is recommended. *Do not flash bulbs in an explosive atmosphere.*

Electronic Flash Guide Numbers: This table is intended as a starting point in determining the correct guide number. The table is for use with equipment rated in beam candlepower-seconds (BCPS) or effective candlepower-seconds (ECPS). Divide the appropriate guide number by the flash-to-subject distance in feet to determine the f/number for average subjects. *Use Filter No. 85B.*

Output of Unit (BCPS or ECPS)	350	500	700	1000	1400	2000	2800	4000	5600	8000
Guide Number For Trial	40	50	60	70	85	100	120	140	170	200

Processing: Processed by Kodak and other laboratories on orders placed through dealers. Some laboratories, including Kodak, also provide direct mail service; purchase special mailing device from your dealer. This film may also be processed by the user, with Kodak Ektachrome Chemicals, Process E-6.

KODAK EKTACHROME-400 FILM

Type of Film: Color transparency film for daylight.

Film Speed and Filters: The number given after each light source is based on a USA Standard and is for use with meters and cameras marked for "ASA" speeds.

Light Source	Speed	With Filter such as:
Daylight	400	None
3200 K Lamps	100	80A
Photoflood Lamps	125	80B

Note: Exposure times 1/10 second or longer may require an increase in exposure to compensate for the reciprocity characteristics of this film. See introduction to this section.

Daylight Exposure Table: Lens openings with shutter at 1/400—1/500 sec.

Bright or Hazy Sun on Light Sand or Snow	Bright or Hazy Sun (Distinct Shadows)†	Cloudy Bright (No Shadows)	Heavy Overcast	Open Shade*
f/16	f/11	f/8	f/5.6	f/5.6

*Subject shaded from sun but lighted by a large area of clear, unobstructed sky.
†For backlighted closeup subjects, use 2 stops larger.

Fill-in Flash: Blue flashbulbs are helpful in lightening the harsh shadows usually found in making close-ups in bright sunlight. A typical exposure is 1/250 sec. at f/22 with the subject 8 to 10 feet away. See introduction to this section, also.

Flash Exposure Guide Numbers: Use *blue flashbulbs* without a filter. With zirconium-filled clear flashbulbs (AG-1, M3 and M5), use a Kodak No. 80D Filter over camera lens. With all other clear flashbulbs, use a No. 80C Filter. Divide guide number by flash-to-subject distance in feet to determine the f/number for average subjects.

Synchronization: X or F		M				Focal-plane	6B§
Shutter Speed	M2B‡	Flash Cube	AG-1B†	AG-3B†	M3B§, M5B§ 5B§, 25B§	Shutter Speed	26B§
Open. 1/25	220	200	220	—	400	1/50	410
1/50	—	145	180	—	360	1/100	200
1/100	—	115	160	—	310	1/250	140
1/200	—	90	125	—	250	1/500	—
1/400	—	—	—	—	—	—	—

Bowl shaped polished reflector sizes: †2-inch; ‡3-inch; §4 to 5-inch. If shallow cylindrical reflectors are used, divide these guide numbers by 2.
Caution: Since bulbs may shatter when flashed, the use of a flashguard over the reflector is recommended. *Do not flash bulbs in an explosive atmosphere.*

Electronic Flash Guide Numbers: This table is intended as a starting point in determining the correct guide number. It is for use with equipment rated in beam candlepower-seconds (BCPS) or effective candlepower-seconds (ECPS). Divide the appropriate guide number by the flash-to-subject distance in feet to determine the f/number for average subjects.

Output of Unit (BCPS or ECPS)	350	500	700	1000	1400	2000	2800	4000	5600	8000
Guide Number For Trial	90	110	125	160	180	220	250	320	360	440

Processing: Kodak Ektachrome-400 Film is processed by commercial laboratories or by Kodak, either through dealers or directly, with the appropriate mailing device. It may be processed by the user, with the Kodak Ektachrome Chemicals, Process E-6. Ektachrome-400 can be push-processed to ASA 800 by increasing the time in the first developer by two minutes. Push-processing is also available from Kodak by the use of the Kodak ESP-1 Mailer.

KODAK EKTACHROME INFRARED FILM

Type of Film: Modified-color ("false-color") reversal film.

Film Speed and Filters: The number given after each light source is based on a USA Standard and is for use with meters and cameras marked for "ASA" speeds.

Light Source	Speed	With Filter such as:
Daylight	100	Wratten No. 12
Photoflood (3400 K)	50	Wratten No. 12 plus Kodak CC-20C plus Corning C.S. 1-59 (2.5mm)
Tungsten (3200 K)	—	—

Note: Exposure times 1/10 second or longer may require an increase in exposure to compensate for the reciprocity characteristics of this film. See introduction to this section.

Daylight Exposure Table: Lens openings with shutter at 1/100–1/125 sec. with Wratten No. 12 filter.

Bright or Hazy Sun on Light Sand or Snow	Bright or Hazy Sun (Distinct Shadows)†	Cloudy Bright (No Shadows)	Heavy Overcast	Open Shade*
f/22	f/16	f/5.6	f/4	f/4

*Subject shaded from sun but lighted by a large area of clear, unobstructed sky.
†For backlighted closeup subjects, use 2 stops larger.

Flash Exposure Guide Numbers: Use *blue flashbulbs* without a filter. With zirconium-filled clear flashbulbs (AG-1, M3 and M5), use a Kodak No. 80D Filter over camera lens. With all other clear flashbulbs, use a No. 80C Filter. Divide guide number by flash-to-subject distance in feet to determine the f/number for average subjects.

Synchronization: X or F		M				Focal-plane	6B§
Shutter Speed	M2B‡	Flash Cube	AG-1B†	AG-3B†	M3B‡, M5B‡ 5B§, 25B§	Shutter Speed	26B§
Open. 1/25						1/50	—
1/50						1/100	—
1/100		NOT RECOMMENDED				1/250	—
1/200						1/500	—
1/400							

Bowl shaped polished reflector sizes: †2-inch; ‡3-inch; §4 to 5-inch. If shallow cylindrical reflectors are used, divide these guide numbers by 2.

Caution: Since bulbs may shatter when flashed, the use of a flashguard over the reflector is recommended. *Do not flash bulbs in an explosive atmosphere.*

Electronic Flash Guide Numbers: This table is intended as a starting point in determining the correct guide number. It is for use with equipment rated in beam candlepower-seconds (BCPS) or effective candlepower-seconds (ECPS). Divide the appropriate guide number by the flash-to-subject distance in feet to determine the f/number for average subjects. (with Kodak Wratten filter No. 12)

Output of Unit (BCPS or ECPS)	350	500	700	1000	1400	2000	2800	4000	5600	8000
Guide Number For Trial	45	55	65	80	90	110	130	160	180	220

Processing: Kodak Ektachrome Process E-4 is recommended for manual processing; Process ME-4 for machine processing. No darkroom illumination of any kind can be used; infrared inspection devices cannot be used. Eastman Kodak Company does not offer processing service for this film.

KODACHROME-25 FILM (126, 135 ROLLS)

Type of Film: Color transparency film for daylight.

Film Speed and Filters: The number given after each light source is based on a USA Standard and is for use with meters and cameras marked for "ASA" speeds.

Light Source	Speed	With Filter such as:
Daylight	25	None
Photoflood Lamps	8	80B
3200 K Lamps	6	80A

Note: Exposure times 1/10 second or longer may require an increase in exposure to compensate for the reciprocity characteristics of this film. See introduction to this section.

Daylight Exposure Table: Lens openings with shutter at 1/50 or 1/60 sec.

Bright or Hazy Sun on Light Sand or Snow	Bright or Hazy Sun (Distinct Shadows)†	Cloudy Bright (No Shadows)	Heavy Overcast	Open Shade*
f/16	f/11	f/5.6	f/4	f/4

*Subject shaded from sun but lighted by a large area of clear, unobstructed sky.
†For backlighted closeup subjects, use 2 stops larger.

Fill-in Flash: Blue flashbulbs are helpful in lightening the harsh shadows usually found in making close-ups in bright sunlight. A typical exposure is 1/50 sec. at f/16 with the subject 8 to 10 feet away. See introduction to this section, also.

Flash Exposure Guide Numbers: Use *blue flashbulbs* without a filter. With zirconium-filled clear flashbulbs (AG-1, M3 and M5), use a Kodak No. 80D Filter over camera lens. With all other clear flashbulbs, use a No. 80C Filter. Divide guide number by flash-to-subject distance in feet to determine the f/number for average subjects.

Synchronization: X or F			M			Focal-plane	
Shutter Speed	M2B‡	Flash Cube	AG-1B†	AG-3B†	M3B§, M5B§ 5B§, 25B§	Shutter Speed	6B§ 26B§
Open. 1/25	65	36	50	60	100	1/50	70
1/50	—	36	50	60	90	1/100	50
1/100	—	28	45	50	70	1/250	34
1/200	—	22	36	40	60	1/500	24
1/400	—	20	28	30	45		

Bowl shaped polished reflector sizes: †2-inch; ‡3-inch; §4 to 5-inch. If shallow cylindrical reflectors are used, divide these guide numbers by 2.
Caution: Since bulbs may shatter when flashed, the use of a flashguard over the reflector is recommended. *Do not flash bulbs in an explosive atmosphere.*

Electronic Flash Guide Numbers: This table is intended as a starting point in determining the correct guide number. It is for use with equipment rated in beam candlepower-seconds (BCPS) or effective candlepower-seconds (ECPS). Divide the appropriate guide number by the flash-to-subject distance in feet to determine the f/number for average subjects.

Output of Unit (BCPS or ECPS)	350	500	700	1000	1400	2000	2800	4000	5600	8000
Guide Number For Trial	20	24	30	35	40	50	60	70	85	100

Processing: Your dealer can arrange to have this film processed by Kodak or any other laboratory offering this service. Some laboratories, including Kodak, also provide direct mail service whereby you can mail exposed film to the laboratory and have it returned directly to you. See your dealer for the special mailing devices required. *Do not mail film without an overwrap or special mailing device intended for this purpose.*

KODACHROME-40 FILM, TYPE A

Type of Film: Color transparency film for Photoflood illumination.

Film Speed and Filters: The number given after each light source is based on a USA Standard and is for use with meters and cameras marked for "ASA" speeds.

Light Source	Speed	With Filter such as:
Photoflood Lamps	40	None
3200 K Lamps	32	82A
Daylight	25	85. Use exposure table for Kodachrome II film

Note: Exposure times longer than 1/10 second may require an increase in exposure to compensate for the reciprocity characteristics of this film. See introduction to this section.

Reflector-Type Lamp Exposure Table: Based on the use of the types of lamp listed below. In the case of 3200 K lamps, some increase in exposure may be required after about 10 hours of burning: with Photoflood types, ½ stop increase is required after 1 hour, and 1 full stop increase is needed after 2 hours of use.

Lens Opening at 1/50 or 1/60 second	f/4	f/2.8	f/2
Lamp-to-subject Distance Reflector Photoflood Lamps	4½	6	9

Flash Exposure Guide Numbers: To get f/number, divide guide number by flash-to-subject distance in feet, taken to a point midway between nearest and farthest details of interest. In small white rooms, use one stop smaller. *Use filter No. 81C.*

Synchronization: X or F		M			Focal-Plane	6§
Shutter Speed	AG-1†	M3†, M5‡ 5§, 25§	11‖ 40‖	M2‡	Shutter Speed	26§
Open. 1/25	95	140	150	100	1/50	105
1/50	—	130	130	—	1/100	80
1/100	—	120	120	—	1/250	55
1/200	—	90	90	—	1/500	38
1/400	—	70	70	—		

Bowl-Shaped Polished Reflector Sizes: †2-inch; ‡3-inch; §4 to 5-inch; ‖6 to 7 inch. If shallow cylindrical reflectors are used, divide these guide numbers by two.

Note: At 1/25 second, cameras having X or F synchronization can use any of the flashbulbs listed under M synchronization.

Caution: Since bulbs may shatter when flashed, the use of a flashguard over the reflector is recommended. *Do not flash bulbs in an explosive atmosphere.*

Electronic Flash Guide Numbers: This table is intended as a starting point in determining the correct guide number. The table is for use with equipment rated in beam candlepower-seconds (BCPS) or effective candlepower-seconds (ECPS). Divide the appropriate guide number by the flash-to-subject distance in feet to determine the f/number for average subjects.

Output of Unit (BCPS or ECPS)	350	500	700	1000	1400	2000	2800	4000	5600	8000
Guide Number For Trial					NOT RECOMMENDED					

Processing: Your dealer can arrange to have this film processed by Kodak or any other laboratory offering such service. Some laboratories, including Kodak, also provide direct mail service whereby you can mail exposed film to the laboratory and have it returned directly to you. See your dealer for the special mailing devices required. *Do not mail film without an overwrap or special mailing device intended for this purpose.*

KODACHROME-64 FILM (110, 126, & 135 ROLLS)

Type of Film: Color transparency film for daylight.

Film Speed and Filters: The number given after each light source is based on a USA Standard and is for use with meters and cameras marked for "ASA" speeds.

Light Source	Speed	With Filter such as:
Daylight	64	None
Photoflood Lamps	20	80B
3200 K Lamps	16	80A

Note: Exposure times 1/10 second or longer may require an increase in exposure to compensate for the reciprocity characteristics of this film. See introduction to this section.

Daylight Exposure Table: Lens openings with shutter at 1/100 or 1/125 sec.

Bright or Hazy Sun on Light Sand or Snow	Bright or Hazy Sun (Distinct Shadows)†	Cloudy Bright (No Shadows)	Heavy Overcast	Open Shade*
f/16	f/11	f/5.6	f/4	f/4

*Subject shaded from sun but lighted by a large area of clear, unobstructed sky.
†For backlighted closeup subjects, use 2 stops larger.

Fill-in Flash: Blue flashbulbs are helpful in lightening the harsh shadows usually found in making close-ups in bright sunlight. A typical exposure is 1/25 sec. at $f/22$ with the subject 8 to 10 feet away. See introduction to this section, also.

Flash Exposure Guide Numbers: Use *blue flashbulbs* without a filter. With zirconium-filled clear flashbulbs (AG-1, M3 and M5), use a Kodak No. 80D Filter over camera lens. With all other clear flashbulbs, use a No. 80C Filter. Divide guide number by flash-to-subject distance in feet to determine the $f/$number for average subjects.

Synchronization: X or F			M				Focal-plane	6B§
Shutter Speed	M2B‡	Flash Cube	AG-1B†	AG-3B†	M3B‡,M5B‡ 5B§,25B§		Shutter Speed	26B§
Open. 1/25	105	55	80	100	150		1/50	110
1/50	—	55	80	100	140		1/100	80
1/100	—	45	70	80	120		1/250	55
1/200	—	36	55	65	95		1/500	38
1/400	—	28	45	50	70			

Bowl shaped polished reflector sizes: †2-inch; ‡3-inch; §4 to 5-inch. If shallow cylindrical reflectors are used, divide these guide numbers by 2.
Caution: Since bulbs may shatter when flashed, the use of a flashguard over the reflector is recommended. *Do not flash bulbs in an explosive atmosphere.*

Electronic Flash Guide Numbers: This table is intended as a starting point in determining the correct guide number. It is for use with equipment rated in beam candlepower-seconds (BCPS) or effective candlepower-seconds (ECPS). Divide the appropriate guide number by the flash-to-subject distance in feet to determine the $f/$number for average subjects.

Output of Unit (BCPS or ECPS)	350	500	700	1000	1400	2000	2800	4000	5600	8000
Guide Number For Trial	32	40	45	55	65	80	95	110	130	160

Processing: Your dealer can arrange to have this film processed by Kodak or any other laboratory offering such service. Some laboratories, including Kodak, also provide direct mail service whereby you can mail exposed film to the laboratory, and have it returned directly to you. See your dealer for the special mailing devices required. *Do not mail film without an overwrap or special mailing device intended for this purpose.*

KODACOLOR II ROLL FILM, Improved Type (110, 120, 126, 127, 135, 616, 620 and 828)

Type of Film: Color negative film for daylight.

Film Speed and Filters: The number given after each light source is based on a USA Standard and is for use with meters and cameras marked for "ASA" speeds.

Light Source	Speed	With Filter such as:
Daylight	100	NONE
Photoflood (3400 K)	32	80 B
Tungsten (3200 K)	25	80 A

Daylight Exposure Table: Lens openings with shutter at 1/100–1/125 sec.

Bright or Hazy Sun on Light Sand or Snow	Bright or Hazy Sun (Distinct Shadows)†	Cloudy Bright (No Shadows)	Heavy Overcast	Open Shade*
f/16	f/11	f/5.6	f/4	f/4

*Subject shaded from sun but lighted by a large area of clear, unobstructed sky.
†For backlighted closeup subjects, use 2 stops larger.

Fill-in Flash: Blue flashbulbs are helpful in lightening the harsh shadows usually found in making close-ups in bright sunlight. A typical exposure is 1/25 sec. at f/22 with the subject 8 to 10 feet away. See introduction to this section, also.

Flash Exposure Guide Numbers: Use *blue flashbulbs* without a filter. With zirconium-filled clear flashbulbs (AG-1, M3 and M5), use a Kodak No. 80D Filter over camera lens. With all other clear flashbulbs, use a No. 80C Filter. Divide guide number by flash-to-subject distance in feet to determine the f/number for average subjects.

Synchronization: X or F			M			Focal-plane	6B§
Shutter Speed	M2B‡	Flash Cube	AG-1B†	AG-3B†	M3B‡, M5B‡ 5B§, 25B§	Shutter Speed	26B§
Open 1/25	120	60	90	110	180	1/50	130
1/50	—	60	90	110	160	1/100	90
1/100	—	50	75	90	130	1/250	60
1/200	—	40	65	75	105	1/500	45
1/400	—	32	50	55	80	—	—

Bowl shaped polished reflector sizes: †2-inch; ‡3-inch; §4 to 5-inch. If shallow cylindrical reflectors are used, divide these guide numbers by 2.

Electronic Flash Guide Numbers: This table is intended as a starting point in determining the correct guide number. It is for use with equipment rated in beam candlepower-seconds (BCPS) or effective candlepower-seconds (ECPS). Divide the appropriate guide number by the flash-to-subject distance in feet to determine the f/number for average subjects.

Output of Unit (BCPS or ECPS)	350	500	700	1000	1400	2000	2800	4000	5600	8000
Guide Number For Trial	35	45	55	65	75	90	110	130	150	180

Processing: Kodacolor-II film is developed by Kodak and other laboratories, on orders placed through photo dealers. Some laboratories, including Kodak, also provide direct mail service; see your dealer for the special mailing devices required. *Do not mail film without an overwrap or special mailing device intended for this purpose.* All the chemicals required for preparing a complete set of processing solutions are available in prepared form in the Kodak Flexicolor Processing Kit.

KODACOLOR-400 FILM

Type of Film: Color negative film for daylight.

Film Speed and Filters: The number given after each light source is based on a USA Standard and is for use with meters and cameras marked for "ASA" speeds.

Light Source	Speed	With Filter such as:
Daylight	400	None
Photoflood (3400 K)	125	80 B
Tungsten (3200 K)	100	80 A

Note: Exposure times 1/10 second or longer may require an increase in exposure to compensate for the reciprocity characteristics of this film. See introduction to this section.

Daylight Exposure Table: Lens openings with shutter at 1/400–1/500 sec.

Bright or Hazy Sun on Light Sand or Snow	Bright or Hazy Sun (Distinct Shadows)†	Cloudy Bright (No Shadows)	Heavy Overcast	Open Shade*
f/22	f/16	f/8	f/5.6	f/5.6

*Subject shaded from sun but lighted by a large area of clear, unobstructed sky.
†For backlighted closeup subjects, use 2 stops larger.

Fill-in Flash: Blue flashbulbs are helpful in lightening the harsh shadows usually found in making close-ups in bright sunlight. A typical exposure is 1/25 sec. at f/32 with the subject 8 to 10 feet away. See introduction to this section, also.

Flash Exposure Guide Numbers: To get f-number, divide guide number by flash-to-subject distance in feet, taken to a point midway between nearest and farthest details of interest. In small white rooms, use one stop smaller.

Synchronization		M			Focal-Plane	6B§
Shutter Speed	Flash Cube	M3B‡, M5B‡ 5B§, 25B§	AG-1B†	AG-3B†	Shutter Speed	26B§
Open. 1/25	140	400	200	250	1/50	240
1/50	130	350	200	250	1/100	140
1/100	110	290	170	200	1/250	135
1/200	90	240	140	160	1/500	100
1/400	75	170	110	120		

Bowl-Shaped Polished Reflector Sizes: †2-inch; ‡3-inch; §4- to 5-inch; ||6- to 7-inch. If shallow cylindrical reflectors are used, divide these guide numbers by two.
Note: At 1/25 second, cameras having X or F synchronization can use any of the flashbulbs listed under M synchronization.

Caution: Since bulbs may shatter when flashed, the use of a flashguard over the reflector is recommended. *Do not flash bulbs in an explosive atmosphere.*

Electronic Flash Guide Numbers: This table is intended as a starting point in determining the correct guide number. The table is for use with equipment rated in beam candlepower-seconds (BCPS) or effective candlepower-seconds (ECPS). Divide the appropriate guide number by the flash-to-subject distance in feet to determine the f-number for average subjects.

Output of Unit (BCPS or ECPS)	350	500	700	1000	1400	2000	2800	4000	5600	8000
Guide Number for Trial	85	100	120	140	170	200	240	280	340	400

Processing: Kodacolor-400 Film is developed by Kodak and other laboratories on orders placed through photo dealers. Some laboratories, including Kodak, also provide direct mail service whereby you can mail exposed film to the laboratory and have it returned directly to you. See your dealer for the special mailing devices required. *Do not mail film without an overwrap or special mailing device intended for this purpose.* Kodak Flexicolor Chemicals for Process C-41, available in kit form (1-pint size) and as individual components in larger sizes, can be used to process this film.

KODAK VERICOLOR-II FILM TYPE L (Long Exposure)

Type of Film: Color negative film for 3200 K illumination.

Film Speed and Filters: The number given after each light source is based on a USA Standard and is for use with meters and cameras marked for "ASA" speeds.

The effective speed depends upon the illumination level and exposure time.

LIGHT SOURCE	KODAK FILTER NO.	EXPOSURE TIME	EFFECTIVE SPEED
3200 K Lamps	None	1/50 to 1/5	ASA 80
3200 K Lamps	None	1	ASA 64
3200 K Lamps	None	5	ASA 50
3200 K Lamps	CC10Y	30	ASA 32
3200 K Lamps	CC20Y	60	ASA 25
3400 K Lamps	81A	1	ASA 50
Daylight	85B	1/50	ASA 50

Caution: Do not expose Kodak Vericolor L film for times shorter than 1/10 sec. or longer than 60 seconds, because the resulting negatives may contain color-reproduction errors that cannot be corrected satisfactorily in the printing operation. For short exposures, use Kodak Vericolor S film.

Processing: Kodak Vericolor II Type L replaces both the former Vericolor L and Ektacolor L films. It may be processed manually, using the Kodak Flexicolor Chemicals (Process C-41). Various types of automatic processor may be used, including Kodak Versamat Processors Model 145, formerly used for Kodak Vericolor films. These latter machines must be modified with the Kodak Versamat C-41V Conversion Kit, Model 145; and are used with Process C-41V chemicals.

Formats Available: Sheet Films: Vericolor II Professional Film 4108 Type L
Estar Thick Base.

Roll Films: Vericolor II Professional Film 6013 Type L
Acetate base VPL-120 in packs of 5 rolls.

To avoid large changes in the filter pack used later during color printing, it is desirable to bring all negatives to approximately the same balance. Therefore, negatives exposed by photoflood or daylight illumination should be brought close to the same balance as negative exposed with 3200 K lamps by use of the filters listed in the table above.

KODAK VERICOLOR-II FILM TYPE S AND VERICOLOR COMMERCIAL FILM

Type of Film: Color negative film for daylight.

Film Speed and Filters: The number given after each light source is based on a USA Standard and is for use with meters and cameras marked for "ASA" speeds.

Light Source	Speed	With Filter such as:
Daylight	100	None
Photoflood (3400 K)	32	80 B
Tungsten (3200 K)	25	80 A

Note: Exposure times 1/10 second or longer may require an increase in exposure to compensate for the reciprocity characteristics of this film. See introduction to this section.

Daylight Exposure Table: Lens openings with shutter at 1/100–1/125 sec.

Bright or Hazy Sun on Light Sand or Snow	Bright or Hazy Sun (Distinct Shadows)†	Cloudy Bright (No Shadows)	Heavy Overcast	Open Shade*
f/22	f/16	f/8	f/5.6	f/5.6

*Subject shaded from sun but lighted by a large area of clear, unobstructed sky.
†For backlighted closeup subjects, use 2 stops larger.

Fill-in Flash: Blue flashbulbs are helpful in lightening the harsh shadows usually found in making close-ups in bright sunlight. A typical exposure is 1/25 sec. at f/32 with the subject 8 to 10 feet away. See introduction to this section, also.

Flash Exposure Guide Numbers: Use *blue flashbulbs* without a filter. With zirconium-filled clear flashbulbs (AG-1, M3 and M5), use a Kodak No. 80D Filter over camera lens. With all other clear flashbulbs, use a No. 80C Filter. Divide guide number by flash-to-subject distance in feet to determine the f/number for average subjects.

Synchronization: X or F				M			Focal-plane	6B§
Shutter Speed	M2B‡	Flash Cube	AG-1B†	AG-3B†	M3B‡, M5B‡ 5B§, 25B§		Shutter Speed	26B§
Open 1/25	130	—	—	120	190		1/50	190
1/50	—	—	—	120	180		1/100	130
1/100	—	—	—	100	150		1/250	95
1/200	—	—	—	80	120		1/500	65
1/400	—	—	—	60	90			

Bowl shaped polished reflector sizes: †2-inch; ‡3-inch; §4 to 5-inch. If shallow cylindrical reflectors are used, divide these guide numbers by 2.
Caution: Since bulbs may shatter when flashed, the use of a flashguard over the reflector is recommended. *Do not flash bulbs in an explosive atmosphere.*

Electronic Flash Guide Numbers: This table is intended as a starting point in determining the correct guide number. It is for use with equipment rated in beam candlepower-seconds (BCPS) or effective candlepower-seconds (ECPS). Divide the appropriate guide number by the flash-to-subject distance in feet to determine the f/number for average subjects.

Output of Unit (BCPS or ECPS)	350	500	700	1000	1400	2000	2800	4000	5600	8000
Guide Number For Trial	40	50	60	70	85	100	120	140	170	200

Note: Kodak Vericolor Commercial Film, Type S, has a higher contrast than Kodak Vericolor-II film, and a speed of ASA 80 to daylight. Other data was not available when this edition went to press.

Processing: Kodak Vericolor-II film in roll film sizes only is processed and printed by Kodak; processing is also available from commercial laboratories, and can be accomplished by the user in Kodak Flexichrome chemicals, Process C-41.

KODAK VERICOLOR ID/COPY FILM

Type of Film: Color negative film, balanced for electronic flash exposure.

Film Speed and Filters: The number given after each light source is based on a USA Standard and is for use with meters and cameras marked for "ASA" speeds.

Light Source	Speed	With Filter such as:
Daylight	80	None
Photoflood (3400 K)	25	80 B
Tungsten (3200 K)	16	80 A

Note: Exposure times 1/10 second or longer may require an increase in exposure to compensate for the reciprocity characteristics of this film. See introduction to this section.

Daylight Exposure Table: Lens openings with shutter at 1/100–1/125 sec.

Bright or Hazy Sun on Light Sand or Snow	Bright or Hazy Sun (Distinct Shadows)†	Cloudy Bright (No Shadows)	Heavy Overcast	Open Shade*
f/16	f/11	f/5.6	f/4	f/4

*Subject shaded from sun but lighted by a large area of clear, unobstructed sky.
†For backlighted closeup subjects, use 2 stops larger.

Fill-in Flash: Blue flashbulbs are helpful in lightening the harsh shadows usually found in making close-ups in bright sunlight. A typical exposure is 1/25 sec. at f/22 with the subject 8 to 10 feet away. See introduction to this section, also.

Flash Exposure Guide Numbers: Use *blue flashbulbs* without a filter. With zirconium-filled clear flashbulbs (AG-1, M3 and M5), use a Kodak No. 80D Filter over camera lens. With all other clear flashbulbs, use a No. 80C Filter. Divide guide number by flash-to-subject distance in feet to determine the f/number for average subjects.

Synchronization: X or F			M			Focal-plane	6B§
Shutter Speed	M2B‡	Flash Cube	AG-1B†	AG-3B†	M3B‡, M5B‡ 5B§, 25B§	Shutter Speed	26B§
Open 1/25	120	60	90	110	180	1/50	130
1/50	—	60	90	110	160	1/100	90
1/100	—	50	75	90	130	1/250	60
1/200	—	40	65	75	105	1/500	45
1/400	—	32	50	55	80		

Bowl shaped polished reflector sizes: †2-inch; ‡3-inch; §4 to 5-inch. If shallow cylindrical reflectors are used, divide these guide numbers by 2.

Caution: Since bulbs may shatter when flashed, the use of a flashguard over the reflector is recommended. *Do not flash bulbs in an explosive atmosphere.*

Electronic Flash Guide Numbers: This table is intended as a starting point in determining the correct guide number. It is for use with equipment rated in beam candlepower-seconds (BCPS) or effective candlepower-seconds (ECPS). Divide the appropriate guide number by the flash-to-subject distance in feet to determine the f/number for average subjects.

Output of Unit (BCPS or ECPS)	350	500	700	1000	1400	2000	2800	4000	5600	8000
Guide Number For Trial	35	45	55	65	75	90	110	130	150	180

Processing: Use Kodak Flexicolor Chemicals for Process C-41.

KODAK PHOTOMICROGRAPHY COLOR FILM 2483 (ESTAR BASE)
35MM AND SHEET FILM

Type of Film: Color reversal film for daylight.

Film Speed and Filters: The number given after each light source is based on a USA Standard and is for use with meters and cameras marked for "ASA" speeds.

Light Source	Speed	With Filter such as:
Daylight	16	None
Photoflood (3400 K)	5	80 B
Tungsten (3200 K)	4	80 A

Note: Exposure times 1/10 second or longer may require an increase in exposure to compensate for the reciprocity characteristics of this film. See introduction to this section.

Daylight Exposure Table: Lens openings with shutter at 1/100–1/125 sec.

Bright or Hazy Sun on Light Sand or Snow	Bright or Hazy Sun (Distinct Shadows)†	Cloudy Bright (No Shadows)	Heavy Overcast	Open Shade*
f/8	f/5.6	f/4	f/2.8	f/2.8

*Subject shaded from sun but lighted by a large area of clear, unobstructed sky.
†For backlighted closeup subjects, use 2 stops larger.

Fill-in Flash: Blue flashbulbs are helpful in lightening the harsh shadows usually found in making close-ups in bright sunlight. A typical exposure is 1/25 sec. at f/11 with the subject 8 to 10 feet away.

Flash Exposure Guide Numbers: Use *blue flashbulbs* without a filter. With zirconium-filled clear flashbulbs (AG-1, M3 and M5), use a Kodak No. 80D Filter over camera lens. With all other clear flashbulbs, use a No. 80C Filter. Divide guide number by flash-to-subject distance in feet to determine the f/number for average subjects.

Synchronization: X or F			M			Focal-plane	6B§ 26B§
Shutter Speed	M2B‡	Flash Cube	AG-1B†	AG-3B†	M3B‡, M5B‡ 5B§, 25B§	Shutter Speed	
Open 1/25	60	40	50	—	90	1/50	85
1/50	—	28	40	—	75	1/100	40
1/100	—	22	—	—	70	1/250	30
1/200	—	18	—	—	55	1/500	22
1/400	—	15	—	—	45	1/1000	15

Bowl shaped polished reflector sizes: †2-inch; ‡3-inch; §4 to 5-inch. If shallow cylindrical reflectors are used, divide these guide numbers by 2.
Caution: Since bulbs may shatter when flashed, the use of a flashguard over the reflector is recommended. *Do not flash bulbs in an explosive atmosphere.*

Electronic Flash Guide Numbers: This table is intended as a starting point in determining the correct guide number. It is for use with equipment rated in beam candlepower-seconds (BCPS) or effective candlepower-seconds (ECPS). Divide the appropriate guide number by the flash-to-subject distance in feet to determine the f/number for average subjects.

Output of Unit (BCPS or ECPS)	350	500	700	1000	1400	2000	2800	4000	5600	8000
Guide Number For Trial	17	20	24	28	32	40	50	55	65	80

Processing: Processed by Kodak and other laboratories on orders placed through dealers. Some laboratories, including Kodak, also provide direct mail service; purchase special mailing device from your dealer. This film can also be processed by the user; all chemicals for preparing a complete set of processing solutions are in the Kodak Ektachrome Film Processing Kit, Process E-4.

POLAROID POLACOLOR FILMS, TYPES 48, 58, 88, 108, AND 668

Type of Film: One-minute color print film for daylight and blue flash.

Film Speed and Filters: The number given after each light source is based on a USA Standard and is for use with meters and cameras marked for "ASA" speeds.

Light Source	Speed	With Filter such as:
Daylight	80	None
Photoflood and 3200 K Lamps	12	80B & CC 20B
150-watt reflector flood	—	80B & CC 40B (use 1 sec. at f/16)

Note: Exposure times 1/10 second or longer may require an increase in exposure to compensate for the reciprocity characteristics of this film. See introduction to this section.

Daylight Exposure Table: Lens openings with shutter at 1/125 sec.

Bright or Hazy Sun on Light Sand or Snow	Bright or Hazy Sun (Distinct Shadows)†	Cloudy Bright (No Shadows)	Heavy Overcast	Open Shade*
f/16	f/11	f/5.6	f/4	f/4

*Subject shaded from sun but lighted by a large area of clear, unobstructed sky.
†For backlighted closeup subjects, use 2 stops larger.

Fill-in Flash: Blue flashbulbs are helpful in lightening the harsh shadows usually found in making close-ups in bright sunlight. A typical exposure is 1/50 sec. at f/16 with the subject 8 to 10 feet away. See introduction to this section, also.

Flash Exposure Guide Numbers: Use *blue flashbulbs* without a filter. With zirconium-filled clear flashbulbs (AG-1, M3 and M5), use a Kodak No. 80D Filter over camera lens. With all other clear flashbulbs, use a No. 80C Filter. Divide guide number by flash-to-subject distance in feet to determine the f/number for average subjects.

Synchronization: X or F		M				Focal-plane	6B§
Shutter Speed	M2B‡	Flash Cube	AG-1B†	AG-3B†	M3B‡,M5B‡ 5B§,25B§	Shutter Speed	26B§
Open. 1/25	105	55	80	100	150	1/50	110
1/50	—	55	80	100	130	1/100	80
1/100	—	45	70	80	120	1/250	55
1/200	—	36	55	65	100	1/500	38
1/400	—	28	45	50	—		

Bowl shaped polished reflector sizes: †2-inch; ‡3-inch; §4 to 5-inch. If shallow cylindrical reflectors are used, divide these guide numbers by 2.
Caution: Since bulbs may shatter when flashed, the use of a flashguard over the reflector is recommended. *Do not flash bulbs in an explosive atmosphere.*

Electronic Flash Guide Numbers: This table is intended as a starting point in determining the correct guide number. It is for use with equipment rated in beam candlepower-seconds (BCPS) or effective candlepower-seconds (ECPS). Divide the appropriate guide number by the flash-to-subject distance in feet to determine the f/number for average subjects.

Output of Unit (BCPS or ECPS)	350	500	700	1000	1400	2000	2800	4000	5600	8000
Guide Number For Trial	32	40	45	55	65	80	95	110	130	160

Processing: Normal development time is 60 sec. at 75 F or above. At 70 F, development should be extended to 70 sec., and at 65 F, to 90 sec. Do not process pictures at temperatures below 65 F. After processing, allow the surface to harden for several minutes before mounting the print on one of the mounts supplied with the film. *Polacolor prints do not require coating.*

This page is being reserved
for future expansion.

INTRODUCTION TO PAPERS AND PRINTING

Photographic papers for black-and-white prints are available in great variety. They fall into a number of basic types and classes, depending upon speed, contrast, and image color. These classes are further subdivided according to the type of paper base they are coated on; paper bases vary according to weight, color, surface sheen or lustre, and texture.

The speed of the paper emulsion depends upon its intended use and is controlled, mainly, by the chemical nature of the emulsion itself. Slow papers intended for contact printing are usually coated with a silver chloride emulsion; faster enlarging papers use a mixed emulsion of silver bromide and silver chloride. Of course, it is possible to make fast silver chloride papers with sufficient sensitivity for use in projection printers; such papers are used mainly in photofinishing. Slow chlorobromide papers are likewise available and are intended mainly for use in portrait printing, where the same paper is often used for both contact prints and enlargements; the main reason for this procedure is to maintain uniformity of image tone and color.

Very fast enlarging papers were at one time made with a pure silver bromide emulsion. These papers have disappeared from the market because they tended to produce inferior blacks. Today's chlorobromides have ample speed for any normal type of projection printing equipment. Product names containing "bromide" or "brom," such as Kodabromide or Ilfobrom, do *not* imply that these papers are straight bromide emulsions.

The type of emulsion coating also influences the color of the image. Normally, slow chloride emulsions are very warm in tone, tending in some cases to definite browns. Chlorobromides vary in tone in accordance with the halide that predominates; those containing mostly silver chloride are warm toned, whereas the faster emulsions with a higher bromide content are colder in color. Since bromide emulsions are faster than chloride, there would appear to be a correlation between speed and image color, and in fact, the warmer toned papers are usually slower than the colder toned papers. However, the converse is not necessarily true, since there are other ways of controlling image color, such as the inclusion of tone modifiers in the emulsion or the use of different developers. Thus, the slow Kodak Velox paper has a very cold blue-black tone. The fast Kodabromide paper, which normally has a neutral black image, can be developed to definitely warm tones by the proper choice of developer.

The term *contrast* when applied to papers has a different meaning from that which it has when applied to negative materials. It does *not* refer to the

121

density scale of the image: papers develop to maximum black in a very short time, and the blackest tone in the image is always the maximum black of which the paper is capable. Likewise, the highest white is usually barely darker than the paper base. The maximum black does vary a small amount depending upon the surface texture and the sheen of the paper coating, but it is not controllable to any useful degree.

Thus, the term *contrast* in the case of papers is a misnomer; it refers not to the density range of the final image, but to the *exposure scale* required to produce a maximum range of tones in a given paper.

Looking at it in another way, the term *contrast* refers not to the paper but to the negative which is intended to be printed on it. Since the entire scale of the paper must be used to secure a good print, one may say that, in effect, papers have no latitude at all. Actually, some small latitude is available, otherwise printing would be an impossible task. However, this latitude is much less than is available in the exposure of a negative; thus it is necessary either to fit the negative meticulously to the scale range of the existing paper or to provide papers with various ranges to fit a variety of negatives. Both methods are actually used.

Portrait photographers working under studio conditions are usually able to control their lighting contrast and negative development to produce quite consistent negative contrast. Hence, most portrait papers are made in a single contrast scale, or at most in two.

On the other hand, since amateur photographers and news cameramen must often work under unpredictable and uncontrollable conditions, their negatives will vary widely. Papers made for these workers may have as many as six different "contrast" grades for printing negatives of as many different scales.

Naturally, the need for a variety of different papers led to a demand for ways in which the contrast of a single paper could be controlled. Many formulas for "variable contrast" paper developers were proposed, most of them based on the false analogy between "contrast" in a negative and "contrast" in a print. One or two chlorobromide papers were slightly susceptible to such a variation in developer formula, and these special developers were published with a good deal of fanfare. In all cases, however, the total available control was less than the difference between two adjacent grades of normal papers, and in some cases, the developer did not produce any useful variation in contrast at all.

However, there are papers having variable contrast ranges from soft to very hard in a single sheet; this is accomplished by coating the papers with a mixed emulsion. One batch of emulsion is made to be of very high contrast and is sensitive only to blue light. The second batch of emulsion is made to be of very low contrast and is dye-sensitized to green light. The two emulsions are mixed and coated as a single layer. If the resulting paper is exposed to white light, it will have a "normal" or average contrast, somewhere between the ranges of the two emulsions used. However, by exposing it through a blue filter, the print is made entirely with the high-contrast emulsion, and the result is the same as if a contrasty paper had been used. On the other hand, exposing it through a yellow filter* limits the print to the soft, green-sensitive emulsion, and the result is the same as if a soft paper had been used. Intermediate degrees of contrast may be secured, either by exposing partly through a blue filter and partly through a yellow one, or by the use of graded sets of filters with different proportions of blue and green transmission.

* Green filters are rather inefficient in terms of total light transmission. The yellow filter transmits green light freely; it also transmits red light, but since the paper is insensitive to red, this added transmission has no effect.

In passing, it should be noted that there is no reason other than custom to make the blue sensitive emulsion the high-contrast coating. It is just as easy to make the soft-working emulsion sensitive to blue and the contrasty one sensitive to green and in fact, the former Ilford Multigrade paper was made in that way.

There is another type of variable contrast emulsion which is mainly used by photofinishers—GAF Monodex and Kodak Velox Unicontrast. In these papers, the emulsion is a normal silver chloride coating, with a characteristic curve of unusual shape, having high contrast at its lower, or toe, end and lower contrast at the upper, or shoulder, end. Thus thin, flat negatives having little contrast, given a short exposure, use the high contrast end of the scale and produce a fairly satisfactory print. Dense, contrasty negatives having a very long scale are mainly exposed on the upper, or low-gradient, end of the curve and produce softer prints. Such papers produce a high proportion of satisfactory prints from run-of-the-mill snapshot negatives in photofinishing plants. However, the curve shape of the paper must necessarily distort the tonal rendition of the print; thus these papers are not used in other areas of photography.

Exposure Scale and Scale Index

So far we have not defined what a "normal" negative is or what the scale of the paper required to match it should be. It is currently accepted that a negative having a 20:1 scale—that is, one in which the densest highlight transmits 1/20 of the light passed by the thinnest shadow—is a normal negative.

In the case of graded papers, the different scales are designated by number, and usually, the #2 grade is considered "normal." Negatives having a greater tonal scale are considered "hard" or "contrasty," and papers of correspondingly longer exposure scale are provided to accommodate these. Such papers will be numbered #1 for somewhat contrastier negatives and #0 for very contrasty negatives. Likewise, where negative transmission range is shorter than normal, it is called a "soft" or "flat" negative, and papers of shorter exposure scale are required—these are numbered #3, #4, and #5 for soft, very soft, and extremely soft negatives respectively. For consistency, the filters for use with variable contrast papers such as Polycontrast, Varilour, and VeeCee are numbered the same way.

Usually, it is not necessary to measure the transmission of the negative at all in order to make satisfactory prints. The steps involved are fairly broad, and the average photographer, with a little practice, can judge the grade of paper required for a given negative by visual examination. Where measurements are made, they are usually not in terms of transmission, because that would involve dividing the maximum by the minimum transmission to get the range of a given negative. Instead, densities are used (density is the logarithm of the reciprocal of the transmission), and it is merely necessary to subtract the minimum density of the negative from the maximum to determine the range. To fit in with this system, the manufacturers list paper ranges in logarithmic terms to match the density scale of the negatives.

It is not necessary to know anything at all about logarithms to use these terms—it is simply a matter of subtraction, since the measuring instrument, a densitometer, is marked directly in density figures. Thus, a negative whose maximum density is 1.6 and whose minimum density is 0.3 will have a density scale of $1.6 - 0.3 = 1.3$, and one has only to refer to the manufacturer's listing to determine which paper grade is needed for a proper print from this negative.

In an attempt to secure uniform grading of papers among the various manufacturers, the United States of America Standards Institute has set up a standard, PH2.2-1953 establishing a series of grade numbers and the log-

arithmic exposure scale corresponding to each number. Since the term *logarithmic exposure scale* is inconveniently long and clumsy, the same standard establishes the term *Scale Index* for this value. It defines *Scale Index* as the logarithmic exposure scale rounded off to the first figure after the decimal point. Thus, a negative having a density range of 1.48 would have a Scale Index of 1.5.

Statistical examination of a great many sample prints has shown that the best print is secured when the Scale Index of the paper is greater than the total scale of the negative by about 0.2. This avoids blocking at either end of the print scale and also allows for a small amount of latitude in exposure and development of the print. The following table from Kodak gives the Scale Index values for their graded papers and the negative density ranges suited to each paper.

Paper Grade Number	Scale Index	Density Scale of Negative (suitable for each scale index or grade)
0	1.7	1.4 or higher
1	1.5	1.2 to 1.4
2	1.3	1.0 to 1.2
3	1.1	0.8 to 1.0
4	0.9	0.6 to 0.8
5	0.7	0.6 or lower

Papers of other manufacturers are graded in much the same way, and the #2 paper of one manufacturer is practically the same in terms of Scale Index as the #2 paper of another manufacturer.

In the data pages which follow, Scale Index values are given for each paper and grade. The source of these figures in all cases is the paper manufacturer. As has been pointed out previously, Scale Indexes for variable contrast papers are given in terms of filter numbers, and it will be seen that they parallel the values for graded papers rather closely.

Paper Speeds

Inasmuch as workable systems of film speeds have been in use for many years, one would imagine that by now an equally workable system of paper speeds would be in use. However, the problem of assigning a speed to printing papers is a much more difficult one for several reasons. For one thing, as mentioned above, the entire scale of the paper is used in making a print; there is little or no latitude. This alone would not prevent the establishment of a speed system, if all papers had the same exposure scale; it is the difference in Scale Index combined with the necessity for using the entire scale that makes it difficult to assign speeds to various papers. In any speed system, the choice of the exposure point, speed point, or point on the characteristic curve from which to measure is an important criterion. In the case of papers, more than one exposure point is used, depending upon whether we wish highlight or shadow to match. This factor, combined with varying exposure scales, produces a variety of different speeds for one and the same paper, depending entirely upon how it is used.

Assume, for example, that we have found an exposure time suitable for a given negative on a paper of wide scale, say a #1 paper with a Scale Index of 1.5. In this sample print, although the highlights are well rendered, the shadows are not black enough, so we wish to change to a #2 paper for a new print. Now, do we rate the paper speeds so that highlight rendition will be alike when the

two papers have the same speed and when the same exposure is given? In this case, the same exposure on the new paper will give a print with similar highlight rendition but deeper blacks in the shadows, and this is what we wanted. It would seem, then, that we ought to rate various papers for the exposure which will just produce a given minimum density in the highlights.

In practice, however, this system has been tried and has failed to give consistent results. Take the opposite case, where we are printing a negative on #2 paper, and have attained good shadow rendition, but the highlights are washed out. If we change to the #1 paper previously mentioned to have the same speed rating, and give the same exposure, we will get a new print with grayer shadows but the highlights will still be washed out. Evidently, if two papers are alike in highlight speed but are different in scale, then they do not have the same shadow speed.

Shadow Speed: Most printers instinctively adjust their exposures so as to secure full black in the shadows of the print; proper highlight gradation is then dependent upon the choice of paper grade. It would appear, then, that if the speed were measured by a system based on the exposure required to secure full black in the print, it would correlate with the way in which papers are actually used and thus produce consistently excellent prints. Unfortunately, this works no better than the highlight speed criterion; the error is simply in the opposite direction.

Printing Index: Perhaps, then, one should rate the speed of a paper by the middle-tone exposure, and this has a certain utility, in practice. Automatic printers used in photofinishing generally read the light transmitted by the negative as a whole; if the negative has average distribution of light and shadow, then the effect will be the same as if a middle-tone density were being measured. Such a method will work as long as average negatives are being printed, on paper of a single contrast grade, as is the case in photofinishing, and a very large proportion of good prints are produced by this system. For a time, the Eastman Kodak Company issued speed figures for their papers called "Printing Indexes;" these were based on the exposure required to produce a middle-tone density of 0.6. Middle-tone speeds are most useful when printing the same negative on different grades of paper, inasmuch as they avoid the problems described above.

ANSI Paper Speeds: In 1966, a new system of assigning paper speeds was issued by the American National Standards Institute; known as the *ANSI Standard: Sensitometry of Photographic Papers, PH2.2-1966,* it provides a usable single-number paper speed which hopefully will be adopted by all manufacturers of photographic papers, at least in the United States.

This standard measures the speed at the midtone (D=0.6) much like the older Kodak Printing Index, but a different scale of numbers is used to express the speed of the paper. The series of ANSI paper speed numbers is as follows:

1, 1.2, 1.6, 2, 2.5, 3, 4, 5, 6, 8, 10, 12, 16, 20, 25, 32, 40, 50, 64, 80, 100, 125, 160, 200, 250, 320, 400, 500, 650, 800, and 1000.

In this series, the difference between any two consecutive numbers represents an exposure increment of 1/3 of an f/stop. Then, of course, if a speed difference between any two papers is three intervals—say from 32 to 64—the exposure difference is one stop. Obviously, this means that the scale is arithmetic—a doubling of the speed number calls for half the exposure and vice versa.

While these speed numbers utilize a similar progression to those in the so-called "ASA" system of film speed rating, it must be remembered that the film speeds are measured in terms of the exposure required to produce a density of 0.1 above base plus fog, whereas the paper speeds are measured at a density of 0.6 above base plus fog. These being at different points on the characteristic curves, the speed numbers for films and papers cannot be compared directly.

The ANSI paper speeds have their principal value in that they distribute the error of other systems equally between highlight and shadow; inasmuch as the measured exposure is that required to produce a middle gray of 0.6 density, exposure will remain more or less constant as paper grades are changed, and the result will be to expand or contract the scale equally at both ends.

There are several minor problems in assigning paper speeds. Certain papers which reach maximum contrast quite rapidly will continue to gain in overall density if left in the developer beyond the normal time. This is equivalent to a change in paper speed; thus such papers have speeds which are dependent upon development. There are also variations in the speeds of papers from one batch to another, for manufacturing tolerances are not as tight as they are with films.

For these reasons, it is usually necessary to consider any speed rating as only a starting point from which the user must determine the exact working speed for his purpose. This is essential when one of the enlarging photometers is being used; it is always necessary to calibrate the meter for each type and contrast grade of paper being used. So far, it has not been possible to produce any meter which can be set simply to a published paper speed; however, with the small labor of individual calibration, these meters produce a very large proportion of perfect prints.

Development Latitude. Although the contrast of paper emulsions is almost incapable of variation by changes in developer composition or development time, many papers do show some exposure latitude in that *density* continues to increase overall after contrast has reached its maximum. Thus, a print which has been slightly underexposed can be pushed to some extent in the developer and can be brought up to a satisfactory density. On the other hand, because paper development is generally very rapid, it is almost impossible to save an overexposed print by shortening the time of development; development will be streaky, and the image tone will often be unpleasantly greenish.

Extended development also has some effect on image tone. Papers such as Kodak Opal get progressively colder with extended development. Some papers with a high chloride content tend to produce yellow stains with overdevelopment. Many modern papers, though, have been made so that extended development is possible, and these provide the necessary latitude for handling where advanced darkroom equipment is not available.

Safelights for Printing

Most printing papers are sensitive only to ultraviolet, violet, and blue light; thus any safelight which excludes the short-wave end of the spectrum, to about 500nm, will serve for such papers. Formerly, a bright yellow light was used for the slow contact papers and an orange light for the fast bromide papers. However, it was always difficult to judge print quality under the orange light, and many years ago, an improved safelight filter, the Kodak Wratten Series 0A Safelight, was introduced. This is a yellow-green color, visually quite bright, yet safe for almost all types of normal enlarging papers. Because of its brightness, it was adopted by most photographers as their standard printing-room light, since it would, of course, be equally safe for contact papers.

However, the advent of variable contrast papers changed this situation. The variable contrast papers are sensitized well into the green and will be fogged if exposed to a Wratten Series 0A safelight. An "orthochromatic," or light red, safelight would be safe for these papers, but visibility would be poor. Therefore, when DuPont first marketed their Varigam paper, they introduced with it a new safelight, DuPont S-55X. This filter is a yellow-brown color and provides ample working illumination, yet it is safe for all green-sensitive papers. The Kodak Safelight Filter, Wratten Series 0C, is similar to this safelight and is likewise safe for all variable contrast papers.

No matter what filter is used, safelight fog can occur if too strong a lamp is used or if the fixture is too close to the developer tray. Gross fog, which causes the borders of the print to be grayish, is of course an obvious fault. However, one is often inclined to overlook a small amount of safelight fog, not enough to cause graying of the borders. Such fog, added to the print exposure, degrades the image highlights, causing muddy tonality, and the resulting poor print quality is often blamed on other factors, such as old paper, exhausted developer, and so forth.

Since safelight filters fade with age, they should be checked for safety at intervals. If a filter has had a good deal of use and its safety is suspected, it is best to discard and replace it at once.

Black-and-White Prints from Color Negatives

Color negatives made on Kodacolor or Kodak Ektacolor films are also the source of black-and-white prints, and these are not difficult to make if the correct materials are used.

The color negative has a dye image, composed of three colors complementary to those of the original subject. It is logical to conclude that when such a negative is printed on an ordinary enlarging paper sensitive only to blue light, the print resulting will have a rendition very much the same as if the negative were made on a blue-sensitive emulsion in the first place. If the color negative had only the complementary-colored image in it (as some European color negative films actually do), this would be the case, and where a "color-blind" rendition is satisfactory, prints could be made on ordinary enlarging papers. Note, though, that whereas variable contrast papers are sensitized to blue and green and might be expected to produce an "orthochromatic" rendition, the situation is complicated by the fact that the blue and green emulsions are of different contrast ranges; thus a distorted tone rendition will probably result.

In the case of Kodacolor Film and Kodak Ektacolor Film, there is a more serious problem. The masking dyes, red and yellow in color, add up to a dense overall orange tint, much like a normal "bromide" safelight. The result is that exposures would be excessively long, and of course, the color-blind rendition would be obtained in any case.

The problem is solved by the use of papers which have panchromatic sensitivity, such as Kodak Panalure Paper, GAF Panchromatic Paper, and others. These papers are sensitive throughout the spectrum and allow short exposures even with masked color negatives; their rendition of the print approximates that which would have been obtained from a negative made of the same subject on panchromatic film.

In fact, the whole procedure parallels that of negative-making on panchromatic films. For instance, if one has a color negative such as one of a landscape with white clouds on a pale blue sky, and wishes to darken the sky and emphasize the clouds, this can be done merely by exposing the print through a yellow, orange, or red filter, exactly as one would have done in photographing

the original scene on black-and-white panchromatic film. Other changes and corrections which can be made by filters in black-and-white photography can likewise be made in printing with panchromatic papers from color negatives. The fact that the negative is in complementary colors is of no importance; the filters used are the same as those which would have been used on the camera.

Panchromatic papers, such as Kodak Panalure Paper, are provided in one contrast grade only for normal negatives. Since the paper is panchromatic, it cannot be handled under ordinary printing safelights. It should be handled in darkness or for a short time only under a safelight fitted with the Kodak Safelight Filter, Wratten Series 10 (dark amber).

Paper Developers

Developers for papers vary a good deal, depending almost entirely upon the image tone required; the developer has little influence on the contrast or density of the finished print. However, image tone is to a large degree characteristic of the paper emulsion, so that different papers will require different developers to bring out their particular capabilities.

The fast, coarse-grained enlarging papers normally produce cold black to blue-black tones. For such papers, the proper developer is one containing Metol and hydroquinone, with a large proportion of alkali and only sufficient bromide to prevent fog. When the true bromide papers were still popular, many workers used developers containing diaminophenol, Amidol, Acrol, and so on, in order to secure richer blacks than these papers normally produced. Modern chlorobromide enlarging papers, even the faster ones, do not react well to diaminophenol developers; tones produced tend to greenish grays and somewhat muddy blacks. Furthermore, diaminophenol developers do not keep well even for the short period they are kept in the tray and often produce yellow stains, although the oxidized developer itself may appear colorless. The use of diaminophenol, therefore, may be considered obsolete and is not recommended.

Even with the correct Metol-hydroquinone paper developers, some papers tend to greenish blacks, especially if development time is shortened to compensate for slight overexposure. This effect may be countered by the use of one of the synthetic antifoggants, such as Benzotriazole, 6-Nitrobenzimidazole Nitrate, or a blue-black agent such as potassium thiocyanate. Full development in a full strength developer is the best guarantee of good image tone with fast chlorobromide papers. Shortened development may produce not only inferior blacks but also streaks, mottle, and other image defects.

Warm-toned papers contain a higher proportion of silver chloride and thus have finer grain. Such papers react best to developers having a lower alkali content and a higher proportion of potassium bromide. Still warmer tones can be produced by increased exposure and shortened development; however, underdevelopment must be avoided since it produces poor image quality and streaks. One way to secure the benefits of shortened development without image defects is simply to dilute the developer with two to three parts of water or to increase the potassium bromide content or both. Developers containing less active developing agents also tend to warmer tones; these include Glycin and Adurol (chlorhydroquinone). In all cases, though, a warm-toned paper must be employed to begin with; most of these development expedients produce little or no effect on fast, cold-toned papers.

Many attempts have been made to design developers that can expand or contract the exposure scale of a paper, in a rather false analogy to the contrast or gamma control of development in negatives. Few of these variable contrast paper developers have had any success, and the best of them produced little

more increase or decrease in print scale than the distance between two adjacent grades of paper. Mainly, such developers were useful for the making of minor adjustments of scale on portrait-style papers which were available only in a single normal grade. Many papers would not react at all to these developers, and this, on occasion, proved embarrassing to their sponsors, who had made glowing claims for their pet formulas in articles in the amateur press. With the availability of modern variable contrast papers, contrast changes are so easily made by the use of the recommended filters that there is scarcely any need for further attempts to vary developer formulas. Such developers as Kodak Developer D-64 and the Dr. Beers Variable Contrast Developer are, today, mere curiosities.

It is evident that with contrast scale and image tone pretty well built into a given paper emulsion, papers are rather rigid. There is little that can be done to the rendition of a paper by variation of developer formula, and tinkering with developer formulas had best be left to those who enjoy experimenting. For practical work, the manufacturer usually recommends two or three different formulas which run the gamut of a particular paper's possibilities, and one of these is usually the best possible choice for, consistently good results.

Not only is the choice of developer fairly narrowly defined, but except for the production of certain very warm tones, dilution of a developer should also be kept within the limits outlined by the manufacturer. Years ago, it was the custom to develop pure bromide papers in what was essentially a dilute negative developer or a print developer diluted as for negatives, such as D-72 diluted 1:4. By force of habit, photographers continued to develop enlargements on chlorobromides in the same weak developer, for times up to three minutes, and complained that the new papers produced inferior blacks, muddy highlights, and other faults. This was exaggerated by the fact that the early chlorobromide papers really required very strong developers, such as D-72 diluted 1:1, and development times were correspondingly short—45 seconds to one minute. Modifications were made in paper emulsions as workers became used to the chlorobromides, and currently, average processing for cold-toned papers is about 1½ minutes in D-72 or the equivalent, diluted 1:2. Contact papers are developed in the same developer for slightly shorter times, averaging about one minute. The best rule is to follow the manufacturer's recommendations, to be found in the data pages that follow.

Fixing of Papers

It has been said that more prints fade from improper fixation than from insufficient washing. The problem of fixing papers is complicated by the fact that one cannot see when the silver halides have been dissolved out; thus there is a tendency to overfix a print for safety's sake. Recommendations have been printed for fixing times up to as much as 15 minutes for average enlarging papers.

The fact is that the thin, fine-grained emulsion of a print paper is very rapidly fixed; in a fresh hypo bath, it takes no more than a minute or two for complete fixation. The difficulty is that in a fixing bath which has had considerable use, fixation will not be complete in *any* length of time.

What happens is that, in dissolving out the silver halides, the fixing bath first converts them to complex silver-sodium-thiosulfate compounds. These are insoluble in water but can be dissolved out by further treatment in fresh hypo, and in fact their removal takes place at the same time as their formation in the case of a fresh fixing bath. When, however, a certain concentration of these

complexes exists in the fixing bath, the bath becomes saturated with the complex salts and will not remove any more of them from the paper emulsion. The remaining complex salts in the paper tend to be adsorbed to the paper fibers from which they are very difficult to remove, and it is this silver-sodium-thiosulfate which is responsible for stains in prints kept for long periods.

The trouble is, this saturation point for silver complexes is reached while the print-fixing bath still has the capability of dissolving silver halides; in some cases, the danger point is reached at a total of only about thirty 8″ x 10″ prints per gallon of fixer. At this stage, the fixer is still capable of clearing negative film, which can be seen by making a simple test, but there is a real danger that prints fixed in this bath will eventually stain.

However, if the print is not allowed to stay in the partly exhausted hypo bath for too long, the silver-sodium-thiosulfate complex is still soluble in *fresh* hypo, and this is the basis for the two-bath fixing systems frequently used. The first bath is expected to remove most of the silver halides; the second bath, naturally, will then accumulate little silver and can easily dispose of the rest, plus the difficult-to-remove complexes. The two baths are good for as many as 200 8″ x 10″ prints per gallon of each; at that point, the first bath is discarded and the second bath takes its place. A new second bath is then mixed, and the combination is again good for 200 8″ x 10″ prints. This procedure should be repeated for no more than three additional changes, after which both baths are discarded and the system started over with two fresh baths. Or, if fewer prints are being made, the pair of baths should be discarded at the end of a week, even if they have not run the full five cycles.

For archival permanence, some sources recommend carrying the system further, and using three baths, moving them up as in the case of the two-bath system.

In either case, prints remain in each fixing bath for only about two minutes. They are then transferred to the wash, with or without an intervening hypo-clearing bath. If washing machines are used and it is not convenient to move prints to the wash immediately, they should not be allowed to soak in the second fixing bath; instead they should be transferred to a holding bath of plain water until the washing machine is available. Prolonged fixation, even in fresh hypo, is deleterious to the print. Such fixation may result in loss of image density, a change of tone, or the adsorption of hypo to the paper fibers, from which it is difficult to remove in the subsequent wash.

Washing

Washing prints is more difficult than washing negatives, because the paper fibers tend to hold the hypo and other chemicals quite tenaciously. Double-weight prints may require as long as three hours of washing for a high degree of permanency. Excessively cold water increases the time required still more.

Washing time can be appreciably shortened by the use of a bath such as Kodak Hypo Clearing Agent or GAF Quix Wash Saver. Prints are immersed in the bath for one to two minutes, without any rinse after the hypo bath. After the two-minute treatment, they are washed in the normal manner; with this treatment washing time for double-weight prints can be reduced to about 30 minutes.

Stabilization Processing

During World War II there was a large demand for rapid processing of military reconnaissance photographs, which were needed for immediate evalua-

tion. Long-term permanence was not essential in this case, and since the time-consuming stages were the fixing and washing steps, these were eliminated by the use of a stabilizing bath which simply converted the remaining silver halides into silver salts that were not sensitive to light. The prints were then dried without washing. Depending upon storage conditions, such stabilized prints might be good for up to about six months; under conditions of high temperature and humidity, they might become badly stained in only a few weeks.

For manual tray processing, the time saving in stabilization is not very great. Rapid access print-making as currently practiced involves the use of specially made papers such as Kodak Ektamatic SC Paper, Ilfoprint Paper, and others, which contain the necessary developing agents incorporated in the emulsion. Such papers require only an activator for development, and this process takes only a few seconds. This is followed by a short squeegee to remove surplus activator and an equally short treatment in the stabilizing bath. The print is again squeegeed almost dry and ejected from the machine; final drying takes place in the air of the room in a few minutes. It is important not to wash these prints at this stage, since washing will remove the stabilizing chemicals and accelerate fading.

Total time in the machine is only a few seconds, and this high-speed processing cannot be accomplished in trays. Machines incorporating solution trays, drive and squeegee rollers, are available from the various paper manufacturers and other sources. With the proper chemicals, any of these machines can be used with any paper intended for stabilization processing. They will not work with ordinary enlarging or contact papers, which do not contain the developing agents in the emulsion. The formulas for the activator and stabilizer are the property of the various manufacturers and are proprietary secrets; none are presently available for publication.

If it is decided at a later time to make the prints more permanent for extended storage and they have not yet begun to fade or stain, they can be fixed in any standard fixing bath, followed by a hypo-clearing bath and the normal washing treatment. Papers made for stabilization processing can also be processed in trays using the standard print developer such as Kodak Developer D-72 or the equivalent, followed by a stop bath, fixing, and washing as usual.

If the stabilization process is used, extreme cleanliness must be observed; traces of stabilizer on the hands can stain or fog unexposed paper. Stabilized prints should not be dried on the same racks or blotters as are used for regular prints. Likewise, stabilized prints should not be stored in the same folder with normally processed prints. Stabilized prints cannot be toned.

Toning

The variety of print tones available in the various papers is limited to a few shades of brown and brown-black. A wider range of image tones is provided by the use of toning baths after processing. These baths either change the silver image to silver sulfide, or they substitute another metal for the silver in the image. Sulfide toning provides mainly a series of brown and sepia tones; metal toning produces a wider variety of colors, depending upon both the metal used and the paper on which it is applied. Thus, for instance, a gold toner applied to a cold black-toned paper produces almost no effect; the same toner used on a warm-toned paper changes the image from brown-black to a bright blue or purple. If, however, the same gold toner is used on a print which has been first treated with a sulfide sepia toner, the final image will not be blue but a bright red-brown or even a pure red.

131

Sulfide toners usually proceed rapidly to a final definite image tone, which is constant for a given paper. On the other hand, most metal toners have a progressive action and proceed through a range of different colors in a definite order. In such cases, a choice of image tone is available, depending upon the time of treatment in the toning bath.

The tones possible from various processes are many, as can be seen from the following list:

Sulfur	Warm black to sepia
Hydrosulfite	Warm brown to sepia
Gold (on untoned prints)	Blue to purple
Gold (on toned prints)	Red
Tin (stannous)	Purple-black to sepia-brown
Selenium	Purple-brown to warm brown
Copper	Warm black to red chalk
Uranium	Warm black to brick-red
Vanadium (on untoned prints)	Yellow
Vanadium (on iron-toned prints)	Green
Nickel	Red, red-brown to magenta
Iron	Blue

One other method of toning, now seldom used, involves treating the silver image to produce a *mordant,* which is a compound having the power to attract and insolubilize a dye. The image is then immersed in a dye bath followed by a thorough wash, which removes all the dye from the highlights, leaving a colored image on a white ground. Obviously, the range of colors possible with this process is almost unlimited, since a great many dyes can be employed. However, the usual mordanting bath leaves the silver image almost completely black, so that only dark colors can be produced. Some mordanting baths which produce a transparent image were used for certain early color print processes employing stripping film layers. For paper prints, dye toning is not very satisfactory because the dyes tend to stain the paper base; the method is still occasionally used for coloring transparencies.

Most prints are toned in sulfur baths, since the resulting browns are generally considered very pleasing. Two major methods are used: hypo-alum toning done in a heated bath, and the "bleach-and-redevelop toner," a two-stage process, worked cold.

The hypo-alum toner has one advantage; since the bath contains hypo, there is no need to wash the prints extensively before toning—a short rinse is all that is necessary. Full washing after toning is, of course, required.

Bleach-and-redevelop toning involves first converting the silver image to silver bromide in a bath containing potassium bromide and potassium ferricyanide. The resulting bleached image is then treated in a sulfide solution, which converts it to silver sulfide. The image tone varies from yellow-brown through sepia to deep browns, mainly depending upon the type of paper used. Prints must be thoroughly washed before such toning, for silver bromide is, of course, soluble in hypo, and any traces of hypo left in the print will cause partial or total loss of image density.

132

One other sulfide toning method is in use; it employs a polysulfide salt applied directly to the fixed and washed print without bleaching. Again, this method works on some papers, not others. For definite recommendations, check the data pages that follow.

In most cases, gold toning is used as a modifier of tones produced by sulfide baths. However, where a deep blue tone is appropriate, a gold toner applied directly to a warm-toned print produces an excellent color, suited to winter landscapes, seascapes, and other subjects for which the blue color is appropriate. Gold toning has little or no effect on the coarse-grained, fast enlarging papers, which have a naturally blue-black or neutral black tone. It works best on papers which are naturally warm toned, and the warmer the tone of the original print, the bluer the gold tone will be. The maximum effect is produced by using a warm-toned paper and developing it in a warm-toned developer such as one containing glycin or chlorhydroquinone.

When gold toners are used on prints which have been previously toned in a sulfide bath, the resulting color is a deep rich red. In the case of the hypo-alum toner, the gold salt can be added directly to the toning bath; the result is to produce darker and colder colors, tending to red-purples.

Currently, selenium toning is most popular. Selenium toners are almost always purchased in ready-mixed form (Kodak Rapid Selenium Toner, GAF Flemish Toner, and others). Although formulas are available by which the user can mix his own selenium toners, they all involve the handling of selenium in powdered metal form. *This is dangerous;* selenium metal is highly poisonous. The toning bath is actually a sodium seleno-sulfide, or a selenium sulfide, depending upon how it is prepared; the toned image is a complex silver seleno-sulfide. The image is of a deep brown color and has very high permanence.

Again, selenium toners work best on papers having naturally warm tones; they produce little change of color on cold-toned chloride or chlorobromide papers. The change in tone is progressive—it can be watched while toning takes place and stopped when the desired color is reached. Some workers use a selenium toner on relatively cold-toned papers for a very short time only; it produces little or no real change in color. These workers claim that the treatment eliminates the tendency to a greenish black characteristic of certain papers, without changing the tone to a brown or brown-black. It is also believed that the treatment enhances the permanence of the prints.

As has been stated several times above, the tones available depend upon both the toner employed and the paper, as well as on the processing conditions under which the original print was made. For this reason, it is best to follow the recommendations of the paper manufacturer as to which toner is preferable for a given paper and how that paper should be processed. Recommendations are given in the data pages that follow. A rule of thumb can be used for other papers or for proprietary toners: cold-toned papers react better to bleach-and-redevelop-type toners, whereas warm-toned papers work well in direct toners such as hypo-alum, polysulfide, and selenium.

Surface and Contrast Grade Data

On the following data pages, most of the information given is self-explanatory. One point needs to be emphasized, however. The listings given of surfaces and contrast grades available are correct and up-to-date as of the time of publication. However, manufacturers do add new surfaces and delete others, as demand indicates, and no such listing can be up-to-date for very long.

Therefore, these pages are not to be taken as a catalog of what is currently available; for this information, see your dealer. The contrasts and surfaces are

listed mainly for comparison; it gives the reader a quick overall picture of the available materials, and from these listings one can quickly ascertain which papers come in many surfaces and contrasts, and which papers offer comparatively few. But, we reiterate, for definite information on what is currently available, it is essential to check with your dealer.

PHOTOGRAPHIC PAPERS: DESCRIPTIONS AND APPLICATIONS

PAPER	TYPE	TONE	SPEED	APPLICATION
AGFA				
Brovira	Enlarging	Cold black	Fast	Amateur, commercial, news
Portriga Rapid	Enlarging	Warm black	Medium slow	Portraits, exhibition prints, pictorial
Contactone	Contact	Neutral black	Slow	Commercial, industrial, publicity
DU PONT				
Emprex	Enlarging	Brown-black	Medium	Portraits, exhibition prints
Mural	Enlarging	Warm black	Medium fast	Murals, portrait proofs
Varilour	Enlarging	Warm black	Medium slow	Variable contrast paper for portraits, exhibition prints, pictorials
Velour Black	Enlarging	Neutral to warm black	Fast	Amateur, commercial, news, illustration
ILFORD				
Ilfobrom and Ilfospeed	Enlarging	Neutral	Fast	Amateur, commercial, news, industrial
CS Ilfoprint	Contact	Neutral	Slow	Contact paper for stabilization processing
LR Ilfoprint	Enlarging	Neutral	Fast	Enlarging paper for stabilization processing
KODAK				
Azo	Contact	Neutral	Slow	General, amateur, commercial
Ektalure	Enlarging	Brown	Medium	Portraits, salon prints
Ektamatic SC	Enlarging	Neutral to warm black	Medium fast	Variable contrast stabilization paper
Kodabrome II RC	Enlarging	Warm black	Fast	For rapid processing in Kodak Royalprint processor
Kodabromide	Enlarging	Neutral	Fast	Amateur, commercial, news
Medalist	Enlarging	Neutral	Medium	Exhibition prints, illustration
Mural	Enlarging	Warm black	Medium fast	Large display prints
Panalure II RC	Enlarging	Warm black	Medium fast	Panchromatic, for black-and-white prints from color negatives
Panalure Portrait	Enlarging	Brown	Medium	Panchromatic, for black-and-white prints from color negatives
Polycontrast	Enlarging	Warm black	Medium	Variable contrast for news, commercial, amateur, photofinishing
Polycontrast Rapid II RC	Enlarging	Warm black	Fast	Variable contrast for news and photofinishing
Portralure	Contact and enlarging	Brown-black	Medium slow	Portraits, exhibition prints
Resisto	Contact	Neutral	Slow	Contact paper on water-resistant base for rapid processing
Velox	Contact	Blue-black	Slow	Aamateur, commercial, photofinishing

See data pages for further information on handling of the papers listed above.

AGFA BROVIRA PAPER

Type of Paper: Fast enlarging paper.

Image Tone: Neutral-black.

Safelight: Wratten Series OA.

Grades, Speeds and Scale Index Values:

Grade	Shadow Speed	Printing Index	Approximate Scale Index	Negative Density Scale
1	—	—	1.70	Very High
2	—	—	1.45	High
3	—	—	1.20	Normal
4	—	—	0.95	Low
5	—	—	0.75	Very Low
6	—	—	0.50	Extremely Low

Tint, Brilliance, Surface, Weight & Symbol

Tint	Brilliance	Surface	Single Weight Symbol and Grades	Double Weight Symbol and Grades
White	Glossy	Smooth	1	111
White	Lustre	Fine Grain	—	119

Development Recommendations

Developer	Dilution	Recommended Time in minutes	Useful Range (in minutes)	Purpose
Kodak Dektol or D-72	1:2	—	1½–2	—
Dupont 55-D	1:2	—	1½–2	—
GAF Vividol	1:2	—	1½–2	—

Toning Recommendations: None.

AGFA PORTRIGA RAPID PAPER

Type of Paper: Warm-tone chlorobromide paper.

Image Tone: Warm-black.

Safelight: Wratten Series OA.

Grades, Speeds and Scale Index Values:

Grade	Shadow Speed	Printing Index	Approximate Scale Index	Negative Density Scale
2	—	—	1.40	High
3	—	—	1.20	Normal
4	—	—	1.00	Low

Tint, Brilliance, Surface, Weight & Symbol

Tint	Brilliance	Surface	Single Weight Symbol and Grades	Double Weight Symbol and Grades
White	Glossy	Smooth	—	111
White	Semi-Matte	Fine Grain	—	118

Development Recommendations

Developer	Dilution	Recommended Time in minutes	Useful Range (in minutes)	Purpose
Kodak Dektol or D-72	1:2	—	1½–2	Normal Tones
Kodak Selectol or D-52	1:1	—	1½–4	Warmer Tones
GAF Ardol	1:1	—	1½–2	Warm Black
Dupont 55-D	1:2	—	1½–2	Warm Black

Toning Recommendations: None.

Note: Air dry only; do not use heat, if warm-tone characteristics are to be preserved.

AGFA CONTACTONE PAPER

Type of Paper: Contact paper for amateur and commercial use.

Image Tone: Neutral-black

Safelight: Kodak Safelight Filter, Wratten Series OA

Grades, Speeds and Scale Index Values:

Grade	ANSI Speed	Approximate Scale Index	Negative Density Scale
0	—	—	Very high
1	—	—	High
2	—	—	Normal
3	—	—	Low

Tint, Brilliance, Surface, Weight & Symbol

Tint	Brilliance	Surface	Single Weight Symbol and Grades	Double Weight Symbol and Grades
White	Glossy	Smooth	1(0,1,2,3)	111(1,2)

Development Recommendations

Developer	Dilution	Recommended Time in minutes	Useful Range (in minutes)	Purpose
Kodak Dektol or D-72	1:2	1	¾−2	Cold Tones
Kodak Ektaflo Type 1	1:9	1	¾−2	Cold Tones
Kodak Versatol	1:3	1	¾−2	Cold Tones

Toning Recommendations: None.

DUPONT EMPREX PORTRAIT PAPER

Type of Paper: Medium speed enlarging paper.

Image Tone: Olive-brown.

Safelight: Dupont S55X.

Grades, Speeds and Scale Index Values:

Grade	Shadow Speed	Printing Index	Approximate Scale Index	Negative Density Scale
Normal	—	—	1.0	Normal

Tint, Brilliance, Surface, Weight & Symbol

Tint	Brilliance	Surface	Single Weight Symbol and Grades	Double Weight Symbol and Grades
Natural	Lustre	Velvet grain	—	DL
Natural	Lustre	Rough	—	DDL
Natural	High Lustre	Velvet grain	—	DS
Brilliant White	Lustre	Silk	—	YW

Development Recommendations

Developer	Dilution	Recommended Time in minutes	Useful Range (in minutes)	Purpose
Dupont 53-D	1:2	1½	1–2	Higher Contrast
Dupont 55-D	1:2	1½	1–2	Warmer Tones

Toning Recommendations: Polysulfide toners produce a golden-yellow tone; Selenium produces deep rich browns. Combinations of the two tones may be used.

DUPONT MURAL PAPER

Type of Paper: Rough medium-weight paper for murals and portrait proofs.

Image Tone: Warm black.

Safelight: Wratten Series 0A, 0C; Dupont S55X.

Grades, Speeds and Scale Index Values:

Grade	Shadow Speed	Printing Index	Approximate Scale Index	Negative Density Scale
2	—	—	1.35	Normal
3	—	—	1.08	Low

Tint, Brilliance, Surface, Weight & Symbol

Tint	Brilliance	Surface	Single Weight Symbol and Grades	Double Weight Symbol and Grades
White	Lustre	Rough	BW (2,3)	—

Development Recommendations

Developer	Dilution	Recommended Time in minutes	Useful Range (in minutes)	Purpose
Dupont 55D	1:2	1½	1–2	Warm Black

Toning Recommendations: Not used.

DUPONT VARILOUR PAPER

Type of Paper: Variable contrast enlarging paper.

Image Tone: Blue-black to warm-brown.

Safelight: Dupont S55X.

Grades, Speeds and Scale Index Values:

Filter	Shadow Speed	Printing Index	Approximate Scale Index	Negative Density Scale
00	—	—	1.50	Very High
0	—	—	1.35	High
1	—	—	1.25	Moderately High
2	—	—	1.0	Normal
3	—	—	0.85	Low
4	—	—	0.75	Very Low

Tint, Brilliance, Surface, Weight & Symbol

Tint	Brilliance	Surface	Single Weight Symbol and Grades	Double Weight Symbol and Grades
White	Semi-matte	Smooth	AW, ALW	BW
White	Semi-gloss	Smooth	—	BTW
Natural	Lustre	Velvet-grain	—	DL
White	Glossy	Smooth	R, RW	T, TW
White	Lustre	Silk		YW

Development Recommendations

Developer	Dilution	Recommended Time in minutes	Useful Range (in minutes)	Purpose
Dupont 53D	1:2	1½	1½–2½	Normal Tones
Dupont 55D	1:2	1½	1½–2½	Warmer Tones

The tone of Varilour Paper can be varied from a cold blue-black to a semi-warm brown by control of drying temperature and/or the use of Dupont Image Control Solution.

Toning Recommendations: Dupont Redevelopment Toner 4a-T, or Dupont Varigam Toner 6-T.

DUPONT VELOUR BLACK PAPER

Type of Paper: Fast enlarging paper.

Image Tone: Neutral to warm black.

Safelight: Kodak Safelight Filter Wratten Series 0A or 0C; Dupont S55X.

Grades, Speeds and Scale Index Values:

Grade	Shadow Speed	Printing Index	Approximate Scale Index	Negative Density Scale
1	—	—	1.60	High
2	—	—	1.35	Normal
3	—	—	1.08	Low
4	—	—	0.93	Very Low

Tint, Brilliance, Surface, Weight & Symbol

Tint	Brilliance	Surface	Single Weight Symbol and Grades	Double Weight Symbol and Grades
White	Semi-matte	Smooth	AW(2,3,4)	BW(1,2,3,4)
Natural	Lustre	Fine grained	ALW(1,2,3)	DL(1,2,3)
White	Glossy	Smooth	RW(1,2,3,4)	TW(1,2,3,4)
White	Lustre	Silk		YW(1,2,3)

Development Recommendations

Developer	Dilution	Recommended Time in minutes	Useful Range (in minutes)	Purpose
Dupont 55D	1:2	1½	1–2	Normal Tones

Warmer tones are obtainable by adding Potassium Bromide to the developer, and increasing the exposure.

Toning Recommendations: Dupont "Velour Black" Hypo-Alum Sepia Toner, 2-T; Dupont "Velour Black" Hypo-Alum Iodide Sepia Toner, 3-T; Dupont Re-development Toner, 4a-T.

ILFORD ILFOBROM AND ILFOSPEED PAPERS

Type of Paper: Fast enlarging paper.

Image Tone: Neutral black.

Safelight: Ilford S Safelight No. 902 (or Wratten Series 0C)

Grades, Speeds and Scale Index Values:

Grade	Shadow Speed	Printing Index	Approximate Scale Index	Negative Density Scale
0	—	—	1.6	Very High
1	—	—	1.4	High
2	—	—	1.2	Normal
3	—	—	1.0	Low
4	—	—	0.8	Very Low
5	—	—	0.6	Extremely Low

Tint, Brilliance, Surface, Weight & Symbol

Tint	Brilliance	Surface	Single Weight Symbol and Grades	Double Weight Symbol and Grades
White	Glossy	Smooth	1P (0,1,2,3,4,5)	1K (0,1,2,3,4,5)
White	Semi-Matte	Smooth	24P (1,2,3,4)	24K (0,1,2,3,4)
White	Matte	Smooth	—	5K (1,2,3,4)
White	Velvet	Stipple	—	26K (0,1,2,3,4)
White	Velvet	Lustre	—	27K (1,2,3,4)
White	Rayon	Silk	—	35K (1,2,3)

Development Recommendations

Developer	Dilution	Recommended Time in minutes	Useful Range (in minutes)	Purpose
Ilford Bromophen	1:3	1½	1—3	Normal Tones
Ilford PQ Universal	1:9	1½	1½—2	Normal Tones
Ilford Contrast FF	1:4	¾	¾—1	Rapid Processing

Toning Recommendations: Not given.

ILFOSPEED PAPER: A Note: Ilfospeed Paper is essentially similar to Ilfobrom but the emulsion is coated on a plastic-coated paper base, which is practically waterproof. While this paper may be handled exactly the same as Ilfobrom, the real advantage is found when it is developed in the Ilfospeed chemicals, and dried with the special Ilfospeed dryer. Under these circumstances, finished prints can be made in just four minutes: 1 minute development, 30 seconds fixing, 30 seconds washing, and two minutes of drying. It must be emphasized that this is *not* a stabilization process; Ilfospeed prints are fully processed in the times given and are as permanent as prints made by older and slower methods.

ILFORD CS ILFOPRINT CONTACT PAPER

Type of Paper: Contact printing paper for rapid stabilization processing.

Image Tone: Neutral black.

Safelight: None needed in normally lighted room.

Grades, Speeds and Scale Index Values:

Grade	Shadow Speed	Printing Index	Approximate Scale Index	Negative Density Scale
2	—	—	1.2	Normal
3	—	—	1.0	Low
4	—	—	0.8	Very Low

Tint, Brilliance, Surface, Weight & Symbol

Tint	Brilliance	Surface	Single Weight Symbol and Grades	Double Weight Symbol and Grades
White	Glossy	Smooth	2,3,4	—

Development Recommendations

Stabilization process in Ilfoprint processor. Use Ilfoprint Activator IA-13; Ilfoprint Stabilizer IS-21 for processors without heat drying, Ilfoprint Stabilizer IS-22 for processors with heat drying.

ILFORD LR ILFOPRINT PROJECTION PAPER

Type of Paper: Rapid-processing stabilization enlarging paper.

Image Tone: Neutral black.

Safelight: Ilford S Safelight No. 902 (or Wratten Series 0C).

Grades, Speeds and Scale Index Values:

Grade	Shadow Speed	Printing Index	Approximate Scale Index	Negative Density Scale
1	—		1.4	High
2	—		1.2	Normal
3	—		1.0	Low
4	—		0.8	Very Low

Tint, Brilliance, Surface, Weight & Symbol

Tint	Brilliance	Surface	Single Weight Symbol and Grades	Double Weight Symbol and Grades
White	Glossy	Smooth	LR-.1P(1,2,3,4)	LR-.1K(1,2,3,4)
White	Semi-Matte	Smooth	LR-.24P(1,2,3,4)	LR-.24K(1,2,3,4)
White	Lustre	Velvet-stipple	—	LR-.26K(1,2,3,4)
White	Matte	Rough	—	LR-.45P(1,2,3,4)

Development Recommendations

Ilfoprint Activator IA-11 for temperatures up to 80F.
Ilfoprint Activator IA-12 for temperatures above 80F.
Ilfoprint Stabilizer IS-21 for processors without heat drying.
Ilfoprint Stabilizer IS-22 for processors with heat drying.

The keeping properties of stabilized prints are good but direct exposure to sunlight for long periods should be avoided.

Prints which are to be kept for long periods, or are to be exposed to bright sunlight, or which are to be ferrotyped should be fixed in a conventional fixer, then washed and dried in the usual way. Fixing may be carried out immediately after the print has passed through the processor, or later.

KODAK AZO PAPER

Type of Paper: Contact paper for general use.

Image Tone: Neutral-black.

Safelight: Kodak Safelight Filter, Wratten Series 0C.

Grades, Speeds and Scale Index Values:

Grade	ANSI Speed	Approximate Scale Index	Negative Density Scale
0	12	1.7	Extremely High
1	6	1.5	High
2	4	1.3	Normal
3	2.5	1.1	Low
4	1.6	0.9	Very Low
5	1.2	0.7	Extremely Low

Tint, Brilliance, Surface, Weight & Symbol

Tint	Brilliance	Surface	Single Weight Symbol and Grades	Double Weight Symbol and Grades
White	Glossy	Smooth	F(0,1,2,3,4,5)	F(0,1,2,3,4)
White	Lustre	Fine-grained	E(0,1,2,3,4)	E(1,2,3,4)
White	Lustre	Smooth	—	N(1,2,3,4)

Development Recommendations

Developer	Dilution	Recommended Time in minutes	Useful Range (in minutes)	Purpose
Kodak Dektol or D-72	1:2	1	¾–2	Cold Tones
Kodak Versatol	1:3	1	¾–2	Cold Tones
Kodak Ektaflo Type 1	1:9	1	¾–2	Cold Tones
Kodak Ektaflo, Type 2	1:9	2	1½–4	Warm Tones
Kodak Ektonol, Selectol or D-52	1:1	2	1½–4	Warm Tones
Kodak Selectol-Soft	1:1	2	1½–4	Lower Contrast

Toning Recommendations: Kodak Brown Toner, Kodak Poly-Toner, and Kodak Polysulfide Toner T-8.

KODAK EKTALURE PAPER

Type of Paper: Enlarging paper for portrait printing.

Image Tone: Brown-black.

Safelight: Kodak Safelight Filter, Wratten Series 0C.

Grades, Speeds and Scale Index Values:

Grade	ANSI Speed	Approximate Scale Index	Negative Density Scale
Normal	125	1.2	Normal

Tint, Brilliance, Surface, Weight & Symbol

Tint	Brilliance	Surface	Single Weight Symbol and Grades	Double Weight Symbol and Grades
Warm-White	Lustre	Fine Grained	—	E
Cream White	Lustre	Fine Grained	—	G
Cream White	Lustre	Tweed	—	R
Cream White	Lustre	Tapestry	—	X
Warm-White	High Lustre	Fine Grained	—	K
Warm-White	High Lustre	Silk	—	Y

Development Recommendations

Developer	Dilution	Recommended Time in minutes	Useful Range (in minutes)	Purpose
Kodak Ektaflo Type 2	1:9	2	½–4	Normal Tones
Kodak Ektonol, Selectol or D-52	1:1	2	½–4	Normal Tones
Kodak Selectol-Soft	1:1	2	½–4	Lower Contrast

Toning Recommendations: Kodak Poly-Toner, Kodak Rapid Selenium Toner, and Kodak Gold Toner T-21.

KODAK EKTAMATIC SC PAPER

Type of Paper: Variable contrast enlarging paper for stabilization processing.

Image Tone: Warm black with stabilization processing; neutral black with tray processing.

Safelight: Kodak Safelight Filter, Wratten Series 0C.

Grades, Speeds and Scale Index Values: Use Polycontrast Filters.

Filter	ANSI Speed*	*Approximate Scale Index	Negative Density Scale
PC 1	250–320	1.7–1.5	—
PC 1½	250–320	1.5–1.3	—
PC 2	250–320	1.4–1.2	—
PC 2½	250–320	1.3–1.1	—
PC 3	160–200	1.2–1.1	—
PC 3½	125–160	1.1–1.0	—
PC 4	80–100	1.1–1.0	—
No Filter	400–500	1.4–1.3	—

*First figure is for stabilization processing; second is for tray processing.

Tint, Brilliance, Surface, Weight & Symbol

Tint	Brilliance	Surface	Single Weight Symbol and Grades	Double Weight Symbol and Grades
White	Glossy	Smooth	F	—
White	Lustre	Smooth	N	—
White	Lustre	Smooth	A*	—

*Lightweight folding stock.

Development Recommendations

Use Kodak Ektamatic A10 Activator and Kodak Ektamatic S30 Stabilizer. Do not rinse or wash after processing; it will impair stability of prints. For extended keeping of prints, fix 8-12 min. in a normal print fixing bath, then wash and dry normally.

For tray processing, develop about 60 sec. in Kodak Dektol Developer or Kodak D-72, then fix and wash normally.

Toning Recommendations: The following toners are recommended only for prints that have been fixed and washed: Kodak Hypo-Alum Sepia Toner T-1a, Kodak Sulfide Sepia Toner T-7a, Kodak Polysulfide Toner T-8, Kodak Sepia Toner and Kodak Brown Toner.

KODABROME-II RC PAPER

Type of Paper: Fast enlarging paper on water-resistant base for rapid processing.

Image Tone: Neutral-black.

Safelight: Kodak Safelight Filter, Wratten Series 0C.

Grades, Speeds and Scale Index Values:

Grade	ANSI Speed	Approximate Scale Index	Negative Density Scale
Soft	320	—	High
Medium	320	—	Normal
Hard	320	—	Low
Extra Hard	160	—	Very low
Ultra Hard	160	—	Extremely low

The speeds given are "Effective Paper Speeds" and were determined for processing in the Kodak Royalprint Processor.

Tint, Brilliance, Surface, Weight & Symbol

Tint	Brilliance	Surface	Single Weight Symbol and Grades	Double Weight Symbol and Grades
White	Glossy	Smooth	F	—
White	Lustre	Smooth	N	—

Development Recommendations

Developer	Dilution	Recommended Time in minutes	Useful Range (in minutes)	Purpose
Kodak Dektol or D-72	1:2	1	¾−2	Normal tones
Kodak Ektaflo Type 1	1:9	1	¾−2	Normal tones

This paper has the developing agent incorporated in the emulsion and can be processed in trays in 60 seconds or completely dry in the Kodak Royalprint processor, Model 417, in 55 seconds. It may also be processed in roller-transport or continuous paper processors using standard chemicals.

Toning Recommendations: Not recommended.

KODABROMIDE PAPER

Type of Paper: Fast enlarging paper for general use.

Image Tone: Neutral black.

Safelight: Kodak Safelight Filter, Wratten Series 0C.

Grades, Speeds and Scale Index Values:

Grade	ANSI Speed	Approximate Scale Index	Negative Density Scale
1	650	1.5	High
2	500	1.3	Normal
3	320	1.1	Low
4	200	0.9	Very Low
5	160	0.7	Extremely Low

Tint, Brilliance, Surface, Weight & Symbol

Tint	Brilliance	Surface	Single Weight Symbol and Grades	Double Weight Symbol and Grades
White	Glossy	Smooth	F(1,2,3,4,5)	F(1,2,3,4,5)
White	Lustre	Smooth	N(2,3,4)	N(1,2,3,4)
White	Lustre	Fine-grained	E(1,2,3,4,5)	E(1,2,3,4,5)
White	Lustre	Smooth	A(1,2,3,4,5)	—
Cream White	Lustre	Fine-grained	—	G(1,2,3,4,5)

Development Recommendations

Developer	Dilution	Recommended Time in minutes	Useful Range (in minutes)	Purpose
Kodak Dektol or D-72	1:2	1½	1–3	Normal Tones
Kodak Ektaflo Type 1	1:9	1½	1–3	Normal Tones
Kodak Versatol	1:3	1½	1–3	Normal Tones

Toning Recommendations: Kodak Sepia Toner and Kodak Sulfide Sepia Toner T-7a.

KODAK MEDALIST PAPER

Type of Paper: Medium speed enlarging paper.

Image Tone: Warm black.

Safelight: Kodak Safelight Filter, Wratten Series 0C.

Grades, Speeds and Scale Index Values:

Grade	ANSI Speed	Approximate Scale Index	Negative Density Scale
1	250	May be	High
2	250	varied with	Normal
3	250	development	Low
4	250	time.	Very Low

Tint, Brilliance, Surface, Weight & Symbol

Tint	Brilliance	Surface	Single Weight Symbol and Grades	Double Weight Symbol and Grades
White	Glossy	Smooth	F(1,2,3,4)	F(2,3)
White	High Lustre	Smooth	—	J(2,3,4)
Cream White	Lustre	Fine-grained	—	G(1,2,3,4)
White	Lustre	Fine-grained	—	E(2,3)
Cream White	High Lustre	Silk	—	Y(1,2,3)

Development Recommendations

Developer	Dilution	Recommended Time in minutes	Useful Range (in minutes)	Purpose
Kodak Dektol or D-72	1:2	1	¾–2	Warm Tones
Kodak Ektaflo Type 1	1:9	1	¾–2	Warm Tones
Kodak Ektaflo Type 2	1:9	2	1½–4	Warmer Tones
Kodak Ektonol, Selectol, or D-52	1:1	2	1½–4	Warmer Tones
Kodak Selectol-Soft	1:1	2	1½–4	Lower Contrast
Kodak Versatol	1:3	1	¾–2	Warm Tones

Toning Recommendations: Kodak Poly-Toner, Kodak Sepia Toner, Kodak Sulfide Sepia Toner T-7a, Kodak Polysulfide Toner T-8, Kodak Hypo-Alum Toner T-1a, and Kodak Brown Toner. Kodak Brown Toner tends to reduce the higher densities in a print. This effect can be compensated by a slight increase in developing time.

KODAK MURAL PAPER

Type of Paper: Medium-fast enlarging paper for large display prints.

Image Tone: Warm-black

Safelight: Kodak Safelight Filter, Wratten Series 0C.

Grades, Speeds and Scale Index Values:

Grade	ANSI Speed	Approximate Scale Index	Negative Density Scale
2	250	1.3	Normal
3	250	1.1	Low

Tint, Brilliance, Surface, Weight & Symbol

Tint	Brilliance	Surface	Single Weight Symbol and Grades	Double Weight Symbol and Grades
Cream-white	Lustre	Tweed	R(2,3)	—

Development Recommendations

Developer	Dilution	Recommended Time in minutes	Useful Range (in minutes)	Purpose
Kodak Ektonol, Selectol or D-52	1:1	2	1½–4	Normal Tone
Kodak Ektonol, Selectol or D-52	1:3	4	3–8	Large Prints*
Kodak Ektaflo, Type 2	1:9	2	1½–4	Normal Tone
Kodak Selectol-Soft	1:1	2	1½–4	Lower Contrast
Kodak Dektol or D-72	1:2	1	¾–2	Colder Tone
Kodak Dektol or D-72	1:4	2	1½–4	Large Prints*
Kodak Ektaflo Type 1	1:9	1	¾–2	Colder Tone

*In processing large prints, prolonged development in a dilute solution helps to prevent the streaks and marks caused by uneven development.

Toning Recommendations: Kodak Poly-Toner, Kodak Brown Toner, Kodak Polysulfide Toner T-8, Kodak Sulfide Sepia Toner T-7a, Kodak Hypo-Alum Sepia Toner T-1a, and Kodak Sepia Toner.

KODAK PANALURE-II RC PAPER

Type of Paper: Panchromatic enlarging paper for black-and-white prints from color negatives.

Image Tone: Warm-black.

Safelight: Kodak Safelight Filter, Wratten Series 10, 7½-watt bulb, at least 4 feet from the paper.

Grades, Speeds and Scale Index Values:

Grade	ANSI Speed Color Negs.	ANSI Speed B&W Negs.	Scale Index Approximate	Negative Density Scale
Normal	500	800	—	—

Tint, Brilliance, Surface, Weight & Symbol

Tint	Brilliance	Surface	Single Weight Symbol and Grades	Double Weight Symbol and Grades
White	Glossy	Smooth	F	—

Development Recommendations

Developer	Dilution	Recommended Time in minutes	Useful Range (in minutes)	Purpose
Kodak Dektol or D-72	1:2	1½	1–3	Normal Tones
Kodak Ektaflo, Type 1	1:9	1½	1–3	Normal Tones
Kodak Ektaflo, Type 2	1:9	2	1–3	Warmer Tones
Kodak Selectol or D-52	1:1	2	1–3	Warmer Tones
Kodak Selectol-Soft	1:1	2	1–3	Lower Contrast
Kodak Ektonol	1:1	2	1–3	Warmer Tones
Kodak Versatol	1:3	1½	1–3	Normal Tones

This paper has the developing agent incorporated in the emulsion; it can be processed to a completely dry print of optimum process stability in the Kodak Royalprint processor in 55 seconds. It may also be processed in roller-transport or continuous paper processors using standard chemicals, or in trays.

Toning Recommendations: Not recommended.

KODAK PANALURE PORTRAIT PAPER

Type of Paper: Panchromatic enlarging paper for black-and-white prints from color negatives.

Image Tone: Brown-black.

Safelight: Kodak Safelight Filter. Wratten Series 10, 7½-watt bulb, 4 feet from paper.

Grades, Speeds and Scale Index Values:

Grade	ANSI Speed Color Negs.	ANSI Speed B&W Negs.	Approximate Scale Index	Negative Density Scale
Normal	100	160	—	—

Tint, Brilliance, Surface, Weight & Symbol

Tint	Brilliance	Surface	Single Weight Symbol and Grades	Double Weight Symbol and Grades
White	Lustre	Fine-grained	—	E

Development Recommendations

Developer	Dilution	Recommended Time in minutes	Useful Range (in minutes)	Purpose
Kodak Selectol or D-52	1:1	2	1½–4	Warm Tones
Kodak Ektaflo, Type 2	1:9	2	1½–4	Warm Tones
Kodak Selectol-Soft	1:1	2	1½–4	Lower Contrast
Kodak Dektol or D-72	1:2	1½	1–3	Colder Tones
Kodak Ektaflo, Type 1	1:9	1½	1–3	Colder Tones

Toning Recommendations: Kodak Poly-Toner, Kodak Rapid Selenium Toner, Kodak Sulfide Sepia Toner T-7a, Kodak Polysulfide Toner T-8, and Kodak Hypo-Alum Sepia Toner T-1a.

KODAK POLYCONTRAST PAPER

Type of Paper: Variable-contrast medium speed enlarging paper.

Image Tone: Warm-black.

Safelight: Kodak Safelight Filter, Wratten Series 0C (do not use Series 0A!)

Grades, Speeds and Scale Index Values:

Filter	ANSI Speed	Approximate Scale Index	Negative Density Scale
PC 1	160	1.6	—
PC 1½	160	1.4	—
PC 2	160	1.3	—
PC 2½	160	1.2	—
PC 3	100	1.2	—
PC 3½	80	1.1	—
PC 4	64	1.1	—
No Filter	250	1.4	—

Tint, Brilliance, Surface, Weight & Symbol

Tint	Brilliance	Surface	Single Weight Symbol and Grades	Double Weight Symbol and Grades
White	Glossy	Smooth	F	F
White	High Lustre	Smooth	J	J
White	Lustre	Smooth	N, A(L.W.)	N
Cream White	Lustre	Fine Grained	—	G

Development Recommendations

Developer	Dilution	Recommended Time in minutes	Useful Range (in minutes)	Purpose
Kodak Dektol or D-72	1:2	1½	1–3	Normal Tones
Kodak Ektaflo, Type 1	1:9	1½	1–3	Normal Tones

Toning Recommendations: Kodak Brown Toner, Kodak Sepia Toner, Kodak Sulfide Sepia Toner T-7a, Kodak Polysulfide Toner T-8, and Kodak Hypo-Alum Sepia Toner T-1a.

KODAK POLYCONTRAST RAPID PAPER

Type of Paper: Fast, variable-contrast enlarging paper.

Image Tone: Warm-black.

Safelight: Kodak Safelight Filter, Wratten Series 0C (do not use Series 0A!)

Grades, Speeds and Scale Index Values:

Grade	ANSI Speed	Approximate Scale Index	Negative Density Scale
PC 1	320	1.6	—
PC 1½	320	1.4	—
PC 2	320	1.3	—
PC 2½	320	1.2	—
PC 3	200	1.2	—
PC 3½	160	1.1	—
PC 4	100	1.1	—
No Filter	500	1.4	—

Tint, Brilliance, Surface, Weight & Symbol

Tint	Brilliance	Surface	Single Weight Symbol and Grades	Double Weight Symbol and Grades
White	Glossy	Smooth	F	F
White	Lustre	Smooth	N	—
Cream White	Lustre	Fine-grained	—	G
Cream White	Lustre	Silk	—	Y

Development Recommendations

Developer	Dilution	Recommended Time in minutes	Useful Range (in minutes)	Purpose
Kodak Dektol or D-72	1:2	1½	1–3	Warm Tones
Kodak Ektaflo, Type 1	1:9	1½	1–3	Warm Tones

Toning Recommendations: Kodak Brown Toner, Kodak Sepia Toner, Kodak Sulfide Sepia Toner T-7a, Kodak Polysulfide Toner T-8, and Kodak Hypo-Alum Sepia Toner T-1a.

KODAK POLYCONTRAST RAPID-II RC PAPER

This paper combines the variable-contrast characteristics of Kodak Polycontrast Rapid papers with the water-resistant base of Kodak Resisto Paper, for fast processing, washing, and drying. It is available in two surfaces: N (smooth lustre) and F (glossy). The latter dries to a high gloss without ferrotyping. Both are on a medium weight base, approximately midway between single and double weight.

Paper Speed

Polycontrast Filter	PC1	PC1½	PC2	PC2½	PC3	PC3½	PC4	None
ANSI Paper Speed	250	250	250	250	160	100	50	320

Processing: This paper has the developing agent incorporated in the emulsion and is intended for rapid processing in the Kodak Royalprint Processor. It may also be developed in trays, and in roller-transport or continuous machines, using conventional developer formulas.

KODAK PORTRALURE PAPER

Type of Paper: Enlarging or contact-printing paper for portraits and exhibition prints.

Image Tone: Brown-black.

Safelight: Kodak Safelight Filter, Wratten Series 0C.

Grades, Speeds and Scale Index Values:

Filter	ANSI Speed	Approximate Scale Index	Negative Density Scale
None	50	—	Normal
PC-1	32	—	High
PC-3	20	—	Low

Tint, Brilliance, Surface, Weight & Symbol

Tint	Brilliance	Surface	Single Weight Symbol and Grades	Double Weight Symbol and Grades
Warm-white	Lustre	Fine grained	—	G
Warm-white	Matte	Smooth	—	M
Cream-white	Lustre	Tweed	—	R
Warm-white	High-lustre	Silk	—	Y

Development Recommendations

Developer	Dilution	Recommended Time in minutes	Useful Range (in minutes)	Purpose
Kodak Selectol	1:1	2	1¼–4	Warm tone
Kodak Ektaflo Type 2	1:9	2	1¼–4	Warm tone
Kodak Ektonol	1:1	2	1¼–4	Warm tone
Kodak D-52	1:1	2	1¼–4	Warm tone
Kodak Selectol-Soft	1:1	2	1¼–4	Lower contrast
Kodak Dektol	1:2	1	¾–2	Colder tone

Toning Recommendations: Kodak Rapid Selenium Toner, Kodak Poly-Toner, Kodak Gold Toner T-21, Kodak Hypo-Alum Sepia Toner T-1a, Kodak Brown Toner, Kodak Polysulfide Toner T-8, Kodak Sulfide Sepia Toner T-7a, and Kodak Sepia Toner.

KODAK RESISTO PAPER

Type of Paper: Contact printing paper on water-resistant base for rapid processing.

Image Tone: Neutral-black.

Safelight: Kodak Safelight Filter, Wratten Series 0C.

Grades, Speeds and Scale Index Values:

Grade	ANSI Speed	Approximate Scale Index	Negative Density Scale
2	10	1.3	Normal
3	10	1.1	Low

Tint, Brilliance, Surface, Weight & Symbol

Tint	Brilliance	Surface	Single Weight Symbol and Grades	Double Weight Symbol and Grades
White	Lustre	Smooth	N	—

Development Recommendations

Developer	Dilution	Recommended Time in minutes	Useful Range (in minutes)	Purpose
Kodak Dektol or D-72	1:2	1	¾–2	Normal tones
Kodak Ektaflo Type 1	1:9	1	¾–2	Normal tones

Toning Recommendations: Not recommended.

KODAK VELOX PAPER

Type of Paper: Contact paper for amateur and commercial use.

Image Tone: Blue-black.

Safelight: Kodak Safelight Filter, Wratten Series 0C.

Grades, Speeds and Scale Index Values:

Grade	ANSI Speed	Approximate Scale Index	Negative Density Scale
1	16	1.5	High
2	8	1.3	Normal
3	8	1.1	Low
4	3	0.9	Very Low

Tint, Brilliance, Surface, Weight & Symbol

Tint	Brilliance	Surface	Single Weight Symbol and Grades	Double Weight Symbol and Grades
White	Glossy	Smooth	F	—

Development Recommendations

Developer	Dilution	Recommended Time in minutes	Useful Range (in minutes)	Purpose
Kodak Dektol or D-72	1:2	1	¾–2	Cold Tones
Kodak Ektaflo Type 1	1:9	1	¾–2	Cold Tones
Kodak Versatol	1:3	1	¾–2	Cold Tones

Toning Recommendations: Kodak Sepia Toner, Kodak Hypo-Alum Sepia Toner T-1a, and Kodak Sulfide Sepia Toner T-7a.

Note: In addition to the contact-speed paper described above, there are three other kinds of Velox Paper: Kodak Velox Rapid, Velox Unicontrast, and Velox Premier. These materials are used mainly in commercial photofinishing on continuous-roll printers and processors.

INTRODUCTION TO BLACK & WHITE PROCESSING

The processing of black-and-white photographs consists of negative development, fixation, and sometimes aftertreatment; followed by printing, print development, fixing, and sometimes aftertreatment. Some specific problems in the processing of prints have already been covered in the introduction to the previous section. Here we wish to discuss development in more general terms, first. A more explicit discussion follows of the methods of processing negatives, some special processing methods such as reversal processing, low- and high-temperature processing, and a few words on stabilization.

The Photographic Process

Photographic materials, by and large, are coated with so-called* emulsions, consisting of a suspension of a silver halide in gelatin. The halide in question may be either silver bromide, silver chloride, silver iodide, or mixtures thereof. When they are exposed to light, some change occurs in the silver halide; the nature of this change has been the subject of extended investigation for many years and is still not entirely clear.

However, for our purposes, it is not necessary to know the nature of the change that occurs; it is sufficient to state that this change produces in the emulsion what is called a "latent image," and this in turn can be converted into a visible image composed of metallic silver by the action of a developer. Chemically, the action of the developer is the reduction† of the exposed silver halides to metallic silver, with the liberation of free halogen.

The image produced by development contains only part of the silver originally present in the emulsion. The unexposed silver halides remain substantially in their original form and must be removed from the emulsion in order to prevent their eventual blackening and the destruction of the visible image.

* Strictly speaking, an emulsion is a mixture of an oil with water or a mixture of two normally immiscible liquids, stabilized in some manner. In this sense, to call a suspension of silver halides in gelatin an "emulsion" is incorrect. However, the usage is now so well established that there is little chance nor any real need to alter it.

† The word "reduction" here is the correct one; chemically it consists in the removal of a cation from a compound, leaving the pure metallic element behind. This must not be confused with the photographic process called "reduction," which is the controlled removal of part or all of the silver image and is actually a type of oxidation process, the exact opposite of chemical "reduction."

This removal is accomplished in a "fixing bath," traditionally a thiosulfate, either of sodium or ammonium. Although this removes the silver halides, it leaves other residues in the emulsion, which would also be inimical to permanence; hence the final stage of processing is to wash the emulsion free of all chemicals.

A variety of aftertreatments is employed in various cases. Where a silver image is not dense enough for the desired purpose, it can be intensified, or as mentioned above, a too-dense image can be "reduced." Such processes can be performed on either negatives or prints; however, in most cases, they are limited to negative processing, since it is generally quicker and easier to remake a print than to attempt to save it by aftertreatment.

Aftertreatment applied to prints is usually limited to "toning," which changes the color of the silver image, either by changing the metallic silver to a silver sulfide, seleno-sulfide, or other silver compound, or by substituting some other metal for the silver. Various colors are produced in this way, such as iron-blue, copper-red, vanadium-green, and so on. Combinations of both methods are also used; thus, gold or iron is often applied to a sulfide image.

Variations in the basic process are also possible. For example, sometimes it is desired to develop the original film directly to a positive. Since a good deal of unexposed halide always remains after the first development stage, it is quite possible to "print" a positive image on the remaining halide; this is done merely by exposing the film to light immediately after negative development. The negative image is then removed by means of a bleach which is designed neither to affect the sensitivity of the remaining halide nor to produce a developable residue of the negative. After the negative image is bleached, the positive is developed and fixed in a substantially normal manner. Washing and drying are the same as in any other process.

Another special procedure is used in making positive prints, when the print is needed for a short time only and speed in processing is more important than permanence. In this case, a method known as *stabilization* is employed; the exposed print is developed and then treated in a solution that does not remove the remaining silver halides but converts them to a form that is substantially insensitive to light. The paper is then dried without fixing or washing.

Since the major purpose of this procedure is rapid access to a final image, other steps are taken to speed up the process. Usually, special papers that contain the developing agents in the emulsion are employed. They are processed in a machine that contains a highly alkaline activator in the first tank and a stabilizer in the second. The time of treatment, only a few seconds in each bath, cannot be accomplished by manual means. The activator and stabilizer baths used in these machines are trade secrets of the respective manufacturers and are not available for publication; in any case, they work best with the papers of a given manufacturer, and it is not possible to process ordinary papers in these machines with the baths normally used in them.

However, stabilization papers *can* be processed by normal manual methods if necessary. It is simply a matter of ignoring the presence of the developing agent in the emulsion and processing the papers in a normal print developer, stop bath, and fixer, followed by the usual washing and drying steps.

If, though, a print has been processed in the stabilization machine, it must not be washed before drying; washing will remove some of the stabilization chemicals and cause rapid fading. If it is necessary to make a stabilized image permanent, it is done by first immersing the print in a standard fixer/hardener bath, such as Kodak F-5 or similar formulas. After fixing, the print can be

washed and dried in the normal manner; if these steps are thorough, the print will be as permanent as any other print.

Since stabilization must be carried out in machines and with chemicals supplied by the maker of the paper and machine, no useful data are available on the process, and it will not be further discussed in this section.

Developers and Development

A practical developer must contain at least four major components:
1. The developing agent, or reducing agent.
2. The preservative.
3. The accelerator.
4. The restrainer.

The purposes of these four components are more or less obvious from their names. The developing agent, being a reducing agent or de-oxidizer, has a natural affinity for oxygen and will take it up from any source, including the air. Under these conditions it would oxidize and rapidly become useless. However, the preservative, usually a sulfite or bisulfite, also has an affinity for oxygen and when used in a developer solution tends to attract the oxygen of the air in preference to the developing agent. Thus, it leaves the latter free to operate on the silver halides in the film emulsion.

Since most developing agents are active only in alkaline solution, the so-called accelerator is actually an alkali of some kind, and its function is to establish the proper pH level in the solution in order to produce the desired activity of the developer. Having added an accelerator, it may seem strange to require also a "restrainer," but the function of the latter is not exactly the one implied by its name. Its purpose is not to reduce the activity level of the developer overall but to prevent the reduction of unexposed silver halides; in a sense, then, it is really an antifoggant. The most common restrainer is a bromide, usually of potassium, and in modern developers it does not actually slow down the action of the developer to any noticeable extent. Where the intention is to extend the time of development, it is usually accomplished either by simple dilution of the developer or by the addition of a "buffer" to reduce the alkalinity of the bath.

The Developing Agent. Over the past 50 years or so, a great many developing agents have been discovered, and at one time or another, almost miraculous properties have been attributed to nearly all of them. It is gradually being realized that the developing agent serves only to reduce silver halide to metallic silver and that there is little to choose from among the many chemicals that are capable of performing this function. Essentially, what is required is merely a high degree of selectivity; that is, the developing agent must reduce *exposed* silver halide to metallic silver as completely as possible, while affecting unexposed silver halide as little as possible.

The late Dr. C. E. K. Mees, in his *Theory of the Photographic Process* devotes some 36 pages to the chemical structure of the developing agents and then sums the matter up in the following paragraph:

"Owing to the flexibility of the developing agents, fortunately, it is possible to obtain a great variety of results with a few compounds. Thus the abundance of developing agents only increases the number of ways in which identical results can be obtained . . . "

Written over a quarter-century ago, this statement is today more apropos than ever. Moreover, time has shown that the huge proliferation of developing *formulas* was hardly necessary and perhaps not even desirable. They consisted, by and large, of the same five or six ingredients in varying proportions, and

the major difference among them was in rapidity of action. Variations in developers can, indeed, produce some useful variations in image color, and this is valuable in the case of developers for print papers, but there is little to choose from among the various formulas when used in the development of negatives.

The developing agents used today have been chosen from the vast number available, for certain specific properties. They are as follows:

1. p-Methylaminophenol and its salts (Elon, Pictol, Metol, Rhodol, and so on) is a rapid-working developer that brings up shadow detail very early in the process but produces density only with difficulty. For this reason, it is seldom used alone but is generally combined with agents that can produce greater density.

2. p-Dihydroxybenzene (hydroquinone, Quinol, and so on) is a slow-working developer that can build great density but tends to delay the appearance of shadow detail.

3. o-Dihydroxybenzene (pyrocatechin, catechol, and so on) is chemically related to hydroquinone and likewise produces high contrast with low shadow detail. It has the peculiar property of hardening gelatin in proportion to the amount of the silver in the image; hence its main use is in tanning developers for certain gelatin relief processes. It also produces brown tones on papers— its most popular function in modern amateur photography.

4. Trihydroxybenzene (pyragallol, pyrogallic acid, pyro, and so on) is an early developer, now all but obsolete. It produced a variety of results depending upon the alkalinity of the developer in which it was used; thus, it was a highly flexible developer, but its severe staining tendency caused it to lose popularity as more modern developing agents came into use. It also has a selective hardening action similar to pyrocatechin and is used in tanning developers.

5. Diaminophenol (amidol, Acrol, Diamol, Dolmi, and so on) is a very active, rapid developer that can work in neutral and even in acid solution; in most formulas the sulfite used for preservative supplies all the alkali needed as well. It was formerly very popular for the production of rich black tones on bromide enlarging papers, but it does not work well on modern chloro-bromide papers, and its keeping qualities are very poor. It, too, is nearly obsolete.

6. p-Hydroxyphenylaminoacetic acid (Glycin) is a slow and very clean-working developer, much used in early days for tank development. Although it had a reputation for producing very fine-grained negatives, it actually yields no advantage at all in this direction. It produces warm brown tones on papers, and its use is mainly in paper developers.

7. 1-Phenyl-3-pyrazolidone (Phenidone) is a recently discovered developing agent, similar in many ways to Metol but even more active. It is used in both film and paper developers and is preferred by those who are susceptible to dermatitis from Metol. Unlike Metol, though, Phenidone is never used alone; it is always combined with hydroquinone or some other developing agent. Alone it has low contrast and an excessive tendency to fog.

8. p-Aminophenol (Kodelon and others) is similar in its action in normal formulations to Metol, but is somewhat less active. It was formerly used in tropical developers and as a substitute for Metol by persons who were subject to dermatitis caused by the latter agent. Phenidone now takes the place of p-aminophenol in most cases. However, p-aminophenol has one unusual property; it combines with alkalis to form paraminophenolates, which are very powerful developers that work at high dilutions. Sodium paraminophenolate is the basis of such concentrated developers as Rodinal, but this cannot be

mixed in the normal manner; a special technique is required to form a stable solution of the developing agent.

Thus, the overwhelming majority of today's developers are compounded with combinations of Metol and hydroquinone or Phenidone and hydroquinone. The resulting combination has certain advantages over the use of either alone, and the results are not merely an average or compromise between the characteristics of the individual agents. When Metol and hydroquinone are combined in alkaline solution, they form a new developing agent, more active than either alone. It appears that Metol has the power to activate hydroquinone and give it more energy than it alone possesses. This property is known as *superadditivity* and is the main reason why nearly all modern developers use this combination of developing agents. Phenidone has the same property to an even greater degree; thus, whereas a given weight of hydroquinone requires ¼ of its weight of Metol to form a superadditive combination, it requires only about 1/40 of its weight of Phenidone. Therefore, developer formulas using Phenidone generally contain only about 1/10 as much of this developing agent as they would have Metol.

Another less well-known property of the Metol-hydroquinone combination is the preservative action of hydroquinone on Metol. In these developers, the hydroquinone is oxidized more rapidly than the Metol. This comes about because some of the hydroquinone is used up in reducing exposed silver halide to metallic silver, and some of it is used up in reducing oxidized Metol back to its normal state.

This is the real reason for the presence of hydroquinone in low-alkalinity, low-activity developers. For example, in the well-known Kodak D-76 Developer, the alkali used is borax, which has a fairly low pH. It is generally known that hydroquinone is practically inactive at this pH level; in fact, if the hydroquinone is omitted from the Kodak D-76 Developer formula, the developer will act almost exactly the same as it normally does. On the other hand, omitting the Metol and mixing the developer with hydroquinone alone will result in a bath that is practically inactive. It is evident from this that the hydroquinone takes little or no part in the developing action of the Kodak D-76 formula. If, though, the hydroquinone is omitted from a practical Kodak D-76 bath, the developer will oxidize quite rapidly and become totally inactive in a very short time. With hydroquinone present, on the other hand, Kodak D-76 is one of the most stable and long lasting of developers.

These two effects are separate and distinct; that is, the superadditivity of Metol and hydroquinone is not in any way related to the regenerative ability of hydroquinone on Metol. It is the combination of the two separate properties that makes the combination of Metol and hydroquinone so valuable that it has practically displaced all other developing agent combinations. However, the recently-introduced Phenidone has an even greater superadditivity than the Metol-hydroquinone combination, and it is now known that the regenerative action of hydroquinone is even more efficient on Phenidone than on Metol. For this reason, we may expect to see the use of Phenidone-hydroquinone combinations increasing steadily in the future.

Phenidone has one disadvantage: highly alkaline Phenidone-hydroquinone developers do not keep well at high temperatures. The difficulty is found mainly in highly concentrated stock solutions, which are usually of very high pH. Highly concentrated stock solutions should not be made or kept where temperatures are likely to run high; the best way to package developers for the tropics, for example, is in powdered form, ready to mix with water as

needed. Tank developers using replenishment systems are less affected by this problem, but the stronger, more alkaline formulas may give trouble in hot climates.

Phenidone-hydroquinone developers used at high pH levels also tend to produce more fog than Metol-hydroquinone formulas, especially with high-speed films. This particular type of fogging cannot be completely eliminated by the use of potassium bromide at reasonable levels, and an organic anti-foggant such as benzotriazole should be employed. The low pH developers such as the Phenidone-hydroquinone-borax negative developers are not usually susceptible to this type of fogging.

Preservatives

Since the developing agent is in effect a strong deoxidizing agent, it will combine quite readily with the oxygen in the air, as well as with any dissolved oxygen in the water used for mixing. To prevent this reaction, sodium sulfite is usually added to the developing agent as a preservative.

The action of the sodium sulfite was believed to be a differential one; that is, it was said to remove the oxygen from solution before the oxygen had had time to react with the developing agent. However, it does not actually work that way, and the real mechanism of the reaction is not clear. Experiment has shown, though, that the rate of absorption of oxygen by a mixture of sodium sulfite and hydroquinone is much smaller than the rate of absorption of each separately. Evidently, some new compound is formed by the mixture of hydro-quinone and sodium sulfite, which is particularly resistant to attack by at-mospheric oxygen.

Sodium sulfite is slightly alkaline in water solution, and a workable devel-oper can be made with nothing more than Metol and sodium sulfite (see for instance, Kodak Developer D-23). Because of this alkalinity, though, sodium sulfite will not completely protect certain developing agents, such as pyrogallol and diaminophenol. The preferred preservative in these cases is either potassium metabisulfite or sodium bisulfite, both of which are slightly acid in solution. Stock solutions of pyrogallol developers are often made by splitting the solution into two parts — the "A" part containing pyrogallol and sodium bisulfite and the "B" part containing the alkali and bromide. Diaminophenol is not stable even in the presence of sodium bisulfite and cannot be stored as a stock solution. Those who used amidol developers to any great extent usually kept a stock solution of sodium sulfite and potassium bromide, to which was added the diaminophenol in powdered form just before use.

A few high-contrast developers using hydroquinone alone as a developing agent also use sodium bisulfite as a preservative.

Accelerators

The activity of a developer depends in large part upon the alkalinity or pH of the solution. Thus, all developers must contain an alkali of some sort, whose function is to establish the proper pH for the desired activity level.

However, merely establishing the correct pH is not enough; a developer, to be used for any reasonable length of time, must maintain its pH at a constant level without the continual addition of alkali. It is perfectly possible to secure a fairly high pH with a very small amount of sodium hydroxide. Such a solution will lose its alkalinity very rapidly as this small amount of sodium hydroxide is exhausted. Adding more sodium hydroxide at the be-ginning will not solve the problem; the initial pH will be far too high.

Evidently what is needed is some kind of storehouse of alkali that will release it at a controlled rate as required, in order to maintain a constant pH level with an ample reserve of alkalinity. Such a system is known as a *buffered alkali,* and there are various ways of accomplishing the desired end. We can, for instance, use a strong and a weak alkali combined, as is done in some high-contrast developers, or we can use what are known in chemistry as *buffer salts,* which are capable of maintaining a limited pH range regardless of the amount in solution, within reason.

In chemistry, a buffer salt is defined as the salt of a weak acid and a strong base, or a weak base and a strong acid. Since carbonic acid is a weak acid and sodium a strong base, sodium carbonate is a buffer salt. It is found that after a certain amount of sodium carbonate is added to a solution, the pH reaches a more or less stable level and remains there with further additions. The pH attainable with sodium carbonate is a fairly high one; thus, this salt is used in most active developers.

Obviously, though, we cannot lower the pH of a sodium carbonate solution by reducing the amount of chemical; it will remain constant until there is so little carbonate present that the developer would be rapidly exhausted. Luckily, a variety of buffer salts is available, each with its characteristic pH range. For developers of low activity, we generally use borax — sodium tetraborate, which has a fairly low pH range, yet is capable of maintaining a constant level of activity over a long period of time.

Other pH levels are required on occasion; a higher level than is available from the use of sodium carbonate can be obtained by using potassium carbonate instead. This is seldom done, however, although certain now-obsolete formulas using glycin as a developing agent required potassium carbonate to attain their full activity.

Intermediate activity levels between those of sodium carbonate and borax are available through the use of sodium metaborate and the proprietary Kodalk Balanced Alkali, which is similar to it in action.

Remembering that the buffer range of any one of these salts depends upon the comparative strength of the base and weakness of the acid, it is evident that some control of pH is possible within the range of each of them. Thus, the addition of boric acid to a borax developer drops the pH to a lower level and reduces the activity of the developer. This was done in the now obsolete "buffered borax" developer Kodak D-76d, to slow down its action on very fine-grain films and supposedly to produce lowered graininess as well.

It is possible, likewise to reduce the activity of sodium carbonate developers by the addition of sodium bicarbonate, which contains carbonic acid and thus lowers the pH. However, this is seldom worthwhile, since the pH is then merely dropped into the range that is more easily attained by the use of sodium metaborate.

One can also raise the pH of an alkali by adding sodium hydroxide to it; again, the overlap between existing alkalis makes it unnecessary, although sometimes very active developers use a carbonate-hydroxide mixture. Adding sodium hydroxide to borax produces results just about identical to those obtained with sodium metaborate.

It should be obvious from this that the sole function of the alkali in the developer is to attain the pH level required for a desired level of activity. It has no other function, and there is no reason to believe that one alkali will produce results superior in graininess, detail, or gradation to any other alkali used at the same pH level.

The Restrainer

It may seem contradictory to add a restrainer to a bath which has just had the addition of an accelerator, but actually, the term "restrainer" is a misnomer. The use of a soluble bromide in a developer is not intended to "restrain" the action of the developing agents; its function is to improve the selectivity of the developing agent. That is, it is intended to prevent the developer from reducing unexposed silver grains to metallic silver, while leaving it free to produce a metallic silver image from the exposed grains.

This action of the soluble bromides is only relative; any developer will eventually turn a film black all over if the film remains in the bath long enough. Thus, it is merely a question of holding back fog formation for the time needed to secure an image of the desired contrast. Obviously, then, high-contrast developers use more bromide than low-contrast baths, and many soft-working negative developers, such as Kodak D-76, initially contain no bromide at all.

Such a developer can produce the maximum emulsion speed of which a film is capable, because bromides in any notable concentration will not only reduce fogging but will also hold back the development of grains that have received only minimal exposure.

However, a developer that is free of bromide when mixed does not remain so in use. The act of development, in which silver bromide is reduced to metallic silver, sets free the bromide ion, which combines with the sodium in the developer to form sodium bromide. The amount is small but builds up as more film is processed, and a developer in continual use tends to lose shadow detail in the developed images as the exhaustion point is approached. The effect is greatest with developers that initially contained no bromide; those developers like Kodak D-19 that contain a sizable amount of potassium bromide to begin with are less affected by bromides released during use. Thus, the presence of a bromide in a developer tends to stabilize its action, at the expense of some loss of emulsion speed.

Potassium bromide is effective to a different extent with different developing agents. Metol is quite sensitive to bromides, and only a small amount is needed to control its action. Hydroquinone is much less sensitive to bromide addition, and large quantities of potassium bromide are usually used in high-contrast hydroquinone developers. The amount of bromide used in paper developers is usually high because fog in prints is less tolerable than on negatives; however, excess bromide in a paper developer can adversely affect the tone of the image, making the blacks greenish to begin with. Large amounts of bromide in a paper developer are sometimes deliberately used to produce warm black and brown tones.

Other antifoggants are used besides the soluble bromides: benzotriazole and 6-nitrobenzimidazole nitrate are two popular organic fog inhibitors. Developers containing Phenidone require these organic antifoggants; bromides alone are not capable of eliminating fog with Phenidone in high-contrast formulations. Benzotriazole in conventional Metol-hydroquinone developers for papers not only controls fog very effectively; it also tends to improve the image tone of the paper, leaning toward blue-black results.

Combinations of both types of restrainer are sometimes used, especially in Phenidone developers; the organic antifoggant is used to restrain fog production, whereas the bromide is used to stabilize the developer in terms of exhaustion life due to the release of soluble bromides during processing.

166

The organic restrainers have a more powerful fog-inhibiting effect than soluble bromides, with less effect on film speed; for this reason, these chemicals are used where development must be carried out at high temperatures or where processing must be greatly extended for special purposes. They are also useful in salvaging photographic materials that have deteriorated with age or have been stored under adverse conditions.

Other Ingredients

At one time, there was a good deal of experimentation with developer formulas intended to produce fine-grain images on medium- and high-speed films. One or two such formulas containing ingredients that were essentially silver solvents did, indeed, produce some small reduction in graininess, usually at the expense of some loss in film speed. One such developer was the very popular Kodak Developer DK-20, which was essentially a Metol-sulfite-borax formula, containing a small amount of sodium thiocyanate, a powerful silver solvent.

These developers of the solvent type did have some useful effect on the coarse-grained films of the nineteen thirties, but it was eventually noted that the solvent action tended to destroy edge sharpness in the image, and pictures developed in them, although finer grained, actually appeared less sharp than those developed in coarser-grained formulas.

These formulas had another fault; the dissolved silver remaining in the bath caused serious fogging of the dichroic or "two-color" type, especially if the bath were used only intermittently. The effect is very serious on modern fine-grain emulsions, and Kodak Developer DK-20 is not recommended for use with any modern film type. Actually, there is no reason to use it anyway; modern films are designed for minimal grain and maximum sharpness in normal developers of the Kodak D-76 type, and a solvent developer will merely produce lower emulsion speed and poorer image sharpness.

Some experimenters during the thirties added other chemicals to the developer on a trial-and-error basis; one such addition was resorcinol, which has a chemical relationship to hydroquinone and was believed to have some useful effect in the developer. There is little evidence that such additions really accomplished anything except to reduce the activity of the developer slightly; this could as easily have been accomplished by lowering the pH of the accelerator. One such developer called for the addition of nickel sulfate, then filtering out the precipitate that resulted. Probably all that was accomplished by this procedure was the slight lowering of pH as a result of the loss of carbonate in the form of the nickel carbonate sludge. The same result could have been attained by simply using less sodium carbonate in the first place.

There are a few useful additives that are occasionally used in developers. Developers designed for very short development times somtimes contain a wetting agent to ensure rapid and uniform penetration of the film emulsion by the developer. Such wetting agents include the sulfonated fatty alcohols (Duponol, Dreft, and so on) or one of the Aerosols (Aerosol OT). Generally, though, it is preferable to use a wetting agent as a prebath before development; there is not much evidence that wetting agents incorporated in the developer have any very great effect. Where a formula specifically calls for a wetting agent, it should be used, but there is not much benefit to be expected from the indiscriminate addition of wetting agents to normal developers.

Another additive is a water softener; in areas where the water supply contains a good deal of calcium, these are quite beneficial. Calcium salts react with the sulfites and carbonates in developers and fixing baths to form sludgy

precipitates. These precipitates can only be removed from a film if they are detected before drying; a bath of 2% acetic acid after completion of washing will usually eliminate calcium sludge. Once dried on the film, however, they are irremovable. Where hard water must be used, calcium sequestering agents (called *water softeners* and sold under such trade names as Kodak Anti-Calcium, Calgon*, and so on) added to the developer will prevent the formation of sludge and its deposition on the film.

These water softeners are usually complex sodium polyphosphates (Calgon is sodium hexametaphosphate), and they are generally used in quite small concentrations, most often about three grams per liter of solution.

Replenishment

For small-scale, infrequent amateur processing, it is best to use a fresh developer for each roll of film and to discard the used solution at once. This avoids any chance of non-uniformity from roll to roll and is probably the safest method, especially where valuable pictures are concerned.

However, the professional photographer working on a large scale will find it necessary to maintain a large tank of developer to handle many films at one time; such a quantity of chemicals cannot be economically replaced at short intervals. A large tank of developer, used over a period of time, suffers a gradual loss of activity due to depletion as well as to the accumulation of bromides and other by-products of the reaction. This loss of activity depends upon a number of factors, including the amount of film processed, the amount of developer surface exposed to the air, and to a lesser extent, even the nature of the negatives developed; overexposed images deplete a developer more rapidly since more silver is reduced. If, then, results are to be consistent day to day, some method of maintaining the activity of the developer at a constant level must be employed. The usual method is the addition of measured amounts of a replenisher bath at specific intervals.

Replenishment systems depend upon a number of factors:

1. Loss of developer volume due to carry-out on processed film.

2. Increase of developer concentration due to evaporation of water.

3. Loss of developer activity due to exhaustion of developing agents.

4. Loss of developer activity due to liberation of soluble bromides from the processed film.

Of the four factors, the second—evaporation loss—is usually ignored, because it is very small in proportion to the others. The remaining factors have to be taken into account.

If very much developer is lost by carry-out, it may be replaced with an equal quantity of fresh developer. In most systems, though, drainage or squeegeeing is employed to minimize carry-out; thus, it is often necessary to *remove* some developer from the system at intervals to make room for replenisher.

The design of a replenisher, then, depends mainly upon the last two factors. Loss of developer activity due to exhaustion of developing agents may be compensated for by the use of a replenisher that contains a larger-than-normal quantity of the developing agents than the original formula. Loss of activity due to accumulation of soluble bromides is compensated for by the omission of bromide from the replenisher.

The exact composition of a replenisher, though, depends upon the system in which it is to be used. In automatic processing machines, a metering device

*But avoid "Calgonite," which contains a detergent as well as a water softener.

automatically removes a definite quantity of used developer from the tank and replaces it with replenisher in a quantity sufficient to maintain the correct level of solution in the tank. In such systems, equilibrium is maintained by periodically developing a test strip and measuring the gamma obtained. If the gamma is found to be diminishing, the replenisher system is adjusted to feed more replenisher and drain off more used developer. If, on the other hand, the gamma is rising, then less replenisher is fed and less developer runs to waste. Obviously, such a system can only be maintained where complete sensitometric control is available, as in a motion picture developing laboratory or a large photofinishing plant.

For the average professional photographer, whose daily requirements are more modest, the replenisher formula is designed on a slightly different basis; its strength is adjusted so that it is only necessary to maintain the level of the tank by periodic additions of replenisher. The amount of replenisher added, then, is dictated by the amount of film processed and the quantity of developer carried out of the tank by the film. Under normal circumstances, this simple system can maintain a fairly constant level of developer activity for a period of several weeks. Generally, such systems are maintained on a periodic basis; replenishment is carried out for a limited time, generally until a quantity of replenisher equal to the original volume of the basic bath is used up. As an example, using a standard 3½ gallon tank, when 3½ gallons of replenisher have been used up, the system is drained and refilled with fresh solution.

Such a system cannot be maintained indefinitely, and this periodic refilling is essential. This is because the build-up of soluble bromides from the film eventually reaches a point at which loss of shadow detail becomes serious. Even if the replenisher contains no bromide at all, not enough old developer is being carried out of the tank, and the bromide level increases to an unacceptable degree. Furthermore, since recirculation is usually not used in small tank systems, there is no continuous filtering of solutions; eventually dirt and sludge in the developer tank reach a concentration that demands removal and cleaning.

As has been pointed out, in machine processing systems with developer circulation and storage tanks, none of these difficulties arises. Sufficient old developer can be removed from the system to maintain a constant level of soluble bromides, while the circulating pump system always contains filters and strainers so that solid matter and sludge are continually being removed and the system is kept clean at all times. Nonetheless, the storage tanks themselves eventually accumulate so much slime, scale, and so forth that the machines must be periodically emptied, cleaned, and refilled.

For most consistent processing, it is often the practice to "prime" a fresh tank with a portion of old developer added to the new. A developer that is being continually replenished is not the same in composition as either the original developer or the replenisher. There is a point at which the system stabilizes, where soluble bromide levels, developing agent exhaustion, and other factors reach a desirable level. If, then, we start up a machine with a fresh bath, it will, until it becomes stabilized, produce either excessive contrast, excessive density, or both. Although it is possible to analyze a used developer and devise a formula for a starting bath that corresponds to it in activity, plants that do not have analytic facilities simply start each new run with about one-quarter of a tank of old developer, filled to level with fresh bath. The old developer is, of course, thoroughly filtered before being put back into the tank.

Where analytic facilities are available, the ideal system would be to analyze the developer at frequent intervals and to add then a specially for-

mulated replenisher designed to bring the solution back to its normal composition. This is done, in fact, in the largest motion picture processing plants, but it is not practical on a small scale.

Fixing Baths

A plain solution of sodium thiosulfate (hypo*) will dissolve unexposed silver halides and accomplish the primary purpose of fixation. However, plain hypo does not make a satisfactory fixing bath for other practical reasons.

Some developer is always carried over into the hypo, on the surface of the film or within the gelatin coating. This, in a neutral hypo bath, will oxidize rapidly and possibly cause stains on subsequent films; in addition, such developer as is in the pores of the film will continue to operate until fixation is complete and may result in image streaks. For this reason, it is desirable to have the fixing bath in an acid condition, and the simplest way to accomplish this is to add some salt of sulfurous acid, such as sodium bisulfite or potassium metabisulfite. These will not react with the hypo itself but will make the bath sufficiently acid to keep it clear and to neutralize developer carry-over.

Such a bath is satisfactory for papers and even for films in cold climates, but where temperatures rise above 68 F (20 C), there is danger of swelling the gelatin with subsequent damage to the image. For most work, therefore, a fixing bath containing a hardener is desirable, and the usual hardener is potassium or sodium aluminum sulfate, known as potassium alum or sodium alum.

We cannot add alum directly to plain hypo; it will react with the sodium thiosulfate to form a white sludge of aluminum sulfite. Some acid is required to prevent this reaction, and although sodium bisulfite will work, it does not contain sufficient acid to maintain the solution in good condition for a long enough time. As in the case of the developers, we must resort to a "buffer."

In this case, we use a combination of acetic acid and sodium sulfite; the result is to liberate sulfurous acid in the solution in sufficient quantity to produce optimum hardening by the alum, while protecting the bath from reactions that would cause sludging. As acid is used up in neutralizing carried-over developer, the combination of sodium sulfite and acetic acid liberates more sulfurous acid, thus maintaining the acidity of the solution at the more or less optimum level.

It would appear here that any acid would do, but this is not the case. As previously explained, a buffer is a salt of a strong base and a weak acid, or vice versa. Since we are using sodium as the base, only weak acids, such as acetic, can be used; sulfuric acid, being a strong acid, is not suitable since no buffer action would result. Sulfuric acid *is* used in chrome alum fixing baths because chrome alum will not harden in the presence of organic acids, but such baths have a limited life and must be frequently replenished with small portions of sulfuric acid to maintain the correct pH within a narrow range.

The minimum practical hardening fixing bath, then, contains the following ingredients: 1) sodium thiosulfate, 2) sodium sulfite, 3) acetic acid, and 4) potassium alum.

The bath must be mixed in the order given here, because unwanted reactions will occur between the ingredients if they are mixed in any other order. Having dissolved the hypo first, we cannot add either acid or alum to it, because a sludge will precipitate in either case. The sulfite, therefore, must be

* An old but incorrect name for sodium thiosulfate was "sodium hyposulfite" and this name was shortened by photographers to "hypo". Strictly speaking, sodium hyposulfite is a different chemical, otherwise known as sodium hydrosulfite or sodium dithionite. This is a powerful fogging agent, sometimes used as a bleach.

added next to protect the hypo. Now, we cannot add alum to a hypo-sulfite mixture; they will react to form aluminum sulfite, which is insoluble. Thus the acid comes next and the alum last of all.

Although the combination of sodium sulfite and acetic acid has the necessary buffering action, it tends to become exhausted while the hypo is still active; this exhaustion is indicated by the appearance of the sludge of aluminum sulfite. Modern fixing baths use a second acid—boric acid—as a further buffer and source of reserve acidity. These baths remain clear and free of sludge until the hypo itself is actually exhausted. In addition, it appears that boric acid improves the hardening action of potassium alum, and the hardening powers of boric-acid buffered fixing baths remain substantially constant throughout their lives.

As already mentioned, a simple fixing bath of hypo acidulated with sodium bisulfite is workable with papers when hardening is not required. Such simple fixing baths are sometimes required in special processes when the hardening produced by alum is considered undesirable. The sodium bisulfite will produce sufficient acidity to neutralize a reasonable amount of developer; yet it does not react with or decompose hypo.

In tropical processing, where extreme hardening of the gelatin is necessary, potassium alum is not adequate, and usually a solution of potassium chrome alum is used as a hardener. However, this produces maximum hardening only in a separate bath, between development and fixation. Potassium chromium sulfate reacts with sodium sulfite to form an intermediate material that loses its hardening powers very rapidly. In addition, chrome alum does not develop optimum hardening ability with organic acids such as acetic acid; it must be used with sulfuric acid, which, being unbuffered, can be used only in small amounts. Therefore, the bath will have a very limited life unless it is frequently replenished with small amounts of acid.

Chrome alum is a deep blue-violet color in crystal form and dissolves to form a blue-violet solution when used alone or with sulfuric acid. Sulfite or hypo changes the color of this solution from blue to green; when the chrome alum bath is used as a separate hardener, sulfites carried over from the developer will change its color from blue to green to yellowish green, and the latter color indicates exhaustion of the bath. When, however, chrome alum is used in a fixing bath, the color is green as mixed and indicates nothing. Such a bath will harden well when freshly mixed, but its hardening power falls off rapidly, with or without use.

Because of this poor keeping quality, chrome alum fixing baths are not used to any large extent except in tropical processing. Furthermore, chrome alum baths have some tendency to stain films and an even greater tendency to stain papers. They are, therefore, not recommended as paper fixers in any case.

Formalin (Formaldehyde in 40% solution) is a powerful hardener of gelatin under some conditions. It works only in alkaline solution; hence it cannot be added to an acid fixing bath (although one or two alkaline formalin fixers are used in certain color processes). It also tends to combine with the carried-over developing agents, and the combination product of formalin and hydroquinone may actually soften gelatin instead of hardening it. For this reason, formalin hardeners are used mainly as prebaths, before development, or else as post-hardeners, after fixing and washing. This latter procedure is used mainly as a precaution against reticulation in such post-treatments as intensification, reduction, or in the case of prints, toning.

Hypo Eliminators

Although it usually requires nothing more than thorough washing to remove hypo and the associated silver complexes from the emulsion, there are times when extended washing is impractical, and a means of cutting down the washing time is desirable. This may be due to water shortage or the need of having a finished and dried negative in the shortest possible time.

In the latter case, it may be best simply to rinse the negative briefly to remove surface chemicals and then to dry it and make the required prints. After printing is completed, the negative should be placed in a fresh acid fixing bath for a short time, to remove any undissolved silver complexes, after which it should be thoroughly washed and dried in the normal manner. If this procedure is carried out within a fairly short time, the negative will be as permanent as one that has been fixed, washed, and dried in the normal manner.

The big problem in washing is the tenacity with which hypo and the silver-thiosulfate complexes cling to the gelatin of the film emulsion. Over the past half century, a great many chemical treatments have been proposed, all of which were said to turn the thiosulfates into other forms with less attraction to gelatin, hence could be washed out more easily. Early *hypo eliminators* consisted mainly of ammonium salts, which were supposed to convert the sodium thiosulfate into ammonium thiosulfate, which was believed to be easier to wash out of gelatin. Staining and damage to the emulsion, however, is due to decomposition of the thiosulfate ion, and so this system did not work; unless washing were thorough after either sodium or ammonium baths, the negative would eventually be damaged.

Another approach is merely to use a mild alkali bath, on the principle that at higher pH levels, washing is more thorough and can be accomplished in a shorter time. This method is mainly of value in areas where water tends to be acidic and washing is slower than normal.

Modern hypo eliminators work on a different principle; they are designed to oxidize the thiosulfates to simple sulfates, which are more or less inert and do not tend to damage a silver image, even if not completely washed out. Such hypo eliminators are not used, however, for the sake of cutting down on washing time, but rather, where maximum permanence is required for archival purposes. They contain such oxidizers as potassium permanganate, sodium hypochlorite, various persulfates, iodine, potassium perborate, and hydrogen peroxide. All are capable of attacking silver images, hence can only be used in very dilute solutions. They are, therefore, effective only as post-washing baths, after the bulk of the hypo has been eliminated by normal washing. The remaining traces of hypo are thus converted to very small amounts of sulfate, which have little effect on the image and in addition, being highly soluble, are easy to wash out of the film.

In general, the problem of washing negatives is not a difficult one, and archival permanence can be attained with routine washing, without using a hypo eliminator. The main value of hypo eliminators is in prints; papers tend to adsorb the thiosulfate complexes to the fibers of the paper, rather than to the gelatin of the emulsion coating. The most commonly recommended formulas for hypo-elimination in printing contain ammonia and hydrogen peroxide. The treatment in this bath is followed by thorough washing; it is not intended as a time saver.

Other treatments known as *hypo clearing baths* are not actually hypo eliminators; they are merely mild alkalis of one sort or another, and their major function is to increase the solubility of the hypo and silver complexes

and also to expand the pores of the gelatin emulsion so that it will admit water more freely and release the salts from it. These solutions do shorten washing times somewhat but do not entirely eliminate the need for washing.

Exhaustion of Fixing Baths

A fixing bath becomes exhausted in use, just as does a developer. However, the mechanism of exhaustion is quite different, and replenishment is seldom possible.

Unlike a developer, a fixing bath does not lose volume by carry-out; this is because a film is brought into the bath wet with the previous solutions and carries in about as much liquid as it carries out. However, this poses a problem in contamination, which is usually eliminated by using a wash or stop bath between developer and hypo. In this case, though, what is being carried in is mostly plain water, while full strength fixing bath is being carried out. Thus, the effect of carry-over is to dilute the bath over a period of time.

The rinse before fixing is seldom long enough to completely neutralize the developer; hence the film is still in somewhat alkaline condition when immersed in the fix, and this must be neutralized by the acid in the fixing bath. This acid is thus gradually exhausted during use; this, in turn, diminishes the hardening power of the alum in the bath.

Finally, the fixing action of the bath diminishes with use, but this is not due to exhaustion of the thiosulfate; it is due to saturation of the bath by silver salts. In the case of high-speed film emulsions, some silver iodide is usually present, and this is dissolved by hypo with considerable difficulty. In addition, the accumulation of iodine in the fixing bath diminishes the solubility of silver bromide and slows the action of the fixer. Because of the accumulation of iodides, fixing baths that have been used for films should not thereafter be used for fixing papers.

However, the end of the useful life of a fixing bath is mainly due, as mentioned above, to the accumulation of silver salts, even when only silver bromide and chloride emulsions are being processed. The first step in the solution of silver bromide is its change to a complex silver-sodium thiosulfate salt. This is not soluble in water but is soluble in fresh fixing bath. Thus, the apparent clearing of a film is not a sign that fixation is complete; a fixing bath can be exhausted while visibly it still has the power to clear a film.

Since, then, exhaustion of a fixing bath is not due to loss of hypo but to its saturation with silver salts, it is not possible to replenish a fixing bath by the addition of fresh hypo. It is possible to replenish the hardening agents, such as the acid and alum components, but in the case of modern fixing baths using boric acid, hardening is maintained after the bath has lost all its fixing power, hence replenishment of the hardener components is not necessary.

There is no simple way of removing the silver salts from the bath in small-scale operations. In large processing plants, electrolytic silver-reclaiming units are employed, and small silver recovery devices are available to photographers as well. Their value is mainly in the recovery of the dissolved silver, not in the restoration of the fixing bath to active use. In large scale operations, it has been found that the desilvered hypo requires the addition of acid and other ingredients, and even so, is seldom usable for more than an additional 50 per cent of its original life. On a small scale, silver recovery is not economical; there is not enough silver in a small amount of used hypo to justify the cost and labor of recovering it.

Aftertreatment of Negatives

There are two major aftertreatments that are usually applied to negatives—intensification and reduction.

Intensification consists of the addition to the silver image of either more silver or some other metal, to increase the density of the image. Obviously, such a process is useful where detail exists but density is insufficient; that is, in the case of negatives that were correctly exposed but accidentally underdeveloped. Underexposed negatives have no detail in the shadows, and no intensifier can put detail into an image that lacks it in the first place.

The various metals added to the image to increase density include mercury, chromium, silver, copper, and uranium; the latter, even in its inert form, is not easily obtainable today, and formulas for its use generally come from abroad.

Mercury Intensification. The mercury intensifier employs a salt of mercury, such as mercuric chloride or mercuric iodide, which bleaches the silver image to a mixture of silver chloride and some mercury salt. The bleached image is then blackened, either in an ammonia or sodium sulfite bath, or in a fairly strong Metol-hydroquinone developer. The result, in either case, is to restore the image to its original black color, but with considerably increased density, because in the process not only is the silver chloride reduced to metallic silver but, in addition, some mercuric salt is also reduced to metallic mercury. The process, where a developer has been used, can be repeated, and some further increase in density can be obtained; if, on the other hand, too much density has been added, the image can be reduced with a very weak solution of sodium thiosulfate.

Mercury-intensified images, if ammonia or sulfite blackeners are used, are of limited permanence; if the image has been blackened in a developer, permanence is better.

There are two special mercury intensifiers—one is known as *Monckhoven's Intensifier* and employs the usual mercuric salt bleach, followed by a special blackener composed of silver nitrate and potassium cyanide. This intensifier produces a very great increase in highlight density; at the same time, the cyanide has the property of attacking the thinner parts of the negative and actually dissolving them out. The result is an enormous increase in image contrast; so great, in fact, that the process is usually used only for line negatives in photomechanical work where it serves to intensify the blacks and clear the whites in a single operation.

One other mercury formula is that containing mercuric iodide and sodium sulfite. It differs from the others in that it is a single solution, and separate bleaching and blackening steps are not required. It is not affected to any degree by hypo, and the negative can be placed in it with only a short rinse after fixing. The negative gains density in the bath, and the process can be followed and watched as the negative gets darker. After the desired degree of intensification is obtained, the negative is removed from the bath and thoroughly washed before drying. Permanence is only fair; the intensified image may stain in time, but this can be prevented by treating the negative in a strong black-and-white developer for a short time after intensifying and washing.

Chromium intensification. The system for intensification with chromium is similar to the mercury method in principle; that is, a bleach is used, containing, in this case, chromium instead of mercury. The bleached image is blackened in a developer or by other means, and the resultant image contains a mixture of silver and chromium, the latter supplying the added density.

174

Negatives must be thoroughly washed after fixing and before treatment in the chromium bleach; the bleached image contains silver bromide, which is attacked by hypo. The negative is treated in the bleach, which consists of potassium bichromate and hydrochloric acid or potassium bromide, or both, until the image is a creamy white color throughout. It is washed until free from the yellow stain of the bichromate, then redeveloped in a strong Metol-hydroquinone developer. Developers containing a large amount of sodium sulfite such as Kodak Developer D-76 are not suitable for this purpose.

The redeveloped image contains both silver and chromium in metallic form and is substantially neutral in color and fairly permanent. The process may be repeated to secure further intensification.

Color Intensification. There is a method of intensification in which little density is actually added to the image; instead, the color of the image is changed to one with a higher opacity to blue light to which most papers are sensitive. Thus, although the negative may appear no denser than it was before toning, its *printing* density is increased a great deal, as can be seen by examining the intensified negative through a blue filter.

In general, to increase blue density, the color should be red, orange or yellow, or similar shades of brown. Uranium toners produce a brick-red color with a very high density to blue light; however, the availability of uranium salts is subject to some restrictions. The well-known copper toner, producing a red-chalk color, is likewise a good intensifier and is, indeed, sold in package form for this purpose. A very useful degree of intensification can be produced by the use of any of the bleach-and-redevelop sepia toners, which use a ferricyanide-bromide bleach followed by sulfiding of the image.

No matter which toning method is used (except the rather special Monckhoven's Intensifier), the effect on image gradation is much the same. The added density is applied in proportion to the amount of silver already present; hence the greatest density will be added to the highlights, the least to the shadows. The result is to increase contrast, in almost exactly the same manner as if the original development had been carried on for a longer period of time. Obviously, it cannot add density where none exists to begin with, so that an underexposed negative lacking in shadow detail cannot be usefully improved by intensification. However, a correctly exposed negative that has accidentally been underdeveloped can be brought to a useful printing contrast by any of the above methods.

Harmonizing. The bleach-and-develop type of chromium intensifier has an interesting further possibility—it can be used to improve the contrast of the highlights without much effect on the shadow detail. A process discovered by J. Eder and called *harmonizing* consists of first bleaching the negative in the usual chromium bleach, containing potassium bichromate, hydrochloric acid, and potassium bromide. After washing the negative is immersed in a rather weak developer, but the process is not carried to completion. The faint shadow detail returns almost at once in the developer, and its density is actually increased somewhat by the usual process of chromium deposition.

Highlight densities redevelop rather slowly in the weak developer, and the process may be stopped at any time the desired density is reached. The negative is then rinsed and fixed. This removes the part of the bleached image that has not redeveloped, thus reducing the highlight density. What we have, then, is a negative in which the faint shadow detail has been intensified and the highlights reduced and made more printable.

Again, it must be emphasized that no intensifier can put shadow detail where none existed originally, but in the case of a negative that is too dense in the highlights, while having some slight shadow density visible, the process can improve printability to a notable extent. The process is most useful in the case of negatives that are only slightly underexposed and that have been forced in development in an attempt to bring out the shadows.

Reduction

As generally accepted among photographers, the term *reduction* refers to the selective removal of silver from parts of the image. The word is an unfortunate choice; it can be confused with the chemical term "reduction," which is the process used in the development of the silver image; chemically, the process of image "reduction" is a form of oxidation, which is the exact opposite. It would have been preferable to use a word such as "weakening" to describe the process; this terminology is, in fact, used in other languages.

Be that as it may, reduction in this sense is the process of removing some silver from the developed image, in order to make the negative less dense and easier to print. Since excessive density in a negative may result from overexposure, overdevelopment, or both, different methods are required for aftertreatment according to the basic cause.

For instance, overexposure produces a heavy negative lacking in contrast, whereas overdevelopment produces a heavy negative with too much contrast. Obviously, in the first case we wish to reduce density and increase contrast; in the second case we should like to decrease both density and contrast at the same time. By the proper choice of a reducer, either situation can be handled.

Reducers fall into the following three classes:

1. *Cutting reducers,* which actually attack the entire negative uniformly; since less silver exists in the shadows, these are thus lightened more than the highlights, and the effect is to increase the contrast of the image.

2. *Proportional reducers,* which attack the silver image in proportion to the amount of silver present. Since they attack the highlights at a greater rate than they remove silver from the shadows, their effect is to lower the contrast of the negative, in effect reversing the action of the developer. They are most useful in treating negatives that have been correctly exposed or slightly overexposed and accidentally overdeveloped. No strictly proportional reducer exists, but combinations of reducers that closely approximate the desired action can be made.

3. *Superproportional reducers* remove density at a greater rate from the highlights than from the shadows. These reducers have little effect on shadow detail but remove density rather rapidly from the highlights. Their major use is in the correction of negatives that have been forced in development in an attempt to bring up highlight detail lacking due to underexposure. The major reducers of this type all employ ammonium persulfate, although the Eder process of harmonization may be considered to fall into this class.

These three classes are not mutually exclusive. For instance, the well-known Farmer's Reducer definitely falls into Class 1 (cutting reducers) when normally mixed as a single solution of considerable strength. When the solution is mixed weaker, the cutting effect is less marked, and when it is used as two separate solutions, applied to the film in succession, the action is almost proportional. This latter procedure is a very useful one because of the great control possible; the film is immersed for a short time in the ferricyanide bath and is then put into the hypo, which clears out the small amount of bleached

silver and stops the action completely. If the amount of reduction is not sufficient, the first step may be repeated and again stopped with the hypo bath. The advantage of the procedure is its safety; since the action of the reducer is stopped completely by the immersion in hypo, the operator has ample time to inspect the result and decide whether to accept it or to try additional reduction.

This two-bath method has another advantage; the individual solutions have good keeping qualities, whereas a mixture of hypo and ferricyanide decomposes rapidly and must be used within five minutes of mixing. However, this rapid decomposition is not always a disadvantage; the bath as used by photoengravers for dot-etching can be made very nearly self-timing by proper adjustment of the ferricyanide-hypo ratio. For normal photography, however, the self-timing formula is likely to be too active and is not recommended.

A strong Farmer's Reducer solution is also useful for clearing up a slightly fogged negative; if properly used, it will remove the fog almost completely without any large effect on image densities. This method is also used to remove the colloidal silver antihalation layer from color films that have been accidentally developed in a black-and-white negative developer.

Aftertreatment of Prints

Paper prints can be treated in the same manner as negatives; however, prints are seldom if ever intensified. For one thing, it is easier to make a new print than to attempt to save a bad one; for another, almost all intensifiers have some staining action and tend to spoil the whites of the print.

Likewise, reduction of prints is seldom done merely to save an over-exposed print; again, it is easier and better to make a new print. However, selective reduction by the use of a reducer on a swab or brush can be used to emphasize tones, brighten highlights, or clear muddy shadows. This is an expressive technique often used by the makers of exhibition prints.

Farmer's Reducer sometimes produces an irremovable yellow stain on paper prints; hence local reduction is often done with the iodine-cyanide reducer, which is nonstaining. However, the use of cyanide baths is dangerous, and the process if used, must be done in a very well-ventilated area. Increased contrast in prints can be attained by making a print rather too dark and then reducing the entire print in the iodine-cyanide reducer. Evidently, the action of the iodine-cyanide formula on paper emulsions is that of a cutting reducer.

In any case, reduction is a process of minor importance when used on paper prints. The most important aftertreatment used on papers is toning, which involves alteration of image color from its normal black to some other tint. A discussion of toners and the colors produced by them will be found in the introduction to the preceding section on papers and printing. Formulas for toners will be found in the pages that follow; although they are identified by manufacturer, it should be obvious that since they all operate on a developed silver image, differences between brands of papers have little effect, and toners of one manufacturer may be used freely on papers of other makers.

More important than make is the type of paper; direct toners usually work better on warm-toned, slow papers, whereas the faster, cold-toned papers need the bleach-and-redevelop type of toner to secure full, rich colors. In the final analysis, the only way to be sure of what a toner will do on a given paper is to try it. It is suggested that the photographer save some discarded prints, washing them thoroughly before drying. These prints can later be used to try out various toners.

Essentially, the whole matter of toning boils down to a question of taste. What is a satisfactory tone to one worker may be an unacceptable color to another. Thus, the only way to be sure of whether a given toner will produce the tone desired by any particular individual on any given brand of paper is to try it.

Development and Temperature

In any chemical reaction, including the development of negatives and prints, temperature plays a large part in the dynamics of the reaction. The photographic process has an additional problem; the physical nature of the gelatin emulsion is greatly affected by temperature, too. The chemical and physical effects of temperature are both important and will be discussed in turn.

The chemical effect of temperature in developing is exactly the same as in almost any other chemical reaction; increase in temperature increases the speed of the reaction. Thus, developing times become shorter as temperature increases.

This effect is not due to one single factor; hence it cannot be expressed by any simple rule. It varies with the developing agents used, and the composition of the developer. It is not greatly affected by the type of film being processed, however. That is, if a given developer reaches the desired contrast in, say, ten minutes at 68 F and in five minutes at 80 F, then it will do the same thing with any other film, although the actual contrast level reached will probably not be the same.

The temperature coefficient of a developer is the change in time required to reach a given contrast for a certain number of degrees temperature rise. In most cases, the factor is constant for any developing agent. It is greater for Metol than for hydroquinone, for example; when the two agents are used together in the same formula, the temperature coefficient will be somewhere between that of the two agents separately.

Since the temperature effect of any developer can be taken as a factor or multiple over a given temperature range (for example, if the time halves as the temperature rises 10 F, then it will halve again in the succeeding 10 F interval), the effect is logarithmic over the useful range of temperatures, and a time-temperature chart can be prepared for a given developer by drawing a straight line between two known development times on a semi-logarithmic graph sheet. On this chart, then, the *slope* of the line is constant for a given developer. The *position* of the line, which represents the actual development time at each temperature, differs with the film in question.

The following chart shows the temperature characteristics of a number of representative Kodak developers; these do not, however, represent any actual development times for any particular film or films. They represent only the time *changes* for a range of temperatures from 55 F to 80 F. If, though, you have found by trial that you will secure the desired contrast on a given film in Kodak DK-50, at, say, 68 F in eight minutes, then all you have to do is to draw a line through the point where the eight-minute vertical line crosses the 68 F horizontal line. If you make this line parallel to Line B on the chart, it will then give you the developing times for the same film in Kodak DK-50 for a range of temperatures from 55 to 80 F.

From the chart, we can deduce the temperature characteristics of the various developers quite easily. Note that line F, for Kodak DK-50 diluted 1:1, is quite steep. This indicates that the change in development time over the given temperature range is not very great, and this would be expected in

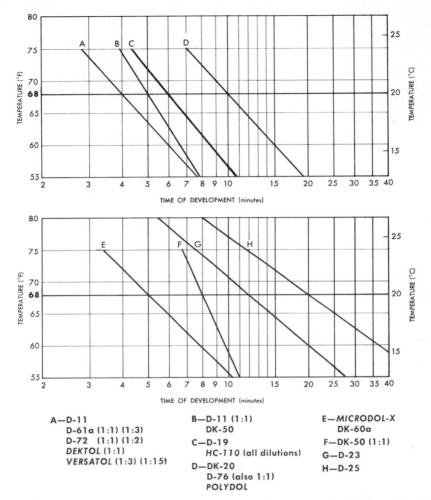

A—D-11
 D-61a (1:1) (1:3)
 D-72 (1:1) (1:2)
 DEKTOL (1:1)
 VERSATOL (1:3) (1:15)

B—D-11 (1:1)
 DK-50

C—D-19
 HC-110 (all dilutions)

D—DK-20
 D-76 (also 1:1)
 POLYDOL

E—*MICRODOL-X*
 DK-60a

F—DK-50 (1:1)

G—D-23

H—D-25

the case of a Metol-hydroquinone developer used at such dilution. On the other hand, Line H has a much less steep slope, showing that a greater change in development time occurs for a given change in temperature. This line is for Kodak Developer D-25, which contains Metol only, without hydroquinone, and shows plainly that Metol developers are quite sensitive to temperature changes.

As we have pointed out, the chemical reactions of development do not follow a very simple rule, merely because, among other reasons, we use several developing agents of different characteristics in a given formula. The chart shows only a limited range of temperatures, from 55 to 80 F, and within this narrow range, the developers given obey the logarithmic rule quite well. However, it is well known that normal hydroquinone developers of moderate alkalinity become nearly inert at temperatures below 50 F; in the case of Metol-hydroquinone combinations, the Metol will be doing all the work at low temperatures. Such a developer will thus have a different slope to its temperature line at low temperatures and at high; that is, over an extended range,

the line will not be straight but will curve, indicating that the logarithmic rule is not being followed.

At the high end of the chart, most developers are not intended to be used at temperatures much above 80 F for several reasons. In many cases, times of development become inconveniently short at higher temperatures, although this is sometimes taken into account in designing processing machines for very short developing times. There is also the problem that with films that are not super-hardened in manufacture, processing above 80 F may result in physical damage to the emulsion.

Taking all these factors into account, the manufacturer limits the range of processing times recommended by making the processing charts cover only the limited range from 55 to 80 F.

There are certain films made mainly for instrumentation purposes—these are known as *rapid-access recording* or *RAR* films, by Kodak. They are superhardened in manufacture so that they may be processed at temperatures as high as 120 F. At such temperatures, development is usually complete in less than a minute; likewise, fixing and washing are accomplished in a matter of some seconds, and drying is equally rapid. In some cases, total processing time to a dry negative is as little as one to two minutes. Obviously, such a high-speed process cannot be adequately controlled manually; processing of these films is carried out in special machines, using specially compounded developers. Since these films are not used to any great extent in normal photography and have no advantage when processed by normal methods anyway, instructions for their use are not given here, and for those who intend to use them, formulas are provided with the processing machine to be installed.

Mechanical Effects of Temperature

Dry gelatin actually contains about 10 per cent of moisture; in this state, it is not very much affected by temperatures normally reached in handling and storage. However, when immersed in water, gelatin can absorb many times its own weight of water; the gelatin does not, however, dissolve but merely swells to a greater total bulk. The swollen gelatin is soft, flexible, and easy to damage. If the temperature is raised to about 104 F (40 C), it melts to a viscous liquid, which may be diluted to any desired degree with water. At concentrations greater than one per cent, the solution will set to a jelly when cooled.

It is this property of absorbing water without dissolving that makes gelatin so valuable in photography. The various solutions used in processing can enter and leave the gelatin with comparative ease, once it has become swollen. The various chemical reactions of the photographic process can take place within the gelatin layer without notably affecting the gelatin itself.*

However, the action of gelatin layers in absorbing liquids other than plain water is not so simple. One important difference in this action is called the *salt effect*. The presence of inorganic salts in the solution results in widely different rates of liquid absorption. Solutions of sulfates are most slowly absorbed; the rate of absorption increases with the presence of other salts until, in the case of iodides and thiocyanates, the gelatin is actually dissolved. Alkaline solutions usually increase swelling, but this effect can be diminished if the solution also contains a neutral salt, especially a sulfate or sulfite.

* Some photographic reactions do affect the gelatin, mostly in a physical manner. Thus, certain developers have the effect of "tanning" gelatin, or raising its melting point, in proportion to the amount of silver deposited. These were used in various gelatin relief methods of color printing and in the preparation of resists for photogravure. They do not have much application to general photography, however.

Thus, for instance, the use of a developer at high temperatures, as in tropical processing, would result in severe and in some cases damaging amounts of swelling due to the alkalinity of the developer, were it not for the fact that sulfites are also present and somewhat counteract the effect. Loading a developer with sodium sulfate, which is otherwise inert, is a useful device to diminish swelling at high temperatures.

Since it is the quantity of salt present that controls the amount of swelling, developers such as Kodak Developer D-76, which contains 100 g/liter of sodium sulfite, can be used at temperatures of 85 F and even 90 F with reasonable freedom from excessive swelling.

Reticulation. Reticulation is a stretching of the gelatin structure beyond its elastic limit by internal strains due to swelling. Once it has occurred, it cannot be rectified; the gelatin fibers have actually been broken, just as a rubber band will be snapped if it is stretched too far.

Swelling of gelatin increases at higher temperatures, and so the danger of reticulation is greatest at high temperatures. However, it is quite possible to produce reticulation even at normal temperatures, around 70-75 F. A sudden change of temperature, either up or down, combined with a transfer from a highly salted solution to a rinse containing no salt at all, can strain the gelatin to the point of reticulation. Even at normal temperatures, gelatin swells considerably in the alkaline developer; if it is transferred to a stop bath that is much colder, the sudden shrinkage of the gelatin can cause the familiar wrinkle pattern. Sometimes the effect is produced merely by the sudden further swelling that occurs as the film enters a bath of plain water, which is more easily absorbed than the highly salted developer.

Mostly, though, reticulation occurs at higher temperatures, simply because the emulsion is subjected to several rather strenuous cycles of swelling and unswelling. The salt effect has much to do with the magnitude of the problem. In the usual case, the film is first immersed in a fairly alkaline developer; swelling is considerable and would be even greater if it were not inhibited to some degree by the high salt content of most developers. From the developer, the film is transferred to a rinse, usually either plain or slightly acidulated water. In this rinse, the salts are diluted rapidly, and the film swells a good deal. Next, the film is transferred to a fixing bath of very high salt content —25% sodium thiosulfate and other salts. Little further swelling takes place here, but there is considerable strain on the already swollen gelatin, due to the neutralization of the developer alkali by the acid in the fixing bath.

The fixer generally contains a hardener, and this has a limited function only; it can and does raise the melting point of the gelatin but cannot act to reduce any swelling that has already occurred. Its major function is to prevent any damage to the already swollen gelatin when the film is transferred to the wash of plain water. It is not, however, a complete protection, because the strain of the hardening reaction is sometimes enough to set up an incipient reticulation. Nevertheless, there are various means of avoiding reticulation.

Probably the best way is, first, to maintain all baths at the same temperature. This is easy enough as far as the processing chemicals are concerned, less easy in the wash stages. Low alkalinity developers, which do not swell the gelatin as highly, are preferable, and at high temperatures, the rate of development will be amply rapid, anyway.

Another method of diminishing the strain on the gelatin is to avoid great variations in the salt content of the various baths, at least until after hardening. Thus, if a developer such as Kodak D-76 is used, which has about a 10 per

cent sodium sulfite content, the rinse that follows should contain either an inert salt such as sodium sulfate, or it may be acidified with sodium sulfite and sodium bisulfite in combination to a salt content, again, of about 10 per cent. The fixing bath, containing about 20 to 25 per cent thiosulfate, follows, and at this point, hardening occurs and prevents further swelling. Even so, to avoid a great shock to the emulsion when it is transferred to the wash, it is sometimes considered practical to use one or two wash stages containing sodium sulfate, say 10 per cent in the first, 5 per cent in the second, and finally a transfer to plain water. This gradual transition allows the hypo and other chemicals to wash out slowly and avoids the explosive swelling that might otherwise occur.

In any case, all baths should be kept at the same temperature, even with the salt system; most reticulation is due not to high temperatures but to sudden changes of temperature. None of these procedures can be said to be 100 per cent reliable, and the best procedure probably is to do everything possible to keep processing temperatures below about 80 F. When this cannot be done, a prehardener of formalin and sodium sulfite or sodium carbonate may help to prevent excessive swelling and softening of the emulsion.

A different method of hardening is used in the preparation of the RAR (Rapid Access Recording) films, and they can be processed at much higher temperatures; ordinary films will not stand such treatment no matter what type of hardener or prehardener is used.

Low Temperature Processing

Processing at temperatures below about 50 F poses no problem of physical damage to the film except that at very low temperatures the water in the film may freeze before it dries, producing some irremovable crystalline patterns in the emulsion.

Since the activity of most developers is roughly halved with a temperature drop of 10 to 20 F, attempting to use ordinary developers at low temperatures will usually result in inconveniently long developing times. For this reason, it is necessary to use developers of high activity such as Kodak D-8, containing hydroquinone and sodium hydroxide. At still lower temperatures, even higher activity developers are needed; one special formula containing amidol, pyrocatechin, and sodium hydroxide is recommended. This latter formula is known as Kodak SD-22 Developer.

Processing below 30 F is subject to the additional difficulty that the developer may freeze. This can be prevented by the addition of an antifreeze to the solution; it must be inert and not affect the properties of the developer. Pure ethylene glycol has been used successfully; it must be of chemical quality, since ordinary grades sold for automotive purposes usually contain oily additives to prevent rusting of engine parts.

Fixation is likewise slowed by low temperatures, and for moderately low temperatures, a rapid fixing bath containing ammonium thiosulfate is preferred. At lower temperatures, potassium thiocyanate is used at concentration of about 40 per cent. Thiocyanate does soften gelatin very severely, even at low temperatures, and it is usually necessary to add about 5 per cent of Formalin to the bath, with sodium carbonate as an activator.

With fixing baths containing ammonium or sodium thiosulfate, no hardener is used or needed, and washing after fixation can be carried out with four successive baths of water containing about 25 per cent ethylene glycol if temperatures are below freezing.

Drying at low temperatures is slow, and there is always a danger of water freezing in the emulsion. The best way to dry film rapidly at a low temperature is to bathe it in isopropyl alcohol or a good grade of denatured alcohol; these should be used at full strength, not diluted with water. Film treated in alcohol will dry in about a half hour at zero F, with no danger of damage to the film base or emulsion.

Gamma and Contrast Index

Although Hurter and Driffield had shown that varying development times affect mainly the contrast of the negative, and that, furthermore, development being a simple chemical process, it could be controlled by proper choice of time at a given temperature, photographers until quite recently continued to develop films by inspection. This was practical as long as orthochromatic films were used; the red safelights were amply bright to allow judging negative density, and with some experience, a high percentage of good negatives could be obtained this way.

Even so, it was realized that this method of control was erratic and what judgment could be applied was mainly unnecessary; attempts to "correct" exposure errors by varying treatment in the developer usually had just the opposite result. An underexposed negative lacks shadow detail and is excessively contrasty; if it is forced in development, it is merely made contrastier yet. Overexposed negatives are lacking in contrast; cutting development short to compensate merely reduces the contrast still further. Most consistent results could be attained simply by giving all negatives the same developing time regardless of exposure conditions, and the method of processing by inspection finally died out with the popularization of panchromatic films, with which no really useful safelight can be employed.

Developer formulas are usually followed by a line of instruction such as "Develop five to ten minutes at 68 F depending on contrast desired." This much information was usually ample for most professionals and advanced amateurs; it gave them a starting point, and one or two tests settled the exact time required. Beginners, however, were bewildered by such instructions; they did not know what contrast they desired, and they were usually unwilling to make the necessary tests to find out what development time would produce a satisfactory negative.

Then too, there were a number of pseudo-scientific types who demanded a degree of precision in the photographic process comparable to that which they believed obtainable in other sciences. They seized upon the Hurter and Driffield concept of "gamma" as a measure of development contrast and proceeded to set up a variety of systems, all involving development to some specified numerical value of gamma, such as 0.65, or 0.70, or whatever.

This type of control is possible and practical if the proper instrumentation is available. In motion picture photography, development to a uniform value of gamma, generally about 0.65, has been the rule since early in the nineteen thirties; the need for such control arose from the requirements for photographic sound recording. Cameramen soon found that rigidly controlled processing could be an asset if they adopted some equally precise means of measuring light values and calculating the optimum exposure. These cameramen adopted ordinary foot-candle meters to this end, before photoelectric exposure meters were in general use, and they developed systems by which they could predict the final rendition of a given scene from brightness measurements taken at the

time of photographing. Thus, gamma control, introduced originally as a means of ensuring optimum sound reproduction, delivered an unexpected bonus in the form of better picture quality.

In early color processes, equally precise control was necessary; all these processes required the exposure and development of three color-separation negatives to equal contrast and substantially equal density. Thus, instruments were needed to control both exposure and processing if any kind of successful color prints were to be made.

In both cases, a certain minimum amount of equipment was necessary. To be able to develop a negative to a known contrast, we require an accurately exposed film sample, on which all exposures are known, so that the density produced by each can be measured. We then need a device to measure the resultant densities. The first requirement is met by an instrument known as a *sensitometer*, which makes a graded series of exposures on a film sample, which must, of course, be from the same batch of film as is being used for picture taking. The second need is met by a device called a *densitometer*, which is merely a transmission meter with a fixed reference to establish a density zero point. The developed test negative is measured, and a characteristic curve is plotted from which gamma measurements can be calculated.

It is clear that without these instruments, and judging strictly on the basis of a negative made from pictorial material, all we can say about any one negative is that it is either of short, normal, or long range—popularly, "soft", "normal," or "contrasty." These three broad classes, or maybe five, with two intermediates, are about as nearly as we can judge the contrast of a negative made by ordinary darkroom methods. Actually, these are about all the gradations needed for practical work; they encompass the ranges of the five standard grades in which most printing papers are made.

For those who would attempt to develop films to a set gamma value, mere time-and-temperature recommendations are not sufficient. The gamma a film attains in a given developer depends upon a number of factors, among which are the following:

1. Variations from one batch of film to another.
2. Size and shape of developing tank.
3. Amount of agitation during development.
4. Method of agitation during development.

These variations are in addition to the basic temperature-and-time relationship, can all be quite large, and are invariably erratic. They may vary in opposite directions and cancel each other, but more often they will add up in one direction and produce a huge error.

It is therefore impossible to publish any kind of directions that will unequivocally state that a certain gamma will be reached in a given developer, at a given temperature, in a given time.

Meanwhile, some workers began to notice that although gamma was, in fact, a measure of development contrast, it did not correlate exactly to the printing quality of the negative nor did development to a known gamma allow the worker to predict the tonalities of the final print. The reason is that gamma only refers to the slope of the straight line portion of the film characteristic, whereas modern printing methods call for negatives so exposed as to use a large part of the toe of the curve as well. Variations in the shape of the curve for different films will result in negatives having different printing scales, even though they are all developed to the same numerical value of gamma.

184

Many modern negative films do not have any real "straight line" to their characteristic curves; furthermore, the range of exposure of such films has been hugely extended, so that the shoulder of the curve of such films is nearly unattainable in practice. Thus, the classic system of Hurter and Driffield is not too applicable to modern film emulsions. Whereas Hurter and Driffield were able to demonstrate a complete S-shaped curve with a fairly short range of exposures and only moderate density in the overexposure portions, some of the newer films show only a small "kink" in the curve at a point that would be considered seriously overexposed; the film continues to gain density with increased exposure and can reach densities as high as 4.0 and 5.0. Such a negative is totally unprintable by any normal method on any paper, although it has some value in the solution of scientific problems where measurements are taken from the negative or where prints can be made with high-intensity equipment on transparency film material.

In one test of this phenomenon, it was found that Kodak Plus-X Pan Sheet Film was capable of recording a luminance range of 1,000,000 to 1, or over 5,000 times the brightness range of a normal scene. The maximum density of the negative was over 5.0, corresponding to a transmission of less than 1/100,000 of the light falling upon it. The development time of this test negative was ten minutes in Kodak D-76 at 70 F (21 C). This corresponds to a published figure in some sources for an ostensible gamma of only about 0.7.

Obviously, in such a case, gamma is totally meaningless, in terms of negative contrast, degree of development, or image density range. Furthermore, there is no mathematical way to specify the actual contrast of that negative; the curve as plotted showed several bends and no straight line portion whatever.

Today, neither gamma nor contrast index has any real utility to the photographer who does not have sensitometric equipment. Provided that a negative has a fairly adequate density range, it is possible to secure a satisfactory print from it, using either one of the graded papers available in as many as six degrees of exposure scale or one of the variable contrast papers that is capable of even wider range and an almost infinite number of steps in its range capabilities. It is, of course, presumed that the negative has been correctly exposed; it is axiomatic that a good print cannot be made from a badly exposed negative, no matter what manipulation is done in processing.

For this reason, in the pages that follow, no gamma or contrast index information will be given. As has been pointed out, gamma information is substantially useless in estimating the printing contrast of the negative; contrast index is more nearly correlated with the printing range of the negative but requires at the very least a densitometer for evaluation. Recommended development times for popular film-developer combinations are found in the data pages in Section 2 on black-and-white films. Development times given under the formulas in this section provide a useful starting point for personal tests. As for the time-temperature tables given for the proprietary developers listed herein, they have been supplied by the manufacturers of those chemicals and may be taken to produce negatives of average printing quality, but again, some personal adjustment may be necessary.

The original reason for critical control of processing was simply that many papers were available only in a single grade of contrast. Such a situation obtains today only in the motion-picture industry, where an entire reel of negatives made at different times and places must be printed on a single strip of positive stock, which is obviously available only in a single contrast grade.

However, in the case of papers, the availability of variable contrast papers has ended the need for any very close control of negative contrast. This is not to say that sloppy processing should be allowed; a consistent development system will make it much easier to turn out good prints. But pseudo-scientific numerical methods have little application to practical photography.

Reversal Processing

There is still considerable use for black-and-white transparencies; also a good deal of motion-picture photography is being done, especially for television broadcast, on black-and-white reversal film.

The principle of reversal processing is simple enough; the film is processed to a negative ordinarily, then the remaining unexposed halides in the film emulsion are used as a material on which to make the positive print. After the residual halides have been exposed to a positive latent image, the negative is bleached out, and the positive is developed, fixed, washed, and dried.

If a good quality image is to be obtained by reversal processing, certain factors must be taken into account. Because it is difficult to judge the density of the negative after the first development stage, one cannot control the exposure of the positive image to any useful degree (although many years ago, one processor did have automatic developing machines with photoelectric control). This being the case, reversal procedures currently in use control only the first development step; all the remaining stages of the process run to completion or to a plateau.

Total-second-exposure reversal processing requires a special first developer. All emulsions contain a proportion of small silver grains, which are almost totally insensitive to light; they cannot be made to develop completely in the first developer stage, and the result is, after completion of processing, an excessive density in the highlights of the final positive image.

This problem is solved by the addition of a silver solvent to the first developer. In some early processes, a small amount of hypo was added to the developer to secure clean whites, but this had a tendency to cause fog in this stage, which resulted in a loss of shadow density in the final positive. Current reversal formulas call for potassium thiocyanate in a very small amount, usually about two grams per liter, or about 0.2% concentration. This not only clears the highlights but appears to raise the effective speed of the film; many reversal films lose as much as 50% of their emulsion speed if processed as negatives.

After the negative image has been developed, the film is washed and then exposed to a strong white light; the purpose is to make all of the remaining silver halide in the film developable. There is no attempt at this stage or in the following stages to control the process to compensate for errors in exposure, hence accurate exposure of the original film is a requisite.

Once the exposure has been made, the negative image serves no further purpose and must be removed before the positive image can be developed. This is done in an oxidizing type of bleach. It is essentially different from the usual toning bleach in that it must remove the silver completely; if it merely turned it into a chloride or bromide, it would redevelop in the final stage along with the positive, and the film would be black all over. The usual bleach for this purpose contains potassium bichromate and sulfuric acid; the silver is converted by this bath into silver sulfate, which is soluble in water and washes out of the film. Bleaching is followed by a clearing bath, which removes the yellow stain of the bichromate solution. The film is then developed

in a strong black-and-white developer, similar to the first developer but without the silver solvent.

After development there should be little or no unexposed silver halide remaining in the emulsion, and fixing is theoretically not necessary. However, a small amount of halide always escapes the action of both developers, and a brighter image results from a short treatment in a normal acid hardening fixing bath; this also serves to harden the gelatin which has been severely swollen by two developing treatments and a vigorous bleach. Washing and drying complete the process.

Since in current processes the silver halide remaining in the emulsion after the first development is exposed and developed to completion, it is possible to eliminate the re-exposure step altogether by the use of a developer containing a fogging agent. This makes it possible to carry out reversal processing in a closed tank or machine without exposure facilities. Some early workers merely treated the film, after bleaching, in a sulfide bath, but this produced a sepia-toned image, which is usually not desirable. Modern fogging developers contain a tiny amount of sodium dithionite combined with a developer capable of producing a neutral black image.

Conclusion

The following pages contain a formulary and some data on proprietary developers for which developing times are not given in the data pages in Section 2 on black-and-white films. The developers, fixing baths, and other formulas listed are those which are most popular today; such antiquities as the A-B-C- Pyro developer have been omitted. There is, however, some duplication—for instance, it is obvious that Kodak D-76, Dupont 6-D, and Ilford ID-11 are substantially identical. Nonetheless, we include them all, to avoid unnecessary page-turning.

The same thing applies to fixers, toners and so on. In the case of the latter, even where two toners appear much the same, there are minor differences, probably to accommodate slight differences in the emulsions of the papers to be used. Some experimenting with the various toner formulas is well worthwhile.

187

BLACK-AND-WHITE DEVELOPERS: DESCRIPTIONS AND USES

Developer	Material	Method	Characteristics and Uses
AGFA			
Agfa Atomal	Film	Small tank	Fine-grain compensating developer for flash exposures
Agfa Rodinal	Film	Tank or tray	Highly concentrated universal negative developer
Agfa 100	Paper	Tray	Neutral tones on contact and enlarging papers
Agfa 105	Paper	Tray	Low-contrast neutral-tone] ortrait developer
Agfa 108	Paper	Tray	High-contrast neutral-tone paper developer
Agfa 120	Paper	Tray	Portrait paper developer for warm black to brown tones
Agfa 123	Paper	Tray	Warmer-toned developer for brown to olive tones
ANSCO			
Ansco 17	Film	Small tank	Fine-grain, low-contrast negative developer
Ansco 47	Film	Tank or tray	Normal contrast developer for larger films
Ansco 48M	Film	Deep tank	Normal contrast developer for photofinishing
Ansco 72	Film	Tank	High-contrast commercial developer for copying
Ansco 90	Film	Tank	Very high-contrast developer for line work, commercial photography
Ansco 103	Paper	Tray	For blue-black tones on contact papers
Ansco 110	Paper	Tray	Portrait developer for brown to olive tones
Ansco 113	Paper	Tray	Amidol paper developer (obsolete)
Ansco 115	Paper	Tray	Glycin developer for very warm tones
Ansco 120	Paper	Tray	Developer for softer contrast on contact papers
Ansco 125	Paper	Tray	Universal neutral-toned paper developer
Ansco 130	Paper	Tray	MQ-Glycin developer for rich black tones on portraits
Ansco 135	Paper	Tray	Developer for warm tones on contact and enlarging papers
BAUMANN			
Acufine	Film	Tank	Maximum-acutance, fast fine-grain developer for small films
ACU-1	Film	Tank	Maximum-acutance, fine-grain, high-emulsion-speed developer
Autofine	Film	Tank	Ultra-fine-grain developer for small films
Diafine	Film	Tank or tray	Two-solution developer for constant developing time on all films
Printofine	Paper	Tray	High-capacity paper developer for neutral black tones
DUPONT			
Dupont 6-D	Film	Tank	Low-contrast, maximum-emulsion-speed developer for small films
Dupont 51-D	Paper	Tray	Warm-tone paper developer
Dupont 53-D	Paper	Tray	Universal paper developer for neutral tones on all papers
Dupont 54-D	Paper	Tray	For blue-black tones on contact papers; photofinishing
Dupont 55-D	Paper	Tray	Portrait paper developer for warm-black tones
Dupont 56-D	Paper	Tray	Commercial developer for blue-black tones on enlarging papers
Dupont 58-D	Paper	Tray	Adurol (chlor-hydroquinone) formula for very warm tones

Continued on page 189

Continued from page 188

Developer	Material	Method	Characteristics and Uses
EDWAL			
Edwal FG-7	Film	Tank or tray	Fine-grain concentrated developer
Edwal Super-12	Film	Tank	Fine-grain, maximum-emulsion-speed developer
Edwal Super-20	Film	Tank	High-acutance developer for miniature films
Edwal Minicol-II	Film	Tank	Compensating developer for thin-emulsion films
Edwal Super 111	Paper	Tray	Neutral-black paper developer for amateur and professional use
Edwal Platinum	Paper	Tray	Neutral-black paper developer for amateur and professional use
Edwal TST	Paper	Tray	Concentrated paper developer for neutral to warm tones
ETHOL			
Ethol TEC	Film	Tank	Compensating developer for one-time use or as two-bath system
Ethol UFG	Film	Tank	Ultra-fine-grain, high-emulsion-speed developer
Ethol LPD	Paper	Tray	Neutral-tone universal paper developer
Ethol V-thol	Film	Deep tank or machine	High-energy developer for sheet and roll films and photofinishing
FR CORP.			
FR X-22	Film	Tank	Compensating developer for thin-emulsion miniature films
FR X-33C	Film	Tank	Fine-grain, maximum-emulsion-speed developer for small films
FR X-44	Film	Tank	One-shot developer for rapid processing
FR X-100	Film	Tank	Universal negative developer
FR Paper Developer	Paper	Tray	Universal developer for contact and enlarging papers
FR Develochrome	Paper	Tray	Color-coupling developer for colored images without toning
GEVAERT			
Gevaert G.206	Film	Tank	Low-contrast, maximum-emulsion-speed negative developer
Gevaert G.207	Film	Tank	Low-contrast, semi-compensating negative developer
Gevaert G.215	Film	Tank	Low-contrast, compensating developer for flash exposures
Gevaert G.251	Paper	Tray	Normal, neutral-tone paper developer
Gevaert G.252	Paper	Tray	Paper developer for blue-black tones on contact papers
Gevaert G.253	Paper	Tray	Soft, warm-toned portrait paper developer
Gevaert G.261	Paper	Tray	Glycin-hydroquinone developer for tones from brown to red
Gevaert G.262	Paper	Tray	Hydroquinone developer for brown to red tones with shorter exposure and developing time than G.261
ILFORD			
Ilford ID-1	Film	Tray	Pyro-soda developer for films
Ilford ID-2	Film	Tank or Tray	Rapid developer for films and plates
Ilford ID-11	Film	Tank	Low-contrast, maximum-emulsion-speed developer for small films

Continued on page 190

Developer	Material	Method	Characteristics and Uses
ILFORD (Concluded)			
Ilford ID-20	Paper	Tray	Normal paper developer for contact and enlarging papers
Ilford ID-22	Paper	Tray	Amidol developer for older types of bromide papers
Ilford ID-36	Paper and film	Tray	Universal developer for plates, films, and papers
Ilford ID-67	Film	Tank or tray	Similar to Ilford ID-2, but based on Phenidone instead of Metol
Ilford ID-68	Film	Tank	Similar to Ilford ID-11, but based on Phenidone instead of Metol
KODAK			
Kodak D-11	Film	Tank	High-contrast developer for films, plates and lantern slides
Kodak DK-15	Film	Tank	Tropical developer for high-temperature processing
Kodak D-19	Film	Tank	Universal high-contrast developer for positive films, aerial films, and x-ray films
Kodak D-23	Film	Tank	Low-contrast, semi-compensating developer for flash exposures
Kodak D-25	Film	Tank	Buffered version of D-23; greater compensating properties
Kodak DK-50	Film	Tank	Fast developer for portrait and commercial negatives
Kodak D-51	Paper	Tray	Amidol developer for old-style bromide papers
Kodak D-52	Paper	Tray	Warm-tone developer for portrait-type papers
Kodak DK-60a	Film	Tank	Modification of DK-50 for photofinishing
Kodak DK-60b	Film	Tank	Modification of DK-50 for aerial film development in rewind tanks
Kodak D-61a	Film	Tank or tray	Fast developer for sheet films in press and commercial photography
Kodak D-72	Paper or film	Tray	Universal paper developer for neutral tones; also suitable for tray development of films, plates, and lantern slides
Kodak D-76	Film	Tank	Low-contrast, maximum-emulsion-speed developer for small films
Kodak Microdol-X	Film	Tank	Fine-grain developer for small films
Kodak Polydol	Film	Tank or machine	Long-life, high-energy developer for commercial, press and photofinishing
Kodak HC-110	Film	Tank or tray	Highly concentrated universal film developer
Kodak Dektol	Paper	Tray	Universal paper developer; improved version of D-72
Kodak Selectol	Paper	Tray	Warm-tone paper developer; improved version of D-52
Kodak Selectol-Soft	Paper	Tray	Low-contrast version of Kodak Selectol
Kodak Versatol	Film and Paper	Tank or tray	Universal developer for films, plates and papers

AGFA ATOMAL DEVELOPER

Atomal is a fine-grain compensating developer for use with black-and-white roll and sheet film. It has a shelf life of six months when stored in sealed bottles. This is reduced to approximately three months when used developer is poured back into the fresh solution. This developer is available in one- and five-liter sizes.

Preparation

Dissolve part A completely in ¾ of the final volume of water at 105 F. Add part B while stirring continuously. Add water to make the final volume. The solution will have a clear yellowish cast and should be cooled to 68 F for use.

Agitation

Daylight tank: Continuous for the first minute, then every 30 seconds.

Deep tank: Continuous for the first minute, then every two minutes.

When using deep tanks with gas-burst agitation (3-second burst every 30 seconds), use the times recommended for daylight tanks.

Capacity

10-12 rolls 35mm film per liter.

40-50 sheets of $4'' \times 5''$ sheet film per liter.

To obtain uniform gradation and film speed, development time should be increased ½ minute with each succeeding roll (or every five sheets of film).

Developing Times

Agfaortho 125	11 min. at 68 F (20 C)
Agfapan 100	11 min. at 68 F (20 C)
Agfapan 200	11 min. at 68 F (20 C)
Agfapan 400	11 min. at 68 F (20 C)

Note: Developing times may vary between 10 and 12 minutes depending on agitation and other conditions. Films of other manufacturers with ratings of ASA 100–400 may also be processed in Agfa Atomal—a suggested time of 11 minutes may be used for an initial trial and modified by the user if negatives are too thin or too dense.

AGFA RODINAL DEVELOPER

Rodinal is a highly concentrated solution, which is diluted by the user to get a working solution. Generally, one part Rodinal is added to 50–100 parts of water. This working solution is discarded after use. It is interesting to note that the Rodinal system of one-time use antedates by about 60 years the now-fashionable "single-use" developing method.

Contrast Control

The degree of dilution of Rodinal solution can be varied by the photographer to fit the contrast characteristics of his film and of the scene. To increase contrast, the degree of concentration is increased. For example, if a photographer photographs a subject with low contrast, he can increase his negative contrast by using a more concentrated solution.

Development Times

In addition to giving the photographer control over contrast, the variable dilution of Rodinal allows him to control his developing times should he require shorter processing times. Recommended times will give gammas between 0.65 and 0.8.

Temperature Control

Temperature control, so important in 35mm photography, is easier with Rodinal since the temperature of the water can easily be adjusted and maintained because of the very small quantity of Rodinal to be added. Development times are given for 68 F. For 65 F, increase developing times 20 per cent. For 72 F, decrease developing times 20 per cent. (See also film data pages.)

Processing Recommendations

Since Rodinal is not a fine-grain developer as such, it is recommended primarily for the slower, fine-grain, thin-emulsion materials. Rodinal may also be used with medium-speed films such as Agfapan 200, but it is not recommended for high-speed materials because of the rather coarse grain produced. For high-speed material, Agfa Atomal gives finer grain without loss of emulsion speed.

The tables below give approximate recommendations for using Rodinal with Agfa films. Rodinal may also be used with other films by taking the Agfa film recommendations as a point of departure and experimenting a little. Under normal circumstances, there should not be too much difference in processing methods using Rodinal with other films of the same approximate ASA rating. Since Rodinal is extremely flexible, the individual photographer can determine the degree of dilution and the developing times that best fit his working method and his materials.

Processing Time Table for Agfa Rodinal 1:25

Agfaortho 125	6 min. at 68 F (20 C)
Agfapan 100	6 min. at 68 F (20 C)
Agfapan 200	6 min. at 68 F (20 C)
Agfapan 400	10 min. at 68 F (20 C)

Note: Working solution of Agfa Rodinal 1:25 is made by taking 40cc of Rodinal concentrate and adding water at 68 F (20 C) to make one liter (or 1 1/3 ounces to make one quart). Other dilutions are as follows:

1:50	20cc to make 1 liter	2/3 ounce to make 1 quart
1:75	15cc to make 1 liter	1/2 ounce to make 1 quart
1:100	10cc to make 1 liter	1/3 ounce to make 1 quart

AGFA DEVELOPER 100

This is a normal paper developer for contact and enlarging papers. Use full strength, develop one to two minutes.

Warm Water (125 F or 52 C)	24 ounces	750.0cc
Metol	15 grains	1.0 gram
Sodium Sulfite, desiccated	180 grains	13.0 grams
Hydroquinone	45 grains	3.0 grams
Sodium Carbonate, monohydrated	1 ounce	30.0 grams
Potassium Bromide	15 grains	1.0 gram
Add cold water to make	32 ounces	1.0 liter

Use full strength; develop one to two minutes.

AGFA DEVELOPER 105

A paper developer intended to produce low contrast on portrait papers. Use full strength, develop 1½ minutes.

Warm Water (125 F or 52 C)	24 ounces	750.0cc
Metol	45 grains	3.0 grams
Sodium Sulfite, desiccated	½ ounce	15.0 grams
Potassium Carbonate	½ ounce	15.0 grams
Potassium Bromide	6 grains	0.4 grams
Add cold water to make	32 ounces	1.0 liter

Use full strength; develop 1½ minutes

AGFA DEVELOPER 108

A paper developer intended to produce high contrast. Use full strength, develop one to two minutes.

Warm Water (125 F or 52 C)	24 ounces	750.0cc
Metol	75 grains	5.0 grams
Sodium Sulfite, desiccated	1 ounce 145 grains	40.0 grams
Hydroquinone	88 grains	6.0 grams
Potassium Carbonate	1 ounce 145 grains	40.0 grams
Potassium Bromide	30 grains	2.0 grams
Add cold water to make	32 ounces	1.0 liter

Use full strength; develop one to two minutes.

AGFA DEVELOPER 120

This developer will produce a variety of brown to warm black tones on various papers depending upon dilution and exposure time.

STOCK SOLUTION

Warm Water (125 F or 52 C)	24 ounces	750.0cc
Sodium Sulfite, desiccated	2 ounces	60.0 grams
Hydroquinone	350 grains	24.0 grams
Potassium Carbonate	2 ounces 290 grains	80.0 grams
Add cold water to make	32 ounces	1.0 liter

AGFA DEVELOPER 123

A very warm-toned developer producing tones from brown-black to olive, depending upon dilution and exposure time. In general, prints should be over-exposed considerably and developed for from two to five minutes, depending upon the paper used.

STOCK SOLUTION

Warm Water (125 F or 52 C) 24 ounces	750.0cc	
Sodium Sulfite, desiccated 2 ounces	60.0 grams	
Hydroquinone350 grains	24.0 grams	
Potassium Carbonate2 ounces 290 grains	80.0 grams	
Potassium Bromide365 grains	25.0 grams	
Add cold water to make 32 ounces	1.0 liter	

ANSCO DEVELOPER 17

This is a fine-grain developer recommended for all GAF-Ansco roll, pack, and 35mm films, also for motion picture negative development. It produces soft gradation on portrait and commercial sheet films.

Water (125 F or 52 C) 24 ounces	750.0cc	
Metol 22 grains	1.5 grams	
Sodium Sulfite, desiccated2½ ounces 80 grains	80.0 grams	
Hydroquinone 45 grains	3.0 grams	
Borax, granular 45 grains	3.0 grams	
Potassium Bromide7½ grains	0.5 gram	
Add cold water to make 32 ounces	1.0 liter	

Dissolve in the order given. Do not dilute for use.

Tank Development Time at 68 F (20 C)—10-15 minutes for fine-grain films, 12-20 minutes for press and portrait sheet films.

Tray Development Time at 68 F (20 C)—8-12 minutes, depending on film type and density desired.

Time-Temperature Development Chart

Shows developing times at various temperatures corresponding to a given time at 68 F (20 C). For other times at 68 F locate the time along the 68 F line and draw through that point a line parallel to the one given. See page 178 for a more complete discussion.

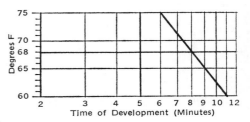

ANSCO REPLENISHER 17a

Water (125 F or 52 C) 24 ounces	750.0cc	
Metol 32 grains	2.2 grams	
Sodium Sulfite, desiccated2½ ounces 80 grains	80.0 grams	
Hydroquinone 65 grains	4.5 grams	
Borax, granular½ ounce 44 grains	18.0 grams	
Add cold water to make 32 ounces	1.0 liter	

Dissolve chemicals in the order given.

Add ½-¾ ounce of replenisher to Ansco 17 for each roll of 120 film or 36-exposure 35mm film (or equivalent) developed. Maintain original volume of developer, discarding if necessary some used developer. No increase in original developing time is necessary when replenisher is used in this manner.

ANSCO DEVELOPER 47

A moderately fast Metol-hydroquinone developer for tank or tray use, mainly for portrait and commercial sheet films. It is similar except for dilution to Kodak D-61a.

Water (125 F or 52 C)	24 ounces	750.0cc
Metol	22 grains	1.5 grams
Sodium Sulfite, desiccated	1½ ounces	45.0 grams
Sodium Bisulfite	15 grains	1.0 gram
Hydroquinone	45 grains	3.0 grams
Sodium Carbonate, monohydrated	88 grains	6.0 grams
Potassium Bromide	12 grains	0.8 gram
Add cold water to make	32 ounces	1.0 liter

For the developing times below, do not dilute for use.

Tank Development—Normal development time, six to eight minutes at 68 F (20 C) with occasional agitation. *Tray Development*—Normal development time, five to seven minutes at 68 F (20 C).

For longer developing times with tank development, dilute one part developing solution with one part water and develop 12-16 minutes at 68 F (20 C).

Time-Temperature Development Chart

Shows developing times at various temperatures corresponding to a given time at 68 F (20 C). For other times at 68 F locate the time along the 68 F line and draw through that point a line parallel to the one given. See page 178 for a more complete discussion.

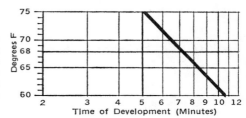

ANSCO REPLENISHER 47a

Water (125 F or 52 C)	24 ounces	750.0cc
Metol	45 grains	3.0 grams
Sodium Sulfite, desiccated	1½ ounces	45.0 grams
Sodium Bisulfite	30 grains	2.0 grams
Hydroquinone	88 grains	6.0 grams
Sodium Carbonate, monohydrated	¼ ounce 65 grains	12.0 grams
Add cold water to make	32 ounces	1.0 liter

Dissolve chemicals in the order given.

Add ½-¾ ounce of replenisher to Ansco 47 for each roll of 120 film (or equivalent) developed. Maintain original volume of developer, discarding if necessary some used developer. No increase in original developing time is necessary when replenisher is used in this manner.

ANSCO DEVELOPER 48M

This is a developer used for small-scale photofinishing operations, where roll films are developed in deep tanks; it has excellent keeping qualities and may be replenished for long term use.

Hot Water (125 F or 52 C)	24 ounces	750.0cc
Metol	30 grains	2.0 grams
Sodium Sulfite	1¼ ounces	40.0 grams
Hydroquinone	22 grains	1.5 grams
Sodium Metaborate	¼ ounce 35 grains	10.0 grams
Potassium Bromide	7½ grains	.5 gram
Add cold water to make	32 ounces	1.0 liter

Do not dilute for use.

195

Tank Development—Normal developing time, five to seven minutes at 68 F (20 C).

Tray Development—Normal developing time, four to six minutes at 68 F (20 C).

These developing times apply to portrait, press, and commercial films and to roll and pack films.

Time-Temperature Development Chart
──────────────────────────

Shows developing times at various temperatures corresponding to a given time at 68 F (20 C). For other times at 68 F locate the time along the 68 F line and draw through that point a line parallel to the one given. See page 178 for a more complete discussion.

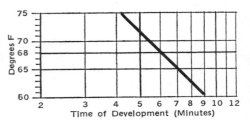

Time of Development (Minutes)

ANSCO REPLENISHER 48M-a

Hot Water (125 F or 52 C)	24 ounces	750.0cc
Metol ..	90 grains	6.3 grams
Sodium Sulfite, desiccated	1 ounce	30.0 grams
Hydroquinone¼ ounce	35 grains	10.0 grams
Sodium Metaborate1¼ ounces		40.0 grams
Add cold water to make	32 ounces	1.0 liter

Dissolve all ingredients in the order stated.

Add ½-¾ ounce of replenisher to Ansco 48M for each roll of 120 film (or equivalent) developed. Maintain original volume of developer, discarding if necessary some used developer. No increase in original developing time is necessary when replenisher is used in this manner.

ANSCO DEVELOPER 72

This is a Glycin developer for use with commercial film in reproduction work; it is also suitable for development of roll film and film pack, and commercial and portrait sheet films. Note that potassium carbonate is specified; sodium carbonate should not be used, since it will not produce a high enough alkalinity to activate the glycin properly.

STOCK SOLUTION

Water (125 F or 52 C)	24 ounces	750.0cc
Sodium Sulfite, desiccated4¼ ounces		125.0 grams
Potassium Carbonate8½ ounces		250.0 grams
Glycin1½ ounces	80 grains	50.00 grams
Add cold water to make	32 ounces	1.0 liter

Tank Development—Take 1 part stock solution, 15 parts water and develop 20-25 minutes at 68 F (20 C).

Tray Development—Take one part stock solution, four parts water and develop five to ten minutes at 68 F (20 C).

196

ANSCO DEVELOPER 90

A high-contrast developer for Commercial and Commercial Ortho films for brilliant negatives. It can also be adapted for even higher contrast purposes, such as line work, by doubling the potassium bromide content.

Water (125 F or 52 C)	24 ounces	750.0cc
Metol	72 grains	5.0 grams
Sodium Sulfite, desiccated	1¼ ounces 40 grains	40.0 grams
Hydroquinone	88 grains	6.0 grams
Sodium Carbonate, monohydrated	1¼ ounces 40 grains	40.0 grams
Potassium Bromide	44 grains	3.0 grams
Add cold water to make	32 ounces	1.0 liter

Do not dilute for use. Normal development time, four to six minutes at 68 F (20 C).

ANSCO DEVELOPER 103

This is a paper developer for blue-black tones on contact papers.

STOCK SOLUTION

Water (125 F or 52 C)	24 ounces	750.0cc
Metol	50 grains	3.5 grams
Sodium Sulfite, desiccated	1½ ounces	45.0 grams
Hydroquinone	¼ ounce 55 grains	11.5 grams
Sodium Carbonate, monohydrated	2½ ounces 35 grains	78.0 grams
Potassium Bromide	18 grains	1.2 grams
Add cold water to make	32 ounces	1.0 liter

Paper Development—Dilute one part stock solution with two parts water. Normal development time is 45 seconds. Some contact papers may require 1-1½ minutes.

ANSCO DEVELOPER 110

A direct brown-black paper developer for both contact and enlarging papers.

STOCK SOLUTION

Water (125 F or 52 C)	24 ounces	750.0cc
Hydroquinone	¾ ounce	22.5 grams
Sodium Sulfite, desiccated	1¾ ounces 50 grains	57.0 grams
Sodium Carbonate, monohydrated	2½ ounces	75.0 grams
Potassium Bromide	40 grains	2.75 grams
Add cold water to make	32 ounces	1.0 liter

For use dilute one part stock solution with five parts water.

Give prints three to four times normal exposure and develop five to seven minutes at 68 F (20 C).

ANSCO DEVELOPER 113

An amidol tray developer for enlarging papers. It must be mixed fresh for each use, cannot be kept as a stock solution, and does not keep well in the tray; only a few prints can be developed in a trayful.

Amidol	96 grains	6.6 grams
Sodium Sulfite, desiccated	1½ ounces	44.0 grams
Potassium Bromide	8 grains	0.55 gram
Add cold water to make	32 ounces	1.0 liter

Do not dilute for use. If hot water is used for dissolving chemicals, the sodium sulfite and potassium bromide should be dissolved first and the amidol added only after the solution has cooled.

For development of Cykora and similar papers, use twice the amount of potassium bromide specified above.

Develop one to two minutes at 68 F (20 C).

ANSCO DEVELOPER 115

A glycin-hydroquinone developer for warm tones on Cykora, Indiatone, and other warm-toned enlarging papers.

Water (125 F or 52 C)	24 ounces	750.0cc
Sodium Sulfite, desiccated	3 ounces	90.0 grams
Sodium Carbonate, monohydrated	5 ounces	150.0 grams
Glycin	1 ounce	30.0 grams
Hydroquinone	¼ ounce 30 grains	9.5 grams
Potassium Bromide	60 grains	4.0 grams
Add cold water to make	32 ounces	1.0 liter

For warm tones, dilute one part stock solution with three parts water and develop prints 2½-3 minutes at 68 F (20 C).

For very warm tones and more open shadows, especially with Cykora, dilute one part stock solution with six parts water, giving prints three to four times normal exposure and 2½-5 minutes' development. Because of dilution of the developer, solution will exhaust more rapidly and will require more frequent replacement.

ANSCO DEVELOPER 120

A straight Metol developer for papers where a softer result is desired. Only a small reduction in contrast is possible, but this may produce useful results on portrait papers.

Water (125 F or 52 C)	24 ounces	750.0cc
Metol	¼ ounce 70 grains	12.3 grams
Sodium Sulfite, desiccated	1 ounce 88 grains	36.0 grams
Sodium Carbonate, monohydrated	1 ounce 88 grains	36.0 grams
Potassium Bromide	27 grains	1.8 grams
Add cold water to make	32 ounces	1.0 liter

For use, dilute one part stock solution with two parts water. Normal developing time, 1½-3 minutes at 68 F (20 C).

ANSCO DEVELOPER 125

A normal paper developer for neutral black tones on contact and enlarging papers; it can also be used for development of films when short developing times and brilliant negatives are desired. It is similar to Kodak D-72 but not identical to it.

Water (125 F or 52 C)	24 ounces	750.0cc
Metol	45 grains	3.0 grams
Sodium Sulfite, desiccated	1½ ounces	44.0 grams
Hydroquinone	¼ ounce 60 grains	12.0 grams
Sodium Carbonate, monohydrated	2¼ ounces	65.0 grams
Potassium Bromide	30 grains	2.0 grams
Add cold water to make	32 ounces	1.0 liter

Paper Development—Dilute one part stock solution with two parts water. Develop 1-2 minutes at 68 F (20 C). For softer and slower development, dilute one to four and develop 1½-3 minutes at 68 F (20 C). For greater brilliance, shorten the exposure slightly and lengthen the development time. For greater softness, lengthen the exposure slightly and shorten the development time.

Film Development—Dilute one part stock solution with one part water and develop three to five minutes at 68 F (20 C). For softer results, dilute one to three and develop three to five minutes at 68 F (20 C).

ANSCO DEVELOPER 130

A universal paper developer containing Metol, hydroquinone, and glycin for rich black tones with brilliance and detail. It has considerable latitude in development time without stain or fog.

STOCK SOLUTION

Water (125 F or 52 C) 24 ounces	750.0cc	
Metol .. 32 grains	2.2 grams	
Sodium Sulfite, desiccated1¾ ounces	50.0 grams	
Hydroquinone ¼ ounce 50 grains	11.0 grams	
Sodium Carbonate, monohydrated2½ ounces	78.0 grams	
Potassium Bromide 80 grains	5.5 grams	
Glycin ¼ ounce 50 grains	11.0 grams	
Add cold water to make 32 ounces	1.0 liter	

The prepared stock solution is clear but slightly colored. The coloration in this case does not indicate the developer has deteriorated or is unfit for use.

For use, dilute one part stock solution with one part water.

Normal developing time at 68 F (20 C) for fast enlarging papers, 2-6 minutes; for slow enlarging and contact papers, 1½-3 minutes.

Greater contrast can be obtained by using the developer stock solution full strength Softer results can be obtained by diluting one part stock solution with two parts water.

ANSCO DEVELOPER 135

A Metol-hydroquinone, warm-tone developer for enlarging and contact papers.

STOCK SOLUTION

Water (125 F or 52 C) 24 ounces	750.0cc	
Metol .. 24 grains	1.6 grams	
Sodium Sulfite, desiccated¾ ounce 20 grains	24.0 grams	
Hydroquinone 96 grains	6.6 grams	
Sodium Carbonate, monohydrated¾ ounce 20 grains	24.0 grams	
Potassium Bromide 40 grains	2.8 grams	
Add cold water to make 32 ounces	1.0 liter	

For use, dilute one part stock solution with one part water. A properly exposed print will be fully developed at 68 F (20 C) in about 1½-2 minutes. Complete development may be expected to take slightly longer with rough-surfaced papers than with semi-glossy or luster-surfaced papers For greater softness, dilute the bath with water up to equal quantities of developer and water. To increase the warmth, add bromide up to double the amount in the formula. The quantity of bromide specified in the formula, however, assures rich, warm, well-balanced tones.

DUPONT DEVELOPER 6-D

A low-contrast, maximum-emulsion speed developer for small-format films. It has long keeping life in a tank and may be replenished. It is used full strength. The formula is similar to, but not identical with, Kodak D-76.

Water (125 F or 52 C)	24 ounces	750.0cc
Metol	29 grains	2.0 grams
Sodium Sulfite, anhydrous	3¼ ounces	98.0 grams
Hydroquinone	75 grains	5.0 grams
Borax, crystals	29 grains	2.0 grams
Add cold water to make	32 ounces	1.0 liter

Dissolve all chemicals in the order given.

Use full strength.

Time-Temperature Development Chart

Shows developing times at various temperatures corresponding to a given time at 68 F (20 C). For other times at 68 F locate the time along the 68 F line and draw through that point a line parallel to the one given. See page 178 for a more complete discussion.

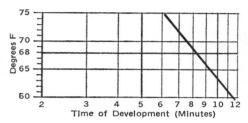

DUPONT REPLENISHER 6-DR

Water (125 F or 52 C)	28 ounces	900.0cc
Metol	44 grains	3.0 grams
Sodium Sulfite, anhydrous	3 ounces 145 grains	100.0 grams
Hydroquinone	¼ ounce	7.5 grams
Borax, crystals	290 grains	20.0 grams
Add cold water to make	32 ounces	1.0 liter

Dissolve all chemicals in the order given.

A replenisher must not only replace that portion of the developer that is physically carried away by the material processed but must also restore the activity of the developer to a level as close as possible to that of fresh developer. Since the rate of exhaustion varies greatly with the type of negative and the manner in which the developer is stored and used, only general recommendations as to the correct rate of replenishment can be made. For average negatives and conditions of use, replenishment of 6-D at the rate of ¾ ounce of 6-DR to the gallon of working solution (25cc per four liters) for each 80 square inches of film processed will usually permit the same development times throughout its useful life. Developer used without replenishment has a useful life of about 2,000 square inches per gallon. Replenished developer can be used to process about 16,000 square inches per gallon.

DUPONT DEVELOPER 51-D

A warm-tone developer for contact and enlarging papers.

Water (125 F or 52 C)	24 ounces	750.0cc
Metol	22 grains	1.5 grams
Sodium Sulfite, anhydrous	¾ ounce	22.5 grams
Hydroquinone	90 grains	6.3 grams
Sodium Carbonate, anhydrous	½ ounce	15.0 grams
Potassium Bromide	22 grains	1.5 grams
Add cold water to make	32 ounces	1.0 liter

For use, dilute one part of stock solution to one part of water and develop from 1½-2 minutes at 68 F (20 C).

DUPONT DEVELOPER 53-D

A general-purpose developer reproducing neutral black tones on contact and enlarging papers; it may also be used for tray development of sheet films and plates. This formula is similar to, but not identical with, Kodak Developer D-72.

STOCK SOLUTION

Water (125 F or 52 C)	16 ounces	500.0cc
Metol	45 grains	3.0 grams
Sodium Sulfite, anhydrous	1½ ounces	45.0 grams
Hydroquinone	175 grains	12.0 grams
Sodium Carbonate, anhydrous	2¼ ounces	67.5 grams
Potassium Bromide	27 grains	1.9 grams
Add cold water to make	32 ounces	1.0 liter

Dissolve chemicals in the order given.

For Paper—Dilute one part of stock solution with two parts of water. Develop projection paper for 1½-2½ minutes at 68 F (20 C).

For Film—Dilute one part of stock solution with two parts of water.

Tank Development—Times given are in minutes for development at 68 F (20 C), with ASA intermittent agitation.

"Cronar" High Speed Pan, Type 428	2¾ minutes
"Cronar" Arrow Pan	4¾ minutes
"Cronar" "X-F Pan"	3½ minutes

DUPONT DEVELOPER 54-D

An active developer formula for use on chloride contact papers to produce cold blue-black tones.

STOCK SOLUTION

Water (125 F or 52 C)	24 ounces	750.0cc
Metol	40 grains	2.7 grams
Sodium Sulfite, desiccated	1 ounce 146 grains	40.0 grams
Hydroquinone	155 grains	10.6 grams
Sodium Carbonate, anhydrous	2½ ounces	75.0 grams
Potassium Bromide	12 grains	0.8 gram
Add cold water to make	32 ounces	1.0 liter

Dissolve chemicals in the order given.

Dilute one part of stock solution with two parts of water and develop for 1½-2½ minutes at 68 F (20 C).

DUPONT DEVELOPER 55-D

This is the standard developer for warm tones on enlarging papers. The tones produced are intermediate between the neutral black of DuPont 53-D and the very warm black of DuPont 51-D.

STOCK SOLUTION

Water (125 F or 52 C)	24 ounces	500.0cc
Metol	36 grains	2.5 grams
Sodium Sulfite, anhydrous	1¼ ounces	37.5 grams
Hydroquinone	146 grains	10.0 grams
Sodium Carbonate, anhydrous	1¼ ounces	37.5 grams
Potassium Bromide	73 grains	5.0 grams
Add cold water to make	32 ounces	1.0 liter

Dissolve chemicals in the order given.

Liberal use of potassium bromide is permissible, with a range of 5-13 grams of bromide per liter of stock solution. When excess bromide is added to the developer, overexposure with 1½-minute development, or less will give warmer tones.

Dilute one part stock solution to two parts of water. Develop for one to two minutes at 68 F (20 C).

DUPONT DEVELOPER 56-D

A rapid developer for commercial use with fast enlarging papers, producing neutral black tones.

STOCK SOLUTION

Water (125 F or 52 C)	24 ounces	750.0cc
Metol	48 grains	3.3 grams
Sodium Sulfite, anhydrous	1 ounce 55 grains	33.5 grams
Hydroquinone	146 grains	10.0 grams
Sodium Carbonate, anhydrous	1 ounce 380 grains	56.0 grams
Potassium Bromide	48 grains	3.3 grams
Add cold water to make	32 ounces	1.0 liter

Dissolve chemicals in the order given.

For use, take one part of stock solution and add two parts of water.

Develop for one to two minutes at 68 F (20 C).

DUPONT DEVELOPER 58-D

Chlor-hydroquinone is used as a developing agent in this formula, to produce warm black and brown tones on Varilour paper.

Water (125 F or 52 C)	24 ounces	750.0cc
Sodium Sulfite	232 grains	16.0 grams
Chlor-Hydroquinone (Adurol)	58 grains	4.0 grams
Sodium Carbonate, anhydrous	232 grains	16.0 grams
Potassium Bromide	7½ grains	0.5 gram
Add cold water to make	32 ounces	1.0 liter

Dissolve chemicals in the order given.

Use one part stock solution and one part water.

It is necessary to develop four minutes at 68 F (20 C) to obtain the maximum black of the paper, at which time the tone is perceptibly warmer than with 55 - D. Shorter developing times with increased exposure will sacrifice the maximum black somewhat, but warmer tones are obtained. Prints developed in this developer, when toned, will give warmer tones throughout the series than when 55 - D is used.

GEVAERT DEVELOPER G.206

A soft-gradation, maximum-emulsion-speed developer for 35mm and roll film negatives. It is similar to but not identical with Kodak Developer D-76.

Metol ...	30 grains	2.0 grams
Sodium Sulfite, desiccated3 ounces 145 grains		100.0 grams
Hydroquinone	60 grains	4.0 grams
Borax ...	30 grains	2.0 grams
Water (distilled) to make	32 ounces	1.0 liter

Due to the high concentration of sodium sulfite, this solution may be difficult to prepare unless the following procedure is used:

1) Dissolve the Metol in about 200cc (approximately six ounces) of water.

2) Dissolve 50 grams (about 1½ ounces) of sodium sulfite in about 200cc (16 ounces) of water. Then add the 4.0 grams (60 grains) of hydroquinone to this solution.

3) When the two solutions above are completely dissolved, mix them and stir well.

4) Dissolve the remainder of the sodium sulfite and the borax in about 400cc (12 ounces) of water at 125 F (52 C).

5) When thoroughly dissolved, cool to room temperature and add to the combined solutions 1 and 2. Then fill up rapidly with water to 1000cc (32 ounces).

Develop ten minutes at 68 F (20 C). Higher temperatures may result in somewhat coarser grain.

Time-Temperature Development Chart

Shows developing times at various temperatures corresponding to a given time at 68 F (20 C). For other times at 68 F locate the time along the 68 F line and draw through that point a line parallel to the one given. See page 178 for a more complete discussion.

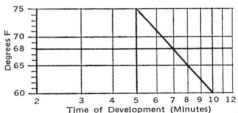

GEVAERT DEVELOPER G.207

A soft-gradation negative developer with some compensating action, tending to hold back highlight density while shadows are gaining strength. It is particularly useful for flash negatives that have a tendency to block in the highlights.

Warm Water (125 F or 52 C)	24 ounces	750.0cc
Metol ...	60 grains	4.0 grams
Sodium Sulfite, desiccated3 ounces 145 grains		100.0 grams
Sodium Carbonate, monohydrated	85 grains	6.0 grams
Potassium Bromide	30 grains	2.0 grams
Add cold water to make	32 ounces	1.0 liter

Develop roll and miniature films five minutes at 68 F (20 C) with constant agitation; seven minutes with intermittent agitation.

GEVAERT DEVELOPER G.215

A softer-gradation compensating developer, suitable for flash exposures on sheet films and plates, as well as the faster 35mm negative films.

Warm Water (125 F or 52 C)	24 ounces	750.0cc
Metol	60 grains	4.0 grams
Sodium Sulfite, desiccated	365 grains	25.0 grams
Sodium Carbonate, monohydrated	175 grains	12.0 grams
Potassium Bromide	7½ grains	0.5 grams
Add cold water to make	32 ounces	1.0 liter

Use at 68 F (20 C).

Develop medium-speed films and plates six to nine minutes, depending upon agitation and contrast desired. High-speed films may require as much as 50 per cent longer development.

Time-Temperature Development Chart

Shows developing times at various temperatures corresponding to a given time at 68 F (20 C). For other times at 68 F locate the time along the 68 F line and draw through that point a line parallel to the one given. See page 178 for a more complete discussion.

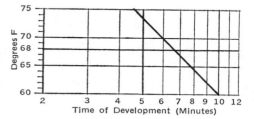

GEVAERT DEVELOPER G.251

Universal developer for neutral black tones on contact and enlarging papers; also suitable for films and plates developed in a tray. Similar to Kodak Developer D-72, at a different concentration.

Warm Water (125 F or 52 C)	24 ounces	750.0cc
Metol	22 grains	1.5 grams
Sodium Sulfite, desiccated	365 grains	25.0 grams
Hydroquinone	88 grains	6.0 grams
Sodium Carbonate, monohydrated	1½ ounces	45.0 grams
Potassium Bromide	15 grains	1.0 grams
Add cold water to make	32 ounces	1.0 liter

Use full strength. For longer development, or for softer results with normal development time, dilute one part of developer to one part of water.

GEVAERT DEVELOPER G.252

This is a paper developer for blue-black tones on contact papers.

Warm Water (125 F or 52 C)	24 ounces	750.0cc
Metol	37½ grains	2.5 grams
Sodium Sulfite, desiccated	365 grains	25.0 grams
Hydroquinone	88 grains	6.0 grams
Sodium Carbonate, monohydrated	1½ ounces	45.0 grams
Potassium Bromide	7½ grains	0.5 gram
Add cold water to make	32 ounces	1.0 liter

Develop papers one minute at 68 F (20 C).

GEVAERT DEVELOPER G.253

This is a warm-tone paper developer tending to produce slightly softer gradation than the normal paper developers and intended as a portrait print developer.

Warm Water (125 F or 52 C)	24 ounces	750.0cc
Metol	45 grains	3.0 grams
Sodium Sulfite, desiccated	292 grains	20.0 grams
Sodium Carbonate, monohydrated	¾ ounce	23.0 grams
Potassium Bromide	15 grains	1.0 gram
Add cold water to make	32 ounces	1.0 liter

This solution may be diluted with one part of water for increased time of development. Warmer tones may be obtained with the addition of potassium bromide, over and above the amount given in the formula.

Developing time one to three minutes at 68 F (20 C).

GEVAERT DEVELOPER G.261

This developer contains glycin and hydroquinone and produces brown tones on warm-tone enlarging papers; if heavily diluted and developing time is increased accordingly, the tones tend to a red on certain papers.

Warm Water (125 F or 52 C)	24 ounces	750.0cc
Sodium Sulfite, desiccated	1 ounce 145 grains	40.0 grams
Glycin	88 grains	6.0 grams
Hydroquinone	88 grains	6.0 grams
Sodium Carbonate, monohydrated	1 ounce 75 grains	35.1 grams
Potassium Bromide	30 grains	2.0 grams
Add cold water to make	32 ounces	1.0 liter

Without dilution this developer will give brown-black tones on papers in about two minutes at 68 F (20 C).

Diluted 1:2, this developer produces brown tones in 4-8 minutes. Diluting 1:4 and developing 8-15 minutes produces a red-brown tone. Diluting 1:6 and developing from 15-25 minutes will produce a red tone on some papers. For still warmer tones, add 145 grains (10.0 grams) of sodium bicarbonate to each liter of the above solution.

GEVAERT DEVELOPER G.262

A concentrated developer containing hydroquinone as a developing agent, producing warm-black, brown, or even red tones, but requiring shorter exposures and development than G.261.

STOCK SOLUTION

Warm Water (125 F or 52 C)	24 ounces	750.0cc
Sodium Sulfite, desiccated	2 ounces 145 grains	70.0 grams
Hydroquinone	365 grains	25.0 grams
Potassium Carbonate	3 ounces	90.0 grams
Potassium Bromide	30 grains	2.0 grams
Add cold water to make	32 ounces	1.0 liter

For use, dilute one part of stock solution with two to six parts of water, according to the tone required (from warm black to red).

Develop two to six minutes at 68 F (20 C).

This developer gives the same tones as G.261, but it allows of shorter exposure times; only 1½-4 times that required when development takes place in a normal developer such as G.251. This is short for a developer giving warm tones.

ILFORD DEVELOPER ID-1

A tray developer of the obsolete pyro-soda type; the two solutions have good keeping quality, but when mixed, deteriorate rapidly. The image is brownish, with good printing quality, but tends to be grainy on the faster films.

STOCK SOLUTION A

Warm Water (125 F or 52 C)	24 ounces	750.0cc
Potassium Metabisulfite	365 grains	25.0 grams
Pyrogallic Acid	3 ounces 145 grains	100.0 grams
Add cold water to make	32 ounces	1.0 liter

Be sure that the potassium metabisulfite is dissolved before adding the pyrogallic acid.

STOCK SOLUTION B

Warm Water (125 F or 52 C)	24 ounces	750.0cc
Sodium Carbonate, monohydrated	1 ounce 200 grains	44.0 grams
Sodium Sulfite, desiccated	1 ounce 292 grains	50.0 grams
Potassium Bromide	17 grains	1.2 grams
Add cold water to make	32 ounces	1.0 liter

For tray development, mix one part A, ten parts B, nine parts water. Develop for 2½-5 minutes at 68 F (20 C). For tank development, mix 1 part A, 5 parts B, 20 parts water. Develop for 5-10 minutes at 68 F (20 C).

ILFORD DEVELOPER ID-2

A rapid Metol-hydroquinone developer for tray development of sheet films and plates; it can be diluted for tank development if desired.

STOCK SOLUTION

Warm Water (125 F or 52 C)	24 ounces	750.0cc
Metol ..	30 grains	2.0 grams
Sodium Sulfite, desiccated	2½ ounces	75.0 grams
Hydroquinone	120 grains	8.0 grams
Sodium Carbonate, monohydrated	1 ounce 190 grains	43.0 grams
Potassium Bromide	30 grains	2.0 grams
Add cold water to make	32 ounces	1.0 liter

For *Tray Development*, dilute one part of the above stock solution with two parts of water. Develop 3-6 minutes at 68 F (20 C). For *Tank Development*, dilute one part of stock solution with five parts of water. Develop 6 to 12 minutes at 68 F (20 C).

Time-Temperature Development Chart

Shows developing times at various temperatures corresponding to a given time at 68 F (20 C). For other times at 68 F locate the time along the 68 F line and draw through that point a line parallel to the one given. See page 178 for a more complete discussion.

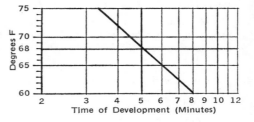

ILFORD DEVELOPER ID-11

A low-contrast, maximum shadow detail negative developer for roll films and 35mm negatives; it is practically identical to Kodak Developer D-76.

Warm Water (125 F or 52 C)	24 ounces	750.0cc
Metol	30 grains	2.0 grams
Sodium Sulfite, desiccated	3 ounces 145 grains	100.0 grams
Hydroquinone	75 grains	5.0 grams
Borax	30 grains	2.0 grams
Add cold water to make	32 ounces	1.0 liter

Use full strength. Develop from 5 to 13 minutes at 68 F (20 C).

An extra-fine-grain developer can be prepared by adding to the above, ammonium chloride at the rate of 40 grams of ammonium chloride per liter of prepared Ilford ID-11 (one ounce 145 grains per quart). Camera exposures should be doubled, and developing time increased to twice the specified time for ID-11.

Time-Temperature Development Chart

Shows developing times at various temperatures corresponding to a given time at 68 F (20 C). For other times at 68 F locate the time along the 68 F line and draw through that point a line parallel to the one given. See page 178 for a more complete discussion.

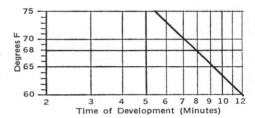

ILFORD REPLENISHER ID-11R

Warm Water (125 F or 52 C)	24 ounces	750.0cc
Metol	44 grains	3.0 grams
Hydroquinone	112 grains	7.5 grams
Sodium Sulfite, desiccated	3 ounces 145 grains	100.0 grams
Borax	291 grains	20.0 grams
Add cold water to make	32 ounces	1.0 liter

Add the replenisher to the developer tank so as to maintain the level of solution. Where the tank is in continuous use, a quantity of replenisher equal to that of the original developer may normally be added before the solution is discarded.

ILFORD DEVELOPER ID-20

An active Metol-hydroquinone developer for bromide enlarging papers; it produces a neutral black on normal papers, warm black on warm-tone papers. Note that the packaged developer sold by Ilford is made to a phenidone formula and is not the same as the formula given below.

STOCK SOLUTION

Warm Water (125 F or 52 C)	24 ounces	750.0cc
Metol	22 grains	1.5 grams
Sodium Sulfite, desiccated	365 grains	25.0 grams
Hydroquinone	88 grains	6.0 grams
Sodium Carbonate, monohydrated	1 ounce 75 grains	35.0 grams
Potassium Bromide	30 grains	2.0 grams
Add cold water to make	32 ounces	1.0 liter

For use, dilute one part of stock solution with one part of water. With fast papers, this developer gives good neutral blacks; with slow portrait papers, a pleasant warm black. Developing time for all papers is 1½ minutes for normal exposures.

ILFORD DEVELOPER ID-22

This is an amidol developer for enlarging papers; it does not keep well in solution, must be mixed immediately before use, and can only be used for a small number of prints in a tray. Reducing the bromide to one-quarter of the amount given above is recommended if this developer is to be used on contact papers with chloride emulsions. The modified formula is known as Ilford ID-30.

Warm Water (125 F or 52 C)	24 ounces	750.0cc
Sodium Sulfite, desiccated	365 grains	25.0 grams
Amidol	88 grains	6.0 grams
Potassium Bromide, ten per cent solution	¼ fluid ounce	8.0cc
Add cold water to make	32 ounces	1.0 liter

Use full strength. Develop about two minutes. This developer should be freshly made just before using and should be discarded after use. It does not keep in stock solution form.

ILFORD DEVELOPER ID-36

A universal developer for films, plates, and papers; it is similar to Kodak D-72 diluted with an equal part of water. It produces neutral black tones on papers. The packaged Ilford ID-36 Developer is not the same formula; it is made up as a phenidone and hydroquinone mixture.

Warm Water (125 F or 52 C)	24 ounces	750.0cc
Metol	22 grains	1.5 grams
Sodium Sulfite, desiccated	365 grains	25.0 grams
Hydroquinone	93 grains	6.3 grams
Sodium Carbonate, monohydrated	1¼ ounce 45 grains	40.5 grams
Potassium Bromide	6 grains	0.4 grams
Add cold water to make	32 ounces	1.0 liter

For contact papers, use full strength; develop 45 to 60 seconds.

For enlarging papers, use one part ID-36 and one part water and develop for 1½-2 minutes.

For *Tray Development* of films and plates, take one part of ID-36 and one part of water; develop three to five minutes.

For *Tank Development* of films and plates, use one part of ID-36 and three parts of water; develop six to ten minutes.

ILFORD DEVELOPER ID-67

A rapid tank or tray developer for films and plates, similar to Ilford ID-2, but made up with phenidone instead of Metol.

STOCK SOLUTION

Warm Water (125 F or 52 C)	24 ounces	750.0cc
Sodium Sulfite, anhydrous	3½ ounces	75.0 grams
Hydroquinone	115 grains	8.0 grams
Sodium Carbonate, desiccated	1¼ ounces	37.5 grams
Phenidone	4 grains	0.25 gram
Potassium Bromide	30 grains	2.0 grams
Benzotriazole	2½ grains	0.15 gram
Add cold water to make	32 ounces	1.0 liter

For *Tray Development*, dilute 1:2 and develop 2½ to 5 minutes.

For *Tank Development*, dilute 1:5 and develop 5 to 10 minutes.

ILFORD MICROPHEN FINE-GRAIN DEVELOPER

Ilford Microphen is a fine-grain developer which gives an effective increase in film speed. Grain size is reduced and grain clumping prevented because of the low alkalinity of the developer.

The majority of developers which give an increase in film speed usually produce a corresponding increase in grain size. Microphen, however, has been specially formulated to overcome this disadvantage and is therefore said to have a high speed/grain ratio. That is, it yields a speed increase while giving the type of fine grain result associated with MQ borax developers. A speed increase of half a stop can be achieved from most films.

Microphen is a clean working long life developer, supplied as a powder, which is dissolved to make a working strength solution.

Useful Life Without Replenishment

If Microphen is stored in a well-stoppered bottle it will keep well and can be repeatedly used. Under normal conditions eight rollfilms or eight 36-exposure 35mm films can be developed in 600 ml of developer—to maintain uniform contrast for all eight films the development time should be increased by 10 per cent for each successive film developed.

Useful Life With Replenishment

Microphen Replenisher is available for deep tank processing. It is designed to prolong the useful life of the developer and to maintain constant activity over a long period of time. The replenisher should be made up according to the instructions packed with it.

The most satisfactory method of replenishing Microphen is to add a small quantity of replenisher when the original volume has decreased by 5 per cent or when about 14 square feet of sensitized material has been processed in each gallon of developer. No limit is set to the amount of replenisher which may be added to a given volume of original developer. Replenishment may be continued until it becomes necessary to discard the solution in order to clean out the tank. If the tank is only used intermittently, it should be covered with a well-fitting floating lid to minimize developer oxidation and loss of water through evaporation.

Development Times

Recommended times for the development of Ilford films and plates are given below. These times may be increased by up to 50 per cent for greater contrast, or where the highest speed is essential, as in the case of known underexposure.

General purpose materials are normally developed to a \overline{G} (average contrast) of 0.55 if a tungsten enlarger is used for printing, and to a \overline{G} of 0.70 if a cold cathode enlarger is used. The times given below are in minutes and refer to development at 20 C (68 F) with intermittent agitation. If continuous agitation is used, these times should be reduced by 25 per cent.

General Purpose Films	\overline{G} 0.55	\overline{G} 0.70
Sheet Film		
HP4	5	8
FP4	5½	9½
Roll Film		
HP4	5	8
FP4	5½	9½
35mm Films		
HP4	5	8
FP4	5½	9½
Pan F	3	4½

Dilute Development

Development of FP4 and HP4 in diluted Microphen increases acutance; the greater the dilution, the better the acutance. Dilute development is particularly suitable for subjects with long tonal scales; shadow and highlight densities are retained while negatives are sufficiently contrasty to produce bright prints. With this development technique film speed is fully maintained, but development times have to be increased.

Diluted developers should be used once only and then discarded.

Ilford Film	Dilution	\overline{G} 0.55	\overline{G} 0.70
FP4	1 + 1	7	12
	1 + 3	8½	16
HP4	1 + 1	9	15
	1 + 3	18	NR
Pan F	1 + 1	4	6
	1 + 3	7	10½

NR — not recommended

Special Materials

Recommended development times for specialized sheet films and plates are given for both intermittent and continuous agitation at a developer temperature of 20 C (68 F). These times can be varied by the user according to the processing conditions.

Ilford material	Continuous agitation	Intermittent agitation
Sheet Film		
Fine Grain Ordinary	4	5
Commercial Ortho	9½	12
Plates		
N.30 Ordinary	4	5
N.25 Soft Ordinary	3¼	4
Special Rapid	3¼	4
G.30 Chromatic	4	5
R.25 FP Special	3¼	4
R.20 Special Rapid Panchromatic	4¾	6
R.10 Soft Gradation Panchromatic	4¾	6
FP4	6	7½
HP3	6	7½

Intermittent agitation — agitation for the first 10 seconds of development, then for 5 seconds every minute for the remainder of the development time.

ILFORD PERCEPTOL DEVELOPER

Perceptol is an extra-fine-grain developer. It has been specifically formulated to exploit the fine grain structure of FP-4 and to produce significantly finer grain in HP-4 negatives when compared with development in ID-11.

Perceptol is supplied as a powder from which a solution is made by dissolving two separately-packed ingredients in warm water at about 105 F (40 C). The solution can be diluted. Perceptol contains a sequestering agent to counteract the effect of hard water precipitates and being in powder form it has excellent keeping qualities even in the tropics. When made up, the unused solution will last for about six months in air-tight bottles.

The solution can be replenished, but without replenishment one gallon (4.5 liters) of full-strength Perceptol will develop twenty 120 roll films in deep tanks or machines. When replenished, one gallon (4.5 liters) will develop ninety 120 films or the equivalent.

Full-strength Development and Replenishment

When it is known that full-strength Perceptol will be the developer used, films must receive about double the normal exposure. Films should therefore be re-rated at the following adjusted figures.

Film	Nominal Rating		Adjusted Rating	
	ASA	DIN	ASA	DIN
Pan F	50	18	25	15
FP-4	125	22	64	19
HP-4	400	27	200	24

Development Times

For enlarging with a tungsten light source, films should be developed to a \overline{G} (average gradient) of 0.55. For enlarging with a cold-cathode source films should be developed to \overline{G} 0.70.

In full-strength Perceptol, the times quoted below will give these values. The times are in minutes and assume intermittent agitation, i. e., agitation for the first ten seconds of development, then for ten seconds every minute for the remainder of the time. Temperature of the solution should be 68 F (20 C). To compensate for loss of activity, increase the development time by ten per cent after eight films have been processed in each gallon (4.5 liters), or forty films per 5 gallons (22.5 liters) of developer.

Film	\overline{G} 0.55	\overline{G} 0.70
Pan F	8½	12½
FP-4 (Roll/flat/35mm)	8	10½
HP-4 (Roll/flat/35mm)	8½	11½

Dilution Technique

To achieve a fuller film speed and to give maximum developer usage, especially when processing in a spiral tank, Perceptol solution can be diluted 1:1 or 1:3 with water. When diluted 1:1, the 600 ml size will make 1200 ml providing enough solution for four 120 roll films to be processed using a 300 ml tank. With the 1:3 dilution, the 600 ml size will make up to 2400 ml so that eight of these films can be processed using a 300 ml tank.

With this technique, the film should have previously been rated at the ASA/DIN figure recommended below. Perceptol should be diluted immediately

211

before use with just the right amount of water to fill the tank and the film processed at the recommended time. Discard each 300 ml of diluted developer after one use.

The following times and speed ratings for this technique are recommended when processing at 68 F (20 C) with intermittent agitation, i. e., agitation for the first ten seconds of development, then for ten seconds every minute for the remainder of the time.

Film	ASA	DIN	Time for 1:1	ASA	DIN	Time for 1:3
Pan F	32	16	10½ min	32	16	13½ min
FP-4 (Roll/flat/35mm)	100	21	9 min	100	21	13 min
HP-4 (Roll/flat/35mm)	320	26	12 min	Not recommended		

Replenishment Technique

When processing in deep tanks or machines, effective developer life is increased if Perceptol developer is replenished. Replenisher should be added at the following rates.

Tank Size	When to Add Replenisher	Amount of Developer to Be Removed	Amount of Replenisher to Be Added
½ gallon (2.5 liters)	After every 6 films*	70 ml (2½ oz)	116 ml (4 oz)
1 gallon (4.5 liters)	After every 10 films*	120 ml (4¼ oz)	210 ml (7½ oz)
3 gallons (13.5 liters)	After every 30 films*	350 ml (12½ oz)	630 ml (22½ oz)
5 gallons (22.5 liters)	After every 50 films*	600 ml (21 oz)	1050 ml (37½ oz)
12 gallons (54 liters)	After every 120 films*	1400 ml (50 oz)	2520 ml (90 oz)

*One 120 rollfilm is the equivalent of one 36-exposure 35mm film or one 8" x 10" sheet film.

ILFORD BROMOPHEN DEVELOPER

Bromophen is the standard universal-type developer in powder form; it replaces ID-20, ID-36, and PFP. It is a Phenidone-hydroquinone formula with long working life and high capacity.

Bromophen is particularly recommended for obtaining maximum quality from Ilfobrom and is suitable for roll, sheet film and plates when a high degree of enlargement is not necessary.

The versatility of Bromophen makes it suitable for a very wide range of applications—the stock solution made up from the powder may be diluted according to application, developing time and contrast desired.

Working Strengths

For use, recommended rates of dilution for Bromophen stock solution are given below.

Sensitive Material	Dilution
Contact papers	1:1
Bromide papers for automatic printing	1:3
Rapid development of paper	1:1
Tray development of sheet films and plates	1:3
Tank development of sheet films and plates	1:7

Development Times—Papers

The development times given below are in minutes and are for development at 68 F (20 C).

Ilford Paper	Dilution	Time
Contact	1:1	¾—1
Ilfobrom	1:3	1½—2
Kenprint-S	1:3	1½—2
For rapid development of papers:		
Ilfobrom	1:1	1—1½
Kenprint-S	1:1	1—1½

Development Times—Films And Plates

The development times given for general purpose films are for two average contrasts \overline{G} and refer to intermittent agitation only. If negatives are to be printed using a tungsten enlarger they should be developed to a \overline{G} of 0.55. Similarly, negatives which are to be printed on a cold cathode enlarger should be developed to a \overline{G} of 0.70. If continuous agitation is to be used at a dilution of 1:7, these times should be reduced by one quarter.

General Purpose Materials	\overline{G} 0.55	\overline{G} 0.70
Sheet film		
HP-4	4	7½
Roll film		
HP-4	3	4½

The development times for Ilford plates are given below for both continuous and intermittent agitation.

Ilford Plates	Continuous Agitation (Dilution 1:3)	Intermittent Agitation (Dilution 1:7)
Selochrome	2	—
R.20 Special Rapid Panchromatic	1½	3
R.10 Soft Gradation Panchromatic	3½	—
Contact Lantern	¾	—
Special Lantern, Soft and Normal	1¾	—
Special Lantern, Contrasty	2½	—

ILFORD DEVELOPER ID-68

A low-contrast borax fine-grain developer, using phenidone instead of Metol; it is otherwise similar to Ilford ID-11 in the type of negative produced.

Warm Water (125 F or 52 C)	24 ounces	750.0cc
Sodium Sulfite, desiccated	2 ounces 372 grains	85.0 grams
Hydroquinone	75 grains	5.0 grams
Borax	92 grains	7.0 grams
Boric Acid	29 grains	2.0 grams
Potassium Bromide	15 grains	1.0 grams
Phenidone	2 grains	0.13 gram
Add cold water to make	32 ounces	1.0 liter

Used undiluted; develop films for eight to ten minutes, plates for four to seven minutes at 68 F (20 C).

ILFORD REPLENISHER ID-68R

Warm Water (125 F or 52 C)	24 ounces	750.0cc
Sodium Sulfite, desiccated	2 ounces 372 grains	85.0 grams
Hydroquinone	117 grains	8.0 grams
Borax	92 grains	7.0 grams
Phenidone	3¼ grains	0.22 gram
Add cold water to make	32 ounces	1.0 liter

Add the replenisher to the developer tank so as to maintain the level of solution. Where the tank is in continuous use, a quantity of replenisher equal to that of the original developer may normally be added before the solution is discarded.

ILFORD DEVELOPER ID-78

A phenidone-hydroquinone paper developer, producing warm tones on contact and enlarging papers and on lantern slide plates.

Warm Water (125 F or 52 C)	24 ounces	750.0cc
Sodium Sulfite, desiccated	1 ounce 292 grains	50.0 grams
Hydroquinone	175 grains	12.0 grams
Sodium Carbonate, desiccated	2 ounces	62.0 grams
Phenidone	7½ grains	0.5 gram
Potassium Bromide	6 grains	0.4 gram
Add cold water to make	32 ounces	1.0 liter

Dilute one part of the above stock solution with one part of water and develop for one minute at 68 F (20 C). For longer development times, dilute one part of stock solution with three parts of water and develop for two minutes at 68 F (20 C).

KODAK DEVELOPER D-11

High-contrast process developer for films and plates, also for line diagrams on lantern slide plates.

Water (125 F or 52 C)	16 ounces	500.0cc
Kodak Elon Development Agent	15 grains	1.0 gram
Kodak Sodium Sulfite, desiccated	2½ ounces	75.0 grams
Kodak Hydroquinone	130 grains	9.0 grams
Kodak Sodium Carbonate, monohydrated	1 ounce	30.0 grams
Kodak Potassium Bromide	73 grains	5.0 grams
Add cold water to make	32 ounces	1.0 liter

Dissolve chemicals in the order given. Develop about five minutes in a tank or four minutes in a tray at 68 F (20 C). When less contrast is desired, the developer should be diluted with an equal volume of water.

KODAK DEVELOPER DK-15

A developer with high salt content to prevent blistering and swelling of the emulsion in high temperature tropical processing.

Water (125 F or 52 C)	24 ounces	750.0cc
Kodak Elon Developing Agent	82 grains	5.7 grams
Kodak Sodium Sulfite, desiccated	3 ounces	90.0 grams
Kodalk	¾ ounce	22.5 grams
Kodak Potassium Bromide	27 grains	1.9 grams
*Kodak Sodium Sulfate, desiccated1½ ounces		45.0 grams
Add cold water to make	32 ounces	1.0 liter

* If it is desired to use crystalline sodium sulfate instead of the desiccated sulfate, then 3½ ounces per 32 ounces (105 grams per liter) should be used.

Dissolve chemicals in the order given.

Average time for tank development is 9-12 minutes at 68 F (20 C) and 2-3 minutes at 90 F (32 C) in fresh developer according to the contrast desired. When working below 75 F (24 C), the sulfate may be omitted if a more rapid formula is required. Development time without the sulfate is 5-7 minutes at 65 F (18 C). Develop about 20 per cent less for tray use.

When development is completed, rinse the film or plate in water for one or two seconds only and immerse in the Tropical Hardener (Formula SB-4) for three minutes (omit water rinse if film tends to soften); then fix for at least 10 minutes in an acid hardening fixing bath, such as Formula F-5, and wash for 10-15 minutes in water (not over 95 F) (35 C).

KODAK DEVELOPER D-19

One of the most useful high-contrast developers for films and plates.

Water (125 F or 52 C)	16 ounces	500.0cc
Kodak Elon Developing Agent	30 grains	2.0 grams
Kodak Sodium Sulfite, desiccated	3 ounces	90.0 grams
Kodak Hydroquinone	115 grains	8.0 grams
Kodak Sodium Carbonate, monohydrated	1¾ ounces	52.5 grams
Kodak Potassium Bromide	75 grains	5.0 grams
Add cold water to make	32 ounces	1.0 liter

Dissolve chemicals in the order given.

This is a high-contrast, long-life, nonstaining tank or tray developer. It causes very little chemical fog and thus produces exceptionally "clear" negatives. Originally designed for use with X-ray materials, D-19 is now recognized as an excellent developer for aero films and for use with films and plates when high maximum contrast is desired, or when it is desired to obtain high contrast with a short developing time. Its good keeping qualities when used in tanks and its rapid development rate make it particularly useful for press photography.

This developer is recommended for use at from 65 F (18 C) to 70 F (21 C) and best results will be obtained within this range. However, acceptable results will be obtained at somewhat higher and lower temperatures.

Increase the time about 25 per cent for tank development.

Time-Temperature Development Chart

Shows developing times at various temperatures corresponding to a given time at 68 F (20 C). For other times at 68 F locate the time along the 68 F line and draw through that point a line parallel to the one given. See page 194 for a more complete discussion.

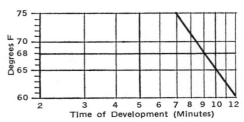

216

KODAK REPLENISHER D-19R

Water (125 F or 52 C)	16 ounces	500.0cc
Kodak Elon Developing Agent	65 grains	4.5 grams
Kodak Sodium Sulfite, desiccated	3 ounces	90.0 grams
Kodak Hydroquinone	255 grains	17.5 grams
Kodak Sodium Carbonate, monohydrated	1¾ ounces	52.5 grams
Kodak Sodium Hydroxide	¼ ounce	7.5 grams
Add cold water to make	32 ounces	1.0 liter

Dissolve chemicals in the order given.

Use without dilution and add to the developer tank in the proportion of one ounce of Kodak D-19R per 100 square inches of film processed (about 25cc for each 8" x 10" film). The maximum volume of replenisher added should not be greater than the volume of the original developer.

KODAK DEVELOPER D-23

A low-contrast developer with some compensating properties, for flash photography.

Water (125 F or 52 C)	24 ounces	750.0cc
Kodak Elon Developing Agent	¼ ounce	7.5 grams
Kodak Sodium Sulfite	3 ounces 145 grains	100.0 grams
Add cold water to make	32 ounces	1.0 liter

Dissolve chemicals in the order given.

Average developing time about 12 minutes in a tank or 10 minutes in a tray at 68 F (20 C).

Time-Temperature Development Chart

Shows developing times at various temperatures corresponding to a given time at 68 F (20 C). For other times at 68 F locate the time along the 68 F line and draw through that point a line parallel to the one given. See page 178 for a more complete discussion.

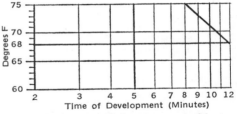

This developer produces negatives of speed and graininess comparable to D-76. Its low alkalinity and high salt content as well as its low fogging propensity make it suitable for use up to 80 F or 85 F, if the chrome alum stop bath, Kodak SB-4, is employed between development and fixing.

If used without replenishment, increase the processing time by ten per cent after each roll of 35mm or 120 roll film (80 square inches) has been processed. The developer should be discarded after processing ten rolls per liter (or 32 ounces).

This developer may be replenished with the Kodak Replenisher. DK-25R. ¾ ounce (22cc) should be added for each roll of film (80 square inches) processed. Most consistent results are obtained if it is added after each roll has been processed (or after each 40 rolls in a ten-gallon tank). With replenishment, the developer has a life of 100 rolls per gallon (or 25 rolls per liter or quart of developer).

A white scum of calcium sulfite frequently occurs on films processed in high sulfite, low alkalinity developers such as D-23. This scum is soluble in acid stop baths and in fresh acid fixing baths, especially if the film is well agitated. It is slowly soluble in wash water and may also be wiped or sponged off the wet film, although light deposits may not be noticed until the film is dry. The non-swelling acid stop bath, Kodak SB-5, is especially recommended for its removal.

217

KODAK DEVELOPER D-25

A modification of the D-23 developer; this formula is buffered for lower contrast and finer grain. It also has notable compensating properties.

Water (125 F or 52 C)	24 ounces	750.0cc
Kodak Elon Developing Agent	¼ ounce	7.5 grams
Kodak Sodium Sulfite, desiccated	3 ounces 145 grains	100.0 grams
Kodak Sodium Bisulfite	½ ounce	15.0 grams
Add cold water to make	32 ounces	1.0 liter

Dissolve chemicals in the order given. Use without dilution.

Average development time for Kodak Roll Films, about 20 minutes in a tank, at 68 F (20 C). At 77 F (25 C) the average development time is about 11 minutes in a tank. Grain is comparable with that obtained with the popular paraphenylene-diamine-glycin developer, but D-25 is nontoxic and nonstaining.

If it is not essential to obtain minimum graininess, or if it is not convenient to work at the higher temperature, use half the specified quantity of sodium bisulfite. The development time will then be approximately 14 minutes at 68 F. Graininess will be intermediate between that for Kodak D-23 and Kodak D-25.

For replenishment, add Kodak Replenisher DK-25R, at the rate of 1¼ ounces per roll for the first 50 rolls processed per gallon (12 rolls per liter) and at ¾ ounce per roll for the next 50 rolls per gallon. The developer should then be replaced with fresh solution.

KODAK REPLENISHER DK-25R

A replenisher containing Kodalk, suitable for use with either Kodak Developer D-23 or D-25.

Water (125 F or 52 C)	24 ounces	750.0cc
Kodak Elon Developing Agent	145 grains	10.0 grams
Kodak Sodium Sulfite, desiccated	3 ounces 145 grains	100.0 grams
Kodalk	290 grains	20.0 grams
Add cold water to make	32 ounces	1.0 liter

Dissolve chemicals in the order given. Use without dilution.

For use with Kodak D-23 Developer. Add ¾ ounce (22cc) of the above replenisher for each roll of 36-exposure 35mm, or 8-exposure 120 or 620, or equivalent (80 square inches) discarding some developer if necessary.

For use with Kodak D-25 Developer. The replenisher should be added at the rate of 1½ ounces (45cc) per roll of 80 square inches for the first 50 rolls per gallon (12 rolls per liter). For the next 50 rolls per gallon (or 12 rolls per liter), add only ¾ ounce per roll (22cc).

Loss of shadow detail becomes excessive after 100 rolls per gallon (25 rolls per liter) have been processed and the developer should be considered exhausted and be discarded at this point.

KODAK DEVELOPER DK-50

The most popular tank developer for commercial and portrait photography and other professional work on sheet film, roll films, and film packs.

Water (125 F or 52 C)	16 ounces	500.0cc
Kodak Elon Developing Agent	37 grains	2.5 grams
Kodak Sodium Sulfite, desiccated	1 ounce	30.0 grams
Kodak Hydroquinone	37 grains	2.5 grams
Kodalk	145 grains	10.0 grams
Kodak Potassium Bromide	7½ grains	0.5 gram
Add cold water to make	32 ounces	1.0 liter

Dissolve chemicals in the order given.

For tank development of roll films, film packs, and other sheet films and plates, use without dilution. Develop five to ten minutes at 68 F (20 C). For tray development, decrease the time about 20 per cent.

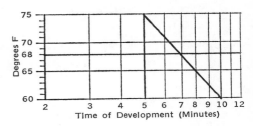

Time-Temperature Development Chart

Shows developing times at various temperatures corresponding to a given time at 68 F (20 C). For other times at 68 F locate the time along the 68 F line and draw through that point a line parallel to the one given. See page 178 for a more complete discussion.

KODAK REPLENISHER DK-50R

Water (125 F or 52 C)	24 ounces	750.0cc
Kodak Elon Developing Agent	75 grains	5.0 grams
Kodak Sodium Sulfite, desiccated	1 ounce	30.0 grams
Kodak Hydroquinone	145 grains	10.0 grams
Kodalk	1 ounce 145 grains	40.0 grams
Add cold water to make	32 ounces	1.0 liter

Dissolve chemicals in the order given.

If developer is diluted with an equal amount of water, the replenisher should likewise be diluted; otherwise it is used full strength. Add replenisher to the tank as needed to maintain the level of the solution. If density of the negative is not maintained, discard some of the developer from the tank at intervals and replace with replenisher.

KODAK DEVELOPER D-51

This amidol formula, although obsolete for use with bromide enlarging papers, has other uses, mentioned below.

STOCK SOLUTION

Water (125 F or 52 C)	24 ounces	750.0cc
Kodak Sodium Sulfite, desiccated	4 ounces	120.0 grams
*Di-Aminophenol Hydrochloride (Acrol)	1¼ ounces	37.5 grams
Add cold water to make	32 ounces	1.0 liter

* Di-Aminophenol (Acrol) is also known as *Amidol.*

Dissolve chemicals in the order given.

For use, take 6 ounces (180cc) stock solution, ¾ dram (3cc) ten per cent potassium bromide solution, and 24 ounces (750cc) of water. This developer oxidizes rapidly when exposed to the air, so that only a quantity sufficient for immediate use should be mixed.

This developer, being nonstaining, can be used advantageously for redevelopment, following the use of stain remover such as Formula Kodak S-6. When removing stains by this method, markings caused by drying of negative without removing the drops of water (water markings) are usually removed also unless the markings are of long standing.

219

KODAK DEVELOPER D-52

A warm-tone paper developer for contact and enlarging papers in professional photography.

STOCK SOLUTION

Water (125 F or 52 C)	16 ounces	500.0cc
Kodak Elon Developing Agent	22 grains	1.5 grams
Kodak Sodium Sulfite, desiccated	¾ ounce	22.5 grams
Kodak Hydroquinone	90 grains	6.0 grams
Kodak Sodium Carbonate, monohydrated	250 grains	17.0 grams
Kodak Potassium Bromide	22 grains	1.5 grams
Add cold water to make	32 ounces	1.0 liter

Dissolve chemicals in the order given.

For Kodak Opal, Athena, Platino, Illustrator's Special, Portrait Proof, Koda-bromide, Azo, and Illustrator's Azo Papers—use stock solution one part, water one part. Develop about two minutes at 68 F (20 C). More bromide may be added if warmer tones are desired.

KODAK DEVELOPER DK-60a

For small-scale photofinishing, using the deep-tank method, this developer is still useful, with the proper replenisher.

Water (125 F or 52 C)	24 ounces	750.0cc
Kodak Elon Developing Agent	37 grains	2.5 grams
Kodak Sodium Sulfite, desiccated1 ounce	290 grains	50.0 grams
Kodak Hydroquinone	37 grains	2.5 grams
Kodalk	290 grains	20.0 grams
Kodak Potassium Bromide7½	grains	0.5 gram
Add cold water to make	32 ounces	1.0 liter

Dissolve chemicals in the order given.

Develop about seven minutes at 68 F (20 C), in a tank of fresh developer.

Tray development times for all Kodak films and film packs should be 20% less than tank development times. Increase or decrease the times for greater or less contrast.

Time-Temperature Development Chart

Shows developing times at various temperatures corresponding to a given time at 68 F (20 C). For other times at 68 F locate the time along the 68 F line and draw through that point a line parallel to the one given. See page 178 for a more complete discussion.

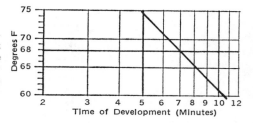

KODAK REPLENISHER DK-60aTR

This replenisher is designed specifically for use with Kodak Developer DK-60a, when used for hand processing of roll film in deep tanks, in small-scale photofinishing operations.

Water (125 F or 52 C)	24 ounces	750.0cc
Kodak Elon Developing Agent	75 grains	5.0 grams
Kodak Sodium Sulfite, desiccated	1 ounce 290 grains	50.0 grams
Kodak Hydroquinone	145 grains	10.0 grams
Kodalk	1 ounce 145 grains	40.0 grams
Add cold water to make	32 ounces	1.0 liter

Dissolve chemicals in the order given.

Add the replenisher before the liquid level in the developer tank has dropped more than two inches.

The development time will be maintained approximately constant, provided eight gallons of replenisher (DK-60aTR) are added per 1,000 rolls of film processed (80,000 square inches), or approximately one ounce (30.0cc) per roll.

KODAK DEVELOPER DK-60b

This developer is a modification of the photofinishing developer DK-60a; it has anti-swelling and anti-fog agents added and is intended specifically for the processing of aerial films in rewind tanks.

Water (125 F or 52 C)	24 ounces	750.0cc
Kodak Elon Developing Agent	18 grains	1.25 grams
Kodak Sodium Sulfite, desiccated	365 grains	25.0 grams
Kodak Hydroquinone	18 grains	1.25 grams
Kodalk	145 grains	10.0 grams
Kodak Sodium Sulfate, desiccated	1 ounce 290 grains	50.0 grams
Kodak Anti-Fog No. 1 0.2% stock solution*	¼ fluid ounce	8.0cc
Kodak Potassium Bromide	4 grains	.25 gram
Water to make	32 ounces	1.0 liter

* A 0.2% stock solution of Kodak Anti-Fog No. 1 may be made by dissolving 15 grains of this chemical in 16 ounces of water, about 125 F (one gram in 500cc at 52 C). Cool the stock solution before use. Kodak Anti-Fog No. 1 is supplied in 1-, 4-, or 16-ounce bottles. For the convenience of small users, it is also available in 0.45 grain tablets. Either of these is available from Eastman Kodak Company, Rochester, N.Y., or through their dealers.

Dissolve the chemicals in the order given.

Use without dilution. Develop in a tank of fresh developer about 20 minutes for high contrast, 13 minutes for medium contrast, or 6 minutes for low contrast, at 68 F (20 C).

When negatives of higher contrast are wanted, develop in formula D-19; for low contrast, use formula D-76 for 15 minutes at 68 F (20 C).

Time-Temperature Development Chart

Shows developing times at various temperatures corresponding to a given time at 68 F (20 C). For other times at 68 F locate the time along the 68 F line and draw through that point a line parallel to the one given. See page 178 for a more complete discussion.

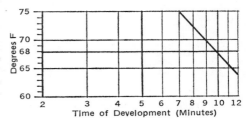

KODAK DEVELOPER D-61a

A fairly active negative developer for tank and tray use on sheet film negatives; in tank use it may be replenished for continued use for several weeks.

STOCK SOLUTION

Water (125 F or 52 C)	16 ounces	500.0cc
Kodak Elon Developing Agent	45 grains	3.0 grams
Kodak Sodium Sulfite, desiccated	3 ounces	90.0 grams
Kodak Sodium Bisulfite	30 grains	2.0 grams
Kodak Hydroquinone	90 grains	6.0 grams
Kodak Sodium Carbonate, monohydrated	200 grains	14.0 grams
Kodak Potassium Bromide	30 grains	2.0 grams
Add cold water to make	32 ounces	1.0 liter

Dissolve chemicals in the order given.

For tray use take one part of stock solution to one part of water. Develop for about six minutes at 68 F (20 C).

For tank use take one part of stock solution and three parts of water. At a temperature of 68 F (20 C), the development time is about 12 minutes. It is advisable to make up a greater quantity than is needed to fill the tank. If the developer in the tank is of normal strength, but the volume of solution has been reduced, add a sufficient quantity of the surplus solution diluted 1:3 to fill the tank.

Time-Temperature Development Chart

Shows developing times at various temperatures corresponding to a given time at 68 F (20 C). For other times at 68 F locate the time along the 68 F line and draw through that point a line parallel to the one given. See page 178 for a more complete discussion.

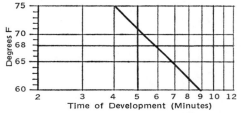

If the strength of the solution, as well as the volume, has been reduced, add a sufficient quantity of the replenisher (formula D-61R) to adjust the development time satisfactorily.

Although this developer does not produce negatives of warm tone, the negatives have good printing density and quality, and the developer has excellent keeping properties. It is one of the most satisfactory developers for continued use, and when kept up to normal volume, will give good results over a period of several weeks.

KODAK REPLENISHER D-61R

STOCK SOLUTION A

Water (125 F or 52 C)	96 ounces	3.0 liters
Kodak Elon Developing Agent	90 grains	6.0 grams
Kodak Sodium Sulfite, desiccated	6 ounces	180.0 grams
Kodak Sodium Bisulfite	60 grains	4.0 grams
Kodak Hydroquinone	175 grains	12.0 grams
Kodak Potassium Bromide	45 grains	3.0 grams
Add cold water to make	1½ gallons	6.0 liters

STOCK SOLUTION B

Kodak Sodium Carbonate, monohydrated	9½ ounces	280.0 grams
Water to make	64 ounces	2.0 liters

Dissolve chemicals in the order given.

For use take three parts of A and one part of B, and add to the tank developer as needed to maintain strength of the solution. Do not mix A and B until ready for use.

KODAK DEVELOPER D-72

A universal paper and negative developer; on papers it produces neutral black tones, which can be made warmer by increased dilution, addition of potassium bromide, and increased exposure of the print.

Water (125 F or 52 C)	16 ounces	500.0cc
Kodak Elon Developing Agent	45 grains	3.0 grams
Kodak Sodium Sulfite, desiccated	1½ ounces	45.0 grams
Kodak Hydroquinone	175 grains	12.0 grams
Kodak Sodium Carbonate, monohydrated	2 ounces 290 grains	80.0 grams
Kodak Potassium Bromide	30 grains	2.0 grams
Add cold water to make	32 ounces	1.0 liter

Dissolve chemicals in the order given.

For use with Kodak Azo, Illustrator's Azo, Ad-Type, Velox, Resisto, Velox Rapid, Kodabromide, and Resisto Rapid—dilute one part stock solution, one part water, and develop 1 minute at 68 F (20 C). For warmer tones on Kodabromide, dilute 1:3 or 1:4 and ¼ ounce (8cc) ten per cent potassium bromide for each 32 ounces (one liter) of working solution, and develop 1½ minutes.

For Lantern Slides dilute 1:2. Develop one to two minutes at 68 F (20 C). For greater contrast dilute 1:1, and for less contrast 1:4. For line drawings, Formula D-11 is recommended.

For Press Negatives dilute 1:1. Develop about five minutes without agitation or four minutes with agitation for average contrast at 68 F (20 C). For less contrast, dilute 1:2. For greater contrast, use full strength. Greater or less contrast may be obtained also by developing longer or shorter times than those indicated.

Time-Temperature Development Chart

Shows developing times at various temperatures corresponding to a given time at 68 F (20 C). For other times at 68 F locate the time along the 68 F line and draw through that point a line parallel to the one given. See page 178 for a more complete discussion.

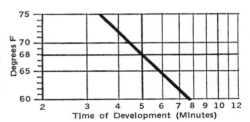

KODAK DEVELOPER D-76

A moderately fine-grain developer, producing maximum emulsion speed on small roll films and 35mm films.

Water (125 F or 52 C)	24 ounces	750.0cc
Kodak Elon Developing Agent	29 grains	2.0 grams
Kodak Sodium Sulfite, desiccated	3 ounces 145 grains	100.0 grams
Kodak Hydroquinone	73 grains	5.0 grams
Kodak Borax, granular	29 grains	2.0 grams
Add cold water to make	32 ounces	1.0 liter

Dissolve chemicals in the order given.

Kodak Developer D-76 is a classic. Its ability to produce full emulsion speed and maximum shadow detail with normal contrast has made it the standard by which other developers are judged. It produces images having high definition and moderately fine grain. Kodak Developer D-76 is recommended for tray or tank use. Its excellent development latitude permits forced development with very little fog. However, forced development increases graininess with any developer. Follow the development times in the table below.

223

DEVELOPMENT TIMES (IN MINUTES) IN KODAK DEVELOPER D-76

Kodak Films 135, rolls, packs, and 35mm, or wider long rolls	Dilution	Small Tank (Agitation at 30 second intervals throughout development)					Large Tank (Agitation at 30 second intervals throughout development)				
		65 F	68 F	70 F	72 F	75 F	65 F	68 F	70 F	72 F	75 F
Verichrome Pan (rolls)	Full Strength	8	7	6½	6	5	9	8	7½	7	6
	1:1	11	9	8	7	6	12	10	9	8	7
Plus-X Pan (135, long rolls, and packs) Plus-X Pan Professional (rolls)	1:1	10	8	7	6	5	11	9	8	7	6
Panatomic-X (roll, 135, and long rolls)	Full Strength	8	7	6½	6	5	9	8	7½	7	6
	1:1	11	9	8	7	6	12	10	9	8	7
Tri-X Pan (roll, 135, and long rolls)	Full Strength	10	8	7	6	5	11	9	8	7	6
	1:1	13	11	10	9	8	15	13	11	10	9
Tri-X Pan Professional (roll and pack)	Full Strength	9	8	7½	7	6	10	9	8½	8	7
Infrared (135 and long rolls)	Full Strength	13	11	10	9	8	—	—	—	—	—
High Speed Infrared (long rolls)	Full Strength	—	—	—	—	—	14	12	11	10	9

DEVELOPMENT TIMES (IN MINUTES) IN KODAK DEVELOPER D-76, FULL STRENGTH

Kodak Sheet Films	Tray Continuous agitation					Large Tank Agitation at 1 minute intervals throughout development				
	65 F	68 F	70 F	72 F	75 F	65 F	68 F	70 F	72 F	75 F
Royal Pan 4141 (Estar thick base)	9	8	7½	7	6	11	10	9	8½	7½
Tri-X Pan 4147 (Estar thick base)	8	7	6½	6	5	10	9	8½	8	7
Super-Panchro Press 6146, Type B	11	10	9½	9	8	14	13	12	11	10
Plus-X Pan 4147 (Estar thick base)	7	6	5½	5	4½	9	8	7½	7	6
Ektapan 4162 (Estar thick base)	8½	8	7½	7	6½	11	10	9	8½	7½
High Speed Infrared 4143	9	8	7½	7	6	12	10	9	8	7½
Tri-X Ortho 4163 (Estar thick base)	8	7	6½	6	5	10	9	8½	8	7

Life and Capacity

The keeping qualities of Kodak Developer D-76 stored in a filled, tightly stoppered bottle are excellent.

Mix the entire contents of the developer (or replenisher) package at one time. You may want to keep the developer in several smaller bottles rather than one large bottle. It will keep for six months in a full, tightly stoppered bottle and for two months in a tightly stoppered bottle that is half full. The capacity of D-76 is 10* rolls of 135-size film (36 exposure), or their equivalent, per gallon when used full strength.

224

When you use D-76 at the 1:1 dilution, dilute it just before using for each batch of film. No reuse or replenishment is recommended. The capacity of the 1:1 dilution in a single use is about 8* rolls of 135-size film (36 exposure, 87 square inches per roll), or equivalent, per gallon. Do not store the diluted developer for future use or allow it to remain in processing equipment for extended periods.

*Increase the development time by 15 per cent after each four rolls of film are processed.

Replenishment

Proper replenishment of D-76 with Kodak Replenisher D-76R will maintain a constant rate of development, film speed, and moderately fine-grain characteristics without the necessity of increasing the development time. The replenisher should be used only to replenish a full-strength solution of the developer. Discard D-76 at the 1:1 dilution after each use and do not replenish it.

KODAK REPLENISHER D-76R

Water (125 F or 52 C)	24 ounces	750.0cc
Kodak Elon Developing Agent	44 grains	3.0 grams
Kodak Sodium Sulfite, desiccated	3 ounces 145 grains	100.0 grams
Kodak Hydroquinone	¼ ounce	7.5 grams
Kodak Borax, granular	290 grains	20.0 grams
Add cold water to make	32 ounces	1.0 liter

Dissolve chemicals in the order given.

To replenish developer in small tanks, use ¾ ounce of D-76R for each roll (87 square inches) of film developed. Add the replenisher to the developer bottle before returning the developer from the tank.

In large tanks, add replenisher as needed, to replace the developer carried out by the films and to keep the liquid level constant in the tank. Ordinarily, this will be achieved by adding ¾ ounce of D-76R for each 8" x 10" sheet of film, or equivalent, that you process. Add the replenisher frequently and stir it in thoroughly after each batch of film or after not more than four 8" x 10" sheets of film, or equivalent, have been processed per gallon of developer. Refer to the Replenishment Table below.

REPLENISHMENT TABLE FOR FULL-STRENGTH KODAK REPLENISHER D-76R

Film Size	Area (Square Inches)	Ounces of Kodak Replenisher D-76R Needed
126 (12-exposure	25	¼
135 (20-exposure)	49	½
135 (36-exposure)	87	¾
828	25	¼
127	43	½
120, 620	80	¾
116, 616	105	1
4" x 5" sheets	20	¼
8" x 10" sheets	80	¾

Kodak Replenisher D-76R extends the capacity of Kodak Developer D-76 to 120 8" x 10" films, or their equivalent, per gallon.

KODAK MICRODOL-X DEVELOPER

Kodak Microdol-X Developer is an excellent fine-grain developer unmatched for its ability to produce low graininess coupled with maximum sharpness of image detail. It has very little tendency to sludge with use, is free from sludge when dissolved in hard water, and has no tendency to form scum on exhaustion, aeration, and replenishment. In addition to these advantages, Microdol-X Developer produces a very low fog level even with forced development of fine-grain films.

Development Recommendations: Average development time (full strength), 12 minutes in a tank at 68 F (20 C) or 9 minutes at 75 F (24 C); Microdol-X Developer diluted 1:3 for increased image sharpness, 14 minutes at 75 F (24 C). See individual film data pages for specific recommendations.

Time-Temperature Development Chart

Shows developing times at various temperatures corresponding to a given time at 68 F (20 C). For other times at 68 F locate the time along the 68 F line and draw through that point a line parallel to the one given. See page 178 for a more complete discussion.

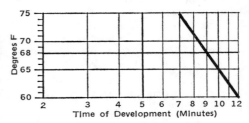

Capacity: Without replenishment, four rolls of 620 roll film or 36-exposure 35mm film or equivalent (320 square inches) per quart of full-strength developer. After the first roll has been developed, the development time must be increased about 15 percent for each succeeding roll developed in a quart, or each four rolls in a gallon. With replenishment, capacity is increased to 15 rolls per quart. Development time remains constant with replenishment.

For Microdol-X Developer, diluted 1:3, capacity is one roll (80 square inches) per pint. Developing times given for this dilution in the film data pages are for processing in large tanks. When developing a 36-exposure roll of 35mm film in an 8-ounce tank of Microdol-X Developer diluted 1:3, exhaustion will cause a reduction of processing rate; in this case, increase the developing time 10 per cent over and above the time given for this dilution in large tanks. Microdol-X Developer diluted 1:3 cannot be replenished; discard after use.

Replenishment: Small-tank—add one ounce of Microdol-X Replenisher per roll or equivalent (80 square inches) processed.

KODAK POLYDOL DEVELOPER

Kodak Polydol Developer has been formulated to meet the needs of portrait, commercial, industrial, and school photographers for a developer that yields high negative quality as well as long life and high capacity. Although Kodak Polydol is primarily a tank developer for sheet and roll films, it performs equally well as a tray developer for sheet films or as a developer for spiral-reel and machine processing of films in long rolls.

With the recommended replenishment procedure, this developer maintains uniform activity throughout a long period of use. Furthermore, Kodak Polydol Developer is free from the high peak of activity characteristic of most developers when they are freshly mixed.

DEVELOPMENT OF SHEET FILMS

	Recommended Developing Time in Minutes			
Kodak Sheet Film	Tray		Tank	
	68 F (20 C)	75 F (24 C)	68 F (20 C)	75 F (24 C)
Commercial Film 4127 and 6127	4	3¼	—	—
Professional Copy Film 4125	4½	—	5½	—
Royal Pan (Estar Thick Base)	6	4½	8	6
Royal-X Pan 4166	6½	4½	8½	6½
Super Panchro-Press Type B	9	6	11	8
Super-XX Pan (Estar Thick Base)	9	6	11	8
Plus-X Pan Professional (Estar Thick Base)	6	4½	8	6
Ektapan	8	5	10	7
Tri-X Pan Professional (Estar Thick Base)	6	4½	8	6
Tri-X Ortho (Estar Thick Base)	6	4½	8	6

Agitation: The times recommended for tray development are for continuous agitation, either by tilting the tray for single films or by leafing through the stack when several films are developed together. The times recommended for tank development are for the development of films in hangers, with agitation by lifting and tilting hangers at one minute intervals.

DEVELOPMENT OF ROLL AND 135 FILMS

	Recommended Developing Time in Minutes			
Kodak Film	Small Tank		Large Tank	
	68 F (20 C)	75 F (24 C)	68 F (20 C)	75 F (24 C)
Verichrome Pan, rolls	10	7	11	8
Plus-X Pan, rolls and 135	7	5	8	6
Plus-X Pan Professional, rolls	7	5	8	6
Panatomic-X, rolls and 135	7	4½	8	5
Tri-X Pan, rolls and 135	8	6	9	7
Tri-X Pan, Professional, rolls	7	5	8	6

Agitation: The times recommended for a small tank apply when the film is developed on a spiral reel with agitation at 30-second intervals. The times given for a large tank are for development of several reels in a basket with agitation at one minute intervals.

Developing times given for Kodak films are aimed to yield negatives that print well on normal-contrast paper. However, if your negatives are consistently too low in contrast, increase the developing time. If they are consistently too high in contrast, decrease the developing time.

Development of Films in Long Rolls

Films in long rolls, such as 35mm or 70mm by 100 feet or 3½ inches by 75 feet, can be developed in spiral reels or in continuous-processing machines.

Kodak Film	Recommended Developing Time in Minutes *	
	68 F (20 C)	75 F (24 C)
Plus-X Pan — 35mm and 70mm rolls	7	5½
Plus-X Pan Professional (Estar Thick Base) — 3½-inch rolls	8	6
Plus-X Pan Professional (Estar base) — 35mm, 46mm, and 70mm rolls	8	6
Tri-X Pan — 35mm rolls	9	6
Tri-X Pan Professional (Estar base) — 70mm	8	6
Tri-X Pan Professional (Estar thick base) — 3½-inch rolls	8	6
Royal Pan (Estar thick base) — 70mm and 3½-inch rolls	8	6
Panatomic-X — 35mm and 70mm rolls	8	5

*These times apply when the reel is agitated as described in the instruction sheet that accompanies the film.

Note: In certain situations, about 4 gallons of solution are required to cover the films adequately. To obtain the required 4 gallons of developer, the 3½-gallon size of Kodak Polydol Developer can be used, with the addition of one quart of Kodak Polydol Replenisher and one quart of water. The above times of development will still apply.

Agitation: Films on spiral reels should be agitated once each minute by the lifting-and-turning technique described in detail in the film instruction sheets.

Replenishment

After developing sheet films or films in rolls, add Kodak Polydol Replenisher as required to maintain a constant level of developer in the tank, or at a rate of approximately ⅝–¾ fluid ounce per 80 square inches of film. If the carry-out rate should vary, or if the average negatives are unusually dense or thin, it may be necessary to adjust the replenishment rate to keep the activity constant.

For films in long rolls, after each roll is developed, Kodak Polydol Replenisher should be added to the developer tank as follows:

Size of Film	Replenisher
35mm by 100 feet	15 fluid ounces
46mm by 100 feet	20 fluid ounces
70mm by 100 feet	30 fluid ounces
3½ inches by 75 feet	30 fluid ounces

Useful Capacity

Without replenishment: About 40 sheets of 8″ x 10″ film can be developed per gallon of Kodak Polydol Developer.

With replenishment: The Kodak Polydol Developer and Kodak Polydol Replenisher system has been designed to maintain constant developing characteristics for an indefinite period when the replenishment rate is properly

adjusted. The replenishment rate should be checked by periodic monitoring of the developer activity.

Although some sludge may appear, the system is free from massive sludge formation as well as from staining tendency. Therefore, the working solution should not need replacement for several months. However, it should be replaced if the activity increases or decreases markedly, which indicates that the replenishment rate needs revision; if the bath shows excessive sludging or develops staining or scumming tendency (usually the result of contamination, as with hypo); or if the bath has been exposed excessively to the air, which can be minimized by the use of a floating cover.

Storage Life

Unused Kodak Polydol Developer and Polydol Replenisher can be stored in a full, tightly stoppered bottle for six months; in a partially full, tightly stoppered bottle for two months; in a tank with a floating cover for one month; or in an open tray for 24 hours.

KODAK HC-110 DEVELOPER

Kodak HC-110 Developer is a highly active solution designed for rapid development of most black-and-white films. It produces sharp images with moderately fine grain, maximum shadow detail, and long density scale but causes no loss in film speed. Kodak HC-110 Developer has excellent development latitude and produces relatively low fog with forced development. In most of these characteristics it exceeds Kodak Developers DK-50 and DK-60a and similar developers. It is particularly suitable for commercial, industrial, graphic arts, and press photography.

How to mix Kodak HC-110 Developer

This developer and its replenisher are viscous concentrates that require a relatively large amount of dilution to make a working solution. The simplest and most accurate procedure is to make a stock solution by mixing the entire contents of the bottle of concentrate with the required quantity of water. Then you can dilute the stock solution to make any of six working dilutions, which are designated with the letters A, B, C, D, E, and F. Alternatively, you can mix these working dilutions directly from the concentrate. However, small amounts of viscous liquid are difficult to measure accurately. Therefore, this mixing procedure is recommended only for relatively large quantities of a working dilution. *The concentrate should not be regarded as a stock solution for mixing small amounts of working dilutions.*

How to make the stock solution

To make a stock solution from the two-gallon size:
1. Pour the whole contents of the original plastic bottle into a reclosable container that holds at least two quarts.
2. Rinse the plastic bottle thoroughly with water and pour the rinse water into the reclosable container.
3. Add enough water to bring the total volume to two quarts.
4. Close the container and shake it until the solution is uniform.

To make a stock solution from the 3½-gallon size: Follow the same procedure as given for the two-gallon size, but use a reclosable container that holds at least 3½ quarts and bring the total volume of solution to 3½ quarts.

Table 1 shows how to mix the working dilutions from the stock solution.

Table 2 shows how to make the working dilution directly from whole bottles of the concentrate.

Uses of working dilutions

Dilution A: This is the most active of the dilutions. It is used when short developing times are needed for sheet and roll films.

Dilution B: This dilution permits longer development times; it is recommended for most Kodak sheet and roll films. Developing times for these materials are given in Tables 3 and 4.

Dilutions C, D, and E: These dilutions are generally used instead of Kodak Developer DK-50 for sheet films. The developing times recommended for DK-50 can be applied if the corresponding dilutions, as given in the following table, are used.

Current Kodak Developer DK-50 Recommendation	Kodak HC-110 Equivalent Developer Working Dilution	For Working Dilution, Mix	
		Stock Solution	Water
DK-50 (full strength)	C	1 part	4 parts
DK-50 (1:1)	D	1 part	9 parts
DK-50 (1:2)	E	1 part	11 parts

TABLE 1. MIXING WORKING DILUTIONS FROM STOCK SOLUTION

Working Dilution*	To Mix All Quantities	To Mix 1 Quart	To Mix 1 Gallon	To Mix 3½ Gallons
A (1:15)	Stock—1 part Water—3 parts	Stock 8 oz. Water 24 oz.	Stock 1 qt. Water 3 qt.	Stock 3 qt. 16 oz. Water 10 qt. 16 oz.
B (1:31)	Stock—1 part Water—7 parts	Stock 4 oz. Water 28 oz.	Stock 16 oz. Water 3 qt. 16 oz.	Stock 1 qt. 24 oz. Water 12 qt. 8 oz.
C (1:19)	Stock—1 part Water—4 parts	Stock 6½ oz. Water 25½ oz.	Stock 26 oz. Water 3 qt. 6 oz.	Stock 2 qt. 26 oz. Water 11 qt. 26 oz.
D (1:39)	Stock—1 part Water—9 parts	Stock 3¼ oz. Water 28¾ oz.	Stock 13 oz. Water 3 qt. 19 oz.	Stock 1 qt. 13 oz. Water 12 qt. 19 oz.
E (1:47)	Stock—1 part Water—11 parts	See Note	Stock 11 oz. Water 3 qt. 21 oz.	Stock 1 qt. 6 oz. Water 12 qt. 26 oz.
F (1:79)	Stock—1 part Water—19 parts	See Note	Stock 7 oz. Water 3 qt. 25 oz.	Stock 23 oz. Water 13 qt. 9 oz.

*Figures in parentheses indicate the proportion of concentrate to water.

NOTE: Some quantities of stock solution are too small for convenient measurement. Where quantities are specified for mixing one pint or one quart, they are rounded to the nearest ¼ fluid ounce. Quantities for mixing larger volumes are rounded to the nearest fluid ounce.

TABLE 2. MIXING WORKING DILUTIONS FROM CONCENTRATE

To make this working dilution	Use this amount of concentrate	With this amount of water
(2-gallon size)		
A	16 fluid ounces	7½ quarts
B	16 fluid ounces	15½ quarts
C	16 fluid ounces	9½ quarts
D	16 fluid ounces	19½ quarts
E	16 fluid ounces	23½ quarts
F	16 fluid ounces	39½ quarts
(3½-gallon size)		
A	28 fluid ounces	13 quarts 4 fluid ounces
B	28 fluid ounces	27 quarts 4 fluid ounces
C	28 fluid ounces	16 quarts 20 fluid ounces
D	28 fluid ounces	34 quarts 4 fluid ounces
E	28 fluid ounces	41 quarts 4 fluid ounces
F	28 fluid ounces	69 quarts 4 fluid ounces

Developing Times for Kodak Sheet and Roll Films

The recommended developing times for Kodak sheet and roll films are aimed to yield negatives that print well on a normal grade of paper. However, if your negatives are consistently too low in contrast, increase the developing time. If they are consistently too high in contrast, decrease the developing time.

TABLE 3. DEVELOPING TIMES FOR KODAK SHEET FILMS

WORKING DILUTION A Kodak Sheet Films and Film Packs	Developing Times (in minutes)									
	Tray*					Large Tank†				
	65F	68F	70F	72F	75F	65F	68F	70F	72F	75F
Ektapan	3¼	3	2¾	2½	2¼	4	3¾	3¼	3	2¾
Royal-X Pan (Estar thick base)	5	4½	4¼	4	3½	7	6	5½	5	4½
Tri-X Pan Professional (Estar thick base)	3¼	2¾	2½	2¼	2	3¾	3¼	3	2¾	2½
Royal Pan (Estar thick base)	3½	3	2¾	2½	2¼	4	3¾	3¼	3	2¾
Super-XX Pan (Estar thick base)	4½	4	3¾	3½	3	6	5	4½	4¼	3½
Super Panchro-Press, Type B	4½	4	3¾	3½	3	6	5	4½	4¼	3½
FILM PACKS:										
Tri-X Pan Professional	3¼	2¾	2½	2¼	2	3¾	3¼	3	2¾	2½
WORKING DILUTION B	65F	68F	70F	72F	75F	65F	68F	70F	72F	75F
Tri-X Ortho (Estar thick base)	5	4½	4¼	4¼	4	7	6	5½	5	4½
Ektapan	5	4½	4¼	4	3½	7	6	5½	5	4¼
Royal-X Pan (Estar thick base)	8½	8	7½	7	6½	11	10	9	8½	7½
Tri-X Pan Professional (Estar thick base)	5	4½	4¼	4	3¼	7	6	5½	5	4½
Royal Pan (Estar thick base)	7	6	5½	5	4½	9	8	7½	7	6
Super-XX Pan (Estar thick base)	8½	7	6½	6	5	11	9	8	7	6
Super Panchro-Press, Type B	7	6	5½	5	4½	9	8	7½	7	6
Commercial	2¾	2¼	2	2	1¾	—	—	—	—	—
FILM PACKS:										
Tri-X Pan Professional	5	4½	4¼	4	3¼	7	6	5½	5	4½
Plus-X Pan Professional	6	5	4¾	4½	4	7	6	5½	5	4½

*Development in a tray, with continuous agitation.
†Development on a hanger in a large tank, with agitation at one minute intervals. If possible, development times of less than five minutes in a tank should be avoided, since poor uniformity may result.

TABLE 4. DEVELOPING TIMES FOR KODAK ROLL FILMS

WORKING DILUTION A / KODAK ROLL FILMS	Developing Times (in minutes)									
	Small Tank*					Large Tank†				
	65F	68F	70F	72F	75F	65F	68F	70F	72F	75F
ROLL FILMS										
Panatomic-X	3	2¾	2½	2¼	2	3½	3	2¾	2½	2¼
Verichrome Pan	4¼	3¾	3½	3	2¾	4¾	4¼	3¾	3½	3
Tri-X Pan	4¼	3¾	3½	3	2¾	4¾	4¼	3¾	3½	3
Royal-X Pan	6	5	4¾	4½	4¼	7	6	5½	5	4½
Tri-X Pan Professional	3¼	3	2¾	2½	2¼	3¾	3¼	3	2¾	2½
135 FILMS										
Panatomic-X	3	2¾	2½	2¼	2	3½	3	2¾	2½	2¼
Plus-X Pan	2¾	2½	2¼	2	1¾	3	2¾	2½	2¼	2
Tri-X Pan	4¼	3¾	3½	3	2¾	4¾	4¼	3¾	3½	3
WORKING DILUTION B	65F	68F	70F	72F	75F	65F	68F	70F	72F	75F
ROLL FILMS										
Panatomic-X	5	4½	4	3¾	3½	6	5	4½	4¼	3¾
Verichrome Pan	9	8	7½	7	6	10	9	8½	8	7
Tri-X Pan	6	5	4½	4	3½	7	6	5	4½	3¾
Plus-X Pan Professional	6	5	4¾	4½	4	7	6	5½	5	4½
Royal-X Pan	10	9	8	7½	6½	11	10	9	8½	7½
Tri-X Pan Professional	6	5	4¾	4½	4	7	6	5½	5	4½
135 FILMS										
Panatomic-X	5	4½	4	3¾	3½	6	5	4½	4¼	3¾
Plus-X Pan	4	3½	3¼	3	2½	4½	4	3¾	3½	3
Tri-X Pan	6	5	4½	4	3½	7	6	5	4½	3¾

*Development on a spiral reel in a small roll-film tank, with agitation at thirty-second intervals.
†Development of several reels in a basket, with agitation at one-minute intervals throughout development.

How to Mix the Replenisher Stock Solution

Kodak HC-110 Developer Replenisher, one-gallon size: Dilute the contents of the bottle of replenisher concentrate with water to make one gallon, using a portion of the water to rinse out the bottle. Stir until the solution is uniform.

How to Replenish the Working Dilutions

Each working dilution of Kodak HC-110 Developer can be replenished with the appropriate replenisher dilution. Instructions for making the replenisher dilutions from the replenisher stock solution are given in the table below.

To maintain constant developer activity, replenish the working dilutions, with the properly diluted replenisher, at the rate of ¾ fluid ounce per 80 square inches of film. This is an average replenishment rate. Therefore, if the negatives are too thin or too dense, it will be necessary to increase or decrease the replenishment rate accordingly.

When dilutions A, B, C, D, and E are used for tank development with the replenishment procedure described above, the developer activity should be monitored by Kodak Control Strips, ten-step (for professional b/w film). The solution can be kept in service for at least one month if these strips indicate proper developer activity.

If the developer is not monitored with control strips, use the following procedure as a guide: Dilutions A, B, C, D, and E can be replenished until 200 8″ x 10″ films (or the equivalent area in other sizes) have been processed; or when the volume of added replenisher equals the original volume of solution in the tank; or after the developer has been used and replenished for two weeks.

When the developer is not in use, always protect it from oxidation with a floating lid.

Dilution F is generally used in a tray for developing masks; therefore, it should not be replenished but used and discarded frequently.

With an average drain period between the developer and the stop bath, the above replenishment rate will usually be sufficient to match the carry-out of developer. However, if much more of the solution is lost in the process than is replaced by replenishment, make up the loss by adding fresh HC-110 Developer of the appropriate dilution.

REPLENISHER DILUTIONS

To replenish working dilution	Replenisher stock solution	Water
A-use	1 part	None
B-use	2 parts	1 part
C-use	1 part	None
D-use	1 part	1 part
E-use	8 parts	11 parts
F-	Do not replenish	—

CAPACITY OF WORKING DILUTIONS

Dilutions	Tray	Tank without replenishment	Tank with replenishment*
A	20 8×10 sheets per gal	40 8×10 sheets per gal	200 8×10 sheets per gal
B	10 8×10 sheets per gal	20 8×10 sheets per gal	200 8×10 sheets per gal
C	15 8×10 sheets per gal	30 8×10 sheets per gal	200 8×10 sheets per gal
D	8 8×10 sheets per gal	15 8×10 sheets per gal	200 8×10 sheets per gal
E	5 8×10 sheets per gal	10 8×10 sheets per gal	200 8×10 sheets per gal
F	2 8×10 sheets per gal	—	—

*Use and replenish for one month only.

STORAGE LIFE OF UNUSED SOLUTIONS

Dilutions	Full stoppered glass bottle	½-full stoppered glass bottle	Tank with floating lid
Stock solution	6 months	2 months	—
Stock replenisher	6 months	2 months	—
A	6 months	2 months	2 months
B	3 months	1 month	1 month
C	6 months	2 months	2 months
D	3 months	1 month	1 month
E	2 months	1 month	1 month
F	Do not store	—	—

KODAK EKTAFLO CHEMICALS

Kodak Ektaflo chemicals are liquid concentrates that save time and effort in black-and-white printing. This group of chemicals includes two developers: one for cold-tone papers, and one for warm-tone papers. In addition, there is an indicator-type stop bath which turns purple when exhausted, and a concentrated fixer. The solutions are sold in concentrated liquid form and require only dilution with water at room temperature. They can be safely mixed in the darkroom because there are no powders to contaminate the air. Since they do not need hot water for mixing, there is no extended cooling time afterward.

Ektaflo chemicals are packed in one-gallon Cubitainers for use and storage. To draw solution from the container, attach the Kodak Screw Cap Dispenser Tube, Model 2 (supplied separately) to the Cubitainer spout. The Cubitainer consists of a cardboard box containing a stout plastic bag with a screw-capped, pull-out spout. As the quantity of concentrate in the bag diminishes, the bag collapses; thus air is excluded from the plastic bag and oxidation is minimized.

Mixing the Concentrates

Kodak Ektaflo Developers, Type 1 and 2, are to be diluted at the rate of one part of concentrate to nine parts of water. Stir well after mixing.

DEVELOPER DILUTIONS

To make	1 Quart	1 gallon
Concentrate	3 ounces	13 ounces
Water	29 ounces	115 ounces

Kodak Ektaflo Stop Bath is to be diluted at the rate of one part of concentrate to 31 parts of water. Stir well after mixing.

STOP BATH DILUTIONS

To make	1 Quart	1 gallon
Concentrate	1 ounce	4 ounces
Water	31 ounces	124 ounces

Kodak Ektaflo Fixing Bath is to be diluted at the rate of one part of concentrate to seven parts of water. Stir well after mixing.

FIXER DILUTIONS

To make	1 Quart	1 gallon
Concentrate	4 ounces	16 ounces
Water	28 ounces	112 ounces

Processing With Kodak Ektaflo Chemicals

For the best quality prints, develop at 68 F (20 C) for the recommended time (see table below). After development, rinse the prints in the Ektaflo Stop Bath for 10 seconds with agitation; agitation is particularly important during the first few seconds.

Fix the prints five to ten minutes at 65–70 F (18–21 C), preferably by the two-bath method if maximum permanence is desired. Agitate the prints in the fixing bath and keep them well separated from each other. Washing time can be reduced by using Kodak Hypo Clearing Agent; follow directions on the package.

235

Recommended Developing Times and Temperatures

The times in this table apply only when the recommended dilutions are used.

Ektaflo Chemical	Kodak Papers	Processing Times	Useful Range	Temp.
Developer Type 1 (for cold tones)	Ad-Type, Azo, Medalist, Mural, Resisto Rapid, Velox, Velox Premier, and Velox Rapid	1 min.	¾—2 min.	68 F (20 C)
	Kodabromide, Panalure, Polycontrast, and Polycontrast Rapid	1½ min.	1—3 min.	68 F (20 C)
Developer Type 2 (for warm tones)	Aristo, Azo, Ektalure, Medalist, Mural, Opal, Polylure, Portrait Proof, and Panalure Portrait	2 min.	1½—4 min.	68 F (20 C)

Storage Life and Capacity

These figures apply only when the recommended dilutions are used.

Ektaflo Chemicals	In partly full Cubitainer	In open tray (days)	Capacity of working Dilutions—(per gallon)
Type 1 Developer	Several Months	1	120 8" X 10" prints or equivalent
Type 2 Developer	Several Months	1	100 8" X 10" prints or equivalent
Stop Bath	Several Months	3	Discard when the color turns to purplish-blue
Fixer	Several Months	7	100 8" X 10" prints or equivalent

KODAK DEKTOL DEVELOPER

Kodak Dektol Developer is a single-powder, easily prepared developer for producing neutral and cold-tone images on cold-tone papers. It remains unusually free from muddiness, sludge, precipitation, and discoloration throughout the normal solution life. It has high capacity and uniform development rate. Although best known as a paper developer, Dektol Developer is also recommended for rapid development of some high-speed negative materials.

The formula for Kodak Dektol Developer is not available for publication. For those who prefer to mix their own solutions, however, Kodak Developer D-72 produces substantially the same results at the same dilutions and processing times. While the two developers are not identical, they are interchangeable for most practical purposes.

Development Recommendations: *Papers*—Dilute one part of stock solution to two parts of water. Develop Kodabromide, Polycontrast, Polycontrast Rapid, and Panalure Papers about 1½ minutes; all other recommended papers, about 1 minute at 68 F (20 C). *Films*—See individual recommendations accompanying each film and data pages.

KODAK SELECTOL DEVELOPER

Kodak Selectol Developer is a long-life developer specially designed for the development of warm-tone papers. It produces the same pleasing image and contrast as Kodak Developer D-52, remains clear during use, and has high development capacity and good keeping properties. Since the development activity decreases only very slowly with use, constant image tone is easy to maintain.

The formula for Kodak Selectol Developer is not available for publication. For those who prefer to mix their own solutions, however, Kodak Developer D-52 produces substantially the same results at the same dilutions and processing times. While the two developers are not identical, they are interchangeable for most practical purposes.

Development Recommendations: Dilute one part of stock solution with one part of water. For average results, develop two minutes at 68 F (20 C). For slightly warmer image tone, develop 90 seconds. Contrast can be increased slightly with some papers by developing up to four minutes. Increased development times will produce colder image tones.

KODAK SELECTOL-SOFT DEVELOPER

Kodak Selectol-Soft Developer, except for what the name implies, is similar in all respects to Kodak Selectol Developer. It is recommended wherever results with Selectol Developer tend to be too contrasty for adequate shadow detail. Much softer results can be obtained than with regular Selectol Developer, and there is no sacrifice in tonal scale. For a description of other characteristics, see the data given above for Kodak Selectol Developer.

KODAK VERSATOL DEVELOPER

Kodak Versatol Developer is an ideal all-purpose developer for use with films, plates, and papers. It is packaged in convenient concentrated liquid form and stays unusually clear during use. Simply dilute with water for use. Versatol Developer is especially handy for the amateur who uses several types of photographic materials but has limited storage space.

Development Recommendations: *Papers*—dilute 1:3; develop Kodabromide, Polycontrast, Polycontrast Rapid, and Panalure Papers about 1½ minutes; other papers about one minute at 68 F (20 C). *Films and plates*—dilute 1:15 and develop Verichrome Pan Film about 4½ minutes at 68 F (20 C) in a tray or about five minutes at 68 F (20 C) in a tank. Dilute 1:3 and develop Kodak Projector Slide Plates, Medium, 1–3 minutes and Kodak Projector Slide Plates, Contrast, 2–6 minutes at 68 F (20 C) in a tray.

REVERSAL PROCESS FOR KODAK DIRECT POSITIVE PAN FILM

The Kodak Direct Positive Film Developing Outfit contains chemicals for the convenient preparation of the following solutions: one quart each of first developer, bleach bath, and clearing bath, and five pints of redeveloper. The fixing solution can be prepared conveniently from Kodak Fixer. When using this outfit, follow the instructions in the package.

If preferred, suitable processing solutions can be made up according to formulas. Although the solutions made to the formulas are not identical chemically with those prepared from the packaged outfit, they produce the same photographic effects. With these solutions, the following instructions will apply.

Safelight

Carry out all operations in total darkness until the bleaching has been completed. You can use a Kodak Safelight Filter, Wratten Series OA, during the subsequent operations. Do not examine the film before an illuminator or otherwise expose it to strong light until final fixing is complete.

Apparatus

The following procedure is recommended for use with small spiral reels, reel and trough, small noninvertible tanks, large spiral reels, or rank and tank. Rewind processing is not recommended with the Kodak Direct Positive Film Developing Outfit.

Select the time of first development according to the degree of agitation (see following section) and the resulting rate of development obtained. Suggested times with various methods of processing are:

Processing Method	Approximate Time of First Development at 68 F (20 C)
1. Small spiral reels	8 minutes
2. Reel and trough	6 minutes
3. Small noninvertible tanks	8 minutes
4. Large spiral reels	6 minutes
5. Rack and tank	9 minutes

Warning: Because the bleach corrodes most metals, do not leave it in contact with metal equipment any longer than necessary. However, you can store it in polyethylene, earthenware, porcelain, rubber, glass, or enamelware receptacles having surfaces that are free from cracks or chips.

Agitation

1. *Small Spiral Reels:* The best method of agitation is to move the reel up and down while it is under solution, and at the same time turn the reel back and forth through approximately half a revolution. Agitate continuously during the first 30 seconds in each solution and for 5 seconds every minute thereafter. With some of these tanks, it is also possible to obtain satisfactory results with the cover on, by using the agitation procedure recommended in the instructions for the tank, but it is more convenient and otherwise preferable to use the cover-off method.

2. *Reel and Trough:* Rotate the reel at a convenient rate and reverse the direction of rotation at 1-minute intervals.

3. *Small Noninvertible Tanks:* Follow the instructions included with the tank.

4. *Large Spiral Reels:* Lower the reel into the solution, giving it a vigorous turning motion sufficient to cause the reel to rotate one-half to one revolution.

Raise and lower the reel approximately ½ inch (keeping the reel in the solution) for the first 15 seconds, tapping it against the bottom of the tank to release air bubbles from the film.

Agitate once each minute by lifting the reel out of the solution, tilting it approximately 30 degrees to drain for 5—10 seconds, and immersing it again with a vigorous turning motion sufficient to cause the reel to rotate one-half to one revolution in the solution. Alternate the direction of rotation each minute. Just before the end of the development time, drain the reel for 15 seconds and proceed to the next step.

5. *Rack and Tank:* Agitate the film for 5 seconds under the solution when you first immerse it. At 1-minute intervals, lift the rack completely out of the solution, drain it for a few seconds, and reimmerse it. With this agitation, the developing time at 68 F (20 C) will be approximately 9 minutes. With the lower rate of agitation usually employed by commercial photofinishers, the developing time will be about 11 minutes.

Processing Temperature

A temperature of 68 F (20 C) is recommended for all the processing solutions. In some instances, however, it may be more convenient to operate at some other temperature. The Kodak Direct Positive Film Developing Outfit will yield satisfactory results at temperatures from 65 F (18 C) to at least 85 F (29 C), provided the processing time is adjusted accordingly.

For development at a temperature higher than the recommended 68 F, the development time should be decreased about one minute for every 5.5 F (3 C) rise in temperature. Decreasing the temperature below 68 F will necessitate a similar increase in development times. At 85 F (29 C), the time in the baths following the developer should be about one-half that at 68 F (20 C). Optimum times should be determined by trial, because they will be affected by the type of processing equipment, time of agitation, and rate of agitation.

Water Rinses

To increase the life of the bleach bath, a two- to five-minute rinse is recommended between first development and bleaching. To increase the life of the fixing bath, use a one-minute rinse between redevelopment and fixing.

Processing

Important: Drain the films 10–15 seconds after development and after each successive treatment.

1. First Development Develop the film for the time required with the apparatus employed.

The contrast of the final positive cannot be changed appreciably by varying the time of development of the negative. Overdevelopment produces an effect similar to that of overexposure—decreased maximum density and loss of highlight detail. Underdevelopment gives dark highlights and a general effect similar to that of underexposure.

KODAK DEVELOPER D-67

Water (about 125 F or 52 C)	16 ounces	500.0cc
Kodak Elon Developing Agent	30 grains	2.0 grams
Kodak Sodium Sulfite, desiccated	3 ounces	90.0 grams
Kodak Hydroquinone	115 grains	8.0 grams
Kodak Sodium Carbonate, monohydrated	1¾ ounces	52.5 grams
Kodak Potassium Bromide	75 grains	5.0 grams
Kodak Sodium Thiocyanate (liquid)	1 fl. dram	3.0cc
Water to make	32 ounces	1.0 liter

This developer can also be made from a solution of Kodak Developer D-19 (available in prepared package form) as follows:

Kodak D-19 Solution	1 gallon	1.0 liter
Kodak Sodium Thiocyanate (liquid)	4 fl. drams	3.0cc

Replenishment of First Developer. Keep the volume of the first developer solution constant by adding Kodak Replenisher D-67R. The activity of this replenisher is based on an average carry-over of about five fluid drams (about 18.5cc) of solution per 36-exposure roll (approximately five feet) processed. To prevent an increase in developer activity, replace any loss of first developer greater than this quantity per roll with First Developer Solution (Kodak D-67), If the volume of solution lost is less than five fluid drams (18.5cc) per roll, remove sufficient solution to permit adding the correct volume of replenisher.

KODAK REPLENISHER D-67R

Water (about 125 F or 52 C)	24 ounces	750.0 cc
Kodak Elon Developing Agent	30 grains	2.0 grams
Kodak Sodium Sulfite, desiccated	3 ounces	90.0 grams
Kodak Hydroquinone	115 grains	8.0 grams
Kodak Sodium Carbonate, monohydrated	1¾ ounces	52.5 grams
Kodak Sodium Thiocyanate (liquid)	2½ fl. drams	7.5cc
Water to make	32 ounces	1.0 liter

2. Rinsing Rinse the film for two to five minutes in running water at 68 F.

3. Bleaching After rinsing the film, drain it for 10–15 seconds and bathe it for one minute in the bleach solution at 68 F (20 C).

KODAK BLEACH BATH R-9

Water	32 ounces	1.0 liter
Kodak Potassium Dichromate	140 grains	9.5 grams
*Sulfuric Acid, concentrated	3 drams	12.0cc

*Caution: Always add the sulfuric acid to the solution slowly, stirring constantly, and never the solution to the acid; otherwise the solution may boil and spatter the acid on the hands or face, causing serious burns.

Note: The Kodak Bleach for Kodak Direct Positive Paper (supplied in packages to make one gallon) can be used instead of this formula.

4. Clearing Immerse the film in the clearing bath for two minutes at 68 F (20 C). You can do this under a Kodak Safelight Filter Wratten Series OA (yellow-green). Avoid white light or the final transparency may be too dense. Avoid times longer than two minutes, because this bath tends to dissolve the silver halide, with a consequent loss in density of the positive image.

KODAK CLEARING BATH CB-1

Water	32 ounces	1.0 liter
Kodak Sodium Sulfite, desiccated	3 ounces	90.0 grams

Note: The Kodak Clearing Bath for Kodak Direct Positive Paper (supplied in packages to make one gallon) can be used instead of this formula.

5. Redevelopment Process in the fogging redeveloper solution Kodak FD-70 for about eight minutes at 68 F (20 C).

KODAK FOGGING DEVELOPER FD-70

Part A

†Sodium Dithionite*290 grains 5.0 grams

Part B

Water115 ounces 900.0cc
Kodalk Balanced Alkali1 ounce 145 grains 10.0 grams
2-Thiobarbituric Acid** 30 grains 0.5 gram
Water to make 1 gallon 1.0 liter

*Available as Eastman Organic Chemical No. P 533.
**Available as Eastman Organic Chemical No. 660.

Unlike photographic products, which are distributed solely through photographic dealers, Eastman Organic Chemicals are available through laboratory supply houses or on direct order ($25 minimum in the United States and Canada; $50 overseas) from Eastman Kodak Company, Eastman Organic Chemicals, Rochester, N. Y. 14650. They are neither intended nor sold for household use. Catalog numbers should be given in the order. At the time of writing, the smallest quantity of sodium dithionite supplied is 500 grams; of 2-thiobarbituric acid, 100 grams.

†CAUTION: Flammable solid. May ignite if allowed to become damp. Keep containers tightly closed. Store in a cool, dry place.

Dissolve 290 grains of part A in one gallon of part B (or five grams in one liter) not more than two hours before use. Discard after one use.

Caution: The Kodak Fogging Developer FD-70 contains compounds that are extremely active photographically. If the dry powder comes into contact with photographic materials, serious spotting may occur. Therefore, take care to prevent the powder suspended in the air from reaching photographic materials or areas where they are handled. Also, wash thoroughly not only your hands but also the containers used for mixing and using this solution.

6 and 7. Rinsing and Fixing Rinse the film for one minute in running water or Kodak Stop Bath SB-1 at 65–70 F (18 to 21 C). Fix it for five minutes at 65–70 F in Kodak Fixer, Kodak F-5 or F-6 Fixing Bath. For reel and trough processing, use the relatively odorless fixing bath Kodak F-6 to avoid the odors of sulfur dioxide given off by the other two fixers.

8. Washing After fixing the film, wash it for 20–30 minutes at about 68 F (20 C) with an adequate supply of running water (sufficient to replace the water in the tank once each 5 minutes). If the processing equipment will permit, wipe the surface of the film carefully with a soft sponge or Kodak Photo Chamois under the water. Then squeegee after removing it from the wash water before drying it in a location as dust-free as possible. The tendency for water-spot formation will be minimized greatly and uniform drainage of water from the film facilitated by immersing it in diluted Kodak Photo-Flo Solution before drying.

To reduce washing time and conserve water, you can use Kodak Hypo Clearing Agent. First, remove excess hypo by rinsing the film in water for 30 seconds. Then bathe the film in the Kodak Hypo Clearing Agent solution for one to two minutes, with moderate agitation, and wash it for five minutes, using a water flow sufficient to give at least one complete change of water in five minutes.

Note: When processing valuable films for maximum permanence, use a fresh fixing bath that has not been used for other material and wash for at least twice the times recommended above.

PROCESSING KODAK SUPER SPEED DIRECT POSITIVE PAPER

Kodak Super Speed Direct Positive Paper is mainly used in coin-operated strip-picture machines; it is also a fast, economical method of obtaining prints from black-and-white transparencies, either by contact or enlargement. Where normal gray-tone rendering is unimportant, as with prints for file use or layout work in printing production, the direct positive system can be utilized for making prints from color transparencies. Kodak Super Speed Direct Positive Paper has an orthochromatic emulsion, sensitive to blue and green, but not to red; thus prints from color transparencies render red areas darker in tone, blue and green areas lighter than the normal appearance to the eye.

Kodak Super Speed Direct Positive Paper can also be used as a test material to determine correct exposure for the more expensive and less easily processed materials such as reversal color films. To use this method, a correctly exposed and carefully processed direct positive print is made, and then the exposure required for the other material is easily determined from the relative speeds of the two emulsions.

Exposure and Processing

Correct exposure is essential to making good quality direct positive prints. In this connection, it must be remembered that an exposure is correct only for a given processing time and temperature. When processing is done in trays, Kodak Super Speed Direct Positive Paper should be developed for 45 seconds at 68 F (20 C). In direct positive photography, overexposure yields a light print, underexposure yields a dark print.

Processing can be carried out under a red safelight (Kodak Wratten Safelight Series 2). The filter should be used with a 15-watt bulb in a suitable fixture, and kept at least four feet from the material.

Chemicals. Kodak prepared chemicals for processing Kodak Super Speed Direct Positive Paper are supplied in ready-to-mix form. The baths can also be mixed from bulk chemicals according to the formulas below. Packaged Kodak Direct Positive Toning Redeveloper, for which the formula is not given, is available in units to make 2 gallons of working solution. The packaged developers, bleach, and clearing bath are available in one-gallon units.

Step 1: Develop exposed prints in Kodak Developer D-88 for 45 seconds at 68 F (20 C). For uniform results, developer must be kept at an even temperature, and must not be overworked. Higher than normal temperature results in light prints; too low a temperature, or stale, overworked, or contaminated developer causes dark prints, which may be stained as well.

KODAK DEVELOPER D-88

Water, about 125 F or 50 C	24 ounces	750.0cc
Kodak Sodium Sulfite, desiccated	1½ ounces	45.0 grams
Kodak Hydroquinone	¾ ounce	22.5 grams
*Kodak Boric Acid, crystals	80 grains	5.5 grams
Kodak Potassium Bromide	36 grains	2.5 grams
†Kodak Sodium Hydroxide (caustic soda)	¾ ounce	22.5 grams
Add cold water to make	32 ounces	1.0 liter

*Crystalline boric acid should be used as specified. Powdered boric acid dissolves only with difficulty, and its use should be avoided.

†CAUTION: Dissolve the caustic soda in a small volume of water in a separate container and then add it to the solution of the other ingredients. Then dilute the whole to the required volume. If a glass container is employed in dissolving the caustic soda, the solution should be stirred constantly until the soda is dissolved, to prevent cracking the glass by the heat evolved.

Dissolve chemicals in the order given.

Use full strength at 68 F (20 C). Develop 45 seconds.

Step 2: Rinse for at least 15 seconds in running water. Failure to rinse the prints properly results in stained prints and contaminated solutions.

Step 3: Bleach in Kodak Bleach or Kodak Bleaching Bath R-9 for 30 seconds or until the image disappears.

Formula for Kodak Bleaching Bath R-9 will be found on page BPR-74.

Step 4: Rinse in running water for at least 15 seconds.

Step 5: Clear for 30 seconds in Kodak Clearing Bath or Kodak Clearing Bath CB-1.

Formula for Kodak Clearing Bath CB-1 will be found on page BPR-74.

Step 6: Rinse in running water for at least 15 seconds.

Step 7 (Process 1): Redevelop the prints in Kodak Direct Positive Paper redeveloper or Kodak Sulfide Redeveloper T-19 for 60 seconds at 68 F (20 C). If a brown tone is desired, redevelop in Kodak Toning Redeveloper for 60 seconds at 68 F (20 C).

KODAK SULFIDE REDEVELOPER T-19

Kodak Sodium Sulfide (not sulfite)	290 grains	20.0 grams
Water to make	32 ounces	1.0 liter

Step 7A (Process 2): If Kodak Developer D-88 is used for redevelopment, re-expose the prints either by the light of a 40-watt bulb for 3 seconds at a distance of 8 inches, or by turning the white light on as soon as the prints are in the clearing bath. In either case, redevelop for 30 seconds at 68 F (20 C).

NOTE: Steps 7 and 7A are alternatives; use either one or the other. Step 7, however, makes re-exposure unnecessary.

Step 8: Wash the prints in running water for 30 seconds and dry.

PROCESSING KODAK REVERSAL MOTION PICTURE FILMS

Reversal processing is a method of producing a positive projection image directly on the film exposed in the camera. Some films designed for negative-positive use can be reversal processed, but the results are better with film designed especially for reversal, such as:

Kodak Plus-X Reversal Film 7276
Kodak Tri-X Reversal Film 7278
Kodak 4-X Reversal Film 7277

The reversal process consists of several steps. The film is first developed to a fairly high-contrast negative. The developed silver grains are then removed by a bleaching solution, leaving a positive image consisting of silver salts. After treatment in a clearing bath, these residual silver salts are either exposed to light and developed in a second developer to form the positive black-and-white image, toned to silver sulfide to form a sepia positive without re-exposure, or redeveloped in a fogging-type developer to a black-and-white image without re-exposure.

In these various steps there are many factors which can affect the final quality, and the best results can be obtained only when the processing is carried out under carefully controlled conditions. Control of the first development is particularly critical since there is no opportunity in the later steps to compensate for variations in the development of the negative image. The time in the first developer will depend on the design and manipulation of the processing equipment used, as well as on the film and the developer formula, and it should be checked by trial, as described later, for each individual case.

Safelight

All operations should be carried out in total darkness until after the bleaching step has been completed. If necessary, the film can be examined, for a few seconds only, after development is 50 per cent complete, by the light from a Kodak Safelight Filter No. 3 (dark green), in a suitable safelight lamp with a 15-watt bulb at a distance of not less than 4 feet.

After the bleaching step, normal room lights can be used.

Processing Equipment

Various types of equipment are available for handling 16mm film during processing. Most of these types are capable of producing results of good quality if the particular model is properly designed and the processing formulas and the handling and agitation techniques are properly adapted to the equipment.

The bleach solution is a strong acid oxidizing solution that will rapidly attack most metals. Therefore, any metal parts of the equipment that will come in contact with the solutions should be made of corrosion-resistant material, such as Type 316 stainless steel.

With some types of equipment, manipulation of the film while it is laden with processing solution is necessary to take up slack and prevent overlapping. It is recommended that goggles, rubber gloves, and protective clothing be worn, especially with the developers containing sodium hydroxide and with the bleaches.

Rack-and-tank equipment can be horizontal (with the film wound into a flat rack or spiral reel, as with the Nikor or Kindermann reels) or vertical (with the film wound on racks to fit deep tanks). In either case the film is completely immersed in the solution. The deep tanks require comparatively large volumes of solution for a given length of film and thus are less economical to use.

Reel-and-trough equipment carries the film on a reel or drum which dips into a trough or tray of solution and is rotated continuously during processing. With properly designed troughs, this equipment requires comparatively small volumes of solutions. There may be some trouble from aerial oxidation of the solutions, however, and there is some tendency for uneven development where the film crosses the reel slats.

Rewind tanks, in which the film is wound back and forth between two reels immersed in the solution, require only small volumes of solution and are capable of producing acceptable results, provided the proper procedure and operating technique are followed. Because the access of the solutions to any particular portion of the film is restricted to the very short time required to cross from one reel to the other, special solutions and much longer times of treatment are needed, and the compositions of the solutions must be closely adjusted to suit the characteristics of each film.

Some rewind equipment, such as the Morse G-3 Developing Tank, winds the film on the reels emulsion out, while some other tanks, such as the Micro-Record Developing Tank, wind the film emulsion in.

Continuous processing machines provide the most efficient handling of large footages, but are hardly practical for small amounts of film. Special modifications of formulas and procedures are often needed, and recommendations for any particular installation can be obtained by writing to the Motion Picture and Education Markets Division, Eastman Kodak Company, Rochester, New York 14650.

Agitation

The agitation procedure that will produce the most uniform development through the length of the film will depend on the design of the particular equipment used. Proper agitation is also important in the bleaching, where vigorous agitation, as by air-bubbling or mechanical means, is desirable.

The following general recommendations should be used as guides and modified as appears desirable for specific cases:

Rack and tank. With a flat spiral reel, secure the end of the film with a rubber band or waterproof tape to keep it from unwinding in processing. Lower the reel into the developer, giving it a vigorous turning motion sufficient to rotate it one-half to one revolution in the developer. Raise and lower the reel approximately one-half inch (keeping it in the solution) for the first 15 seconds of the development, tapping it against the bottom of the tank to release air bubbles from the film. Agitate once each minute by lifting the reel out of the solution, tilting it 30 degrees to drain 5 to 10 seconds, and reimmersing it with a vigorous turning motion as before. Alternate the direction of rotation each minute. Agitate in the same manner in the other solutions.

With a vertical rack in a deep tank, agitate the rack for 5 seconds under the solution when it is first immersed. At one-minute intervals, lift the rack out of the solution, drain it for a few seconds, and reimmerse it.

Reel and trough. Rotate the reel at a convenient rate rapidly enough to effect good agitation, but not so rapidly as to splash solution out of the trough. Reverse the direction of rotation periodically during development.

Rewind tanks. Wind the film back and forth continuously at a rate which will pass 100 feet of film from one reel to the other in approximately 60 seconds. The rate of winding should be adjusted to provide a whole number of round trips (complete transfer from one reel to the other and back again) in each bath, so that all portions of the roll will have the same time of contact with the bath. Because of the large amount of time that the film is tightly wound as compared to the time it is in free contact with the solution, the times required

in the various steps will depend on the length of the roll. A 50-foot roll will require about 75 per cent, and a 25-foot roll about 50 per cent of the time for the 100-foot roll. In the various rinses and final wash, the water should be changed at least after each 2 passes of the film. The re-exposure should be given while the film is in the rinse water.

Processing Temperature

The first developer should be used at a temperature of 68 F (20 C) ±0.5 F. The other baths should be between 65 and 70 F (18 and 21 C).

Processing Control

The degree of development in the first developer is important in determining the quality of the final positive. Best results usually are obtained when the first development is just sufficient to give clean highlights in the final positive with the recommended camera exposure. The contrast of the positive cannot be changed appreciably by varying first development. Overdevelopment produces an effect similar to overexposure, that is, decreased maximum density in the shadows of the positive and loss of highlight detail. Underdevelopment gives veiled highlights and a general effect similar to underexposure.

All of the steps after the first developer operate in a plateau region which offers little chance for alteration of the picture quality by processing variations. The times shown in the processing table are generally adequate, but they can be modified in specific cases if experience indicates that a change is desirable.

The proper development time for any films in the first developer will depend on the temperature of the solution and the degree of agitation. The degree of agitation, in turn, will depend on the type of equipment and the operating technique used. Therefore, when using new equipment, it is advisable to run a series of tests to determine the proper time of first development, preferably with sensitometric checks. The agitation should be standardized and repeatable, and the temperature should be maintained accurately, so that the time determined by the experimental tests will be correct for the camera films.

Notes On Processing Steps In Tables I And II

A. Prebath. With Kodak Plus-X, Tri-X, and 4-X Reversal Films prehardening is unnecessary for normal temperatures. However, in rewind-type apparatus, a nonhardening prebath is recommended to assure uniform wetting of the emulsion surface at the start of development. Optimum fog control is attainable when an antifoggant is used in this prebath together with enough carbonate for maximum effect (Kodak Prebath PB-3). A water rinse should follow in order to avoid carrying an excessive quantity of the prebath into the first developer.

KODAK PREBATH PB-3

Water	28 ounces	900.0cc
*0.5% solution of Kodak Anti-Fog No. 2 (AF-71) (6-Nitrobenzimidazole Nitrate)†	½ ounce	16.0cc
Kodak Sodium Carbonate, monohydrated	½ ounce	15.0 grams
Water to make	32 ounces	1.0 liter

*To prepare a 0.5% solution, dissolve 18 grains of Kodak Anti-Fog No. 2 in 8 oz of distilled water (1 gram in 200 ml of water).

†Kodak Anti-fog No. 2 is available in 1- and 5-pound bottles from any of the Eastman Kodak Regional Marketing and Distribution Centers. Smaller quantities of this chemical can be obtained from a number of chemical companies such as the J. T. Baker Chemical Company, Phillipsburg, New Jersey 08865, or Pfaltz and Bauer, Flushing, New York 11368.

TABLE I

OUTLINE OF REVERSAL PROCESS FOR KODAK PLUS-X, TRI-X, AND 4-X
REVERSAL FILMS IN REEL-AND-TROUGH OR RACK-AND-TANK EQUIPMENT
AT 68 F (20 C)

Operation	Kodak Formula	Approximate Time (Minutes)
1. First development	D-94	2*
2. Rinse	Water only	2
3. Bleach	R-9	3
4. Rinse	Water	1
5. Clear	CB-3	3†
6. Rinse	Water	1
7. Re-exposure	About 800 footcandle-seconds‡	
8. Redevelop	D-19	3
9. Rinse	Water or SB-1a	1
10. Fix	F-6	5
11. Wash	Water §	As required
12. Dry	—	—

*2 minutes for reel-and-trough and 2½ minutes for rack-and-tank equipment. Also, Kodak 4-X Reversal Film can be exposed at twice the recommended exposure index if the time of its first development is extended to 3 minutes, 20 seconds. This practice will result, however, in a slight loss of image quality.

†Times in excess of this should be avoided because of the tendency of this bath to dissolve the silver halide, with consequent loss of density in the positive image.

‡This exposure can be given to the film on a 15-inch-diameter reel in about ½ minute by the use of an opal-glass illuminator, fitted with 25-watt tungsten lamps spaced 4 inches from each other and located 7 inches from the nearest point of approach of the film.

§Washing time can be greatly shortened by using Kodak Hypo Clearing Agent. Proceed as follows:

Rinse in water . 2 min.
Treat in Kodak Hypo Clearing Agent Solution. 2 min.
Wash . 5 min.

NOTE: When it is not convenient to re-expose the film (Step 7) and a sepia-tone image is acceptable, you can substitute the use of Kodak Sulfide Redeveloper T-19 for Steps 7 and 8. If a black image is required, the fogging developer Kodak FD-70 can be used. See page BPR-74.01.

1. First development. The proper developing time, which should be just sufficient to give clean highlights with normal camera exposures, will usually have to be determined by trial with any particular equipment. When the recommended agitation procedures are used, the times shown in the tables are suggested for the first trials with the various types of equipment.

KODAK DEVELOPER D-94

Water, about 70 F (21 C) .	24 ounces	750.0cc
Kodak Elon Developing Agent	9 grains	0.6 gram
Kodak Sodium Sulfite, desiccated 1 oz.	290 grains	50.0 grams
Kodak Hydroquinone .	290 grains	20.0 grams
Kodak Potassium Bromide	120 grains	8.0 grams
or Sodium Bromide .	100 grains	7.0 grams
Kodak Sodium Thiocyanate	88 grains	6.0 grams
†Kodak Sodium Hydroxide (Caustic Soda)	290 grains	20.0 grams
Water to make .	32 ounces	1.0 liter

†CAUTION: Dissolve the caustic soda in a small volume of water in a separate container and then add it to the solution of the other constituents. Then dilute the whole to the required volume. If a glass container is employed in dissolving caustic soda, the solution should be stirred constantly until the soda is dissolved, to prevent cracking the glass by the heat evolved.

TABLE II

OUTLINE OF REVERSAL PROCESS FOR KODAK PLUS-X, TRI-X, AND 4-X
REVERSAL FILMS IN REWIND PROCESSING EQUIPMENT AT 68 F (20C)

For 100-foot rolls, the film should be wound back and forth continuously at a rate sufficient to pass 100 feet of film from one reel to another in about one minute. For 50-foot rolls, the times of treatment can be decreased to 75 per cent of those given below, and for 25-foot rolls, to 50 per cent.

Operation	Kodak Formula	Approximate Time (Minutes)
A. Prebath	PB-3	4
Rinse	Water only	4
1. First development *	D-88	Plus-X: 20
		Tri-X: 18
		4-X: 18
2. Rinse	Water only	4
3. Bleach	Plus-X: R-9 (2X normal strength)	10
	Tri-X: R-9 (3X normal strength)	10
	4-X: R-9 (2X normal strength)	10
4. Rinse	Water	4
5. Clear	Plus-X: CB-1	10
	Tri-X: CB-2	20
	4-X: CB-2	15
6. Rinse	Water	10
7. Simultaneously re-expose, passing the film 8 times from one reel to the other while exposed to a No. 1 Photoflood lamp at 12 inches.		
8. Redevelop	D-88 + 0.25 gram/liter potassium iodide	10
9. Rinse	Water or SB-1a	4
10. Fix	F-6	10
11. Wash	Water	40 †
12. Dry		

*Extended first development to raise the effective speed of Kodak 4-X Reversal Film is not recommended in rewind processing equipment.

†Kodak Hypo Clearing Agent can be used to shorten this time greatly. Proceed as follows:

Rinse in water for two passes . 2 min.
Pass twice through Kodak Hypo Clearing Agent solution 2 min.
Rinse for six passes in water . 6 min.

NOTE: When it is not convenient to re-expose the film (Step 7) and a sepia-tone image is acceptable, you can substitute the use of Kodak Sulfide Redeveloper T-19 for Steps 7 and 8. See page BPR-74.03.

KODAK DEVELOPER D-88 See page 242 for formula.

While some control of maximum density, minimum density, and contrast can be exercised in other steps of the process, the effect of excessive or insufficient first development cannot be fully compensated for in the later steps, and a loss in quality is almost inevitable.

2. Rinse. A water rinse is necessary in order to prevent the carrying over of first developer into the bleaching solution. An acid rinse should not be used at this point. With the rewind type of tank, all the water rinses should be changed at least after each two passes of the film.

If water of satisfactory temperature and purity is not available, rinses can be omitted entirely except after the first developer, when a good water rinse is necessary to prevent staining by reaction of developer with the bleach.

3. Bleach. In the black-and-white reversal process, the bleach must dissolve the metallic-silver negative image produced in the first developer without affecting the remaining undeveloped silver halide. Kodak Bleaching Bath R-9 (page 262) or the packaged Kodak Bleach for Kodak Direct Positive Paper will normally work satisfactorily with all types of equipment, provided the concentration is adjusted as indicated (normal strength for rack-and-tank or reel-and-trough with all three films; with rewind tanks, two times normal strength for Plus-X, three times normal strength for Tri-X, and two times normal strength for 4-X).

The bleaching step can leave a residue in the form of a yellowish or brownish stain in the highlight and lower-density regions, which is not very noticeable at the end of the bleaching stage but usually contributes appreciable density after re-exposure and redevelopment. The use of a bleach that is too concentrated for a particular film, especially when replacement of solution at the film surface is restricted, as in rewind-type processing tanks, is a common cause of this stain. An increase in pH of the bleach, due to use of the bleach solution beyond its capacity limits, is another cause of stain. Excessive bleaching time can result in a depressed sensitivity to re-exposure, which, with Plus-X Film, can cause a selective loss in lower middletone densities and consequent excessive contrast. The use of proper bleach concentration and time for the particular film and processing system is important in avoiding these difficulties. A high level of agitation is required in the bleach.

4. Rinse. See Step 2. A water rinse between bleaching and clearing baths is needed to minimize destruction of the sodium sulfite in the clearing bath by the carried-over bleach.

5. Clear. Treatment in the sodium sulfite clearing solution removes any bleach left after rinsing and prepares the residual silver salts for re-exposure or toning. A clearing solution stronger than recommended or an immersion time in excess of the recommendation will often cause a loss in density. A shortened time in the clearing bath can lead to stains.

KODAK CLEARING BATH CB-1

Water ..	24 ounces	750.0cc
Kodak Sodium Sulfite, desiccated	3 ounces	90.0 grams
Water to make	32 ounces	1.0 liter

KODAK CLEARING BATH CB-2

Water ..	24 ounces	750.0cc
Kodak Sodium Sulfite, desiccated	7 ounces	210.0 grams
Water to make	32 ounces	1.0 liter

KODAK CLEARING BATH CB-3

Water ..	24 ounces	750.0cc
Kodak Sodium Sulfite, desiccated	145 grains	10.0 grams
Water to make	32 ounces	1.0 liter

6. Rinse. See Step 2.

7. Re-expose. The second exposure should be sufficient to render the residual silver salts fully developable. The rack or reel should be rotated during the exposure so that the exposure will be fairly uniform over the whole area of the film. Optimum re-exposure is about 800 footcandle-seconds. This will be provided by a 10-second exposure to a 60-watt lamp at 12 to 18 inches. With rewind equipment, the re-exposure should be given while the film is in the rinse following the clearing bath. For instance, with the Morse G-3 tank, after one

change of rinse water, open the window and expose for 8 passes to a No. 1 photoflood lamp held about 12 inches from the window.

The amount of re-exposure is not critical. However, an excessive exposure (in the order of 10 times) may cause a slight and undesirable increase in density, which will be most noticeable in the highlight areas of the projected image. Too little re-exposure (in the order of 1/100 of the optimum) tends to reduce the maximum density objectionably. Exposure levels should be checked by trial to assure that no noticeable change in picture quality accompanies a 2- to 5-times change in re-exposure in either direction.

Re-exposure can be applied at any point in the processing cycle from the latter part of the clearing treatment to the early part of redevelopment. If re-exposure is given in the clearing bath, no additional time of contact with that bath should be required. If given while the film is in the redeveloper, sufficient time must be allowed subsequently for the redeveloper to complete its work. In rewind-type processing, the re-exposure should be given while the film is in the rinse bath following clearing.

7a. Fogging redeveloper. (Alternative to Steps 7 and 8). In situations where re-exposure is difficult to apply or control, due to the limitations of the apparatus, a redevelopment procedure which acts without need for light exposure is used. A fogging redeveloper has the property of reacting with the remaining silver halide in the emulsion without its having first been exposed to light. Kodak Sulfide Redeveloper T-19 (page 265) can be used with any type of processing apparatus if a brown image is acceptable. Kodak Fogging Developer FD-70 (page 263) can be used to give a black image with reel-and-trough or rack-and-tank processing, but this type of redeveloper is not recommended for rewind processing.

8. Redevelop after re-exposure. When the re-exposure and redevelopment method is used, the redeveloper can be any vigorous developer that completes its action in the time available under the existing equipment conditions. A first developer containing a silver halide solvent, such as sodium thiocyanate, should not be used as redeveloper, because it will lower the maximum density and may produce dichroic fog.

Developers such as Kodak Developer D-19 (page 238), D-72 (page 245), or D-88 (page 264) are commonly used as redevelopers. It is sometimes desirable to add a small quantity of antifoggant to reduce stain and lower the minimum density.

9. Rinse. See Step 2.

10. Fix. In the processes employing re-exposure, redevelopment leaves a small proportion of the silver halide grains undeveloped. Also, there may be deposited, during processing, silver salts or other hypo-soluble compounds that will darken and discolor the highlights after keeping and exposure to light. One of the functions of the fixing bath is to dissolve these residues and thus effect a reduction in minimum density and an improvement in overall brilliance and highlight quality.

For reel-and-trough processing, the odor of sulfur dioxide from most acid fixing baths may be objectionable. The use of Kodak Fixer F-6 (page 341) will minimize this difficulty.

11. Wash. The time of washing is determined by the efficiency of water application and the permissible residual hypo concentration for the intended use. Water can be run continuously or replaced in steps periodically during washing.

The use of Kodak Hypo Clearing agent as described in the footnote to the processing tables will greatly shorten washing times.

TABLE III

OUTLINE OF REVERSAL PROCESS FOR KODAK PLUS-X, TRI-X, and 4-X REVERSAL FILMS IN THE KODAK DIRECT POSITIVE FILM DEVELOPING OUTFIT AT 68 F (20 C)

The following processing times are for rack-and-tank equipment, either horizontal or vertical. Reel-and-trough and rewind processors are not recommended for this process. Drain the film for 10 to 15 seconds between each bath.

SOLUTION	Approximate Time (Minutes)
1. First Developer	6
2. Water Rinse	2 to 5*
3. Bleach Bath	1
4. Clearing Bath	2†
5. Redeveloper ‡	PLUS-X: 4
	TRI-X: 6
	4-X: 8
6. Water Rinse	1
7. Fixing Bath	5
8. Wash	As required §
9. Dry	

*A 2-minute time is sufficient in a running-water wash with good agitation.

†Times in excess of these should be avoided because of the tendency of this bath to dissolve the silver halide, with consequent loss of density in the positive image.

‡This is a fogging-type redeveloper; re-exposure to light is not required.

§Washing time can be greatly shortened by using Kodak Hypo Clearing Agent. Proceed as follows:

Rinse in water . 2 min.
Treat in Kodak Hypo Clearing Agent Solution 2 min.
Wash . 5 min.

Capacity Of Solutions

With reel-and-trough, spiral-reel, or rewind equipment, baths should be replaced after each batch of film. Replenishment and re-use of solution is not recommended.

Processing In The Kodak Direct Positive Film Developing Outfit

If you use only small amounts of Kodak Plus-X, Tri-X, and 4-X Reversal Films and want the convenience of a kit of packaged chemicals for processing, you can use the Kodak Direct Positive Film Developing Outfit. This kit contains the chemicals for mixing all the necessary solutions except the fixing bath, which can be prepared from packaged Kodak Fixer. One roll of 16mm film up to 100 feet in length can be processed with the contents of one outfit.

The processing times are shown in Table III. Other details of the procedure are given in the instructions packaged with the Direct Positive Film Developing Outfit.

ACUFINE FILM DEVELOPER

Acufine is a maximum acutance, ultra-fine grain film developer, combining optimum quality, with the highest effective speeds currently available with single solution developers. Acufine's higher speed ratings permit the use of slower films, with superior resolving power and finer grain in situations that previously required high-speed films.

Acufine Film Developer is packaged in single-mix dry powder form, readily soluble in water (70 to 90 F). Although the water in most areas is suitable, we recommend the use of distilled water wherever the mineral content or alkalinity is high. Acufine, either dry or in solution, may assume a slight coloration, that which will in no way affect its chemical properties.

Acufine Film Developer, in solution, will retain its full strength for approximately one year if normal precautions are taken against contamination and oxidation. All storage and processing equipment must be clean. If deposits of previously used chemicals remain on any items of equipment, these should be soaked overnight in a solution of approximately one ounce of sodium sulfite per gallon of water, and then thoroughly rinsed. To minimize oxidation, Acufine Film Developer should be stored in full, tightly capped, amber glass or polyethylene bottles. When stored in open tanks, floating lids should be used.

Recommended Exposure Indices: The high film speed ratings listed on the chart are the normal exposure indices for Acufine. The recommended exposure-development values are calculated for optimum quality negatives and are not the result of "pushing." To alter the speed ratings and/or developing times will result in negatives of less than Acufine's optimum quality.

Developing Times: The developing times will produce negatives of ideal contrast for printing in modern condenser enlargers. For cold light and diffusion type of enlargers, development may be increased by 25 per cent. Contrast may be increased or decreased to meet the individual's requirements by varying developing times ± 25 per cent from normal. Extreme variations from the chart recommendations will affect quality and film speed.

Whenever the conditions require higher than normal Acufine ratings, medium and high-speed emulsions may be "pushed" in Acufine to produce the maximum possible speeds but at some sacrifice in quality. The maximum gain of 2–3 times the recommended indices is achieved at approximately double the developing time. With slow films the speed gained by forced development is negligible.

Agitation: The developing times listed on this chart are based on gentle agitation for the first ten seconds after immersion, followed by gentle agitation for five seconds every minute. Excessive or vigorous agitation is to be avoided since it results in greatly increased contrast, with little or no speed gain. Less than recommended agitation promotes the possibility of irregular development, low contrast, and loss of speed. Constant agitation cannot be compensated for by decreasing development.

Replenishment: Acufine Replenisher is strongly recommended for maintaining consistency in quality and developing time. Replenisher should be added and thoroughly stirred into the developer at the end of each processing cycle. Average replenishment is at the rate of ½ fluid ounce per 80 square inches of film. (one roll of 36-exposure 35mm, or one roll of 120/620, or four 4″ x 5″ sheets.) Replenishment may be continued until a volume equal to the original amount of developer has been added. Without replenishment four rolls may be developed at normal times. Increase the developing time by two per cent for each additional roll. Develop no more than 16 rolls per quart in this manner.

One Time Use: If longer developing times are desired for more convenient control, Acufine Film Developer may be used as a diluted preparation with no change in either film speed or quality. The following chart gives the time factors for the recommended dilutions.

Recommended Dilution Ratio:	Development Increase
1 part Developer to 1 part water	2X
1 part Developer to 3 parts water	4X

Diluted developer must be used only once, immediately after preparation, and then discarded.

Reciprocity Failure: Reciprocity failure is the speed loss incurred by all photographic emulsions with exposure of extremely short or long duration. This effect is unnoticed with most popular electronic flash units, but if the flash duration is 1/2000 of a second or faster, development should be increased by 25 per cent. Reciprocity failure also becomes noticeable with exposures of approximately ten seconds and becomes more pronounced with increased times. The exposure compensation necessary for these conditions varies with each type of film, but for most practical applications exposures of 2 to 4 times the calculated time should be used.

ACUFINE INDUSTRIAL DEVELOPER

Acufine Industrial, offering all the characteristics of regular Acufine, is adjusted to work at twice the developing time. The extended processing time is advantageous where large-scale inspection techniques are employed and also where some of the regular Acufine times may be inconveniently short.

Acufine Industrial is outstanding for use in either automatic processing machines or deep tanks. The extreme latitude of Acufine Industrial makes it ideal for photofinishers, since all types of film may be processed at the standard time of seven minutes at 68 F.

The chemical similarity of regular and Industrial Acufine permits the use of the one Acufine Replenisher with both formulas. The replenishment procedures indicated above for regular Acufine also apply to Industrial. Automatic replenishment is practical since the necessary amount of replenisher is similar to the average "carry-out."

DEVELOPMENT TABLE FOR ACUFINE DEVELOPER

	Acufine Exposure *Index	Developing Time at					
		65 F	68 F	70 F	75 F	80 F	85 F
35mm Films							
Kodak Tri-X Pan	1200	6	5¼	4¾	3¾	3	2¼
Kodak Plus-X	320	5	4½	4	3¼	2½	2
Kodak Panatomic-X	100	2½	2¼	2	1¾	1¼	1
Kodak 2475 Recording	3200	8¾	7¾	7	5½	4½	3½
Ilford HP-4	1600	10	8¾	8	6¼	5	4
Ilford FP-4	200	5	4½	4	3¼	2½	2
Ilford Pan-F	64	2½	2¼	2	1¾	1¼	1
Agfa Isopan Record	1000	8¾	7¾	7	5½	4½	3½
Agfapan 100	320	8¾	7¾	7	5½	4½	3½
Agfapan 400	800	8¾	7¾	7	5½	4½	3½
Adox KB-21	250	3¾	3¼	3	2¼	1¾	1½
Adox KB-17	160	3¼	2¾	2½	2	1¾	1¼
Adox KB-14	64	2½	2¼	2	1¾	1¼	1
Roll Films							
Kodak Tri-X Professional	800	7½	6½	6	4¾	3¾	3
Kodak Tri-X	1200	7½	6½	6	4¾	3¾	3
Kodak Plus-X	320	5	4½	4	3¼	2½	2
Kodak Verichrome Pan	250	5¾	5	4½	3½	2¾	2¼
Kodak Panatomic-X	100	5¾	5	4½	3½	2¾	2¼
Ilford HP-4	1600	12½	11	10	8	6½	5
Ilford FP-4	200	7½	6½	6	4¾	3¾	3
Agfa Isopan Record	1000	8¾	7¾	7	5½	4½	3½
Adox R-21	250	5	4½	4	3¼	2½	2
Adox R-17	160	3¾	3¼	3	2¼	1¾	1½
Adox R-14	64	3¼	2¾	2½	2	1¾	1¼
Sheet Films							
Kodak Royal-X Pan	3000	15	13	12	9½	7½	6
Kodak Royal Pan	1000	10	8¾	8	6¼	5	4
Kodak Super Panchro Press Type B	320	10	8¾	8	6¼	5	4
Kodak Tri-X Pan	800	6¼	5½	5	4	3¼	2½
Kodak Tri-X Pan Packs	1200	10	8¾	8	6¼	5	4
Kodak Plus-X Pan	320	10	8¾	8	6¼	5	4
Kodak Super-XX Pan	500	12½	11	10	8	6½	5

For Acufine Industrial, double the developing times given; Exposure Indexes remain unchanged.

*For meters calibrated in ASA Exposure Indexes or ASA Film Speeds.

ACU-1 FILM DEVELOPER

ACU-1 is a maximum acutance, ultra-fine grain film developer, combining optimum quality with great effective speed. ACU-1's higher speed ratings permit the use of slower films with superior resolving power and finer grain in situations that previously required high-speed films. ACU-1 is a developer designed for those who prefer to work with a "one-time" use preparation with convenient dilution ratios.

Preparation: ACU-1 concentrate is packaged in single-mix dry powder form, readily soluble in water (70–90 F). Prepare the concentrated stock solution by dissolving completely the full contents of the can in one quart of water (946cc). Although the water in most areas is suitable, we recommend the use of distilled water wherever the mineral content or alkalinity of the tap water is high. ACU-1 concentrate, either dry or in solution, may assume a slight coloration which in no way will affect its chemical properties.

Storage: ACU-1 stock solution will retain its full strength for approximately one year if normal precautions are taken against contamination and oxidation. All storage and processing equipment must be clean. All equipment suspect of contamination should be soaked for eight hours in a solution of approximately one ounce of Sodium Sulfite per gallon of warm water and then thoroughly rinsed. To minimize oxidation, ACU-1 should be stored in full, tightly capped amber glass or polyethylene bottles. For infrequent use, we recommend that the concentrate be stored in several small bottles to assure longer life.

Recommended Exposure Indexes: The high-speed ratings listed on the chart are the normal exposure indexes for ACU-1. The recommended exposure-development values are calculated for optimum quality negatives and are not the result of "pushing." Alteration of these values, variations of personal technique excepted, will result in negatives of less than ACU-1's best quality.

Developing Times: The listed times for development will produce negatives of ideal contrast for printing in modern condenser enlargers. For cold light and diffusion-type enlargers, development may be increased by 25 per cent. Contrast may be varied to suit individual requirements by varying the developing times ± 25 per cent from normal. Extreme variations from the chart recommendations will affect quality and film speed.

Developing Procedure: Dilute the concentrate with water as specified on the chart. Two convenient dilutions of 1:10 and 1:5 are employed. Do not alter the dilutions. Use the diluted "working solution" within four hours after preparation and discard the solution after use.

Agitation: The developing times listed on the chart are based on gentle agitation for the first ten seconds after immersion, followed by gentle agitation for five seconds every minute thereafter.

The recommended procedure for gentle agitation with the popular stainless steel tanks is to invert the tank twice during a five-second interval. With the type of tank in which agitation is accomplished by rotating reels, it is best to turn the reels about a quarter of a turn backwards and forwards at the rate of two such cycles in a five-second interval.

Excessive or vigorous agitation is to be avoided since it results in greatly increased contrast, with little or no speed gain. Less than recommended agitation promotes the possibility of irregular development, low contrast, and loss of speed. Constant agitation cannot be compensated for by decreasing development.

DEVELOPING TIME TABLE FOR ACU-1 DEVELOPER

	Exposure Index	Dilution Developer: Water	Time in Minutes				
			68 F	70 F	75 F	80 F	85 F
35mm Films							
Kodak Tri-X Panchromatic	1200	1:5	11	10	8	6½	5
Kodak Plus-X Panchromatic	320	1:10	10	9	7	5½	4½
Kodak Panatomic-X	100	1:10	6¼	5½	5	4	3¼
Ilford HP-4	1000	1:5	13½	12½	10	8	6½
Ilford FP-4	250	1:10	10	9	7	5½	4½
Ilford Pan-F	125	1:10	6¼	5½	5	4	3¼
Agfa Isopan Record	1000	1:5	12½	11	10	8	6½
Agfapan 100	320	1:5	8½	7½	6	4¾	3¾
Agfapan 400	800	1:5	8½	7½	6	4¾	3½
Agfapan 1000	2400	1:5	11	10	8	6½	5
Adox KB-21	250	1:10	11	10	8	6½	5
Adox KB-17	160	1:5	6¼	5½	5	4	3¼
Adox KB-14	64	1:10	5½	5	4	3¼	2½
Roll Films							
Kodak Tri-X Pan Professional	800	1:5	10	9	7	5¾	4½
Kodak Tri-X Pan	1200	1:5	15½	14	11	9	7
Kodak Plus-X Pan Professional	320	1:10	6¼	5½	5	4	3¼
Kodak Verichrome Pan	250	1:5	12½	11¼	9	7¼	5¾
Kodak Panatomic-X	100	1:10	6¼	5½	5	4	3¼
Ilford HP-4	1000	1:5	12½	11	10	8	6½
Ilford FP-4	250	1:10	12½	11¼	9	7¼	5¾
Agfa Isopan Record	1000	1:5	12½	11	10	8	6½
Agfa Isopan ISS	200	1:5	11	10	8	6½	5
Adox R-21	250	1:10	11	10	8	6½	5
Adox R-17	160	1:5	6½	6	4½	3½	3
Adox R-14	64	1:10	7¼	6¼	5½	5	4

For 1:5 dilution, take 5⅓ ounces or 157cc of developer. Add water to make one quart or 946cc.
For 1:10 dilution, take three ounces or 86cc of developer. Add water to make one quart or 946cc.

Reciprocity Failure: Reciprocity failure is the speed loss incurred by all photographic emulsions with exposures of extremely short or long duration. This effect is unnoticed with most popular electronic flash units, but if the flash duration is 1/2000 of a second or faster, development should be increased by 25 per cent. Reciprocity failure also becomes noticeable with exposures of approximately ten seconds and becomes more pronounced with increased times. The exposure compensation necessary for these conditions varies with each type of film, but for most practical applications exposures of 2–4 times the calculated time should be used.

AUTOFINE FILM DEVELOPER

Autofine is a long-scale, ultra-fine grain, maximum acutance film developer formulated for use with all films at *manufacturer-rated speeds*. Autofine has been created with a specific eye to the needs of photofinishers with automatic processing equipment. The time-temperature chart will indicate that a developing time of seven minutes at 70 F will process all widely-used films to produce negatives of almost ideal contrast.

Preparation: Autofine is packaged in single-mix dry powder form, readily soluble in water (80–90 F). Although the water in most areas is suitable, we recommend the use of distilled water wherever the mineral content or alkalinity is high. Autofine, dry or in solution, may assume a slight coloration that in no way will affect its chemical properties.

Storage: Autofine Film Developer, in solution, will retain its full strength for approximately one year if normal precautions are taken against contamination and oxidation. All storage and processing equipment must be clean. If deposits of previously used chemicals remain on any items of equipment, the equipment should be soaked overnight in a solution of approximately one ounce of Sodium Sulfite per gallon of water, then thoroughly rinsed. To minimize oxidation, Autofine should be stored in full, tightly capped bottles of polyethylene or amber glass.

Exposure Indexes: Use the manufacturers' recommended ASA rating on films to be developed in Autofine; these ratings contain some safety factor for the sake of latitude in exposure. If results are too dense or too thin, raise or lower the exposure index accordingly. Although some speed gain can be obtained by extending development in Autofine, there is risk of increased grain and contrast. Where additional emulsion speed is required, it is better to use a developer intended for that result, such as Acufine or Diafine.

Developing Times: The developing times will produce negatives of ideal contrast for printing in modern condenser enlargers. For cold light and diffusion type enlargers, development may be increased by 25 per cent. Contrast may be increased or decreased to meet individual requirements by varying developing times ±25 per cent from normal. Extreme variations from the chart recommendations will affect quality and film speed.

Agitation: The developing times listed on this chart are based on gentle agitation for the first ten seconds after immersion, followed by gentle agitation for five seconds every minute. Excessive or vigorous agitation is to be avoided since it results in greatly increased contrast with little or no speed gain. Less than recommended agitation promotes the possibility of irregular development, low contrast, and loss of speed. Constant agitation cannot be compensated for by decreasing development. For users of nitrogen burst equipment, the recommended rate of agitation is two seconds at 30-second intervals.

Replenishment: Autofine Replenisher is strongly recommended for maintaining consistency in quality and developing time. Replenisher should be added and thoroughly stirred into the developer at the end of each processing cycle. Average replenishment is at the rate of ½ fluid ounce per 80 square inches of film. (One roll of 36-exposure 35mm, or one roll of 120/620, or four 4" x 5" sheets.) Replenishment may be continued until a volume equal to the original amount of developer has been added.

Reciprocity Failure: Reciprocity failure is the speed loss incurred by all photographic emulsions with exposures of extremely short or long duration. This effect

is unnoticed with most popular electronic flash units, but if the flash duration is 1/2000 of a second or faster, development should be increased by 25 per cent. Reciprocity failure also becomes noticeable with exposures of approximately ten seconds and becomes more pronounced with increased times. The exposure compensation necessary for these conditions varies with each type of film, but for most practical applications, exposures of 2–4 times the calculated time should be used.

AUTOFINE DEVELOPING TIME TABLE

	Exposure Index		Time in Minutes				
		65 F	70 F	75 F	80 F	85 F	90 F
35mm Films							
Kodak Tri-X Panchromatic	400	11	8¾	7	5¾	4½	3½
Kodak Plus-X Panchromatic	125	9½	7½	6	4¾	3¾	3
Kodak Panatomic-X	32	9½	7½	6	4¾	3¾	3
Ilford Pan-F	50	6½	5	4	3¼	2½	2
Agfa Isopan Record	640	11	8¾	7	5¾	4½	3½
Agfa Isopan IF	100	9½	7½	6	4¾	3¾	3
Agfa Isopan IFF	25	6½	5	4	3¼	2½	2
Agfa Isopan ISS	200	9½	7½	6	4¾	3¾	3
Adox KB-21	100	9½	7½	6	4¾	3¾	3
Adox KB-17	40	6½	5	4	3¼	2½	2
Roll Films							
Kodak Royal-X Panchromatic	1250	15¾	12½	10	8	6½	5¼
Kodak Tri-X Professional	320	11	8¾	7	5¾	4½	3½
Kodak Tri-X Panchromatic	400	11	8¾	7	5¾	4½	3½
Kodak Plus-X Panchromatic	125	6½	5	4	3¼	2½	2
Kodak Verichrome Pan	125	9½	7½	6	4¾	3¾	3
Kodak Panatomic-X	50	9½	7½	6	4¾	3¾	3
Agfa Isopan Record	640	15¾	12½	10	8	6½	5¼
Agfa Isopan IF	100	9½	7½	6	4¾	3¾	3
Agfa Isopan IFF	25	6½	5	4	3¼	2½	2
Agfa Isopan ISS	160	9½	7½	6	4¾	3¾	3
Adox R-21	100	9½	7½	6	4¾	3¾	3
Adox R-17	40	9½	7½	6	4¾	3¾	3
Adox R-14	20	9½	7½	6	4¾	3¾	3
Sheet Films							
Kodak Tri-X Panchromatic	320	13	10	8	6½	5	4
Kodak Plus-X Panchromatic	125	13	10	8	6½	5	4
Kodak Panatomic-X	64	13	10	8	6½	5	4
Kodak Super-XX Panchromatic	200	13	10	8	6½	5	4
Kodak Portrait Panchromatic	125	13	10	8	6½	5	4
Kodak LS Panchromatic	50	13	10	8	6½	5	4
Kodak Royal-X Panchromatic	1250	15¾	12½	10	8	6½	5¼
Kodak Royal Panchromatic	400	13	10	8	6½	5	4
Kodak Super Panchro Press Type B	250	13	10	8	6½	5	4

DIAFINE DEVELOPER (Improved)

Diafine is usable over a wide temperature range with one developing time for all films. Fast, medium, and slow films can now be developed simultaneously without adjustment in developing time. All films with the exception of a few extremely slow emulsions are automatically developed to the most desirable contrast. Time and temperature have no practical effect if the minimum recommendations are observed.

Diafine film developer is unsurpassed in its ability to produce greatest effectice speed, ultra-fine grain, maximum acutance, and highest resolution. It is a characteristic of Diafine film developer to permit the widest latitude of exposure known without the necessity of time-temperature compensation.

Diafine is supplied in dry powder form to make two separate solutions (A and B). The two powders contained in a carton of Diafine are to be prepared and used separately.

Dissolve the contents of the smaller can (solution A) in water (75–85 F) to make the volume specified on the carton. Dissolve the contents of the larger can to make an equal amount of solution B. Label the storage containers clearly. For maximum consistency and stability, we recommend the use of distilled water. As with any photographic developer, all storage and processing equipment must be clean.

In use, the solutions will become discolored and a slight precipitate may form, which in no way will affect the working properties of Diafine. The precipitate may be removed, if desired, by filtering.

Diafine may be used within a temperature range of 70–85 F with a minimum time of three minutes in each solution. Increased developing times will have no practical effect on the results. It is recommended that you do not exceed five minutes in either solution.

Developing Procedure

Do not presoak films.

Any type of tank or tray may be used.

1. Immerse film in solution A for at least three minutes, agitating very gently for the first five seconds and for five seconds at one minute intervals. Avoid excessive agitation as this may cause some loss of shadow speed and excessive contrast.

2. Drain, but do not rinse.

3. Immerse film in solution B for at least three minutes, agitating gently for the first five seconds and for five seconds at one minute intervals. Avoid excessive agitation.

4. Drain and rinse in plain water for about 30 seconds. (We do not recommend the use of an acid stop bath.)

5. Fix, wash, and dry in the usual manner.

Optimum results are obtained if all solutions, including the wash, are maintained at the same temperature. Care must be exercised to prevent any amount of solution B from entering solution A.

Replenishment

Diafine does not require replenishment. It is an extremely stable formula and has an unusually long work life, if normal precautions are taken against contamination.

When necessary, the level of the solutions can be maintained by the addition of fresh Diafine. Add equal amounts of fresh A and B to their respective working solutions. Since the introduction of dry film into solution A decreases the volume of A more rapidly than that of B, some of the B will have to be discarded before adding the fresh B solution.

EXPOSURE INDEXES FOR DIAFINE DEVELOPER

Film Type	Exposure Meter Setting
Roll and 35mm Films	
Kodak Tri-X Pan	2400
Kodak Tri-X Professional 120	1600
Kodak Plus-X Pan	640
Kodak Panatomic-X	200
Kodak Verichrome Pan	640
Kodak Royal-X Panchromatic	3200
Agfa ISS	500
Ilford Pan F	200
Adox KB-14	125
Adox KB-21	500
Adox KB-17	250
Sheet Films	
Kodak Royal-X Pan	3000
Kodak Royal Pan	2000
Kodak Tri-X Pan	1600
Kodak Super-XX Pan	1000
Kodak Plus-X Pan	640
Kodak Super Panchro-Press Type B	640

Exposure meter settings determined by sensitometric means and verified by practical test for meters calibrated in ASA exposure indexes. Slight adjustment of the ratings may be necessary to compensate for variations in meters, equipment, and personal technique.

PRINTOFINE PAPER DEVELOPER

Printofine Paper Developer is a high capacity print developer usable with all contact and enlarging papers. Characteristic of this product are its long tonal scale, rich, deep blacks, freedom from fog, and outstanding shelf and tray life.

In dry powder form, Printofine may be slightly pink or brown. Dissolve the powder in water at a temperature of 75 to 95 F. Printofine will be slightly yellow or pink upon mixing but will clear somewhat on standing. Shelf life of stock solution in full container is approximately one year at 75 F.

For use, dilute stock solution 1:2. Normal developing time for enlarging papers is 1½ minutes at 75 F. Developing time may be varied to correct for minor exposure errors. No fog is evident with Printofine even with developing times up to six minutes (at 75 F).

For convenience, a working temperature of 75 F is recommended, but equally good results will be obtained with a range of 60–85 F. The time corrections necessary to maintain a constant degree of contrast and density are as follows:

60 F—3 minutes	75 F—1½ minutes
65 F—2 minutes	80 F—1¼ minutes
70 F—2 minutes	85 F—1 minute

The working life of Printofine in an open tray is two days. One quart of Printofine will process more than 60 8″ x 10″ prints with no change in quality or processing.

Diluted one to one, Printofine Paper Developer is well suited to litho-type films used for line copy. Normal development time at 70 F is from two to four minutes.

The Baumann Index

The B-Index (Baumann Index) indicates the relative speeds of the various papers when developed in Printofine. On this chart, 1000 is the index assigned to the fastest of the papers tested.

Paper	Grade or Filter	B Index	Paper	Grade or Filter	B Index
Dupont Varilour	0	75	Kodabromide	1	1000
	1	135		2	500
	2	250		3	600
	3	250		4	500
	4	165		5	375
Dupont Velour Black	1	500	Kodak Ektalure	—	200
	2	600	Kodak Medalist	1	250
	3	750		2	215
	4	500		3	335
Agfa Brovira	1	250		4	300
	2	600	Kodak Polycontrast	1	165
	3	500		2	335
	4	500		3	300
	5	700		4	190
	6	375			
Agfa Portriga Rapid	2	700			
	3	700			
	4	1000			

If one has determined the correct exposure for the paper he normally uses, the B-Index will permit him to estimate the exposure required by a different type of paper. If the paper presently in use has a B-Index of 500 and the photographer wishes to change a paper with a B-Index of 250, he will know that the new paper is only one-half as fast as his normal grade and he will, therefore, have to expose it twice as long.

The B-Index is not an absolute speed rating and is designed only to show the relative speeds of various papers when developed in Printofine.

The data is based on the most commonly used light source, the #212 150-watt lamp. Color changes caused by the use of other lamps, filters, or large voltage changes will produce differences in the indexes, especially with the variable contrast papers. Speeds are based on the minimum exposure necessary to produce a maximum black for a given paper.

H & W CONTROL DEVELOPER

H & W Control Developer Concentrate is diluted for use and discarded when development has been completed. Each roll of film is processed in fresh developer according to the following dilution rates, times and temperatures. Water used for dilution must be suitable for general photographic purposes.

Film	Dilution	Developing Time (minutes)				
		68 F	72 F	74 F	76 F	80 F
H&W Control VTE Pan 35mm (Exposure Index 80) H&W Control VTE Ultra Pan 35mm (Exposure Index 25)	10.5ml in 235ml (8 ounces)	12	11	—	10	9
H&W Control VTE Pan 120 roll film (Exposure Index 80)	18ml in 414ml (14 ounces)	11	—	10	—	9
Kodak High Contrast Copy Film 5069, Kodak AHU, Ilford Micro-Neg, Fuji Microfilm Negative HR, and 3M Microfilm (Exposure Index 25)	8ml in 235ml (8 ounces)	10	—	9	—	8
Kodak Contrast Process Pan sheet film (Exposure Index 40)	12ml in 235ml (8 ounces)	14	—	13	—	—

The preferred development procedure for all films listed above is as follows:

Dilution: Dilute H & W Control Developer Concentrate according to the preceding table. In multiple-reel tanks simply multiply the amount of developer concentrate and water by the number of rolls of film to be developed. The H & W Control measuring cap has indicating lines placed at 6ml and 8ml. A level full cap contains 10½ml.

Agitation: Give the film ten seconds' continuous agitation after the developer has been poured into the tank. With a spiral-reel inversion-type tank, agitation is best accomplished with gentle inversions and rightings of the tank, each cycle taking approximately two seconds. After the initial agitation, the bottom edge of the tank should be rapped smartly with the heel of the hand to dislodge any air bubbles which may have been trapped in the reel. At the start of each minute (timed from the beginning of the pouring of the developer into the tank) the tank should be inverted and righted three times, taking about six seconds.

End of Development: Begin to pour the developer from the tank at the end of the time cycle which began with the start of the pour-in. The used developer should be discarded.

Stop Bath: The use of an acid stop bath is recommended to halt development and to prolong fixer stability, although a plain water rinse can be substituted. There is no degradation of the image as a result of following the alkaline developer with an acid stop bath; in fact, if there is any difference with VTE films, 60-diameter enlargements showed that it is in favor of negatives processed with a stop bath.

Fixer: Any standard fixing bath can be used and because of the thinness of the emulsion, fixing time need be no longer than two minutes.

Clearing Bath: Any standard hypo clearing bath can be used and is recommended to conserve water. Follow the manufacturer's recommendation.

Washing: Again because of the thinness of the emulsion, washing time can be significantly reduced after the use of a clearing bath. One minute with at least five changes of water is ample for ordinary needs; two minutes with ten changes of water should make for archival permanence.

Wetting Agent: After the final wash, a wetting agent is recommended in order to prevent water spots on the negatives. The water used for this step is critical; the wetting agent should be mixed with distilled water. Use as weak a wetting agent solution as is necessary for the film to dry cleanly, because if the concentration is too high a scum will be left on the film.

All subsequent treatment of the film is standard. Drying time at room temperature, with unblown air, is between five and fifteen minutes, depending on humidity. Dry in a dust-free place; dust or dirt which dries into the emulsion will leave spots even if the film is cleaned chemically after drying. The photographer is wise who takes all steps possible to eliminate dust from his darkroom.

When these instructions are adhered to, properly exposed negatives will have a gamma of about .65. More contrast can be obtained by extending development at the lower temperatures. For instance, with H & W Control VTE Pan Film, 35mm x 36 exposures, development at 68 F for 16 minutes produces a gamma of about .75. Extending time at 80 F to 12 minutes strengthens shadow detail and produces a gamma of about .7; however, D_{max} is relatively low, and with subject matter of a normal 5-stop range (16:1 brightness range) highlight tones are not as well separated as they are with less development time. Minimum graininess is achieved, of course, by limiting development to the time recommended for the specified temperature.

CLASSIFICATION OF FILMS BY DEVELOPMENT TIME FOR EDWAL DEVELOPERS

Development times in Edwal Developers fall into seven groups, from Group I, the shortest times, to Group VIII, the longest. These groupings apply to all Edwal Developers except Minicol; for the latter, increase the group listing by one for each film (that is, a Group III film will develop in Group IV for Minicol).

35mm FILMS

Adox KB-14	I
Adox KB-17	III
Adox KB-21	IV
Adox Dokupan	I minus 20 per cent
Kodak Panatomic-X	II
Kodak Infrared	III
Kodak Plus-X	II
Kodak Tri-X Panchromatic	III
Kodak Type 2475	V
Ilford FP-4	II
Ilford HP-5	III
Ilford Pan F	I
Minox ASA 25	I
Minox ASA 50	II
Minox ASA 100	IV

ROLL FILMS

Adox	Same as 35mm
Kodak Plus-X	II
Kodak, all other roll films	III
Ilford FP-4	II
Ilford HP-5	III
Lumipan	V

SHEET FILMS

Kodak Commercial Film	IV
Kodak Super Panchro-Press Type B	VI
Kodak Super-XX	VI
Kodak Royal Pan	V
Kodak Tri-X Ortho	III
Kodak Tri-X Pan	III
Kodak Royal-X Pan	VI
Kodak Plus-X Pan	III

EDWAL FG7 DEVELOPER

Edwal Fine Grain Concentrate #7 (FG7) will develop every modern film for any common use by variation of dilution and developing time. Its normal color is pale tan to lavender. It keeps well even in a partly full bottle but should be stored at room temperature (below 85 F) for longest shelf life.

1. Rapid development for sheet films: (Fine grain in four minutes) Dilute FG7 Concentrate with an equal amount of water. Develop (minutes):

Film Class	I	II	III	IV	V	VI	VII
65 F	2	2½	3	3½	4	5	6
70 F	1¾	2	2½	3	3½	4	5
75 F	1½	1¾	2	2½	3	3½	4
80 F	1¼	1½	1¾	2	2½	3	3½
85 F	1	1¼	1½	1¾	2	2½	3

2. Rapid development for Roll Films: (Fine grain in five minutes) Dilute FG7 Concentrate with two parts water. Develop (minutes):

Film Class	I	II	III	IV	V	VI	VII
65 F	3	3½	4	5	6	7½	9
70 F	2½	3	3½	4	5	6	7½
75 F	2	2½	3	3½	4	5	6
80 F	1¾	2	2½	3	3½	4	5
85 F	1½	1¾	2	2½	3	3½	4

3. For available light: Use Method 4 or Method 7. Prolong developing times 50 per cent for a 100 percent film speed increase, or 100 per cent for maximum speed (usually 300 per cent to 400 per cent increase.)

4. For deep tank development: Dilute FG7 Concentrate with three parts water. Develop (Minutes):

Film Class	I	II	III	IV	V	VI	VII
60 F	4	5	6	7½	9	11	13
65 F	3	4	5	6	7½	9	11
70 F	2½	3	4	5	6	7½	9
75 F	2	2½	3	4	5	6	7½
80 F	1¾	2	2½	3	4	5	6
85 F	1½	1¾	2	2½	3	4	5

To get film speed equal to Method 7, develop in next higher film class.

5. For FG7 automatic (two-bath) development: Especially good for high contrast subjects. To make solution A, dilute FG7 1:1 for most films, 1:3 or 1:5 for fine grain films. To make solution B, dilute FG7 B Concentrate 1:1. Develop all films one minute in solution A and two minutes in solution B. See solution B label.

6. For Thin-emulsion Films: (high resolution) Dilute FG7 Concentrate with 15 parts water. Use developing times twice as long as those shown for the same film under Method 7, but for best results do not develop above 75 F. Three rolls may be developed in 16 ounces if all done the same day. Increase time ten per cent for each roll.

7. For One-Use development of medium- and high-speed films: Dilute FG7 Concentrate with 15 parts of an approximately nine per cent sodium sulfite solution and develop (minutes):

Film Class	I	II	III	IV	V	VI	VII
65 F	5	6	7	8	9	11	14
70 F	4	5	6	7	8	9	11
75 F	3	4	5	6	7	8	9
80 F	2½	3	4	5	6	7	8
85 F	2	2½	3	4	5	6	7

This method gives very fine grain on the medium- and high-speed films. Film speed is about ½ f/stop higher than with the 1:3 dilution described above. Use developer only once.

A nine per cent solution of sodium sulfite can easily be made in any of the following ways:

1. Dissolve a pound of sodium sulfite in five quarts of water. (If a five quart container is not available, dissolve one pound sulfite in a gallon of water in a gallon jug. Then add one ounce water for each four ounces sulfite solution when diluting the FG7.

2. Dissolve 45 grams of sulfite in one pint of water (45 grams is approximately one fluid ounce by volume of sodium sulfite filled level full but not packed down).

3. Use an Edwal Speed Cup, which holds one fluid ounce to measure out sulfite for one pint of solution.

Use of nine per cent sulfite for finer grain: For finest grain on small size medium- and high-speed films, FG7 concentrate should be diluted 1:15 with nine per cent sulfite as in Method 7 (One-Use Development). Nine per cent sulfite may also be used if desired for increased fineness of grain as follows:

a) In method 2 dilute with one part water and one part nine per cent sulfite instead of two parts water.

b) In Method 3 and 4 dilute with one part water and two parts nine per cent sulfite instead of with three parts of water. Use same developing times as when diluting with water above.

Agitation: Agitate ten seconds out of each 30 seconds for Methods 1 and 2 above; five seconds in each 30 seconds for all other methods.

To Replenish: For the 1:1, 1:2 or 1:3 dilution, add ½-ounce concentrate for each roll (80 square inches) developed in Methods 1, 2, 3, and 4 above. No replenishment in Methods 5, 6, and 7.

Film Speed: For Methods 4, 6, and 7 on 35mm and roll films, use at least twice the film manufacturer's exposure index. Adjust exposure to give the thinnest negative that has good shadow detail. See the free Edwal FG7 Bulletin. Typical roll film exposure indexes: Tri-X 2400, HPS 1600, Isopan Record 1600, Super Hypan 1000, HP3 800, Plus X 500, Adox-21 320, Panatomic-X 125, Pan-F 160.

For sheet films developed by Methods 4, 6, or 7, and for any film developed by Methods 1 or 2, use ½ to 1 stop more exposure than the above, as experience indicates.

Crystals: Because FG7 is extremely concentrated, a few crystals may form on long storage. These have no effect on developing power and may be ignored or filtered out.

Flash & speedlight

1. For bulb flash on camera, speedlights with flash duration of 1/500 to 1/1000 seconds and other contrasty lighting situations, proceed as for "normal speed" development but reduce developing times from ten per cent to 30 per cent depending on degree of softness required.

2. For bounce light and for speedlights with 1/1000 to 1/2000 seconds flash duration, use "normal speed" developing times.

3. For speedlights with 1/2000 to 1/10,000 seconds flash duration, increase developing time 20 per cent to 50 per cent as experience indicates.

The Edwal "Controlled Monobath" Method

Travelers or others who do not wish to save used solutions will find the following "single-use" method for developing and fixing in the same solution very convenient:

1. Develop the film in FG7 using Method 6 (see above).

2. When development is finished, add one ounce Edwal Hi-Speed Liquid Fix Concentrate for each pint of working solution direct to the developer in the tank. Mix thoroughly and fix two to three minutes for Class I, II, or III films; four to six minutes for films in Classes IV through VII. For films in Classes IV through VII, or for any film developed in Method 7, use two ounces Hi-Speed Liquid Fix Concentrate (instead of one ounce) per pint of developer. Fix Royal-X or Isopan Record three to four minutes.

3. Discard the used solution and wash film as usual. If hardening is desired, immerse film in a solution of ½ -ounce of Edwal Anti-Scratch Hardener in a pint of water for two to three minutes with agitation between fixer and washing.

Precaution: The Hi-Speed Liquid Fix Concentrate must be quickly and completely mixed with the developer in the tank in step 2. Tanks that can be picked up and shaken are the best. For other small roll film tanks, it is best to pour out four or five ounces of developer, then add the Hi-Speed Liquid Fix Concentrate, and then pour back part of the used developer (or plain water) to force the fixer out of the center of the reel into the main body of solution. Agitate vigorously to get complete mixing.

EDWAL SUPER-12 DEVELOPER

Edwal Super 12 is an old style (introduced about 1936), fine-grain developer, which has continued in use because it produces better results for certain uses than more recent formulations. It is a "high fidelity" developer, which produces negative densities that are exactly proportional to the brightness values of the subject over a much wider range than with the "compensating" developers now in common use. Hence, it is unexcelled in putting "snap" into a flat scene, for high-speed electronic flash, for developing copy negatives in mural-making where the big enlargement must have the same tone range as the print being copied, and so on. Also, it is used industrially as a replenisher for Super 20, in deep tanks.

Film Speed: Edwal Super 12 produces maximum film speed. It can be used with the same exposure index ratings that are recommended for Edwal FG7, e. g., 640 for Kodak Plus-X and 2400–3200 for Kodak Tri-X Pan Film at normal developing times.

Grain: Edwal Super 12 produces "fine-grain" negatives, giving 10–12 diameter enlargements on coarse grain films, more on medium- and fine-grain types.

Precautions: Super 12 is a "staining developer" in that it will produce purple or black stains if spilled and allowed to dry out or oxidize in the air. Stains can be prevented by using newspaper under developing tanks and other things to catch stray splashes or spills. Spills on other surfaces or on the hands should be washed off thoroughly with soap and water within 10 or 15 minutes to prevent oxidation, which produces the stain color. Stains can be removed with permanganate and muriatic acid. Persons who are allergic to developing agents may have an irritation or rash if Super 12 comes in contact with their skin. Caution: Super 12 contains sodium sulfite and paraphenylene diamine. Harmful if swallowed. A strong sensitizer. Allergic persons should avoid direct contact. *Keep out of reach of children.*

Temperature: Super 12 may be used "as is" at any developing temperature from 65–85 F. It may be used above 85 F if 45 grams of anhydrous sodium sulfate (not sulfite) are dissolved in each quart of developer.

For average contrast use times given in table below. For the first batch of film cut developing time 20 per cent (next lower film class).

Film Class	Developing Times in Minutes						
	I	II	III	IV	V	VI	VII
65 F (18 C)	8	10	12	15	18	22	26
70 F (21 C)	6	8	10	12	15	18	22
75 F (24 C)	5	6	8	10	12	15	18

After developing ten rolls per quart, without replenishment, increase developing times five per cent per roll.

Developing times at 85 F with sulfate are the same as for the same film at 80 F without sulfate. Developing times decrease about 20 per cent for each five-degree rise in temperature up to 100 F. For processing above 75 F all solutions, including wash water should, if possible, be at the same temperature, and if a stop bath is used, it should be made up with only about 10cc (⅓ ounce) of acetic acid per quart and should contain 2 ounces (60 grams) of anhydrous sodium sulfate per quart to prevent undue emulsion swelling.

Replenishment: For small tanks, self-replenishment is recommended as follows: Develop three rolls in a quart of fresh Super 12 and then replenish by adding three ounces of fresh developer after the third roll and after each succeeding roll. Discard enough old solution each time to maintain the proper level in the storage bottle. Replenishment is continued indefinitely. The developer is maintained in efficient working condition, giving the finest possible grain and good film speed. If the developer shows signs of weakening, use a double quantity (six ounces) of fresh developer for one replenishment and then proceed as usual.

Super 12 may also be used without replenishment, according to directions on the bottle label. For self-replenishment in deep tanks, the quantity of solution to be added is usually ½ – ⅓ that recommended for small tanks.

Speed Light And Bulb Flash: Super 12 is suitable for speedlight units with a flash duration between 1/2000 and 1/10,000 seconds. Usually no increase in developing time is needed. Also, for bounce flash or floodlighted shots. For longer flash-duration speedlights or for bulb flash on camera, a softer working developer such as Edwal FG7 or Minicol II should be used.

For Fine-Grain (Thin-Emulsion) Films: For *maximum resolution,* develop at 70 F in fresh Super 12 diluted with nine parts of water, using a developing time twice that recommended for the class number of your film in undiluted Super 12. Use diluted solution only once. At this dilution Super 12 loses its "high fidelity" characteristics and becomes a mildly compensating developer.

For *general photography,* develop in fresh Super 12 diluted 1:1 with water, using the regular developing time recommended on the bottle label. Replenish with one ounce of undiluted Super 12 after each roll until 17 rolls have been developed per quart.

Keeping Characteristics: Super 12 normally has the color of weak tea and will retain that color as long as it is in good condition. It will keep for years in a tightly sealed bottle. If the cap should be loose enough to allow air to gradually enter the bottle, the solution will become chocolate brown or red and should then be discarded.

EDWAL SUPER-20 DEVELOPER

Edwal Super 20 is a long-scale developer, producing a rather "snappy" negative. It gives densities exactly proportional to the brightnesses in the original subject over a longer range than do the compensating-type developers. Super 20 gives high acutance (detail delineating power) so that small details will appear more clearly on very big enlargements than is usually the case.

Film Speed: Super 20 should be used with an exposure index half that recommended for use with Edwal FG7. Typical recommended Super 20 film speeds for 35mm and smaller films are: Improved Tri-X 800 and improved Panatomic-X 40. Super 20 contains paraphenylene diamine and because of this gives higher film speed than the "non-diamine" super-fine grain developers.

Film Class	Developing Times in Minutes						
	I	II	III	IV	V	VI	VII
65 F (18 C)	12	15	18	22	26	31	37
70 F (21 C)	10	12	15	18	22	26	31
75 F (24 C)	8	10	12	15	18	22	26

Temperature: Edwal Super 20 gives best results at 70 F but the full strength solution can be used up to 85 F if all solutions, including wash water, are at the same temperature. Care should be taken to avoid excessively rapid drying or touching the emulsion of the film with any solid object until completely dry. For development at 85 F or above, dissolve 45 grams of anhydrous chemically pure sodium sulfate (not sulfite) in each quart of developer and 22½ grams in each 16 ounces of replenisher. Developing times for 85 F with sulfate are the same as at 80 F without sulfate. Times at 90 F with sulfate are the same as times at 85 F without sulfate, and so forth.

For Medium-Speed Films and Kodak Tri-X Pan Film: Develop in full strength Super 20 with replenishment, using Super 20 Replenisher at the rate of 1-ounce replenisher per 80 square inch roll of film. Two 16-ounce bottles of replenisher may be used with one quart of Super 20 to develop 33 36-exposure rolls of 35mm film or the equivalent in other sizes.

For Minox or other subminiature tanks holding very small amounts of developer, full strength Super 20 can be used once and then discarded.

For Fine-Grain Films: Use Super 20 diluted 1:1 with water as the working solution and replenish with ½-ounce Super 20 Replenisher for each 80 square inch roll of film or equivalent. Use the same developing times that are given for full strength Super 20 in the table.

For "Single-Use" Development of Fine-Grain Films: Dilute Super 20 1:7 (2 ounces Super 20 to make 16 ounces working solution) and use a developing time twice as long as that given in the developing time table. Do not use above 75 F.

Recommended Films for Use with Super 20: Super 20 gives good results under ordinary developing conditions with Tri-X and most medium-speed and fine-grain films. It should not be used with Royal-X, Super Hypan, or with the European high-speed films, except with continuous and efficient agitation, because these films tend to produce dichroic fog with developers of this type. Recently two medium-speed U. S. films, Verichrome Pan and Professional Plus-X, have also begun to show dichroic fog with Super 20, so should have continuous efficient agitation if used.

Removal of Dichroic Fog: If it is desired to use Super 20 to develop one of the above mentioned films that tend to give dichroic fog, or if this fog is accidentally obtained through poor agitation, it can be easily removed by soaking the film in water until thoroughly wet and then dipping or swabbing it for four–ten seconds in ½ strength Farmer's Reducer and immediately immersing it in water. It should then be washed and dried as usual. Repeat if necessary.

For Super Fine-Grain Photo-Finishing: Photofinishers, who specialize in subminiature work, use Super 20 in their deep tanks and replenish by adding Edwal Super 12 (instead of Super 20 Replenisher) from time to time as needed to keep the level up. Tank life is very long—often six months to a year —and negative quality is better than with the usual developers.

Precautions: Super 20 is a "staining developer" in that it will produce deep purple or black stains if spilled and allowed to dry out or oxidize in the air. Stains can be prevented by using newspaper under developing tanks, and to catch stray splashes or spills. Spills on other surfaces should be washed up thoroughly within a few minutes, before oxidation has a chance to produce colors. Stains on the skin will be prevented by prompt and thorough washing with soap and water. If stains do appear, they can be removed with potassium permanganate and hydrochloric acid, followed by a bath of sodium bisulfite to remove the permanganate stain. **CAUTION:** Super 20 contains sodium sulfite and paraphenylene diamine. Harmful if swallowed. A strong sensitizer. Allergic persons should avoid direct contact. Keep out of reach of children.

EDWAL MINICOL-II DEVELOPER

Minicol II at 1:7 dilution is primarily intended for use with thin-emulsion, fine-grain films, such as Panatomic-X, Adox 14, and Pan-F. It also gives excellent results with the medium-speed films, such as Plus-X, Versapan, FP3, and Adox-17. Minicol II may also be used at 1:7 dilution with nine per cent sulfite for single use, super-compensating, fine-grain development of fast films, such as Tri-X, Super Hypan, HPS, and so on. When so used, it requires one f/stop more exposure than Edwal FG-7.

Film Speed

Typical recommended film speeds for low- and medium-speed 35mm and roll films to be developed in Minicol II diluted 1:7 with water are:

Adox Dokupan	10	Ilford Pan-F	80
Adox-14	25	Kodak Panatomic-X	80
Adox-17	40	Kodak Plus-X	320
Agfa IFF	40	GAF Versapan	200

For fast films when developed in Minicol II diluted 1:7 with nine per cent sulfite:

Kodak Tri-X	1200	GAF Super-Hypan	500
Ilford HPS	800	Agfa Isopan Ultra	400

These suggested ratings give a not-too-dense negative with very fine grain. Usually an acceptable negative can be obtained with one f/stop less exposure.

For Slow- And Medium-Speed Films: Minicol II Concentrate is diluted with seven parts water to give eight parts working solution. This is recommended for development of one roll of film in a small spiral reel tank of developer, but two rolls can be satisfactorily processed without increase in developing time if they can be loaded into the tank at the same time. If necessary, two films can be developed consecutively in 16 ounces of Minicol II working solution, provided the second film is developed within an hour or two after the first and if the developing time of the second film is increased 15 per cent.

Film Class	Developing Times in Minutes				
	I	II	III	IV	V
65 F	16	20	24	28	32
70 F	13	16	20	24	28
75 F	11	13	16	20	24

For High-Speed Films: High-speed films may be developed in Minicol II diluted with plain water. For finest grain on these films, however, it is recommended that Minicol II Concentrate be diluted with a nine per cent sulfite solution and the developing times be reduced to one-half those given on the Minicol II label for Minicol II diluted with plain water. Minicol II produces a rather soft, highly compensated negative with the fast films. For most purposes Edwal FG7, which produces a snappier negative, will be more suitable on these films.

Temperature: Developing times from 65 to 75 F are given above for Minicol II diluted with water. If it is desired to use Minicol II above 75 F, dilute the concentrate with a solution of two ounces of anhydrous (chemically pure) sodium sulfate (not sulfite) in a quart of water, instead of plain water. The developing time at 80 F in such a solution would be the same as the developing time at 75 F without the sodium sulfate. For each increase of five

degrees above 80 F, reduce the developing time 20 per cent. Some increase in contrast will occur at higher developing temperatures.

Keeping Characteristics: Minicol II normally has a very faint yellowish color and will retain that color as long as it is in good condition. It will keep for years in a tightly sealed glass bottle. The working solution should be made up just before use. If it is desired to make up working solution and keep it for several days before use, this can be done if the water is deoxygenated by boiling for ten minutes or by letting it stand several hours in a sealed bottle after dissolving about ten grams of sodium sulfite in a quart.

If it is desired to keep Minicol II Concentrate for several months when the bottle is half full, the concentrate can be diluted with an equal part of water. After that, two ounces of the 1:1 Minicol II should be used in place of one ounce of full strength concentrate. This procedure can be repeated again after the bottle becomes half empty the second time. From that point on, four ounces of the partly diluted Minicol II would be used instead of one ounce of full strength Minicol II Concentrate.

Precautions: Persons who are allergic to Metol or similar developing agents should avoid direct contact with Minicol II since it may produce a skin rash. Minicol II will not stain hands or clothing under ordinary conditions. However, brown stains may result if it is allowed to oxidize severely. Such stains usually wash out with ordinary soap and water. Warning: Minicol II contains sodium sulfite and hydroquinone. Harmful if taken internally. Keep out of reach of children.

EDWAL SUPER-III & EDWAL PLATINUM DEVELOPER

Edwal Super 111 is a professional and industrial paper developer. It gives a neutral (not bluish) black image.

Edwal Platinum Developer is an amateur-type paper developer based on the same formula and giving the same results as Super 111 but somewhat less concentrated. It is sold in 4 ounces (to make one quart of working solution) and 16 ounces (to make one gallon). It is packed in glass bottles and is guaranteed for a shelf life of five years. Glass is the only container that keeps developer as good the day it is used as it was the day it was made.

Exposure: Exposure is best determined by means of test strips or a projection print scale. However, where these are lacking an initial estimate can be made on the basis that when correctly exposed the print will begin to show an image in 7–12 seconds at 70–75 F. For best results, exposure should be regulated so that the print can be developed at 70 F a full 45 seconds for contact paper, and 1½ to 2 minutes (maximum 3 minutes) for enlarging papers. Development is more rapid at higher temperatures.

Contrast: The usual dilution of 1:9 for Super 111 and 1:7 for Platinum concentrate produces standard contrast on cold-tone papers and a somewhat snappier-than-usual print on warm-tone papers. Softer results can be obtained by diluting with more water. Contrast can be increased if needed by diluting with less water. For developing copy papers or line reproduction papers, a 1:7 dilution is usually used with Super 111.

Temperature: Both Edwal Super 111 and Edwal Platinum Developer may be used at any temperature from 65–75 F with normal procedure, and up to 85 F if care is taken not to handle the emulsion side of the print while wet with developer. Above 85 F, two ounces of anhydrous sodium sulfite should be added to each quart of working solution to allow use up to 95 F without fogging or staining.

Development of Slides: Super 111 at 1:9 or Platinum at 1:7 are excellent developers for slides because they give practically no fog and avoid the necessity of using Farmer's Reducer to "clean up" a slide, which is often necessary with ordinary developers.

Development of Film: Super 111 and Edwal Platinum Developer can be used to develop film. For tray development, dilute Super 111 with 10 parts of water, or Platinum with 8 parts, and develop 3 to 7 minutes at 70 F. For tank development, dilute Super III with 25 parts of water, or Platinum with 20 parts, and develop common roll films 10–12 minutes at 70 F; thin-emulsion films are developed 5–6 minutes at 70 F. These are "long-scale" developers, giving rather snappy negatives. Shorter developing times will give less contrast.

Keeping Qualities: Super 111 and Platinum are clear solutions with a slight tan or lavender color and will remain in this condition without loss of strength for years in a tightly closed glass bottle. Developers should not be stored in polyethylene plastic (squeeze type) bottles for long periods, since they may lose strength due to oxygen and carbon dioxide, which diffuse through the walls of such bottles. If Super 111 or Platinum become dark brown or black, it is a sign of serious oxidation and the developer should be discarded. Both concentrates keep well in partly full, tightly closed glass bottles because they contain so much active ingredient that the small amount of air in the bottle has practically no effect.

EDWAL T. S. T. PAPER DEVELOPER

Edwal T. S. T. (Twelve-Sixteen-Twenty) is a liquid paper developer concentrate that will handle paper development from high-volume print production to warm-tone portrait work.

Edwal T. S. T. is very highly concentrated. It has the good qualities of both metol and phenidone: good tray life, good maintenance of activity under heavy use, and constant contrast at varying temperatures. It is a normal speed, detail-delineating developer that has little tendency to "block up."

Mixing

Each T. S. T. package contains a large bottle of concentrate (Solution A) and a small bottle (Solution B). To make a standard T. S. T. working developer, one ounce Solution B is used with each eight ounces Solution A, no matter what the final dilution of the working bath may be. Dilute Solution A first and then add Solution B. Use of extra Solution B (up to 25 per cent more) gives longer tray life. Use of less Solution B gives a faster working, more contrasty developer. Solution A may be diluted and used alone, without B, for maximum contrast and speed, but should be made up fresh each day. Dilution with very hard water may cause milkiness to appear during use. If so, use Edwal Water Conditioner in dilution water.

1. **For Heavy Duty** (1:11) Pour 1 gallon T. S. T. Concentrate into 10 gallons water with continuous mixing. Then add 16 ounces Solution B and water to make 12 gallons. Mix thoroughly. For a stronger working solution (1:7) use less water to give 8 gallons total instead of 12. These strengths give cold tones and normal contrast at 2 to 3 minute developing times.

2. **Commercial** (1:15) Proceed as in paragraph 1 but make final volume 16 gallons instead of 12. Cool tones. Normal contrast. Tray life: 5 working days under light load.

3. **Portrait** (1:19) Proceed as in paragraph 1 but make final volume 20 gallons instead of 12. Cool tones. Normal contrast at full 2½ to 3 minutes development. Warmer tones and softer contrast are obtained at 1¼ to 1½ minutes development or through higher dilutions, up to 1:39 for warm-tone papers. Recommended tray life: 1 day.

4. **Small Quantities:** to make 1 gallon T. S. T. working solution:

 at 1:7 dilution — use 16 ounces Solution A and 2 ounces Solution B.
 at 1:11 dilution — use 12 ounces Solution A and 1½ ounces Solution B.
 at 1:15 dilution — use 8 ounces Solution A and 1 ounce Solution B.
 at 1:19 dilution — use 6½ ounces Solution A and 25cc Solution B.

Use the graduated measuring cup (packed in each 1-gallon T. S. T. carton) to measure Solution B.

Contrast Control

Edwal T. S. T. gives uniform contrast at all recommended dilutions and at all temperatures from 50 F to 90 F when full development (2½ minutes for enlarging papers) is used. However, when the developing time is cut down to the minimum that will give a well-developed print (1 to 1½ minutes, depending on the paper), the contrast difference between the 1:11 and the 1:15 dilution is about the same as between grade 3 and grade 2 papers. The contrast difference between the 1:15 and the 1:19 dilutions is about half the difference between grade 2 and grade 1 papers. That between the 1:7 and the 1:11 dilutions is very small.

Exposure and Working Temperature

To get identical print densities on a single grade of paper with 1:7, 1:11,

1:15, and 1:19 dilutions requires slightly more exposure (about 10 per cent) for each increased dilution. Addition of potassium bromide to T. S. T. working solution has no effect on contrast but does cause some increase in exposure needed to give the same density. Best working temperature is between 65 F and 75 F, but any temperature from 50 F to 90 F is satisfactory. Underexposed prints can often be salvaged by extending development beyond three minutes without staining.

Containers

T. S. T. Concentrate is packaged in 1-gallon plastic bottles and 5-gallon plastic carboys, which have become very popular because they do not break easily and are reusable. However, all such bottles allow gradual diffusion of air through the walls, which in time will cause loss of developer strength. Although T. S. T. can be satisfactorily stored for several months in these containers, it should not be stockpiled but should be purchased as needed and used promptly.

Precautions

Since Edwal T. S. T. Paper Developer Concentrate contains metol, persons who are allergic to this or any other photo chemicals should avoid direct contact with the solution. Irritation or rash may result. Edwal T. S. T. Paper Developer is "non-staining" in the usual sense, in that it will not stain hands or equipment in normal use. It will, however, produce brown stains if spilled and allowed to dry. Such stains can usually be washed out with warm water and a laundry-type detergent.

Keeping Developer Tray Clean

When T. S. T. is used and then left overnight in the tray, silver will often form a black or brown deposit on the tray. This is due to silver bromide which is dissolved from the prints and then gradually reduced, depositing silver as the developer stands. This does no harm, and the tray can be easily cleaned by switching trays between developer and fixer when a new fixer bath is made. If the developer is pushed hard the first day, some of this silver may be formed fast enough to cause an appearance of "milkiness." If this happens, it does not indicate that the developer is exhausted. The "milkiness" does no harm and will settle out overnight.

ETHOL TEC COMPENSATING DEVELOPER

TEC is a compensating developer, offering maximum shadow detail, economy, developing control, and acutance. TEC is panthermic and may safely be used at temperatures from 60 to 80 F.

TEC is available as a liquid concentrate in a package of three one-ounce bottles and also in a four-ounce bottle. For use it is diluted 1 part developer to 15 parts water; use once and discard. It is recommended that a temperature range of 70–75 F be used. TEC is also available in a two-solution powder form. Dissolve can A in ½ gallon of water and can B in ½ gallon of water. For use: Take 1 part A, 1 part B, and 14 parts water, use once and discard.

Two-bath development may be used as an alternate method of processing with the two-solution TEC. To use this method, prepare "stock" A and B solutions in the usual way. Use two containers for developing. (Plastic two-quart juice containers with lids are excellent). Fill one with the A solution, the other with the B solution; adjust temperatures to 75 F. Place film reels into A and then into B, for the recommended times, *without any rinse between.* Follow with water rinse and rapid fixer.

Note: For economy and negative control: A is the developing agent, which will help control your density. B is the activator for controlling contrast. Times may be changed in A or B or both, in order to achieve the desired control. If you desire to develop by inspection, start your inspection as you are ready to remove the film from the A bath.

The recommended E.I. (Exposure Index) listed may be above or below that listed by the film manufacturer but is said by Ethol to be the best exposure index to arrive at the optimum negative with proper development in TEC.

Water quality is important for quality processing. It should be as pure as possible. If your water supply is not free of minerals and foreign matter, the use of bottled or distilled water is recommended.

If possible, do not pour solutions in and out of daylight loading tanks. Preferably, fill the tank with developer, and, in the dark, drop the loaded reel into it. Following development, lift the reel out, into the next solution. This contributes to more accurate timing and more uniform development of the negatives.

TEC is *not* a fine-grain developer for high-speed films. Although high-speed films will achieve maximum definition when developed in TEC, they will have more grain than if developed in a fine-grain developer. There is no film speed loss to high-speed films when developed in TEC; *i.e.,* Tri-X 35mm exposed at ASA 50 to ASA 2400 on the same strip of film renders printable negatives from each frame.

Cleanliness is a must. TEC, as well as other film developers can be contaminated by foreign matter. Tanks and reels should be cleaned periodically: a tooth-brush makes an excellent tool for cleaning reels. Always dry tanks and reels immediately after use, with a clean, lint-free towel.

Storage: TEC will keep almost indefinitely in its original sealed container. After opening a bottle and using part, it is recommended the remainder be placed in small, full bottles, or used within a period of three weeks. For maximum life, opened bottles should be stored in the cooling chamber of the refrigerator. Tests indicate a life beyond six months when stored in this manner. *Do not use if developer has turned brown or reddish brown.*

Longer life can be expected from two-solution TEC, because of the separation of chemicals.

Agitation: For 35mm and 120 roll films, tanks that can be inverted during agitation are preferred. Immediately after immersing films, agitate for the first 15 seconds, then agitate 5 seconds at the end of each 30 seconds. Our method is three gentle inversions during the 5 seconds, with a gentle rotation of the tank followed by putting the tank down with a gentle tap at the end of each interval to dislodge any air bubbles that may have formed. Where very deep roll-film tanks are used, it is suggested reels be placed on a long wire and agitation carried out by a gentle lifting and turning of the reel during the agitation periods. Do not lift out of the solution.

For agitation of sheet film in hangers, agitate during the first 15 seconds, then follow with agitation 5 seconds each 30 seconds thereafter. Hangers should be placed in the tank as a group, tapping the hanger bars on the top of the tank to dislodge any air bells. After the agitation period, lift hangers clear of the solution, drain 1—2 seconds from each of the lower corners and replace smoothly in the tank. Repeat these cycles until development is complete. Developing in a tray or dish, with constant agitation, will reduce developing time by approximately 20 per cent.

Short stop: A short stop is *not* recommended except in cases where the temperature exceeds 75 F. If temperatures over 75 F are encountered, a hardening stop bath is advised. Use one teaspoon sodium bisulfite and one teaspoon potassium chrome alum per quart of water. Use once and discard. In lieu of the short stop, a brief water rinse of 20—30 seconds may be used, if desired.

Fixing: Use a rapid hardening fixer. Fix for twice the clearing time. Thick emulsion or high-speed films will require about 1/3 longer to fix than the slower, thin-emulsion films. Do not overfix—delicate half-tones will be destroyed and grain clumping will result. If your fixer is not fresh, fogged or stained film may be expected.

Washing and Drying: Follow the wash with a brief 30- to 60-second immersion in a good wetting agent; use three or four drops to a quart of distilled water. Tap water is not recommended. Remove film from reel and hang by the end. Soak a viscose sponge in the wetting solution, squeeze out, and wipe down film, one side at a time. Allow film to dry in a dust-free area and at a temperature not in excess of five degrees higher than the final bath. Use no heat or fan.

Time-Temperature Table for Ethol TEC Developer will be found on the following page.

TIME-TEMPERATURE TABLE FOR ETHOL TEC DEVELOPER

Exposure Index Used for Dilution Discard Method		35mm FILMS	Developing Time in Minutes for Dilution Discard Method				Exposure Index Used for Two-Solution Method		Time in Minutes for Two-Solution Method at 75 F	
Day-light	Tung-sten		65F	70F	75F	80F	Day	Tung	A	B
1000	800	Kodak Tri-X Pan	16	12	9½	7¼	1200	1000	4	3
400	320	Kodak Plus-X Pan (new)	15	12	9¾	7¾	500	400	3	3
80	64	Kodak Panatomic-X	6¼	5½	4¾	4½	80	64	1½	1
8	6	Kodak High Contrast Copy (diluted 1:30)	5¼	5	4¾	4½	8	6	3¾	#
80	80	Kodak Photomicro-graphy Monochrome Film SO-410 (diluted 1:30)	—	7	—	—	*—	—	—	—
1000	800	Ilford HP-4	16½	15	13¾	12½	*—	—	—	—
320	250	Ilford FP-4	11¼	10	8¾	7¾	320	250	3½	3½
64	50	Ilford Pan-F	7½	6½	5½	4¾	100	80	2¼	2
1000	800	Fuji Neopan SSS	24	21	18¼	16	*—	—	—	—
160	125	Adox KB-17	14¾	13	11½	10	125	100	4	3
64	40	Adox KB-14	11¼	8	5¾	3¾	64	40	2¾	2½
80	64	VTE Pan (diluted 1:30)	—	10	—	9	*—	—	—	—
25	20	VTE Ultra Pan (diluted 1:45)	23½	20	17	14½	*—	—	—	—
		120 ROLL FILMS								
800	800	Kodak Tri-X Pan	15	13	11	9½	640	640	4	3
400	320	Kodak Tri-X Pan Prof	17	14½	11½	9½	400	320	2½	2
320	250	Kodak Plus-X Pan Prof (new)	11	9	7¼	6	*—	—	—	—
80	64	Kodak Panatomic-X	7¾	6	4¾	3¾	100	80	2¼	2¾
1000	800	Ilford HP-4	23	18½	14½	12¼	*—	—	—	—
250	200	Ilford FP-4	7½	6½	5¾	5	*—	—	—	—
1000	800	Fuji Neopan SSS	32	26	21½	17½	*—	—	—	—
800	640	Fuji Neopan SSS	26½	22	18¾	15¾	*—	—	—	—
125	100	Adox RB-17	11	9¾	8¾	8	100	80	3	2½
80	64	Adox RB-14	11¼	9¼	7½	6	80	64	3	3
		SHEET FILMS								
400	400	Kodak Tri-X Pan	11	9¾	8½	7½	320	320	2	2
200	160	Kodak Plus-X	9	8	7	6¼	200	160	3	2½
100	80	Kodak Ektapan	16¾	14¼	12	10¼	*—	—	—	—
500	400	Agfapan 400	27½	21½	16¾	13¾	*—	—	—	—
25	20	Agfapan 25	11¾	10	8¾	7½	*—	—	—	—

*Data not available at this time.
NOTE: The liquid ready-mix TEC is diluted 1:15 for use. The 2-solution TEC, as per instructions under General Information. Shake "A" and "B" stock solution before use. The above tables apply to all TEC packings.
#Omit "B" solution unless you wish to obtain added contrast.

ETHOL UFG DEVELOPER (Ultra-Fine Grain)

This developer, when used as instructed, produces negatives of very high acutance, normal contrast, and extreme latitude with all types of films, ranging in size from the subminiature Minox film to the 8″ x 10″ sheet film. Tri-X 35mm exposed at ASA 50–3200 on the same strip of film renders quality prints from each frame, when developed in UFG (three stops underexposed and three stops overexposed). As indicated, UFG adapts itself to contrast control of the negatives, according to the brightness range of the lighting and subject matter. For very contrasty subjects, increase exposure and decrease the development; for flatly lighted subjects, decrease the exposure and increase the developing time. Additional compensation in negative development is obtained by diluting UFG and using as a "one-time" developer; a replenisher is available for repeated or deep-tank use of the "stock" developer. Both UFG and the replenisher, when fresh, reveal a characteristic pale, yellow-brown color, approximately the color of weak tea; this is normal and is not an indication of oxidation. UFG and its replenisher is supplied, both in powder form and in liquid "ready-mix." UFG is panthermic and may be safely used at temperatures from 60 to 90 F; preference is limited to the range of 65–80 F.

Water quality is important for quality UFG processing; it should be as pure as possible for longest "stock life." If your water supply is not free of minerals and foreign matter, the use of boiled or distilled water is recommended. If you feel that contamination is not your problem and you are having some difficulty with the life of your developer, the answer may be the water.

If possible do not pour solutions in and out of the daylight load tanks; preferably fill the tank with developer first and in the dark, drop the loaded reel into it. Following development, lift reel out, into the next solution instead of pouring in and out; this contributes to more accurate timing and more uniform developing of the negatives.

Note: Tri-X Pan has been assigned the exposure index of 1000 and 500; developing times have been given for each rating. It is suggested the exposure index of 500 be used when the subject brightness is very contrasty or where the additional speed is not required; the negative quality at both exposure indexes 1000 and 500 is very comparable.

Storage: If UFG is stored properly, in full or covered containers, away from excessive heat, it will last well over a year. It is suggested, where possible, to store the developer in the cooling chamber of the refrigerator, for maximum life; allow it to reach proper temperature before use. Filled sheet film tanks should have floating lids or be covered tightly with plastic wrap.

Replenishment: Although development may be carried out in UFG without replenishment, it is not generally recommended. If you are developing in this manner, then add ten per cent to the developing time after your second roll and limit to 25 rolls per quart. Replenishment is definitely recommended, if UFG is not used with the "dilution and discard" method. The average rate of replenishment is at the rate of ½ ounce per 80 square inches of developed film; this means (1) roll of 120 or 35mm, 36-exposure, (4) sheets of 4″ x 5″ or (1) 8″ x 10″. Add the replenisher to the "stock" after each batch of film and stir well. Replenisher may be added, until the amount of replenisher added equals the amount of the original "stock" UFG. Properly replenished it will develop at least 60 rolls of film per quart. Replenishment is affected by types of emulsions, storage conditions, overexposures, contamination, and so on.

Dilution: Where longer developing times are desirable or greater contrast control is needed, then dilution is definitely recommended; discard immediately after one-time use. Certain films are listed for both full strength or diluted UFG development; dilution has been indicated for one or more of the following reasons: time control, finer grain, contrast control, higher acutance, or increased effective film speeds. *Never* dilute UFG "stock" that has had replenisher added to it. Constant agitation is used with diluted UFG to prevent the gradation from becoming too soft. (Remember that exposure controls density, development controls contrast). As a guide for developing films by a dilution of 1:5, where it is not indicated, it is recommended normal times be multiplied by approximately 2½ times and constant agitation used. For those who wish to develop for longer times, but do not wish to dilute, then add (1) ounce of sodium bisulfite per gallon of developer and triple the development times shown in the chart. If you wish to replenish this solution, then add (2) ounces of sodium bisulfite per gallon of replenisher. Note: Using the sodium bisulfite makes UFG reusable and is not in the category of a one-time use developer as when dilution is used. The sodium bisulfite does not affect quality, but care must be exercised where film speed is important, since the speed will be affected slightly.

Agitation: For 35mm and 120 roll films, tanks are preferred that can be inverted during agitation. Immediately after immersing films, agitate for the first 15 seconds; thereafter, agitate 5 seconds at the end of each 30 seconds. Our method is (3) gentle inversions during the 5 seconds every 30 seconds, followed by putting the tank down with a gentle tap at the end of each 5-second inversion period, to dislocate any air bubbles that may have formed. If multiple reel tank is used for the development of one roll, insert empty reels to prevent too violent agitation by the reel shooting the length of the tank with each inversion. Where very deep roll-film developing tanks are used, it is suggested reels be placed on a long wire and agitation carried out by a gentle lifting and turning of the reels during the agitation periods; do not lift out of the solution.

For agitation of sheet film in hangers, agitate during the first 15 seconds, then follow with agitation 5 seconds each 30 seconds thereafter. Hangers should be placed in the tank as a group, tapping the hanger bars on the top of the tank to dislodge any air bells. After the agitation period, lift hangers clear of the solution, drain 1–2 seconds from each corner and replace smoothly into the tank; repeat these cycles until development is complete. Developing in a tray or dish, with constant agitation, will reduce developing time by 20 per cent.

Short Stop: A short stop is not recommended except in cases where the temperature exceeds 80 F. If temperatures over 80 F are encountered, a hardening stop bath is advised; use one teaspoon of sodium bisulfite and one teaspoon of potassium chrome alum per quart of water. Use once and discard.

Fixing Film: Use a rapid hardening fixer. Fix for twice the clearing time. Thick-emulsion or high-speed films will require about ⅓ longer to fix than the slower thin-emulsion films; do not overfix—delicate half-tones will be destroyed. If your fixer is not fresh, fogged or stained films may be expected.

Washing & Drying: Follow the wash with a brief 30–60-second immersion in a good wetting agent; remove film from reel and hang up by the end. Soak a photo sponge in the wetting solution, squeeze out, and wipe down film one side at a time. Allow film to dry in an area free from dust and at a temperature, as close as possible to the processing temperature; use no heat or fan.

TIME-TEMPERATURE TABLE FOR ETHOL UFG (35mm & ROLL FILM)

The exposure index indicated in the following chart may or may not be the same as the ASA given by the manufacturer of the film but is that determined by Ethol Chemicals, Inc. to produce the optimum negative with proper development in UFG.

Exposure Index Day	Tung	Film	Normal Developing Time 65F	70F	75F	80F
		35mm FILMS				
—	4000	Kodak 2475 (gamma .70)	12½	10½	8¾	7½
—	6000	Kodak 2475 (gamma 1.00)	18½	16½	14½	13
—	3200	Kodak 2484 (gamma .70)	11¼	9¾	8½	7¼
—	5000	Kodak 2484 (gamma 1.00)	17¾	14½	11½	9¾
1200	1000	Kodak Tri-X	7	5¼	4	3
650	500	Kodak Tri-X	4	3½	3	2¾
400	400	Kodak Tri-X	3½	3	2¾	2¼
—	2000	**Kodak Tri-X	—	7½	—	—
—	4000	**Kodak Tri-X	—	9½	—	—
320	250	Kodak Plus-X Pan (new)	4¾	4	3½	3
80	64	Kodak Panatomic-X	3¼	2	1¼	—
320	250	Ilford FP-4	4¼	3½	2¾	2½
1000	800	Ilford HP-4	6¼	5¼	4½	3¾
80	64	Ilford Pan F	3	2¼	—	—
40	32	Adox KB-14	1¾	1½	1¼	1
100	80	Adox KB-17	2½	2	1¾	1¼
160	125	Adox KB-21	4	3¼	2¼	1¾
800	640	Fuji Neopan SSS	8½	7	6	5
		**These are "push-processing indexes" only.				
		120 ROLL FILMS				
1200	1000	Kodak Tri-X	6½	5¼	4¼	3½
650	500	Kodak Tri-X	4¾	4	3½	2¾
400	400	Kodak Tri-X	4¼	3½	3	2½
800	650	Kodak Tri-X Pan Prof.	7	5	3½	2½
320	250	Kodak Plus-X Pan Prof. (new)	6¾	5	3¾	2¾
125	125	Kodak Plus-X Pan Prof. (new)	2¾	2¼	2	1½
160	125	Kodak Verichrome Pan	3	2½	2¼	1¾
80	64	Kodak Panatomic-X	6¼	4½	3¼	2½
—	1600	Kodak Royal-X Pan Impr.	11	8	5¾	4
200	160	Ilford FP-4	4½	3½	2¾	2
1600	1200	Ilford HP-4	5¾	4¾	2¾	2¼
160	125	Agfapan ISS	2½	2¼	2	1¾
40	32	Adox R-14	1¾	1½	1¼	¾
100	80	Adox R-17	2½	2	1½	1¼
200	160	Adox R-21	3	2½	2	1¾
1000	800	Fuji Neopan SSS (optimum)	11¼	9	7¼	5¾
800	640	Fuji Neopan SSS	8¾	7	5½	4½
500	400	Fuji Neopan SSS	5¾	5	4¼	3¾

Development table for Ethol UFG with sheet films and a note on electronic flash will be found on the next page.

TIME-TEMPERATURE TABLE FOR ETHOL UFG (SHEET FILM)

Sheet films always require longer development times than do roll and 35mm film for equal exposure indexes.

Use table below for processing times and exposure indexes.

Exposure Index		Film	Normal Developing Time			
Day	Tung		65F	70F	75F	80F
500	400	Kodak Tri-X (Estar Base)	3¾	3¼	2½	2
200	160	Kodak Plus-X	4¼	3¼	2¾	2
200	160	Kodak Super-XX	9¼	7¼	5¾	4¾
100	80	Kodak Ektapan	7	5¾	4½	3¾
1250	1000	Kodak Royal-X Pan Impr. 4166	13	11	9¼	8
400	400	Kodak Royal Pan	5¼	4	3¼	2½
400	320	Kodak Super Panchro Press Type B	7	5¼	4¼	3¼
64	32	Kodak Commercial Ortho	4½	3¾	3	2½
—	20	Kodak Prof. Copy 4125	—	4	—	—
32	25	Agfapan 25	7¾	6¾	5¾	5
100	80	Agfapan 100	6¾	5½	4¾	3½
250	200	Agfapan 200	9¾	8½	7¼	6¼
400	320	Agfapan 400	9½	7¾	6½	5¼
160	125	Ilford FP-4	7¼	5½	4	3
400	320	Ilford HP-4	8¾	7	5½	4½

Electronic Flash

Negatives exposed by electronic flash units having a duration shorter than 1/2000 second will require from 25 per cent to 50 per cent increase in developing time. Most of the popular flash units do not fall in this category, and developing times will remain unchanged.

General

The exposure indexes and developing times recommended in the above charts are based on tests conducted in the laboratories of Ethol Chemicals, Inc. A small tolerance must be allowed to compensate for the many variables involved, *i. e.,* thermometers, water supply, exposure meters, agitation, and shutter speeds. If any questions or problems arise, please write the Technical Department, Ethol Chemicals, Inc.

ETHOL BLUE DEVELOPER

Ethol Blue is highly concentrated for the dilution and one-time-use method of processing. It is panthermic and may be safely used at temperatures from 65 to 90 F; preference is limited to the range of 65 to 80 F.

Ethol Blue is available in a one-pint and a 4-ounce liquid concentrate. It is normally diluted 1:30 for use, but for extended processing control or for special applications, it may be diluted upwards to 1:120.

The recommended Exposure Index listed here may be considerably above that listed by the film manufacturer, but has been determined by Ethol, Inc. to be the best exposure index for a negative of optimum quality with proper development in Ethol Blue.

Because Ethol Blue has such great latitude, it is possible to use more than one index for certain films. Where this is the case, the asterisk (*) will indicate the optimum index for that film.

If possible, do not pour solutions in and out of daylight-loading tanks. Preferably, fill the tank with developer and, in the dark, drop the loaded reel into it. Following development, lift the reel out, into the next solution. This contributes to more accurate timing and more uniform development of the negatives.

Dilution: Where longer developing times are desirable or greater contrast control is needed, then extended dilution upwards to 1:120 is suggested; discard immediately after one-time use. Do not be alarmed if any crystallization occurs in the stock developer. Simply place the bottle in hot water and shake occasionally until crystals dissolve.

Storage: Ethol Blue has extremely long shelf life in its stock solution form. Do not dilute stock until ready to use. Simply store bottle at room temperature. Do not refrigerate. Ethol Blue will last well over one year if kept tightly stoppered in its original bottle. Occasionally the stock solution will darken to a brown or a black color. This is due to peculiarities in certain raw materials and does not indicate that the developer is exhausted. Continue to use as recommended.

Agitation: For 35mm and 120 roll films, tanks that can be inverted during agitation are preferred. Immediately after immersing the films, agitate for the first 15 seconds, then agitate 5 seconds at the end of each 30 seconds. One method is three gentle inversions with a gentle rotation during the 5 seconds every 30 seconds, followed by putting the tank down with a gentle tap at the end of each 5-second agitation period, to dislodge any air bubbles that may have formed. This method of agitation is advised for even development of the films, and consistently reproducible results. If you are getting consistent negatives, but the developing times in the tables are too short for your purposes, then do not change your agitation, but instead change the developing times based upon your dilution or the need for more or less contrast. Where deep roll film tanks are used, it is suggested reels be placed on a long wire and the agitation be carried out by a gentle lifting and turning of the reels during the agitation periods. Do not lift reels out of the solution.

Temperature: The importance of accurate temperature uniformity throughout the developing procedure cannot be overemphasized. Inaccuracies in thermometers are very common, and can play havoc with negative contrast. Check your thermometer often. Keep developer, fix, wash and drying at the same temperature. Avoid high temperature processing of high speed films, if possible; chemical fog may result.

Time and Temperature Table. Photography is not an exact science, and variables are encountered with each photographer and his equipment. The following tables are furnished as a guide; a starting point so that you may achieve the optimum

negative quality. Using a double condenser enlarger, you should get optimum print quality with the Exposure Indices given in the table when the negatives are developed as instructed. Negatives that are to be enlarged with a semi-diffusion or diffusion type of enlarger will require about 20 to 30 per cent longer developing times respectively, as they require a negative to be developed to a higher contrast index for ease of printing. There is no single correct developing time to give optimum results under all conditions.

DEVELOPING TIME TABLE FOR ETHOL BLUE DEVELOPER

Exposure Index			Dilution	Normal Developing Time			
Day	Tung			65F	70F	75F	80F
		35mm FILMS					
2400	2000	Kodak 2475	1:30	12¾	10	8	6¼
2400	2000	Kodak Tri-X	1:30	8¼	6¾	5½	4½
2000	1600	*Kodak Tri-X	1:30	7¾	6	4¾	3¾
1600	1250	Kodak Tri-X	1:30	7½	5¼	3¾	2¾
400	400	Kodak Tri-X	1:60	6	5½	5	4¾
400	320	Kodak Plus-X (new)	1:30	3¾	3	2½	2¼
400	320	Kodak Plus-X (new)	1:60	6	5	4¼	3½
125	100	Kodak Panatomic-X	1:60	7	5½	4¼	3¼
64	50	*Kodak Panatomic-X	1:60	4½	3½	3	2½
80	64	Kodak Panatomic-X	1:120	8	7	6	5¼
10	8	Kodak High Contrast Copy	1:120	—	6	—	—
320	250	Ilford FP-4	1:30	3¾	3	2½	2
320	250	Ilford FP-4	1:60	7	6	5	4¼
1600	1200	Ilford HP-4	1:30	11	8	5½	4
1200	1000	*Ilford HP-4	1:30	8¼	6½	5	3¾
80	64	Ilford Pan-F	1:60	5¼	4½	3¾	3¼
1200	1000	*Fuji Neopan SSS	1:30	9½	7½	6	4¾
640	500	Fuji Neopan SSS	1:30	6¼	5	4	3
250	200	Lumipan	1:60	—	5¼	—	—
800	640	Imperiale S Pan	1:30	—	5	—	—
32	25	VTE Pan	1:90	6¼	5½	4¾	4¼
		120 FILMS					
1000	800	*Kodak Tri-X	1:30	5¾	4½	3¾	3
1600	1200	Kodak Tri-X	1:30	6¼	5	4	3¼
32	25	Kodak Panatomic-X	1:60	4¼	3¼	2¾	2
200	160	Kodak Verichrome Pan	1:60	6½	5	3¾	3
320	250	Kodak Plus-X Prof. (new)	1:30	4½	3½	2¾	2¼
320	250	*Kodak Plus-X Prof. (new)	1:60	8¼	6½	5	4
125	125	Kodak Plus-X Prof. (new)	1:60	5	4	3¼	2¾
1200	1000	Kodak Royal-X Pan Impr.	1:30	9	7¼	5¾	4¾
800	640	Fuji Neopan SSS	1:30	9¼	6½	4¾	3½
160	125	Ilford FP-4	1:30	3	2½	2¼	1¾
1000	800	Ilford HP-4	1:30	7¼	6	5	4
		SHEET FILMS					
500	400	Kodak Tri-X Pan Prof.	1:30	6¾	5½	4¼	3½
160	125	Kodak Plus-X Pan Prof.	1:60	7¾	7	6¼	5¾
2000	1600	Kodak Royal-X Pan Impr.	1:30	12	9¾	8	6½
640	500	Kodak Royal Pan	1:30	7¼	6	5	4¼
125	100	Kodak Ektapan	1:60	8½	6¾	5¼	4
200	160	Ilford FP-4	1:60	7¾	6¾	6	5
500	400	Ilford HP-4	1:30	7	6	5	4¼

*Optimum Exposure Index; see page 285

ETHOL LPD PAPER DEVELOPER

LPD is a neutral tone, long-scale, normal-contrast paper developer, which may be used in the usual dilute-discard method or may be replenished for extended life.

LPD offers great print capacity, *i.e.*, a tray of ½ gallon of working solution will process a minimum of 360 8" x 10" single-weight prints, when properly replenished. Uniform quality and tone is maintained throughout the useful life of the developer. No longer is it necessary to throw out good developer just because a few prints had been run in it. Simply replenish per the simple directions.

LPD does not stain and irritate the skin, as is characteristic of so many other developers. Most developers contain Metol, which is a toxic developing agent. LPD contains phenidone. This developing agent is nontoxic and has made it possible for many photographers to return to the lab without fear of skin problems.

LPD contains hydroquinone, which is a regenerating chemical that acts very rapidly on the phenidone. When LPD is used as directed, full strength of the solution is maintained until all the working and replenishment solution has been used.

LPD may be used with all types of printing papers. Tones may be varied from the very cold to very warm, just by selection of the paper and the dilution of the "stock" developer. It may also be used for lantern slides, press negatives, and microfilms.

Mixing: LPD is a single-mix powder, which dissolves easily in tap water at 80–100 F. The contents of the can should be dissolved in ¾ the final volume of water, and then cold water added to bring the solution up to the indicated amount. This becomes the stock solution. When diluting the developer, be sure to stir well to obtain a more uniform solution. LPD Liquid Concentrate in one-quart and five-gallon sizes are also available and should be mixed as per directions on the container.

Normal Use: To make a working solution, dilute the stock solution 1:2 with water and develop the prints for 1½–2 minutes at 70 F. This dilution will produce a neutral tone.

Tone Control: LPD offers the ability of print tone control. Where most developers change in contrast as they are diluted, LPD maintains a uniform contrast but changes tone, *i.e.*, a dilution of 1:4 produces warm tones; 1:2 neutral tones; and 1:1, or full strength, produces the colder tones.

Very wide tone latitude is obtained by the choice of paper, coupled with the appropriate dilution of the developer. Fast bromide papers will give a very blue-black tone, whereas the chloro-bromide papers would naturally produce warmer tones. Prints should be exposed sufficiently to give good blacks. LPD does not sacrifice emulsion speed, so the normal exposure should be correct.

Short Stop and Fix: Even though LPD has a minimum tendency to stain, it is advisable to use a short stop. Any regular stop bath may be used and any of the fixers; however, if a rapid fix is used, care should be taken not to leave the prints in too long, or bleaching will result and tones will be sacrificed.

Replenishment: To use LPD Paper Developer on a continuously replenished basis, mix both replenisher and working developer from a single can of powdered LPD as follows. First (using the 1-gallon size as an example) mix the contents of

287

one can of LPD with enough water to make a gallon, in a 1-gallon bottle. Then, when it is thoroughly mixed, pour one-third of the stock solution into another 1-gallon bottle. Fill both bottles with water, and stir well. The first bottle, containing 2/3 of the original stock solution, is now the replenisher; the second bottle, containing 1/3 stock and 2/3 water, is the working bath.

When printing, using one quart of working solution in a tray, after developing fifteen 8" × 10" prints, add 5 ounces of replenisher. If using a ½-gallon tray, replenish with 10 ounces of replenisher after developing thirty 8" × 10" prints. If using a 1-gallon tray, develop 60 prints, then add 20 ounces of replenisher.

After finishing a printing session, pour the remaining developer from the tray into the working-solution bottle, then add enough replenisher to fill the bottle to the neck again.

When all the replenisher has been used, discard the working solution, and mix fresh developer and replenisher.

For those wanting softer prints, the solution is made on a 1:4 basis, and is done as follows. Make the original stock solution as before in a 1-gallon bottle. Then remove 1/5 of this to another bottle and fill with water; this is your 1:4 working solution. Take the remaining solution and pour half of it into each of two 1-gallon bottles, and fill each with water; these two bottles are now your replenisher for the diluted working bath. Follow the same replenishment routine as above, and discard the working solution when the replenisher is all used up.

MAY & BAKER PROMICROL DEVELOPER

Films to be developed in Promicrol can generally be exposed at emulsion speeds higher than those claimed by the manufacturers. This increase in speed is dependent upon the emulsion and technique and is best determined by experience, but twice the manufacturer's rating may be adopted as a basis. The graininess and definition of the negatives will be improved if exposures are kept to a minimum.

Development using Standard Strength Promicrol

In order to provide a guide to the user in determining the development times which will best suit his own particular method of working, times are given for three different levels of contrast. The "best" development time will depend upon many factors of which the subject brightness range, the camera, lens flare, and the characteristics of the enlarger are the most important.

It is suggested that as a basis for initial trial the figure quoted under "medium" contrast should be used; this can then be modified if experience shows it to be necessary.

Development Conditions

Consistent results will only be obtained if consistent processing temperatures and methods of agitation are employed. For this reason the particular processing conditions used for the determination of the listed development times are given below.

Roll and 35mm Films. The development times were determined using standard strength Promicrol Developer at 20 C (68 F) and employing moderate agitation, i. e., 20 seconds on immersion or four inversions, then 10 seconds or two inversions every minute.

When processing roll and 35mm films in deep tanks it is necessary to increase the development times by 10 to 15 per cent, to compensate for the less efficient agitation.

Sheet Films and Plates. The development times were determined using standard strength Promicrol Developer at 20 C (68 F) and employing moderate agitation, i. e., 20 seconds on immersion, then 10 seconds agitation of the film, or film rack, every minute.

Development Times

The times listed in the following tables should be regarded as a guide and can be modified to suit individual techniques and requirements.

If films have not been exposed at an increased speed rating, development times should not be reduced; normal development will simply produce a slightly more dense negative than is necessary, although a slight increase in graininess may be observed.

Replenishment

A replenisher is available for use with standard strength Promicrol and the method of employment is discussed fully in the technical information leaflet dealing with Deep Tank Processing, available from Messrs. May & Baker, Ltd.

One-Shot Development Technique

This technique is recommended for the processing of roll and miniature films in small spiral tanks.

Among the advantages of using fresh solution for each film, and discarding it after use are, consistency of results and an enhancement of the acutance (edge sharpness). But at dilutions over 1 + 4 a compromise between acutance and graininess may be necessary on some types of film. The constituents of the

DEVELOPING TIMES FOR M & B PROMICROL

Manufacturer	Emulsion Designation	Relative Contrast Soft	Medium	Hard
	35mm FILMS			
Adox	KB-14	5	9	14
	KB-17	6	11	18
	KB-21	8	11	18
Agfa-Gevaert	Isopan F	5	8	15
	Isopan ISS	5½	8½	12
	Agfapan 100 Professional	5	8	11½
	Agfapan 400 Professional	6½	9	12
	Agfapan 1000** Professional	10	12½	16
Ferrania	P-24	6	11	19
	P-30	6	8½	11
	P-33	8½	11	16
Fuji	Neopan F	4½	6½	10
	Neopan SS	7	11	16
	Neopan SSS	8	12	16
Ilford	Pan F	3½	5	6½
	FP-4	4½	6	7½
	HP-4	6	8	10
Kodak (U. S. A.)	Panatomic-X	4	5½	7½
	Plus-X Pan	4	6½	9½
	Tri-X Pan	5	6½	8
	2475 Recording Film	8	11	14
	High Speed Infrared Film	7½	12	21
Orwo	N. P. 10	3	4½	5½
	N. P. 18	4	6	8½
	N. P. 22	7	10	13
	N. P. 27	8	11	14
Perutz	17	6	10	16
	21	6½	9	12
	27	6½	8½	11
Sakura	Konipan SS	6	9½	15

**Agfapan 1000 Professional should not be processed at temperatures higher than 20C (68 F)

600ml (21 fl oz) Promicrol pack are dissolved as directed (see section *Preparation* in Promicrol direction slip). The standard strength solution is then stored in one or two bottles (i. e. 2 X 300ml bottles) and can be conveniently used as required. The unused standard strength solution will keep for about six months in a full, well sealed, glass bottle, preferably in the dark. High temperature storage should be avoided. If the bottle is only partly full the life of the solution will be decreased to a few weeks. At least 85ml (3 fl oz) of the standard strength solution is taken for each 120 roll or 36-exposure 35mm film. This quantity is diluted to the volume required for the tank being used. As the dilution increases, the development time increases and a dilution of more than 1 part of Promicrol plus 6 parts of water (7 times) is not recommended. A dilution development time nomograph is provided in the Promicrol direction slip.

It is suggested that to reduce some of the longer development times brought about by dilution, development in diluted Promicrol be carried out at 24 C (75 F). The appropriate development times in diluted Promicrol at 24 C (75 F) are shown on the right-hand side of the scale marked "C" on the nomograph in the direction slip.

Manufacturer	Emulsion Designation	Relative Contrast		
		Soft	Medium	Hard
	ROLL FILMS			
Adox	R-14	9	14	20
	R-17	9½	19	26
	R-21	5½	7	11
Agfa-Gevaert	Isopan F	6	9½	13
	Isopan ISS	7	11	14
	Agfapan 100 Professional	5	8	11½
	Agfapan 400 Professional	6½	9	12
	Agfapan 1000** Professional	10	12½	16
Ferrania	P-24	7	11	17
	P-30	5½	9½	12
	P-33	9½	13	18
Fuji	Neopan F	6	8½	12
	Neopan SS	6	9½	13
	Neopan SSS	7½	10	12
Ilford	Selochrome	6½	9	12
	FP-4	5½	7	8½
	HP-4	5	7	9
Kodak (U. S. A.)	Panatomic-X	6	8½	12
	Verichrome Pan	5½	7½	9½
	Tri-X Pan	6	8	10
	Royal-X Pan*	8	11	15
Orwo	N. P. 10	3	4½	6
	N. P. 18	5	7½	10
	N. P. 22	9	13	16
	N. P. 27	9	11	14
Sakura	Konipan SS	6	9	13
Perutz	17	6½	10	20
	21	5½	7½	10
	27	6	10	15

*It is essential to use an acid stop-bath to prevent dichroic fog.
**Agfapan 1000 Professional should not be processed at temperatures higher than 20C (68F)

Use of Stop-Bath

When the film is developed it is advisable to employ a stop-bath even when working at normal temperatures. A rinse in running water is usually adequate before fixation but, especially where high temperatures are concerned or consistent results are important, a stop-bath is recommended. This prevents the fixer life being shortened by the addition of developer and also stops development immediately the film is immersed. The stop-bath formula recommended is as described in the direction slip. After development, films should be immersed in this solution for twenty to thirty seconds before transference to the fixer. The stop-bath should be replaced before it becomes alkaline.

Fixation

It is important to use an efficient fixing solution such as Amfix. Hardener S Type is available for addition to Amfix where required. This hardener helps to prevent damage to the emulsion and to shorten the drying time. Immersion of films in the fixer should be long enough to ensure that fixation is complete and

Manufacturer	Emulsion Designation	Relative Contrast		
		Soft	Medium	Hard
	SHEET FILMS			
Ilford	Commercial Ortho	16	20	†
	FP-4	4½	6½	9½
	HP-4	7½	10	12
Kodak Ltd. (England)	Plus-X Pan Professional	6	9	11
	Tri-X Pan Professional	6½	11	15
	Panchro-Royal	6	10	16
	Royal-X Pan*	10	13	16
Kodak (U. S. A.)	Ektapan 4162	5	8	10½
	Royal Pan 4141	7	11	16
	High Speed Infrared 4143	9½	16½	†
	PLATES			
Ilford	Selochrome	13	19	27
	R10 Soft Gradation Pan	10	17	†
	FP-4	8	12	18
	HP-3	7	11	15

*It is essential to use an acid stop-bath to prevent dichroic fog.
†This emulsion does not reach a high enough contrast in a reasonable time.

that hardening has been effective. It is also a wise precaution to standardize the temperature throughout the series of three solutions, developer, stop-bath, and fixer; and also to the wash water, although some leeway may be allowed here. The recommended fixing times of films and papers are given in the Amfix direction slip and technical information leaflet.

FR X-22 COMPENSATING DEVELOPER

X-22 is a compensating developer for use with high-resolution, thin-emulsion, fine-grain films. It is designed to bring out the maximum of shadow detail without blocking up highlights. The middle tones are affected linearly so that resulting negatives possess full-scale gradation. In addition, X-22 allows increased speed ratings.

The ASA exposure index range listed opposite each film will serve as a guide for the proper exposure of that particular film.

Table 1 — Film Types

	Type 1	Type 2	Type 3
Adox	KB 14—32	KB 17—64 to 80	KB 21—160
Ilford	Pan F—50	———	———
Kodak	———	Panatomic X— 40 to 64	Plus X—160

X-22 is diluted according to the contrast of the film, as indicated in Table 2.

Table 2 — Rate of Dilution

Film	Dilution
Type 1 — High-contrast Film	Add contents of bottle to 19 ounces water
Type 2 — Medium-contrast Film	Add contents of bottle to 15 punces water
Type 3 — KB-21 Film	Add contents of bottle to 9 ounces water
Type 3 — Plus-X Film *	Add contents of bottle to 15 ounces water

*Process for times listed under Type One films in Table 3.

The contents of each bottle are sufficient to develop two rolls of film, both at one time, or one immediately after the other. Developer is then discarded. Where the volume of diluted solution is greater than the tank capacity, a small excess may be discarded. Thus, two rolls of Type 1 film may be developed in the FR Special Roll Film Tank, using the double flange accessory in 16 ounces of solution. For smaller size tanks, use no less than 8 ounces of solution per roll and develop for the longer developing times as listed under "2 Rolls Together." The table below gives developing times for different gammas. Note that the developer is so precisely balanced that two films take slightly longer to develop than one alone.

Table 3

Film	Gamma	First Roll	Second Roll	Two Rolls Together
TYPE 1	0.5	9 minutes	12 minutes	10½ minutes
High Contrast	0.6	11	14	12½
	0.7	13	16	14½
TYPE 2	0.5	8 minutes	10 minutes	9 minutes
Medium Contrast	0.6	10	12	11
	0.7	12	14	13
TYPE 2	0.5	6 minutes	8 minutes	7 minutes
Panatomic-X	0.6	8	10	9
	0.7	10	12	11
TYPE 3	0.5	9 minutes	12 minutes	10½ minutes
Plus-X	0.6	11	14	12½
	0.7	13	16	14½

Developing Temperature 68 F

The above times are for intermittent agitation at ten seconds each minute. For constant agitation, the times should be decreased 25 per cent.

Select a gamma value based upon the size of the enlargements planned. Enlargements (unless a diffusion enlarger is used), increase the apparent contrast of negatives and, therefore, require negative gammas lower than those suitable for contact printing.

The recommended gamma for miniature film is 0.5 to 0.6. For roll or cut film, the recommended gamma is 0.7.

For films exposed by electronic flash, the developing times should be increased 20 per cent. When a roll contains mixed shots, an increase of 10 per cent in developing time will provide a safe compromise.

FR X-44 FINE-GRAIN DEVELOPER

FR X-44 is a highly concentrated fine-grain developer designed for one-shot rapid processing of films. Formulated specifically for high- and medium-speed films, it may also be used for rapid processing of the slower (thin-emulsion) films. X-44 offers consistent uniformity of results, and produces negatives with finest grain. Contrast may be controlled by varying dilution as shown below.

X-44 allows increased speed ratings as indicated in the following tables.

Directions

Dilute contents of each bottle as follows:

Medium- and High-Speed Films

For normal contrast: Dilute concentrate to make 16 ounces of solution.

For low contrast: Dilute concentrate to make 20 ounces of solution.

Process films as directed in Table 1.

Slow-Speed (thin-emulsion) Films

For normal contrast: Dilute concentrate to make 32 ounces of solution.

For low contrast: Dilute concentrate to make 40 ounces of solution.

Process films as directed in Table 2.

The working strength solution should be used within eight hours after preparation.

Table 1

Time-Temperature-Development Chart (16 or 20 ounces of working strength solution)					
Film Speed (ASA)	Film	Developing Time (Minutes)			
		65 F	70 F	75 F	80 F
1000	Ilford HPS	6	4½	3½	2¾
800	Kodak Tri-X	4½	3¼	2½	1¾
500	Ilford HP3	4½	3¼	2½	2
160	Kodak Plus-X	3½	2½		
160	Kodak Verichrome Pan	5¼	4	3¼	2½
160	Adox KB-21	4	3	2½	2
80	Ilford FP3	2½	1¾		

Agitate films for 5 seconds every 30 seconds

Two rolls of 36-exposure 35mm, 120 roll film or equivalent may be processed in 16–20 ounces of solution with no increase in developing times. Where the volume of diluted solution is greater than the tank capacity, a small excess may be discarded. For smaller tanks use 8–10 ounces per roll of film. Discard developer after use.

(Continued on page 296)

Table 2

Time-Temperature-Development Chart (32 or 40 ounces of working strength solution)

Film Speed (ASA)	Film	Developing Time (Minutes)			
		65 F	70 F	75 F	80 F
200	Kodak Plus-X	8	6¼	4½	3¾
100	Ilford FP3	5½	4	3¼	2½
80	Adox KB-17	5	4	3	2¼
64	Kodak Panatomic-X	5½	3¾	2½	
50	Ilford Pan F	4¾	3½	3	2¼
40	Adox KB-14	4¾	3½	2¾	2

Agitate films for 5 seconds every 30 seconds

Four rolls of 36 exposure, 120 roll film or equivalent may be processed in 32–40 ounces of working strength solution. For tanks of smaller capacities, process two rolls in each 16–20 ounces of solution. Increase developing time shown above by ½ minute when processing second roll or two rolls together. Where volume of diluted solution is greater than the tank capacity, a small excess may be discarded. Discard developer after use.

FR X-TROL PROFESSIONAL CHEMICALS

X-Trol 76 Film Developer

X-Trol 76 Film Developer is a concentrated moderately fine-grain developer designed for the processing of films. X-Trol 76 is intended to produce full emulsion speed and maximum detail. Dilute one part of concentrate with four parts water. 160 square inches (2 rolls 120, or 8 sheets 4 × 5) may be processed in each 16 ounces of working solution provided the developing time is increased by 10%.

	DEVELOPING TIME (Minutes)			
	68F	70F	72F	75F
*Kodak Panatomic-X	9	8	7	6
†Kodak Ektapan	12	11	9½	8½
*Kodak Plus-X Pan	8	7	6	5
†Kodak Plus-X Pan Professional Type 4147	9	8½	8	7
†GAF Superpan Gafstar Type 2881	10	9½	9	8
*Kodak Tri-X Pan	11	10	9	8
†Kodak Tri-X Pan Professional Type 4164	11	10	9	8

*Agitation 10 seconds every 30 seconds
†Agitation 10 seconds every 60 seconds

X-Trol Tray Cleaner

X-Trol Tray Cleaner (for photographic or technical purposes only). For removing stains from photo trays, rinse tray with a small amount of solution. The stain should be removed in a few minutes. Pour out the cleaner and rinse with cold water until all traces of the orange color have disappeared.

X-Trol 72 Paper Developer

X-Trol 72 Paper Developer produces neutral and cold-tone prints. For photographic papers dilute one part stock solution with four parts water. For Kodagraph Contact and Repro-Negative papers and films for press photography dilute 3 parts concentrate with 7 parts water. Develop photographic paper ½ to 1½ minutes at 68 F. For films for press photography develop 1 to 4 minutes at 68 F.

X-Trol Warm-Tone Paper Developer

X-Trol Warm-Tone Paper Developer is a non-carbonate long-life developer specially designed to produce warm tones and minimum stain. Dilute 1 part concentrate with 4 parts water. Develop photographic papers about 2 minutes at 68 F.

X-Trol Fast Fixer

X-Trol Fast Fixer is a fast speed acid hardening fixing solution. For film dilute 1 part concentrate with 4 parts water. Fix films 3 to 5 minutes at 70 to 75 F. For paper dilute 1 part concentrate with 9 parts water. Fix papers 6 to 10 minutes at 70 to 75 F.

As solution becomes exhausted fixing times should be increased. This solution is highly concentrated and may be subject to crystallization at freezing temperatures. Redissolve by warming bottle to room temperature and shaking.

This solution minimizes image bleaching. Where minimum stain in toned prints is desired, use a non-hardening fixer, such as FR Vitafix without hardener.

X-Trol Acetic Acid, Glacial

X-Trol Acetic Acid, Glacial (99.5% minimum). To make Stop Bath, use 2 fluid ounces of Glacial Acetic Acid per gallon of water.

FR X-100 DEVELOPER

"All-purpose" developer, X-100 may be used to process all popular films exposed under varying conditions.

Due to its versatility as a developer for films exposed at normal speeds, by electronic flash, or by available light, X-100 replaces FR Negative, Electronic Flash, and X-500 developers.

Simply select, from the instruction sheet attached to the bottle, the dilution and developing time most suitable for the film to be processed. Each working strength developer prepared from X-100 concentrate will produce optimum results for the type of processing intended.

Normal Exposure—Fine-Grain Development

Expose films at manufacturer's recommended speed rating.

High-Speed Films:

Dilute one part of concentrate with four parts of water. Develop for the following times at 70 F:

GAF Super Hypan	4 to 5 minutes
Kodak Tri-X	3½ to 4½ minutes

Medium-Speed Films:

Dilute one part of concentrate with five parts of water. Develop for the following times at 70 F:

Adox KB-21	3 to 4½ minutes
Ilford FP3	3 to 4 minutes
Kodak Plus-X	3 to 4½ minutes
Kodak Verichrome Pan	4½ to 5½ minutes

For use with roll or sheet film, or where higher contrast is desired, use the maximum times listed above. Increase developing times shown above by 10 to 20 per cent when still higher contrast is desired.

Film Capacity—Replenishment

Twenty-six ounces of X-100 concentrate, diluted 1:4 or 1:5 for use, will process up to 60 rolls of film with an increase in developing time of one minute for each five rolls processed. Replenishment at the rate of ½–¾ ounce of concentrate per roll of film developed will keep developing times constant and greatly increase the life of the developer. The convenient eight-ounce size may be used as the replenisher to minimize oxidation of partially empty bottles.

Available Light

In general, with subject lighting of normal or low contrast, expose films up to five times the recommended speed ratings. Dilute concentrate as directed above and double developing times listed in instruction sheet accompanying bottle. Under conditions where subject-lighting is exceptionally soft, still higher speeds are possible. Highly directional lighting that causes pronounced highlights and deep shadows will curtail speed. Prolonged developing times, however, will not enable further increases in speed without the accompaniment of excess fog resulting in lower over-all contrast.

Electronic Flash

To process films exposed by electronic flash, dilute concentrate as recommended above. Increase developing times listed in instruction sheet by 20 per cent. When a roll contains exposures made by both day-light and electronic flash, increase developing time by 10 per cent as a compromise.

One-Time-Use Fine-Grain Processing

X-100 may be used as a "one-time-use" developer by diluting the concentrate either 1:15 for high- and medium-speed films, or 1:19 for "thin-emulsion" films. Developing times range from 8 to 12 minutes for high-speed films, 5–9 minutes for medium-speed and thin-emulsion films. For precise developing times, consult instruction sheet attached to bottle.

High & Medium Speed Films

Expose films at manufacturer's recommended speed rating. Dilute 1 part of concentrate with 15 parts of water. Develop for the following times at 70 F:

Adox KB-21	7 to 9 minutes
GAF Super Hypan	10 to 12 minutes
GAF Versapan	10 to 12 minutes
Kodak Tri-X	8 to 10 minutes
Kodak Plus-X	8 to 10 minutes
Kodak Verichrome Pan	10 to 12 minutes

Discard solution after processing one roll of film.

Thin Emulsion Films

Expose films at manufacturer's recommended speed rating. Dilute 1 part of concentrate with 19 parts of water. Develop for the following times at 70 F:

Adox KB-14	5 to 7 minutes
Adox KB-17	7 to 9 minutes
Ilford Pan F	5 to 7 minutes
Kodak Panatomic-X	5 to 7 minutes

Two rolls may be processed in each 16 to 20 ounces of working strength solution. Increase times by 10 per cent when processing second roll or two rolls together. Discard solution after use.

Developing Time–Temperature Factor

Times listed in the instruction sheet accompanying the bottle are for processing at 70 F. For each five-degree change in temperature decrease or increase developing times by 25 per cent. X-100 may be safely used at temperatures ranging from 65 to 80 F.

Time-Temperature Development Chart

Shows developing times at various temperatures corresponding to a given time at 68 F (20 C). For other times at 68 F locate the time along the 68 F line and draw through that point a line parallel to the one given. See page 194 for a more complete discussion.

Agitation

For optimum results, agitate films ten seconds per minute.

Instant Fixol

Instant Fixol may be used as a one-time-use fixing additive in conjunction with X-100, when used as a one-time-use developer, offering the convenience and uniformity of a complete one-time-use system plus reduced processing times.

FR PAPER DEVELOPER

FR Paper Developer contains a new type of developing agent that has been tested and re-tested to assure maximum results. This new agent guarantees a developer with remarkable "lasting qualities." In tray or tank, FR Paper Developer will continue to give good results long after most other paper developers are completely oxidized. Its long life enables complete capacity to be utilized, and up to 600 4" x 5" prints can be developed per gallon of working strength solution.

Diluted with four parts of water, the new FR Paper Developer makes a superior paper developer for both contact and enlarging papers. Developing times range from 1–2 minutes and prints have extra "snap" due to the blue-black tones produced by FR Paper Developer.

FR DEVELOCHROME COLOR DEVELOPER FOR PAPERS

Develochrome produces color images in papers by direct development; no toning or aftertreatment is required. The dye-coupling system is similar to that used in the development of color films and papers.

Papers must be exposed somewhat longer than normal, to two times the usual exposure. They are developed for 2–4 minutes in the color developer, prepared by mixing parts A, B, and C in 12 ounces of water at 75 F. A plain water rinse is given after development. The prints are then fixed in the Develochrome Fixer, prepared by dissolving contents of the Develochrome Fixer package in 12 ounces of water at 75 F. *Use no other fixer!* Fix for 3–5 minutes, then wash for 15 minutes. Prints may be dried in any normal manner, including ferrotyping for glossy papers.

Solutions should not be prepared until needed for use; they keep for only a short time. To avoid skin irritation, avoid contact with powders and solutions; use print tongs to handle prints in the developer.

Photographic Papers

Any enlarging or contact paper can be used with Develochrome. In general, prints will show pure and unstained whites and highlights, which hardly could be duplicated by any other toning process. The majority of papers can be used without difficulty. Particularly recommended are:

Enlarging Papers:
> Kodabromide, all grades and surfaces
> Ansco Cykora, Kashmir
> Kodak Platino G, grade 2
> Kodak Illustrator's Special *
> Kodak Opal G*
> *Requires up to ten times black-and-white exposure.

Contact Papers:
> Kodak Azo, all grades and surfaces
> Kodak Velox, all grades and surfaces
> Kodak Illustrator's Azo, all grades and surfaces
> Kodak Athena B and G
> Kodak Aristo

Special Effects with Develochrome

To Obtain Brighter Colors: All prints made in Develochrome contain some black due to the presence of silver. Brighter colored prints may be obtained by removing the silver. In order to do this, wash for five minutes after fixation and place in a bleach made as follows:

Water	16 ounces	500.0cc
Sodium Thiosulfate (Hypo)	4 ounces	120.0 grams
Potassium Ferricyanide	½ ounce	15.0 grams

By watching the prints in the bleaching solution, the elimination of black can be seen. When all, or the desired amount of black has been bleached out, wash in cool running water for 15 minutes and dry as previously recommended.

The Addition of Color to Black-and-White Prints: A black-and-white print seems brilliant and rich with the addition of an almost imperceptible amount of the proper Develochrome color. The print, after exposure, is immersed in a black-and-white developer, such as FR Paper Developer, until the image begins to appear. Then rinse in plain water and develop, wash, and fix in the Develochrome solutions.

Redeveloping Black-and-White Prints in Develochrome: Develochrome may be used as a toner to convert ordinary black-and-white prints, on any type of photographic paper, to prints of the desired color. Immerse the print in cool water for a few minutes, then place print in a solution made as follows:

Water	16 ounces	500.0cc
Potassium Bromide	½ ounce	15.0 grams
Potassium Ferricyanide	½ ounce	15.0 grams

When image is only faintly visible, wash print thoroughly in cool running water, then redevelop in the desired Develochrome color for 2–3 minutes at 75 F. Wash for 15 minutes. Fixing is not necessary. This entire process should be carried out in a lighted room.

PUSH-PROCESSING BLACK-AND-WHITE FILMS

On many occasions a photographer finds it necessary to expose film under light conditions that do not permit full exposure at the standard film speed rating. The question thus arises: Can any compensation be made in processing for a deliberate underexposure, and if so, how much compensation can be made and at what cost in loss of image quality?

To begin with, all films have some exposure latitude. Thus, the speed rating of the film can vary considerably, depending upon what standard is used. Specifically, a speed rating can be changed by an arbitrary decision to assign all the available latitude to the overexposure side, in which case a high rating will result, or to have some latitude both above and below the "correct exposure" point, in which case the speed rating will be lower. The change from the old to the new ASA speed ratings was, in fact, merely a decision to have all (or almost all) the available latitude on the side of overexposure. At present, the ASA speed rating of a black-and-white film contains a "safety factor," or underexposure latitude, of only about one-third of a lens stop.

Evidently, if the user's equipment is correctly calibrated, the reading of his exposure meter will give a camera setting that is practically the minimum safe exposure; at best, he can use one-third of a stop less, equivalent, for example, to increasing the meter setting from ASA 100 to ASA 125. Such a small gain in apparent film speed hardly seems worthwhile.

This is based, however, on the tacit assumption that shadow detail in the negative is important. If the photographer is willing to sacrifice some detail in the deepest shadows, then an exposure of half that indicated by the meter can be given, equivalent to using a meter setting of ASA 200 instead of ASA 100, ASA 400 in place of ASA 200, and so on. Now, if we examine the curve of the film below, we find that we have moved the exposure to the left, and the highest light has dropped in density from C to D. The negative, exposed at a higher rating, will be much thinner than a normally exposed one.

If, though, we develop this negative for an extended time, we get a new and steeper characteristic curve for the film, corresponding to the increased gamma. Thus, the highlight of the negative has been raised to the density E, which is exactly the same as the highlight density of the normally exposed and developed negative. This underexposed and "push-processed" negative will have about the same density range as a normally exposed and processed one and apparently can be printed on the same grade of paper.

It is very important to notice, though, that we have not in any way increased the speed of the film by this change in exposure and processing. It should be clear from the diagram above that the only change resulting from the extended development is an increase in highlight density. Little or no gain is noted in the density of shadow detail, and some is inevitably lost.

303

In addition, although the overall density range of the negative is the same as that of the correctly exposed and developed image, the image quality is not at all the same. For one thing, extended development will inevitably increase graininess. Furthermore, it can be easily seen from the curves above that the highlight end of the curve of the push-processed negative is much steeper than that of the normal negative, and the result will be much greater contrast in the highlights. This may, in fact, necessitate printing on a softer grade of paper, even though the overall density range of the image is correct for normal paper.

Development Recommendations

Assuming that a gain of one stop or a doubling of the exposure meter setting is desired, processing may be carried out in almost any developer recommended for the film in the data sheets in Section 2. The exceptions to this rule are the fine-grain, low-contrast developers, which do not take well to pushing, either because they cause a loss of film speed to begin with or because they are inherently low-contrast developers and cannot attain the higher gamma needed for pushing. Thus, developers such as Kodak Microdol-X, GAF Hyfinol, and others of this class are not suited to push-processing.

The increase of one stop, in the case of other developers listed in the tables, can be attained by increasing the development time from that given in the tables by 50 per cent. As an example, Kodak Tri-X Panchromatic 35mm film, normally rated at ASA 400, when developed in Kodak D-76 for 8 minutes at 68 F, can be exposed at ASA 800 if development is extended to 12 minutes at 68 F.

Obviously, the same gain in speed can be attained with low-speed films, such as Kodak Panatomic-X, but there is little reason to do so. The pushing will result in the loss of the fine-grain quality of the slow film; we might as well use a faster film to begin with and avoid pushing unless absolutely necessary.

Subject Contrast and Push-Processing

Up to this point, we have assumed that the subject matter is substantially normal, that is, of full scale and range from black to white. In the diagram below, the range A represents a subject having tones extending from deepest black to full white. If such a subject utilizes the entire scale of the negative film, then push-processing should not be attempted, because it will definitely spoil the image quality of the resulting negative.

But, suppose we are photographing a subject such as a gray poodle on a white rug. The entire scale of this image is from gray to white; it uses only the upper half of the exposure scale of the film, as shown by B above. In this case, we have considerable latitude in the underexposure direction and can expose the film at double its normal rating without any change in development what-

ever. The result will be to move the image down the negative scale to C; the resulting negative will be thinner and easier to print, but will have the same density range as the normally exposed one and can be printed on the same grade of paper.

If, however, insufficient light is available even for this setting, we can expose this subject at *four times* its normal ASA rating, equivalent to a two-stop push. This moves it down the scale to D (diagram above) and the resulting negative will have a shorter scale; its maximum density will be at F instead of E. But a 50 per cent increase in development will raise the contrast sufficiently to move the maximum density of this negative to G, which is the same as that of point E in the original. Again, the highlights will be more contrasty and the negative will have somewhat coarser grain, but a satisfactory print can be obtained on a slightly softer paper.

Thus, the amount of push which is possible depends largely on the character of the subject matter. With a normal full-scale subject, a gain of one lens stop can be attained with a small loss in shadow detail. With soft or short-scale subjects, pushing can permit an underexposure of two lens stops, or an apparent gain in the film speed of four times; with exceedingly short-scale subjects, the gain may increase to five times. Beyond this, there will inevitably be a severe loss in image quality. Some early books reported the use of meter settings as high as ten times the ASA rating; however, at that time, the ASA ratings contained a safety factor of 2.5×. Thus, the published ASA ratings were roughly half those issued today, and the 10× gain reported then is equivalent to a 4× gain today.

Maximum-Energy Processing

For best results in terms of image quality, push-processing should be carried out in normal developers to times not greater than 50 per cent above normal, and the gains of one to two stops attainable with various types of subject matter are about maximum.

However, there are occasions, particularly in news photography, where light is hopelessly inadequate and a negative will be underexposed by three and even four stops. The situation is shown below. Where the normal negative, whose scale is A has its blacks recorded at E, its whites at C, and its grays in between, the underexposed negative B has more than half its scale off the bottom of the curve. This being the case, whites will reproduce at D, light grays at E, and nothing darker than the grays will appear on the negative at all.

Such a negative would be a mere "ghost" image; it would be quite un-printable, even if intensified. There is no way in which such an extreme under-exposure can be made to produce a high-quality negative. Nonetheless, on occasion even a skeleton of an image is acceptable, and it is therefore necessary to save such an extreme underexposure.

To do so will require a degree of push beyond the capability of the ordinary negative developer, no matter how long development is extended. A developer is required which is capable of producing a very high gamma; unfortunately, most high-contrast developers usually cause a further loss in emulsion speed.

It is possible to compound a very high-contrast developer that will actually produce a gain in emulsion speed of nearly a full lens stop. Such a developer will be much less selective than a normal one, and in bringing out every possible trace of latent image in the extreme toe of the curve, it will necessarily also develop a number of unexposed grains. The result will be a very high fog level, which is unavoidable; if development time is shortened to reduce the fog, there will be no appreciable gain in emulsion speed. In the diagram above, the presence of fog is evident in the upper curve, which is considerably above the first curve on the density scale. Notice, though, that the curve is steeper even at the bottom, which indicates improved shadow-tone separation, corresponding to an actual gain in emulsion speed. The formula used is as follows:

KODAK SPECIAL DEVELOPER SD-19a

SOLUTION A

Kodak Anti-Fog No. 2* (0.2% solution)	5 fluid drams	20.0cc
Hydrazine Dihydrochloride**	24 grains	1.6 grams
Cold water to make	1 ounce	30.0cc

SOLUTION B

Water (about 125 F or 52 C)	16 ounces	500.0cc
Kodak Elon Developing Agent	29 grains	2.0 grams
Kodak Sodium Sulfite, desiccated	3 ounces	90.0 grams
Kodak Hydroquinone ¼ ounce	8 grains	8.0 grams
Kodak Sodium Carbonate, monohydrated	1¾ ounces	52.5 grams
Kodak Potassium Bromide	72 grains	5.0 grams
Add cold water to make	32 ounces	1.0 liter

*To prepare a 0.2% solution of Kodak Anti-Fog No. 2, dissolve two grams (30 grains) in 1000cc (32 ounces) of hot distilled water.

**Caution: Hydrazine Dihydrochloride is a skin irritant. Avoid contact of the powder or solutions with the skin or eyes. If contact does occur, wash with plenty of water immediately. It is advisable to wear rubber gloves and an apron while working with this formula.

Hydrazine Dihydrochloride is obtainable as Eastman Organic Chemical No. 1117, from laboratory supply houses or on order through the Eastman Organic Chemicals Department, Distillation Products Industries, Division of the Eastman Kodak Company, 755 Ridge Road West, Rochester, N.Y. 14603.

Dissolve chemicals in the order given. To prepare a working solution add 30cc (one ounce) of Solution A to one liter (32 ounces) of Solution B (which is identical to Kodak Developer D-19) and mix thoroughly. The working solution should be prepared just before using.

The best speed increase is obtained by developing for the time required to give a fog value between 0.20 and 0.40. The developing time will depend on the temperature, processing equipment, and agitation. In general, with intermittent agitation in a tray or tank, the correct time of development at 68 F (20 C) with conventional high-speed emulsions is between 12 and 20 minutes. The optimum time can be determined for a particular emulsion by cutting a trial under-exposure into three or more pieces and developing these pieces for a series of times ranging from 10 to 20 minutes. The time of development that produces the lowest fog density at which a satisfactory speed increase is obtained can be selected.

When the special chemicals required for the above developer cannot be obtained, there is an older high-energy developer that may be used which

produces similar results, although the gain in shadow detail is not as great. This is as follows:

KODAK DEVELOPER D-82

```
Water (125 F or 52 C) .........................  24 ounces      750.0cc
Kodak Wood Alcohol ......................... 1½ fluid ounces   48.0cc
Kodak Elon Developing Agent .................200 grains       14.0 grams
Kodak Sodium Sulfite, desiccated ..............1¾ ounces       52.5 grams
Kodak Hydroquinone ..........................200 grains       14.0 grams
*Kodak Sodium Hydroxide (Caustic Soda) .........125 grains      8.8 grams
Kodak Potassium Bromide ....................125 grains        8.8 grams
Add cold water to make ......................  32 ounces       1.0 liter
```

Dissolve chemicals in the order given.

*Note: Cold water should always be used when dissolving sodium hydroxide (caustic soda) because considerable heat is evolved. If hot water is used, the solution will boil with explosive violence and may cause serious burns if the hot alkali spatters on the hands or face. It is best to dissolve sodium hydroxide separately in a small volume of water and add the solution after the hydroquinone has been dissolved while stirring vigorously.

Develop about five minutes in a tray at 68 F (20 C).

The prepared developer does not keep more than a few days. If wood alcohol is not added and the developer is diluted, the solution is not so active as in the concentrated form.

PUSH-PROCESSING KODAK FILMS IN AGFA RODINAL

Agfa Rodinal is a very highly concentrated developer which can be used at dilutions of up to 1:100. By varying the concentration its activity can be controlled to a fairly large extent, and many photographers find it particularly useful for push-processing. The table below was compiled by Agfa-Gevaert, Inc. for two popular films of Kodak manufacture; it is suggested that the user make some tests on unimportant subjects before using the recommendations for highest emulsion speeds.

Light Intensity	Subject Contrast	Meter Setting	Developer Dilution	Time in min. (68 F or 20 C)
KODAK PLUS-X ROLL FILM AND 35mm FILM				
Bright	Highest	80	1:100	10½
Bright	High	125	1:100	11½
Bright	Moderate	160	1:75	11½
Bright	Low	400	1:50	12
Dim	High	400	1:75	12½
Dim	Moderate	400	1:50	13
Dim	Low	640	1:50	14
Very dim	High	800	1:75	15
Very dim	Low	800	1:50	16½
Normal	Moderate	200	1:85	12 (at 75 F)
KODAK TRI-X PANCHROMATIC ROLL FILM AND 35mm FILM				
Bright	High	250	1:85	14
Bright	Moderate	400	1:75	14½
Bright	Low	400	1:50	14½
Dim	High	640	1:75	15½
Dim	Moderate	800	1:50	16½
Very dim	High	1200	1:65	17½
Very dim	Low	1600	1:50	18½
Very dim	High	3200	1:65	20
Very dim	Low	6400	1:50	22½
Available Light	Moderate	800	1:100	17½ (at 75 F)

PUSH-PROCESSING TABLE

To save calculation, the following table for push-processing certain popular films is offered. It is fairly conservative as far as the amount of push obtainable is concerned and may be depended upon in most cases; however, for critical situations, we suggest making a preliminary test on the same film, with the same developer, on an unimportant subject.

The table lists only fairly high-speed films; there is no point in push-processing slower films, since better results can be obtained in all cases by using the faster film at normal ratings.

These recommendations are for the use of the manufacturer's recommended developer and will give either a 2-times gain in film speed on normal subject matter or a 4-times gain in film speed on subject matter of low contrast. For those who prefer to use commercial developers, Ethol UFG gives about a one-stop gain in speed when used normally according to directions (see tables elsewhere in this section).

In general, a 50 per cent increase in processing time with certain developers will give similar results to those listed above; there are two exceptions. The first is fine grain developers such as Hyfinol, Kodak Microdol-X, and similar formulas; these produce little gain in speed with extended processing. The second is highly bromided developers such as Kodak D-72, Dektol, and similar formulas, used for rapid processing of press-type emulsions. These produce nearly their maximum possible speed at normal processing times, and little increase is secured if processing time is extended.

There is one special case: Kodak Royal-X Panchromatic Film is designed to produce maximum film speed with extended development as shown in the table. This additional speed is accompanied by some fog, which is normal. Reducing development to eliminate the fog, or adding potassium bromide or other restrainer to the developer to reduce fog density, will result in loss of the additional speed.

Film and Developer	Processing time for normal ASA rating	Push-Processing for 2 times normal speed for normal subject matter, OR for 4 times normal speed for short scale subject matter				
	68 F	65 F	68 F	70 F	72 F	75 F
Agfapan 400 (Rodinal 1:25)	10	16½	15	13½	12	9¾
Kodak 2475 (DK-50)	6	10	9	8	7¼	6½
†Kodak 2484 (D-76)	10	16½	15	13½	12	9¾
§Kodak 2485 (D-19)	—	—	—	—	—	12
Kodak Royal-X Pan Roll Film (DK-50)	7	11½	10½	9¾	9	8¼
Kodak Tri-X Pan Roll and 35mm film (D-76)	9	16½	13½	12	10½	9

*Maximum speed can be attained by developing 8 min. at 68 F.
†Maximum speed (ASA 3200): develop in D-76, 4 min. at 95 F.
§Maximum speed (ASA 8000): develop in D-19, 2½ min. at 95 F.

STOP BATHS

Basically, all a stop bath has to do is to neutralize the developer before the film is transferred to the fixing bath. Some, however, contain chrome alum for hardening and/or sodium sulfite to minimize swelling of the emulsion. Only a few stop baths are really required, and the ones that follow offer the required selection. Formulas of other manufacturers are essentially the same.

KODAK STOP BATH SB-1

A simple acid rinse, suitable for papers. The print is immersed in this bath for about 15 seconds to neutralize the developer, then is transferred to the fixing bath without further rinsing.

Water	32 ounces	1.0 liter
*Kodak Acetic Acid (28 per cent pure)	1½ fluid ounce	48.0cc

* To make 28 per cent acetic acid from glacial acetic acid, dilute three parts of glacial acetic acid with eight parts of water.

Rinse prints for not less than 15 seconds. Assuming a 1-2-second drain of a print following development, the equivalent of approximately 20 8" x 10" prints may be processed in 32 ounces (one liter) of this solution before it becomes alkaline and should be discarded.

KODAK STOP BATH SB-1a

This stop bath is similar to Kodak SB-1 above but is more concentrated and is recommended for use with high-contrast developers and others containing a good deal of alkali.

Water	32 ounces	1.0 liter
*Kodak Acetic (28 per cent pure)	4 ounces	125.0cc

* To make 28 per cent acetic acid from glacial acetic acid, dilute three parts of glacial acetic acid with eight parts of water.

KODAK STOP BATH SB-3

A chrome alum hardening rinse for films processed in hot weather. Hardening time is three minutes for maximum effect. When the bath turns yellow-green, it no longer hardens and should be replaced.

Water	32 ounces	1.0 liter
Kodak Potassium Chrome Alum	1 ounce	30.0 grams

Agitate the negatives for a few seconds when first immersed in hardener. Leave them in the bath for three minutes. This bath should be renewed frequently.

KODAK STOP BATH SB-4

This stop bath contains both chrome alum and sodium sulfate to minimize swelling of the film. It is intended to be used following the Kodak Tropical Developer DK-15 when working at temperatures above 75 F (24 C).

Water	32 ounces	1.0 liter
Kodak Potassium Chrome Alum	1 ounce	30.0 grams
*Kodak Sodium Sulfate, desiccated	2 ounces	60.0 grams

* If crystalline sodium sulfate is preferred instead of desiccated sulfate, use four ounces 290 grains (140.0 grams) in the formula.

After development in a concentrated developer such as DK-15, rinse the film in water for not more than 1 second and then immerse in the SB-4 bath for three minutes. Omit the water rinse above 85 F (29.4 C) and transfer directly to the hardener bath for three minutes. Agitate for 30 to 45 seconds immediately after immersing in the hardener or streakiness will result.

The hardening bath is violet-blue color by tungsten light when freshly mixed, but it ultimately turns to a yellow-green with use; it then ceases to harden and should be replaced with a fresh bath. The hardening bath should never be overworked.

An unused bath will keep indefinitely but the hardening properties of a partially used bath fall off rapidly on standing for a few days.

KODAK STOP BATH SB-5

A nonswelling acid rinse for films where maximum hardening is not required. It prevents excessive swelling between development and fixation, which might occur in a plain water rinse.

```
Water ......................................... 16 ounces      500.0cc
*Kodak Acetic Acid (28 per cent pure) ............  1 ounce      32.0cc
†Kodak Sodium Sulfate, desiccated ..............1½ ounces      45.0 grams
Water to make  ............................... 32 ounces       1.0 liter
```

* To make 28 per cent acetic acid from glacial acetic acid, dilute three parts of glacial acetic acid with eight parts of water.

† If it is desired to use sodium sulfate crystals instead of the desiccated sulfate, use 3½ ounces per 32 ounces (105 grams per liter).

Agitate the films when immersed in this bath and allow to remain about three minutes before transfer to the fixing bath.

This bath is satisfactory for use to 80 F. It should be replaced after processing about 100 rolls per gallon provided approximately three quarts of developer have been carried into the acid rinse bath by 100 rolls. The bath should not be revived with acid.

When working at temperatures below 75 F (24 C), the life of the acid rinse bath may be extended by giving films a few seconds rinse in running water previous to immersion in this rinse bath.

INDICATOR STOP BATHS

Since the purpose of the stop bath in paper processing is to neutralize the developer absorbed in the paper pores and emulsion, it can only function as long as there is some available acid in the bath. That is, it is useful as long as the pH of the bath is below the neutral point, pH 7.0.

Certain indicator dyes are used by chemists to estimate the approximate pH of solutions; these dyes have the property of changing color at certain pH levels. For stop baths the usual indicator is Bromocresol Purple, which is yellow at pH 5.2 or below and purple at pH 6.8 or above. Thus, it will change color just before the stop bath is totally neutralized. The color change has another advantage — the yellow color of the normally acid bath is invisible under the usual paper safelight, but the purple color appears black in this illumination, calling attention to the change most forcefully.

Bromocresol Purple is available from Distillation Products Industries, Rochester, N. Y. 14603, in the form of a powdered dye (Eastman Organic Chemical No. 745) or as a solution in water (Eastman Organic Chemical No. A745). Only a very small amount of the solution need be added to the stop bath; the indicator is also available in small dropper bottles at some chemical laboratory supply houses. In either case, it is preferable to purchase the dye in solution; the powdered dyestuff is very strong, and preparation of the solution involves weighing very small quantities. In addition, a special technique is required to prepare the solution from the basic dye. This can be avoided if the dye powder is purchased as the sodium salt (Eastman Organic Chemical No. 6349).

FIXING BATHS

The fixing baths of the various manufacturers are mostly pretty much alike; however, each manufacturer has one or two that are unique. We have not attempted to eliminate all duplications here, however; it is felt that the reader will be benefited by the inclusion of the various versions of the same bath from different makers. For the researcher, it will facilitate references to the literature.

ANSCO FIXING BATH 201

A standard acid hardening and fixing bath for films or papers; it has excellent keeping qualities both before and with use and may be used repeatedly until exhausted. However, if it froths or turns cloudy, it must be replaced at once; it is not practical to regenerate it.

SOLUTION 1

Water (125 F or 52 C)	16 ounces	500.0cc
Sodium Thiosulfate (hypo)	8 ounces	240.0 grams

SOLUTION 2

Water (125 F or 52 C)	5 ounces	150.0cc
Ansco Sodium Sulfite, desiccated	½ ounce	15.0 grams
Acetic Acid (28 per cent)	1½ ounces	45.0cc
Ansco Potassium Alum	½ ounce	15.0 grams
Add solution 2 to 1 and add water to make	32 ounces	1.0 liter

Dissolve chemicals thoroughly in order given and stir rapidly while adding solution 2 to solution 1. Glacial Acetic Acid may be diluted to 28 per cent concentration by adding three parts of acid to eight parts of water. Do not dilute for use. Normal fixing time five to ten minutes at 68 F (20 C).

ANSCO FIXING BATH 202

A high-temperature fixing bath for films only; it should not be used with papers since it may stain. The color of the bath when the two solutions are mixed is green; this is normal. When maximum hardening is required, the films should be rinsed in a chrome alum stop bath before transferring to this fixer.

SOLUTION 1

Water (125 F or 52 C)	80 ounces	2.5 liters
Sodium Thiosulfate (hypo)	2 pounds	960.0 grams
Ansco Sodium Sulfite, desiccated	2 ounces	60.0 grams
Add cold water to make	96 ounces	3.0 liters

SOLUTION 2

Water	32 ounces	1.0 liter
Ansco Potassium Chrome Alum	2 ounces	60.0 grams
Sulfuric Acid (C.P.)*	¼ ounce	8.0cc

* Caution: *Always add the sulfuric acid to the water slowly while stirring and never the water to the acid, otherwise the solution may boil and spatter the acid on the hands or the face, causing serious burns.*

Slowly pour solution 2 into solution 1 while rapidly stirring the latter. Do not dilute for use. Do not dissolve the chrome alum at a temperature higher than 150 F (66 C). Always rinse films thoroughly before fixing. Normal fixing time, five to ten minutes at 68 F (20 C).

ANSCO FIXING BATH 203

A nonhardening acid fixing bath, used mainly with papers having pre-hardened emulsions and in some cases, with reproduction films for greater accuracy of registration.

STOCK SOLUTION

Sodium Thiosulfate (hypo)	16 ounces	475.0 grams
Ansco Potassium Metabisulfite	2¼ ounces	67.5 grams
Add cold water to make	32 ounces	1.0 liter

The potassium metabisulfite should be added to the hypo solution after it gets cool. Dilute one part stock solution with one part water. Normal fixing time, five to ten minutes at 68 F (20 C).

ANSCO FIXING BATH 204

This is a buffered type of acid hardening fixing bath; it does not turn cloudy with age and may be used until the time of fixation becomes too long. Unused, it may be stored indefinitely.

Water (125 F or 52 C)	24 ounces	750.0cc
Ansco Sodium Thiosulfate (hypo)	8 ounces	240.0 grams
Ansco Sodium Sulfite	½ ounce	15.0 grams
Ansco Acetic Acid (28 per cent)	2½ fluid ounces	75.0cc
Borax	½ ounce	15.0 grams
Ansco Potassium Alum	½ ounce	15.0 grams
Add cold water to make	32 ounces	1.0 liter

Dissolve chemicals thoroughly in the order given and stir rapidly. Do not dilute for use. Normal fixing time, five to ten minutes at 68 F (20 C). Glacial acetic acid may be diluted to 28 per cent concentration by adding three parts of acid to eight parts of water.

DUPONT FIXING BATH 1-F

General purpose acid hardening fixing bath for films, plates, and papers.

Water (125 F or 52 C)	26 ounces	850.0cc
Sodium Thiosulfate (hypo)	8 ounces	240.0 grams
Sodium Sulfite, anhydrous	½ ounce	15.0 grams
*Acetic Acid (28 per cent pure)	1½ fluid ounces	48.0cc
†Boric Acid, crystals	¼ ounce	7.5 grams
Potassium Alum	½ ounce	15.0 grams
Add cold water to make	32 ounces	1.0 liter

* To make 28 per cent acetic acid from glacial acetic acid, dilute three parts of glacial acetic acid with eight parts of water.

† Crystalline boric acid should be used as specified. Powdered boric acid dissolves only with difficulty, and its use should be avoided.

Dissolve chemicals in the order given.

This fixing bath remains clear even after being exhausted. For this reason, it is not recommended for fixing paper, unless accurate check is kept on number of prints fixed. This formula will fix completely the equivalent of 20 to 25 8" x 10" films or sheets of paper per quart (liter). Using an exhausted fixing bath of this type may easily result in stains on finished prints.

Negatives should be fixed for approximately five to ten minutes in freshly prepared 1-F Fixer or for twice the time it takes the film to clear. The fixer should be discarded when the clearing time exceeds ten minutes.

The life of this and other fixers and the efficiency of the fixation process can be greatly improved by a two-bath technique. Partially exhausted fixer is used for the first bath and fresh fixer for the second. Immerse the negatives for five minutes in the first bath and then transfer them to the fresh fixer for five minutes.

DUPONT FIXING BATH 2-F

Unbuffered acid hardening fixer for papers.

Water (125 F or 52 C)	26 ounces	850.0cc
Sodium Thiosulfate (hypo)	8 ounces	240.0 grams

After hypo has been dissolved, add the following hardening solution to the cool hypo solution:

Water (125 F or 52 C)	2½ ounces	75.0cc
Sodium Sulfite, desiccated	½ ounce	15.0 grams
*Acetic Acid (28 per cent pure)	1½ fluid ounces	47.0cc
Potassium Alum	½ ounce	15.0 grams
Add cold water to make	32 ounces	1.0 liter

* To make 28 per cent acetic acid from glacial acetic acid, dilute three parts of glacial acetic acid with eight parts of water.

The 2-F fixing bath will tend to show a white flocculent precipitate as its exhaustion point is near. When this precipitation occurs, the hypo should be discarded.

The 2-F fixing bath, prepared as instructed, will fix approximately 15 8″ x 10″ prints per quart (liter) or their equivalent in other sizes if a water rinse is used; or approximately 30 8″ x 10″ prints per quart (liter) if the acid rinse bath (Formula 1-S) is used between development and fixation. The temperature of the bath should be kept as near 68 F (20 C) as possible.

Immerse prints carefully, face up, to prevent air bells forming on the surface. Keep them separated and allow them to fix for at least 15 minutes in fresh bath to assure complete fixation.

DUPONT FIXING BATH 3-F

Chrome alum fixing bath for maximum hardening during hot weather processing of films; it should not be used on papers as it may cause a green stain.

SOLUTION A

Water (125 F or 52 C)	64 ounces	2 liters
Sodium Thiosulfate (hypo)	2 pounds	958 grams
Sodium Sulfite, desiccated	2 ounces	60 grams
Add cold water to make	3 quarts	3 liters

SOLUTION B

Water ...	32 ounces	1 liter
Potassium Chrome Alum	2 ounces	60 grams
*Sulfuric Acid (C.P.)	¼ fluid ounce	8cc

* *When preparing the solution B, always add the sulfuric acid to the water slowly and never water to the acid, otherwise the solution may boil and spatter the acid on the hands or face, causing serious burns.*

Dissolve all chemicals in the order given.

Add solution B to solution A while stirring vigorously and rapidly. Stirring is necessary to avoid precipitation of sulfur, which would show up by a milky or cloudy appearance of the bath. This formula, when freshly mixed, is especially recommended for use in hot weather but loses its hardening properties quite rapidly with or without use.

ILFORD FIXING BATH IF-2

A nonhardening acid fixing bath for use with papers and suitable for use with films where temperatures can be kept low enough to minimize swelling and softening of the emulsion.

Sodium Thiosulfate (hypo)6 ounces 288 grains		200.0 grams
Potassium Metabisulfite183 grains		12.5 grams
Add cold water to make 32 ounces		1.0 liter

For films and plates: use undiluted and fix for 10-20 minutes.

For papers: dilute with an equal volume of water and fix for five to ten minutes.

For more rapid fixing, the quantities of hypo and metabisulfite may be doubled.

ILFORD FIXING BATH IF-9

Chrome alum hardening fixing bath intended for X-ray materials but usable for other films and plates in hot weather. It should not be used for papers, since it may stain.

Chrome Alum183 grains		12.5 grams
Sodium Metabisulfite183 grains		12.5 grams
Sodium Sulfite, desiccated 93 grains		6.25 grams
Sodium Thiosulfate (hypo)12½ ounces		400.0 grams
Add cold water to make 32 ounces		1.0 liter

Dissolve the chrome alum, metabisulfite, and sulfite in 750cc of warm water not above 100 F (38 C). Then add and dissolve the hypo. Finally add cold water to make 1000cc.

ILFORD FIXING BATH IF-15

Buffered acid fixing bath using potassium alum as a hardener. It is suitable for films and plates and also for papers to be dried on heated dryers.

SOLUTION A

Water (125 F or 52 C) 16 ounces		500.0cc
Sodium Thiosulfate (hypo)10 ounces 292 grains		320.0 grams
Sodium Sulfite, desiccated 1 ounce		30.0 grams

SOLUTION B

Warm Water (125 F or 52 C) 6 ounces		150.0cc
Boric Acid crystals145 grains		10.0 grams
Acetic Acid 99 per cent (Glacial) 4.8 fluid drams		18.0cc
Potassium Alum crystals365 grains		25.0 grams

Dissolve the hypo in hot water and when cool add the sulfite. Dissolve the boric acid, acetic acid, and alum in hot water. When both solutions are cold, slowly pour solution B into solution A, then add cold water to make 32 ounces or one liter, respectively.

FR FIXOL ACID HARDENING FIXING SOLUTION

FR Fixol is a concentrated all-purpose liquid fixer, containing a hardening agent. A 26-ounce bottle of concentrate is sufficient to make one gallon of working strength solution. It is recommended for general use for both paper and film.

Its acidity is sufficiently buffered so as to resist a normal amount of developer "carry-over", and its hardening action allows a workable variance in processing temperatures.

FR Fixol contains a unique combination of ingredients, which insures a longer working life. A gallon of working strength solution has the capacity to safely fix 600 4″ × 5″ prints or 150 rolls of film.

The liquid form of FR Fixol makes it easier and quicker to mix the proper solution—while at the same time preparing the exact amount of fixer needed with no waste.

To insure maximum hardening, fix films and prints at least five minutes.

When more rapid fixing is desired, FR Rapid Fixol should be used.

FR RAPID FIXOL FIXING SOLUTION

This is a concentrated liquid fixer that enables rapid processing of films and prints. Films and prints fix in one to two minutes. It allows bulk work in a minimum amount of time, with absolutely no loss in print quality.

FR Rapid Fixol is a very stable solution as well. At normal temperatures, it will keep indefinitely either in concentrated or diluted form. Its capacity is twice that of regular fixers. When used with a short stop bath, it will safely fix 300 rolls of film or 1200 4″ x 5″ prints per gallon of working strength solution.

The acidity of Rapid Fixol is so buffered as to tolerate abnormally large amounts of developer "carry-over" without adversely affecting its working properties.

For Film

Dilute one part of FR Rapid Fixol with four parts water. Fix for approximately 1½ minutes 68 F. Lower processing temperatures require longer fixing periods.

For Paper

Dilute one part of FR Rapid Fixol with nine parts of water and fix for approximately three minutes.

Twenty-six ounces of concentrate make up to two gallons of fixer. For hot weather use, add FR Liquid Hardener.

FR INSTANT FIXOL

Instant Fixol when used in conjunction with FR One-Shot developers or any other one-time use developer offers complete control over processing. There is no sacrifice of negative quality or undue softening of emulsion. There is the convenience and uniformity of a one-time processing system plus reduced washing time and no intermediate rinses.

Directions

For fixing thin-emulsion films (slow-speed), follow directions on the back of the Instant Fixol Package.

Fix films two to four minutes.

For fixing high-speed films, proceed as follows:

a) Prepare developer in the normal manner.

b) At the conclusion of the selected developing time, simply add the contents of one bottle of Instant Fixol to the tank. Agitate for 30 seconds, thereafter 10 seconds per minute.

c) Fix films for three to five minutes.

d) After fixing, discard solution and wash film for five to seven minutes.

For processing two rolls of 35mm film simultaneously or one or two rolls of 120 or 127 film, use 16–20 ounces of developer solution.

a) At the conclusion of the developing period, simply add the contents of one bottle of Instant Fixol to the tank. Agitate as noted above.

b) Fix films six to eight minutes.

After fixing, discard solution and wash film for five to seven minutes.

Note: When no more than 16 ounces of solution are used in the FR special tank, the contents of one bottle of Instant Fixol may be added without the removal of any developer. Should a processing tank not be capable of holding the additional ounce of liquid, discard approximately one ounce of developer prior to addition of Instant Fixol.

Important

Since clearing times of films vary, only ranges are given. Experience will allow you to choose the proper fixing times for each individual film.

It is imperative that the Instant Fixol be thoroughly dispersed throughout the developer as quickly as possible. Use the most efficient method of agitation for your tank. If at the conclusion of the fixing period films do not appear clear, reimmerse in bath for an additional period of time.

316

KODAK FIXING BATH F-5

Buffered acid fixing bath for films, plates, and papers. This is the standard acid hardening fixing bath, which is used in the majority of cases by workers where high-temperature conditions are not excessive.

Water (125 F or 52 C)	20 ounces	600.0cc
Kodak Sodium Thiosulfate (hypo)	8 ounces	240.0 grams
Kodak Sodium Sulfite, desiccated	½ ounce	15.0 grams
*Kodak Acetic Acid (28 per cent pure)	1½ fluid ounces	48.0cc
†Kodak Boric Acid, crystals	¼ ounce	7.5 grams
Kodak Potassium Alum	½ ounce	15.0 grams
Add cold water to make	32 ounces	1.0 liter

* To make 28 per cent acetic acid from glacial acetic acid, dilute three parts of glacial acetic acid with eight parts of water.

† Crystalline boric acid should be used as specified. Powdered boric acid dissolves only with great difficulty, and its use should be avoided.

Dissolve the hypo in the specified volume of water (about 125 F or 52 C) and then add the remaining chemicals in the order given, taking care that each chemical is dissolved before adding the next. Then dilute with water to the required volume.

Films or plates should be fixed properly in ten minutes (cleared in five minutes) in a freshly prepared bath. The bath need not be discarded until the fixing time (twice the time to clear) becomes excessive, that is, over 20 minutes. The solution remains clear and hardens well throughout its useful life. About 20-25 8″ x 10″ films or plates (or their equivalent in other sizes) may be fixed per 32 ounces (1 liter).

The F-5 fixing bath has the advantage over the older types of fixing baths, which do not contain boric acid, that it gives much better hardening and has a lesser tendency to precipitate a sludge of aluminum sulfite throughout its useful life.

KODAK FIXING BATH F-6

For those who wish to use the standard acid fixer but find the odor of sulfur dioxide annoying, especially in very small darkrooms, this bath will be found useful; it is practically odorless. It uses Kodalk instead of boric acid as a buffer.

Water (125 F or 52 C)	20 ounces	600.0cc
Kodak Sodium Thiosulfate (hypo)	8 ounces	240.0 grams
Kodak Sodium Sulfite, desiccated	½ ounce	15.0 grams
*Kodak Acetic Acid (28 per cent pure)	1½ fluid ounces	48.0cc
Kodalk ..	½ ounce	15.0 grams
Kodak Potassium Alum	½ ounce	15.0 grams
Add cold water to make	32 ounces	1.0 liter

* To make 28 per cent acetic acid from glacial acetic acid, dilute three parts of glacial acetic acid with eight parts of water.

Dissolve the hypo in the specified volume of water, about 125 F (52 C) and then add the remaining chemicals in the order given, taking care that each chemical is dissolved before adding the next. Then dilute with water to the required volume.

KODAK FIXING BATH F-7

A very rapid fixing bath, intended for fast machine processing of films; it can be used for papers but has no real advantage over the normal fixing bath, and there is a danger of dichroic fog if the bath becomes alkaline. The bath fixes much more rapidly than Kodak Fixing Bath F-5, and the life of the bath is 50 per cent greater than that of Kodak F-5.

Water (125 F or 52 C)	20 ounces	600.0cc
Kodak Sodium Thiosulfate (hypo)	12 ounces	360.0 grams
Kodak Ammonium Chloride	1 ounce 290 grains	50.0 grams
Kodak Sodium Sulfite, desiccated	½ ounce	15.0 grams
*Kodak Acetic Acid (28 per cent pure)	1½ ounces	47.0cc
Kodak Boric Acid crystals	¼ ounce	7.5 grams
Kodak Potassium Alum	½ ounce	15.0 grams
Add cold water to make	32 ounces	1.0 liter

* To make 28 per cent acetic acid from glacial acetic acid, dilute three parts of glacial acetic acid with eight parts of water.

When compounding this formula, the ammonium chloride should be added to the hypo solution and not to the final fixing bath; otherwise a sludge may form.

Caution: With rapid fixing baths, do not prolong the fixing time for fine-grained film or plate emulsions or for any paper prints; otherwise, the image may have a tendency to bleach, especially at temperatures higher than 68 F (20 C). This caution is particularly important in the case of warm-tone papers.

KODAK FIXING BATH F-10

A special fixing bath for use with highly alkaline developers such as Kodak D-11, D-19, or X-ray developers.

Water (125 F or 52 C)	16 ounces	500.0cc
Kodak Sodium Thiosulfate	11 ounces	330.0 grams
Kodak Sodium Sulfite, desiccated	¼ ounce	7.5 grams
Kodalk	1 ounce	30.0 grams
*Kodak Acetic Acid (28 per cent pure)	2¼ fluid ounces	72.0cc
Kodak Potassium Alum	¾ ounce	22.5 grams
Add cold water to make	32 ounces	1.0 liter

* To make 28 per cent acetic acid from glacial acetic acid, dilute three parts of glacial acetic acid with eight parts of water.

Dissolve the chemicals in the order given, taking care that each chemical is dissolved completely before adding the next.

This bath is especially recommended for use with highly alkaline developers, such as Kodak D-11, D-19, or D-95. Agitate thoroughly on first placing the films in the bath, and at intervals until fixation is completed.

Fix for twice the time to clear the film of its milky appearance. Wash thoroughly and wipe each negative carefully before drying. When the time to clear has been increased through use, to twice the time required with a fresh bath, the solution should be discarded. In continuous processing machines, however, the following replenisher should be used to maintain the solution at constant working efficiency.

KODAK REPLENISHER F-10R

Water (125 F or 52 C)	16 ounces	500.0cc
Kodak Sodium Thiosulfate (hypo)	14 ounces	420.0 grams
Kodak Sodium Sulfite, desiccated	145 grains	10.0 grams
Kodalk ..	1 ounce	30.0 grams
*Kodak Acetic Acid (28 per cent)3 ounces	7 fluid drams	120.0cc
Kodak Potassium Alum	¾ ounce	22.5 grams
Add cold water to make	32 ounces	1.0 liter

* To make 28 per cent acetic acid from glacial acetic acid, dilute three parts of glacial acetic acid with eight parts of water.

Replenishment rate—one gallon per 3,700 feet of 16mm film (1.0cc per foot).

KODAK FIXING BATH F-23

A chrome alum fixing bath, intended for hot weather processing of motion picture films; it should not be used for papers since it may stain.

SOLUTION A

Kodak Sodium Thiosulfate (hypo)	8 ounces	240.0 grams
Kodak Sodium Sulfite, desiccated	180 grains	12.5 grams
Water to make	24 ounces	750.0cc

SOLUTION B

Water ..	5 ounces	150.0cc
Kodak Sodium Sulfite, desiccated	75 grains	5.0 grams
*Sulfuric Acid (5 per cent solution)	1¼ fluid ounces	40.0cc
Kodak Potassium Chrome Alum	1 ounce	30.0 grams
Water to make	8 ounces	250.0cc

* To prepare 5 per cent sulfuric acid, add 1 part by volume of sulfuric acid C.P. (concentrated) to 19 parts of cold water by volume slowly while stirring. The acid must be added to water, not vice versa, otherwise the solution may boil with explosive violence, and if spattered on the hands or face, will cause serious burns.

Solutions A and B must be cooled to about 70 F before they are mixed in order to avoid sulfurization. Add solution B to solution A while stirring the latter thoroughly. It is not desirable to store solution B as a stock hardener because it loses its hardening powers on keeping.

The hardening properties fall off rapidly with use, and sulfuric acid should be added at regular intervals to maintain the proper acidity. The quantity required can be determined by titrating 30cc of the fixing bath with 2.5 per cent solution of sulfuric acid, using brom-phenol blue as the indicator. Sufficient acid should be added to change the color of the solution to yellow.

KODAK FIXING BATH F-24

A nonhardening acid fixing bath, intended for films, plates, and papers when no hardening is desired.

Water (125 F or 52 C)	16 ounces	500.0cc
Kodak Sodium Thiosulfate (hypo)	8 ounces	240.0 grams
Kodak Sodium Sulfite, desiccated	145 grains	10.0 grams
Kodak Sodium Bisulfite	365 grains	25.0 grams
Add cold water to make	32 ounces	1.0 liter

Dissolve chemicals in the order given.

This solution may be used satisfactorily only when the temperature of the developer, rinse bath, and wash water is not higher than 68 F (20 C) and provided ample drying time can be allowed so that relatively cool drying air can be used.

ANSCO TONER 221

A bleach and redevelop-type toner for warm brown tones on the faster contact and enlarging papers.

SOLUTION 1

Water (125 F or 52 C)	24 ounces	750.0cc
Ansco Potassium Ferricyanide	1½ ounces 80 grains	50.0 grams
Ansco Potassium Bromide	¼ ounce 35 grains	10.0 grams
Ansco Sodium Carbonate, monohydrated	½ ounce 70 grains	20.0 grams
Add cold water to make	32 ounces	1.0 liter

SOLUTION 2

Ansco Sodium Sulfide, desiccated	1½ ounces	45.0 grams
Add cold water to make	16 ounces	500.0cc

For use as described below, dilute one part solution 2 with eight parts water.

Important—Be sure to use sodium sulfide, not sodium sulfite, in compounding the redeveloper. Also use clean trays, free from exposed iron spots, especially with bleaching bath. Otherwise, blue spots may form on prints.

Prints should be washed thoroughly and then bleached in solution 1 until the black image is converted to a very light brown color (about one minute). Prints should then be washed for 10-15 minutes and redeveloped in diluted solution 2.

Redevelopment should be complete in about 1 minute. After redevelopment the prints should be washed for about 30 minutes and then dried. If the toner should leave sediment, which results in streaks or finger marks on the surface of the paper, the print should be immersed for a few seconds in a 3 per cent solution of acetic acid, after which a 10-minute washing is necessary.

ANSCO TONER 222

The well-known hypo-alum toner producing rich reddish-brown tones on most papers.

SOLUTION 1

Water	80 ounces	2350.0cc
Ansco Sodium Thiosulfate (hypo)	15 ounces	450.0 grams

SOLUTION 2

Water	1 ounce	30.0cc
Ansco Silver Nitrate	20 grains	1.3 grams

SOLUTION 3

Water	1 ounce	30.0cc
Ansco Potassium Iodide	40 grains	2.7 grams

Add solution 2 to solution 1. Then add solution 3 to the mixture. Finally add 105 grams (3½ ounces) of Ansco potassium alum to this solution and heat the entire bath to the boiling point, or until sulfurization takes place (indicated by a milky appearance of the solution). Tone prints 20-60 minutes in this bath at 110-125 F (43−52 C). Agitate prints occasionally until toning is complete.

Care should be taken to see that the blacks are fully converted before removing the prints from the toning bath, otherwise double tones may result.

ANSCO TONER 231

This formula gives a range of red tones to sepia-toned prints, the brillance of the tone depending on the paper used. Brilliant chalk-red tones are produced on cold-toned contact papers whereas with warm-toned enlarging papers darker shades are formed. If desired, deep blue tones may also be obtained with this formula by using black-and-white prints instead of prints that have first been sepia-toned. Unusual effects of mixed tones of blue-black shadows and soft reddish highlights can be produced by using prints that have been partially toned in a hypo alum sepia-toner.

Water (125 F or 52 C)	24 ounces	750.0cc
Ammonium Thiocyanate	3½ ounces	105.0 grams
Gold Chloride (1 per cent solution)	2 fluid ounces	60.0cc
Add cold water to make	32 ounces	1.0 liter

For red tones: Prints must first be bleached and toned by the sulfide re-development method. After washing, place prints in above solution until toning is complete (requires 15-45 minutes). For redder tones, one-half the specified amount of thiocyanate may be used.

For deep blue tones: Omit sepia toning operation and place well-washed black-and-white prints directly in above toning solution.

For mixed tones: Prints should be incompletely toned in a hypo alum toner, such as Ansco 222, and washed before treatment in above solution.

ANSCO TONER 241

An iron toner for blue tones on enlarging papers and lantern slides.

Water (125 F or 52 C)	16 ounces	500.0cc
Ferric Ammonium Citrate	¼ ounce	8.0 grams
Ansco Potassium Ferricyanide	¼ ounce	8.0 grams
Ansco Acetic Acid (28 per cent)	9 ounces	265.0cc
Add cold water to make	32 ounces	1.0 liter

Solution should be prepared with distilled water if possible. If enameled iron trays are used, no chips or cracks in the enamel should be present or spots and streaks may appear in the print.

Prints for blue toning should be fixed in plain, nonhardening hypo bath (which should be kept at a temperature of 68 F, 20 C, or under to avoid undue swelling). When prints have been fully toned in the above solution, they will be greenish in appearance but will be easily washed out to a clear blue color when placed in running water.

The depth of the blue toning will vary somewhat with the quality of prints toned in it, light-toned prints generally toning to lighter blues. Some intensification of the print usually occurs in toning; consequently, prints should be slightly lighter than the density desired in the final toned print.

Wash water should be acidified slightly with acetic acid, since the blue tone is quite soluble in alkaline solutions and is considerably weakened when wash water is alkaline. Pleasing variations in the tone can be obtained by bathing the washed prints in a ½ per cent solution (five grams per liter) of borax, which produces softer, blue-gray tones, the extent depending on the length of treatment.

ANSCO TONER 251

This formula produces rich green tones by combining the effects of iron blue toning and sulfide sepia toning. It must, however, be employed carefully and with particular attention to cleanliness in handling prints throughout all steps of the process. The formula is not adaptable to all types of papers and surfaces.

SOLUTION 1

Potassium Ferricyanide1¼ ounces 35 grains	40.0 grams	
Water .. 32 ounces	1.0 liter	
Ammonia .91 S.G. (25 per cent in weight) 3 drams	15.0cc	

SOLUTION 2

Ferric Ammonium Citrate½ ounce 30 grains	17.0 grams	
Water .. 32 ounces	1.0 liter	
Hydrochloric Acid Concentrate1¼ ounces	40.0cc	

SOLUTION 3

Sodium Sulfide 30 grains	2.0 grams	
Water .. 32 ounces	1.0 liter	
*Hydrochloric Acid Concentrate2½ drams	10.0cc	

* Do not add hydrochloric acid to solution 3 until immediately before use.

Black-and-white prints to be toned should be darker and softer than a normal print, using approximately 25 per cent overexposure on the next softer grade of paper. Development of the print should be carried out in a suitable developer (A125 or A135) with particular attention given to avoid underdevelopment or forcing the print with overdevelopment. Prints should be fixed as usual, thoroughly washed and completely dried before toning.

Prints to be toned should first be soaked in cold water until limp and then placed in solution 1 until bleached. This operation should be completed in 60 seconds or less, and the bleached prints immediately transferred to running water where thorough washing (at least 30 minutes) is effected.

Bleached prints are then placed in solution 2 for 45 seconds to one minute, toning being permitted to continue until the deepest shadows are completely toned. Prints should then be washed briefly (four to six minutes), excessive washing being undesirable in view of the solubility of the blue image. If wash water is slightly alkaline, it should be acidified somewhat with acetic acid to prevent degradation of the blue tone during washing.

The blue-toned prints are next immersed in solution 3 until the green tone is sufficiently strong, the operation requiring about 30 seconds. Toned prints should then receive a final washing of 20-30 minutes in neutral or slightly acidified wash water and dried. Avoid heat and belt drying machines for drying.

All solutions should be prepared within 24 hours before use. Great care should be taken to avoid contamination of solutions 1 and 2. Even slight traces of solution 1 carried over on hands or prints into solution 2 can cause blue stains. Solution 3 should be used in a well-ventilated room, preferably near an open window or exhaust fan to lessen chance of inhaling hydrogen sulfide formed in the solution.

DUPONT TONER 2T

The standard hypo-alum toning bath for brown tones on enlarging papers, such as Varilour and others.

SOLUTION A

Boiling Water	128 ounces	4.0 liters
Sodium Thiosulfate (hypo)	16 ounces	480.0 grams
Potassium Alum	4 ounces	120.0 grams

Let above solution cool thoroughly and complete the toner by the addition of the following:

SOLUTION B

Water	1 ounce	30.0cc
*Silver Nitrate, crystals	20 grains	1.4 grams
Sodium Chloride (table salt)	20 grains	1.4 grams

The silver nitrate prevents bleaching and should be present in the formula in the exact quantity given above at start of toning. Excess of silver nitrate will "clog" the toning bath and is apt sometimes to cause bluish tones.

Sodium chloride is to be added after the silver nitrate has been thoroughly dissolved.

The complete toning bath should stand for a few hours to "ripen." It is then heated to the temperature desired for toning. The temperature is not to exceed 110 F (43 C).

Prints will tone in 15-30 minutes at the above temperature. Handle prints face up. Move them around a little at the start and remove all air bells from the surface by means of cotton swabs. Toned prints should be thoroughly washed in several changes of water. Wash water should not be too cold at the start. A sudden change of temperature from the warm toning bath to cold tap water will sometimes cause blisters.

DUPONT TONER 3-T

A modified hypo-alum toner containing an iodide salt for fast enlarging papers.

SOLUTION A

Boiling Water	128 ounces	4.0 liters
Sodium Thiosulfate (hypo)	16 ounces	480.0 grams
Potassium Alum	4 ounces	120.0 grams

Hypo should be dissolved first completely, then the alum should be added with constant stirring.

Solution A is boiled for a few minutes.

SOLUTION B

Water	1 ounce	30.0 grams
Potassium Iodide	20 grains	1.4 grams

Solution B (iodide) is poured into solution A with constant stirring, and the mixture is then permitted to cool. The cool mixture of solutions A and B is then completed by the addition of the following:

SOLUTION C

(1) Water	1 ounce	30.0 grams
Potassium Bromide	20 grains	1.4 grams
(2) Water	1 ounce	30.0 grams
Silver Nitrate, crystals	20 grains	1.4 grams

The nitrate solution (2) is slowly poured into the bromide solution (1) and stirred briskly.

The completed toning bath should be permitted to stand for a few hours to "ripen" and then reheated to a temperature not exceeding 110 F (43 C), which is recommended for toning of Velour Black and similar prints.

DUPONT TONER 6-T

This is actually a whole series of toners for different effects on Varigam paper. By combining the different toners and bleaches, a variety of different tones may be obtained; these tones may be further influenced by the use of the gold tone modifier.

"Varigam" Toning Bleach 6B-1

Water	24 ounces	750.0cc
Potassium Ferricyanide	320 grains	22.0 grams
Potassium Bromide	365 grains	25.0 grams
Add water to make	32 ounces	1.0 liter

"Varigam" Toning Bleach 6B-2

Water	24 ounces	750.0cc
Potassium Ferricyanide	320 grains	22.0 grams
Potassium Iodide	146 grains	10.0 grams
Add water to make	32 ounces	1.0 liter

"Varigam" Toning Bleach 6B-3

Water	24 ounces	750.0cc
Potassium Ferricyanide	320 grains	22.0 grams
Sodium Chloride	1 ounce 75 grains	35.0 grams
Nitric Acid	½ ounce	15.0cc
Add water to make	32 ounces	1.0 liter

Prints should be developed for 1½ minutes at 68 F (20 C) in DuPont 55-D and fixed for 10 minutes in DuPont 8-F. Acid-hardening fixing baths are not recommended because slow and sometimes incomplete bleaching may take place.

Prints are then thoroughly washed, after which they are bleached in one of the above bleaching baths for twice the time necessary to completely convert the black image. Then wash again through three changes of water until the image is free from the yellow color of the bleach.

The bleached print is then placed in one of the following toning baths and left until toning is complete.

"Varigam" Toner 6T-1

Water	24 ounces	750.0cc
Thiocarbamide (Thiourea)	44 grains	3.0 grams
Sodium Hydroxide	88 grains	6.0 grams
Add water to make	32 ounces	1.0 liter

"Varigam" Toner 6T-2

Water	24 ounces	750.0cc
Thiocarbamide (Thiourea)	44 grains	3.0 grams
Sodium Carbonate	1½ ounces	45.0 grams
Add water to make	32 ounces	1.0 liter

"Varigam" Toner 6T-3

Water	24 ounces	750.0cc
Thiocarbamide (Thiourea)	44 grains	3.0 grams
Potassium Carbonate	1 ounce 262 grains	48.0 grams
Add water to make	32 ounces	1.0 liter

Various combinations of bleach and toner will give different tones as shown by the following table:

Bleach in	Tone in	Type of Tone Resulting
6B-3	6T-1	Deep brown, slight purplish tint.
6B-1	6T-1	Deep brown tint.
6B-2	6T-3	Increasing warmth with a golden tinge till a bright sunlit type of sepia is produced with the B-3-T-3 combination.
6B-1	6T-3	
6B-3	6T-3	

6T-2 can be used instead of 6T-3 but it gives a little colder color and is given as an alternative when potassium carbonate is not available.

324

Gold Tone Modifier For "Varigam" Prints

Gold Chloride	14 grains	1.0 gram
Potassium Thiocyanate	90 grains	6.0 grams
Add water to make	32 ounces	1.0 liter

If this bath is used directly on a black-and-white Varigam print, the resulting tone is an interesting blue-black.

The gold tone modifier may also be used on prints that have been toned by any of the preceding methods. The toned print is first immersed in a three per cent sodium chloride solution.

Sodium Chloride Solution For Toning Varigam Prints

Water	24 ounces	750.0cc
Sodium Chloride	1 ounce	30.0 grams
Add water to make	32 ounces	1.0 liter

After treatment in the above bath, the prints are rinsed briefly and placed in the gold solution. In general, the effect of this bath is to replace the golden tint by a reddish one. Toning may be continued from 2 to 16 minutes, the color becoming more purple as the toning proceeds. A short wash should follow before drying.

If a slight yellowish stain appears on the gold-toned print, it may be cleared with a second treatment in any standard fixing bath such as the 8-F previously recommended. Thorough washing should follow.

The following table indicates the effect obtained by gold modification after toning in the various bleach-toner combinations.

Bleach in	Tone in	Tone Resulting after Gold Modification
6B-1	6T-1	From purplish-brown to rich purple colors.
6B-2	6T-1	Produces a more crimson-like tone.
*6B-1	6T-3	A rich reddish brown.
*6B-3	6T-3	A remarkably brilliant light reddish-brown color, darkening as toning progresses.

* The 6T-3 toners when gold modified produce less purple colors than the 6T-1 toners.

All gold tone modified prints change color somewhat on drying and this change cannot be avoided. The color descriptions given above apply to the dried prints.

GEVAERT TONER G.411

A bleach and redevelop toner for fast enlarging papers and cold-toned contact papers.

BLEACHING

Warm Water (125 F or 52 C)	24 ounces	750.0cc
Potassium Ferricyanide	½ ounce	15.0 grams
Potassium Bromide	½ ounce	15.0 grams
Add cold water to make	32 ounces	1.0 liter

This solution keeps well in the dark, or in dark brown bottles, and may be reused several times.

The prints are bleached in subdued light (not in sunlight, nor in the dark) until the deepest shadows have assumed a pale yellow color. The bleached prints are washed thoroughly, until the yellowish stain has disappeared. They are then redeveloped in the following solution, in which they will tone in a few minutes:

REDEVELOPER

Sodium Sulfide (not sulfite)	½ ounce	15.0 grams
Cold water to make	32 ounces	1.0 liter

After toning, the prints are washed for 20 minutes in running water.

The prints should remain in this bath for four to five minutes. If still warmer sepia tones are desired, 30-50 grains of potassium iodide should be added to each 32 ounces of toning solution (two to four grams per liter). This addition should be made at least 30 minutes before the use of the solution.

If the whites of the print are somewhat stained, they may be cleared by a short rinse in a ten per cent sodium bisulfite solution, followed by thorough washing. The treatment may be repeated if necessary.

Note: Sodium sulfide is best kept as a 20 per cent stock solution and diluted for use. It does not keep well in more dilute solutions. Too high a temperature or too strong a sodium sulfide solution may cause blisters and softening of the emulsion.

Prints should be fixed and washed very thoroughly before toning, otherwise defects may result. These can also occur if bleaching or toning is carried out in strong sunlight, or if the toning bath is nearly exhausted.

GEVAERT TONER G.416

An iron blue toner, which can also produce green tones by subsequent treatment in a sulfide bath. The print must have been thoroughly fixed and washed before toning.

BLUE TONE

Stock Solution A

Ferric Ammonium Citrate (Green Scales) ..1 ounce 290 grains		50.0 grams
Add cold water to make	32 ounces	1.0 liter

Stock Solution B

Potasium Ferricyanide	365 grains	25.0 grams
Add cold water to make	32 ounces	1.0 liter

Stock Solution C

Hydrochloric Acid Concentrated	2½ drams	10.0cc
Add cold water to make	32 ounces	1.0 liter

For use, take

Water	17 ounces	550.0cc
Stock Solution A	2½ ounces	75.0cc
Stock Solution B	2½ ounces	75.0cc
Stock Solution C	10 ounces	300.0cc

Toning in this bath takes about ½ minute at 68 F (20 C). After toning is complete, the print should be washed until the highlights are clear.

The toning bath should be made up in exactly the order given, just before use. This solution does not keep well. The bath should not be allowed to come into contact with metal; glass, porcelain, or enameled trays should be used. Work should be done in subdued daylight or artificial light; direct sunlight may cause stains.

BLUE-GREEN TONE

Water ..	16 ounces	500.0cc
Sodium Sulfide..............................	2½ ounces	75.0 grams
Sodium Thiosulfate (hypo)	16 ounces	500.0 grams
Add cold water to make	32 ounces	1.0 liter

Dilute one part of the above solution with ten parts of water.

Just before use add ten ounces (300.0cc) of a ten per cent solution of hydrochloric acid to each quart (liter) of the diluted solution. The mixed bath does not keep well after addition of the acid.

The prints must first have been toned blue as directed above and washed thoroughly. They are then treated in the above solution until the blue tone reaches the desired blue-green shade. The prints are then washed for 30 minutes and dried as usual.

GEVAERT TONER G.417

A gold-thiocarbamide toner, which produces blue tones on warm toned papers by direct treatment. The warmer the original print tone, the lighter and brighter will be the blue that is produced. Prints must be thoroughly fixed and washed before toning.

SOLUTION A

Gold Chloride	15 grains	1.0 gram
Calcium Carbonate	45 grains	3.0 grams
Water to make	8 ounces	250.0cc

SOLUTION B

Thiocarbamide	292 grains	20.0 grams
Sodium Thiosulfate (hypo)	292 grains	20.0 grams
Potassium Metabisulfite	75 grains	5.0 grams
Water to make	8 ounces	250.0cc

These solutions are prepared at least 24 hours before use. They are mixed in equal parts just before use.

Toning takes about five minutes.

After toning, the prints are washed thoroughly. If deposits of chalk appear on the surface, the prints should be swabbed with wet cotton before drying.

GEVAERT TONER G.418

A gold toner for producing red tones on papers. Prints must first be toned brown in any standard brown toner, such as Gevaert G.411, then thoroughly washed before treatment in this bath.

STOCK SOLUTION A

Warm Water (125 F or 52 C)	24 ounces	750.0cc
Ammonium Thiocyanate	145 grains	10.0 grams
Hydrochloric Acid	2½ fluid drams	10.0cc
Sodium Chloride	145 grains	10.0 grams
Add cold water to make	32 ounces	1.0 liter

STOCK SOLUTION B

Gold Chloride	15 grains	1.0 grams
Water to make	3¼ ounces	100.0cc

For use take one ounce of solution B and ten ounces of solution A (10cc of solution B to 100cc of solution A).

The color of the print begins to change after about ten minutes of immersion in the mixed bath. When the desired tone is obtained, the prints are rinsed and then immersed in a ten per cent solution of plain hypo (not an acid fixing bath). After the hypo treatment they are washed thoroughly and dried.

Prints must be kept in motion during toning to avoid sticking together and consequent uneven toning.

GEVAERT TONER G.420

A direct hypo-sulfide toner for brown tones on papers. It has a slight bleaching effect on the print, so that original prints for toning must be made somewhat darker than normal.

STOCK SOLUTION

Warm Water (125 F or 52 C)	24 ounces	750.0cc
Sodium Sulfide	2½ ounces	75.0 grams
Sodium Thiosulfate (hypo)	16½ ounces	500.0 grams
Cold water to make	32 ounces	1.0 liter

For use dilute one ounce of the above stock solution with 20 ounces of water (or 50cc with one liter of water).

Prints are washed for 5 minutes after fixing and then placed in the above working solution until the desired tone is obtained. Toning will take from 10 to 35 minutes, depending on the type of paper and the tone desired.

Prints should be kept in motion during toning. After toning, prints are washed thoroughly in running water and dried.

The above stock solution keeps indefinitely in well stoppered bottles. The diluted working bath does not keep and is discarded after use.

ILFORD TONER IT-1

Bleach and redevelop toner for Ilfobrom papers and other fast, cold-tone enlarging papers.

SOLUTION 1

Warm Water (125 F or 52 C) 24 ounces		750.0cc
Potassium Ferricyanide3 ounces 145 grains		100.0 grams
Potassium Bromide3 ounces 145 grains		100.0 grams
Add cold water to make 32 ounces		1.0 liter

For use, dilute one part of the above solution with nine parts of water.

SOLUTION 2

Sodium Sulfide1 ounce 292 grains		50.0 grams
Cold water to make 32 ounces		1.0 liter

For use, dilute one part of the above stock solution with nine parts of water.

Prints that have been correctly exposed and fully developed produce the best tones. After the print has been fixed and thoroughly washed, immerse in the diluted ferricyanide solution until it is completely bleached. Then wash for about ten minutes and place in the sulfide solution, where it will redevelop to a rich sepia color. Warmer tones can be produced by reducing the potassium bromide in the above formula to ¼ of the amount given. Wash the print thoroughly after toning.

ILFORD TONER IT-2

Hypo-alum toner for all papers.

Hot Water 32 ounces		1.0 liter
Sodium Thiosulfate 5 ounces		150.0 grams

Dissolve and then add, a little at a time:

Potassium Alum365 grains		25.0 grams

Until ripened, this bath has a reducing action on prints; ripening is best done by immersing some spoiled prints, or by adding about 2½ grains. (.12 gram) of silver nitrate, which has previously been dissolved in a small amount of water, to which is added, drop by drop, sufficient strong ammonia to form and then redissolve the precipitate formed.

This bath lasts for years and improves with keeping; it should be kept up to level by addition of fresh solution.

The prints, which should be developed a little further than for black-and-white, are toned at about 120 F (50 C) for about ten minutes. A lower temperature is not recommended as toning is unduly prolonged; higher temperatures give colder tones.

Finally, wash the prints thoroughly and swab with a tuft of cotton before drying.

Warmer tones can be obtained by adding 15 grains (or one gram) of potassium iodide to each liter of the toner.

ILFORD TONER IT-3

This selenium toner produces rich purple to red-brown tones on most papers, although it has less effect on the colder toned, fast enlarging papers. The preparation of this toner involves heating a solution of sodium sulfide and dissolving the selenium metal (in finely powdered form) in it. This presents some dangers; selenium metal is highly poisonous, and care should be taken not to inhale it or the fumes of the boiling liquid.

SOLUTION 1

Potassium Ferricyanide3 ounces 145 grains	100.0 grams	
Potassium Bromide3 ounces 145 grains	100.0 grams	
Add cold water to make 32 ounces	1.0 liter	

For use dilute one part with nine parts of water.

SOLUTION 2

Sodium Sulfide3 ounces 205 grains	104.0 grams	
Selenium Powder 99 grains	6.8 grams	
Add cold water to make 32 ounces	1.0 liter	

Dissolve the sulfide and warm the solution before adding the selenium; continue heating until the latter is completely dissolved.

For use dilute one part with ten parts of water.

Tone the prints for two to three minutes keeping them moving in the bath. Wash the prints thoroughly before drying.

ILFORD TONER IT-4

A gold toner for red tones on papers; the print must first be toned in a sulfide toner, such as Ilford Toner IT-1 or IT-2. The print is then immersed in the gold toning bath, which changes the tone to a reddish color.

Warm Water (125 F or 52 C) 24 ounces	750.0cc	
Ammonium Thiocyanate292 grains	20.0 grams	
Gold Chloride 15 grains	1.0 gram	
Add cold water to make 32 ounces	1.0 liter	

Prints are first toned in the sulfide or hypo-alum toners, then in the above gold toning bath, where the sepia tone will change to reddish brown and then to red. The approximate time of toning is ten minutes for a red tone. The prints are then refixed in a ten per cent solution of sodium thiosulfate (hypo) for five to ten minutes and finally washed thoroughly in running water.

ILFORD TONER IT-5

Gold toner for direct treatment of papers, producing a blue tone.

STOCK SOLUTION A

Thiocarbamide225 grains	14.0 grams	
Water to make 32 ounces	1.0 liter	

STOCK SOLUTION B

Citric Acid Crystals225 grains	14.0 grams	
Water to make 32 ounces	1.0 liter	

STOCK SOLUTION C

Gold Chloride 88 grains	6.0 grams	
Water to make 32 ounces	1.0 liter	

For use, take one part solution A, one part solution B, one part solution C, and ten parts of water. Prints on Ilfobrom papers should be toned from 15 to 30 minutes, according to tone required. Prints on slow, warm-tone papers require about 5 minutes. Keep prints moving during toning and wash thoroughly after the desired tone is reached.

ILFORD TONER IT-6

Iron blue toner for prints and transparencies.

SOLUTION A

Warm Water (125 F or 52 C)	24 ounces	750.0cc
Potassium Ferricyanide	30 grains	2.0 grams
*Sulfuric Acid Concentrated	1 fluid dram	4.0cc
Add cold water to make	32 ounces	1.0 liter

SOLUTION B

Warm Water (125 F or 52 C)	24 ounces	750.0cc
Ferric Ammonium Citrate	30 grains	2.0 grams
*Sulfuric Acid Concentrated	1 fluid dram	4.0cc
Add cold water to make	32 ounces	1.0 liter

* Caution: Always add the acid to the water, slowly, while stirring. Never add water to the acid, which may boil violently.

For use, mix equal parts of each solution just before use. The prints, which should be slightly lighter than normal, must be thoroughly washed before toning. They are then immersed in the toning solution until the desired tone is reached. They are then washed until the yellow stain is removed from the whites. If the wash water is alkaline, some bleaching of the image may take place; this may be prevented by washing the toned prints in several changes of water, each slightly acidified with a few drops of sulfuric or acetic acid.

KODAK TONER T-1a

Hypo-alum sepia toner for brown tones on paper.

Cold Water	90 ounces	2800.0cc
Kodak Sodium Thiosulfate (hypo)	16 ounces	480.0 grams

Dissolve thoroughly and add the following solution:

Hot Water (about 160 F) (70 C)	20 ounces	640.0cc
Kodak Potassium Alum	4 ounces	120.0 grams

Then add the following solution (including precipitate) slowly to the hypo-alum solution while stirring the latter rapidly.

Cold Water	2 ounces	64.0cc
Kodak Silver Nitrate, crystals	60 grains	4.2 grams
Kodak Sodium Chloride	60 grains	4.2 grams

After combining above solutions.

Add water to make	1 gallon	4.0 liters

Note: *The silver nitrate should be dissolved completely before adding the sodium chloride and immediately afterward, the solution containing the milky white precipitate should be added to the hypo-alum solution as directed above. The formation of a black precipitate in no way impairs the toning action of the bath if proper manipulation technique is used.*

For use, pour into a tray supported in a water bath and heat to 120 F (49 C). At this temperature prints will tone in 12-15 minutes depending on the type of paper. Never use the solution at a temperature above 120 F (49 C). Blisters and stains may result. Toning should not be continued longer than 20 minutes at 120 F (49 C).

In order to produce good sepia tones, the prints should be exposed so that the print is slightly darker than normal when developed normally (1½-2 minutes).

The prints to be toned should be fixed thoroughly and washed for a few minutes before being placed in the toning bath. Dry prints should be soaked thoroughly in water. To insure even toning, the prints should be immersed completely and separated occasionally, especially during the first few minutes.

After prints are toned, they should be wiped with a soft sponge and warm water to remove any sediment and washed for one hour in running water.

KODAK TONER T-7a

Bleach and redevelop-type sepia toner, intended mainly for papers of the fast, cold-toned type.

STOCK BLEACHING SOLUTION A

Kodak Potassium Ferricyanide2½ ounces	75.0 grams	
Kodak Potassium Bromide2½ ounces	75.0 grams	
Kodak Potassium Oxalate6½ ounces	195.0 grams	
*Kodak Acetic Acid (28 per cent pure)1¼ fluid ounces	40.0cc	
Water 64 ounces	2.0 liters	

* To make 28 per cent acetic acid from glacial acetic acid, dilute three parts of glacial acetic acid with eight parts of water.

STOCK TONING SOLUTION B

Kodak Sodium Sulfide, desiccated (not sulfite)1½ ounces	45.0 grams	
Water to make 16 ounces	500.0cc	

Prepare Bleaching Bath as follows:

Stock Solution A 16 ounces	500.0cc	
Water to make 16 ounces	500.0cc	

Prepare toner as follows:

Stock Solution B 4 ounces	125.0cc	
Water to make 32 ounces	1.0 liter	

The print to be toned should first be washed thoroughly. Place it in the bleaching bath and allow it to remain until only faint traces of the half-tones are left and the black of the shadows has disappeared. This operation will take about one minute.

Particular care should be taken not to use trays with any iron exposed, otherwise blue spots may result.

Rinse thoroughly in clean cold water.

Place in toner solution until original detail returns. This will require about 30 seconds. Give the print an immediate and thorough water rinse; then immerse it for five minutes in a hardening bath composed of 1 part of the stock hardener Kodak F-1a and 16 parts of water. The color and gradation of the finished print will not be affected by the use of this hardening bath. Remove the print from the hardener bath and wash for one-half hour in running water.

KODAK HARDENER F-1a

A stock hardener solution, which may be used for quick preparation of hardening fixing baths; it is also used without the hypo after certain toning baths, such as the Kodak Toner T-7a above.

Water (125 F or 52 C) 14 ounces	425.0cc	
Kodak Sodium Sulfite, desiccated 2 ounces	60.0 grams	
*Kodak Acetic Acid (28 per cent pure) 6 fluid ounces	190.0cc	
Kodak Potassium Alum 2 ounces	60.0 grams	
Add cold water to make 32 ounces	1.0 liter	

* To make 28 per cent acetic acid from glacial acetic acid, dilute three parts of glacial acetic acid with eight parts of water.

To make up the hardener dissolve the chemicals in the order given above. The sodium sulfite should be dissolved completely before adding the acetic acid. After the sulfite-acid solution has been mixed thoroughly, add the potassium alum with constant stirring.

A fixing bath is made quickly by adding one part of this acid hardener stock solution to four parts of 25 per cent cool hypo solution or eight ounces (250cc) of this hardener to 32 ounces (one liter) of cool hypo solution. A 25 per cent hypo solution is prepared by dissolving eight ounces (240 grams) of sodium thiosulfate (hypo) in sufficient water to make a final volume of 32 ounces (one liter). If the hypo is not thoroughly dissolved before adding the hardener, a precipitate of sulfur is likely to form.

KODAK TONER T-8

This is a polysulfide-type toner recommended for all papers except those of cold tone, such as Kodabromide. The tones produced are darker than the bleach-and-redevelop type of toner will produce; it has the advantage over the hypo-alum process of not requiring heating, although it will work when heated, and the time of toning at 100 F is reduced from 15 to 3 minutes.

Water	24 ounces	750.0cc
Polysulfide (Liver of Sulfur)	¼ ounce	7.5 grams
Kodak Sodium Carbonate, monohydrated	35 grains	2.4 grams
Water to make	32 ounces	1.0 liter

Dissolve chemicals in the order given.

Immerse the well-washed, black-and-white print in the Kodak T-8 bath and agitate for 15-20 minutes at 68 F (20 C) or for 3 or 4 minutes at 100 F (38 C).

Approximate life of toning bath is about 150 8" x 10" prints (or equivalent) per gallon. When the bath begins to become cloudy, the life can be extended by the addition of the same quantity of carbonate as in the formula.

After toning, if any sediment appears on the print, the surface should be wiped with a soft sponge and the print then washed for at least 30 minutes before drying.

KODAK TONER T-11

Iron-blue toner for films or lantern slides; it is not recommended for papers. Paper prints may be toned a similar blue shade in Kodak Toner T-12.

Kodak Potassium Persulfate	7 grains	0.5 gram
Kodak Iron and Ammonium Sulfate (Ferric Alum)	20 grains	1.4 grams
Kodak Oxalic Acid	45 grains	3.0 grams
Kodak Potassium Ferricyanide	15 grains	1.0 gram
Ammonium Alum	73 grains	5.0 grams
Kodak Hydrochloric Acid (10 per cent)	¼ dram	1.0cc
Water to make	32 ounces	1.0 liter

Dissolve chemicals in the order given.

The method of compounding this bath is very important. Each of the solid chemicals should be dissolved separately in a small volume of water, the solution then mixed strictly in the order given, and the whole diluted to the required volume. If these instructions are followed, the bath will be pale yellow in color and perfectly clear.

Immerse the slides or films from 2 to 10 minutes at 68 F (20 C) until the desired tone is obtained. Wash for 10-15 minutes until the highlights are clear. A very slight permanent yellow coloration of the clear gelatin will usually occur but should be too slight to be detectable on projection. If the highlights are stained blue, then either the slide (film) was fogged during development, or the toning bath was stale or not mixed correctly.

Since the toned image is soluble in alkali, washing should not be carried out for too long a period, especially if the water is slightly alkaline.

KODAK TONER T-12

Iron-blue toner for papers.

Kodak Ferric Ammonium Citrate (Green Scales)	60 grains	4.0 grams
Kodak Oxalic Acid, crystals	60 grains	4.0 grams
Kodak Potassium Ferricyanide	60 grains	4.0 grams
Water to make	32 ounces	1.0 liter

Dissolve each chemical separately and filter before mixing together.

Immerse the well-washed print in the toning bath for 10-15 minutes until the desired tone is obtained. Then wash until the highlights are clear.

KODAK TONER T-18

An unusual toner, which produces a blue color only in the deepest shadows of the print. The highlights and middle tones remain white but have the property of mordanting a dye. Thus, it is possible to produce prints having blue shadows, pink, yellow, violet, orange or green middle tones, and clear white highlights. Only basic dyestuffs can be used; the ones suggested below have been tested and do work as stated.

Kodak Ammonium Persulfate	7 grains	0.5 gram
Kodak Iron and Ammonium Sulfate (Ferric Alum) ...	20 grains	1.4 grams
Kodak Oxalic Acid	45 grains	3.0 grams
Kodak Potassium Ferricyanide	15 grains	1.0 gram
Kodak Hydrochloric Acid (10 per cent)	¼ dram	1.0cc
Water to make	32 ounces	1.0 liter

The method of compounding this bath is very important. Each of the solid chemicals should be dissolved separately in a small volume of water, the solutions then mixed strictly in the order given, and the whole diluted to the required volume. If these instructions are followed, the bath will be pale yellow in color and perfectly clear.

Directions for use: Tone until the shadows are deep blue. Then wash 10-15 minutes. Immerse in the basic dye solution T-17a, below for 5-15 minutes until the desired depth of color in the half-tones is obtained. Wash 5-10 minutes after dyeing until the highlights are clear.

KODAK DYE BATH T-17a

Dye ..	3 grains	0.2 gram
*Kodak Acetic Acid (10 per cent)1¼ drams		5.0cc
Water to make	32 ounces	1.0 liter

* To convert glacial acetic acid into ten per cent acetic, take one part glacial acetic acid and add it slowly to nine parts of water.

Thoroughly dissolve the dye in hot water, filter, add the acid, and dilute to volume with cold water.

The following dyes are suitable for toning:

Safranine A..........Red		Victoria GreenGreen	
Chrysoidine 3ROrange		Methylene Blue BB ...Blue	
AuramineYellow		*Methyl VioletViolet	

* For Methyl Violet, use one-fourth the quantity of dye called for in the above formula.

334

KODAK TONER T-20

This toner converts the silver image to a mordant, which then attracts and fixes a dye to the image. The dye is incorporated in the toning bath, so that mordanting and dyeing occur simultaneously and the process can be followed. However, because the dyes have some tendency to stain paper, this process is not very useful for paper prints and is mainly employed on slides, transparencies, and motion picture films.

*Dye ...	X grains	X grams
Kodak Wood Alcohol (or Acetone)	3¼ fluid ounces	100.0cc
Kodak Potassium Ferricyanide	15 grains	1.0 gram
Kodak Acetic Acid (glacial)	1¼ drams	5.0cc
Add water to make	32 ounces	1.0 liter

* The quantity of dye varies according to the dye used as follows:

Safranine Extra Bluish	3 grains	0.2 gram
Tannin Heliotrope	3 grains	0.2 gram
Safranine 6B	3 grains	0.2 gram
Safranine Base	1½ grains	0.1 gram
Pink B	18 grains	1.2 grams
Chrysoidine Base	3 grains	0.2 gram
Chrysoidine 3R	3 grains	0.2 gram
Thioflavine T	3 grains	0.2 gram
Auramine	6 grains	0.4 gram
Victoria Green	6 grains	0.4 gram
Rhodamine B	6 grains	0.4 gram

The nature of the tone varies with time of toning, and eventually a point is reached beyond which it is unsafe to continue as the gradation of the toned image becomes affected. Average toning time at 68 F (20 C) is from three to nine minutes.

KODAK TONER T-21

This is the well-known Nelson Gold Toner, covered by U.S. Patent 1,849,-245. The toning is progressive and may be followed by eye as it occurs; the print may be removed from the toning bath whenever the desired color is reached. Normal toning takes from 5 to 20 minutes on professional contact papers.

STOCK SOLUTION A

Water (about 125 F or 52 C)	1 gallon	4.0 liters
Kodak Sodium Thiosulfate (hypo)	2 pounds	960.0 grams
Kodak Potassium Persulfate	4 ounces	120.0 grams

Dissolve the hypo completely before adding the potassium persulfate. Stir the bath vigorously while adding the potassium persulfate. If the bath does not turn milky, increase the temperature until it does. Prepare the following solution and add it (including precipitate) slowly to the hypo-persulfate solution while stirring the latter rapidly. *The bath must be cool when these solutions are added together.*

Cold Water	2 ounces	64.0cc
Kodak Silver Nitrate (crystals)	75 grains	5.2 grams
Kodak Sodium Chloride	75 grains	5.2 grams

Note: The silver nitrate should be dissolved completely before adding the sodium chloride.

STOCK SOLUTION B

Water	8 ounces	250.0cc
Kodak Gold Chloride	15 grains	1.0 gram

For use, slowly add four ounces (125cc) of solution B to solution A while stirring the latter rapidly.

The bath should not be used until after it has become cold and has formed a sediment. Then pour off the clear liquid for use.

Add the clear solution to a tray standing in a water bath and heat to 110 F (43 C). The temperature, when toning, should be between 100 and 110 F (38 and 43 C). Dry prints should be soaked thoroughly in water before toning.

Keep at hand an untoned black-and-white print for comparison during toning. Prints should be separated at all times to insure even toning.

When the desired tone is obtained, rinse the prints in cold water. After all prints have been toned, return them to the fixing bath for five minutes, then wash for one hour in running water.

The bath should be revived at intervals by the addition of further quantities of the gold solution B. The quantity to be added will depend upon the number of prints toned and the time of toning. For example, when toning to a warm brown, add one dram (4cc) of gold solution after each 50 8″ x 10″ prints or their equivalent have been toned. Fresh solution may be added from time to time to keep the bath up to proper volume.

EDWAL COLOR TONERS

Edwal Color Toners are solutions for converting the silver image on black-and-white prints, slides, movie films, and so on, into colored images. The print or slide or film is immersed in the appropriate color toner working solution with occasional agitation until the desired image color is obtained, whereupon the print, slide, or film is washed in running water 10–20 minutes to remove excess toner. Five colors—red, brown, yellow, green, and blue—are available. Intermediate colors can be obtained by toning first in one color toner and then in another.

Edwal Color Toners are available in 4-ounce bottles of concentrate which make 64-ounces of working solution, enough for about 120 4" x 5" prints; also in one-gallon jugs. The toners themselves are single-solution types, with no offensive odor. They require no heating or other manipulation other than inserting the print, slide, or film into the solution, agitating it occasionally, and putting it into the wash water when the desired tone has been obtained. Edwal Toners can be used at any temperature from 65 to 110 F. Toning is usually complete in four to ten minutes, but the warmer the solution, the faster the toning takes place.

The colored images produced by Edwal Toners are (except for the blue, which is an iron-type toner) dyes which are mordanted onto the silver image. The permanence of the colors is about the same as that of the colors in present-day color films. Most dyes can be made to fade by long exposure to an atmosphere containing industrial fumes, especially in the presence of high humidity and bright direct sunlight. Under ordinary storage conditions, Edwal color-toned images can be expected to last through a normal lifetime.

Although Edwal Color Toners will tone any kind of paper or film that has a silver image, the best effect on prints is obtained with warm-tone papers, such as Kodak Opal Paper or GAF-Ansco Indiatone, developed in Edwal Super 111 or Platinum Developers. Exposure should be kept low enough to allow full development of the paper, but development should never be forced, since this tends to produce fog, which will produce a color even though the fog itself may be invisible in the black-and-white print.

Prints should be fixed not more than one or two minutes in Edwal Hi-Speed Liquid Fix or Quick Fix without hardener, or Industrafix using a 1:5 dilution and should be washed completely free of hypo. The use of Edwal Hypo Eliminator is strongly recommended between fixing and washing to insure complete and rapid removal of fixer. Prints should not be ferrotyped before toning. Ferrotyping can be done after toning if desired.

Toning The Print, Slide, or Film

The toning solution (prepared according to the direction sheet with the bottle) is placed in a porcelain, glass, stainless steel, or rubber tray, and the print, slide, or movie film is immersed in the toner, agitated occasionally, and examined from time to time to see how toning has progressed. The color will look somewhat brighter after the picture has been washed in water than while it is still in the toner, so it is best to tone and wash a sample print or slide first to test the time required for the correct final tone.

If a large number of prints are to have exactly identical color tone, they should all be inserted in the same batch of toner at the same time and toned identically. The toner gradually loses its strength as prints are toned in it, so that simultaneous toning is the best way to get matching tones on a number of different prints.

The longer the toning proceeds, the brighter the color will become until all the silver of the image has been used up. Toning for long periods (15-20 minutes or more) will produce "chalk-like" tones, which have very little depth because of complete removal of the silver.

Toning Slides

Black-and-white slides for instructional purposes, especially those showing machinery, engineering setups, chemical equipment, and so on, benefit by color toning because the addition of the extra color enables the audience to distinguish complicated detail much more readily. Slides are toned in exactly the same fashion as prints and should be washed in running water until the background areas are clear before being dried and mounted in the usual fashion.

Toning Movie Film

Black-and-white movie films, especially titles, can be advantageously toned. The film frequently has to be left in the toner several times as long as a print because the extreme hardening and the coating sometimes applied to the film slow down diffusion of the toners. However, the image eventually will take the color. A two-color effect can be obtained by toning the image one color, washing, and then dyeing the clear areas with a gelatine dye. Nice effects are obtained, for instance, by toning forest scenes green or buildings brown and then tinting the clear areas (mostly sky) blue.

Intensification of Negatives with Color Toners

Toning tends to intensify and increase the contrast of the image on film, so the color toners can be used in this fashion. The green toner is usually preferred. There is no effect on the grain structure. As a matter of fact, if a little background color is allowed to remain, it tends to hide graininess. Tone only until maximum density is obtained. Prolonged toning removes too much silver and flattens the image.

Toning As a Test for Completeness of Washing

In commercial print-making operations, the effectiveness of a print washing system can be tested by toning a washed print in Edwal Brown Toner. If the print is completely washed, it will tone satisfactorily, giving true brown tones over the entire image. If small quantities of hypo are present, the darker areas of the print will tone brown, but the lighter areas will tone a rather wild, bright orange. If still more hypo is present, the darker areas of the print will tone very little, if at all. (Incidentally, very interesting effects can be obtained this way on Christmas cards.) If still more hypo is present, the highlight areas of the print will fade out and the image will be completely lost.

Making of Full Color Pictures from Black-and-White Prints

Some commercial artists and others skilled with a brush use partial toning of different areas with Edwal Color Toners to make full color prints, which are said to be less expensive than prints made by the usual color separation methods. The color toning method has the advantage that any desired hue can easily be obtained just by brushing on the appropriate color toner. Edwal Kwik-Wet is added to the color toners for this type of work in order to get ease of flow.

Keeping Characteristics

Edwal Color Toner concentrates are furnished with one ingredient in a small plastic cup on the four-ounce bottles and in a separate bottle for the one-

gallon size. The toners will keep indefinitely as long as this separate ingredient is not added to the concentrate. Once the separate ingredient has been dissolved in the concentrate, the toner concentrate can be kept satisfactorily for six to eight weeks for all colors except blue, which can be kept for a year or more. Once the toning solution has been used, it should not be stored for future use if the same tone is desired. However, dilution and storage of the toner for days or weeks before use often produce rather exotic shades, which may be quite interesting.

Pertinent Points

Prolonged washing of a toned print, especially if the wash water is slightly alkaline, will gradually remove the image color. This is useful if a too strong color is to be "washed out" somewhat but should be otherwise avoided. The dyes themselves can be washed out of clothing with soap and water if stains should occur. Washing with water at room temperature (70–80 F) removes background color from the non-image areas more efficiently than washing with cold water.

Iron from chipped spots in processing trays or from water supply pipes will cause small blue or green spots on the surface of a print through reaction with the toner.

Clean highlights can be obtained in a toned print only if the highlights of the black-and-white prints are completely free of fog. Fog can be caused by using old or light-struck paper, forced development, insufficient restrainer in the developer, or use of an old fixing bath loaded with silver.

The highlights of a green-toned print may be more quickly cleared of excess dye by a short bath in a one per cent sodium bisulfite solution (or one per cent sodium sulfite plus one per cent acetic acid). A brief bath in a one per cent sodium carbonate solution will help clear a blue-toned print. Stronger solutions will remove part or all of the color from the image itself, if desired. In all cases, at least five minutes wash in water should follow clearing.

Toning speed and brightness of the image can both be increased by adding between ½ ounce and one ounce of 28 per cent acetic acid to the 64 ounce toner obtained from a 4-ounce bottle of brown, red, yellow, or green toner. There is little effect with the blue.

ANSCO REDUCER 310

This is a basic version of the well-known Farmer's Reducer; it tends to cut the shadows before affecting the highlights very much; it is therefore recommended for negatives that are dense due to overexposure. It is also useful to clear fog from reproduction films.

SOLUTION 1

Sodium Thiosulfate (hypo)	8 ounces	240.0 grams
Add cold water to make	32 ounces	1.0 liter

SOLUTION 2

Ansco Potassium Ferricyanide	½ ounce 55 grains	19.0 grams
Add cold water to make	8 ounces	250.0cc

For use mix 1 part solution 2 and 4 parts solution 1 in 32 parts water. Solutions 1 and 2 should be stored separately and mixed immediately before use.

ANSCO REDUCER 311

A superproportional reducer, that attacks highlight detail before the shadows; hence, useful for reducing negatives that have been overdeveloped.

Ansco Potassium Ferricyanide	1 ounce 75 grains	35.0 grams
Ansco Potassium Bromide	¼ ounce 40 grains	10.0 grams
Add cold water to make	32 ounces	1.0 liter

Bleach in this solution and after thorough washing, redevelop to desired density and contrast in Ansco 47 or other negative developer except fine-grain developers. Then fix and wash in usual manner. Conduct operation in subdued light.

ILFORD REDUCER IR-1

A two-solution Farmer's Reducer for lowering the density of overexposed negatives.

SOLUTION A

Sodium Thiosulfate	6¾ ounces	200.0 grams
Water to make	32 ounces	1.0 liter

SOLUTION B

Potassium Ferricyanide	3 ounces 145 grains	100.0 grams
Cold water to make	32 ounces	1.0 liter

To use, take sufficient solution A to cover the negative and add just enough solution B to color the solution a pale yellow. Energy of reduction is proportional to the amount of solution B used, and the process should be closely watched. When sufficient reduction is attained, wash thoroughly and dry in the normal manner.

ILFORD REDUCER IR-2

Superproportional reducer for reduction of overdeveloped and excessively contrasty negatives.

Ammonium Persulfate	365 grains	25.0 grams
Cold water to make	32 ounces	1.0 liter

It is important that the water be free from dissolved chlorides; distilled water is preferable. One or two drops of sulfuric acid should be added to the mixed solution to insure consistent action. Remove the negative from the reducer just before reduction is complete and rinse with a five per cent solution of sodium sulfite to stop the action, then wash thoroughly.

ILFORD REDUCER IR-3

A combination of a persulfate reducer and a permanganate reducer, which is very nearly proportional in its action.

SOLUTION A

Warm Water (125 F or 52 C) 24 ounces	750.0cc	
Potassium Permanganate 4 grains	0.25 grams	
*Sulfuric Acid Concentrated 22 minims	1.5cc	
Add cold water to make 32 ounces	1.0 liter	

SOLUTION B

Ammonium Persulfate 365 grains	25.0 grams	
Cold water to make 32 ounces	1.0 liter	

* Caution: Always add the acid to the water, never water to acid.

For use mix one part of solution A with three parts of solution B. When reduction has gone far enough, pour-off the reducer and flood the negative with a one per cent solution of sodium bisulfite to clear it.

ILFORD REDUCER IR-5

An iodine-cyanide reducer, which has little tendency to stain and can be used on films, plates, and papers.

STOCK IODINE SOLUTION

Warm Water (125 F or 52 C) 24 ounces	750.0cc	
Potassium Iodide 365 grains	25.0 grams	
Iodine Crystals 60 grains	4.0 grams	
Add cold water to make 32 ounces	1.0 liter	

STOCK CYANIDE SOLUTION

*Potassium Cyanide 120 grains	8.0 grams	
Add cold water to make 32 ounces	1.0 liter	

* Caution: Potassium cyanide is a dangerous poison; it must be used only in a well-ventilated room. Avoid breathing its fumes; do not discard cyanide solutions into a sink that may contain acid.

For use, take 1 ounce of each stock solution and add water to the mixed solutions to make 20 ounces (or take 25cc of each solution and add water to make 500cc of working bath).

KODAK REDUCER R-2

This is a cutting reducer, with much the same effect as the Farmer formula; it attacks shadows before highlights and is mainly used to lower the density of overexposed negatives.

STOCK SOLUTION A

Water 32 ounces	1.0 liter	
Kodak Potassium Permanganate1¾ ounces	52.5 grams	

STOCK SOLUTION B

Water 32 ounces	1.0 liter	
Kodak Sulfuric Acid, C.P. 1 fluid ounce	32.0cc	

The best method of dissolving the permanganate crystals in solution A is to use a small volume of hot water (about 180 F or 82 C) and shake or stir the solution vigorously until completely dissolved; then dilute to volume with cold water. When preparing stock solution B, always add the sulfuric acid to the water slowly with stirring and never the water to the acid, otherwise the solution may boil and spatter the acid on the hands or face, causing serious burns.

Note: If a scum forms on the top of the permanganate solution or a reddish curd appears in the solution, it is because the negative has not been sufficiently washed to remove all hypo, or because the permanganate solution has been contaminated by hypo. The separate solutions will keep and work perfectly for a considerable time if proper precautions against contamination are observed. The two solutions should not be combined until immediately before use. They will not keep long in combination.

The negative must be thoroughly washed to remove all traces of hypo before it is reduced. For use, take 1 part A, 2 parts B, and 64 parts water. When the negative has been reduced sufficiently, place it in a fresh acid fixing bath (Formula F-5) for a few minutes to remove yellow stains; then wash thoroughly.

If reduction is too rapid, use a large volume of water when diluting the solution for use. This solution should not be used as a stain remover as it has a tendency to attack the image before it removes the stain.

KODAK REDUCER R-4a

The well-known Farmer's Reducer for reducing the density of overexposed negatives; it has cutting action and attacks the shadows before the highlights.

STOCK SOLUTION A

Kodak Potassium Ferricyanide 1¼ ounces	37.5 grams	
Water to make 16 ounces	500.0cc	

STOCK SOLUTION B

Kodak Sodium Thiosulfate (hypo) 16 ounces	480.0 grams	
Water to make 64 ounces	2.0 liters	

For use take: Stock solution A, 1 ounce (30cc); stock solution B, 4 ounces (120cc), and water to make 32 ounces (one liter). Add A to B, then add the water.

Pour the mixed solution at once over the negative to be reduced. Watch closely. The action is best seen when the solution is poured over the negative in a white tray. When the negative has been reduced sufficiently, wash thoroughly before drying.

For less rapid reducing action, use one-half the above quantity of stock solution A, with the same quantities of stock solution B and water.

Solutions A and B should not be combined until they are to be used. They will not keep long in combination.

Farmer's Reducer may also be used as a two-solution formula by treating the negative in the ferricyanide solution first and subsequently in the hypo solution. Almost proportional reduction is obtained by this method. See Formula R-4b.

KODAK REDUCER R-4b

Whereas Farmer's Reducer in a single solution has a cutting action and attacks the shadows first, it may also be used as two separate solutions, treating the negative first in the ferricyanide bath, then in the hypo. This method gives almost proportional reduction and can be used to compensate for overdevelopment.

SOLUTION A

Kodak Potassium Ferricyanide	¼ ounce	7.5 grams
Water to make	32 ounces	1.0 liter

SOLUTION B

Kodak Thiosulfate (hypo)	6¾ ounces	200.0 grams
Water to make	32 ounces	1.0 liter

Treat the negatives in solution A with uniform agitation for one to four minutes at 60 to 70 F (18 to 21 C) depending on the degree of reduction desired. Then immerse them in solution B for five minutes and wash thoroughly. The process may be repeated if more reduction is desired. For the reduction of general fog, one part of solution A should be diluted with one part of water.

The ferricyanide solution will keep indefinitely if shielded from strong daylight. If hypo is introduced by alternate treatment, the life of the ferricyanide solution will be shortened.

KODAK REDUCER R-5

A combination of a persulfate, superproportional reducer, and a permanganate cutting reducer, this formula gives almost proportional reduction and is recommended for the reduction of normally exposed negatives that have been overdeveloped.

STOCK SOLUTION A

Water	32 ounces	1.0 liter
Kodak Potassium Permanganate	4 grains	0.3 gram
*Kodak Sulfuric Acid (ten per cent solution)	½ fluid ounce	16.0cc

STOCK SOLUTION B

Water	96 ounces	3.0 liters
Kodak Ammonium Persulfate	3 ounces	90.0 grams

* To make a 10% solution of sulfuric acid, take one part of concentrated acid and add it to nine parts of water, slowly with stirring. *Never add the water to the acid,* because the solution may boil and spatter the acid on the hands or face, causing serious burns.

For use, take one part of A to three parts of B. When sufficient reduction is secured, the negative should be cleared in a one per cent solution of sodium bisulfite. Wash the negative thoroughly before drying.

This solution does not keep well.

KODAK REDUCER R-8a

A modified Belitzski Reducer, which is recommended for the reduction of negatives that are both overexposed and overdeveloped; its action is between a cutting and a proportional reducer.

Water (125 F or 52 C)	24 ounces	750.0cc
Kodak Ferric Ammonium Sulfate (Ferric Alum)	1½ ounces	45.0 grams
*Kodak Potassium Citrate	2½ ounces	75.0 grams
Kodak Sodium Sulfite, desiccated	1 ounce	30.0 grams
Kodak Citric Acid	¾ ounce	22.5 grams
Kodak Sodium Thiosulfate (hypo)	6¾ ounces	200.0 grams
Add cold water to make	32 ounces	1.0 liter

* Sodium citrate should not be used in place of potassium citrate because the rate of reduction is slowed up considerably.

Dissolve chemicals in the order given.

Use full strength for maximum rate of reduction. Treat negatives one to ten minutes at 65-70 F (18-21 C). Then wash thoroughly. If a slower action is desired, dilute one part of solution with one part of water. The reducer is especially suitable for the treatment of dense, contrasty negatives.

KODAK REDUCER R-15

Like all reducers using persulfate, this has a superproportional action, reducing highlight density before it attacks the shadows. It is thus useful for normally exposed and overdeveloped negatives, or for negatives that are slightly underexposed and have been forced too far in development in an attempt to compensate.

STOCK SOLUTION A

Water	32 ounces	1.0 liter
Potassium Persulfate	1 ounce	30.0 grams

STOCK SOLUTION B

Water	8 ounces	250.0cc
*Sulfuric Acid (10% solution)	½ ounce	15.0cc
Water to make	16 ounces	500.0cc

* To prepare a ten per cent solution of sulfuric acid, take one part of Kodak sulfuric acid and, with caution to avoid contact with the skin, add it slowly to nine parts of water with stirring. *Never add the water to the acid,* because the solution may boil and spatter the acid on the hands or face, causing serious burns.

For use: Take two parts of solution A and add one part of solution B. Only glass, hard rubber, or impervious and unchipped enamelware should be used to contain the reducer solution during mixing and use.

Treat the negative in the Kodak Special Hardener SH-1 for three minutes and wash thoroughly before reduction. Immerse in the reducer with frequent agitation and inspection (accurate control by time is not possible) and treat until the required reduction is almost attained; then remove from the solution, immerse in an acid fixing bath for a few minutes, and wash thoroughly before drying. Used solutions do not keep well and should be promptly discarded.

For best keeping in storage, the persulfate stock solution A should be kept away from excessive heat and light. Keeping life of stock solution A—about two months at 75 F.

AMMONIUM THIOSULFATE REDUCER

A useful reducer and stain remover can be made quite easily by adding citric acid to an ammonium thiosulfate rapid fixing bath such as Kodak F-7, Kodafix Solution, Kodak Rapid Fixer, or similar products of other manufacturers.

Because of the strong odor of sulfur dioxide that is emitted, the solution should be used in a well-ventilated, large room, and kept away from sensitized materials. If it has been handled to any great extent, the film should be carefully cleaned with a solvent to remove surface grease. Then pre-wet the film or print in a solution of wetting agent such as Kodak Photo-Flo, Agfa Agepon, or one of the aerosols on the market.

The course of reduction can be watched while the film is in the tray because the solution is clear. When the desired degree of reduction has been attained, wash the film thoroughly, and dry in the usual way.

Normal Reduction

For the removal of silver stains, dichroic fog, and for the reduction of prints and fine grain negative materials, dilute one part of Kodafix solution with two parts of water, or dilute Kodak Rapid Fixer and add hardener as recommended for negatives, or use Kodak F-7 full strength. Then dissolve citric acid in the proportion of one-half ounce for each quart of diluted fixer (15 grams per liter). Possible sulfurization of the thiosulfate in the fixer can be avoided by dissolving the citric acid in part of the water to be used for dilution.

To remove silver stains and dichroic fog, immerse the negative or print in the solution and swab the surface with absorbent cotton to hasten removal of surface scum. The action is usually complete in two to five minutes. Stop the process immediately if any reduction of low-density image detail is noted.

To reduce dense prints and fine-grain negatives, this solution is recommended for the correction of slight overexposure or overdevelopment; however, excessive reduction may cause loss of image quality.

Strong Reduction

For reduction of negative materials, dilute the fixer as above, but double the amount of citric acid, that is, add citric acid in the proportion of one ounce per quart of diluted solution (30 grams per liter).

The time of treatment will depend on the type of material and the amount of reduction desired. On high-speed films that have a relatively coarse-grained image, the action is likely to be very slow.

Always wash thoroughly after the reduction treatment, and dry in the normal manner.

ANSCO INTENSIFIER 330

A mercury intensifier for increasing the printing density of underdeveloped negatives.

Ansco Potassium Bromide ¼ ounce 35 grains	10.0 grams	
Mercuric Chloride ¼ ounce 35 grains	10.0 grams	
Add cold water to make 32 ounces	1.0 liter	

Do not dilute for use. Negatives to be intensified must be very thoroughly washed first, or yellow stains may result on the intensified negative. Immerse negatives in above solution until thoroughly bleached to the base of the film and then wash in water containing a few drops of hydrochloric acid. Redevelop bleached negatives in five per cent sodium sulfite or any standard developer. Surface scum that forms during storage of the bleaching solution does not affect the bleach but should be removed before using the solution.

ANSCO INTENSIFIER 331

Based on Monckhoven's formula, this intensifier produces very great density and contrast and is used mainly for line work and photomechanical processes.

SOLUTION 1

Ansco Potassium Bromide ¾ ounce	23.0 grams	
*Mercuric Chloride ¾ ounce	23.0 grams	
Add cold water to make 32 ounces	1.0 liter	

SOLUTION 2

Cold Water 32 ounces	1.0 liter	
*Potassium Cyanide ¾ ounce	23.0 grams	
Ansco Silver Nitrate ¾ ounce	23.0 grams	

* Warning—*Because of the deadly poisonous nature of this intensifier, it should be used with care, and bottles containing it should be suitably marked. Never mix cyanide solutions with acids or use them in poorly ventilated rooms. Discard waste solutions into running water.*

The silver nitrate and the potassium cyanide should be dissolved in separate lots of water, and the former added to the latter until a permanent precipitate is produced. The mixture is allowed to stand 15 minutes, and after filtering, forms solution 2.

Place negatives in solution 1 until bleached through, then rinse and place in solution 2. If intensification is carried too far, the negative may be reduced with a weak solution of hypo.

ANSCO INTENSIFIER 332

The normal chromium intensifier, most popular because the results are permanent. The amount of intensification can be influenced by variations of the time and formula of the redeveloper.

Cold Water 32 ounces	1.0 liter	
Ansco Potassium Bichromate135 grains	9.0 grams	
Hydrochloric Acid (C.P.) 1.6 drams	6.0cc	

Immerse negatives in this solution until bleached, wash for 5 minutes in running water and redevelop in bright but diffused light in a Metol-hydroquinone developer, such as Ansco 47. Negatives should then be given a 15-minute wash before drying. Intensification may be repeated for increased effect.

If any blue coloration of the film base is noticeable after intensification, it may be easily removed by washing the film for two or three seconds in water containing a few drops of ammonia, in a five per cent solution of potassium metabisulfite, or a five per cent solution of sodium sulfite. This treatment should be followed by a thorough washing in water.

DUPONT INTENSIFIER 1-I

Another chromium intensifier, differing from the above mainly in that it is a concentrated stock solution, requiring only dilution for use.

STOCK SOLUTION

Water	32 ounces	1.0 liter
Potassium Bichromate	3 ounces	90.0 grams
Hydrochloric Acid (C.P.)	2 fluid ounces	64.0cc

For use, take one part of stock solution to ten parts of water. Bleach thoroughly; then wash five minutes and redevelop in artificial light or daylight (not direct sunlight) in a nonstaining developer, such as 53-D, diluted one to three.

Developers containing a high concentration of sulfite are not suitable for redevelopment, since the sulfite tends to dissolve the bleached image before the developing agents have time to act on it.

The degree of intensification can be controlled by varying the time of redevelopment. If the negative is not redeveloped fully, fix for five minutes and then wash thoroughly. Fixing is unnecessary if redevelopment is thorough. Repeating the process gives greater intensification.

DUPONT INTENSIFIER 2-I

A variation on the mercury intensifier formula using mercuric iodide.

STOCK SOLUTION

Mercuric Iodide	292 grains	20.0 grams
Potassium Iodide	292 grains	20.0 grams
Sodium Thiosulfate (hypo)	292 grains	20.0 grams
Add water to make	32 ounces	1.0 liter

Use without dilution.

Film should be washed briefly before immersing in this bath. The amount of intensification is proportional to the time of treatment and may be followed visually. When the desired degree of intensification has been achieved, wash the film in running water for 20 minutes. Treatment in excess of 15-20 minutes is ineffectual.

The image produced is not permanent unless treated by redevelopment in an ordinary nonstaining developer such as DuPont 53-D or by bathing in a one per cent sodium sulfide solution before washing.

DUPONT INTENSIFIER 3-I

This is a silver intensifier, which adds density more or less proportionally to the amount of silver already present in the image; thus, its effect is more or less the same as continued development. That is, it increases not only the density of the image but also its contrast. It is most suited, then, to the intensification of fully exposed negatives that have accidentally been underdeveloped.

STOCK SOLUTION 1
(Store in a brown bottle)

Silver Nitrate, crystals	2 ounces	60.0 grams
Add distilled water to make	32 ounces	1.0 liter

STOCK SOLUTION 2

Sodium Sulfite	2 ounces	60.0 grams
Add water to make	32 ounces	1.0 liter

STOCK SOLUTION 3

Sodium Thiosulfate (hypo)	3½ ounces	105.0 grams
Add water to make	32 ounces	1.0 liter

STOCK SOLUTION 4

Sodium Sulfite	½ ounce	15.0 grams
Metol	350 grains	24.0 grams
Add water to make	96 ounces	3000.0cc

The intensifier solution is prepared as follows: Add one part of solution 2 to one part of solution 1, stirring constantly. A white precipitate will form, which is dissolved by adding one part of solution 3. Allow the resulting solution to stand until it is clear. Add, stirring constantly, three parts of solution 4. The intensifier is now ready for use and must be used within 30 minutes of mixing.

The degree of intensification is proportional to the time of treatment, which should not be more than 25 minutes. After treatment the film is immersed in a plain 30 per cent hypo solution for 2 minutes and then washed thoroughly.

ILFORD INTENSIFIER I.In-5

This intensifier depends on a change in image color from black to red for added printing density, although visually the negative does not appear to be noticeably denser.

STOCK SOLUTION A

Uranium Nitrate	¾ ounce	22.0 grams
Water to make	32 ounces	1.0 liter

STOCK SOLUTION B

Potassium Ferricyanide	¾ ounce	22.0 grams
Water to make	32 ounces	1.0 liter

The intensifier is prepared for use by mixing solution A, four parts; solution B, four parts; acetic acid 99 per cent (glacial), one part. After treatment the negative is washed in several changes of water acidulated with a few drops of glacial acetic acid. The intensification can be removed by washing in a weak solution of sodium carbonate, and is, in any case, of limited permanence.

KODAK INTENSIFIER In-1

A basic mercury bleach and redevelop intensifier, which is convertible to the Monckhoven formula by the use of the silver-cyanide redeveloper given below.

Bleach the negative in the following solution until it is white, then wash thoroughly:

Kodak Potassium Bromide	¾ ounce	22.5 grams
Mercuric Chloride	¾ ounce	22.5 grams
Water to make	32 ounces	1.0 liter

The negative can be blackened with ten per cent sulfite solution, a developing solution (such as Formula D-72), diluted one to two, or ten per cent ammonia (one part concentrated ammonia, 28 per cent to nine parts of water), these giving progressively greater density in the order given. To increase contrast greatly, treat with the following solution:

SOLUTION A

Water	16 ounces	500.0cc
*Sodium or Potassium Cyanide	½ ounce	15.0 grams

SOLUTION B

Water	16 ounces	500.0cc
Kodak Silver Nitrate, crystals	¾ ounce	22.5 grams

* Warning: *Cyanide is a deadly poison and should be handled with extreme care.* Use rubber gloves and avoid exposure to its fumes. Cyanide reacts with acid to form poisonous hydrogen cyanide gas. When discarding a solution containing cyanide, always run water to flush it out of the sink quickly. Cyanide solutions should never be used in poorly ventilated rooms.

To prepare the intensifier, add the silver nitrate (solution B) to the cyanide (solution A) until a permanent precipitate is just produced; allow the mixture to stand a short time and filter. This is called Monckhoven's Intensifier.

Redevelopment cannot be controlled as with the chromium intensifier (Kodak In-4) but must go to completion.

This Mercury Intensifier is recommended where extreme intensification is desired but where permanence of the resulting image is not essential. If permanence is essential, either the Chromium (In-4) or Silver (In-5) Intensifier should be used.

KODAK INTENSIFIER In-4

The basic chromium intensifier for films and plates.

STOCK SOLUTION

Water	24 ounces	750.0cc
Kodak Potassium Bichromate	3 ounces	90.0 grams
Kodak Hydrochloric Acid (C. P.)	2 fluid ounces	64.0cc
Add cold water to make	32 ounces	1.0 liter

For use, take one part of stock solution to ten parts of water.

Harden the negative with an alkaline solution of formalin (Formula SH-1) before treatment with the chromium intensifier, or the gelatin may reticulate and ruin the negative.

Bleach thoroughly at 68 F (20 C), then wash five minutes and redevelop fully (about five minutes) in artificial light or daylight (not sunlight) in any quick-acting, nonstaining developer containing the normal proportion of bromide, such as Formula D-72, diluted 1:3. If the negative is not redeveloped fully then, fix for five minutes and wash thoroughly. Fixing is unnecessary if redevelopment is thorough. The degree of intensification may be controlled by varying the time of redevelopment. Greater intensification can be secured by repetition.

Negatives intensified with chromium are more permanent than those intensified with mercury.

Developers containing a high concentration of sulfite, such as Formula D-76, are not suitable for redevelopment, since the sulfite tends to dissolve the bleached image before the redeveloping agents have time to act on it.

KODAK INTENSIFIER In-5

This is a silver intensifier that gives proportional intensification, thus increasing image contrast. It is suitable for lantern slides and motion picture print films, because it does not change the color of the image.

STOCK SOLUTION 1 (Store in a brown bottle)

Kodak Silver Nitrate, crystals	2 ounces	60.0 grams
Distilled water to make	32 ounces	1.0 liter

STOCK SOLUTION 2

Kodak Sodium Sulfite, desiccated	2 ounces	60.0 grams
Water to make	32 ounces	1.0 liter

STOCK SOLUTION 3

Kodak Sodium Thiosulfate (hypo)	3½ ounces	105.0 grams
Water to make	32 ounces	1.0 liter

STOCK SOLUTION 4

Kodak Sodium Sulfite, desiccated	½ ounce	15.0 grams
Kodak Elon Developing Agent	365 grains	25.0 grams
Water to make	96 ounces	3.0 liters

Prepare the intensifier solution for use as follows: Slowly add one part of solution 2 to one part of solution 1, shaking or stirring to obtain thorough mixing. The white precipitate that appears is then dissolved by the addition of one part of solution 3. Allow the resulting solution to stand for a few minutes until clear. Then add, with stirring, three parts of solution 4. The intensifier is then ready for use, and the film should be treated immediately. The degree of intensification obtained depends upon the time of treatment, which should not exceed 25 minutes. After intensification, immerse the film for 2 minutes with agitation in a plain 30 per cent hypo solution. Then wash thoroughly.

The mixed intensifier solution is stable for approximately 30 minutes at 68 F (20 C).

KODAK INTENSIFIER In-6

A relatively new formula, using quinone and thiosulfate to produce a brown image that has great printing density; this formula can produce a greater degree of intensification than any other single-solution intensifier when used with high-speed negative materials. The brown image is not entirely permanent but ample for all but archival purposes. The intensified image is soluble in hypo, so that the intensified negatives must not be placed in a fixing bath, nor even in a wash tank contaminated with fixing bath.

Avoid touching the emulsion side of films with the finger before or during intensification or surface markings will be produced. All negatives either dry or freshly processed should be washed five to ten minutes and hardened in the alkaline formaldehyde hardener, Kodak SH-1, for five minutes at 68 F (20 C) and then washed for five minutes after intensification. During treatment in the intensifier, agitate frequently to avoid streaking. Treat only one negative at a time when processing in a tray.

For highest degree of intensification, treat for about 10 minutes at 68 F (20 C), then wash 10-20 minutes and dry as usual; for a lower degree of intensification, treat for shorter times.

SOLUTION A

*Water (about 70 F)	24 ounces	750.0cc
**Sulfuric Acid Concentrated	1 ounce	30.0cc
Kodak Potassium Bichromate	¾ ounce	22.0 grams
Water to make	32 ounces	1.0 liter

SOLUTION B

*Water (about 70 F)	24 ounces	750.0cc
Kodak Sodium Bisulfite	52 grains	3.8 grams
Kodak Hydroquinone	½ ounce	15.0 grams
Kodak Photo-Flo	1 dram	3.8cc
Water to make	32 ounces	1.0 liter

SOLUTION C

*Water (about 70 F)	24 ounces	750.0cc
Kodak Sodium Thiosulfate (hypo)	¾ ounce	22.5 grams
Water to make	32 ounces	1.0 liter

* The water used for mixing the solutions for the intensifier should not have a chloride content greater than about 15 parts per million (equivalent to about 25 parts of sodium chloride per million), otherwise the intensification will be impaired. If in doubt as to chloride content, use distilled water.

** Caution: Add the acid slowly and cautiously to the water, stirring carefully to avoid local overheating.

For use: To one part of solution A with stirring add two parts of solution B, then two parts of solution C; continue stirring and finally add one part of solution A. The order of mixing is important and should be followed.

The stock solutions for the intensifier will keep in stoppered bottles for several months. The intensifier should usually be mixed fresh before use, but it is stable for two or three hours without use. The bath should be used only once and then discarded, because a used bath may produce a silvery scum on the surface of the image.

This page is being reserved
for future expansion.

INTRODUCTION TO "COLOR PROCESSING"

Practically all of today's color processes are based on the single chemical procedure known as *dye-coupling development*. The principle is older than its use in color photography; the coupling reaction has been in use for a long time in textile printing, to form colors within the fibers of a fabric. In that industry, the fabric is first printed with a pattern; essentially colorless intermediates are used. After printing, the fabric is immersed in a coupling solution, which reacts with the intermediates already printed on the fabric to form a colored dye within the cloth itself. Some of the chemicals involved in this procedure are much the same as those used in early color photographic materials.

The basic difference between fabric printing and color photography is simply that in color photography the colors have to be formed only where the material has already been exposed to light in order to form the colored image. Thus, although the color-forming chemicals may be the same as or similar to those used in fabric printing, the dye coupler must be one affected only by the presence of a latent silver image.

Certain substituted paraphenylene diamines have the necessary properties: they are developers of a latent silver image and do not couple with dye formers in their normal state, but the oxidation product that results from the development of the silver image can and will couple with dye formers to produce colored dyestuffs. Although the substituted paraphenylene diamines, such as diethyl-paraphenylene diamine and dimethyl-paraphenylene diamine, are still used with some color films, other developing agents have since been found that will work in the same way but have superior properties of other kinds, such as lack of toxicity.

The coupling reaction takes place at the same time as the development and oxidation reaction, before the developer molecule has had time to move from the location of the silver bromide grain being developed. Thus, the dye is formed at the exact location of the silver grain and surrounds it like a small cloud.*

* Therefore, the general belief that color films, having a dye image, are grainless, is not true. The dye image in a color film is composed of numerous small spots of dye, corresponding in position and spacing to the original grains of the film emulsion. A coarse-grained silver image will result in a coarse-grained dye image. The very fine-grained results produced by such reversal films as Kodachrome 25 and similar films are due first, to the very fine-grained emulsions used in their manufacture and second, to the reversal process, which always produces a very fine-grained image.

Kodachrome Film was the first dye-coupling film introduced in the United States in the early 1930's. It consisted of three layers of emulsion, sensitized to blue, green, and red, respectively, with intermediate layers for separation. The first intermediate layer contained a yellow dye to prevent blue light from reaching the lower layers; the second intermediate layer was clear gelatin and was used merely as a separator. Processing was done by a rather complex procedure, which, omitting some unimportant stages and several intermediate dryings, was roughly as follows:

1. Black-and-white negative development of all three layers.

2. Re-exposure to light for reversal to positive.

3. Development of all three layers in a coupling developer producing a cyan dye plus a silver image in all three layers.

4. Bleaching in a controlled-penetration bleach, which reconverted the silver image in the top two layers to silver bromide and at the same time destroyed the cyan dye formed therein.

5. Re-exposure to light to form a developable image in the top two layers, followed by development in a coupling developer to form a magenta dye in these layers.

6. Bleaching in a controlled-penetration bleach to reconvert only the top layer to silver bromide and to destroy the magenta dye therein at the same time.

7. Re-exposure to light and development in a coupling developer to produce a yellow image in the top layer only.

8. Bleaching in a silver bleach to remove all positive silver images and to leave only the three dye images in their respective layers.

Even with the intermediate separator layers, which were designed not only to prevent color mixing but also to provide a factor of safety in processing, the process was quite critical and could be done only on very complex machines with incredibly precise control. It could not be performed with ordinary darkroom equipment nor even with the machines available to the average photofinisher; hence all Kodachrome Film at that time had to be returned to the manufacturer for processing.

Some time later, Kodak devised a new and simpler method of processing Kodachrome Film; the assumption was that a properly designed first developer would not destroy the color sensitivity of the individual layers. This eliminated the need for controlled-penetration of processing solutions; the layers could simply be re-exposed separately to the appropriate colored light and then be processed in a simple coupling developer without danger of putting a color in the wrong layer. Again, schematically only, with some minor steps omitted, the process is essentially as follows:

1. Development of all three layers in a black-and-white negative developer.

2. Re-exposure of the film to red light from the back side.

3. Development in a color-coupling developer to produce a cyan image, which will be in the bottom layer only because this is the only layer that has been affected by exposure to red light.

4. Re-exposure of the film to blue light from the front side. Because of the yellow filter layer, this will not affect the middle emulsion layer.

5. Development in a color-coupling developer to form a yellow image in the top layer.

6. Now, a negative image is in all three layers, and positive dye and silver images are in the top and bottom layers. Since these images interfere with exposing the middle layer, this layer is developed in a coupling developer for the magenta image containing a chemical fogging agent, so no re-exposure is required.

7. Bleaching and fixing to remove all silver images, leaving only the three-color dye image.

Although the new process does not have many fewer steps than the older one, it is much easier to control and can be carried out on fairly conventional processing machines. Thus, Kodachrome Film now can be processed by commercial photofinishers, but it still cannot be developed conveniently with simple tank equipment in the ordinary darkroom.

Another approach was always theoretically possible. It has already been pointed out that a single developing agent can produce all three dyes by the use of three appropriate dye-formers. As far back as 1913, Fischer and Siegrist had demonstrated a color film in which the necessary color formers were incorporated directly in the emulsion layers; thus, when this film was processed in a coupling developer, the proper color was automatically formed in each layer.

Early attempts to apply this simple and elegant method to practical color films failed. When the emulsion layers were as thin as they had to be to secure adequate image sharpness and to prevent loss in speed due to light absorption, it was impossible to keep the color formers in their respective layers. A good deal of wandering of color couplers between layers took place, and colors were badly degraded by unwanted intermingling.

This kind of mixing could not be prevented by putting separator layers between the emulsion coats, because of the resultant loss in image sharpness and the existence of desirable inter-image effects, too complex to discuss here, which should not be eliminated.

After many years of research, two practical methods have been devised to avoid the wandering of color couplers. In the case of Agfa color films, Anscochrome, and several other types, the method used to immobilize the color former in its own layer was to design a color former whose molecule is large, heavy, and relatively immobile. This end is attained by adding a very long but inert side chain, containing upwards of 18 carbon atoms, to the color-former molecule. This molecule thus becomes too large to move freely through the sponge-like structure of the gelatin; at the same time, the addition of the chain does not interfere with the chemical ability of the molecule to react with the color-coupler developer to form the desired dyes.

A second method, employed in Kodacolor, Kodak Vericolor II, and Kodak Ektachrome films, uses color formers in their normal state but suspends them in a protective colloid, made of a water-permeable but insoluble plastic material. Since the colloid is permeable, the processing solutions can penetrate it and react as desired, but since it is insoluble in water, the action of the processing solutions cannot move it from one layer to another. The addition of certain solvents to the baths, such as benzyl alcohol, facilitates the penetration of the processing solutions.

Several other processes have been proposed. In one case the color formers are actually plastics, which are used as substitutes for the gelatin of the emulsion layers, i. e., as carriers for the silver halides. In another, plastic layers containing the needed color formers are coated between the emulsion layers. Evidently, neither of these processes was successful, since they were never marketed.

Whichever system is used, the method of processing is quite straightforward. For a color negative, processing merely consists of development in a coupling developer that forms the required dyes in the three layers, together with the silver image. This operation is followed by a bleach to remove the unwanted silver image and a fixing bath to eliminate both the bleached silver and the unexposed silver halides of the original emulsion. The result is a negative image in complementary colors, which can, in turn, be printed on a paper having a similar arrangement of emulsion coatings.

For color films producing a positive transparency image, the process is slightly longer but equally direct. In essence, it is a normal reversal process, with a color-coupling developer substituted for the normal second developer of the black-and-white reversal process. The film is first developed in a typical black-and-white reversal developer containing a silver solvent to ensure clean whites. This procedure is followed by re-exposure to light and development of the fogged emulsion in a color-coupling developer that produces the proper colors in each layer. Both negative and positive silver images are removed by bleaching, leaving the dye images in the film in the form of a color positive. A paper can be coated with a similar reversal emulsion and used for the making of color prints directly from positive transparencies, and several are, notably GAF Printon and Kodak Ektachrome Paper.

Processing Solutions

The problem of processing color films is complicated by two facts. The first is that since many, though not all, color films are the subjects of patents, the manufacturers must make certain changes to avoid patent infringement. Thus, the processing of the various films of different makers is different, and at this time, there is no such thing as a universal color developer that will work on all films of all makers.* The second problem is that color processing formulas often utilize fairly exotic chemicals, not usually available in the normal channels of trade, so that even if one had the formulas for the various baths, one would not be able to prepare them for want of the necessary ingredients.

For this reason, the following discussion will be only schematic. No attempt will be made to give specific formulas, and likewise, the latter part of this section will give instruction for the use of chemical kits only, as supplied by the various manufacturers for use with their films.

Color developers, which include those designed for negative color films and those used as second developers in color reversal processes, have some common characteristics. The developing agent in any of these must, of course, be one whose oxidation product will act as a coupler with the color formers in the films. Early color films all used the p-aminodiethylaniline (diethyl paraphenylene diamine) or one of its salts—the hydrochloride or sulfate. The dimethyl variant was also used but produced a less-saturated color. The substituted paraphenylenes are still used with many foreign color films and some American-made ones.

A color developing agent of a different class, used with certain of the earlier Kodak color films, was 2-amino-5-diethylaminotoluene. In connection with Kodak's color formers, this agent produced very bright, pure colors but could not be used to process color films of other makes, such as Anscochrome or Agfacolor.

*Some manufacturers, however, such as Fuji, are now offering color films that are compatible with Kodak Process C-41, normally used for Kodacolor, Vericolor, and some printing films. The intent, evidently, is to enable commercial photofinishers to process all makes of color negative films with a single machine and a single set of chemicals.

Although these developing agents are satisfactory from the standpoint of efficiency and the colors produced, they have some disadvantages. Like all paraphenylene derivatives, they tend with some persons to cause a kind of contact dermatitis, similar to the commonly known "Metol poisoning,"* which poses a real danger in the handling of these chemicals, both in mixing formulas and in processing films.

Certain newer developing agents, such as 4-amino-N-ethyl-N-[β-methane-sulfonamidoethyl]-m-toluidine sesquisulfate monohydrate and 4-amino-3-methyl-N-ethyl-N-[β-hydroxyethyl]-aniline sulfate, are designed both to produce better color rendition and to have reduced toxicity. All must be considered poisonous to some extent, however, and they must be handled with some care, especially when they are used in powdered form to mix developers.

Whichever developing agent is used, its oxidation product couples with the color former to produce a dye. Obviously, then, the developer formula cannot contain a large amount of sulfite or other antioxidant, since this will inhibit its action in the formation of a dye. Thus, color developers contain the minimum practical amount of sulfite, and their keeping qualities are necessarily poor.

With a minimum of sulfite, some atmospheric oxidation of the developing agent will take place; the oxidation product will couple with the color formers in the film, causing an overall color fog or stain. This effect cannot be overcome by the use of ordinary antifoggants, but special color-fog restrainers, such as hydroxylamine hydrochloride, are used in developers for papers where clean whites are essential.

In the case of films such as Kodak Vericolor, Ektachrome, and Kodacolor films, where the color formers are carried in a protective colloid, some solvent, such as benzyl alcohol, is used to assist in the rapid penetration of the emulsion by the developer.

Still another problem in the processing of color films and papers is the essentially high-contrast nature of the emulsions, combined with the necessity for a high-pH developer to secure adequate color coupling. Special contrast control agents are required in color developers to secure proper gradation without loss of color saturation. One of these is citrazinic acid, which controls both contrast and color balance when used in a developer in the proper amount. Other such control agents include ethylene-diamine tetraacetic acid; the ferric salt of this acid is also used as a bleach for some color papers.

In the above paragraphs we have gone into some detail as to the various special chemicals used in color developers; our purpose is simply to show that the compounding of a color developer is by no means as easy as making up a black-and-white developing bath. Because three separate layers of the film must be developed simultaneously and must arrive at the identical contrast and density levels at some given time, a developer must be meticulously designed to match a given film material. In addition, replenishment must be carried out carefully if consistent results are to be obtained over a reasonably long period of time.

Reversal color films must first be developed to a black-and-white negative image; this parallels exactly the first development stage in the processing of black-and-white reversal films, and the problems are the same. The first developer must be of fairly high contrast, and it must contain a silver solvent, such as potassium thiocyanate, to ensure clean whites. This addition also tends to promote maximum emulsion speed as well. Most of the older first developer

* Actually, Metol poisoning has been found to be caused not so much by the Metol itself as by traces of paraphenylenes, which are found as impurities therein.

formulas resembled Kodak D-19 with the addition of a small amount of potassium thiocyanate. More recent formulas are based on a Phenidone-hydroquinone formula and contain other changes as well.

The color developer for a reversal process is usually more active than a color negative developer; in addition, it does not require as much contrast control or antifoggant concentration, because most of the final color and density balance has been established in the first developer. The developing agent varies from one maker to another, and in the case of Kodak films and others containing protected couplers, the benzyl alcohol penetrating agent must be present.

In machine-processing and the development of 35mm films in small, self-loading tanks, it is often inconvenient to re-expose the film to light before the color developer stage. In the Kodak Ektachrome Process E-4, the re-exposure step is eliminated by the use of a chemical fogging agent in the color developer. This has the same effect as the second exposure. It makes the remaining silver grains in the emulsion that have not been affected by the first developer capable of being developed. The color developer proceeds to form both a positive silver image and the desired dye images in this step. The Kodak Ektachrome Process E-4 is not compatible with all Kodak reversal color films; it is important to check the instruction sheets for a given film to be sure it is given the proper treatment. Those films which cannot be processed in the E-4 baths must be handled in the Ektachrome Process E-3.

Bleaching

Since color developers all produce a combined silver and dye image, some means must be used to eliminate the silver image if pure, clean colors are to be obtained. The silver bleach used in just about all cases is a potassium ferricyanide and potassium bromide formula, quite similar to the ones used in the bleach-and-redevelop type of toner, but considerably stronger. Bleaching is simply followed by a fixing bath containing hypo, which removes not only the silver bromide formed by the bleach but also any remaining silver halides in the emulsion that were not used up in the processing.

Since potassium ferricyanide is a strong oxidizer, it may attack the materials of which the developing equipment is made; to avoid this, a buffer is usually added to the bleach bath, in order to maintain its pH at the level where it is least corrosive to metals. The buffer may be a phosphate or some other salt. This pH adjustment also avoids the danger of partial dye bleaching.

Ferricyanides also react with color developers to form a pink dye. The film must therefore be washed very thoroughly after color development and before bleaching; otherwise an irremovable pink stain will be formed. Some processes use a clearing or fixing bath before bleaching to neutralize traces of developer.

Fixing, Washing, and Drying

The ordinary acid-hardening fixing bath cannot be used with color materials as it has a tendency to bleach the dyes. For this reason, the hardening of color films is done either in a pre-bath, as in the Kodak Ektachrome Process E-4 or by a chrome alum bath after the first, and sometimes the second, developer.

Hardening of color print papers is usually done in the same way, but sometimes, instead, by the use of an alkaline hardener and fixing bath combined. Since alums will not harden in an alkaline condition, the hardener is usually formalin, made alkaline with sodium carbonate.

Washing and drying are done in much the same manner as in black-and-white processing. An additional step must follow the washing, however; the fading of dyes can be reduced very markedly by the use of a stabilizing bath. In its simplest form, the stabilizer is merely a very weak solution (about ¼ of 1 per cent) of formalin. In other processes, the formalin rinse is combined with a wetting agent; in either case, the film is usually hung to dry without further rinsing directly after this treatment. This apparently simple step must not be omitted or overlooked; the very tiny amount of formalin remaining in the film after drying has a powerful preservative action on the dyes.

Some other stabilizers are used with various foreign makes of color films; their composition may differ from the simple formalin stabilizer mentioned above. Since they are provided in the developing kits, there is no problem; they are used according to directions. In one or two cases, a final rinse in plain water may be specified after the stabilizer bath; this differs from the recommendations for a formalin stabilizer and should be watched for.

Time and Temperature Control

In processing black-and-white films, a variation in processing time or temperature merely produces a change in contrast, and a fairly broad latitude is usually possible. In the case of color films, however, this change of contrast with time of development may not be the same in all three layers. There is usually only one optimum temperature and development time at which all three layers will have the same contrast and at which the colors will balance from highlight to shadow. Hence instructions for the processing of color films indicate an exact development time and a narrow range of temperatures, generally ± ½ degree F, for the first development and sometimes for color development too. If satisfactory color is to be obtained, these directions must be followed precisely, and it is well to be sure that the thermometer used is accurate.

Early color films could not be hardened in manufacture; hence processing had to be carried out at precisely 68 F (20 C) and no higher. Even so, some of these emulsions were extremely soft, and if the water were unusually free of mineral salts ("soft" water), reticulation sometimes occurred even at 68 F. The processing baths for these films were used in connection with intermediate salt rinses at least until the chrome alum hardening stage.

It is generally realized that it is easier to heat a solution than to cool it, at least without expensive equipment. In most parts of the United States, it is very difficult to hold processing solutions at 68 F during the larger part of the year. On the other hand, even the smallest amateur darkroom usually has hot water available, and heating the baths to a higher temperature is usually easy enough.

For this reason, current color films are all designed to be processed at higher temperatures—from 75 F to 80 F is the usual range. In the case of the Kodak Ektachrome Process E-4, safe processing at the higher temperature is assured by the use of a prehardener stage before the first developer.

Currently, then, most color films are designed for processing between 75 F and 80 F, the exact time being given by the manufacturer in the processing kits supplied. As far as the first developer is concerned, this recommended time and temperature should be strictly observed, within a tolerance of no more than ½ degree F.

A welcome bonus results from the change to a higher processing temperature. Since all chemical processes work faster at higher temperatures, there is a decided time saving in the processing cycle. Kodak Ektacolor Paper can be

processed on a drum at 100 F, reducing the total time for processing a print to about eight minutes.

After first development in a reversal process and color development in processing a negative color film, the remaining steps are less critical; there is usually a leeway of ±2 or 3 degrees F for the remaining baths and rinses. Nonetheless, it is best to try to maintain a uniform temperature throughout; aside from producing more uniform results, it will also minimize the danger of reticulation.

Color Printing

Formerly popular color print procedures requiring color - separation negatives, such as Trichrome Carbro and Wash-Off Relief printing, are completely obsolete today. Carbro, which was capable of producing exceedingly beautiful prints in practiced hands, cannot even be used experimentally today; no source of materials remains. Dye Transfer is a modernized form of Wash-Off Relief printing and is still used to a limited extent in commercial photography where it provides the capability of handwork and combination printing. For amateur photography, Dye Transfer is likewise obsolete.

As far as the making of prints is concerned, today color negative films are the main source of preprint material. The advantage, of course, is simplicity. A color print can be made from a color negative in a single step; given a first rate, properly exposed and developed negative, a color print of very high quality can be made. The older processes all had to start with a set of three color-separation negatives; these were usually made in special "one-shot" cameras that produced a set of negatives in one exposure. Separation negatives could be made from immobile objects with an ordinary camera, by three successive exposures through the required filters, but there is not much subject matter of this class. In regard to making negatives from color transparencies only the use of extensive correction methods, such as masking, made the process at all practical. Often additional handwork was needed to secure a top-quality print. Masking is employed in modern color negative films, but here colored couplers built into the film emulsion accomplish it, and no extra processing steps are required.

Color prints are mostly made on paper; print emulsions, however, are also available on film base. Thus, it is just as easy to make slides or display transparencies from color negatives as to make prints on paper. Obviously, the images can be enlarged, reduced, or cropped in making the transparency, which is not possible when shooting a color transparency directly on reversal color film. Color negatives can also be used to make high-quality black-and-white paper prints on certain panchromatic papers; thus, a single color negative can be the original for the production of slides, color prints, and black-and-white prints.

Color prints and transparencies are made on papers or films coated with emulsions similar to the color negative film except that no masking dyes are included; they are not only unnecessary but would interfere with viewing. The sensitivity balance of color papers and slide films is adjusted to the light sources to be found in most enlarging equipment. Finally, dyes are chosen for the best visual balance rather than for printing quality.

The usual light source in printing equipment is the white opal enlarger lamp, which burns at 2950 K to 3100 K, depending upon the wattage. Because of this variation, a filter pack must be used in the enlarger to bring the color quality of the light to the standard required for the paper in use.

In addition to the filters required for color balancing, it is necessary to have an ultraviolet absorber and an infrared absorber in the pack. Although there is not much ultraviolet in the output of an incandescent lamp, what little is present could make for difficulty in color balancing if it were not removed. The infrared absorber has two functions; its major use is to absorb the heat of the lamp, which would otherwise eventually damage the negative being printed and would also cause problems with the filters. Furthermore, all the dyes used in color films are substantially transparent to infrared, but the transmission in this part of the spectrum varies from one type of film to another. By eliminating any far red and infrared from the illumination, much more uniform results are produced when printing from different types of negative film.

Even if the standard filter pack recommended for a given light source is used, it is unlikely that the first print from a given negative will be satisfactory. Some compensation must be made for variations in negative color balance. In addition, there are variations in color balance from one batch of paper to another.

In general, it is best to make correction for paper-batch variations first; this is done by printing a standard test negative with selected filter combinations until a satisfactory print is obtained. In general, this test is combined with one for light-source correction, so that the one filter pack takes care of both matters.

The filter pack thus determined will handle almost all good negatives. There are certain problems in negative color balance, however, which may require further correction.

For example, Kodacolor film was formerly intended for use in daylight or with clear flash lamps without a filter in either case. The resultant negatives made under the two conditions were quite different in quality, and separate filter packs had to be devised to handle each type of negative. Even so, the printer could be deceived; it is not always easy to distinguish a negative made of an interior scene with existing light from one made of the same scene with flash lamps.

For this reason, current recommendations for the use of Kodacolor II film are to use it outdoors in daylight without a filter, indoors with *blue* flash lamps. This way, all negatives have approximately the same balance and can be printed with a single filter pack. Additionally, the use of blue flash lamps indoors allows for making pictures with a combination of existing light and flash illumination for shadow fill.

Kodak Vericolor II Sheet Films are made in two separate types—one for outdoor and electronic flash exposure, which is balanced for daylight and short exposure times; the other is balanced for tungsten light and longer exposures. For ordinary work, the two types of film can be printed with the same filter pack, but for critical applications, it will probably be necessary to establish a separate filter pack for each type.

Color Printing Filters

The basic filters used for color printing, aside from the ultraviolet and infrared absorbers, are known as color compensating filters; these are normally made in magenta, yellow, and cyan colors, graded in density from 0.025 to 0.50 in each color. Additional filters are provided in red, green, and blue colors, which are equivalent to pairs of the above filters and are occasionally useful to simplify a filter pack.

Kodak Filters come in two types. Kodak Color Compensating Filters preceded by CC, such as CC20M or CC025Y*, are made of optical quality gelatin and may be used over the lens in the path of image-forming light. Kodak Color Printing Filters, with numbers preceded by CP, such as CP20Y or CP40C, are made of dyed acetate plastic and are intended to be used in the lamphouse of an enlarger, in contact printers, or in other applications where they are not in the path of an image-forming beam. They are not of optical quality but are intended for use mainly in large sizes in which optical-quality gelatin would be excessively costly.

Color compensationg filters of other manufacturers are substantially the same as those made by Kodak; in any case, since filters must be chosen by trial, minor variations in filter color make little difference. Nomenclature is usually similar to that used by Kodak.

In general, it is best to use as few filters as possible, especially when they are used over a lens, in the path of image-forming light. Thus, if tests show that a CC20M must be added to a CC30M already in the pack, it is best to remove the CC30M and use a CC50M as a substitute for the pair. This point should be obvious. What is less obvious is that one should never have filters of all three colors in a filter pack. The reason is simply that yellow plus magenta plus cyan add up to gray, and this does nothing except increase the required exposure. When it is found that all three colors have been added to a given filter combination, a simpler pack can be obtained by subtracting the density of the lightest filter from that of the other two. Thus, say we now have a filter pack that contains

$$CC30M + CC40C + CC20Y.$$

This contains the equivalent of 0.20 neutral density, which will require almost 60 per cent more exposure than would otherwise be necessary. We can eliminate this merely by subtracting the 0.20 density from the pack as follows:

$$
\begin{array}{l}
CC30M + CC40C + CC20Y \\
- CC20M + CC20C + CC20Y \\
\hline
CC10M + CC20C
\end{array}
$$

The new pack thus contains only two filters, both lighter than those used originally; hence exposure will be shorter. It is perfectly possible for a pack to end up as a single filter, in one of two ways:

$$
\begin{array}{l}
CC50M + CC30C + CC30Y \\
- CC30M + CC30C + CC30Y \\
\hline
CC20M
\end{array}
$$

In this case, we will require exactly half the exposure needed with the complete pack, which contained the equivalent of 0.30 neutral density, a transmission of 50 per cent. When a pack comes out with two filters of the same density, we can always simplify by using one of the secondary color filters, thus

$$
\begin{array}{l}
CC40M + CC40C + CC20Y \\
- CC20M + CC20C + CC20Y \\
\hline
CC20M + CC20C
\end{array}
$$

But CC20M plus CC20C is the same as a CC20B (blue) filter, which can therefore be substituted for the two filters. This also aids in simplifying a pack that happens to require a greater density than is available (maximum is usually 0.50). A pack requiring CC50M + CC30M + CC40Y, equivalent to CC80M + CC40Y, can be replaced by a CC40R, which is equal to CC40M and

* The number represents the density, the final letter the color — Y-Yellow, M-Magenta.

CC40Y, plus a CC40M, thus making a two-filter pack equivalent to the former three-filter pack.

The same filters are used for setting up printing equipment to make transparencies on color print films and also to print color transparencies onto reversal color print papers. Combining and simplifying the pack is the same in all cases. And in all cases, it is necessary to establish a corrected filter pack for each new batch of material.

Judging the Negative and Choosing Filters. It is just about impossible to judge the color balance of a negative by visual examination; there are instruments of varying complexity for analyzing color negatives, but these are found mainly in the larger color-processing establishments. For the average worker, the only practical way to judge the color balance of a negative and determine the filter pack required is to make a test print. This is usually necessary anyway in order to determine the exposure required.

The question of sensitivity balance of the three layers of the film tends, however, to complicate the matter of making tests to some extent. The use of a graduated scale such as the Kodak Projection Print Scale, which makes a whole series of tests with a single exposure, is not recommended for color papers; the range of intensities is too wide, and reciprocity failure will cause the resulting tests to be unreliable. The best method of testing is to make a strip of four exposures, ranging from, say, $f/5.6$ to $f/16$ by full stops and keep the exposure time constant. Within this limited range, the reciprocity characteristics of the paper will not give trouble. If none of these tests produces a good exposure, then increase or decrease the exposure time, keeping the intensities within the range of the same four stops.

Having a first test that is fairly satisfactory for exposure but off color, one can judge roughly the correction required by viewing the print through various CC filters until one is found that produces what appears to be proper balance. Thus, if the first print has a greenish cast, viewing it through a magenta filter will probably make it look about right.

This being a negative process, though, if the print looks right through a magenta filter, then we must *remove* magenta from the filter pack or *add* green — the color originally in excess. The amount of correction required depends upon the fact that color-printing papers are high in contrast and a change in filtration will produce a greater change in print color. As a rule of thumb, one may simply use a filter of about half the density of the one that gives the best visual balance. Thus, if the print looks best through a CC20M filter, then one would remove a CC10M from the pack or add a CC10G (green) or the combination of CC10C + CC10Y.

Just as any other filters, these have an effect on exposure, and adjustments to the basic exposure must be made when adding or subtracting filters. The *Kodak Color Dataguide* contains all the necessary information on combining filters and adjusting exposure accordingly; it also contains a computer to simplify the necessary calculations.

Color Prints from Transparencies

Prints are often required from positive transparencies as well as from color negatives. There are two possible ways of doing this, paralleling exactly the methods used in black-and-white printing. That is, one can make a copy negative and use it to print on color print paper, or one can print the transparency directly on a reversal color print material, such as GAF Printon or Kodak Ektachrome Paper. In the latter case, the transparency is simply projected on the paper, just as a color negative is printed on Kodak Ektacolor

Paper. After exposure, the paper is processed by a reversal procedure, in much the same manner as the transparency film was processed.

Again, a filter pack is required, in this case mainly to correct for batch-to-batch variations in the print material and for the color quality of the printing lamp. A small amount of correction for color error in the original transparency is possible, but it is not as great as that which can be accomplished with color negatives. Fortunately, since transparencies are made for direct viewing and must have fairly good color rendition to begin with, such corrections are seldom required.

The limited amount of color correction possible in direct printing from transparencies is due to the nature of the reversal process itself. In all reversal procedures, it is necessary to incorporate a silver solvent in the first developer, to ensure pure whites. This being the case, it is clear that the whites of the final print come about by the chemical action of the silver solvent, rather than by the color of the exposing light. Thus, "white" will remain "white", regardless of the color of the printing light.

Then, the shadows of a reversal print are simply areas that are substantially unexposed; if the shadow tones of a given batch of paper are greenish-black, pinkish-black, or some other off-color cast, this is due to a variation in the dyestuffs in the paper or to some unbalance in processing. Since the shadow areas are practically unexposed, filter changes will obviously have little or no effect on them.

Since neither shadow nor extreme highlight is much affected by changes in the filter pack, only the middle tones can be corrected by means of filters. Such corrections should be quite subtle; otherwise they will cause the color rendition of the print to be distorted. Some correction of the black tones can be accomplished by variation of the time in the color developer, but this also affects the overall contrast of the print and may upset the middle-tone balance.

For mass production, most photofinishers have come around to making internegatives and printing them on color paper; the process is economical and the color prints brighter and more colorful. Color rendition is not quite as good as in prints from original color negatives however; the masking in the internegative film corrects mainly for the dyes in the internegative, not for those in the original transparency.

Professional photographers who use the internegative method, therefore, have found it necessary to make a set of correction masks for the original transparency, before making the internegative. The improvement is quite large; an internegative made from a masked transparency can come very close to equalling the quality of an original camera negative. But this is an extended procedure and one not likely to be used by the average amateur or professional working on a small scale. For these workers, the best procedure is to use color negative film in the camera; from these negatives one can make high-quality color prints, color transparencies, and black-and-white prints.

Filter Packs for Reversal Color Printing. The major use of the filter pack in reversal color printing is to secure the correct color balance of the illumination source and to compensate for batch variations in the material. The initial filter pack is determined by making prints from a good, colorful transparency, using as a starting point the filter pack recommended by the manufacturer of the paper.

If this print is off color, it is viewed through a filter or a combination of filters, in exactly the same way as a print from a negative is checked. In this case, however, whatever filter appears to produce the proper rendition is added

to the filter pack. For instance, if a print is greenish and looks best through a magenta filter, then the magenta filter is *added* to the printing filter pack. Or, if it will produce a simpler or better filter pack, we remove the complementary filters — in this case, an equal amount of cyan and yellow filtration. Reversal print materials are not as high in contrast as papers for printing from negatives; hence the filter used for printing is about the same strength as that used for viewing. If the print looks best through a CC30M, then we simply add a CC30M or subtract a CC30C + CC30Y combination. Exposure corrections for the new filter pack are the same as in printing from negatives and can be determined with the calculator in the *Kodak Color Dataguide.*

Processing Color Prints

The materials used for color prints, whether reversal or negative-positive, are processed much as their negative or transparency counterparts. The process differs from black-and-white print-making only in certain details.

Black-and-white papers develop very rapidly, usually in 45 seconds to no more than three minutes. Fixing is equally rapid, and the image can be seen substantially in its final form a minute or two after the print is placed in the fixing bath. Thus, except for large-scale operations, it is the custom to develop black-and-white prints, one by one, in trays.

Color print materials take longer to process, and the image cannot be seen in final form until the bleach and fix stage; in the case of Kodak materials, the image cannot be seen until after drying, although there are emergency procedures for temporary clearing of the protective plastic, for evaluating a print. For these reasons, it is usually the custom to process color prints in the same manner as film, in large tanks, with racks or baskets, to hold a number of prints for processing simultaneously.

For those who need prints rapidly and at the same time do not have quantity requirements large enough to justify tank processing, Kodak has introduced a new system of drum processing. By taking advantage of the gain in speed from processing at high temperatures, this machine reduces processing time for one or two prints to eight minutes, using special processing solutions at 100 F.

On these drum processors, the paper is held in loose contact with the surface of a stainless-steel drum, which is embossed with a large number of small, rounded pockets, that carry the processing solutions to the print surface from a shallow tray. Only four ounces of solution are required in the smaller of these machines, which will process one print at a time, up to 11″ x 14″ in size. A different developer formula is used with these machines; the bleach-fix, though, is the same as that used with other processing methods. The reason for the change is mainly the much higher degree of agitation attainable with the drum; this developer should not be used for attempts at high-temperature tray processing.

The larger machine uses eight ounces of each solution and can process one 16″ x 20″ print or two 11″ x 14″ or smaller prints at one time. A big advantage of both machines is that each print is processed in fresh solutions; the small quantity is exhausted in one use and immediately discarded.

It is also possible to process Kodak Ektachrome Paper in the drum processors. A special procedure, using a combination of Kodak Ektaprint R and CP-5 chemicals, is used.

Finishing Color Prints

Kodak Ektachrome and Ektacolor papers are coated on water-resistant (resin coated) paper base, and cannot be ferrotyped; the glossy (F) surface produces a

very high gloss with simple air drying. Cibachrome material is coated on a cellulose acetate base, and likewise cannot be ferrotyped; it also produces a high gloss with natural air drying.

Conclusion

The following pages are basically data sheets; they contain specific information for the exposure and processing of most of the important color materials for printing. They also contain processing data for the major color films.

The purpose of these pages is to provide the necessary technical information for the proper handling of the materials in question. It is not possible in the limited space of this book to teach the mechanics and art of color printing; for this, the manufacturers' data books and advanced textbooks on photography should be consulted.

PROCESSING AGFACHROME FILMS

Processing chemicals for Agfachrome film are available in separate units of 1 gallon, 3½ gallons, and replenishers for first and color developers in 5 gallons.

A complete set consists of the following parts:

First Developer(CU I)
Stop(CU II)
Color Developer(CU III)
Bleach(CU V)
Fixer(CU VI)

Replenishers for stop, bleach, and fixer are prepared by dissolving the chemicals in two-thirds the volume of water used for preparing the working solutions.

Solution Storage Life

	Full, Tightly Stoppered Glass Bottles	Tanks with Floating Lids
First and Color Developer, unused	4 weeks	1 week
First and Color Developer, partially used	2 weeks	1 week
Other solutions	8 weeks	8 weeks
First and Color Developer Replenishers	4 weeks	1 week

Processing without replenishment

Without replenishment, the processing capacity per 1 gallon of first and color developer is 1,900 square inches of film (24 sheets 8" x 10", 95 sheets 4" x 5", or 24 rolls 120). In 3½ gallons, (84 sheets 8" x 10", or 336 sheets 4" x 5", or 84 rolls 120). Twice this amount can be processed in the secondary solutions.

Use the *Time Compensation Chart,* for the *first developer* to compensate for increasing exhaustion in an unreplenished system. (The color developer does not require an increase in processing time with increased exhaustion.)

First Developer Time (Minutes)*	Square Inches Processed		Approximate Conversion into Number of Sheets			
			1 Gallon		3½ Gallons	
	1 Gallon	3½ Gallons	4"x5"	8"x10"	4"x5"	8"x10"
13	0–380	0–1320	0–19	0–5	0–66	0–16
13½	381–760	1321–2640	20–38	6–10	67–132	17–33
14	761–1140	2641–3960	39–57	11–15	133–198	34–49
14½	1141–1520	3961–5280	58–76	16–19	199–264	50-66
15	1521–1900	5281–6600	77–95	20–24	265–330	67–84

*1. These time compensations are based on a 1-week's use of the first developer in a tank with a floating cover. The first developer and the color developer should be discarded after 1 week regardless of any unused capacity.

*2. An additional time allowance in the first developer of about 15 seconds per day should be given for its aging.

Processing with replenishment

Replenishment is recommended because it improves the control of color balance and speed, increases the working capacity of the solutions, and maintains their activity at a constant level. In order to monitor the quality of a replenished line, it is advisable to use control strips with every run, and plot the readings graphically.

Film Size	First Developer Replenisher RCU I	Color Developer Replenisher RCU III	Other Solutions (chemicals diluted in ⅔ water)
11"x14"	330cc	290cc	195cc
8"x10"	172	150	100
5"x7"	74	65	45
4"x5"	42	35	23
120	172	150	100
35mm x 36 exp.*	100	100	65
35mm x 20 exp.*	65	65	45

*Use these rates also for Agfachrome Duplicating Film.

Replenishment Techniques

1. Remove a larger amount of solution from processing tanks than is to be replenished and set it aside.
2. Add the required amount of replenisher to the tank solution.
3. Fill tank solution to level with solution held aside and stir.
4. Discard remaining solution.

This technique will insure that solution level in the first developer will not drop because of carry-out; it will also maintain the levels in the other tanks and prevent dilution of the chemical concentration by water carry-over.

Compensation for Aging

Add 19cc of first developer replenisher per 1,000cc tank solution for each 24-hour day since the processing line was last used. For example, in a 3½-gallon line (13.2 liters), add 250cc for each day, or, for a weekend (Saturday and Sunday), add 500cc. The color developer does not require a replenishment for aging. However, if the developers have not been used for longer than one week, replace both first and color developers with fresh solutions. These rates are guides only and will vary somewhat with each individual system. They should, therefore, be verified with sensitometric control strips.

Replenishment Chemicals

For replenishment of first and color developers, special replenishers are required that are available as:

Replenisher for first developer (RCU I) 5-gallon size.

Replenisher for color developer (RCU III) 5-gallon size.

For replenishment of stop bath, bleach, and fixer dissolve the chemicals used for tank solutions in only ⅔ the amount of water; i.e. 1-gallon size in 2,530cc water; 3½-gallon size in 8,800cc water.

Replenisher for the stabilizer is the same strength as the working solutions. To make up the stabilizer, use 2cc wetting agent*, and 15cc formaldehyde 37% per 1,000cc water.

*Wetting agents that may be used are: Agepon, Pako-Wet, and Photo-Flo.

Storage Life of Replenishers

The replenishers have the same storage life as unused working solutions.

	Full, tightly stoppered bottles	Tanks with floating lids
First and Color Developer Replenisher	4 weeks	1 week
Replenisher for stop, bleach, fix, and stabilizer	8 weeks	8 weeks

Chemical Control of Processing Line

As long as the control strips stay within tolerance, the indications are that the chemical solutions are in good working condition. However, regular readings of pH values of the processing solutions are further means of process control.

Processing Solution	pH Value
First Developer	10.1 – 10.3
Stop Bath	5.0 – 5.4
Color Developer	11.6 – 11.8
Bleach	5.0 – 5.4
Fixer	6.5 – 8.5
Stabilizer	Not below 6.5

Agitation

Nitrogen Burst: Burst cycle 20 seconds –Duration 1.2 seconds.

Pressure to be sufficient to raise the solution level a minimum of ½ inch.

Upon initial insertion of hangers in first developer, tap them sharply against the tank to dislodge air bubbles.

Should any hanger marks, streaks, or reel marks be visible, increase nitrogen pressure. Burst agitation is also required in the wash steps and should also be sufficient to raise the wash water level by at least ½ inch.

Manual Agitation: Upon initial insertion of hangers in first developer, tap them sharply against the tank to dislodge air bubbles.

Remove film every 10 seconds during the first minute in each solution, thereafter, every 30 seconds. Agitation is also required in the wash step.

Temperature

The first developer temperature is most critical because of its effect on the density of processed films. For consistent results, the processing temperature of the first developer should always be exactly the same; i.e., 75 F. As an example, a deviation of –½ degree F produces a density shift of about +0.15, whereas +½ degree F produces –0.10 in the magenta density reading in the shoulder step of the control strip.

The temperatures of the other solutions are not as critical, and the tolerances given can readily be adhered to.

Washing

The wash water flow rate should be sufficient to completely replace the tank volume once a minute. This requires a flow rate of 3½ gallons per minute for a 3½-gallon tank; 5 gallons per minute for a 5-gallon tank, and so on. Since wash steps are as important as processing steps, please follow the instructions carefully in the section, "Summary of Agfachrome Processing."

Processing Variations

Instructions for gaining or losing speed by changing first development time:

+f/stop change	Change of first develop- ment time at 75 F	Density change of control strip*
Plus 1 stop	Plus 2 min.	−0.60
Plus ⅔ stop	Plus 80 sec.	−0.40
Plus ⅓ stop	Plus 40 sec.	−0.20
Normal	None	0
Minus ½ stop	Minus 1 min.	+0.30
Minus 1 stop	Minus 2 min.	+0.60

*Reading of shoulder step through green filter of densitometer.

Processing Steps for Agfachrome Film at 75 F

In Total Darkness	Time in Minutes	Temperature (F)
1. First Development	13	75
2. Rinse	10 sec. (Do not exceed 20 sec.)	73–77
3. Stop	3	73–77

In Room Light	Time in Minutes	Temperature (F)
4. Wash	7	73–77
5. Re-exposure	30 sec. each side	
6. Color Development	11	75
7. Wash	20	73–77
8. Bleach	4	73–77
9. Wash	4	73–77
10. Fix	4	73–77
11. Final Wash	7	73–77
12. Stabilizer	1	73–77
13. Drying		110

Summary of Agfachrome Processing

1. First developer processing time, temperature, and agitation are most critical for the final result. Processing temperature is 75 F; time with fresh developer is 13 minutes. Check Time Compensation Chart, and make time additions for aging of first developer in nonreplenished system.

2. Rinse for 10 seconds; not longer than 20 seconds. A yellow stain will form in the clear areas if 20 seconds is exceeded.

3. Stop for three minutes. Agitate continuously during first minute.

4. Wash for seven minutes in running water at flow rate of 3½ gallons per minute for 3½-gallon line. Use manual or air burst agitation.

5. Re-expose with 500-watt lamp for 30 seconds for each side at 3 foot distance. Remove films from tanks and reels. Make sure the light is reaching the overlapping parts of the sheet film hangers. Re-exposure time exceeding 30 seconds does not affect the color balance.

6. Color developer time is 11 minutes at 75 F. No increase of time is necessary for increased exhaustion. Note precautions when handling color developers.

7. Wash in running water at a flow rate of 3½ gallons minimum for 20 minutes. Dump water every 5 minutes. Use manual or air-burst agitation.
Note: Insufficient wash will result in magenta stain. These recommendations should be followed carefully.

8. Bleach for four minutes.

9. Wash with agitation in running water for four minutes.

10. Fix for four minutes.

11. Wash with agitation in running water for seven minutes.

12. Stabilize one minute. Use 2cc wetting agent and 15cc 37% formaldehyde per 1,000cc water.

13. Drying temperature should not exceed 100 F. If excessive curl occurs, due to low humidity in the drying cabinet, dry film in hangers. Wet film changes color balance slightly toward cyan when drying; therefore, ultimate color balance can be judged only when film is completely dry.

Antifading Treatment

If Agfachrome transparencies are to be used for illuminated displays, the following procedures should be followed:

1. In the final wash, dump the wash water three times, or, use three different wash tanks in order to completely remove the hypo.

2. Use formaldehyde stabilizer as recommended.

3. After transparencies have been dried, treat them in clear Agfachrome antifading lacquer.

4. If possible, the interior of the display case, as well as the bulbs and interior facing of the diffusion sheet on which the transparency is mounted, should be treated with the same antifading lacquer.

COLOR REDUCERS FOR AGFACHROME FILMS

YELLOW REDUCER FOR AGFACHROME TRANSPARENCIES

Water .	24 ounces	750.0cc
Cholic Acid .	292 grains	20.0 grams
Sodium Carbonate, monohydrated 1 oz.	290 grains	50.0 grams
Calgon .	15 grains	1.0 gram
Add water to make	32 ounces	1.0 liter

Presoak transparencies one to two minutes in water before treatment. Treat for two to eight minutes at 75 F, depending on amount of reduction desired. Wash for ten minutes in running water and dry.

MAGENTA REDUCER FOR AGFACHROME TRANSPARENCIES

SOLUTION 1

Water .	24 ounces	750.0cc
Stannous Chloride	75 grains	5.0 grams
Add water to make	32 ounces	1.0 liter

SOLUTION 2

Water .	24 ounces	750.0cc
Borax .	1 ounce	30.0 grams
Calgon .	15 grains	1.0 gram
Add water to make	32 ounces	1.0 liter

Presoak transparencies one to two minutes in water before treatment. Immersion in Solution 1 turns transparency red; transparency should remain in this bath for one to two minutes. Rinse in running water for two minutes, then immerse for three minutes in Solution 2, which will restore all colors except magenta. Wash ten minutes in running water and dry.

RED REDUCER FOR AGFACHROME TRANSPARENCIES

SOLUTION 1

Water .	24 ounces	750.0cc
Sodium Bisulfate (NOT bisulfite) ½ oz. 44 grains		18.0 grams
Add water to make	32 ounces	1.0 liter

SOLUTION 2

Water .	24 ounces	750.0cc
Borax .	1 ounce	30.0 grams
Calgon .	15 grains	1.0 gram
Add water to make	32 ounces	1.0 liter

This reducer reduces both magenta and yellow together. Presoak transparencies one to two minutes in water before treatment. Immersion for five minutes in Solution 1 will reduce the red by the equivalent of a CC10R reduction (or increase of CC10C). Rinse for two minutes, then treat in Solution 2 for three minutes. Wash ten minutes and dry.

CYAN REDUCER FOR AGFACHROME (Tungsten) TRANSPARENCIES

Water .	24 ounces	750.0cc
Calgon .	15 grains	1.0 gram
Sodium Carbonate Monohydrated	60 grains	4.0 grams
3% Hydrogen Peroxide 1 oz. 5 fl. drams		50.0cc
Add water to make	32 ounces	1.0 liter

CYAN REDUCER FOR AGFACHROME (Daylight) TRANSPARENCIES

Water .	24 ounces	750.0cc
Acetoacetanilide	120 grains	8.0 grams
Sodium Carbonate (monohydrated)	68 grains	4.6 grams
Add water to make	32 ounces	1.0 liter

Reduction corresponding to a CC10R filter is obtained in about two minutes at 75 F. The degree of reduction can be controlled by immersion time. Wash film for ten minutes in running water and dry.

PROCESSING AGFACOLOR NEGATIVE FILM CNS

The following packaged chemicals are available to make 1 liter (34 ounces) of working solution:

Agfacolor—Film Developer S (Abbreviated Code NPSI)
Agfacolor—Intermediate Bath (Abbreviated Code NZW)
Agfacolor—Bleach (Abbreviated Code NII)
Agfacolor—Fixer (Abbreviated Code NIII)

Processing Step	Time Minutes	Temperature	Remarks
1. Develop Agfacolor Film Developer S	7–9	68 ± ½ F (20 ± 0.2 C)	
2. Intermediate Bath NZW	4	68 ± ½ F (20 ± 0.2 C)	See Note 1
3. Wash	15	57–68 F (14–20 C)	Running water or change every minute
4. Agfacolor Bleach	5	68 ± 1 F (20 ± 0.5 C)	See Note 2
5. Wash	5	57–68 F (14–20 C)	Running water
6. Agfacolor Fixer	5	64–68 F (18–20 C)	See Note 3
7. Wash	10	57–68 F (14–20 C)	Running water
8. Wetting Agent (Agepon 1:200)	1	57–68 F (14–20 C)	Always prepare fresh

Note 1: To achieve uniform results, 30cc of Film Developer S must be added to each liter of Agfacolor Intermediate Bath NZW.

Note 2: As the masks are formed in the bleach bath, care should be taken that the processing times are maintained exactly and that the temperature is held at exactly 20 C ± 0.5 C (68 F ± ½ F). The bath should not be overworked; in the case of machine processing, proper replenishment procedures should be followed.

Note 3: Make sure fixing is complete; in machine processing, use Replenisher RNIII carrying batch no. 32,400 or higher.

The capacity of all working strength solutions is six rolls of 120 or 620 film or six 36-exposure 35mm films, or ten 20-exposure 35mm films per liter.

Unused, properly diluted Film Developer S keeps for six weeks when stored in completely filled, tightly stoppered bottles. Used developer, on the other hand, keeps adequate working strength only for a few days.

For this reason, it is recommended that users of the Rondinax tank store the developer after mixing in several small bottles of five-ounce (150cc) or seven-ounce (200cc) capacity; each roll of film is then developed with a fresh batch of developer, which is discarded immediately after use.

The bleach and the fixer solutions keep satisfactorily for three months.

PROCESSING AGFACOLOR PAPER TYPE MCN III

Agfacolor Paper Type MCNIII is a high-speed color paper for printing color negative materials. MCNIII is suitable for amateur photofinishing and professional applications. It is available in standard sheet and roll sizes.

Emulsion Structure
Upper layer—sensitive to blue light, develops yellow dye.
Middle layer—sensitive to green light, develops magenta dye.
Bottom layer—sensitive to red light, develops cyan dye.

Peak Sensitivities
Blue-sensitive layer—approximately 455 nanometers.
Green-sensitive layer—approximately 550 nanometers
Red-sensitive layer—approximately 700 nanometers

Safelight Filter
Agfa-Gevaert 0 8 (transmission maximum at 580 nanometers.)
Note: Safelight filters of other manufacture can be used, provided they have similar spectral transmission characteristics. We recommend testing your safelights.

Storage
Refrigeration recommended. (Temperatures below 50 F.)

Processing Times and Sequence (77 F)

(Continuous processors, Basket lines, and Tray Processing)

	Time	
Solution	77 F	85 F
Developer Pa 1/60	3 min.	2 min.
After rinse	¾ min.	½ min.
Stop-fix PPa II/KM	1¾ min.	1 min.
Room lights may be turned on at this point.		
Bleach-fix PPa III/KM	3½ min.	2 min.
Wash	5¼ min.	5 min.
Stabilizer Pa VI S	1¾ min.	1 min.

Note: Treatment in stop-fix, bleach fix, second wash, and stabilizer may be extended, if this is more practical due to the design of the processing equipment.

Keeping Properties of Agfacolor Paper Chemicals
Mixed in stoppered bottles:

Developer	1 month
Secondary Solutions	3 months

Keeping properties of solutions in a well-replenished processing line are excellent.

Capacity of Solutions without Replenishment

Developer	40	8" x 10" per gallon
Secondary Solutions	120	8" x 10" per gallon

Replenishing Rates

Solution		Per Sheet 8″ x 10″	Per Foot* 3½″ Wide
Developer Replenisher	RPa 60	22ml	11ml
Stop-fix Replenisher	RPPa II/KM	28ml	14ml
Bleach-fix	PPa III/KM**	28ml	14ml
Stabilizer Replenisher	RPa VI S	22ml	11ml

*To obtain 5-inch rates, multiply the 3½-inch rates by 1.43. Likewise, to obtain rates for 8-inch paper use 2.29.

**Bleach-fix is replenished with starter solution.

Preparation of Solutions

The preparation of the different starter and replenisher solutions is very simple. Each component of a mix is identified by a letter. When preparing the solution, the various parts are simply dissolved in alphabetical order. The label on each chemical kit gives complete instructions for mixing.

When making a stabilizer or a stabilizer-replenisher, formaldehyde (which is not part of the kit) should be added to the mix. The recommended quantity to be added is given on the label of the stabilizer kit.

With the use of a pressure ferrotyper, the formaldehyde to be added to stabilizer and stabilizer-replenisher should be reduced to 1 ounce per gallon. A higher concentration may result in poor gloss.

Note: Whenever the developer is found to be contaminated, the replenisher should also be checked, since the contamination could have originated from the replenisher.

When a processing error is traced to the bleach-fix and this bath is being changed, it is advisable also to change the stop-fix.

Agfacolor Paper Control Strips

MCNIII test strips are used for the control of the paper processing. The strips, which are basically designed for visual comparison, come in packages of 25. The size of of the pre-exposed material is 3½″ x 10¾″.

A factory-processed master is enclosed with each package. The strips should always be kept under refrigeration, in order to minimize changes of the latent image.

Processing Times for Rapid Drum Type Processors (77 F)

Prerinse (water in tray)	½ min.
Developer	2½ min.
Wash	½ min.
Stop-fix	1 min.

Room lights may be turned on at this point.

Bleach-fix	2 min.
Wash	2 min.
Stabilizer	1 min.

Print Defects and Their Causes

Print Defects	Causes
Gradual loss of density.	Sign of under-replenishment of developer.
Gradual gain of density.	Sign of over-replenishment of developer.
Less density, Possibly blue shadows, Lower contrast.	Low developing temperature, Under-replenishment, Developing time too short.
High density, Possibly yellow shadows, Higher contrast.	High developing temperature, Over-replenishment, Developing time too long.
Low density, Low contrast, Green shadows.	Developer heavily under-replenished. pH too low.
Stain, gray or gray-yellow. Increase in overall density and contrast.	Developer heavily over-replenished.
Whites have heavy yellow cast.	Contamination of developer with stop-fix or bleach-fix.
Very light and green prints.	Contamination of developer with formaldehyde.
Color balance shifting during the day from red towards cyan.	Heavy oxidation of developer during night or weekend. (Turn off pumps overnight, possibly add replenisher before starting in the morning).
Density and contrast normal, but color balance too blue, especially in shadows.	Insufficient afterdevelopment in first wash. (Increase wash time, decrease wash rate, do not use squeegee between developer tank and wash tank.)
Heavy staining, possibly all colors, partially or over entire area.	Traces of stop-fix in wash after developer.
Stain gray or gray-yellow.	Stop-fix and bleach-fix under-replenished.
Red shadows.	pH of bleach-fix too low; temperature too low, under-replenished, time too short.
Red shadows, Whites gray-yellow, Colors possibly have somewhat higher gray content.	Heavily under-replenished bleach-fix.
Whites, cyan, or gray.	Insufficient wash; insufficient formaldehyde in stabilizer; prints possibly washed again after treatment in stabilizer.

RAPID ACCESS COLOR PAPER

This color paper, supplied in sheets and rolls, is a multi-layer color material designed for direct printing or enlarging from masked or unmasked color negative materials. It can be exposed with ordinary printing or enlarging equipment.

Safelight

Rapid Access Color Paper can be handled under a dark amber Wratten No. 10 safelight equipped with a 15-watt bulb.

Storage

The paper should be stored in a cool, dark area or in a refrigerator or freezer. Refrigeration is *not absolutely* necessary with Rapid Access color paper, but refrigeration will greatly reduce the aging characteristics of the paper for extended periods of time.

The exposed paper has excellent latent image storage capability. Prints should be processed as soon as possible after exposure, but if this is not practical, exposed paper may be stored in a cool or refrigerated area and processed when convenient.

Exposing Equipment

Rapid Access color paper can be exposed in any equipment having a tungsten light source, such as a Photo Enlarger Lamp No. 302, No. 212, and so on, operating at the recommended voltage. *Fluorescent lamps are not recommended.* The exposing device must be equipped to hold filters, either color printing (CP) or color compensating (CC). When printing masked color negative materials, an infrared absorbing filter must always be used. This filter, the Rapid Access Basic Filter, is available as an acetate color printing filter in 2" x 2", 3" x 3", 6" x 6" sizes. A glass infrared absorbing filter, such as that sold by Omega, or Eastman Kodak's No. 301, may be substituted for the Rapid Access Basic Filter.

Filters

Filters are used to alter the color of the printing light so that a pleasing color balance is obtained in the print. Any number of CC or CP filters can be used if they are placed between the light source and the color negative. Only CC (gelatin) filters should be used between the negative and the printing paper. Only yellow (Y) and magenta (M) filters are necessary with the Rapid Access system. A complete set of 15 color printing filters, including 7 yellow. 7 magenta, and the Rapid Access Basic Filter is available.

Printing Information

Use the following procedure when you set up your enlarger:

1. Place the Rapid Access Basic Filter or glass infrared absorbing filter in the enlarger. This filter should always be used when you print masked color negatives, such as Kodacolor, Ektacolor, and so on. If unmasked films are being printed, the Rapid Access Basic Filter is not needed.

2. The enlarger should be equipped with a heat-absorbing glass to protect your negatives and filters. It is advisable to purchase one (Pittsburgh #2043, 3mm thick) if it is not already in the enlarger.

3. Add the trial filter pack. Each color film prints differently from others. The following starting packs may be used as a guide:

Kodacolor-X exposed to daylight without 85C filter	10M + 20Y
Kodacolor-X exposed to tungsten	30M + 30Y
Ektacolor CPS	40M + 70Y
Ektacolor S and L	30M + 50Y
Internegative	40M + 70Y
Unmasked negatives (Do not use Rapid Access Basic Filter)	40M + 40Y

4. Make a test print. If, for example, a condenser enlarger is equipped with a No. 212 photo enlarger lamp, a trial filter pack of 30M + 50Y, the Rapid Access Basic Filter, a $f/5.6$ aperture, and an enlargement adjustment to make 8" x 10" prints from a 4" x 5" negative, the trial exposure is about 10 seconds. A test strip should be made at 5, 10, and 15 seconds.

5. Process the print as recommended and evaluate it for color balance and exposure level.

Viewing Prints

Prints can be viewed after 30 seconds in the running water wash. This time is required to wash the residual bleach/fix from the print. The wet print looks exactly the same as a dry print, and final evaluation for color balance and exposure can be made at the wash step.

Evaluating The Test Print

First, choose the area that has the best exposure. If none of the exposures are correct, remake the test strip. Now ask yourself two questions: (1) What color is in excess: Is it too red, green, blue, cyan, magenta, or yellow? (2) How much of that color is in excess: Is the amount slight, considerable, or great? Apply these decisions to the following table:

Exposure Adjustment For Filters

Exposure Factors for CC and CP Filters

Filter	Factor	Filter	Factor
05Y	1.1	05M	1.2
10Y	1.1	10M	1.3
20Y	1.1	20M	1.5
30Y	1.1	30M	1.7
40Y	1.1	40M	1.9
50Y	1.1	50M	2.1

1. Divide the old exposure time by the factor for any filter removed from the pack. For two or more filters removed, multiply the individual factors together and use the product.

2. Multiply the time determined from Step 1 by the factor for any filter added. For two or more filters added, multiply the individual factors together and use the product.

Example: A test print was made at 30M + 50Y, at 5, 10, and 15 seconds. The 10-second exposure time appears correct but the print is considerably green and slightly yellow. From the color balance table, we see that a 20M must be removed and a 05 Y added to the filter pack:

Original Pack	30M + 50Y
Correction	− 20M + 05Y
New Pack	10M + 55Y

From the exposure factor table: 20M = 1.5 and 05Y = 1.1

378

$$\text{New exposure time} = \frac{\text{old exposure time}}{\text{factor of filters removed}} \times \text{factor of filters added}$$

$$= \frac{10 \text{ sec.}}{1.5} \times 1.1 = 7.3 \text{ seconds}$$

Print Curl

Print flatteners, such as Pakosol, may be added directly to the stabilizer if prints curl excessively. The amount of print flattener depends upon many factors and should be determined in your specific environment.

Drying

Prints may be dried by any conventional methods. A drying temperature of 200 F should not be exceeded or slight density differences may be noticeable between the wet and dry prints.

THE RAPID ACCESS ONE-SHOT PROCESSOR

The Technology, Inc., One-Shot Processor is a processing device designed to produce consistently high-quality color prints. Read and follow these instructions carefully.

Material Required

- 2 8" x 10" or 11" x 14" trays
- 1 good thermometer
- 4 graduated 4-ounce (120ml) beakers (available from laboratory supply houses); the beakers should be labeled: Pre-soak, Developer, Quick Wash, and Bleach/Fix.
- 1 timer with second hand
- 1 electric water temperature controller (optional) Rapid Access One-Shot processing chemistry or equivalent

It is strongly recommended that the setup and processing procedures be carefully studied. A practice run should then be made, using an old piece of paper and water instead of chemicals.

Setting Up

The beakers should be filled with the proper volume of solution and placed in a water bath that is 2 F above the chemical recommendation. Use the following amounts of solution:

	One-Shot	Big One-Shot
Presoak	4 oz.	4 oz.
Developer	2 oz.	4 oz.
Quick Wash	4 oz.	4 oz.
Bleach/Fix	2 oz.	4 oz.
Wash	4 oz.	4 oz.
Stabilizer	In tray	In tray

The cap on the tube should be removed by pushing up on the "bump" with both thumbs. The cap and tube are placed in the water bath to preheat the plastic and to moisten the O-ring on the cap so it closes tightly. The stabilizer

should be mixed and placed in another tray. If a temperature controller is used, it should be turned on and adjusted.

Processing

Room lights should be turned off and a Wratten No. 10 safelight turned on. The paper is exposed as usual and then curved into a cylindrical shape with the emulsion facing in. While holding the paper in your right hand, remove the tube from the water bath, set it upright (any water in it will drain out automatically) and slide the print down into the tube. Push the print all the way into the tube with your thumbs, to prevent the top edge from being crushed by the cap. The cap is pushed back in place.

Room lights may now be turned on and left on. The small amount of water remaining on the walls of the drum will in no way spot the print if processing is begun within ten minutes. Holding the drum upright, pour the first solution, four ounces of presoak, into the cap.

With the timer started, turn the drum into a horizontal position and begin rolling it over. No processing takes place until the drum is turned to the horizontal position. Agitation is accomplished by rolling the drum gently back and forth between your hands or by wedging it against the edge of the sink and spinning it. Make certain you are processing on a level surface so the chemistry is evenly distributed inside the drum. It is not necessary to keep the drum in a water bath during processing.

Ten seconds before the end of the step lift the drum back to the vertical position, and pour the next solution into the top. As the solution pours into the top, the used chemistry flows out the bottom drain. *There is absolutely no contamination.* The drum is placed back in a horizontal position, and the remaining steps are carried out in the same way.

To wash the print, simply fill the drum with fresh water and change the water every 20–30 seconds for the duration of the wash. Continue agitating throughout the wash by spinning the drum. To prevent contamination, the prints should be stabilized in a separate tray for the recommended time. After the wash, the drum is ready to process another print — it does not have to be dried.

When removing the print, simply press your fingers against the emulsion and slide it out until you can uncurl the print. If you attempt to lift up an edge, you may rip the corner.

When storing, remove the cap to prevent sticking.

PROCESSING RAPID ACCESS COLOR PAPER

Chemicals for processing Rapid Access Color Paper are available in kits. Each kit contains

Developer	Part A	4 bottles
Developer	Part B	1 bottle
Developer	Part C	1 bottle
Bleach/Fix		1 bottle
Stabilizer		1 bottle

Included is a 1-ounce measuring graduate for mixing the solutions.

The solutions can be mixed with tap water. The use of distilled or deionized water is recommended in areas where hard or rusty water conditions prevail.

Developer: Developer is packaged so that only one quart need be mixed at a time, eliminating needless waste and insuring unsurpased shelf life. Store the working strength developer in tightly capped plastic bottles. As the solution is used, gently squeeze the bottle to remove air, and recap. Mixed developer has a shelf life of two to three months. Avoid excessive heat and sunlight during storage.

1. While stirring, add the entire contents of one bottle of developer–part A to 12 ounces (360ml) of water. Refill the bottle with water and add to the mix.

2. Using the graduate supplied with the kit, carefully measure one ounce of developer–part B and add to the mix. Rinse the graduate with water and add the rinse to the mix.

3. Measure 8 ounces of developer–part C and add to the mix. Rinse the measuring graduate with 8 ounces of water, and add the rinse to the mix.

The final volume should be 32 fluid ounces (1 quart). Stir until solution is uniform.

Bleach Fix: Mixing instructions are printed on each bottle. The entire contents of each bottle makes 1 gallon of working strength bleach/fix. To prepare 32 ounces (1 quart), use 8 ounces of concentrate.

Stabilizer: *Caution:* Stabilizer contains formaldehyde — a strong sensitizer. Read the caution notice on the bottle label carefully before using. Mixing instructions are printed on each bottle. The entire contents of the bottle makes 1 gallon of working strength stabilizer. To prepare 32 ounces (1 liter), use 2 ounces (60ml) of concentrate.

Precaution

Because of an individual's varying sensitivity to skin irritants, processing solutions, especially the developer, should never be left for any length of time in contact with the hands. In case of chemical contact, an acid-type hand cleaner, such as pHisoHex, pH6, or Sulfo Hand Cleaner, should be used to wash the skin. To minimize chemical contact, the use of rubber gloves during mixing and processing is recommended.

The stabilizer contains formaldehyde, which is a skin and eye irritant. Adequate ventilation should be provided to prevent accumulation of the vapors near the solution or drying area.

The manufacturer is not responsible for any skin ailment resulting from use of this product.

Safelight

During exposure and processing, a Wratten No. 10 Filter with a 15-watt bulb may be used, placed at least 4 feet away. Do not store color paper directly under the safelight.

Processing Procedure

Rapid Access Color Paper is processed in a one-shot procedure, using the Technology, Inc., One-Shot Processor. Drum or canoe processors can also be used; follow the instructions supplied with the particular equipment. Processing is carried out at 85 F (29 C). Tolerances in temperature are given in the instructions below.

	TIME	TEMP. F	COMMENT
Presoak	30 sec.	87 ± 2	Temperature is important.
Developer	1 min. 30 sec.	85 ± ½	Start timing when developer touches the paper. Follow drum or canoe manufacturer's recommended method for agitation. Be consistent with agitation.
Drain	10 sec.		
Quick Wash	(1) 15 sec. (2) 15 sec.	85 ± 2	*Important:* Without these washes staining will occur. Two 15-sec. washes are more efficient than one 30-sec. wash.
Bleach-Fix	1 min. 30 sec.	85 ± 2	This time can be extended with no noticeable difference.
Drain	10 sec.		
Final Wash	2—4 minutes	85 ± 2	The shorter time is good. For maximum stability use the longer wash. Change water frequently.
			Four 1-minute washes are more efficient than one 4-minute wash. After washing, transfer prints to the stabilizer tray where they may be accumulated until drying.
Stabilizer	2 min. to 1 hour in tray	85 to room temperature	Prints can be stabilized up to one hour, at room temp. Stabilize prints in a tray to avoid contamination.
Drying	Do not dry at temperatures exceeding 180 F (82 C).		

The quantity of each solution, when processing 8" x 10" prints, will range from 2 ounces for the smaller drums or canoes to 5 to 8 ounces for Kodak Models 11 and 16 drum processors. Follow the equipment manufacturer's recommendations for chemical and water volumes necessary for processing, pre-heating, presoaking, and washing.

Color Evaluation

After one half to one minute in the final wash, the print can be evaluated for both color balance and exposure level.

Color Paper Storage

If possible, store color papers below 50 F. This will greatly reduce the emulsion aging common with all photographic materials.

KODAK FLEXICOLOR CHEMICALS FOR KODACOLOR-II FILM

Caution: Care should be taken to prevent abrasions, scratches, kinks, and creases. When processing on reels, use only one film roll per reel. For best results in printing Kodacolor II Film, it is of the utmost importance to minimize dirt, water-spotting, and other matter that impair the negative image. Squeegee before drying to reduce this tendency.

Processing Chemicals

Kodak Flexicolor chemicals are designed for processing *only* Kodacolor II Film. To prevent contamination of the processing chemicals or physical damage to the film, do *not* process any other kind of film in these chemicals. Mixing directions are included with each package and must be followed carefully.

Precautions in Handling Chemicals

Notice: Observe precautionary information on containers and in instructions.

The developing agents used in this process may cause skin irritation. In case of contact of solutions or solid chemicals (especially developers or developing agents) with the skin, wash at once with an acid-type hand cleaner and rinse with plenty of water. The use of clean rubber gloves is recommended, especially in mixing or pouring solutions and in cleaning the darkroom. Before removing gloves after each use, rinse their outer surfaces with acid hand cleaner and water. Keep all working surfaces, such as bench tops, trays, tanks, and containers, clean and free from spilled solutions or chemicals.

The stabilizer contains formaldehyde, which is a skin and eye irritant. Adequate ventilation should be provided to prevent the accumulation of formaldehyde vapor in the vicinity of the solution or the drying area. Tanks should be tightly covered when not in use.

Contamination of Solutions

The photographic quality and life of the processing solutions depend upon the cleanliness of the equipment in which solutions are mixed, stored, and used. Clean processing reels, racks, and tanks thoroughly after each use. Likewise, avoid the contamination of any chemical solution by any other. The best procedure is to use the same tanks for the same solution each time, and to make sure that each tank or other container is thoroughly washed before it is refilled.

Storage of Solutions

For best results, do not use solutions that have been stored longer than the following times.

Mixed Solutions (Unused, Used, or Partially Used)	Full, Stoppered Glass Bottles	Tanks with Floating Covers
Developer or Developer Replenisher	6 weeks	4 weeks
Other Solutions	8 weeks	8 weeks

Capacity of Solutions

If not replenished, the developer can be used to process the number of rolls of film shown in the table below. The bleach, fixer, and stabilizer solutions have twice the capacities shown.

Film Size	Developer Capacity* Per		
	Pint	Gallon	3½ Gallons
No. 110 (20-exposure)	15	24	84
No. 110 (12-exposure)	18	24	84

*See development-time compensation table on page 442 for developing in one pint of solution. Time compensations are not used when developing in large tanks.

Bleach Regeneration

You can obtain significant savings and reduce pollution with automatic processors by using a simple method for regenerating Kodak Flexicolor Bleach. For further information, see the instruction sheet packaged with Kodak Flexicolor Bleach Regenerator.

Process Monitoring

To monitor the quality of the processing, Kodak Flexicolor Control Strips should be processed on a regular basis. Complete information on the use of the control strips can be obtained from Eastman Kodak Company, Dept. 942-C, Rochester, N. Y. 14650.

PROCESSING IN SMALL (1-PINT) TANKS

Equipment

Tanks: Small 1-pint tanks that use spiral reels
Reels: Kodak 110 Processing Reel
> or
> Stainless steel spiral reels supplied with small tanks

Temperature

The developer temperature must be maintained at 100 ± ¼ F (37.8 ± 0.15 C). The importance of maintaining the developer at this temperature cannot be overemphasized. The other solutions and the wash water should be used at the temperatures recommended in the table on page 441.

To control the temperatures of the solutions, maintain a water bath in a tray. Adjust the depth of the bath so that it is at least equal to the solution depth in the processing tank. The temperature of the water bath should be 100.5 F (38 C) for a 75 F (24 C) room temperature. Processing solutions and the empty processing tank can be kept at 75 F (24 C) room temperature before processing, but they must be brought to 100 F (37.8 C) just prior to processing. After development begins, place the processing tank in the water bath between agitation cycles.

Timing

Start the timer *immediately* after the developer solution is poured into the tank. The time of each processing step includes the drain time (usually about ten seconds). This will vary, depending on the construction of the tank and whether the cover is on or off. In each case, start draining in time to end the processing step (and start the next one) on schedule.

Handling

Load the reels and tanks in total darkness. Total darkness is required during development and the bleach step.

Agitation

The use of a single small reel in a multiple reel tank is not recommended. The back-and-forth motion of the reel in the solution (with inversion) can give excessive agitation in the developer. If a single roll of film is processed, use blank spacer reels to hold the loaded reel in place.

Vigorous agitation as described below is recommended. Because of variations in personal technique, these recommendations may have to be altered to obtain satisfactory results.

Developer: Agitation is critical and must be done with care and precision. As soon as the tank is filled, rap the bottom firmly on the sink or table to dislodge any air bells. Then agitate vigorously for four seconds. For invertible tanks, one complete inversion should be completed in two seconds. Therefore, two complete inversions are required.

After the initial agitation, place the tank in the water bath for four seconds. At the end of this time, remove it and perform one 2-second inversion (or otherwise agitate vigorously for two seconds). Then return the tank to the water bath for four seconds. Continue this procedure until ten seconds before the end of the processing step. Then discard the solution by draining for ten seconds.

Other Solutions: Use the same agitation procedure as described for the developer. The frequency of agitation can be adjusted to suit individual requirements.

PROCESSING PROCEDURE FOR SMALL TANKS

Solution or Procedure	Remarks	Temp (F)	Temp (C)	Time in Minutes	Total Minutes at End of Step
1. Developer	Total darkness	100 ± ¼	37.8 ± 0.15	3¼*	3¼
2. Bleach	Total darkness	100 ± 5	37.8 ± 3	6½	9¾
	Remaining steps can be done in normal room light.				
3. Wash	See note below	100 ± 5	37.8 ± 3	3¼	13
4. Fixer		75—105	24—41	6½	19½
5. Wash	See note below	100 ± 5	37.8 ± 3	3¼	22¾
6. Stabilizer		75—105	24—41	1½	24¼
7. Dry	Remove film from reel	75—105	24—41		

*Time listed is for initial films through a 1-pint set of solutions. See development-time compensation table below for development times of subsequent films through the same set of solutions.

Note: Use fresh water changes throughout the wash cycles. Fill the processing tank as rapidly as possible from a running water supply (about four seconds), When full, agitate vigorously (about two seconds) and drain (about ten seconds). Repeat the full wash cycle. If desired, use a running water inflow-overflow wash with the cover removed from the tank.

Development-Time Compensation

For processing more than three rolls of 20-exposure or 12-exposure film, replenishment is recommended for consistently satisfactory photographic quality. The 1-gallon, 3½-gallon, and larger sizes of Kodak Flexicolor Chemicals are recommended for this purpose. If not replenished and the pint volumes must be used, best results are obtained if the development time is increased in the *same pint* of developer as shown in the following table.

Film Size	Rolls of Film Processed Per Pint Before Each Time Adjustment*	Developer Time Adjustments					
		1st	2nd	3rd	4th	5th	6th
No. 110 (20-exp)	3	3 min. 15 sec.	3 min. 22 sec.	3 min. 30 sec.	3 min. 37 sec.	3 min. 45 sec.	NR
No. 110 (12-exp)	3	3 min. 15 sec.	3 min. 20 sec.	3 min. 26 sec.	3 min. 31 sec.	3 min. 37 sec.	3 min. 43 sec.

*A total of three rolls of 20-exposure or 12-exposure film may be developed (together or individually) per process in each time increment.

NR= Not recommended.

Note: The bleach, fixer, and stabilizer have twice the capacity of the developer. In successive processes, use normal processing times for these solutions and washes.

PROCESSING IN LARGE (1 and 3½ GALLON) TANKS

Equipment

Sinks: Sinks with tempered-water bath to maintain solution temperatures at 100 F (37.8 C)

Tanks: Kodak Hard Rubber Tanks
or
Tanks provided with processing lines

Reel Holders: Kodak Processing Rack (for stainless steel film reels)
or
Other reel holders

Note: Use caution in selecting reel holders and processing tanks because sizes are not standardized.

Reels: Kodak 110 Processing Reel
or
Other similar reels

Note: Use care in selecting the reel to make sure that it fits into the reel holder. For example, the diameter of the plastic side of some reels is slightly too large to easily load into the Kodak or other reel holders. Therefore, it may be necessary for operators using these reels to fabricate a spindle-type or T-bar-shaped reel holder.

When using the lightweight Kodak 110 Processing Reel, it may be necessary to provide photographically inert weights such as a stainless steel reel to keep it from moving upward in the reel holder during vigorous agitation.

The metallic clip on the loading tab of some reels may impinge on the emulsion side of the film and leave a mark caused by lack of development. Minimize this by loading the film emulsion side out rather than emulsion side in toward the core.

Reel Loader: Kodak 110 Processing Reel Loader (for use with Kodak 110 Processing Reel.

PROCESSING PROCEDURE FOR LARGE TANKS

Solution or Procedure	Remarks	Temp (F)	Temp (C)	Time in Minutes*	Total Minutes at End of Step
1. Developer	Total darkness	100 ± ¼	37.8 ± 0.15	3¼	3¼
2. Bleach	Total darkness	100 ± 5	37.8 ± 3	6½	9¾
	Remaining steps can be done in normal room light				
3. Wash		100 ± 5	37.8 ± 3	3¼	13
4. Fixer		75—105	24—41	6½	19½
5. Wash		100 ± 5	37.8 ± 3	3¼	22¾
6. Stabilizer		75—105	24—41	1½	24¼
7. Dry	See instructions	75—105	24—41		

*Include drain time (ten seconds) in time for each processing step.

Agitation

Agitation is very critical and procedures should not vary from process to process. Manual agitation is recommended in the developer and initially in all other solutions. If desired, gaseous-burst agitation can be used in all other solutions.

Manual Procedure

Developer, Initial: Immerse the rack fully into the developer and rapidly tap it on the bottom of the tank to dislodge any bubbles. Then raise the rack once until the bottom is out of the developer and reimmerse it. This requires four to five seconds.

Developer, Subsequent: Allow the rack to remain undisturbed until ten seconds have elapsed (including the initial agitation time). Then raise the rack straight up until the bottom is just out of the developer solution and reimmerse it without draining. The lifting and reimmersing cycle should be done with an even, uniform action taking two to three seconds to complete. Repeat this cycle once every ten seconds (six times per minute). Just before the end of the development time, drain for ten seconds by raising the rack and tilting it about 30° with one corner held over the tank. Then immerse the rack into the bleach.

Note: The agitation frequency of one 2-second lifting cycle six times per minute should be adequate to maintain satisfactory film contrast. However, the agitation frequency can be reduced as low as two times per minute or increased as high as ten times per minute if the contrast is slightly high or low.

Other Solutions and Washes, Initial: Use one lifting cycle. Only the initial agitation need be given during the wash steps.

Other Solutions, Subsequent: Use four lifting cycles per minute at 15-second intervals.

Gaseous-Burst Procedure

The general principles are given in Kodak Pamphlet No. E-57, *Gaseous-Burst Agitation in Processing,* a single copy of which is available on request from Dept. 412-L, Eastman Kodak Company. Equipment sold by dealers includes the Kodak Intermittent Gaseous Burst Valve, Model 90B, and the Kodak Gas Distributor (for Kodak Hard Rubber Tank, 8" x 10").

If subsequent manual agitation is not to be used in the developer, nitrogen-burst agitation rather than air-burst agitation should be used. However, nitrogen-

387

burst agitation in the developer is not a preferred recommendation since optimum image uniformity cannot be expected. The extent of image nonuniformity will depend on a number of factors such as reel design, reel location in the tank, and the distributed gaseous-burst pattern, frequency, and bubble size. Nitrogen- or air-burst agitation can be used in all other solutions, with the latter preferred in the bleach.

Developer, Initial: Use the same procedure described on page 387 for *Developer, Initial,* under *Manual Procedure.*

Developer, Subsequent: Eight seconds after the film has first been immersed, give a two-second burst of nitrogen at a pressure sufficient to raise the solution level about 5/8 inch with each burst of gas. Repeat the two-second burst at eight-second intervals (six times per minute). If desired, the frequency of the two-second burst can be decreased as low as two times per minute or increased as high as ten times per minute to maintain satisfactory film contrast.

Other Solutions and Washes, Initial: Use the same procedure described on page CPR-36.05 for *Other Solutions and Washes, Initial,* under *Manual Procedure.*

Other Solutions, Subsequent: The use of air is recommended for the bleach solution. Nitrogen can be used in all other solutions. Give a 2-second burst every 15 seconds (four times per minute) at a pressure sufficient to raise the solution level about 5/8 inch with each burst of gas.

Special Treatment for Bleach Solutions

In a seasoned process, the bleaching efficiency depends upon a certain amount of aerial oxidation in the bleach solution. The preferred way to achieve this oxidation is to bubble air through the solution. For maximum effect, continue the air bursts in the bleach throughout the complete processing cycle.

This can be done in a number of ways. First, a 2-second burst every 15 seconds (four times per minute) at a pressure sufficient to raise the solution level about 5/8 inch with each burst of air can be used. Second, air can be bubbled through the bleach from a separate compressed-air supply through a sparger, such as the Kodak Gas Distributor or equivalent. This should be done for about 30 minutes during or after each full process at a valve pressure of about 2½ pounds per square foot. Longer times are required if a lower pressure is used. Since it is not possible to over-aerate the bleach, it is recommended that low-level aeration continue throughout the day. Third, if manual agitation (lift-and-drain) is used for processing and no air is available, stir the bleach vigorously with a mixer so that air is drawn into the solution. This can be done by locating the mixer blade near the surface of the bleach solution.

Drying

Remove the film from the reels and hang it up to dry for 10 to 20 minutes at 75 to 105 F (24 to 41 C) in a dust-free atmosphere with adequate air circulation. If a drying cabinet is used, the air should be filtered and its temperature must not exceed 110 F (43 C). Increase the relative humidity if excessive curl is encountered.

Replenishment

Use replenishment procedures for greater solution capacity, process uniformity, and economy when 1-, 3½-gallon, and larger processing systems are used. Consistently satisfactory photographic quality is obtained by using the proper replenishment rates and calculating carefully the actual quantities of replenisher solutions required. Whether manually or by automatic metering devices, replen-

ishers should be added to the tank solutions as frequently as possible (for example, with each rack or just before processing the next batch).

Each laboratory must determine replenishment rates based on its own operating conditions. Replenishment rates per rack or batch are calculated for each solution based on a representative period of time, such as a week or month. To do this, keep a record of the number of rolls processed and the number of racks or batches used. Add up the total number of rolls and multiply by the replenishment rate (see the following table). Divide by the number of racks or batches to determine the average rate per rack or batch for each solution. Frequent recalculation of replenishment rates is recommended because of changing conditions. Over- or under-replenishment will be indicated by control strip results, assuming precise mechanical operation, accurate temperature control, and calibration of flowmeters.

Replenishment Rates for Reel Processing in Large Tanks

The table below gives replenishment rates for a single roll of film processed in a reel. In addition to the amounts shown, extra bleach replenisher solution is required to compensate for developer that is carried over into the bleach by the reel holder. Use the following amounts of bleach replenisher *in addition* to the normal amount of replenisher:

Kodak Processing Rack
 (open wire construction) —11 ml per holder
Closed tube-type reel holders—95 ml per holder
Other reel holders —Use 11 ml for wire-type reel holders that carry over a very low amount of residual developer. Use 95 ml for reel holders having substantial areas of metal or other materials. If you are uncertain about the amount of carry-over, use the higher rate.

Film Size	Replenishment Rates in ml Per Roll			
	Developer	Bleach	Fixer	Stabilizer
No. 110 (12-exposure)	22.6	10	10.7	6.5
No. 110 (20-exposure)	28.8	15	15	9

389

PROCESSING PROCEDURE FOR KODAK EKTACHROME FILMS
(PROCESS E-6)

Kodak chemicals for Process E-6, in various sizes, are available for processing the new Kodak Ektachrome professional films in small and large tanks, in rack-and-tank processors, in rotary tubes, and in continuous processing machines such as the Kodak Ektachrome E-6 processor. Kodak chemicals for Process E-6 are supplied as liquids and liquid concentrates in Cubitainers® for in-line replenishment. The processing procedures are described in detail in the instruction sheets packaged with the chemicals, and in Kodak Publication No. Z-119, *Using Process E-6*, which also describes the use of control strips for process monitoring. Pint-size E-6 chemicals and the procedures for processing the film in pint-size tanks will be available at a later date.

Here are some important items to consider about sink-line processing for these films:

1. For better temperature control at lower cost,
 a. Use recirculated heated water
 b. Use stainless steel tank for the first developer.
2. To conserve water and energy in wash steps, non-flowing washes can be used.
3. Only manual agitation is recommended for roll film on reels.
4. Gaseous-burst agitation is recommended for sheet films.
5. Nitrogen used for the first and color developers must be humidified.
6. Air used for the bleach and fixer must be oil-free.
7. The gaseous-burst agitation consists of a 2-second burst every 10 seconds. Initial manual agitation must be used in sink lines.
8. No gaseous-burst agitation should be given in the reversal bath, conditioner, or stabilizer.
9. An initial manual agitation is required in each solution except the reversal bath, conditioner, and stabilizer. In these solutions, merely tap the hangers or reels to dislodge air bubbles.
10. The agitation procedures are similar to those used for Process E-3 films.

Process Summary

The table below summarizes the cycle for a professional sink line used to process sheet films or roll films on reels. The table on the following page is more specific and should be used for actual working instructions.

Process E-6
38 C (100.4 F)

	Minutes
1. First Developer	6*
2. First Wash	2
3. Reversal Bath	2
4. Color Developer	6
5. Conditioner	2
6. Bleach	6
7. Fixer	4
8. Final Wash (two tanks, counterflow)	2
9. Stabilizer	½
Total	32½

*6¼ minutes if manual agitation is used exclusively.

(Continued on Page 392)

TIME TABLE FOR KODAK EKTACHROME PROCESS E-6

Solution or Procedure	Remarks	Temperature		Time in Minutes*	Time Total
		C	F		
1. First Developer	First three	38 ± 0.3	100.4 ± 0.5	6†	6
2. First Wash ‡	steps in	33 to 39	92 to 102	2	8
3. Reversal Bath	total darkness	33 to 39	92 to 102	2	10

Remaining steps can be done in normal room light.

Solution or Procedure	Remarks	Temperature		Time in Minutes*	Time Total
		C	F		
4. Color Developer		38 ± 0.6	100.4 ± 1.1	6	16
5. Conditioner		33 to 39	92 to 102	2	18
6. Bleach		33 to 39	92 to 102	6	24
7. Fixer		33 to 39	92 to 102	4	28
8. Final Wash ‡	Two tanks;	33 to 39	92 to 102	2	30
	Counterflow	33 to 39	92 to 102	2	32
9. Stabilizer		Ambient	Ambient	½	32½
— Dry	Remove films from hangers or reels before drying.	Not over 60	Not over 140		

*Include drain time of 10 seconds in each step.

†Time for nitrogen agitation for sheet films. Increase time by 15 seconds when only manual agitation is used. Manual agitation must be used for roll films in reels.

‡For flowing water washes. Nonflowing water washes can be used as follows: for the first wash, use a single tank filled with water at 25 to 39 C (77 to 102 F). Replace this wash. after two processing runs, regardless of the quantity of film processed. For the final wash, use three tanks filled with water at 20 to 39 C (68 to 102 F) for two minutes each. Replace the water in all three tanks after four processing runs, regardless of the total quantity of film processed. Do not use any final wash tank for a first wash tank. All wash tanks should be drained at the end of each day and left empty overnight.

Processing Steps

The following details supplement the specific operation instructions supplied with Kodak Ektachrome film chemicals, Process E-6.

1. *First Developer:* This solution converts the silver halides exposed in the camera to metallic silver. The temperature is more critical here than it is for the other solutions and washes—38.0 ± 0.3 C (100.4 ± 0.5 F). As with Process E-3, nitrogen-burst agitation is recommended with sheet films, but not with roll films on reels.

2. *First Wash:* This wash stops the action of the first developer and washes out chemicals from it to avoid contamination of the reversal bath. Water flowing at 7.6 litres (2 gallons) per minute is recommended for this and the final wash, but nonflowing washes can be used to conserve water and energy.

3. *Reversal Bath:* This bath fogs the remaining silver halides that were not converted to metallic silver in the first developer. Note that reversal exposure by light is not required as it was in Process E-3.

After the film has been in this bath for one minute, the remainder of the process can be conducted in normal room light.

4. *Color Developer:* In this solution, the silver halides fogged in the reversal bath are developed to positive silver images. As the developing agent reduces the silver halides to metallic silver, it is converted to an oxidized form that reacts with dye couplers incorporated in the film emulsion layers. In this way, cyan, magenta, and yellow dye images are formed in the bottom, middle, and top emulsion layers respectively.

As with the first developer, nitrogen-burst agitation can be used with sheet films only, not with roll films on reels.

5. *Conditioner:* This solution prepares the metallic silver formed in the first and color developers for oxidation to silver halide in the following bleach step. It also helps protect the acidity of the bleach solution by reducing carry-over of the alkaline color developer into the bleach.

6. *Bleach:* This non-ferricyanide solution oxidizes all the metallic silver formed during the first and color developing steps. Both the negative and positive silver images are converted to silver salts.

In the bleach and the following fixer step, oil-free compressed air, either continuous or in bursts, is recommended. Nitrogen agitation must not be substituted. Note that air is needed to regenerate the bleach; in processing with manual agitation, sufficient aeration is provided by the lift and reimmersion cycles.

7. *Fixer:* This solution converts the silver salts formed in the bleach to water-soluble silver thiosulfates. Note that there is no rinse between the bleach and fixer; silver removal is more efficient without it.

8. *Final Wash:* This wash removes dissolved silver salts and processing chemicals, to prevent them from affecting the processed film adversely. Counterflow washing in two tanks is the primary recommendation, but other setups can be used, including nonflowing washes.

9. *Stabilizer:* This solution is necessary for optimum dye stability. It contains a wetting agent for spot-free drying.

Replenishment of Solutions

With proper replenishment and care to avoid dirt and oxidation of the developers, reversal bath, and conditioner, the processing solutions can be used for extended periods of time. For small-scale users, adjustments of time in the first developer enable it to be used to a capacity of 0.44 square metre per litre (18 square feet per gallon). Other solutions have even greater capacity.

Processing Adjustments for Underexposed or Overexposed Films

Process E-6 Ektachrome Professional Film should always be exposed at its stated effective speed for the best results. Compensating for under- or overexposure with process adjustments produces a loss in picture quality. Underexposed and overdeveloped film results in a loss of D-max, a decrease in exposure latitude, a color-balance shift, and a significant increase in contrast. Overexposure and underdeveloped film results in a low toe contrast and a color shift. If these losses in quality can be tolerated, and if the processing machine has the flexibility, the first development time in the following table can be used as a guide to compensate for abnormal exposures.

Film Exposure	First Development Time
One stop under	*Approx. 8 minutes*
(Normal)	*(6 minutes)*
One stop over	*Approx. 4 minutes*

Retouching Dyes for E-6 Transparencies

Use Kodak E-6 Transparency Retouching Dyes for retouching original transparencies intended for photomechanical reproduction or for duplicating on Kodak Ektachrome Duplicating Film 6121 (Process E-6). Process E-3 retouching dyes can be used but some color mismatch may result.

Identifying Processed E-6 Ektachrome Films

Kodak-processed and mounted E-6 Ektachrome slides have a plus (+) symbol on the front and back of the mounts to distinguish them from E-4 Ektachrome slides. Other laboratories may use the same symbol for this purpose. On unmounted E-6 Ektachrome film strips, the edge print reads "Kodak Safety Film," followed by a four-digit code number. This is repeated at approximately 2-inch intervals. A solid square follows each frame number. On 135-20 size film, the three digit emulsion number appears at the No. 4 frame; on 135-36 size film, the emulsion number is at the No. 21 frame. In addition, the 135-size E-6 films have a 0.05-inch-diameter hole after every fourth perforation along one edge. Long rolls of 35mm E-6 films are frame numbered 1 through 44, and the emulsion number is printed at 12-inch intervals. The 120-size film has frame numbers 1 through 12, with the emulsion number between the third and fourth frame. Sheet films are identified by code notches.

Ektachrome 64 Daylight Code 6117

Ektachrome 50 Tungsten Code 6118

Ektachrome Duplicating Code 6121

Printing the films

No infrared cutoff filter is required when E-6 Ektachrome films are printed onto Kodak Ektachrome RC Paper, Type 1993. It is recommended, however, that a Kodak Infrared Cutoff Filter No. 301A be used for printing mixtures of Process E-3, E-4, and E-6 Ektachrome films for printing compatibility. Consult

Kodak Publication No. E-96, *Printing Color Slides and Larger Transparencies,* for more complete information on the use of the filter.

Duplicating the Films

Two new Ektachrome duplicating films for use with Process E-6 are available for making duplicate transparencies. Kodak Ektachrome Duplicating Film 6121 (Process E-6) is a color sheet film for the making of high-quality duplicate color transparencies in large sizes. Kodak Ektachrome Slide Duplicating Film 5071 (Process E-6) is available in 135-36 size and long rolls in 35mm and 46mm widths for making duplicate slides from original Kodachrome and Kodak Ektachrome transparencies. Information on these two films will be found elsewhere in this section.

PROCESSING KODAK EKTACHROME FILMS (Process E-4)

Kodak Process E-4 differs from the earlier Kodak Ektachrome processing kits in that it contains a fogging developer, which eliminates the necessity for re-exposing the film to light after the first development.

Although the process was originally devised for the convenience of photo-finishers and other large-scale workers, it has been found to have benefits even for those who process films only occasionally. Many small amateur film tanks have opaque reels; re-exposure cannot be done in the reel, and removing and reinserting the wet film is difficult and often leads to scratches and other damage. With Process E-4, the entire processing of the film can be carried out in any kind of tank, open or closed, the film remaining in the reel throughout the entire process.

The chemicals required for each of the processing solutions are supplied in prepared form, as follows:

Kodak Prehardener, Process E-4
(Replenish with Kodak Prehardener Replenisher, Process E-4.)

Kodak Neutralizer and Replenisher, Process E-4

Kodak First Developer, Process E-4
(Replenish with Kodak First Developer Replenisher, Process E-4.)

Kodak Stop Bath and Replenisher, Process E-4
Note: The same chemical is used to make both the "First Stop Bath" and the "Second Stop Bath" tank solutions and the replenisher solution for both stop baths. *But,* once these tank solutions have been used, they cannot be interchanged.

Kodak Color Developer, Process E-4
(Replenish with Kodak Color Developer Replenisher, Process E-4.)

Kodak Bleach and Replenisher, Process E-4

Kodak Fixer and Replenisher, Process E-4

or

Kodak Liquid Fixer and Replenisher, Processes C-22, E-2, E-3, and E-4

Kodak Stabilizer and Replenisher, Process E-4

Directions for preparing all solutions are included with the chemicals.

Important: The chemical characteristics of processing solutions are affected differently by color-film products. Therefore, Kodak Ektachrome Films designated for Process E-3 should never be processed in Process E-4.

The stabilizer contains formaldehyde. The prehardener contains formaldehyde and dimethoxytetrahydrofuran (DMTF), which hydrolyzes in the prehardener solution to form succinaldehyde. Succinaldehyde and formaldehyde vapors and solutions are skin and eye irritants. Adequate ventilation should be provided to prevent the accumulation of the aldehyde vapors in the processing and mix areas. Local exhaust ventilation and covers are recommended for the prehardener tank.

One part of either the color developer or the color developer replenisher formula contains tertiary butylamine borane (TBAB), which has a high degree of toxicity. This chemical is provided in pellet form to reduce the chance of inhaling any dust when mixing the developer solution. Since it is absorbed through the skin, repeated or prolonged skin contact with the solid chemical should be avoided.

Replenishment

When used as directed, replenishers extend the capacity of the working solutions to a maximum. An important advantage is the improved control of color balance and speed obtainable by making gradual compensation for the

use and aging of the solutions. Also, a considerable saving in mixing time results.

As long as the control strips used to monitor the quality of the processing indicate that the replenished solutions are giving satisfactory results, it is not necessary to dump the solutions except for routine cleaning. In an unfiltered system, however, dirt contamination places a limit on the use of the working solutions.

To prevent dirt and scum, the stabilizer should be dumped and replaced on a regular basis of twice per week in a replenished system and daily in an unreplenished system.

Agitation

Uniformity of results depends upon proper agitation, particularly in the first developer. Roll films on Kinderman or Nikor reels should receive *manual agitation only*. The following recommendations are specifically intended to cover use of the Kodak Processing Rack designed for roll film reels in 3½-gallon tanks.

Prehardener and Neutralizer. Lower the loaded rack into the solution and tap it vigorously against the tank to dislodge any air bubbles clinging to the film. Agitate continuously for the first 15 seconds by lifting the rack completely out of the solution and reimmersing it about four times. No further agitation is required in either of these solutions.

First Developer. Lower the loaded rack into the solution and tap it vigorously against the tank to dislodge any air bubbles clinging to the film. Then lift the rack completely out of the developer and reimmerse it about four times during the first 15 seconds of development. Allow the rack to remain undisturbed for 15 seconds. Then, in rapid succession, (1) lift the rack clear of the solution, (2) tilt it 60° or more in one direction, (3) reimmerse it, (4) lift the rack clear again, (5) tilt it 60° or more in the opposite direction, and (6) reimmerse it. Note that two tilts are required, with no time for draining. The entire agitation cycle should be completed in approximately 7 seconds. Repeat this cycle once every 30 seconds. Just before the end of the development time, drain the rack for 10 seconds.

Other Solutions. Agitate continuously for the first 15 seconds by lifting the rack completely out of the solution and reimmersing it about four times. Thereafter, agitate once each minute by lifting the rack completely out of the solution and draining it for 5 seconds from one corner. Alternate the direction of tilting the rack for draining.

Agitation for Automatic Film Processing Machines: With this type of equipment, the agitation, if required, should consist of a 2-second nitrogen burst every 30 seconds, at a pressure sufficient to raise the solution level about ⅝ inch with each burst of gas. For specific agitation procedures, refer to the manual for the equipment being used.

Temperature

The prehardener temperature should be 85 F (29.5 C) and maintained within 1 degree F (½ degree C). The first developer temperature should be 85 F (29.5 C), with a variation of no more than ½ degree F (¼ degree C). Good results depend on an accurate control of the temperature at this stage of the process.

Note: For automatic film processing machines *only,* 86 F (30 C) can be used.

The other processing solutions can be used at 83–87 F (28–31 C), with a temperature range of 80–90 F (27–32 C) permitted for wash water.

Timing

The time for each processing step includes the time required to drain the films—approximately 10 seconds. In each case, start draining in time to end the processing step (and start the next one) on schedule.

Washing

In determining the required flow rate of wash water, the area of the film being washed is of more consequence than the size of the tank. The minimum rate is 0.3 gallon per minute per square foot of film, and 0.4 gallon is recommended as a good operating level. Example: The area of a full load of reels in the Kodak Processing Rack is approximately 10 square feet; therefore, 4 gallons of wash water per minute should be provided.

Processing Steps

Agitate as prescribed in each step.

1. Prehardener. Check the temperature of all solutions, turn off all lights, and load the films into the reels. Load the rack and place it in a lighttight compartment. Turn on the light and recheck the prehardener and first developer temperatures. Turn off all lights, place the loaded rack in the prehardener, and start the timing operation. At the end of 3 minutes, including drain time, proceed to Step 2.

2. Neutralizer. Only 1 minute is required for neutralizing. The solution level in this tank must be higher than the solution level in the prehardener tank, to insure complete neutralization of the prehardener.

3. First Developer. Strict adherence to the recommended developer times is mandatory. After 6¼ minutes, proceed to Step 4.

4. First Stop Bath. 1¾ minutes are required in the stop bath.

5. Wash the film in running water for 4 minutes. At this point, the room lights can be turned on and left for the remainder of the process. No reversal exposure using lights is necessary, as reversal is accomplished chemically in the color developer.

6. Color Developer. Develop for 9 minutes in the color developer solution in replenished systems only. Old or exhausted Process E-4 Color Developer working solution may result in transparencies having low, green-colored maximum densities. In a nonreplenished system, this may occur when the capacity or storage life of the developer is exceeded. If it occurs sooner, it is probably due to dilution of the color developer by carried-over rinse water or to insufficient agitation. Therefore, to provide a factor of safety, the time in all unreplenished E-4 systems, including freshly prepared developer, should be increased from 9 minutes to 15 minutes. The time in the color developer for replenished systems remains at 9 minutes.

7. Second Stop Bath. 8 minutes are required for this stop bath.

8. Wash the films in running water for 3 minutes.

9. Bleach the films for 5 minutes. The appearance of the film does not indicate the degree of bleaching.

Caution: This bath corrodes most metals and therefore should not be left in contact with metal equipment any longer than necessary. However, it can be stored in red brass, polyethylene, porcelain, rubber, or glass receptacles, or in enamelware having surfaces that are free from cracks or chips.

10. Fixing Bath. 4 minutes are required for fixing with Kodak Liquid Fixer and Replenisher, Processes C-22, E-2, E-3, and E-4. 6 minutes are required with Kodak Fixer and Replenisher, Process E-4.

11. Wash the films for 6 minutes in running water.

12. Stabilizer. Bathing the films for 1 minute in this solution stabilizes the dye images. The stabilizing solution is an essential part of the process. Omission of this step will result in rapid fading of the dyes and in water spots. Do not rinse in water after this solution.

13. Drying. Remove the films from the reels and hang them up to dry in a dust-free atmosphere. If a drying cabinet is used, the air should be filtered and its temperature must not exceed 110 F (43 C).

When viewed by reflected light, the emulsion side of the wet film looks reddish; the base side, bluish. The opalescence that causes these effects disappears as the film dries.

KODAK EKTACOLOR 74 RC PAPER

Kodak Ektacolor 74 RC paper is a water-resistant (resin-coated) color paper that is suitable for printing Vericolor II, Kodacolor II, and similar color negatives. The paper offers up to a 50 per cent reduction in printing time on certain equipment compared to Kodak Ektacolor 37 RC paper. Available in sheets and rolls, this material can be used for contact printing and enlarging, or it can be exposed with equipment designed for quantity production of color prints.

The paper can be processed interchangeably with the same chemicals and equipment as are used for Kodak Ektacolor 37 RC Paper.

Surfaces Available

Kodak Ektacolor 74 RC Paper is supplied in E, F, N, and Y surfaces. *Caution:* The F surface paper must not be ferrotyped; normal drying yields a glossy surface.

Safelight

Use a Kodak safelight filter No. 13 (amber) or the equivalent, with a 7½-watt bulb in a suitable safelight lamp at a distance of at least 4 feet. After exposure, the paper can be handled for no longer than 3 minutes under the safelight. Before exposure, a slightly longer safelight exposure can be tolerated, but in any case, safelight exposure should be kept to a minimum.

Note: The Kodak Safelight Filter No. 10, used with other color papers, is *not* recommended for use with Kodak Ektacolor 74 RC Paper.

Storage

As with any sensitized photographic material, storage at high temperatures and high humidity can cause undesirable changes in the sensitometric properties of Kodak Ektacolor 74 RC paper. Store the paper at 50 F (10 C) or lower.

Warm-Up Time

To avoid moisture condensation on the surfaces, paper that has been held in cold storage should be allowed to warm up to room temperature before the sealed bag is opened. Ideally, the packages should be removed from cold storage the day before the paper is used. Otherwise, follow the warm-up directions in the instruction sheet packaged with the material.

Exposing Equipment

Kodak Ektacolor 74 RC Paper can be exposed on enlargers and printers with tungsten or tungsten-halogen light sources. The printer or enlarger should have a heat absorbing glass and an ultraviolet absorber such as the Kodak Wratten Filter No. 2B or 2C (gelatin), or the Kodak Color Printing Filter CP2B (acetate). Since voltage variations affect both light output and color quality, the use of a suitable voltage regulator is recommended. Recommendations for proper ultraviolet absorbers and heat-absorbing glass are given in the instruction sheet packaged with the paper.

A number of enlargers are available that have been specifically designed for printing color negatives. Some of these enlargers have light sources that incorporate long-lasting cyan, magenta, and yellow dichroic filters of graduated density to modify the color of the light reaching the paper, thus eliminating a filter-pack of individual filters. Some of the newer enlargers also have a tungsten-halogen light source that will not blacken with age. Thus, light output and color temperature remain constant throughout the life of the lamp.

When individual filters are used, they should be placed in the lamphouse, so the less-expensive CP filters may be used. CP filters available include:

Red	Cyan*	Magenta	Yellow
	CP025C-2		
CP05R	CP05C-2	CP05M	CP05Y
CP10R	CP10C-2	CP10M	CP10Y
CP20R	CP20C-2	CP20M	CP20Y
CP40R	CP40C-2	CP40M	CP40Y
	CP2B (Equivalent to Kodak Wratten Filter No. 2B)		

*Another series of cyan filters is available in 0.05, 0.10, 0.20, and 0.40 densities. These filters do not have the suffix "-2" and are less suitable for color printing.

The CP Filters are not supplied in green or blue, because the number of filters between the lamp and the negative is not important. Hence these colors can, if they are needed, be obtained by using the proper combinations of cyan, magenta, and yellow filters.

Exposure

The exposure methods and conditions for Kodak Ektacolor Paper 74 RC are generally the same as those used for Kodak Ektacolor 37 RC Paper, except that exposure time is shorter on certain equipment, and less filtration is required.

STARTING FILTER PACKS FOR PRINTING WITH
KODAK EKTACOLOR 74 RC PAPER

For Negatives on these Kodak Films	Enlargers Using Dichroic Filters* and Tungsten-Halogen Lamps	Enlargers Using Kodak CC Filters with Tungsten-Halogen Lamps	Enlargers Using Kodak CC Filters with Tungsten Lamps (No. 212 or 302)
Vericolor II Professional	60M + 110Y	55M + 65Y	55M + 35Y
Kodacolor II	50M + 100Y	45M + 55Y	45M + 25Y

*Dial settings for equivalent filtration may vary somewhat among different types of enlargers

Adjust subsequent exposures to produce a satisfactory density. Then, if the balance of the print is not satisfactory, adjust the filters in the filter pack.

If Previous Print Is	Amount of Change Desired		
	Very Slight	Slight	Considerable
TOO RED	add 05M & 05Y	add 10M & 10Y	add 20M & 20Y
TOO GREEN	subtract 05M or add 05C-2 & 05Y	subtract 10M or add 10C-2 & 10Y	subtract 20M or add 20C-2 & 20Y
TOO BLUE	subtract 05Y or add 05C-2 & 05M	subtract 10Y or add 10C-2 & 10M	subtract 20Y or add 20C-2 & 20M
TOO CYAN	subtract 05M & 05Y or add 05C-2	subtract 10M & 10Y or add 10C-2	subtract 20M & 20Y or add 20C-2
TOO MAGENTA	add 05M	add 10M	add 20M
TOO YELLOW	add 05Y	add 10Y	add 20Y

Exposure Adjustments

An exposure time that produced a print of satisfactory density may not produce the same density when the printing filter pack is changed. The new

exposure time can be found by either of two procedures, depending upon which of the following methods is used to judge color prints.

1. In printing color negatives, some workers think of exposure time as controlling density and of the filter combination as controlling color balance. They therefore judge the *overall* apparent density and color balance of a print. Whenever the filter pack is changed, allowance should be made for the change in exposure introduced by (1) the change in filtering action, and (2) the change, if any, in the number of filter surfaces. The following table provides methods of determining such exposure adjustments. Both the computer numbers and the filter factors include allowance for the loss of light caused by reflections from the filter surfaces.

If the pack is changed by only one filter, use of the appropriate filter factor is convenient. Otherwise, the use of the computer numbers with the Color-Printing Computer in the *Kodak Color Dataguide* will probably be preferred.

Computer Numbers and Factors for Kodak CC and CP Filters

Filter	Computer Number	Factor	Filter	Computer Number	Factor	Filter	Computer Number	Factor
05M	0.07	1.2	05Y	0.04	1.1	05R	0.07	1.2
10M	0.10	1.3	10Y	0.04	1.1	10R	0.10	1.3
20M	0.16	1.5	20Y	0.04	1.1	20R	0.17	1.5
30M	0.22	1.7	30Y	0.05	1.1	30R	0.23	1.7
40M	0.27	1.9	40Y	0.05	1.1	40R	0.29	1.9
50M	0.32	2.1	50Y	0.05	1.1	50R	0.34	2.2

To use computer numbers: Add the computer-number values for all the filters in the old pack. On the "Density" scale of the Color-Printing Computer, set the sum of the computer numbers so that it is opposite the exposure time used. Read the new exposure time opposite the sum of the computer numbers for the new pack.

To use factors: First divide the old exposure time by the factor* for any filter removed from the pack. Then multiply the resulting time by the factor* for any filter added.

*For two or more filters, multiply the individual factors together and use the product.

2. If color prints are evaluated in terms of the three separate dye layers, the exposure change for a filter-pack change need allow only for the change in the number of filter surfaces.

If one filter is added to the pack, increase the exposure time by 10 per cent; if two filters are added, increase the exposure by 20 per cent; and so on. If one filter is subtracted from the pack, decrease the exposure time by 10 per cent; if two filters are subtracted, decrease by 20 per cent; and so on.

Tricolor Printing

For tricolor printing, the recommended Kodak Wratten Filters are No. 25 (red), No. 99 (green), and No. 98 (blue). A heat-absorbing glass should be in place near the light source. Assuming a Photo Enlarger Lamp No. 212 or No. 302 as the light source, typical exposure times at *f*/8 for a 3X enlargement from a normal color negative are: red—2 seconds, green—12 seconds, and blue—5 seconds.

For more detailed exposure information, refer to the instruction sheet packaged with the paper.

Viewing Prints

If possible, evaluate prints under lights of the same color quality and intensity as those under which the final print is to be viewed. If this is not possible, evaluate prints under standard illumination. For a good average condition, use a 50- to 100-footcandle light source with a color temperature of 4000±1000 K and a CRI (Color Rendering Index) of 85 or higher (A CRI of 90 or higher is desir-

able). This color quality is approximated by several types of fluorescent lamps (in fixtures) such as General Electric Deluxe Cool White, Sylvania Deluxe Cool White, Westinghouse Deluxe Cool White, and Westinghouse Living White.

Satisfactory results can also be obtained by using a mixture of incandescent and fluorescent lamps. For each pair of 40-watt Deluxe Cool White fluorescent tubes, add a 75-watt frosted tungsten bulb.

Processing

Kodak Ektacolor 74 RC Paper can be processed by either batch or continuous methods using Kodak Ektaprint2 or Ektaprint 3 chemicals, or with similar chemicals of other makers. Instructions for processing this paper are given on the following pages.

Bleach-Fix Regeneration

In processing Kodak Ektacolor 74 RC Paper with Kodak Ektaprint 2 chemicals, recommendations for bleach-fix regeneration are the same as for the former Ektacolor 37 paper. For information on bleach-fix regeneration, refer to Kodak Publication No. Z-122A, *Regenerating Kodak Ektaprint 2 Bleach Fix.*

Mounting

Prints on water-resistant paper can be mounted with Kodak Dry Mounting Tissue, Type 2, or a similar mounting tissue. The press temperature across the heating plate should be 180 to 210 F (82 to 99 C). Pressure should be applied for 30 seconds, or longer for thick mounts. To remove moisture that might cause sticking, preheat the cover sheet used over the face of the print.

CAUTION: Temperatures above 230 F (110 C) and/or high pressures may cause physical and color changes in color prints.

Prints can also be mounted satisfactorily with Kodak Rapid Mounting Cement.

PROCESSING KODAK EKTACOLOR 74 RC PAPER

Kodak Ektacolor 74 RC paper is available in sheet and roll form; it replaces both Kodak Ektacolor Paper 30 and Kodak Ektacolor Paper 37.

Kodak Ektaprint 2 Chemicals are used to process this paper, though the Kodak Ektaprint 3 Stabilizer can be used if desired. For processing on drums and other high-agitation devices, the Kodak Ektaprint 300 developer is used in place of the normal Ektaprint 2 Developer.

Instruction sheets containing complete information will accompany the paper and chemical packages. The following pages summarize the main procedures for processing the paper in trays, Kodak Processing Baskets, and Kodak Rapid Processors, Models 11, 16-K, 30, and 30-A. Other equipment manufacturers can be consulted for processing information for their equipment.

PROCESSING PROCEDURES FOR TRAY AND BASKET PROCESSES

Chemicals Required

Kodak Ektaprint 2 Developer
Kodak Ektaprint 2 Developer Replenisher
Kodak Ektaprint 2 Bleach-Fix and Replenisher
Kodak Ektaprint 3 Stabilizer and Replenisher (*Optional*)
Kodak Stop Bath and Replenisher, Process C-22 (*Optional*)

(Mixing instructions are included with the chemicals)

Chemical Storage Life

Solution	Storage Tank, Floating Lid	Full, Stoppered Glass Bottles
Developer (unused)	6 weeks	6 weeks
Developer (partially used, unreplenished)	1 week	2 weeks
Developer Replenisher	6 weeks	6 weeks
Bleach-Fix	8 weeks	8 weeks
Stabilizer	8 weeks	Indefinite
C-22 Stop Bath	8 weeks	8 weeks

Tray Processing

In an 8 by 10-inch tray, one quart of processing solution is required for processing three 8 by 10-inch sheets at a time. Immerse the first sheet in the developer, emulsion side down, then add the second and third sheets (also emulsion down) at 20-second intervals. (Identify the first sheet by clipping one corner.) Continuously interleave the sheets by pulling the bottom sheet out, placing it on top without draining, and reimmersing it completely in the solution. Twenty seconds before the end of the development time, remove the first sheet and allow it to drain 20 seconds. Then immerse it in the bleach-fix solution. Transfer the other two sheets in the same manner at 20-second intervals. Repeat this procedure in each of the other processing steps.

When processing more than three sheets at one time, divide the number of sheets into 60 seconds to determine the immersion interval. In no case should the drain time at the end of each step exceed 20 seconds; with more than three sheets, the drain time will be shorter than 20 seconds.

Discard the developer after processing each batch of prints in the tray. Other solutions can be used up to their normal exhaustion point, which is seven 8 by 10-inch sheets (4 square feet) per liter of solution.

Perform the optional steps if marks or streaks are observed on the surface of the prints.

Basket Processing

1. Loading:

Place two 8 × 10- or 11 × 14-inch prints, back-to-back, in each basket slot. With larger size prints, it may be necessary to place only one sheet of paper in each slot. Such is the case if you see a red or brown residue of bleach-fix on the back of prints when you remove the prints from the stabilizer.

2. Proper agitation is very important:

Manual Agitation: Upon placing the basket in each solution, agitate continuously for 30 seconds, and for 5 seconds every 15 seconds thereafter. Agitation should consist of rapid up-and-down movement of about 2 inches with as much movement toward the sides of the tanks as can be managed. Don't lift the processing basket out of the solution during agitation. Be sure the cover is on the basket.

Gaseous-Burst Agitation: Use vigorous manual agitation plus continuous gaseous-burst agitation during the first 15 seconds of each step. Thereafter a 1-second gaseous burst every 10 seconds. Nitrogen must be used in the developer and bleach-fix. Oil-free compressed air can be used in the washes and stabilizer. The gaseous pressure should be sufficient to raise the solution level $5/8$ inch with each burst.

Timing: Include a 20-second drain time in each processing step. Baskets of complex design can be drained for 30 seconds. Tilt the basket at a 45-degree angle to improve draining.

3. The Optional Stop-Bath Step:

Some batch operations may carry over excess developer into the bleach-fix. This carry-over plus low agitation can result in patterns or streaks on prints, as was true with the processing of Ektacolor Professional Paper in Ektaprint C Chemicals. If you found it necessary to use the stop-bath step with Ektacolor Professional Paper, continue using it with Ektacolor 74 RC Paper. See the summary of steps.

4. The Bleach-Fix Solution:

Care must be taken to avoid the contamination of the developer with bleach-fix. A very little bleach-fix in the developer produces cyan stain. Bleach-fix regeneration is not recommended for batch processing operations. The bleach-fix will corrode brass and copper rapidly. Use type 316 stainless steel or plastic for bleach-fix tanks and fittings.

5. Washing:

Adequate washing procedures are important for print quality and print life. The minimum wash-water flow rate is .15 gallon per minute per square foot of paper. A 3½-gallon wash tank should allow a rate of at least 2 gallons per minute. In basket systems larger than 10 gallons, the flow rate per minute is 1/10 of the wash tank volume but no less than 5 gallons per minute. If possible, a 10-gallon system should use two wash tanks with a countercurrent flow.

If the baskets or the carriers are to be washed in the machine wash tank, that tank should be dumped and filled with fresh water before the baskets are washed.

(Continued on page 462)

SUMMARY OF STEPS FOR TRAY AND BASKET PROCESSING

Processing Step	Remarks	Temp C	Temp F	Time in Minutes		Time at end of step (w/option-al steps)
1. Developer	No. 13 Safelight Filter	32.8±0.3	91 ± 0.5	3½	3½	
(Optional Steps)†						
a. C-22 Stop bath	Agitate as described	30—34	86—93	1		4½
b. Wash	Running water	30—34	86—93	1		5½
2. Bleach-Fix		30—34	86—93	1½	5	7

Remaining steps can be done in normal room light

Processing Step	Remarks	Temp C	Temp F	Time in Minutes		Time at end of step (w/option-al steps)
3. Wash	Running water	30—34	86—93	3½	8½	10½
4. Dry	Air dry—don't ferrotype!	Not over 107	Not over 225			

*Include a 20-second drain time in each process step. Baskets of complex design can be drained for 30 seconds to prevent excessive carry-over.

†Optional steps are suggested if marks or streaks are observed on the surface of prints. Excessive developer carry-over and inadequate agitation are usually responsible for such marks.

A wash time of 20 minutes is recommended. If the prints tend to become covered with small air bubbles, which decrease the washing efficiency, install an aspirator (filter pump) in the water line. Adjust the aspirator to provide a steady flow of large air bubbles. This will prevent the formation of small bubbles on the print surfaces.

6. Drying

Prints can be dried in racks or air impingement dryers. Forced-air circulation will hasten the rack-drying. Prints can also be dried emulsion out on double-belt dryers equipped with special liners to prevent sticking of the emulsion to the belts. Prints cannot be hot- or cold-ferrotyped. Squeegeeing the prints will minimize the drying time, but care should be taken to avoid abrasion of the emulsion side.

7. Use of Solutions with Development-Time Compensation:

If the development time is increased as these solutions are used, the capacity of a 3½-gallon basket line is 90 sheets of 8 by 10-inch paper (50 square feet). Increase the development time 15 seconds after each 30 sheets. Before starting each succeeding batch, bring the solutions up to their initial volume by adding fresh solution. Discard all solutions after processing the above-mentioned quantity of paper. For critical work, the chemical-replenishment method is recommended.

8. Chemical Replenishment

Replenishment of the solutions should be done after each batch of prints has been processed. In each case, remove and retain more than enough solution to make room for the replenisher. Add the replenisher and then enough of the retained solution to restore the proper volume. The replenishment rates for Ektaprint 2 chemicals are as follows:

Developer	30 ml/ft^2
Bleach-Fix	30 ml/ft^2

PROCESSING KODAK EKTACOLOR 74 RC PAPER IN KODAK RAPID PROCESSORS MODELS 11, 16-K, 30 AND 30-A

Chemicals Required

Kodak Ektaprint 300 Developer
Kodak Ektaprint 2 Bleach-Fix and Replenisher
(Mixing instructions are included with the chemicals)

Chemical Storage Life

Solution	Partially Filled, Stoppered Glass Bottles	Full, Stoppered Glass Bottles
Developer	3 weeks	6 weeks
Bleach-Fix	6 weeks	8 weeks
Stabilizer	8 weeks	Indefinite

Summary of Steps for Kodak Rapid Color Processor, Models 11 and 16-K

Processing Step	Remarks	Drum Temperature C	F	Time in Minutes*	Time End of Step
1. Prewet	In tray of water	21—39	70—102	½	½
2. Developer	Kodak Safelight Filter No. 13 for first four steps	37.8±0.3	100 ± ½	2	2½
3. Wash	Running water	37.8 ± 1	100 ± 2	½	3
4. Bleach-Fix		37.8 ± 1	100 ± 2	1	4
Remaining steps can be done in normal room light					
5. Wash	Running water	37.8 ± 1	100 ± 2	1	5
6. Dry	Air dry—don't ferrotype!	Not over 107	Not over 225	—	—

*Include drain time of 10 seconds for prewet step; 5 seconds for all other steps.

Notes on Models 11 and 16-K Processors

1. Be sure processor is leveled. See processor manual instructions.

2. A green-coated processing blanket is recommended for processing this paper. The green coating grips the smooth base side of the paper and prevents the paper from slipping off the drum. Be sure the green end of the blanket is installed on the bar assembly so that the rough side will face the drum during the operation.

3. Only sheet-size paper is recommended for processing on these processors. If roll paper is used, it should be cut and stored in a flat position for a period of time to remove roll curl.

4. Use 118 ml (4 fluid ounces) of each solution for the Model 11 processor and 236 ml (8 fluid ounces) of each solution for the Model 16-K processor.

5. After each process, rinse the blanket, drum and tray with running water to remove all traces of processing chemicals. Replace the prewet water and wipe excess water from the drum and tray before starting each process.

6. Dry the print as suggested in the instructions for tray and basket processing.

Summary of Steps for Kodak Rapid Processors, Models 30 and 30A

Processing Step	Container Number	Temperature		Time in Minutes*	Time at End of Step
		C	F		
1. Prewash	1	37.8 ± 1	100 ± 2	½	½
2. Developer	2	37.8 ± 0.3	100 ± ½	2½	3
3. Stop†	3	37.8 ± 1	100 ± 2	½	3½
4. Wash	4	37.8 ± 1	100 ± 2	½	4
5. Bleach-Fix	5	37.8 ± 1	100 ± 2	½	4½
6. Wash	6	37.8 ± 1	100 ± 2	½	5
7. Wash	7	37.8 ± 1	100 ± 2	½	5½
8. Stabilizer	8	37.8 ± 1	100 ± 2	½	6
9. Dry	—	Not over 107	Not over 225	—	—

*Include a 10-second drain time in each process step.
†Use Ektaprint 3 Stabilizer for this step.

Notes on Model 30 Processor

1. See the processor manual for operation instructions.

2. The timing disk on the older Model 30 processors can be used to time step *number* operations only. The names of process steps on the disk should be ignored. New disks are available for these machines, and the Model 30A has the correct disk for Ektacolor 74 RC paper.

3. The smooth interior of the older processing tubes does not allow the back of the print to be washed completely. Therefore, be sure the processed print is removed carefully to avoid transferring any residual chemical solution from the back of the print to the front of the print. Rinse or wipe off the back of the print with a clean wet sponge. Later models of the processor have spirally ribbed drum interiors to avoid this problem.

You can also remove residual bleach-fix chemicals from the back of the print while the print is still in the tube. After step 6, the first wash following the bleach-fix, stop the processor with the tube in the vertical position. Remove the lid and lower the tube to the horizontal position. Rotate the tube so that the leading edge of the print is in the lowest curvature of the tube. Pour in one container of water and lift the leading edge of the paper away from the tube wall. Start the processor. Drop the leading edge as soon as the drum begins to rotate. The water should begin to flow between the back of the print and the tube. After several rotations, stop the processor and repeat the lifting of the leading edge to facilitate the flow of water beneath the paper. These operations should take about 30 seconds. Return the tube to the vertical position to drain. Repeat the previously described operations with another container of water. Replace the lid and continue with the remaining steps 7 (Wash) and 8 (Stabilizer). If a timing disk is used with the smooth wall tubes, the last wash and

stabilizer times should be adjusted to compensate for the time lost in the special rinsing operation.

New processing tubes with spiral ribs to facilitate the washing of prints are available for replacements in older machines.

4. Use 946 ml (1 quart) of each solution for the Kodak 3040 Processing Tube, and 384 ml (13 fluid ounces) of each solution for the Kodak 2024 Processing Tube.

5. After each process, rinse the processing tube and cover with warm water (not above 43 C, 110 F). Before loading the tube for the next process, be sure that the inside of the tube is dry. Wet surfaces can prevent correct positioning of paper in the tube.

6. Dry the print as suggested in the instructions for tray and basket processing.

This page is being reserved
for future expansion.

KODAK EKTACHROME DUPLICATING FILM 6121 Process E-6

Kodak Ektachrome Duplicating Film 6121 is a color reversal sheet film for the making of high-quality duplicate color transparencies of original transparencies on Kodak Ektachrome Films, either Process E-3 or Process E-6. Duplicate transparencies can be made same-size, reduced or enlarged. The film can also be used to make enlarged transparencies from slides on any of the Ektachrome Films, Process E-4 or E-6, or Kodachrome Films. If somewhat lower contrast is acceptable, the film can be used to copy color prints or other colored reflection copy.

No masking or other means of contrast control is normally required.

The duplicate transparencies made on this film can be displayed on illuminators or can be used as originals for graphic reproduction. They can be separated by conventional film methods, or by color scanner for use in catalogs, magazines, and other publications.

The thickness of the duplicating film base is the same as that of camera sheet films, so that both original and duplicate transparencies can be joined by cutting and butting operations. The base has a matte-gel (dyed) antihalation backing, and both sides of the film can be retouched. Duplicate transparencies made on this film can be retouched with Kodak E-6 Transparency Retouching Dyes if they are to be reproduced. Original E-6 transparencies that require dye retouching can be retouched with the same dyes if they are to be duplicated on this film.

Film Storage and Handling

Unexposed film should be stored in a dry place at temperatures not exceeding 13 C (55 F). The film must be handled in total darkness. To prevent moisture condensation on the film surfaces after taking the film from refrigeration, allow the film packages to reach room temperature before opening. A 25-sheet box requires a warm-up time of ½ to 1 hour after removal from refrigerated storage, and of 1 to 1½ hours after removal from freezing-unit storage. Exposed film should be processed as soon as possible to avoid changes in the latent image. Processed film should be kept at 50 per cent relative humidity or lower and at 21 C (70 F) or lower to minimize image fading. For long-term keeping, the duplicate transparencies should be sealed in Kodak Storage Envelopes for Processed Film, or equivalent, and stored under refrigeration.

Light Source and Exposing Equipment

Kodak Ektachrome Duplicating Film 6121 (Process E-6) is intended primarily for exposure with tungsten illumination such as that supplied by Photo Enlarger Lamps No. 212 or 302, or with tungsten-halogen lamps. Pulsed-xenon light sources can also be used, but fluorescent light sources are not recommended. Appropriate light-balancing filters are usually required with sources other than tungsten.

An enlarger is a convenient light source for making exposures by either contact or projection. The exposing equipment should have a heat-absorbing glass and an ultraviolet absorbing filter such as the Kodak Wratten Filter No. 2B or Kodak Color Printing Filter CP2B. A constant-voltage power source minimizes short-term changes in light intensity and color balance.

As a starting point for color correction with a pulsed-xenon light, add CC25M and CC85Y filters to those recommended for tungsten light exposure. See the supplementary Data Sheet packaged with each emulsion for suggested color correction filters for tungsten illumination.

Contact Printing: For adjusting color balance, the exposing equipment must be fitted with a means of holding several filters in the exposing light beam. These

can be either CC or CP filters. A color enlarger with color filter dials can also be used.

Projection Printing: If the enlarger has provision for filters between the light source and the transparency being duplicated, use Kodak Color Printing Filters (Acetate), or equivalent, for color-balance adjustments. If filters can be placed only between the lens and the easel, use Kodak Color Compensating Filters (Gelatin), or equivalent, which minimize loss in definition. Use the minimum number of CC filters over an enlarger or camera lens by combining filters as described under "Color Balance Adjustments" below. Color enlargers with dial filter settings can also be used.

Copying: When used for copying color prints or other colored reflection copy such as paintings or drawings, Kodak Ektachrome Duplicating Film yields transparencies of somewhat lower contrast than duplicate transparencies. A standard copy setup can be used for copying on this film, with great care being taken to assure even illumination on the copyboard.

When incandescent illumination is used (3000 to 3200 K) start with the filter pack recommended on the instruction sheet packaged with the film, and make changes based on results. Use only CC filters (gelatin) and not CP filters (acetate), because the filters are used in the image-forming beam. When using pulsed-xenon for illumination, start with an 85B filter only, and then make changes based on results. See the section below on color balance adjustments.

Exposing The Film

Mask any unwanted portion of the original transparency with black paper. The intensity of the light should be controllable to allow an exposure time of approximately 5 seconds. Exposure is usually then controlled by the lens diaphragm; Kodak Wratten Neutral Density Filters can be used if the illumination level is too high. Changes in voltage *must not be used* because the color balance of the exposing light changes with changing voltage. As a guide to determining the correct exposure conditions, make the initial exposure as follows:

Illumination at the Exposure Plane: ½ footcandle, without color correction filters in the light beam. Use a light integrator to measure pulsed-xenon illumination.

CC Filter Pack: Starting point recommendations are given in the Data Sheet packaged with each emulsion (for pulsed-xenon, add CC25M and CC85Y to the filter pack recommendations given in the Data Sheet.

Trial Exposure Time: 5 seconds at three intensity levels: normal, one stop above normal, and one stop below normal. Normal is the aperture that produces ½ footcandle illumination on the exposing plane.

While 5 seconds is recommended as a convenient exposure time for many situations, shorter times can also be used satisfactorily without getting uncontrollable color shifts. Avoid exposures much longer than 5 seconds. In situations where it is applicable, suitably filtered electronic flash can be used as a light source.

Processing

The film is processed in Process E-6 chemicals. All processing times are the same as for camera films—the duplicating film and camera films can be processed together. The duplicating film can be processed in rack-and-tank as well as other processors; detailed information on rack-and-tank processing can be found in Kodak Publication No. Z-119, *Using Process E-6,* sold by photo dealers. It can also be processed in a professional tank sink line or in rotary-tube processors.

Sink-Line Processing

Several sheets of Kodak Ektachrome Duplicating Film 6121 can be processed at the same time when a 3½-gallon tank sink line is used. Color balance and speed are more consistent in consecutive process runs when solution replenishment is carried out as recommended. Complete replenishment instructions are packaged with Kodak First Developer Replenisher, Process E-6. Replenishers increase the capacities of the working solutions to a maximum and increase their life considerably.

For better processing uniformity of 8″ × 10″ films in 3½-gallon tanks, you can use a Kodak Developing Hanger Rack No. 40 with Kodak Hanger Separators Load the film in Kodak Film and Plate Developing Hangers, No. 4A, or equivalents, and place the hangers in the rack. Use the separators to maintain equal spacing between the hangers.

If films of different sizes are developed at the same time in a tank, a spacer sheet of discarded E-6 film or acetate sheeting should be loaded in a hanger and placed between the groups of different-sized hangers. This should be the largest size being processed. For example, if 8 × 10-inch film is being processed with 4 × 5-inch film in multiple hangers, the separator sheet should be the 8 × 10-inch size. The spacer avoids uneven density that would otherwise occur in a large sheet next to smaller sheets, caused by turbulence around the multiple hanger frame members.

Proper agitation is especially important in the first and color developers. Both gaseous-burst and manual agitation procedures can be used. The gaseous-burst procedure is preferred because it produces a somewhat higher agitation level than the manual procedure, and for this reason tends to yield more consistent process uniformity.

Details for sink-line, rack-and-tank, and continuous machine processing are given on the instructions packaged with Kodak Ektachrome Film Chemicals, Process E-6. Instructions for using Process E-6 in tube-type processors are given in Kodak Publication No. Z-119A, *Special Instructions for Using Rotary-Tube Processors for Process E-6.* For a single copy, write to Eastman Kodak Company, Department 761-B, Rochester, N. Y. 14650.

Retouching Dyes

Kodak E-6 Transparency Retouching Dyes are recommended for use on E-6 transparencies that are to be duplicated on Kodak Ektachrome Duplicating Film 6121 (Process E-6). Retouching done with other dyes may not reproduce as it appears visually and may show up as obvious retouching on the duplicate transparency. The E-6 Retouching Dyes are also designed to be used on duplicates made on this duplicating film that are to be used for photomechanical reproduction. Retouching done with other dyes, such as Kodak Ektachrome Film Retouching Dyes designated for Process E-3 Films, may show up in the reproduction. More information can be found in Kodak Publication No. E-68, *Retouching Color Transparencies,* 7-76 printing.

Judging Exposures for Density and Color Balance

All transparencies should be viewed on a standard illuminator (5000 K, as recommended in ANSI Standard PH2.31-1969). Such an illuminator provides the correct light intensity and the spectral distribution characteristics necessary for the critical analysis of color transparencies.

Density: In the section entitled "Exposing the Film," it was suggested that three trial exposures be made. When processed, the three transparencies should be evaluated on the illuminator. It is likely that one of the three exposures was close to correct. If all three exposures produced densities that are too great

413

(dark), give more exposure by changing the aperture (not the time) in making a new exposure series. It is important to keep the exposure time relatively constant in order to maintain a consistent filter pack. If the exposure series produced transparencies that are too low in density (light), make a new test-exposure series with less intensity (smaller apertures).

Color Balance Adjustments: If the color balance is not as desired, determine the color or colors that are present in excess. This can be done by viewing the test transparencies through various CP or CC filters. The Kodak Color Print Viewing Filter Kit, sold by photo dealers, is convenient for this purpose. When making judgments, look at the middletones instead of the shadows or the high-lights. The required filter-pack adjustment involves removing a filter of the color that is present in excess in the transparency or adding a filter of a color complementary to the excess color. The amount of change is approximately the amount of the viewing filter that is required to make the middletones of the test transparency appear balanced.

For example, if a transparency is too red and requires a 20 cyan viewing filter to make it appear balanced, 20 red filtration should be removed from the original filter pack or 20 cyan filtration should be added to the pack. Whenever there is a choice, remove filters rather than adding them. The table below may be useful in determining filter adjustment.

As a general rule, keep the number of filters in the filter pack to a minimum. Where CP filters are being used between the light source and the transparency, this is not critical. Some users find the use of just C, M, and Y filters convenient, because they do not have to stock red, green, or blue color printing filters. In using the CC filters in the image forming beam, the use of more than three filters may lead to loss of definition in the duplicate, and to lowered contrast due to flare.

When some filters of all three colors (C, M, Y) are in the pack, the pack in effect contains some *neutral density,* which can be removed without changing the basic correction of the pack. For instance, if the pack contains 40C + 40M + 20Y the amount of the lowest value filter can be removed from all three colors, leaving only two colors in the pack.

Filter pack	40C + 40M + 20Y	
Subtract	−20C − 20M − 20Y	(remove neutral density)
Reduced Filter Pack	20 C + 20M 0Y	
	20B	(Combine: 20M + 20C = 20B)

When the filter pack is changed, the pack filter factor changes also. This means that the exposure must be changed, or the density of the corrected transparency will differ from that of the test transparency. A table of filter factors, along with instructions for figuring the change in exposure, is given in Kodak Publications E-96, *Printing Color Slides and Larger Transparencies;* E-66, *Printing Color Negatives;* and R-19, *Kodak Color Dataguide.* The *Color Dataguide* contains a dial that is useful for finding changes in exposure time.

If overall color balance is:	View through these filters:	Remove these filters from pack:	OR	Add these filters to pack:
Yellow	Magenta + cyan	Yellow		Magenta + Cyan
Magenta	Yellow + Cyan	Magenta		Yellow + Cyan
Cyan	Yellow + Magenta	Cyan		Yellow + Magenta
Blue	Yellow	Magenta + Cyan		Yellow
Green	Magenta	Yellow + Cyan		Magenta
Red	Cyan	Yellow + Magenta		Cyan

KODAK EKTACHROME SLIDE DUPLICATING FILM 5071

Process E-6

Kodak Ektachrome Slide Duplicating Film 5071 is a color reversal film for making slides from original transparencies. It is designed for Process E-6 and can be intermixed with camera films in processing with no adjustment of development times. The film is available in long rolls—35mm and 46mm widths—and 135-36 magazines. The characteristics of this slide duplicating film, including low matched color-layer contrasts, contribute to good color reproduction in most slide duplicating operations.

The film base is 0.013mm (0.005-inch) acetate. There is no gelatin backing; an antihalation layer is located beneath the emulsion layers.

Applications

This material is intended for use in photofinishing and professional slide-duplicating operations for making slide sets or filmstrips. The film is intended primarily for exposure with tungsten illumination (conventional photo enlarger lamps or tungsten-halogen lamps). It can also be exposed in electronic-flash slide-copying devices if color-compensating or color-printing filters are used to balance the light source. Fluorescent lights are not recommended for exposing this film.

Film Storage and Handling

Color films are seriously affected by adverse storage conditions. High temperatures or high humidity may produce undesirable changes in the film. These adverse conditions usually affect the three emulsion layers to differing degrees, thus causing a change in color balance as well as a change in film speed and contrast.

Keep unexposed film in a refrigerator or a freezer at 13 C (55 F), or lower, in the original sealed container. Remove film from a refrigerator and let it stand about two hours before opening the container; remove film stored in a freezer about eight hours before opening. Sufficient warming time is necessary to prevent the condensation of atmospheric moisture on the cold film. Keep exposed film cool and dry. Process the film as soon as possible after exposure to avoid undesirable changes in the latent image. Store processed film in a dark, dust-free area at a temperature of 10 to 21 C (50 to 70 F) and at a relative humidity of 30 to 50 per cent.

Handle unprocessed film only in total darkness. During processing, the film can be exposed to room light after it has been in the reversal bath for one minute.

Printing Equipment and Exposure

Use either optical or contact-printing equipment to expose this film. A diffuse optical system minimizes difficulty with dust and scratches. Make a series of exposure tests to determine the proper exposure level. For a tungsten light source, the exposure time should be about one second. For electronic flash, the exposure time will be about 1/1000 second. Start with the suggestions given and vary the intensity of the light at the film plane until the slide density is correct. The reciprocity effect with this slide duplicating film is minimal. Adjustment in light intensity may be necessary to maintain correct slide density if extremely short or long exposure times are used.

Starting Filter Pack

Kodak Ektachrome Slide Duplicating Film 5071 has significant sensitivity to both ultraviolet and infrared radiation. An ultraviolet absorber, such as the Kodak

(Continued on page 417)

Trial Filter Pack and Exposure Time

PAKOPY PRINTER WITH 3075 K LIGHT SOURCE (4 BEJ LAMPS, TOTAL 800 WATTS)

When you duplicate from originals on these Kodak films *	Use a filter pack containing these Kodak filters or equivalent	And this printer exposure
Intermixed: Kodachrome (Process K-12) Kodachrome (Process K-14) Ektachrome (Process E-4) Ektachrome (Process E-6)	Infrared Cutoff No. 304 +Wratten No. 2B +Color Compensating CC45M +Color Compensating CC105Y +Wratten Neutral Density No. 96 (.40 density)	
Ektachrome (Process E-4)	Wratten No. 2B +Color Compensating CC45Y +Color Compensating CC10M +Wratten Neutral Density No. 96 (.50 density)	One second at f/8
Kodachrome (Process K-12) Kodachrome (Process K-14) Ektachrome (Process E-6)	Wratten No. 2B +Color Compensating CC35Y +Wratten Neutral Density No. 96 (.50 density)	

SICKLES-HOMRICH PRINTER
WITH 3350 K LIGHT SOURCE (1 ELH 300 WATT LAMP OR 1 ENH 250 watt LAMP)

Intermixed: Kodachrome (Process K-12) Kodachrome (Process K-14) Ektachrome (Process E-4) Ektachrome (Process E-6)	Infrared Cutoff No. 304 +Wratten No. 2B +Color Compensating CC50M +Color Compensating CC95Y	With ELH Lamp One second at f/8 †
Ektachrome (Process E-4)	Wratten No. 2B +Color Compensating CC15M +Color Compensating CC35Y	With ENH Lamp One second at f/5.6 †
Kodachrome (Process K-12) Kodachrome (Process K-14) Ektachrome (Process E-6)	Wratten No. 2B +Color Compensating CC05M +Color Compensating CC25Y	

HONEYWELL-REPRONAR, Model 805A
WITH 5600 K ELECTRONIC-FLASH LIGHT SOURCE §

Intermixed: Kodachrome (Process K-12) Kodachrome (Process K-14) Ektachrome (Process E-4) Ektachrome (Process E-6)	Infrared Cutoff No. 304 +Wratten No. 2B +Color Compensating CC115Y +Color Compensating CC50R	f/8 High Beam
Ektachrome (Process E-4)	Wratten No. 2B +Color Compensating CC120Y +Color Compensating CC10M	f/11
Kodachrome (Process K-12) Kodachrome (Process K-14) Ektachrome (Process E-6)	Wratten No. 2B +Color Compensating CC110Y	High Beam

*Each listing includes all original camera films intended for the processing method noted in parenthesis.

†When making 110-size duplicates on 16mm width film (Kodak Ektachrome Slide Duplicating Film 7071) double the exposure.

§With the Bowens Illumitran or other printers having an electronic flash head, use these filter recommendations as a starting point.

Wratten Filter No. 2B, is needed in the basic filter pack. The dye systems of Kodachrome and Ektachrome Films (both older films and recently improved products) display differing degrees of infrared absorption. This can lead to a difference in the color quality of duplicates made from a mixture of original transparencies. The table shows where a Kodak Infrared Cutoff Filter No. 304 is recommended to compensate for this variability of infrared absorption.

The Kodak Infrared Cutoff Filter, No. 304, is a multilayer dichroic interference filter on glass. For effective results with an interference filter, position it *with care* in the light beam. Place the filter close to the light source, perpendicular to a specular, collimated part of the beam. Tipping the filter or allowing the light to pass through the filter at an angle changes the spectral transmittance characteristics of the filter. The Kodak Infrared Cutoff Filter, No. 304, is avail-in 70mm (2¾-inch) filter size (Kodak Part No. 541052) to fit several slide duplicating units.

Slide Duplicating with 35mm Camera

A 35mm single lens reflex camera having a through-the-lens metering system and equipped with a slide duplicating attachment is a convenient unit for making small numbers of duplicate slides. As a starting point, use a tungsten exposure index of 8 (with meters calibrated in ASA speeds) and the following filters:

Original on this Kodak Film	Use these Kodak Color Compensating Filters, or equivalent
KODACHROME (Process K-12)	CC10C + CC30Y
EKTACHROME (Process E-4)	CC40Y
EKTACHROME (Process E-6)	CC30Y

Place the filters between the transparency and the 3200 K tungsten light source. Make sure that the filter pack is in place when metering or making exposures. Make a filter ring-around and an exposure series to determine the correct color balance and exposure for each new film emulsion used.

Processing and Process Control

Process Kodak Ektachrome Slide Duplicating Film 5071 in Process E-6 chemicals. Process the duplicating film separately or along with camera films; no adjustment in the process is necessary. Use the standard first developer time for all films.

Follow the process control methods recommended for Process E-6. Eastman Kodak Company supplies process control strips for Process E-6. Complete information is included in Kodak Publication No. Z-119, *Using Process E-6*, available from your dealer.

Judging Exposures and Adjusting The Filter Pack

An ANSI committee has proposed standards for a new projector-type viewer for evaluating small transparencies. The Macbeth Color and Photometry Division of Kollmorgen Corporation (Newburgh, N. Y.) produces the Macbeth Prooflight V-135 viewer, which conforms to the draft specifications.

View slides on a standard illuminator (5000 K, as recommended in ANSI Standard PH2.31-1969) or project them in a darkened room. After examining a slide with illumination of the correct intensity and color distribution, decide if changes in density or color balance of the duplicate are necessary to make it

match the original. The following table will be helpful in determining the filter pack adjustment.

If the overall color balance is	Subtract these filters	OR	Add these filters
Yellow	Yellow		Magenta + cyan
Magenta	Magenta		Yellow + cyan
Cyan	Cyan		Yellow + magenta
Blue	Magenta + cyan		Yellow
Green	Yellow + cyan		Magenta
Red	Yellow + magenta		Cyan

When making corrections in the filter pack, remove filters from the pack whenever possible. For example, if a slide is reddish, remove yellow and magenta filters rather than add a cyan filter. The filter pack should contain filters of only two of the three subtractive colors (cyan, magenta, yellow). The effect of including all three is to form neutral density, which only lengthens the exposure time without accomplishing any color correction. To eliminate neutral density, determine the color with the lowest filter value, remove filters of that color entirely, and remove the same density from the other two colors. For example:

Filter pack	40C + 40M + 20Y	
Subtract (−)	20C + 20M + 20Y	(remove neutral density)
Minimum filter pack	20C + 20M	

Note that in the example given the filter pack of 20C + 20M is nominally equivalent to 20B. Thus a single blue filter would serve in place of the two filters.

When making simplifications of the filter pack such as removing neutral density or combining filters, keep these factors in mind:

1. The subtraction or substitution may not be exactly equivalent due to differences in absorption characteristics of the different filters.

2. A change in the number of filter surfaces changes the total transmission of the filter pack, because a small amount of image-forming light is lost through reflection at each filter surface.

KODAK EKTACHROME RC PAPER TYPE 1993

Kodak Ektachrome Paper RC Type 1993 is a multilayer color material designed for direct printing or enlarging from Kodachrome or Ektachrome transparencies. It can be exposed with ordinary contact-printing or enlarging equipment and processed in trays, tanks, or drum- and tube-type rapid processors in sheet sizes. It is coated on water-resistant (resin coated) stock for rapid washing and drying. Processing is done, using Ektaprint R-5 chemicals in tanks or trays, and in R-500 chemicals for tube and drum processors.

Important Note: As this book was going to press, a new paper, Kodak Ektachrome Paper RC, Type 2203, is being made available to large-scale users. This paper is faster, for shorter exposures and greater output in automatic printers used in photofinishing plants; in addition, it requires different chemicals (Kodak Ektaprint R-100) for processing. At this time it is not being offered in sheet sizes, and data is not available for small-scale use.

Safelight

Handle the Kodak Ektachrome RC Paper, Type 1993, in total darkness only. During processing on a Kodak Rapid Processor, Model 11 or 16-K, a safelight fitted with a Kodak Safelight Filter No. 10 (dark amber) and a 7½-watt bulb, or a Kodak Safelight Filter OA (greenish yellow) and a 15-watt bulb can be used during the first wash and color developer steps. Handling under a safelight should be kept to a minimum in order to avoid blanket shadow patterns on some of the lower density areas of the print. The safelight should be located above the processor at least four feet away.

Storage

High temperatures or high humidities may produce undesirable changes in Kodak Ektachrome Paper. Protection against heat **must** be provided by storing the paper in a refrigerator at 50 F (10 C) or lower. Even when stored at 50 F (10 C), the paper may change slowly; it will not yield satisfactory results indefinitely. Lower temperatures, such as 35 F (2 C), may retard any gradual change. However, the paper should be used as soon after receipt as is practical.

To prevent condensation of moisture on the cold paper, remove it from the refrigerator at least 2 hours before it is to be used. Do not open the package as long as there is any condensed moisture on the laminated foil bag. After removing the paper to be exposed, restore the moisture barrier around the unused paper by pressing out excess air, making a double fold in the open end of the bag, and securing the bag with a rubber band or tape.

Keep exposed paper cool and dry, and process it promptly to avoid changes in the latent image. Prolonged storage after exposure should be at 0 F (−18 C) or below.

Exposing Equipment

Kodak Ektachrome Paper can be exposed in a roll paper printer, an enlarger, or any other equipment having a light source with a color quality equivalent to that of a Photo Enlarger Lamp No. 302 or No. 212 operating at 115 volts. Fluorescent lamps are not recommended. The exposing device must be equipped to hold filters, such as Kodak Color Printing Filters (acetate) or Kodak Color Compensating Filters (gelatin). For optimum print quality, use an ultraviolet absorber, such as the Kodak Wratten Filter No. 2E. To minimize printing difference among transparency materials, use a Kodak Infrared Cut-Off Filter No. 301.

Filters

Filters are used to alter the color of the printing light so that a pleasing color balance is obtained in the print. Any number of CC or CP Filters can be used if they are placed between the light source and the color transparency; only CC Filters are usable between the transparency and the printing paper, and their number should not exceed three if definition is of major importance.

Printing Information

Follow the procedure below when setting up your equipment for the first Ektachrome Paper emulsion used.

Printers: Set up Kodak Roll Paper Color Printers as outlined in the instruction manual accompanying the printer.

Enlargers: With a Kodak Wratten Filter No. 2E, a Kodak Infrared Cut-Off Filter No. 301, and a trial filter pack in the light beam, use transparencies of good quality to make trial exposures.

Viewing Prints

Always evaluate test prints under illumination of the same color quality and intensity (about 50 foot-candles) as that under which the final print is to be viewed.

Illumination of color quality corresponding to a color temperature of 3800–4000 K serves well for judging prints. This color quality is approximated by several types of fluorescent lamps (in fixtures), including General Electric Deluxe Cool White, Sylvania Deluxe Cool White, Westinghouse Deluxe Cool White, and Macbeth Avlite.

Adjusting the Filter Pack

When the test print is viewed, the desirability of some change in color balance may be apparent. The nature of this change is determined by the predominant color balance of the print; the required filter adjustment involves subtracting a filter of the color of the overall hue or adding a filter that is complementary to this overall hue. The following table may be useful in determining the filter adjustment:

If the overall color balance is:	Subtract these filters:	or	Add these filters:
Yellow	Yellow		Magenta+Cyan
Magenta	Magenta		Yellow+Cyan
Cyan	Cyan		Yellow+Magenta
Blue	Magenta+Cyan		Yellow
Green	Yellow+Cyan		Magenta
Red	Yellow+Magenta		Cyan

Evaluating an area in the print that should be reproduced as a neutral (gray) is useful in determining what filter correction is needed. If it is difficult to decide which filter will correct the print, examine the print through a filter that is complementary to the overall hue. The filter that makes the print appear most pleasing represents the correct color to add, but not necessarily the correct density.

When making filter correction to the filter pack in the printer, remove filters from the beam whenever possible. For example, if a test print is reddish in balance, remove yellow and magenta filters rather than add cyan filters. The filter pack should not contain more than two colors of the subtractive filters (yellow, magenta, and cyan). The effect of all three is to form neutral density, which lengthens the exposure time without accomplishing any color correction.

To eliminate neutral density, remove the filter or filters of one color entirely, and remove the same density values of the other two colors.

Exposure Adjustment for Filters

Whenever the filter pack is changed, allowance should be made for the change in exposure introduced by (1) the change in filtering action, and (2) the change, if any, in the number of filter surfaces. Otherwise, the density of the corrected print will differ from that of the test print.

White Borders

White borders can be obtained by exposing the border area of a print while the picture area is protected by an opaque mask. When the enlarger is adjusted as suggested in these instructions, an exposure time from 1½ to 2 times the print exposure time will be required, with no transparency in the beam. The filters can be included when the border is flashed. Some overlapping of the print exposure and the border exposure is necessary in order to eliminate dark edges.

With automatic and semi-automatic equipment, follow the instructions supplied with the equipment.

Processing

Kodak Ektachrome RC Paper Type 1993 is processed in Kodak Ektaprint R-500 chemicals for tube or drum processors, and in Kodak Ektaprint R-5 chemicals for tank, tray or continuous machine processing. The chemicals are supplied in packaged form in several sizes to make convenient quantities.

PROCESSING KODAK EKTACHROME RC PAPER IN KODAK EKTAPRINT R-5 AND R-500 CHEMICALS

These directions supplement the instructions packaged with the Kodak color print processing chemicals. The instructions should be consulted for details of the processing steps.

Kodak Ektachrome RC Paper, Type 1993, can be processed quickly and easily on all of the Kodak Rapid Color Processors, the Model 11, Model 16-K, the Model 30A (or Model 30 equipped with a processing tube having a spiral liner), and in small processing tubes, using Kodak Ektaprint R-500 Chemicals (formerly designated Kodak Ektaprint RD Chemicals), or equivalent.

Kodak Ektaprint R-500 Chemicals are packaged in concentrated liquid form to make 1 gallon and 1 quart of solution per unit. A set of chemicals consists of:

Kodak Ektaprint R-500 First Developer
Kodak Ektaprint R-500 Stop Bath
Kodak Ektaprint R-500 Color Developer
Kodak Ektaprint R-500 Bleach-Fix
Kodak Ektaprint R-500 Stabilizer
*Kodak Potassium Iodide, Crystals, 25 grams
(Model 30A and small tube-type processors only)

*To prepare a stock solution, start with 946 ml (32 fluid ounces) of water and add approximately 8 grams (1 teaspoon) of potassium iodide. Mix the solution until all of the crystals are completely dissolved.

Mixing directions are included with each package and must be followed carefully.

Add 30 ml (1 fluid ounce) of the potassium iodide stock solution to the wash water preceding the bleach-fix to prevent excessive stain (Model 30A only). Add 30 ml (1 fluid ounce) of the potassium iodide stock solution to each 964 ml (32 fluid ounces) of wash water preceding the bleach-fix for small tube-type processors.

Tank, Tray and Machine Processing

Kodak Ektachrome RC Paper, Type 1993, can also be processed in a continuous-processing machine. Rolls of paper can also be processed on reels, such as Kodak Processing Reels. Sheets of paper can be processed in suitable hangers, in a basket such as the Kodak Processing Basket, or in trays, using Kodak Ektaprint R-5 Chemicals.

The following Kodak Ektaprint R-5 Chemicals are supplied in packaged form. Carefully follow the mixing directions included with the chemicals.

Kodak Ektaprint R-5 First Developer Starter
Kodak Ektaprint R-5 First Developer Replenisher
Kodak Ektaprint R-5 Stop Bath and Replenisher
Kodak Ektaprint R-5 Color Developer Starter
Kodak Ektaprint R-5 Color Developer Replenisher
Kodak Ektaprint R-5 Bleach-Fix and Replenisher
Kodak Ektaprint 3/R5 Bleach-Fix Regenerator Starter
Kodak Ektaprint R-5 Bleach-Fix Regenerator
Kodak Ektaprint R-5 Stabilizer and Replenisher
Kodak Ektaprint Bleach-Fix Defoamer

Observe precautionary information on containers and in instructions.

Contamination of Solutions

Both the photographic quality and the life of processing solutions depend upon cleanliness of equipment in which solutions are mixed, stored, and used.

The contamination of any chemical solution by any other is to be avoided, since it will seriously impair print quality. Take extreme care to avoid contamination of developer with bleach-fix during mixing and processing.

If metal processing or storage tanks are to be used with bleach-fix, they should be constructed of Type 316 stainless steel.

Avoid the mixing of chemicals in printing and processing areas, because the chemicals may cause spots on prints. Whenever a tank is drained, thoroughly clean and flush it with water before refilling.

Storage Of Solutions

Store solutions at a room temperature of 24 to 29.5 C (75 to 85 F). For best results do not use solutions stored longer than the following times:

KODAK EKTAPRINT R-500 CHEMICALS

	Full, Stoppered Glass Bottles	Partially Full, Stoppered Glass Bottles
First Developer	4 weeks	2 weeks
Stop Bath	8 weeks	8 weeks
Color Developer	4 weeks	2 weeks
Bleach-Fix	8 weeks	8 weeks
Stabilizer	8 weeks	8 weeks
Potassium Iodide stock solution	6 months	6 months

KODAK EKTAPRINT R-5 CHEMICALS

	Tanks With Floating Lids
First Developer Replenisher	2 weeks
Stop Bath and Replenisher	8 weeks
Color Developer Replenisher	2 weeks
Bleach-Fix and Replenisher	8 weeks
Stabilizer and Replenisher	8 weeks

Time and Temperature

Tray, drum, and tank processing require a timer with a sweep-second hand that can be followed in the dark.

The time required for each processing step includes the draining time. In each case, start draining in time to end the processing step (and start the next one) on schedule.

Good results depend on accurate control of processing temperature, particularly during the development step. Recommended temperatures are included in the processing tables on the following pages.

The ideal way of holding solution and wash-water temperatures at the proper level is with a thermostatic mixing valve. In tray or tank processing, the drain of the darkroom sink can be fitted with a standpipe; then water can be allowed to overflow from the washing tray or tank, and to surround the solution trays or tanks to the level of the standpipe.

As a substitute means of temperature control, an ordinary mixing faucet can be used. With such an arrangement, a thermometer placed in the water flow should be checked often to make sure that varying loads on the water supply lines do not change the temperature of the mixture.

Processing Procedure

The tables which follow provide the essential outline of the procedure for various processing machines. Refer to the instructions which came with your machine for step-by-step directions.

Processing with Kodak Ektaprint R-500 Chemicals in the Kodak Rapid Processors, Models 11 and 16-K

Processing Step	Remarks	Model 11 Solution Volume		Model 16-K Solution Volume		Time in Min. *	Total Min. at end of step
		Metric	U. S. Liq.	Metric	U. S. Liq.		
1. Prewet	In tray of water—total darkness†					1	1
2. First Developer	Total Darkness	200 ml.	7 fl. oz	325 ml.	11 fl. oz.	1½	2½
3. Stop Bath	Total Darkness	200 ml.	7 fl. oz.	325 ml.	11 fl. oz.	½	3
4. First Wash	Use safelight No. 10 or OA	7.5—9.5 l/min.	2—2½ gal/min	7.5—9.5 l/min.	2—2½ gal/min	2	5
5. Color Developer	Use safelight No. 10 or OA	200 ml.	7 fl. oz	325 ml.	11 fl. oz.	3	8
Remaining steps can be done in normal room light							
6. Second Wash	—	7.5—9.5 l/min.	2—2½ gal/min	7.5—9.5 l/min.	2—2½ gal/min	½	8½
7. Bleach-fix	—	200 ml.	7 fl. oz.	325 ml.	11 fl. oz.	1½	10
8. Final Wash	—	7.5—9.5 l/min	2—2½ gal/min	7.5—9.5 l/min	2—2½ gal/min	1½	11½
9. Stabilizer	—	200 ml.	7 fl. oz.	325 ml.	11 fl. oz	1	12½
10. Rinse	—	—	—	—	—	¼	12¾
11. Dry	See below 49—66 C 120—150 F	—	—	—	—	—	—

*The time for each step, except the prewet, includes a 5-second drain time. The drain time after the prewet should be 10 seconds. In each case, start draining in time to end the processing step and start the next one on schedule.

†Agitate frequently. Do not handle the dry print with wet fingers, or the wet print with dry fingers.

Important: After each process, rinse blanket, drum, and tray with running water to remove all traces of processing chemicals. Wipe excess water from drum and tray before starting to process next print.

Drying: Dry prints naturally or with heat impingement dryer. F-surface paper dries to a high gloss without special treatment; *do not ferrotype!*

Processing with Kodak Ektaprint R-500 Chemicals in the Kodak Rapid Color Processor, Model 30A

Processing Temperatures:
(75 F ambient room temperature)

First Developer
Solution: 43.5 ± 0.3 C (110 ± ½ F)
Other solutions 43.5 ± 0.6 C (110 ± 1 F)
Washes 37.8 to 46 C (100 to 115 F)

Processing Step	2024A Processing Tube Solution Volume		3040A Processing Tube Solution Volume		Time Min*	Total Min at end of step.
	ml	fl oz	ml	fl oz		
1. Water prewet	385	13	945	32	½	½
2. First Developer	385	13	945	32	1½	2
3. Stop Bath	385	13	945	32	½	2½
4. First Wash	945	32	1890	64	½	3
5. Second Wash	945	32	1890	64	½	3½
6. Color Developer	385	13	945	32	2	5½
7. Third Wash†	945	32	1890	64	½	6
8. Bleach-Fix	385	13	945	32	1½	7½
9. Fourth Wash	945	32	1890	64	½	8
10. Fifth Wash	945	32	1890	64	½	8½
11. Stabilizer	385	13	945	32	½	9
12. Rinse	385	13	945	32	¼	9¼

13. Dry—see note below—120 to 150 F (49 to 66 C)

*All times include a 10-second drain time.
†Add 1 fluid ounce (30 ml) of potassium iodide stock solution to each 32 ounces (946 ml) of wash water.

Drying: Dry prints naturally or with heat impingement dryer. F-surface paper dries to a high gloss without special treatment; *do not ferrotype!*

Processing with Kodak Ektaprint R-500 Chemicals
In Small Tube-Type Processors

Ektaprint R-500 Chemicals can be used for processing Kodak Ektachrome RC Paper, Type 1993, in small tube-type processors. The addition of approximately 0.2 gram per liter of potassium iodide to the wash water preceding the bleach-fix is recommended to prevent excessive stain. Since the amount of potassium iodide required in the wash is not critical, it is convenient to add the potassium iodide to the water in the form of a stock solution, just prior to processing. See page 422 for instructions on preparing the stock solution.

The processing solution volume is calculated by multiplying the tube size by 0.8 ml and rounding up to the nearest 10 ml. For example, 80 sq in x 0.8 = 64 ml rounded to 70 ml of processing solution for an 8 x 10-inch sheet of paper.

The wash water volume is twice the processing solution volume rounded up to the nearest 50 ml. Thus wash water volume for an 8 x 10-inch sheet of paper is 150 ml.

It is necessary to test the washing efficiency of the tube to determine whether you require two or three washes after the bleach fix. This is done by loading the tube with a sheet of scrap photographic paper. Wet the tube and paper with plain water, drain for 10 seconds and then add a normal volume of bleach-fix. Agitate for 90 seconds, drain for 10 seconds, and add a normal wash-volume of water. Agitate for a 30-second wash that includes a 10-second drain. Drain into a clear glass or bottle. Repeat for three washes, draining each wash into a separate glass or bottle, then compare against a white background. If the second container is as clear as the third, only two washes are required after the bleach-fix. If not, repeat the washing step and drain into another clear glass or bottle. If the third and fourth washes are equally clear, the processor requires three washes after the bleach-fix.

Processing Time Table for Tube-Type Processors

Nominal solution temperature is 38 C (100 F).

Processing Step	Time in Minutes*	Accumulated Time in Minutes
1. Prewet (water)	½	½
2. First Developer	1½	2
3. Stop Bath	½	2½
4. Wash	½	3
5. Wash	½	3½
6. Color Developer	2	5½
7. Potassium Iodide Wash	½	6
8. Bleach-Fix	1½	7½
9. Wash	½	8
10. Wash†	½	8½
11. Stabilizer	½	9
12. Rinse (water)	¼	9¼

*All times include a 10-second drain (to avoid excess solution carryover). Some processing tubes may require a slightly longer drain time. Be sure to allow enough time to make certain that the tube is drained and to add the next solution on time for the next step. The next step begins when the solution contacts the paper.

†An additional wash step may be needed, depending upon the processing tube you are using. See instructions above, to decided if this step is needed.

426

Batch Processing of Kodak Ektachrome RC Paper, Type 1993, In Reels or Baskets, Using Kodak Ektaprint R-5 Chemicals

Solution or Procedure	Comments	Time of step in Min.*	Total time to end of step
1. First Developer	Temperature tolerance ±0.3 C(½ F)	4	4
2. Stop Bath		1	5
REMAINING STEPS MAY BE DONE IN NORMAL ROOM LIGHT.			
3. First Wash	Running water at 3 to 4 gallons per minute.	4	9
4. Reversal exposure	Expose emulsion side for 15 seconds, 1 foot from No. 1 Photoflood lamp.		Reset Timer
5. Color Developer		4	4
6. Wash		1	5
7. Bleach-Fix		3	8
8. Final Wash	Running water at 3 to 4 gallons per minutes	3	11
9. Stabilizer	See warning on label	1	12
10. Rinse	Agitate in running water	½	12½
11. Dry	Not above 93 C (200 F)		
	Total Process Time	21½	

*All times include a 15-second drain.

Replenishment of Solutions

To produce consistently high-quality results, replenish the solutions after processing each batch of paper. Calculate the exact amount of replenisher needed from the number of sheets processed, and add this amount to the tank just before processing the next batch of paper. The amount of replenisher may be determined from the following area factors:

First Developer	70 ml. per square foot
First Stop Bath	140 ml. per square foot
Color Developer	140 ml. per square foot
Bleach-Fix	45 ml. per square foot
Stabilizer	70 ml. per square foot

MAKING COLOR TRANSPARENCIES FROM COLOR NEGATIVES

Three Kodak materials are available for making color transparencies from color negatives. Kodak Vericolor Print Film 4111, supplied in sheet sizes, and on special order, in rolls, can be used to make contact or enlarged transparencies. Kodak Vericolor Slide Film 5072, supplied in rolls 35mm wide by 100 feet long, is used to make same-size transparencies from 35mm negatives, or reduced transparencies from larger negatives. Kodak Ektacolor 74 Duratrans SO-103 is a translucent material intended for making large display transparencies.

The first two materials are similar and are exposed in the same way as Kodak Ektacolor Paper, but are processed in Kodak Flexicolor C-41 chemicals. The third material is also exposed like Ektacolor Paper, but is intended for processing in Kodak Ektaprint-2 Chemicals.

With these materials, brilliant color transparencies of practically any size are obtainable; a photographer is not limited to transparencies of camera-film size as he is with reversal color materials. Two or more sheets of processed transparency film can be joined to make large-size display transparencies.

Safelight

Like Ektacolor Paper, Vericolor Print Film is sensitive to light of all colors and preferably should be handled and processed in total darkness. It can, however, be handled for a limited period of time under a suitable safelight lamp fitted with a Kodak Safelight Filter No. 13 (dark amber) and a 15-watt bulb. The lamp can be used at no less than 4 feet from the film for no longer than 30 seconds.

Storage

To protect Vericolor Print Film from high temperatures and high humidities, store unexposed film at 55 F or lower. Keeping effects can be arrested almost completely for long periods of time by actually freezing the sealed film in a freezing unit operated at 0 to −10 F.

To prevent moisture condensation on the cold film, remove it from the refrigerator about 3 hours before use and do not open the package as long as there is danger of moisture condensation. Open the bag by cutting carefully along the edge of the heat seal and, after removing film to be exposed, restore the moisture barrier around the unused film by pressing out excess air, making a fold in the open end of the bag, and securing it with a rubber band or tape.

Process the film *as soon as possible after exposure* to avoid changes in the latent image.

Exposure

The same enlarging equipment and filters used to expose Ektacolor Paper can be used to expose Vericolor Print Film and Duratrans material. For exposing contact-size transparencies, some workers may prefer to devise a separate light source.

As with Ektacolor Paper, variations in speed and color balance are unavoidable from one emulsion to another of Vericolor Print Film. It is difficult, therefore, to suggest accurate exposure and filter information for making transparencies from a negative for which the Ektacolor Paper filter pack and exposure time are already known. Some testing is always necessary.

Processing

Kodak Vericolor Print Films are processed in Flexicolor Cehmicals, Process C-41, the same as other Verciolor Films. Kodak Duratrans Material, SO-103, is processed in Kodak Ektaprint 2 Chemicals, the same as Kodak Ektacolor Paper.

MAKING BLACK-AND-WHITE PRINTS FROM COLOR NEGATIVES

It is possible to make black-and-white prints from color negatives on most ordinary black-and-white papers. However, since such ordinary papers are color-blind (sensitive to blue light only), they will reproduce blues too light and reds much too dark. Kodak Polylure and Kodak Polycontrast Papers will give slightly better tonal rendition, because these papers are sensitive to green light as well as to blue light. Monochromatic prints from color negatives can also be made on Kodak Resisto Rapid Pan Paper, although this product is specifically designed for making black-and-white color-separation prints for photomechanical reproduction from color negatives.

By far the best rendering in monochrome prints from color negatives is obtained with Kodak Panalure Paper. It was specially designed for making black-and-white prints from Kodacolor-X and Ektacolor negatives. Since Panalure Paper is sensitive to light of all colors (panchromatic), it reproduces each color in its correct tonal relationship. Also, since Kodacolor-X and Ektacolor negatives contain colored couplers that provide automatic masking for color correction but interfere with printing on conventional black-and-white papers, Panalure Paper is specially sensitized to compensate for the effect of these couplers.

Panalure Paper allows photographers to standardize on color-negative film in their cameras, making black-and-white or color prints as needed. The versatility that Panalure adds to the color negative is valuable for many purposes, especially for portraits. Besides using it for finished prints, photographers find it handy for proofing negatives—either to choose the ones they want to print in color or to check what negative retouching may be needed. Panalure prints are also useful in preparing layouts and for press releases.

Safelight

Panalure Paper requires the same safelight as Ektacolor Professional Paper and Ektacolor Print Film – that is, a Kodak Safelight Filter, Wratten Series 10 (dark amber), used in a suitable safelight lamp with a 7½-watt bulb, kept at least 4 feet from the paper. Since the paper is sensitive to light of all colors, exposure to the safelight should be kept at a minimum until the paper has been in the developer at least 30 seconds.

Exposure

The paper can be exposed in an enlarger or, with reduced illumination, in contact-printing equipment. It can be exposed without filters to tungsten lamps, such as No. 302 or No. 212. Exposures made with other light sources, such as fluorescent lamps, or from color negatives that have been exposed under special conditions may require the use of filters to adjust the light quality to that necessary to obtain panchromatic gray-tone rendition.

By using Kodak Color Compensating or Color Printing Filters, you can darken blue skies, accent a man's ruddy complexion, or add contrast wherever there is a color difference in the subject. To lighten a subject color, use a filter of the subject color in the enlarger; to darken a subject color, use a complementary color filter in the enlarger. For example, to darken reds and make them appear as they would in a print from a negative on orthochromatic film, use two CC50C filters in the light beam.

Processing

Since the development of Panalure Paper must be accomplished essentially in the dark, it is customary to develop the paper for a specified length

of time at a certain developer temperature. Adjustment for a print of optimum quality is therefore made by altering the exposure time. This time-temperature processing method also provides prints of better quality than under- or over-development.

For best results, Kodak Dektol Developer diluted 1:2 is recommended. Those who prefer to mix a developer by formula should use Kodak Developer D-72 diluted 1:2. Develop with continuous agitation about 1½ minutes at 68 F (20 C). The useful range of developing time is between 1 and 3 minutes.

For lower contrast, use Kodak Selectol Developer diluted 1:1. To obtain lowest contrast, use Kodak Selectol-Soft Developer diluted 1:1. In these developers, develop with continuous agitation about 2 minutes at 68 F (20 C).

After the development step, Panalure prints are rinsed, fixed, washed, and dried exactly as any other black-and-white prints.

UNICOLOR CHEMICALS FOR COLOR NEGATIVE FILMS

The Unicolor kit contains chemicals for processing the following color negative films:

Kodacolor-X Film
Ektacolor Films, Type S and Type L
Eastman Color Negative Films, Type 5251 and Type 5254
Kodak Internegative Film, Type 6008
GAF Color Print Film
Fujicolor Film

The kit contains sufficient chemicals to process six rolls of 120 roll film or its equivalent area in other sizes. The chemicals may be mixed as directed below for a quantity of one quart of working solution, or partial quantities may be mixed if desired. Using half the given quantities will make 16 ounces of working solution for one-pint developing tanks.

Unicolor chemicals are designed for mixing in average tap water. If you have reason to believe that your water conditions are unusual, use distilled water for mixing solutions.

Shake all bottles well before using. Measure quantities accurately, and mix thoroughly.

To prepare 1 quart (32 ounces) of working solution	Start with (80-85 F)	Then add and mix	Finally add and mix
Film developer*	24 ounces water	4 ounces Film Developer Activator from Bottle 1	4 ounces Basic Developer from Bottle D
Stop-Fix	20 ounces water	12 ounces Stop-Fix from Bottle 2	
Blix †	24 ounces water	4 ounces "BL" from Bottle B-"BL"	4 ounces "IX" from Bottle B-"IX"
Film Stabilizer	28 ounces water	4 ounces Film Stabilizer from Bottle 3	

*Developer should be stored in thoroughly clean, well-capped amber glass bottles.
†"Blix" is a registered trademark of Unicolor for a combined Bleach-Fix solution.

Processing Instructions for Color Negative Films

Step 1: Film Developer (75 F ± ½ F) 14 minutes **

Pour film developer working solution into loaded film tank until full.

Invertible-Type Tank. Agitate capped tank continuously for 20 seconds, then agitate by turning tank over and back twice (about 5 seconds) every 20 seconds.

**Each 16 ounces of working solution will process up to three rolls of 120 color negative film or the equivalent area in other sizes. When processing several rolls in succession, develop first roll for 14 minutes. Develop second roll in same solution for 15 minutes and third roll in same solution for 16 minutes; then discard solution. *Do not add fresh solution to a used bath and never return used solution to a bottle of fresh solution.*

Non-Invertible-Type Tank. Agitate continuously by turning shaft for 20 seconds, then agitate by rotating shaft for 3 seconds every 20 seconds. Start emptying ten seconds before end of step.

Step 2: Stop-Fix (75 F ± 2 F) 4 minutes

Pour stop-fix into processing tank until full. Agitate in same manner as in Step 1. Start emptying tank ten seconds before end of Step 2. (NOTE: When processing 120 films or larger, follow this step with a one-minute water rinse, then proceed to Step 3.)

Step 3. Blix (75 F ± 2 F) 8 minutes

Pour Blix into processing tank until full. Agitate in the same manner as in above steps. Start emptying tank ten seconds before end of step.

Step 4. Wash (running water, 75 F ± 2 F) 8 minutes

With top removed, place tank under running water. Maintain water temperature at 75 F ± 2 F. Empty tank at end of step.

Step 5. Film Stabilizer (75 F ± 2F) 1 minute.

Pour film stabilizer into tank until full. Agitate continuously during this step. Empty tank at end of this step. Carefully remove film and hang to dry in dust-free area. *Do not squeegee or work with film until thoroughly dry.*

UNICOLOR CHEMICALS FOR COLOR PRINT PAPERS

The Unicolor chemical kit is intended for processing all current color print papers. There are, however, differences in treatment between certain papers, and for this reason, papers to be processed in the Unicolor baths are divided into two classes.

Group A Papers: Kodak Ektacolor Paper, GAF Color Paper, Sakura Color Paper.

Group B Papers: Unicolor Paper, Mitsubishi Color Paper, Agfacolor Paper, Oriental Color Paper, Rapid Access Color Paper.

The kit contains sufficient chemicals to process a minimum of 25 8″ × 10″ sheets of color print paper or the equivalent area in trays or 32 sheets in the Unidrum or Color Canoe. Although these instructions are for mixing the total amount at one time, partial quantities may be mixed if desired.

Unicolor chemistry has been designed for mixing with average tap water. If you have unusual water conditions, use distilled water for mixing solutions. Shake all bottles well before using. Measure quantities accurately. Mix thoroughly.

To prepare 2 quarts (64 ounces) of working solution	Start with (80-85 F)	Then add and mix	Finally add and mix
Paper Developer*	52 ounces water	Group A papers: 4 ounces Paper Activator from Bottle 5 — — Group B papers: 4 ounces Paper Activator from Bottle 4	8 ounces Basic Developer from Bottle D
Blix†	48 ounces water	8 ounces "BL" from bottle B-"BL"	8 ounces "IX" from bottle B-"IX"
Paper Stabilizer	60 ounces water	4 ounces Paper Stabilizer from Bottle 6	

*Developer should be stored in thoroughly clean, well-capped amber glass bottles.
†"Blix" is a registered trademark of Unicolor for a combined bleach-fix solution.

Processing Instructions for Color Print Papers

The following instructions are for processing the respective papers in trays or tanks. For Unidrum or Color Canoe processing, see instructions packed with the drum or canoe, respectively.

Group A Papers

Step 1. Paper Developer (95 F ± 1 F) 6 minutes

With lights off, place exposed paper into paper developer tray or tank. Agitate continuously during this step. Remove print for draining ten seconds before end of step.

Step 2. Water (95 F ± 1 F) ½ minute

Rinse paper in running water for ½ minute.

Step 3. Blix (95 F ± 3 F) 2 minutes

Place drained paper from Step 2 into Blix tray. Agitate continuously during this step. Remove print for draining ten seconds before end of this step. Lights may be turned on and left on after print has been in Blix for one minute.

Step 4. Water (95 F ± 3 F) 4 minutes

Place drained paper from Step 3 into wash tray. Use running water. Remove print for draining ten seconds before end of step.

Step 5. Paper Stabilizer (95 F ± 3 F) ½ minute

Place drained paper from Step 4 into paper stabilizer tray. Agitate continuously during this step. At end of step drain print well and dry. *Do not wash after stabilizer.* **Prints may remain in stabilizer (not plain water) up to one hour prior to drying.**

Group B Papers

Step 1. Paper Developer (85 F ± 1 F) 1½ minutes

With lights off, place exposed paper into paper developer tray or tank. Agitate continuously during this step. Remove print for draining ten seconds before end of this step.

Step 2. Water (85 F ± 1 F) ½ minute

Rinse paper with running water for ½ minute.

Step 3. Blix (85 F ± 3 F) 2 minutes

Place drained paper from Step 2 into Blix tray. Agitate continuously during this step. Remove print for draining ten seconds before end of step. Lights may be turned on and left on one minute after print is placed in Blix tray.

Step 4. Water (85 F ± 3 F) 2 minutes

Place drained paper from Step 3 into wash tray. Use running water. Remove print for draining ten seconds before end of step.

Step 5. Paper Stabilizer (85 F ± 3 F) ½ minute

Place drained paper from Step 4 into paper stabilizer tray. Agitate continuously during this step. At end of step drain print well and dry. *Do not wash after stabilizer.* **Prints may remain in stabilizer (not plain water) up to one hour prior to drying.**

Time and Temperature Charts for Color Print Papers

These charts are for tray or tank processing only. To process papers at temperatures other than those given in instructions above, use times and temperatures below. (Notice that only a single time and temperature is given for the developer step for Group A papers.)

Group A papers (————) Ektacolor, GAF Color, Sakura Color

Group B papers (- - -) Unicolor, Mitsubishi Color, Agfacolor Oriental Color, Rapid Access

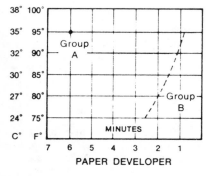

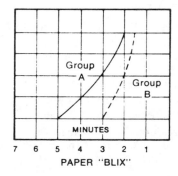

The Unicolor Professional Chemicals are designed for use by photofinishers and commercial photographers who make prints in large quantities. The sequence of steps is slightly different from the amateur Unicolor chemistry, because an additional step, a stop-fix bath, has been added. The Unicolor Professional Chemicals are for use only with Group B papers, which include Unicolor Paper, Agfacolor Paper, Mitsubishi Color Paper, Oriental Color Paper, and Rapid Access Color Paper.

The Unicolor Professional Chemistry also differs from the amateur type in that the baths are designed to be replenished during use, and replenishers are available.

Packaging of Unicolor Chemicals

Component	Stock No.	To make total amount
1. Basic Developer	M-01	8 gallons
2. Basic Developer Replenisher	M-02	8 gallons
3. Developer Additive and Replenisher	M-03	64 gallons
4. Developer Activator and Replenisher*	M-04	16 gallons
5. Stop-Fix and Replenisher	M-05	8 gallons
6. "Blix"† and Replenisher	M-06	4 gallons
7. Stabilizer and Replenisher	M-07	32 gallons

*Four 16-ounce bottles in carton
† "Blix" is a registered trademark of Unicolor for a combined bleach-fix bath.

Mixing Unicolor Professional "B" Chemicals

Although it is recommended that you mix the total amount of chemistry at one time, partial quantities may be mixed if desired.

Unicolor chemicals have been designed for mixing with average tap water. If you have unusual water conditions, use distilled water for mixing chemicals.

To prepare 4 gallons of working solution	Start with (80-85 F)	Then add and mix	Finally add and mix
Paper Developer* (3-part)	3 gallons + 40 ounces water	Basic Developer 2 quarts	Developer Additive 8 ounces, then add Developer Activator 16 ounces
Paper Stop-Fix (1-part)	3 gallons + 64 ounces water	Stop-Fix 2 quarts	—
Blix † (2-part)	3 gallons water	Blix-BL 2 quarts	Blix-IX 2 quarts
Paper Stabilizer (1-part)	3 gallons + 112 ounces water	Stabilizer 16 ounces	—

* Developer should be stored in thoroughly clean, amber glass bottles.
† "Blix" is a registered trademark of Unicolor for a combined bleach-fix bath.

Time and Temperature Charts for Color Print Papers

With Unicolor Professional "B" Chemistry, it is possible to process Group "B" papers at temperatures between 75 and 95 F (24 to 35 C). In any case, it is necessary that a temperature, once chosen, be used throughout the process; transferring papers from hot to cold baths or vice versa can damage the emulsion and produce inferior color quality.

The processing time in developer and Blix must be adjusted according to the processing temperature. See charts below for processing times.

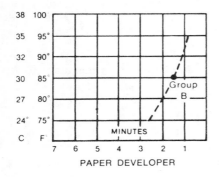

PAPER DEVELOPER

PAPER "BLIX"

Group B papers:
 Unicolor Paper
 Agfacolor Paper
 Mitsubishi Color Paper
 Oriental Color Paper
 Rapid Access Color Paper

Processing Procedure for Tray or Tank Processing

Step 1. Developer (85 F ± 1 F) 1½ minutes
Place exposed paper in tray or tank. Agitate continuously during this step. Remove print for draining ten seconds before end of step.

Step 2. Stop-Fix (85 F ± 3 F) 1 minute
Place paper in tray or tank. Agitate continuously during this step. Remove and drain for ten seconds.

Step 3. Blix (85 F ± 3 F) 2 minutes
Place fixed paper in Blix tray or tank. Agitate continuously during this step. Lights may be turned on and left on after one minute. Remove print and drain, ten seconds before end of step.

Step 4. Wash Water (85 F ± 3 F) 2 minutes
Place drained paper from Step 3 into wash tray or tank with running water. Remove and drain print ten seconds before end of step.

Step 5. Stabilizer (85 F ± 3 F) ½ minute.
Place drained paper from Step 4 in stabilizer tray or tank. Agitate continuously during this step; then drain print well and dry. Do not wash after this step.

436

Processing Procedure for Basket Processing

Unicolor Professional "B" Chemistry may be used with basket processing systems, using nitrogen-burst agitation. Baskets must be absolutely clean and perfectly dry at the beginning of each processing cycle.

Agitation Conditions: Gas Burst (Nitrogen)

Pressure: 8 pounds (See manufacturer's recommendations)
Burst interval: 12 seconds
Burst duration: 3 seconds

Suggested Processing Cycle *

		75 F ± ½ F Time in minutes	85 F ± ½ F Time in minutes
Prewet	40 seconds	1	1
Drain	20 seconds		
Develop		2¾	2¼
Stop-Fix		1	1
"Blix"		2	1½
Wash		4	3
Stabilize		1	1
	Total	11¾	9¾

* Times will vary with different equipment
Underdevelopment is indicated by a magenta-blue cast
Overdevelopment is indicated by a yellow cast

Note: In processing with the basket technique, the operator should exercise great care to prevent contamination of solutions. Processing chemistry must be kept adequately replenished and under constant control at all times.

Replenishment of Unicolor Professional "B" Chemistry

The basic replenishment rate for Unicolor Chemistry is 0.4375cc per square inch of paper processed, equivalent to 63.0cc per square foot. For convenience, the following tables have been set up, for single sheets and for 100-sheet quantities.

Paper Size Inches	Area Square Inches	Area Square Feet	Replenishment Rate Metric	Replenishment Rate U. S. Customary
8 x 10	80	0.55	35.00cc	1.16 ounces
11 x 14	154	1.07	67.38cc	2.25 ounces
16 x 20	320	2.22	140.00cc	4.67 ounces
20 x 24	480	3.33	210.00cc	7.00 ounces

NUMERICAL REPLENISHMENT BASE
(100 sheets)

Base Quantity	Paper Size Inches	CC	Replenishment Rate Ounces	Replenishment Rate Quarts	Gallons
100	8 x 10	3,500	116	3.62	0.9
100	11 x 14	6,738	225	7.03	1.76
100	16 x 20	14,000	467	14.593	3.648
100	20 x 24	21,000	700	21.875	5.47

Using Unicolor Chemistry in Pako Processor

Unicolor Professional "B" Chemistry is well suited to use in the Pako 6-tank processor Model G-24-3C. Modification to the machine for this process can be suggested by the manufacturer, and automatic replenishment is possible, for prints from $4'' \times 5''$ to $20'' \times 24''$.

Machine Capacity (Prints per hour)

Size (inches)	4 x 5	5 x 7	8 x 10	11 x 14	16 x 20	20 x 24
Prints per hour	500	500	240	120	60	60

Machine Processing Procedure

Typical Speed Setting (variable)	24 inches per minute
Typical temperature	95 F
Water consumption	4 gallons per minute
Tank capacity (individual)	9 gallons

Tank	Solution	Dwell Time
1	Paper Developer	1½ minutes
2	Stop-Fix	1½ minutes
3	"Blix"	1½ minutes
4	Wash	1½ minutes
5	Wash	1½ minutes
6	Stabilizer	1½ minutes
7	Drying	1 minute 50 seconds

Total Access Time 10 minutes 50 seconds

CIBACHROME COLOR PRINT PROCESS

Cibachrome print material is a silver-halide-type photographic product with highest quality azo dyes incorporated in the emulsion layers. It consists of a white opaque support coated with light-sensitive emulsion layers and auxiliary layers on one side and a matte, anticurl gelatin layer on the opposite side.

When unexposed, unprocessed material is viewed in white light, it appears dark brownish-gray from the front (emulsion) side and pure white from the back. After processing, normal drying produces a beautiful glossy print without special treatment.

Cibachrome print material is packaged in light-tight, hermetically-sealed plastic pouches which protect it from moisture and other harmful vapors until the seal is broken.

Storage

Unopened packages of Cibachrome print material may be kept at temperatures near 70 F for periods of several months. For longer storage refrigeration is recommended. After refrigeration, the material should be allowed to come to room temperature before opening the package, to avoid moisture condensation on the emulsion layers.

Opened packages of Cibachrome print material should not be refrigerated, but kept at normal room temperature.

Basic Filter Pack Designation

Imprinted on each package of Cibachrome print material is a basic filter pack designation, for example:

Y 70 M 00 C 25

for .70 yellow and .25 cyan color printing filters.

This designation may change from batch to batch, depending upon the inherent color balance of the particular Cibachrome emulsions.

The designated filter combination is one which yields correct color reproduction under standardized test conditions in the factory. Modifications may be necessary with your own darkroom equipment, but differences between filter pack designations generally are maintained under most normal working conditions. Therefore, the filter pack designations may be used as a guide in selecting filter combinations with a new batch of material.

For example, if your conditions are such that a Y 70 and C 35 filter pack gives you a perfect print, and the designated filter balance is Y 70 and C 25, then you should apply the difference of a +C 10 filter to the basic filter pack designation of the next package of Cibachrome you purchase.

Example:

1st batch designation	Y 70	M 00	C 25
Your correct balance	Y 70		C 35
			+C 10
2nd batch designation	Y 70	M 00	C 20
You should try	Y 70		C 30

Cibachrome Chemistry

There are only three solutions required for processing Cibachrome print material:

Step 1: developer
Step 2: bleach
Step 3: fixer

In mixing the chemicals, please be sure to follow all the directions on each label carefully, as errors in preparation can cause various faults in final prints.

Use clean vessels for mixing, and wash and rinse carefully after each use, to avoid contamination.

The developer can be mixed to make one quart at a time (for ten 8" x 10" prints) or ½ gallon at a time (for twenty 8" x 10" prints) or you may mix for individual 8" x 10" prints as follows:

> 20 ml Part A developer
> 20 ml Part B developer
> add water to make 90 ml (3 ounces)

The bleach can be mixed to make one quart or ½ gallon at a time. See directions on packages.

The fixer *must* be mixed to make ½ gallon at a time. See directions on package.

Storage

All Cibachrome chemicals should be stored at room temperature in well-sealed glass or polyethylene bottles. The concentrated solutions will keep for several months in the tightly-sealed bottles.

Storage life of the *working solutions* at room temperature is as follows:

> developer: up to three weeks
> bleach: up to five weeks
> fixer: up to one year.

Cibachrome Processing Drum

The Cibachrome processing drum has been designed to allow you to develop your prints in room light. The drum can be converted from an 8" x 10" drum to an 11" x 14" drum by simply changing the center tube portion. Each of the end pieces has a cup which holds over six ounces of fluid, more than enough to process one 11" x 14" print.

Cibachrome Printing Filters

Cibachrome filters are cast acetate in which the colorant is dispersed throughout the sheet; therefore, they withstand abrasions better than gelatin filters. The filters are supplied in 6" x 6" size, large enough to fit all amateur enlarger filter drawers. For enlargers that accept 3" x 3" filters, the Cibachrome filters may be cut in four pieces to make four complete sets.

The Cibachrome filter set contains yellow, magenta, and cyan filters in densities of .05, .10, .20, .30, .40, and .50. A UV-absorbing filter is also included in the filter set.

Equipment

Your enlarger need not be elaborate, but should have:

- a color-corrected projection lens of at least $f/4.5$ maximum aperture.
- a 150- or 100-watt lamp (a 75-watt lamp will be satisfactory if the enlarger has efficient utilization of light.
- a color head, or a filter drawer or system to hold the filters, preferably between the light source and the slide to be projected.
- optionally, a voltage regulator for the enlarger, especially if your electrical supply is subject to fluctuations of more than ±10 volts.
- a heat-absorbing glass in the enlarger head.

You should also have available:

- a photographic thermometer accurate to ±½ F.
- a darkroom timer or clock.

●clean bottles for chemicals, either glass or polyethylene. For ease in mixing use wide-neck bottles of at least ½-gallon capacity.

●rubber gloves for mixing chemicals, or anytime your hands may come in contact with the chemicals. Gloves are essential for tray processing.

●measuring cups for chemicals. Each Cibachrome kit provides three specially-marked cups for your convenience.

Although it is recommended that Cibachrome be handled in *total darkness,* weak green safelight illumination (such as is provided by a safelight lamp equipped with either an Ilford GB-908, an Agfa-Gevaert 64, or a Wratten Series 3 filter and a 15-watt lamp) may be used at least 30 inches from the working area.

Handling Cibachrome

The first and most important thing to remember in printing Cibachrome is that it is a *direct-positive* material. That is, it reacts to exposure variations in the same way as reversal color films, such as Kodachrome, Agfachrome, and others do. That is, more exposure gives you a lighter image, less exposure, a darker image. By the same token, if the light becomes more yellow, the image also becomes yellower; if the light is more red, the image is redder, and so on. Thus, it is easy to estimate the exposure and color corrections required in printing.

Dodging and burning-in, then, are reversed from what you are accustomed to in black-and-white printing; that is, to darken an area, you must hold it back, while to lighten it, you must add light or burn it in. The methods and tools are exactly the same as those you used in black-and-white printing.

Identifying the Emulsion Side

The emulsion side of Cibachrome print material is only a little smoother than the base side, and it may be difficult to determine the emulsion side in the dark. If you have difficulty in feeling the difference, try swishing your thumb across one side at a time while holding it close to your ear. You will hear a "whisper" from the back side, and no sound at all from the emulsion side. If you should make a mistake and put the material on the easel the wrong way up, you will be able to spot it at once; the emulsion side is a dark gray color, while the back is a gleaming white. It may be possible, in such a case, to stop the exposure at once, and possibly save the sheet.

Reciprocity Failure

This effect refers to the loss in photographic efficiency at low light intensities. With dark slides, a weak light source in your enlarger, or great magnification, you may expect to encounter reciprocity failure, and will have to make adjustments in exposure and filter balance. Your print will tend to become darker and more bluish or cyan in color balance. Correct by increasing exposure and adding yellow or subtracting cyan filters.

Selection of Standard Slide

Select a slide to be used as a standard, print, process, and adjust the color balance until you get a print to your satisfaction. Use that same filter pack as the starting point for later prints from other slides on the same type of film. You will find that you need a different basic filter pack for each different type of color film that you use (Kodachrome, Ektachrome, Agfachrome, Fujichrome, and so on. See below.)

To select a slide to be used as a standard, choose one with the following characteristics:

●correct exposure (within ½ stop)
●good color balance
●good range of colors
●flesh tones or neutral grays if possible.

Starting Filter Pack

Suggested starting filter packs for various types of film are as follows:

Kodachrome	Y 80 M 00 C 30
Ektachrome	Y 90 M 00 C 40
Agfachrome	Y 70 M 00 C 20
Fujichrome	Y 65 M 00 C 25
GAF Color Slide	Y 80 M 00 C 30

Initial Exposure Procedure

1. Insert suggested filter pack, plus the UV-absorbing filter.
2. Adjust the enlarger for the desired print size.
3. Focus sharply on the back of a discarded sheet of Cibachrome or photo paper.
4. Determine exposure as follows:

If you have a direct-reading light meter, remove the slide and leave filters in place. Set the meter on the easel and adjust the f/stop to secure a reading of 0.5 foot candle. Replace slide and set exposure timer for 10 seconds.

If you do not have a direct-reading light meter, use one sheet of Cibachrome print material to make a test series of at least four exposures. Use 10-second exposures at f/4.5, f/5.6, f/8, and f/11, to make an 8" x 10" enlargement from a full 35mm slide. A handy exposure mask is packed in 8" x 10" packages of Cibachrome print material for your convenience.

In exposing Cibachrome, it is preferable to adjust the lens aperture, and maintain constant exposure time, but if your enlarger does not deliver sufficient light, you will have to increase the time of exposure to obtain a well exposed print.

5. In *total darkness,* insert Cibachrome material into easel or frame, emulsion side up.
6. Expose print.
7. Process print.

Latitude of Cibachrome

Because Cibachrome has a wide latitude in both exposure and filtration, you will note in studying your tests, that you must be bold in making exposure corrections. To make a significant change in density, you may have to increase or decrease lens apertures by one to two full stops, or to alter exposure time by a factor of two to four.

Also, in making corrections for color halance, a change of at least .20 in filter density may be required.

Latent Image Stability

The latent image of Cibachrome is very stable. You may process immediately after exposure, or if you wish, prints may be kept at room temperature, unprocessed overnight, or even over a weekend without noticeable change in overall density or color balance.

Drum Processing Procedure

Total darkness is required for inserting the exposed Cibachrome material into the processing drum. Curve the exposed sheet to be processed into a cylinder with the emulsion side facing in. Make sure the tube is perfectly dry so the print will easily slide all the way in, and will not be damaged when you replace the end cap on the drum. Once the cap is securely in place, the lights may be turned on for the remainder of the process.

Measuring Chemicals

Chemicals should be carefully measured in the graduated beakers furnished with the Cibachrome kit as follows:

 8″ x 10″ print: 3 ounces (90 ml)
 11″ x 14″ print: 6 ounces (180 ml)

Care should be taken to use the correct beaker for each chemical every time so there will be no chance of contamination. Rinse well after each use. Note: some graduates you may already have in your darkroom may be marked in cc (cubic centimeters). Cubic centimeters and milliliters (cc and ml) are interchangeable for all practical purposes, so you would simply use 90cc for an 8″ x 10″ print.

Temperature and Time

The standard temperature for processing Cibachrome print material is 75 F. If necessary, however, you can work with solution temperatures from 65 F to 85 F if appropriate compensation is made in processing time, as indicated in the table below. Whatever temperature is used must be maintained uniformly in all three solutions within ±3 F.

	68 F ± 3 F 20 C ± 1½ C	75 F ± 3 F 24 C ± 1½ C	82 F ± 3 F 28 C ± 1½ C
Developer	2½ min	2 min	1½ min
Bleach	4½ min	4 min	3½ min
Fix	3½ min	3 min	2½ min
Wash	3½ min	3 min	2½ min
Total time	14 min	12 min	10 min

An increase or decrease in image contrast equal to about one paper grade can be achieved through variations in developing time up to ±½ minute. Shorter times will yield lower contrast at some sacrifice in speed and vice versa.

Unless processing is done under extreme climatic conditions, the short duration of each step should enable you to stay within the prescribed temperature limits. Otherwise, it is recommended that you pre-heat or pre-cool the drum, depending upon the temperature condition, and that you roll the drum in a water bath at the proper temperature.

Agitation

Agitation during processing should be uniform and gentle. A proper agitation procedure would be to roll the drum back and forth during the entire cycle of each step.

Tray Processing

Plastic, hard rubber, or Type 316 stainless steel trays are recommended, but enamelled trays may be used if they are not chipped or rusted. For processing a single 8″ x 10″ print in just three ounces of solution, it is important that the bottom of the tray be flat, with no ridges or depressions.

Procedure

Because steps 1 and 2 are done in *total darkness,* you should prepare one tray with developer and one tray with bleach before the lights are turned off.

Although the beginner is well advised to start tray processing with one print at a time, the more experienced worker may wish to process prints in batches. This can be done with Cibachrome print material provided only that adequate volumes of solution are employed; that is, at least three ounces per 8" x 10" print, and that care is taken to avoid scratching or gouging the swollen and fairly delicate emulsion during interleaving of the sheets. It is essential also that each print of a batch receive the correct treatment time in each solution. This can be assured by immersing and removing the sheets in 10-second intervals, always maintaining the same order.

Measuring Chemicals

Chemicals should be carefully measured in the graduated beakers furnished in the chemical kits, as follows:

| 8" x 10" print: | 3 ounces (90 ml) |
| 11" x 14" print: | 6 ounces (180 ml or 180cc) |

Care should be taken to use the correct beaker for each chemical every time so there will be no chance of contamination. Rinse well after each use.

Temperature and Time

The standard temperature for processing Cibachrome print material is 75 F. If necessary, however, you can work with solution temperatures from 65 F to 85 F if appropriate compensation is made in the time of processing (see table below). It is important that in any given processing run, the temperature of all solutions and of the wash water be kept within ±3 F of each other.

	68 F ± 3 F 20 C ± 1½ C	75 F ± 3 F 24 C ± 1½ C	82 F ± 3 F 28 C ± 1½ C
Developer	2½ min	2 min	1½ min
Bleach	4½ min	4 min	3½ min
Fix	3½ min	3 min	2½ min
Wash	3½ min	3 min	2½ min
Total time	14 min	12 min	10 min

An increase or decrease in image contrast equal to about one paper grade can be achieved through variations in developing time up to ±½ minute. Shorter times will yield lower contrast at some sacrifice in speed and vice versa.

Unless processing is done under extreme climatic conditions, the short duration of each step should enable you to stay within the prescribed temperature limits. Otherwise, it is recommended that you pre-heat or pre-cool the trays, depending upon the temperature condition, and that you float the trays in a water bath at the proper temperature.

Agitation

For a single print, constantly agitate by raising and lowering each of the four sides of the tray to make sure that the entire surface of the sheet is swept over by solution throughout each processing step.

For several prints, agitate by interleaving, continually taking the print from the bottom and placing it on top. Processing prints face down will help reduce scratching of the emulsion.

INTRODUCTION TO "MOTION PICTURES & SLIDES"

The motion-picture data in this section are limited to those films and to other information required by advanced amateurs and professional cameramen using 16mm or 35mm films.

In view of the huge popularity of 8mm and Super 8mm films, the lack of data on these two sizes may seem strange, but the simple fact is that practically no useful data are available for users of 8mm films. The reason is that all modern 8mm and Super 8mm equipment is highly automated. Most 8mm cameras utilize zoom lenses and built-in exposure meters; most 8mm filmers use color film exclusively. The automation of exposure control has been carried to the point where many of these cameras simply have no numerical markings on their lenses, either for aperture or focal length in the case of zoom lenses. In many Super 8mm cameras, the exposure system is set for film speed by notches in the film magazine, and again no numerical data are used. Zoom lenses are usually connected with reflex viewing and focusing, so the image is seen on the groundglass exactly as it will appear on the film.

Thus it is simply impossible to find any *useful* data that can be published in this volume for the user of 8mm equipment. Film speed data are hardly necessary for the very few color films currently utilized. Exposure tables are not needed when the lens adjusts itself under the control of a built-in meter. The very short focus lenses used in 8mm cameras have such a huge depth of field that tables serve no purpose; in the case of zoom lenses, the operator usually has no way of knowing at what focal length he is working. Furthermore, since the reflex viewer permits the operator to see both his field area and the depth of field in the image, he has no need to consult tables and calculations.

Film Data

The film data pages included in this section are similar to those in sections 2 and 3. It was considered desirable, however, to separate motion-picture films from those used for still photography. In many cases a motion-picture product carries the same name as a well-known still film; having several data pages for what would appear to be the same film would possibly lead to confusion. Therefore, the data pages for motion-picture films are segregated in this section, and in addition, are presented in a somewhat different form, more useful in connection with motion-picture cameras and the methods of working with them.

Exposure indexes, for instance, are mainly given for both daylight and tungsten light. Although this practice differs from that for still photography, it is accounted for by the fact that motion-picture films are processed by very precise machine methods, and the difference, which would be trifling in the case of still films, becomes quite noticeable in this case.

Safelight data are required mainly for loading and for processing test strips; color sensitivity data aid in deciding on filters and illuminants.

Exposure data are given in terms of incident light rather than by meter readings of reflected illumination. This is done for several reasons. The studio photographer working with the same equipment over a period of time becomes familiar with the light levels that can be attained in a given studio; from these tables he can decide which film will produce correct exposure at a given lens aperture. If this seems peculiar, it is dictated by a definite difference in the manner of working between still and motion-picture photographers.

The main problem in motion-picture photography is that the scenes are not necessarily photographed in the order in which they will finally appear, yet a smooth continuity must be maintained in all cases. Whereas continuity is ordinarily understood to refer simply to the action of the film, this is only the most common form of continuity. Photographic continuity implies a uniformity of photographic quality from one scene to the next and throughout the film. Thus contrast must be uniform from shot to shot; density must be uniform from shot to shot; image sharpness or diffusion must be uniform from shot to shot.

Lenses vary in sharpness at different apertures. At their widest openings, there is usually a trace of residual aberrations, and the image is slightly soft. At very small apertures, some diffusion appears at times, because of diffraction. Somewhere between the two extremes, a lens produces the sharpest image of which it is capable.

The professional cameraman, recognizing this situation, generally decides in advance that a given series of shots will require either very sharp rendition or somewhat softer definition. Having made this decision, he arrives at a lens aperture and thereafter attempts to make all the separate shots in that sequence at that particular aperture—closeups, medium shots, and long shots. In this way the image quality will match from scene to scene, regardless of how these scenes may later be rearranged by the film editor. If a softer rendition is desired than any lens aperture will produce, the cameraman may use a diffusion disk, but in this case, the disk must be used on all the shots in that sequence. The practice of using heavier diffusion on closeups than on long shots is now considered quite antiquated.

It thus follows that the professional will *not* use his exposure meter to determine the lens aperture that will produce the correct exposure for each shot. To do this would negate the principle explained above; it would result in a sequence of scenes shot at many different apertures depending upon light conditions and having noticeably different image qualities. Instead, the cameraman decides first what lens aperture he intends to use; he may prefer the slight softness attainable at $f/2.3$ or the crisper rendition at $f/4$. Then, referring to the tables on the film data pages, he can decide which film will produce the correct exposure at the light level available or what light level he will need to utilize a given film. Having done this, he proceeds, in the studio, to light the scene to the predetermined level, knowing that the exposure will be correct at the desired $f/$stop, without even taking a meter reading.

446

The meter, then, is used for two other purposes. One purpose is to check the incident-light level on the set to insure that it is correct. The other is to balance the light on various parts of the scene.

Establishing an exposure level from the incident-light level produces an additional bonus; it tends to produce a negative that will print with a minimum of exposure adjustment from scene to scene. If, for example, the photographer worked in the normal amateur manner, taking a separate exposure meter reading for each shot, and if the scene had action in highlight and shadow areas, then these separate meter readings would result in giving more exposure to dark areas, less to bright ones. This not only upsets the whole idea of photographic continuity as already explained, but furthermore, it tends to even out lighting differences that exist for dramatic reasons.

That is, such a procedure would expose the shots made in dim light more than those made in bright areas, and the negatives of these scenes would all be of equal density. Thus, in the final print, all these shots would be alike in brightness, which would not be the effect intended in the lighting to begin with. To correct this equal density in the print, some scenes would require more printing exposure than others.

On the other hand, if the sequences were all made at one exposure, as determined from the incident light on the scene, the negative density of individual scenes would vary. Printing this negative at a single exposure would result in light areas being light, dark areas being dark, exactly as intended in the original lighting of the scene. The whole idea of incident-light exposure measurement originated in the motion-picture studios of Hollywood, and the intent was, mainly, to produce negatives that would print with the least scene-to-scene exposure adjustment.

The reflected-light meter is used by motion-picture cameramen primarily to balance the light falling on various objects in a scene. It is particularly useful to indicate when a given object requires more or less light than its surroundings. One might check the various parts of a scene for reflected brightness and find, for example, that all the actors' faces are 12 candles per square foot; the gray walls, about 6 candles; and the white objects, about 25 candles. This indicates a brightness range, so far, of only 4:1, but black-and-white films can accommodate a range of at least 30:1 and under some circumstances as high as 100:1. For the best screen quality, however, and taking the normal processing of motion-picture film into account, the usual scene range is limited to about 20:1. In the scene in question, with a white reading of 25 candles, the darkest object in the scene should not fall below 1.5 candles per square foot. Reading the blacks in the scene, shadows under and behind furniture, dark clothing, and so on, wherever an area that does not reach at least 1.5 candles is found, additional light is used to raise the brightness of that area.

On the other hand, if a given object, such as a lampshade, a paper in bright light, or a window, reads above 25 candles, it will wash out, and the light falling on it must be reduced either by dimming the lamps or by other methods.

It must be understood that the exposure data in the data pages are those of the manufacturer. Some variations will necessarily be due to the processing differences among laboratories. Thus for tests to be valid, they should be processed by the same laboratory as will later process the film itself. Hand tests are useful only to check camera operation, freedom from scratches, and so on; they should not be used to check exposure levels. Most laboratories will provide, on request, an exposure meter setting for film to be processed in their plants. If

this setting differs from the manufacturer's recommendation, it should be used in preference to the latter. In such a case, incident-light levels can be corrected by simple proportion.

Since control of incident light is mainly possible in the studio, most of the incident-light settings given in these data pages are for tungsten light. Where the figures are given for daylight, as in the case of certain color films, this fact is clearly indicated.

Exterior photography poses another problem—if, for instance, it has been decided to work at $f/4$ and the light intensity outdoors calls for $f/11$, some means must be employed to adjust the exposure other than changing the lens aperture. With some motion-picture cameras, the shutter angle is adjustable for this purpose. Filters can be used to adjust exposure, as well as for color correction; motion-picture cameramen use several special filters, which combine a yellow tint with a neutral density. When no change in color rendition is desired or when color negative or reversal films are used, neutral-density filters can be employed for exposure control. Polarizers, which are useful with all films, have a uniform factor of 2.5X with all of them.

Processing Conditions

Motion-picture films are always processed by machine because of the long lengths of film that must be handled in one continuous piece and because of the need for day-to-day uniformity to maintain photographic continuity. Almost all motion-picture laboratories use strict sensitometric controls to maintain optimum processing conditions; this involves running test strips through the machine at frequent intervals and measuring the gamma actually attained. Gamma in this instance has a definite meaning, although this meaning is not the same as that usually assigned to it by amateur photographers. In this connection, gamma means only the degree of development attained and does not relate directly to the reproduction ratio attainable.

If gamma is constant from day to day, however, the reproduction ratio will likewise be constant, even though different. Thus, the cameraman can determine precisely the useful range of his particular film at whatever gamma is being used, and he can be sure that this range will remain constant as long as he uses that particular laboratory.

Machine processing is carried out in developers that have been designed to fit the particular machine in use—its agitation, recirculation, and replenishment conditions will determine the exact composition of the developer. Thus, machine developers do not correspond to any of the published formulas, and hand tests made in Kodak Developer D-76, for example, will not provide any useful information. For this reason, processing conditions on the following pages are given, not in terms of time in a given developer formula, but in terms of the "control gamma."

The term *control gamma* has a specific meaning: it refers to the gamma attained on the test strips run through the machine between batches of customers' negative. The customers' negative may be on Kodak, GAF, or Dupont film; the control strips on one of the three, most likely, but seldom on more than one. Obviously, one cannot expect a developed negative on Kodak film to have the same gamma as a test strip made on Dupont film. One can, however, expect a more or less constant *ratio* between the gammas of the test and the production negative, and in most cases this is all that is really needed.

For critical work, and when fairly large batches of negative are being processed at a given time, the cameraman will usually allow from 10 to 20

feet of unexposed film on the outside (end) of the roll. One or more pieces of this unexposed film are cut off by the laboratory; exposed in its own sensitometer, and processed, to determine the exact gamma being attained on this particular type and batch of film. Minor adjustments in machine conditions can then be made before the exposed rolls are developed.

This is done only on very important productions and for critical control. However, most cameramen make it a habit to leave an unexposed tail on the end of the film and leave it up to the laboratory to choose whether to make specific gamma tests or to run the film at the normal control gamma. In such a case, the laboratory is always notified by a label on the film can itself, carrying some such wording as "10 feet unexposed gamma test on outside of roll."

Actually, the main use of these control strips is when a special type of film, such as a fine-grain background film or an ultra-high-speed film, is being used. Normal types of medium-speed production negative stock are designed by the several manufacturers so that all will attain roughly the same gamma in a given processing machine, thus making it unnecessary for the laboratory to segregate films by make and to process each under different conditions.

Color films, of course, constitute a different problem; they must be processed by the manufacturer's specified procedure because the color-coupling chemicals in the various makes of film are different. However, the trend in the case of color negative films is now, at least, to make them all compatible with a single processing method, which is currently equivalent to the Kodak Process C-22 chemistry. Some modification is made to the formulas, however, to adapt them to the machine in use.

Reversal films, much used in 16mm production, require special handling to which no reference is made here. One or two procedures for black-and-white processing for reversal films will be found in section 5: Black-&-White Processing.

Aspect Ratios

The term *aspect ratio* refers to the relationship between the height and width of a picture format. When the first motion-picture films were made, Americans used a 35mm film having a picture area of ¾″ x 1″. The French also used a 35mm film, and their picture area was 19mm x 25mm. The two picture areas were so similar that international standards were quickly agreed upon.

The aspect ratio of such a picture, then, is 3:4 or 1:1.33, and this aspect ratio was an international standard for many years; it carried over into 16mm, 8mm, and the proportions of television screens as well. When a sound track was added to the standard 35mm film, resulting in a nearly square picture, the 1:1.33 proportion was restored by cutting down the picture height in proportion, leaving a heavy line between pictures.*

In the early 1930's, producers of certain "spectacular" films felt the need of a wider screen image, and some wide-screen movies using 65mm and 70mm film were produced. These were moderately popular on a "road-show" basis, but theater owners resisted them because of the great expense involved in installing new projection equipment. The wide-screen fad died out in the later 1930's, mainly because there was little or no real need for a screen of such

*The standard 35mm sound aperture (*Academy aperture,* so-called) is actually a little wider than a 1:1.33 ratio; this, however, is done to compensate for the fact that most theaters project their pictures at a downward angle. The screen image, properly masked, is still 1:1.33.

shape; the main use made of it had been for musical films, to accommodate a long chorus line across the screen.

In the late 1940's, the wide-screen idea was revived, probably to counter the inroads of television. With the experience of the 1930's in mind, the industry avoided, at the beginning, any new film sizes and arrived at a wider format by the use of *anamorphic optics*. A system of taking and projecting lenses designed by Professor Henri Chretien was adopted and named *Cinemascope*.

The Cinemascope lens originally compressed the image laterally by a factor of 2X; thus if an aperture plate with the normal 1:1.33 ratio was used, the projected image would have twice this aspect ratio, or 1:2.66. The normal aperture plate was not used however; a new aperture was designed with the height of the old "silent" aperture and the width of the "sound" plate. With this aperture the actual projected aspect ratio of Cinemascope became 1:2.55.

This aspect ratio, too, was later decided to be too wide for the average small theater, where it gave less of an effect of a "wide" screen, than of a normal screen with the top and bottom cut off. Later Cinemascope films were made for an aspect ratio of 1:2.35.

Since the theaters had to install new screens for the Cinemascope picture, they decided to project all normal 35mm film at a wider aspect ratio as well, simply by installing a cut-down aperture in the projector, along with a lens of higher magnification. The two most popular ratios for this kind of wide-screen film are 1:1.75 and 1:1.85. Currently, the latter appears to be used in most theaters showing both standard and wide-screen movies.

From the standpoint of the cameraman, this makeshift wide-screen system did not make any great difference in his manner of working, outside of his simply insuring that no important detail or action appeared on the top or the bottom of the screen. The camera aperture is not masked down at all, so that the image appearing in the film occupies the standard Academy aperture, 1:1.33, and such films can be used for both normal and wide-screen projection, as well as for television transmission and reduction to 16mm.

Obviously, a 16mm reduction print can be made from a 35mm "squeezed" negative, and such a 16mm print can be projected in the 1:2.35 aspect ratio by the use of a properly designed projection lens on the 16mm machine. Because of the limited illumination of 16mm projectors, the size of the image is rather restricted, and a real "wide-screen" effect is seldom attained. It is necessary to use such a system, however, when only a Cinemascope negative is available from which to make 16mm prints.

Various processes using wider films have since come into use; in many cases the wider film prints are used only for first run and road show presentations. By the use of optical printers containing anamorphic lenses, it is possible to make a 35mm Cinemascope print from a 65mm or 70mm wide-screen negative, and this is often done to provide release prints of these films. It is equally possible to enlarge a 35mm "squeezed" negative to an "unsqueezed" 70mm print; this has been done in a few cases, for road show revivals of older films. Extended information on various wide-screen processes can be found in the *American Cinematographer Manual*.

Slide Formats

There are currently three standard slide sizes in the United States: the 2″ x 2″ slide, used with 35mm films in single- and double-frame formats, as well as the new 126 film; the 2¾″ x 2¾″ slide, used with #120 roll films; and the 3¼″ x 4″ slide, formerly the one standard slide size.

There is nearly no such thing as a standard mask opening for any of these slides; masks are frequently cut to fit odd-sized image areas or to crop a poorly composed picture. One supplier of die-cut masks for 3¼″ x 4″ slides lists no fewer than 27 different cut-out sizes and shapes. A few mask sizes account for the bulk of most slide production, however, and these are listed in the following table:

Mounts and Film Sizes	Aperture Inches	Millimeters
2″ × 2″ mount		
35mm single frame	¹¹⁄₁₆ × ²⁹⁄₃₂	17.5 × 23
35mm double frame	²⁹⁄₃₂ × 1¹¹⁄₃₂	23 × 34
#126 film	1³⁄₆₄ × 1³⁄₆₄	26.5 × 26.5
#127 film	1½ × 1½	38 × 38
2¾″ × 2¾″ mount		
#120 roll film	2³⁄₁₆ × 2³⁄₁₆	56 × 56
3¼″ × 4″ mount		
Old standard slide	2¾ × 3	70 × 76
Movie theater slide	2¼ × 3	57 × 76
Polaroid 46L and 146L	2³⁄₁₆ × 3¼	62 × 83

The dimensions given above are taken from masks made by one manufacturer, and one may expect some variation among products of different makers. The apertures for the first two 3¼″ x 4″ slide mats are nominal only, and the actual apertures will be smaller than these figures by as much as 1/16 to 1/8 inch.

Projection

The projection of 8mm and 16mm motion pictures and most slides is usually done with projectors utilizing incandescent lamps. The amount of light available to the screen, then, is dependent upon the amount that can be obtained from the incandescent filament, limited by the aperture of the projection lens. This is not always clearly understood. There is a general belief that a 200-watt lamp will put more light on the screen than a 100-watt lamp, and a 500-watt lamp more than either; that is, increases in screen illumination can be obtained simply by increasing the wattage of the lamp. This is not so; given a certain size of film image and a certain lens aperture, the screen brightness will then depend only upon the size of the projected image and not at all upon the wattage of the lamp, provided the projector is correctly designed to utilize the entire output of whatever filament is being used. Let us examine this apparent contradiction further.

As tungsten is heated, it glows hotter and hotter, and the amount of light emitted increases, slowly at first, then more and more rapidly. A limit is set to the attainable brightness by the melting point of the tungsten filament itself; we cannot approach much closer than 200 C below the actual melting point in the use of an incandescent lamp. At these high temperatures, filament evaporation is very rapid, and the life of the lamp is correspondingly short. Sometimes, as in the case of photoflood lamps, we are willing to trade burning life for brightness. In the case of expensive projection lamps, a reasonably long life —about 25 hours—is usually the least we will accept. However, a few 10-hour lamps are available, where maximum light output is required, regardless of cost.

Normally, though, we use projection lamps burning around 3200 K, and all such lamps will have the same brightness regardless of the wattage. The definition of *brightness* (or more correctly, *luminance)* is emittance per unit area. On this basis, tungsten at 3200 K has a brightness of about 24 candles

(Continued on page 456)

Projection Table: 35mm Double Frame Slides (24 x 36mm image)

NOTE: Upper figure is WIDTH, lower figure is height of projected image.

Focal Length mm	Dim.	6 ft.	6 in.	8 ft.	8 in.	10 ft.	10 in.	12 ft.	12 in.	15 ft.	15 in.	20 ft.	20 in.	25 ft.	25 in.	30 ft.	30 in.	40 ft.	40 in.	50 ft.	50 in.	60 ft.	60 in.	75 ft.	75 in.
35	W	6	0	8	1	10	2	12	2	15	3	20	5	25	7	30	8	41	0	51	3	61	7	77	0
35	H	4	0	5	4	6	9	8	1	10	2	13	7	17	0	20	5	27	4	34	2	41	0	51	4
40	W	5	3	7	0	8	10	10	8	13	4	17	10	22	4	26	10	35	10	44	10	53	10	67	4
40	H	3	6	4	8	5	11	7	1	8	11	11	11	14	11	17	11	23	11	29	11	35	11	44	11
50	W	4	2	5	7	7	0	8	6	10	8	14	3	17	10	21	5	28	8	35	10	43	0	53	10
50	H	2	9	3	9	4	8	5	8	7	1	9	6	11	11	14	3	19	1	23	11	28	8	35	11
75	W	2	9	3	8	4	8	5	7	7	0	9	5	11	10	14	3	19	0	23	10	28	8	35	10
75	H	1	10	2	5	3	1	3	9	4	8	6	3	7	11	9	6	12	8	15	11	19	1	23	11
85	W	2	5	3	3	4	1	4	11	6	2	8	4	10	5	12	7	16	9	21	0	25	3	31	7
85	H	1	7	2	2	2	8	3	3	4	1	5	6	6	11	8	4	11	2	14	0	16	10	21	1
105	W	1	11	2	7	3	3	3	11	5	0	6	8	8	5	10	2	13	7	17	0	20	5	25	7
105	H	1	3	1	9	2	2	2	7	3	4	4	5	5	7	6	9	9	0	11	4	13	7	17	0
120	W	1	8	2	3	2	10	3	5	4	4	5	10	7	4	8	10	11	10	14	10	17	10	22	4
120	H	1	1	1	6	1	11	2	3	2	11	3	11	4	11	5	11	7	11	9	11	11	11	14	11
135	W	1	5	2	0	2	6	3	0	3	10	5	2	6	6	7	10	10	6	13	2	15	10	19	10
135	H	0	11	1	4	1	8	2	0	2	7	3	5	4	4	5	3	7	0	8	9	10	7	13	3
150	W	1	3	1	9	2	3	2	9	3	5	4	8	5	10	7	0	9	5	11	10	14	3	17	10
150	H	0	10	1	2	1	6	1	10	2	3	3	1	3	11	4	8	6	3	7	11	9	6	11	11
165	W	1	2	1	7	2	0	2	6	3	1	4	2	5	4	6	5	8	7	10	9	12	11	16	2
165	H	0	9	1	1	1	4	1	8	2	1	2	9	3	6	4	3	5	8	7	2	8	7	10	9
180	W	1	0	1	5	1	10	2	3	2	10	3	10	4	10	5	10	7	10	9	10	11	10	14	10
180	H	0	8	0	11	1	3	1	6	1	11	2	7	3	3	3	11	5	3	6	7	7	11	9	11
200	W	0	11	1	3	1	8	2	0	2	6	3	5	4	4	5	3	7	0	8	10	10	8	13	4
200	H	0	7	0	10	1	1	1	4	1	8	2	3	2	11	3	6	4	8	5	11	7	1	8	11

NOTE: Upper figure is WIDTH, lower figure is height of projected image.

452

Projection Table: 3¼″ × 4″ Stereopticon Slides (2¾″ × 3″ mask opening)

In each cell the upper figure is WIDTH and the lower figure is height of projected image (ft. in.).

Focal Length (inches)	15	20	25	30	35	40	45	50	60	70	80	90	100
5	8'10" / 8'0"	11'10" / 10'10"	14'10" / 13'6"	17'10" / 16'4"	20'10" / 19'0"								
5½	7'11" / 7'4"	10'8" / 9'8"	13'5" / 12'4"	16'1" / 14'10"	18'10" / 17'4"	21'7" / 19'10"							
6	7'4" / 6'7"	9'8" / 8'11"	12'4" / 11'2"	14'10" / 13'6"	17'4" / 15'10"	19'10" / 18'1"	22'4" / 20'5"						
6½	6'8" / 6'1"	9'0" / 8'2"	11'4" / 10'5"	13'7" / 12'6"	15'11" / 14'7"	18'2" / 16'8"	20'10" / 18'10"						
7	6'2" / 5'8"	8'4" / 7'7"	10'6" / 9'7"	12'7" / 11'7"	14'10" / 13'6"	16'11" / 15'6"	19'0" / 17'6"	21'2" / 19'5"					
8		7'4" / 6'7"	9'1" / 8'5"	11'0" / 10'1"	12'11" / 11'10"	14'10" / 13'6"	16'7" / 15'2"	18'6" / 17'0"	22'4" / 20'5"				
10		5'10" / 5'4"	7'4" / 6'7"	8'10" / 8'0"	10'4" / 9'5"	11'10" / 10'10"	13'4" / 12'2"	14'10" / 13'6"	17'10" / 16'4"	20'10" / 19'0"	23'10" / 21'10"		
12			6'0" / 5'6"	7'4" / 6'7"	8'6" / 7'0"	9'10" / 8'11"	11'0" / 10'1"	12'6" / 11'7"	14'10" / 13'6"	17'4" / 15'10"	19'10" / 18'1"	22'4" / 20'5"	
14				6'2" / 5'7"	7'4" / 6'7"	8'4" / 7'7"	9'5" / 8'7"	10'1" / 9'5"	12'7" / 11'7"	14'10" / 13'6"	16'11" / 15'6"	19'0" / 17'6"	21'2" / 19'5"
16					6'4" / 5'10"	7'4" / 6'7"	8'2" / 7'6"	9'1" / 8'5"	11'0" / 10'1"	12'11" / 11'10"	14'10" / 13'6"	16'7" / 15'2"	18'6" / 17'0"
18					5'7" / 5'1"	6'5" / 5'11"	7'4" / 6'7"	8'4" / 7'7"	9'10" / 8'11"	11'5" / 10'6"	13'1" / 12'0"	14'0" / 13'6"	16'6" / 15'1"
20						5'10" / 5'10"	6'6" / 6'0"	7'4" / 6'7"	8'10" / 8'0"	10'4" / 9'5"	11'10" / 10'10"	13'4" / 12'2"	14'10" / 13'6"

NOTE: Upper figure is WIDTH, lower figure is height of projected image.

453

Projection Table: 16mm Motion Pictures (Aperture Size .284″ × .380″)

NOTE: Upper figure is WIDTH, lower figure is height of projected image.
(Values given as ft.–in.)

Focal Length (in.)		6	7	8	10	12	15	20	25	30	40	50	60	75	100
¾	W	3'0"	3'6"	4'0"	5'0"	6'0"	7'0"	10'0"	12'6"	14'10"	20'0"	25'0"	—	—	—
¾	H	2'2"	2'7"	2'11"	3'9"	4'6"	5'3"	7'6"	9'4"	11'0"	14'11"	18'8"	—	—	—
1	W	2'4"	2'8"	3'0"	3'9"	4'7"	5'8"	7'6"	9'4"	11'8"	15'0"	18'8"	22'0"	—	—
1	H	1'9"	2'0"	2'2"	2'10"	3'5"	4'2"	5'6"	6'11"	8'7"	11'2"	13'10"	16'5"	—	—
1½	W	1'6"	1'9"	2'0"	2'6"	3'0"	3'10"	5'0"	6'4"	7'6"	10'0"	12'6"	15'6"	18'8"	25'0"
1½	H	1'2"	1'4"	1'6"	1'10"	2'3"	2'10"	3'9"	4'8"	5'8"	7'5"	9'4"	11'7"	13'9"	18'8"
2	W	1'2"	1'4"	1'6"	1'10"	2'3"	2'10"	3'9"	4'9"	5'8"	7'5"	9'4"	11'7"	14'2"	18'9"
2	H	11"	1'0"	1'2"	1'4"	1'8"	2'2"	2'10"	3'7"	4'3"	5'7"	6'11"	8'11"	10'6"	14'0"
2½	W	10"	1'0"	1'2"	1'6"	1'9"	2'3"	3'0"	3'10"	4'6"	6'0"	7'6"	9'6"	11'4"	15'2"
2½	H	7"	9"	10"	1'2"	1'4"	1'8"	2'3"	2'10"	3'5"	4'6"	5'6"	7'0"	8'6"	11'4"
3	W	—	—	—	1'3"	1'6"	1'11"	2'6"	3'2"	3'10"	5'0"	6'4"	8'0"	9'6"	12'8"
3	H	—	—	—	11"	1'1"	1'5"	1'10"	2'4"	2'9"	3'6"	4'8"	6'0"	7'0"	9'5"
3½	W	—	—	—	—	1'3"	1'8"	2'2"	2'8"	3'4"	4'3"	5'5"	6'6"	8'2"	10'10"
3½	H	—	—	—	—	11"	1'2"	1'7"	2'0"	2'4"	3'2"	4'1"	4'10"	6'0"	8'1"
4	W	—	—	—	—	1'1"	1'5"	1'10"	2'4"	2'10"	3'10"	4'8"	5'10"	7'2"	9'6"
4	H	—	—	—	—	10"	1'0"	1'4"	1'9"	2'2"	2'10"	3'6"	4'4"	5'4"	7'0"

Projection Table: Standard 8mm Motion Pictures (Aperture Size .129" × .172")

Focal Length (In.)		3	4	5	6	8	10	12	15	18	20	30	40	50	75
½	width	1'0"	1'5"	1'9"	2'1"	2'9"	3'5"	4'2"	5'2"	6'2"	6'11"	10'4"			
	height	0'9"	1'0"	1'3"	1'7"	2'1"	2'7"	3'1"	3'10"	4'8"	5'2"	7'9"			
¾	width	0'8"	0'11"	1'2"	1'5"	1'10"	2'4"	2'9"	3'5"	4'2"	4'7"	6'11"	9'2"		
	height	0'6"	0'8"	0'10"	1'0"	1'5"	1'9"	2'1"	2'7"	3'1"	3'5"	5'2"	6'11"		
1	width		0'8"	0'10"	1'0"	1'5"	1'9"	2'1"	2'7"	3'1"	3'5"	5'2"	6'11"	8'7"	
	height		0'6"	0'8"	0'9"	1'0"	1'3"	1'7"	1'11"	2'4"	2'7"	3'10"	5'2"	6'5"	
1½	width				0'8"	0'11"	1'2"	1'5"	1'9"	2'1"	2'4"	3'5"	4'7"	5'9"	8'7"
	height				0'6"	0'8"	0'10"	1'0"	1'3"	1'7"	1'9"	2'7"	3'5"	4'3"	6'5"

(Distance in Feet across the top; figures given as ft. in.)

NOTE: Upper figure is WIDTH, lower figure is height of projected image.

455

per square millimeter of filament area. Now, if a 100-watt lamp has 100 square millimeters of filament, at this luminance it will emit a total light of 2,400 candles. The 200-watt lamp, then, will have 200 square millimeters of filament and will emit 4,800 candles. But in each case, each square millimeter of filament is emitting 24 candles of light.

But the light reaching the screen is only that which passes through the projection lens. If, with a given condenser system, the aperture of the lens is just filled with the light of a 100-watt lamp, then replacing it with a 200-watt lamp will not increase the light output—the larger filament image will simply not be able to get into the lens. If we reduce the magnification of the condenser system so that we can put the image of the entire 200-watt filament into the projection lens, we find we have to move the lamp farther from the condenser, which then picks up exactly that much less light, so that the screen illumination remains constant.

Why, then, use bigger projection lamps? If we can magnify the image of a small lamp filament to fill a given lens, we will secure just as much screen illumination as we could get with a bigger lamp and less magnification. Condenser systems of high magnification are difficult to make, however; they generally have a good deal of spherical aberration, which results in uneven, streaky illumination. Early 16mm projectors generally used $f/2.5$ projection lenses, which could easily be filled with light with a lamp of 200 to 400 watts. To get any more light involved increasing the lens aperture to as much as $f/1.6$, and to fill this large aperture lens with light required either a much more expensive condenser system or a bigger lamp. Since the bigger lamp—750 watts to 1,200 watts—was the easier solution, it was used. (Incidentally, it also gave an advertising advantage to these projectors; somehow, the public will always believe that a 1,000-watt projector must be of truly formidable brilliance.)

Obviously, though, if the *image* is being magnified to a greater degree, less light will be available, even through a lens of the same f/number. A brief examination will show that since the magnification depends upon the focal length and the light on the f/number, the net screen illumination depends only upon the relation between the two, which is simply the diameter of the lens. Thus, given a 16mm projector with an $f/1.6$ lens of 2-inch focal length and an 8mm projector with an $f/1.6$ lens of 1-inch focal length, the latter will be half as big in diameter, and the screen image will be half as bright (for equal image size).

In an attempt to equalize the screen illumination between 16mm and 8mm projectors, therefore, manufacturers are making 8mm projection lenses of very large aperture—$f/1.0$ is not uncommon in 8mm projectors. In this way, and with a proper light source and condenser system, we can make an 8mm projector as bright as a 16mm projector.

Even so, we do not necessarily need a large lamp. By the use of specially formed mirrors that are built into the lamp and eliminate condenser lenses completely, we can secure filament images magnified sufficiently to fill these larger projection lenses without excessive spherical aberration. Such lamps usually work at around 150 watts, and since the lens is fully filled with an image of the filament, screen illumination is ample; it can easily equal that of a 500-watt or bigger lamp in a conventional optical system.

Two conclusions can be drawn from the discussion above. The first is that given projection lenses of equal aperture, an 8mm projector can never be more than half as bright as a 16mm, with incandescent illumination. In-

creasing the f/number of the 8mm projection lens can increase the light output, but a similar increase in the aperture of the lens of the 16mm machine restores the advantage.

The second conclusion is, of course, that as long as the incandescent lamp is used as an illuminant, the maximum screen illumination is rather inexorably fixed. Increasing the wattage will not add any light to the screen image. Although raising the temperature of the filament will give some increase in light, at the expense of shorter lamp life, the amount of increase is fairly limited. Even so, a useful increase in light can be attained by a raise of temperature of about 50 K to 75 K. This can be accomplished without excessively shortening lamp life, either by using the quartz-iodine principle, which allows the lamp to burn hotter without excessive evaporation of tungsten, or by the use of low-voltage lamps, which have thicker filaments and thus last longer.

Carried to the ultimate, all of these methods will permit the projection of a picture perhaps six to eight feet wide from 16mm film, and about half that from 8mm.* To get any bigger image than this simply requires that we find another light source having a higher luminance or brightness than incandescent tungsten. One such source, of course, is the *carbon arc,* used in theater projectors for screen images of fairly huge size. In 16mm projection, carbon-arc projectors can produce pictures from 12 to 16 feet in width, of satisfactory brightness.

A new illuminant, the *xenon arc,* shows much promise for small projectors. One version, known as the MARC-300, burns only 300 watts in the lamp itself, draws a total of 400 watts from the line for the lamp and its auxiliary apparatus, and has a brightness more than four times as great as a tungsten lamp. 16mm projectors fitted with this lamp are useful in small auditoriums for pictures up to at least 12 feet in width; even larger pictures can be projected on highly reflective screens.

Projection Screens

The brightness of the projected image depends not only upon the luminance of the projector, but also upon how much of the projector light is reflected back to the audience by the screen. Obviously, if we projected a picture on a dead-black screen, which has nearly zero reflectance, we would see nothing. A freshly plastered white wall reflects well over 90 per cent of the light falling upon it; it would seem to be the ideal screen, as there appears at first little chance of gaining much in the way of added light.

In one way, the plastered wall *is* an ideal screen; it reflects nearly all the light falling upon it, and it appears equally bright whether viewed head-on or from the side. When an audience must be seated at wide angles to the screen, only a highly diffuse reflector, such as a plaster wall or one of the white rubberized screens, will serve. This wide angle of view is not always an advantage, however. In a narrow theater, it is unnecessary, and in any case, viewing the picture from extreme angles is undesirable because of the inevitable distortion.

*This is true for a fixed minimum screen illumination of 10 foot-Lamberts as called for by a former U. S. Standard. It is recognized that larger screen images are often obtained from 8mm incandescent lamp projectors. While these images are considered acceptably bright, they are usually well below the 10 ft -L standard. The acceptability comes about from a property of the eye, known as *contrast sensitivity.* The contrast sensitivity of the eye increases with the size of the image on the retina, up to a certain point; thus a dimmer image is acceptable in the case of a large picture. This principle has application in professional projection as well; the huge screens of most drive-in theaters generally have a brightness considerably less than the 10 ft -L standard.

Early in the days of motion pictures it was discovered that if the screen were painted with matte aluminum paint, brightness on axis could be increased as much as five to ten times. Since a white screen already reflects nearly 90 per cent of the light falling upon it, it may be puzzling to account for the great gain in illumination produced by the silver-painted screen. We are not, however, getting something for nothing; we are merely redirecting the light that would otherwise be reflected to the sides. By reflecting this light into the center of the room instead, we can increase the light in this area many times. The total amount of light remains the same, only its distribution is changed. The silver-painted screen has disadvantages, mainly a glare in the highlights; however, it is still used for special purposes, such as polarized stereo projection.

Recently, however, the glass-beaded screen has been preferred for most uses; it has nearly as much light gain as the silver screen, but its angle of view is somewhat controllable by the size of the beads and their distribution. The beaded screen has another problem, however—unlike any other form of reflector, it does not reflect light at an opposite angle, like a mirror or an aluminum screen. It has the peculiar property of reflecting light directly back at the source, regardless of the angle. When the projector and audience are all directly in front of the screen, this does not matter; however, when the projector is in, for example, an auditorium balcony and the audience is downstairs, a silver screen is preferable, since the light will be directed downward. The beaded screen, on the other hand, will return the brightest image to the balcony. Beaded screens are most valuable for home movies; they never attained any popularity for classroom or theater use.

Until the recent "wide-screen" introduction, theaters using arc lamps had ample light on the screen and continued to use matte white screens. With the advent of the wide screen, however, with projected images 40 feet wide and wider, even the arc lamp was strained to provide sufficient light, and a reexamination of the use of high-gain screens began.

A compromise between the characteristics of the aluminum and beaded screen was finally arrived at; this was accomplished by molding the surface of a silver screen into cylindrical ribs called *lenticulations*. By careful shaping of the lenticular surface, it was found possible to direct the light to the sides of the theater while maintaining a fair light gain in all usable directions. The gain in this case comes from the cylindrical shape of the lenticules; they produce a reflectance greatest in the horizontal plane, least vertically. Thus light that would have been wasted on the floor and ceiling of the theater is redirected to the audience, and a bright image is obtained, through a fairly wide angle.

For home use, a different type of lenticular screen is now available. The modified shape of the lenticules produces a peculiar effect — the screen is brighter than a plain white one at any useful angle, to about 40°. Although less bright than a beaded screen on axis, it is brighter than the same beaded screen when viewed at a 30° angle. This indicates a more even light distribution than the beaded surface within the angle usually used for seating. Incidentally, the lenticular silver screen can also be used for stereo projection with polarized light; the silver screen does not depolarize the light, even when ribbed.

Daylight Screens. For many years, there has been a demand for screens that can be used without darkening the room; these are required for sales meetings, demonstrations, and educational purposes.

The earliest "daylight" screens used a translucent material, with the picture projected from behind the screen. The light transmission of such a material can

be controlled to make the image brightest through a moderate angle on or near the axis of projection, so that we get a "light gain" comparable to that of beaded or aluminum-painted screens. By making the surface of the material rather dark in color, we lose little of the transmitted light, while rejecting a good deal of light falling on the front of the screen. In this way, we can produce a fair amount of ambient light rejection and get an image of satisfactory contrast even in a lighted room.

The main disadvantage of rear projection is the large amount of space required behind the screen for the projection equipment, and the distance required to produce a large enough image. Earlier, extremely wide-angle lenses were used in projectors placed behind the screen, but image definition inevitably suffered. Today, rear projection is seldom used for pictures of any size; it is limited to small cabinet projectors with the screen sizes measured in inches.

A new principle of daylight projection has recently been employed by Kodak in their Ektalite screen. This is a rigid plastic backing, covered with aluminum foil produced by a special process called *pack-rolling*. This surface shows enormous light gain, up to as much as 15 to 20 times that of a matte screen on axis and about half as much through a total viewing angle of about 25°. Beyond that angle, the reflectance drops off very rapidly, falling to about one per cent at about 40°.

There is an interesting consequence of this low reflectance beyond 40°. If light projected onto the screen is not reflected to such an angle, it follows from the reversibility of optical phenomena that light falling on the screen from beyond the 40° angle will not be reflected back into the axial (or viewing) area. Thus the material has the property of almost total rejection of ambient light outside the 40° angle. If, then, the room is illuminated by light sources that are more than 40° off the axis of the screen, either horizontally or vertically, these light sources will have no effect whatever on the contrast of the projected image, and one can project bright images on this screen in a fully lighted room.

The sharply directional reflectance of this screen material, though, poses other problems. A single viewer, on axis, will see a noticeable difference in illumination between the center of the screen and the corners, due to the difference in viewing angle. In the commercial version of this screen, this is overcome by making the surface curved rather than flat. The curvature is at a radius equal to the most-used viewing distance and is consequently quite shallow; it is not great enough to cause depth-of-field problems with the projector.

Another problem stemming from the high directionality of the material is that wrinkles and dents in the screen surface will show up as strong shadows in the picture. For this reason and also because of the requisite curved surface, the Ektalite screen cannot be made in roll-up form; it is presently supplied in 40" x 40" size on a rigid foam plastic backing of the proper curvature. Possibly, further development of this material may lead to a type of lenticular surface that does not need to be curved for even illumination; whether this will solve the roll-up problem is not yet known.

Screen Masking. In all motion-picture systems, the camera produces an image on the film that is slightly larger than the area actually projected. To avoid difficulty with edge guiding and errors in alignment, the aperture plate of the projector is made slightly smaller than that of the camera; this crops out a small amount of image all around.

The aperture plate cannot be put in contact with the film, though, or it will cause scratches and other damage. Because the aperture is not in contact with the film, its image on the screen is out of focus, and the picture has a

fuzzy outline. Short focus, large aperture lenses particularly reveal this difficulty; thus the fuzzy outline of the picture is most noticeable on 8mm projectors. This blurred outline is further degraded by dust, dirt, and lint, which collect on the edges of the aperture plate during the running of a reel, making the outline not only fuzzy but ragged.

Professional projectionists are conscious of this problem and to eliminate it provide the screen with a nonreflective black outline, several inches in width. They adjust the size of the projected image so that it overlaps into the black mask by an inch or so. This covers up the ragged edge and lends a clean, crisp outline to the projected picture. Subjectively, this sharp outline appears to produce a brighter, more contrasty picture, and also, for reasons not understood, it appears to reduce the unsteadiness of a slightly shaky picture.

Screen masking cannot be used with slides, but usually it is not necessary. A screen for slide projection is almost always square in shape, allowing both vertical and horizontal picture formats to be projected on it without cropping. In every case, the image in the slide itself is masked to the exact projected area desired with a black paper or foil mask. Since this mask is under the cover glass, the outline of the image remains clean, and since the mask is in contact with the picture itself, the outline of the picture is crisp and sharp on the screen.

Filmstrips are usually projected on unmasked screens too; the problem of the edge is solved in a different manner. Here the situation is simply the reverse of that of the motion picture; that is, the camera aperture is made smaller than the projector aperture. Thus, in a normally-printed filmstrip, each picture is surrounded by a sizable black outline, and if the projector is correctly framed, the outline of its aperture plate is actually covered by the printed black outline of the film. Thus, the outline of the screen image is the black frame printed on the film — this is necessarily in focus, sharp, and clean.

Motion Pictures and Slides for Television

A great deal of program material on television is in the form of either film or slides. One major question—whether density range and contrast should be adjusted in film-making to suit transmission characteristics, or whether the transmission system should be adjusted to the characteristics of normal films — appears to have been resolved in favor of making films normally and adjusting the transmission system to produce the optimum received image quality. This decision was probably dictated by the necessity for making most films for multiple use — for both theatrical and television projection.

When material is being produced strictly for television, though, some adjustment of format is usually made. As we have already seen, in theatrical projection there is some cropping of image area by the projector aperture and screen masking, and allowance is usually made for this by masking down the camera finder to show the final projected image rather than the somewhat larger image area actually recorded on the film.

In television transmission, however, there are two additional areas of image cropping. In addition to the projector aperture, there is some further cropping in transmission and still more in the home receiver. In both cases, these are to provide "safe" areas. Since the projector aperture crops the image slightly and produces a fuzzy black edge around the image, the transmitting scanner is set to scan a slightly smaller area and avoid picking up any of the black outline. Home receivers are usually adjusted to produce a larger than optimum image, in order to allow for picture shrinkage under low-voltage conditions; this excess image area is hidden under the tube mask and is lost in addition to whatever has been lost in the previous stages.

Because of this cumulative loss of picture area, only a little more than half the original picture area recorded on the film can surely be seen on each and every home receiver. This is taken into account in photographing the original film or slide. Excess image area must be allowed around important parts of the picture image, and this excess area must contain detail — it cannot simply be masked down, because it will appear on some receivers, if not on all. Enough image detail must be provided for the best-adjusted receivers, but important detail must be kept within a confined area if it is to be seen on the worst-adjusted receivers.

Early charts and field masks for camera finders showed this "safe" area as a sort of pumpkin-shaped field centered in the rectangular image area. The pumpkin shape corresponded to the tube masks used on home receivers with round tubes, which have mostly disappeared. Modern TV receivers use rectangular picture tubes, and the image masks used with them are fairly straight-sided, although some "decorator" masks are used that have rather fanciful shapes, usually composed of several arcs of circles. The "safe" area currently employed is therefore a bit bigger than that once recommended, thus allowing for the use of bigger type in titles, for one thing.

In the case of slides, cropping is a far more drastic matter. The standard 2″ x 2″ slide with the ordinary 35mm double-frame aperture has an aspect ratio of 1:1.5, whereas the television screen is in the normal 1:1.33 ratio. Thus some excess image area at the sides has to be cropped off in any case. In addition, of course, there is still the cropping due to the scanning process and to the home receiver. The 3¼″ x 4″ slide, however, has the opposite problem; its normal mask is in a squarer ratio, and some cropping must occur at top and bottom, in addition to that normally required for the "safe" area.

The following table shows current practices in allowing "safe" areas for 35mm sound films, 16mm sound films, 3¼″ x 4″ slides, and 2″ x 2″ slides:

Film Size or Slide	Camera Aperture (Inches)	Projector Aperture (Inches)	Scanned Area (Inches)	Safe Action Area (Inches)	Title Area (Inches)
35mm Sound Film	.631 × .868	.612 × .816	.594 × .792	.523 × .642	.466 × .621
16mm Film	.292 × .402	.284 × .380	.276 × .368	.242 × .297	.217 × .289
3¼″ × 4″ Slide	—	2¾ × 3	2⁷⁄₁₆ × 2¾	1¾ × 2¼	—
2″ × 2″ Slide	—	29⁄32 × 1 11⁄32	53⁄64 × 1 7⁄64	45⁄64 × 55⁄64	—
4″ × 5″ Opaque	4 × 5	3³⁄₁₆ × 4¼	3 × 4	2¼ × 3¼	—

The use of Polaroid transparency films for making television slides is fairly common. The aperture in the Polaroid slide mount is smaller than the standard 2¾″ x 3″ opening in the regular 3¼″ x 4″ slide; therefore the figures above for 3¼″ x 4″ slides will not apply to Polaroid slides. Unfortunately, there are no official standards for the making of slides in the Polaroid format, and scanned areas, "safe" areas, and title areas have to be determined by trial and error.

Methods of Making Slides

Those who use color film in 35mm cameras usually receive their processed film from the laboratory, already cut and mounted in one form or another of cardboard or plastic mount. These slides are ready to show in this form, and thus the question of making slides with 35mm color film does not even arise. Those working in other formats, however, or in 35mm black and white, do have several different ways of making slides from their pictures, and these require some discussion.

The simplest way of making a slide from a black-and-white negative is to contact print the negative on a lantern-slide plate, a thin sheet of glass coated with an emulsion similar to that used on enlarging papers. This plate is developed in a standard paper developer, such as Kodak D-72, fixed, washed, and dried in the usual way. After drying, a paper mask, covering all but the projectable area of the image, is placed on the emulsion side of the plate; a thin cover glass is placed over the mask; and the whole thing is bound with tape.

Obviously this method will only work when the original negative is of the correct size to produce a more or less standard-size image. Negatives of 35mm film can be printed on 2″ x 2″ slide plates and masked with a normal 24 x 36mm mask. Negatives from 2¼″ x 2¼″ up to about 3¼″ x 4¼″ can be printed on 3¼″ x 4″ plates, and a variety of masks are available to accommodate different image formats, such as 2¼″ x 3¼″ and other sizes. The maximum projectable area of a 3¼″ x 4″ slide is about 2¾″ x 3″, however, and this sets a limit to the size of the negative that can be used.

Obviously, since the slide plate is coated with an emulsion of about the same speed as that on an enlarging paper, it can be exposed with a conventional enlarger. Any size negative can thus be made into a slide, and the image can be cropped in any way desirable. Outside of the need, in some cases, for additional lens extension, almost any enlarger is suitable for this purpose. There is one caution: although a standard slide mask may be used to determine the usable area being printed on the slide, the mask should not be placed on the slide plate while the image is being printed. To do so will surround the picture with an area of clear glass, which will make registration of the mask difficult. It is better to print the slide plate right to the edges, masking off unwanted image area later in binding up the slide.

This method is the same in principle as the classic one used for many years in the making of black-and-white slides, except that instead of using an enlarger, a long-bellows camera was used with holders for either 3¼″ x 4″ or 2″ x 2″ slide plates. The negative was placed on an illuminator and focused to the desired size in the camera. This system is most practical when only one or two slides of a given subject are required. When slides are to be made in quantity, the usual method is to prepare a copy negative, reduced or enlarged to the desired size, and then to make contact prints from this negative. Although the system described employs glass plates for its sensitized material, this is not actually necessary. Films are available with similar characteristics, such as Kodak Fine Grain Positive Film, and black-and-white slides can be made on film as well as on plates.

Positive film can be obtained in both sheets and rolls; the latter being the usual 35mm motion-picture film generally used as printing material for motion pictures. Although it is convenient to make large numbers of duplicate slides by printing on a roll of film, the mounting is more tedious. The film must be cut into individual frames, mounted in masks, and then bound between two pieces of glass. In the case of black-and-white film, glass mounting is essential; the film absorbs much more heat from the projector lamp than does color film, and slides mounted in cardboard frames will buckle and warp very badly.

The making of filmstrips is a different problem, and the procedure differs. To begin with, since filmstrips are usually produced in quantity, what is needed is a negative from which to print an entire strip in one operation. This is usually done by motion-picture laboratories on motion-picture printers. Such printers are not able to make frequent exposure changes such as might be required in a negative in which each frame has a different density.

For this reason, a filmstrip negative is prepared in the following manner. First, all of the required material is photographed with conventional cameras;

the size and format is immaterial. These negatives in turn are used to make glossy prints, generally about 8″ x 10″, and are very carefully exposed so that all prints have the same density. Any minor defects are retouched out of the prints. Captions, if desired, are printed and pasted along the bottom edge of the prints. When all the material is ready, it is photographed on what is essentially the same as an animation camera, except that a special aperture plate is employed to produce a clean black outline around each frame. The negative strip thus produced should be uniform in density. It is then spliced into a loop with the required leader and trailer, so that repetitive printing can be done without stopping to rethread the printer after each pass of the negative.

Such a negative can be made with simpler apparatus; there are methods of producing single-frame filmstrips with double-frame cameras, by exposing two pictures at a time, masked with a special frame that produces the required black outlines. Single-frame cameras making an image about 18 x 24mm are available, but their apertures are a bit too large for proper outlining; however, for less critical filmstrip work, they may be adequate.

There are a few short-cut methods for making black-and-white slides; one of these is to use Kodak Direct Positive Panchromatic Film (see section 2) in the camera. Processing of the film in a reversal process produces black-and-white positives ready to mount and project. As mentioned above, they must be glass-mounted to avoid heat damage.

Another method is to use a Polaroid camera with either 46L or 146L Transparency film. Type 46L produces a low-contrast image suitable for continuous-tone slides; Type 146L produces a very high-contrast image suitable for line work, diagrams, titles, and similar material. These produce an image a bit smaller than the standard mask opening in a 3¼″ x 4″ slide, and special plastic mounts are supplied for slides made on this film. Glass mounting is less necessary with Polaroid slides because they contain much less silver in the image and thus do not absorb so much heat.

All of the methods described for making black-and-white filmstrips and slides can be used with color also. For instance, most color filmstrips are produced by a method paralleling that given above: color prints, art work, titles, and other material are all made to uniform size and density, then photographed on an animation camera using color negative stock. From this, any number of color prints can be made by normal motion-picture methods.

For small-scale work, color duplicating films are available, in reversal types, for copying transparencies to positive color images in a single step, and in positive types, for printing slides from color negatives. There is also an internegative material available, by which color slides and transparencies may be directly photographed to a negative from which color filmstrip prints may be made. This is an advanced professional material, requiring sensitometric equipment for proper control. Further information on its use is available from the manufacturers.

MOTION PICTURE FILMS

FILM	TYPE	SIZES*	SPEED	USES
AGFA				
Agfachrome CK-17S	Tungsten color reversal	D-8, Su-8	D-25, T-40	Home movies
Agfachrome CT-13S	Daylight color reversal	D-8	D-16	Home movies
DU PONT				
Superior-2, Type 136	Black and white negative	16mm, 35mm, 70mm	D-125, T-100	Commercial, theatrical, TV
Rapid Reversal 930A	Black and white reversal	16mm	D-64, T-50	Commercial, TV films
High Speed Rapid Reversal 931A	Black and white reversal	16mm	D-160, T-125	Commercial, TV, news
Ultra Speed Rapid Reversal 932A	Black and white reversal	16mm	D-320, T-250	Sports, TV, news
FUJI				
Fujichrome R-25	Daylight color reversal	S-8	D-25	Home movies
Fujichrome RT-200	Tungsten color reversal	S-8	T-200	Home movies
GEVAERT				
Gevachrome Type 6.00	Tungsten color reversal	35mm, 16mm, DS-8	D-25, T-50	TV, commercial, studio
Gevachrome Type 6.05	Tungsten color reversal	35mm, 16mm, DS-8	D-64, T-125	TV, news, sports
ILFORD				
FP-4 Cine Film	Black and white negative	35mm, 16mm	D-80, T-64	Studio interiors, TV
Mark-V Cine Film	Black and white negative	35mm, 16mm	D-250, T-200	Newsreel, TV, commercial
Pan F Cine Film	Black and white negative	35mm, 16mm	D-25, T-20	Exteriors, background plates
KODAK				
Color Negative Type 5247/7247	Tungsten color negative	35mm, 16mm	D-64, T-100	Professional motion pictures
Kodachrome 25 Daylight	Daylight color reversal	16mm, D-8, Su-8	D-25, T-8	Home movies, TV
Ektachrome Commercial 7252	Tungsten color reversal	16mm	D-16, T-25	Commercial, industrial, TV
Ektachrome EF 5241	Daylight color reversal	35mm, 16mm	D-160	Instrumentation, news, sports
Ektachrome EF 5242	Tungsten color reversal	35mm, 16mm, DSu-8	T-125	Instrumentation, news, sports
Ektachrome 160 Type G	Special color reversal	Su-8	T-160	Available light amateur movies
Ektachrome 40 Type A	Tungsten color reversal	Su-8	T-40	Amateur movies
Ektachrome MS	Daylight color reversal	35mm, 16mm	D-64	Instrumentation, TV
Double-X Negative	Black and white negative	35mm, 16mm	D-250, T-200	Studio and exterior films
4-X Negative	Black and white negative	35mm, 16mm	D-500, T-400	News, sports, night exteriors
4-X Reversal	Black and white reversal	16mm	D-400, T-320	Sports, TV news
Plus-X Negative	Black and white negative	35mm, 16mm	D-80, T-64	Studio production, exteriors
Plus-X Reversal	Black and white reversal	16mm, Su-8	D-50, T-40	TV exteriors, amateur
RP Pan	Black and white negative	16mm	D-250, T-200	Instrumentation, news
Tri-X Reversal	Black and white reversal	16mm, Su-8	D-200, T-160	TV, sports, amateur movies
XT Panchromatic	Black and white reversal	35mm, 16mm	D-25, T-20	Background plates, copying
Fine Grain Positive	Black and white negative	35mm, 16mm	Find by test	Titles, prints, diagrams
3M CORP.				
Panchromatic Reversal CR-64	Black and white reversal	16mm, Su-8	D-64, T-50	Production, commercials
Panchromatic Reversal CR-160	Black and white reversal	16mm, Su-8	D-160, T-125	TV, commercial
Panchromatic Reversal CR-250	Black and white reversal	16mm, Su-8	D-250, T-160	News, sports, available-light

* D-8= Double-8mm. S-8=Single 8mm. Su-8= Super 8mm. DS-8= Double Super 8mm.

AGFACHROME CK-17S FILM (Double-8mm and Super-8mm)

Exposure Index: *Daylight: 25 (with #85 filter)* *Tungsten: 40*

These settings are recommended for meters marked for American Standard Exposure Indexes. Because of differences in individual meters and methods of use, higher or lower values than those given above may be desirable. The effective speed of this film, as with other films, is also influenced by the particular formulas and manner of processing employed. The values given should be considered only as preliminary guides subject to revision on the basis of tests processed with the actual formulas to be used.

Color Sensitivity: Color reversal film for 3400 K (Photoflood) illumination.

Safelight: Total darkness required. A series 3 (dark green) safelight filter, in a suitable safelight lamp with a 15-watt bulb can be used for a few seconds only, at 4 feet, after development is half completed.

Illumination (Incident Light) Table for Tungsten Light

Shutter speed approximately 1/50 sec. (24 frames per sec., 170° shutter)

Lens Apertures	f/1.4	f/2.0	f/2.8	f/4.0	f/5.6	f/8.0
Foot-candles required	64	125	250	500	1000	2000

Filter Factors

Kodak Wratten Filter No.	No. 3 Aero-1	No. 6 K-2	No. 12 Minus Blue	No. 15 G	No. 21	No. 23A	8N5	No. 25 A	No. 29 F
Factor for Sunlight				NOT RECOMMENDED					

Recommended control gamma: Processed by Agfa; price of processing is included in the cost of the film.

Base: Clear safety.

Identification: None.

AGFACHROME CT-13S FILM (Double-8mm)

Exposure Index: *Daylight: 16* *Tungsten: Not Recommended*

These settings are recommended for meters marked for American Standard Exposure Indexes. Because of differences in individual meters and methods of use, higher or lower values than those given above may be desirable. The effective speed of this film, as with other films, is also influenced by the particular formulas and manner of processing employed. The values given should be considered only as preliminary guides subject to revision on the basis of tests processed with the actual formulas to be used.

Color Sensitivity: Color reversal film for daylight.

Safelight: Total darkness required. A series 3 (dark green) safelight filter, in a suitable safelight lamp with a 15-watt bulb can be used for a few seconds only, at 4 feet, after development is half completed.

Illumination (Incident Light) Table for Tungsten Light

Shutter speed approximately 1/50 sec. (24 frames per sec., 170° shutter)

Lens Apertures	f/1.4	f/2.0	f/2.8	f/4.0	f/5.6	f/8.0
Foot-candles required			NOT RECOMMENDED			

Filter Factors

Kodak Wratten Filter No.	No. 3 Aero-1	No. 6 K-2	No. 12 Minus Blue	No. 15 G	No. 21	No. 23A	8N5	No. 25 A	No. 29 F
Factor for Sunlight				NOT RECOMMENDED					

Recommended control gamma: Processed by Agfa; price of processing is included in the cost of the film.

Base: Clear safety.

Identification: None.

DUPONT SUPERIOR-2 PANCHROMATIC FILM 136 (Cronar Base) 16mm, 35mm, 70mm

Exposure Index: *Daylight: 125* *Tungsten: 100*

These settings are recommended for meters marked for American Standard Exposure Indexes. Because of differences in individual meters and methods of use, higher or lower values than those given above may be desirable. The effective speed of this film, as with other films, is also influenced by the particular formulas and manner of processing employed. The values given should be considered only as preliminary guides subject to revision on the basis of tests processed with the actual formulas to be used.

Color Sensitivity: Panchromatic.

Safelight: Total darkness required. A Series 3 (dark green) safelight filter, in a suitable safelight lamp with a 15-watt bulb can be used for a few seconds only, at 4 feet, after development is half completed.

Illumination (Incident Light) Table for Tungsten Light

Shutter speed approximately 1/50 sec. (24 frames per sec., 170° shutter)

Lens Apertures	f/1.4	f/2.0	f/2.8	f/4.0	f/5.6	f/8.0
Foot-candles required	25	50	100	200	400	800

Filter Factors

Kodak Wratten Filter No.	No. 3 Aero-1	No. 6 K-2	No. 12 Minus Blue	No. 15 G	No. 21	No. 23A	8N5	No. 25 A	No. 29 F
Factor for Sunlight	1.5	2.0	2.0	3.0	3.0	4.0	8.0	6.0	16.0

Recommended control gamma: 0.65 to 0.70.

Base: Gray safety.

Identification: The letter "V" following the Dupont Safety stencil, also "2" in the inked footage number.

DUPONT RAPID REVERSAL PANCHROMATIC CINE FILM 930A (16mm)

Exposure Index: *Daylight: 64 Tungsten: 50*

These settings are recommended for meters marked for American Standard Exposure Indexes. Because of differences in individual meters and methods of use, higher or lower values than those given above may be desirable. The effective speed of this film, as with other films, is also influenced by the particular formulas and manner of processing employed. The values given should be considered only as preliminary guides subject to revision on the basis of tests processed with the actual formulas to be used.

Color Sensitivity: Panchromatic.

Safelight: Total darkness required. A series 3 (dark green) safelight filter, in a suitable safelight lamp with a 15-watt bulb can be used for a few seconds only, at 4 feet, after development is half completed.

Illumination (Incident Light) Table for Tungsten Light

Shutter speed approximately 1/50 sec. (24 frames per sec., 170° shutter)

Lens Apertures	f/1.4	f/2.0	f/2.8	f/4.0	f/5.6	f/8.0
Foot-candles required	50	100	200	400	800	1600

Filter Factors

Kodak Wratten Filter No.	No. 3 Aero-1	No. 6 K-2	No. 12 Minus Blue	No. 15 G	No. 21	No. 23A	8N5	No. 25 A	No. 29 F
Factor for Sunlight	1.5	2.0	2.0	3.0	3.0	6.0	8.0	8.0	16.0

Recommended control gamma: Reversal processing; if developed as negative, use Daylight 32, Tungsten 25 speed.

Base: Gray safety.

Identification: The letter "Y" in the Dupont Safety stencil; also = in the inked footage number.

DUPONT HIGH-SPEED RAPID REVERSAL CINE FILM 931A (16mm) AND 931B (35mm)

Exposure Index: *Daylight: 160 Tungsten: 125*

These settings are recommended for meters marked for American Standard Exposure Indexes. Because of differences in individual meters and methods of use, higher or lower values than those given above may be desirable. The effective speed of this film, as with other films, is also influenced by the particular formulas and manner of processing employed. The values given should be considered only as preliminary guides subject to revision on the basis of tests processed with the actual formulas to be used.

Color Sensitivity: Panchromatic.

Safelight: Total darkness required. A series 3 (dark green) safelight filter, in a suitable safelight lamp with a 15-watt bulb can be used for a few seconds only, at 4 feet, after development is half completed.

Illumination (Incident Light) Table for Tungsten Light

Shutter speed approximately 1/50 sec. (24 frames per sec., 170° shutter)

Lens Apertures	f/1.4	f/2.0	f/2.8	f/4.0	f/5.6	f/8.0
Foot-candles required	20	40	80	160	320	640

Filter Factors

Kodak Wratten Filter No.	No. 3 Aero-1	No. 6 K-2	No. 12 Minus Blue	No. 15 G	No. 21	No. 23A	8N5	No. 25 A	No. 29 F
Factor for Sunlight	1.3	2.0	2.0	3.0	3.0	6.0	8.0	11.0	32.0

Recommended control gamma: 0.65 to 0.70 if processed as negative; use Daylight 80, Tungsten 64.

Base: Gray safety.

Identification: The letter "Z" following the Dupont Safety stencil; also + in inked footage number.

DUPONT ULTRA-SPEED RAPID REVERSAL CINE FILM 932A (16mm) AND 932B (35mm)

Exposure Index: *Daylight: 320 Tungsten: 250*

These settings are recommended for meters marked for American Standard Exposure Indexes. Because of differences in individual meters and methods of use, higher or lower values than those given above may be desirable. The effective speed of this film, as with other films, is also influenced by the particular formulas and manner of processing employed. The values given should be considered only as preliminary guides subject to revision on the basis of tests processed with the actual formulas to be used.

Color Sensitivity: Panchromatic.

Safelight: Total darkness required. A series 3 (dark green) safelight filter, in a suitable safelight lamp with a 15-watt bulb can be used for a few seconds only, at 4 feet, after development is half completed.

Illumination (Incident Light) Table for Tungsten Light

Shutter speed approximately 1/50 sec. (24 frames per sec., 170° shutter)

Lens Apertures	f/1.4	f/2.0	f/2.8	f/4.0	f/5.6	f/8.0
Foot-candles required	10	20	40	80	160	320

Filter Factors

Kodak Wratten Filter No.	No. 3 Aero-1	No. 6 K-2	No. 12 Minus Blue	No. 15 G	No. 21	No. 23A	8N5	No. 25 A	No. 29 F
Factor for Sunlight	1.3	2.0	2.0	3.0	3.0	6.0	6.0	8.0	16.0

Recommended control gamma: 0.65 to 0.70 if developed as negative; use Daylight 160, Tungsten 125.

Base: Gray safety.

Identification: The letters "UY" following the Dupont Safety stencil.

FUJICHROME R-25 COLOR FILM FOR DAYLIGHT (Single-8mm)

Exposure Index: *Daylight: 25*

These settings are recommended for meters marked for American Standard Exposure Indexes. Because of differences in individual meters and methods of use, higher or lower values than those given above may be desirable. The effective speed of this film, as with other films, is also influenced by the particular formulas and manner of processing employed. The values given should be considered only as preliminary guides subject to revision on the basis of tests processed with the actual formulas to be used.

Color Sensitivity: Color film for daylight.

Safelight: Total darkness required. A series 3 (dark green) safelight filter, in a suitable safelight lamp with a 15-watt bulb can be used for a few seconds only, at 4 feet, after development is half completed.

Illumination (Incident Light) Table for Daylight.

Shutter speed approximately 1/50 sec. (24 frames per sec., 170° shutter)

Lens Apertures	f/1.4	f/2.0	f/2.8	f/4.0	f/5.6	f/8.0
Foot-candles required	100	200	400	800	1600	3200

Filter Factors

Kodak Wratten Filter No.	No. 3 Aero-1	No. 6 K-2	No. 12 Minus Blue	No. 15 G	No. 21	No. 23A	8N5	No. 25 A	No. 29 F
Factor for Sunlight				NOT RECOMMENDED					

Recommended control gamma: Color reversal processing by manufacturer.

Base: Clear polyester.

Identification: None.

FUJICHROME RT-200 COLOR MOVIE FILM

Exposure Index: *Daylight: ASA 50 (LBA-12Ax4 Filter) Tungsten 200*

These settings are recommended for meters marked for American Standard Exposure Indexes. Because of differences in individual meters and methods of use, higher or lower values than those given above may be desirable. The effective speed of this film, as with other films, is also influenced by the particular formulas and manner of processing employed. The values given should be considered only as preliminary guides subject to revision on the basis of tests processed with the actual formulas to be used.

Color Sensitivity: Color reversal film for tungsten light.

Safelight: Total darkness required. A series 3 (dark green) safelight filter, in a suitable safelight lamp with a 15-watt bulb can be used for a few seconds only, at 4 feet, after development is half completed.

Illumination (Incident Light) Table for Daylight.

Shutter speed approximately 1/50 sec. (24 frames per sec., 170° shutter)

Lens Apertures	f/1.4	f/2.0	f/2.8	f/4.0	f/5.6	f/8.0
Foot-candles required						

Filter Factors

Kodak Wratten Filter No.	No. 3 Aero-1	No. 6 K-2	No. 12 Minus Blue	No. 15 G	No. 21	No. 23A	8N5	No. 25 A	No. 29 F
Factor for Sunlight				NOT RECOMMENDED					

Recommended control gamma: Color reversal process by manufacturer.

Base: Clear polyester.

Identification: None.

Exposure Index: *Daylight: 25* Tungsten: 50*

**With CTO-12 or 85B filter.*

These settings are recommended for meters marked for American Standard Exposure Indexes. Because of differences in individual meters and methods of use, higher or lower values than those given above may be desirable. The effective speed of this film, as with other films, is also influenced by the particular formulas and manner of processing employed. The values given should be considered only as preliminary guides subject to revision on the basis of tests processed with the actual formulas to be used.

Color Sensitivity: Color reversal film for 3200 K tungsten illumination.

Safelight: Total darkness required. A series 3 (dark green) safelight filter, in a suitable safelight lamp with a 15-watt bulb can be used for a few seconds only, at 4 feet, after development is half completed.

Illumination (Incident Light) Table for Tungsten Light.

Shutter speed approximately 1/50 sec. (24 frames per sec., 170° shutter)

Lens Apertures	f/1.4	f/2.0	f/2.8	f/4.0	f/5.6	f/8.0
Foot-candles required	50	100	200	400	800	1600

Filter Factors

Light Source	Filter	Exposure Index
3200 K Lamps	none	50
Photoflood lamps	CTO-2 or 81A	40
White flame carbon arc	CTO-8 or 85	32
Daylight 5000 K, 3 hours after sunrise or before sunset	CTO-8 or 85	32
Daylight 5500 K, mixture of sunlight and skylight	CTO-12 or 85B	25
Daylight 8000 K, summer, open shade	CTO-16	20

Recommended control gamma: Color reversal processing using Gevaert process 6N1 chemistry.

Base: Clear triacetate safety.

Identification: The letter "N" preceding the footage number.

GEVACHROME ORIGINAL TYPE 6.05
(35mm, 16mm, and Double Super-8mm)

Exposure Index: *Daylight: 64* Tungsten: 125*

*With CTO-12 or 85B filter.

These settings are recommended for meters marked for American Standard Exposure Indexes. Because of differences in individual meters and methods of use, higher or lower values than those given above may be desirable. The effective speed of this film, as with other films, is also influenced by the particular formulas and manner of processing employed. The values given should be considered only as preliminary guides subject to revision on the basis of tests processed with the actual formulas to be used.

Color Sensitivity: Color reversal film for 3200 K tungsten illumination.

Safelight: Total darkness required. A series 3 (dark green) safelight filter, in a suitable safelight lamp with a 15-watt bulb can be used for a few seconds only, at 4 feet, after development is half completed.

Illumination (Incident Light) Table for Tungsten Light.

Shutter speed approximately 1/50 sec. (24 frames per sec., 170° shutter)

Lens Apertures	f/1.4	f/2.0	f/2.8	f/4.0	f/5.6	f/8.0
Foot-candles required	20	40	80	160	320	640

Filter Factors

Light Source	Filter	Exposure Index
3200 K lamps	none	125
Photoflood lamps	CTO-2 or 81A	100
White flame carbon arc	CTO-8 or 85	80
Daylight 5000 K, 3 hours after sunrise or before sunset	CTO-8 or 85	80
Daylight 5500 K, mixture of sunlight and skylight	CTO-12 or 85B	64
Daylight 8000 K, summer, open shade	CTO-16	50

Recommended control gamma: Color reversal processing using Gevaert process 6N1 chemistry.

Base: Clear triacetate safety.

Identification: The letter "H" preceding the footage number.

474

ILFORD FP-4 NEGATIVE CINE FILM (35mm and 16mm)

Exposure Index: *Daylight: 80 Tungsten: 64*

These settings are recommended for meters marked for American Standard Exposure Indexes. Because of differences in individual meters and methods of use, higher or lower values than those given above may be desirable. The effective speed of this film, as with other films, is also influenced by the particular formulas and manner of processing employed. The values given should be considered only as preliminary guides subject to revision on the basis of tests processed with the actual formulas to be used.

Color Sensitivity: Panchromatic.

Safelight: Total darkness required. A Series 3 (dark green) safelight filter, in a suitable safelight lamp with a 15-watt bulb can be used for a few seconds only, at 4 feet, after development is half completed.

Illumination (Incident Light) Table for Tungsten Light
Shutter speed approximately 1/50 sec. (24 frames per sec., 170° shutter)

Lens Apertures	f/1.4	f/2.0	f/2.8	f/4.0	f/5.6	f/8.0
Foot-candles required	30	60	120	240	480	960

Filter Factors

Kodak Wratten Filter No.	No. 3 Aero-1	No. 6 K-2	No. 12 Minus Blue	No. 15 G	No. 21	No. 23A	8N5	No. 25 A	No. 29 F
Factor for Sunlight			NOT GIVEN — SEE SECTION 9						

Recommended control gamma: 0.65 to 0.70.

Base: Gray safety.

Identification: The letters "A", "B", or "C" preceding the footage number.

ILFORD MARK-V NEGATIVE CINE FILM (35mm and 16mm)

Exposure Index: *Daylight: 250 Tungsten: 200*

These settings are recommended for meters marked for American Standard Exposure Indexes. Because of differences in individual meters and methods of use, higher or lower values than those given above may be desirable. The effective speed of this film, as with other films, is also influenced by the particular formulas and manner of processing employed. The values given should be considered only as preliminary guides subject to revision on the basis of tests processed with the actual formulas to be used.

Color Sensitivity: Panchromatic.

Safelight: Total darkness required. A Series 3 (dark green) safelight filter, in a suitable safelight lamp with a 15-watt bulb can be used for a few seconds only, at 4 feet, after development is half completed.

Illumination (Incident Light) Table for Tungsten Light

Shutter speed approximately 1/50 sec. (24 frames per sec., 170° shutter)

Lens Apertures	f/1.4	f/2.0	f/2.8	f/4.0	f/5.6	f/8.0
Foot-candles required	13	25	50	100	200	400

Filter Factors

Kodak Wratten Filter No.	No. 3 Aero-1	No. 6 K-2	No. 12 Minus Blue	No. 15 G	No. 21	No. 23A	8N5	No. 25 A	No. 29 F
Factor for Sunlight				NOT GIVEN					

Recommended control gamma: 0.65 to 0.70.

Base: Gray safety.

Identification: The letter "S" or "T" preceding the footage number.

ILFORD PAN F NEGATIVE CINE FILM (35mm and 16mm)

Exposure Index: *Daylight: 25* *Tungsten: 20*

These settings are recommended for meters marked for American Standard Exposure Indexes. Because of differences in individual meters and methods of use, higher or lower values than those given above may be desirable. The effective speed of this film, as with other films, is also influenced by the particular formulas and manner of processing employed. The values given should be considered only as preliminary guides subject to revision on the basis of tests processed with the actual formulas to be used.

Color Sensitivity: Panchromatic.

Safelight: Total darkness required. A Series 3 (dark green) safelight filter, in a suitable safelight lamp with a 15-watt bulb can be used for a few seconds only, at 4 feet, after development is half completed.

Illumination (Incident Light) Table for Tungsten Light

Shutter speed approximately 1/50 sec. (24 frames per sec., 170° shutter)

Lens Apertures	f/1.4	f/2.0	f/2.8	f/4.0	f/5.6	f/8.0
Foot-candles required	120	240	480	960	—	—

Filter Factors

Kodak Wratten Filter No.	No. 3 Aero-1	No. 6 K-2	No. 12 Minus Blue	No. 15 G	No. 21	No. 23A	8N5	No. 25 A	No. 29 F
Factor for Sunlight				NOT GIVEN — SEE SECTION 9					

Recommended control gamma: 0.65 to 0.70.

Base: Gray safety.

Identification: The letters "J" or "K" preceding the footage number.

EASTMAN COLOR NEGATIVE II FILM 5247 (35mm) and 7247 (16mm)

Exposure Index: *Daylight: 64 (Wratten filter No. 85), Tungsten: 100*

These settings are recommended for meters marked for American Standard Exposure Indexes. Because of differences in individual meters and methods of use, higher or lower values than those given above may be desirable. The effective speed of this film, as with other films, is also influenced by the particular formulas and manner of processing employed. The values given should be considered only as preliminary guides subject to revision on the basis of tests processed with the actual formulas to be used.

Color Sensitivity: Color negative film balanced for tungsten light

Safelight: Total darkness required. A series 3 (dark green) safelight filter, in a suitable safelight lamp with a 15-watt bulb can be used for a few seconds only, at 4 feet, after development is half completed.

Illumination (Incident Light) Table for Tungsten Light.
Shutter speed approximately 1/50 sec. (24 frames per sec., 170° shutter)

Lens Apertures	f/1.4	f/2.0	f/2.8	f/4.0	f/5.6	f/8.0
Foot-candles required	25	50	100	200	400	800

Filter Factors

Kodak Wratten Filter No.	No. 3 Aero-1	No. 6 K-2	No. 12 Minus Blue	No. 15 G	No. 21	No. 23A	8N5	No. 25 A	No. 29 F
Factor for Sunlight				NOT RECOMMENDED					

Processing: Eastman Color Negative II Films Types 5247 and 7247 must be processed in Kodak ECN-2 chemistry only, in special equipment to accomplish removal of the rem-jet antihalation backing without contamination of the developer. Processes C-22 and C-41 must *not* be used.

Base: Clear safety with removable jet antihalation backing.

Identification: The letter "E" appears at the extreme left of the latent-image footage number.

KODACHROME-25 FILM (16mm, 8mm and Super 8mm)

Exposure Index: *Daylight: 25, Tungsten: 8 (with 80B filter)*

These settings are recommended for meters marked for American Standard Exposure Indexes. Because of differences in individual meters and methods of use, higher or lower values than those given above may be desirable. The effective speed of this film, as with other films, is also influenced by the particular formulas and manner of processing employed. The values given should be considered only as preliminary guides subject to revision on the basis of tests processed with the actual formulas to be used.

Color Sensitivity: Color reversed film balanced for daylight

Safelight: Total darkness required. A series 3 (dark green) safelight filter, in a suitable safelight lamp with a 15-watt bulb can be used for a few seconds only, at 4 feet, after development is half completed.

Illumination (Incident Light) Table for Tungsten Light.

Shutter speed approximately 1/50 sec. (24 frames per sec., 170° shutter)

Lens Apertures	f/1.4	f/2.0	f/2.8	f/4.0	f/5.6	f/8.0
Foot-candles required	100	200	400	500	1600	3200

Filter Factors

Kodak Wratten Filter No.	No. 3 Aero-1	No. 6 K-2	No. 12 Minus Blue	No. 15 G	No. 21	No. 23A	8N5	No. 25 A	No. 29 F
Factor for Sunlight				NOT RECOMMENDED					

Recommended control gamma: Processed by Kodak and other laboratories in Process K-14 chemistry.

Base: Clear safety

Identification: None

KODAK EKTACHROME COMMERCIAL FILM 7252 (16mm)

Exposure Index: *Daylight: 16 (with Wratten filter No. 85)* *Tungsten: 25*

These settings are recommended for meters marked for American Standard Exposure Indexes. Because of differences in individual meters and methods of use, higher or lower values than those given above may be desirable. The effective speed of this film, as with other films, is also influenced by the particular formulas and manner of processing employed. The values given should be considered only as preliminary guides subject to revision on the basis of tests processed with the actual formulas to be used.

Color Sensitivity: Color reversal film balanced for 3200 K illumination.

Safelight: Total darkness required. A series 3 (dark green) safelight filter, in a suitable safelight lamp with a 15-watt bulb can be used to illuminate dials, clocks, meters, and so on, but must not be allowed to shine directly on the film.

Illumination (Incident Light) Table for Tungsten Light

Shutter speed approximately 1/50 sec. (24 frames per sec., 170° shutter)

Lens Apertures	f/1.4	f/2.0	f/2.8	f/4.0	f/5.6	f/8.0
Foot-candles required	100	200	400	800	1600	3200

Filter Factors

Light Source	Light Source Filter	Camera Filter
3200 K Tungsten Lamps	None	None
Photoflood Lamps	None	Kodak Wratten No. 81
3350 K Tungsten Lamps	None	Kodak Wratten No. 81
Carbon Arcs M-R Type 170 150 Amp H. I. Arc	Straw-colored gelatin filter such as Brigham Y-1	Kodak Wratten No. 85
M-R Type 40 40 Amp Duarc	Florentine glass	Kodak Wratten No. 85
M-R Type 450 "Brute" 225 Amp Molarc with white-flame carbons	Brigham Y-1	Kodak Wratten No. 85
with yellow-flame carbons	Mole-Richardson YF-101	None
Daylight (sunlight plus some skylight	None	Kodak Wratten No. 85

Recommended control gamma: Reversal color process by Kodak and commercial laboratories. Use process ECO-3 only. This film can be push-processed to an effective exposure index of ASA 50 by changing the time, temperature, or both, of the first developer.

Base: Clear safety with removable jet anti-halation backing.

Identification: None.

KODAK EKTACHROME EF FILM 5241 (35mm) AND 7241 (16mm) DAYLIGHT

Exposure Index: *Daylight: 160 Tungsten: 40 (with Wratten Filter 80A)*
50 (with Wratten Filter 80B)

These settings are recommended for meters marked for American Standard Exposure Indexes. Because of differences in individual meters and methods of use, higher or lower values than those given above may be desirable. The effective speed of this film, as with other films, is also influenced by the particular formulas and manner of processing employed. The values given should be considered only as preliminary guides subject to revision on the basis of tests processed with the actual formulas to be used.

Color Sensitivity: Color reversal film balanced for daylight.

Safelight: Total darkness required. A series 3 (dark green) safelight filter, in a suitable safelight lamp with a 15-watt bulb can be used for a few seconds only, at 4 feet, after development is half completed.

Illumination (Incident Light) Table for Daylight

Shutter speed approximately 1/50 sec. (24 frames per sec., 170° shutter)

Lens Apertures	f/1.4	f/2.0	f/2.8	f/4.0	f/5.6	f/8.0
Foot-candles required	15	30	60	125	250	500

Filter Factors

Kodak Wratten Filter No.	No. 3 Aero-1	No. 6 K-2	No. 12 Minus Blue	No. 15 G	No. 21	No. 23A	8N5	No. 25 A	No. 29 F
Factor for Sunlight				NOT RECOMMENDED					

Recommended control gamma: Use Kodak Process ME-4 only.

Base: Clear safety (acetate).

Identification: The name "Ektachrome EF" is latent-image printed along one edge of the 16mm film only.

KODAK EKTACHROME EF FILM 5242 (35mm), 7242 (16mm and double Super-8mm)

Exposure Index: *Daylight: 80 (with Kodak Wratten Filter 85)*
Tungsten: 125 (3200K lamps)
100 (Photoflood lamps and 81A Filter)

These settings are recommended for meters marked for American Standard Exposure Indexes. Because of differences in individual meters and methods of use, higher or lower values than those given above may be desirable. The effective speed of this film, as with other films, is also influenced by the particular formulas and manner of processing employed. The values given should be considered only as preliminary guides subject to revision on the basis of tests processed with the actual formulas to be used.

Color Sensitivity: Color reversal film balanced for 3200K lamps.

Safelight: Total darkness required. A series 3 (dark green) safelight filter, in a suitable safelight lamp with a 15-watt bulb can be used for a few seconds only, at 4 feet, after development is half completed.

Illumination (Incident Light) Table for Tungsten Light

Shutter speed approximately 1/50 sec. (24 frames per sec., 170° shutter)

Lens Apertures	f/1.4	f/2.0	f/2.8	f/4.0	f/5.6	f/8.0
Foot-candles required	20	40	80	160	320	640

Filter Factors

Kodak Wratten Filter No.	No. 3 Aero-1	No. 6 K-2	No. 12 Minus Blue	No. 15 G	No. 21	No. 23A	8N5	No. 25 A	No. 29 F
Factor for Sunlight				NOT RECOMMENDED					

Recommended control gamma: Color reversal process ME-4 only.

Base: Clear safety (acetate).

Identification: The name "Ektachrome EFB" is latent-image printed along the edge of the 16mm film only.

KODAK EKTACHROME 160 MOVIE FILM, TYPE G (Super 8mm)

Exposure Index: *Daylight or Tungsten:* 160

These settings are recommended for meters marked for American Standard Exposure Indexes. Because of differences in individual meters and methods of use, higher or lower values than those given above may be desirable. The effective speed of this film, as with other films, is also influenced by the particular formulas and manner of processing employed. The values given should be considered only as preliminary guides subject to revision on the basis of tests processed with the actual formulas to be used.

Color Sensitivity: Color reversal film, specially sensitized to be used in either daylight or artificial light without filters. By limiting the response at the extreme red and blue ends of the spectrum, the film emulsion produces nearly normal color rendition in daylight, and a slightly warm overall cast under tungsten illumination. Cameras having automatic filter insertion will require a slight modification to disable the filter mechanism when this film is used.

Safelight: Total darkness required. A series 3 (dark green) safelight filter, in a suitable safelight lamp with a 15-watt bulb can be used for a few seconds only, at 4 feet, after development is half completed.

Illumination (Incident Light) Table for Tungsten Light.

Shutter speed approximately 1/50 sec. (24 frames per sec., 170° shutter)

Lens Apertures	f/1.4	f/2.0	f/2.8	f/4.0	f/5.6	f/8.0
Foot-candles required	15	30	60	125	250	500

Filter Factors

Kodak Wratten Filter No.	No. 3 Aero-1	No. 6 K-2	No. 12 Minus Blue	No. 15 G	No. 21	No. 23A	8N5	No. 25 A	No. 29 F
Factor for Sunlight				NOT RECOMMENDED					

Recommended control gamma: This film is processed by Kodak and other laboratories; it may also be processed in the Kodak Ektachrome Autoprocessor, Model 1A, using the current chemicals without modification to the machine.

Base: Clear safety (acetate).

Identification: None.

KODAK EKTACHROME 40 MOVIE FILM TYPE A (Super 8mm)

Exposure Index: *Daylight:* 25* *Tungsten:* 40

*With Kodak Wratten Filter No. 85.

These settings are recommended for meters marked for American Standard Exposure Indexes. Because of differences in individual meters and methods of use, higher or lower values than those given above may be desirable. The effective speed of this film, as with other films, is also influenced by the particular formulas and manner of processing employed. The values given should be considered only as preliminary guides subject to revision on the basis of tests processed with the actual formulas to be used.

Color Sensitivity: Color reversal film, balanced for Photoflood illumination

Safelight: Total darkness required. A series 3 (dark green) safelight filter, in a suitable safelight lamp with a 15-watt bulb can be used for a few seconds only, at 4 feet, after development is half completed.

Illumination (Incident Light) Table for Tungsten Light.

Shutter speed approximately 1/50 sec. (24 frames per sec., 170° shutter)

Lens Apertures	f/1.4	f/2.0	f/2.8	f/4.0	f/5.6	f/8.0
Foot-candles required	64	125	250	500	1000	2000

Filter Factors

Kodak Wratten Filter No.	No. 3 Aero-1	No. 6 K-2	No. 12 Minus Blue	No. 15 G	No. 21	No. 23A	8N5	No. 25 A	No. 29 F
Factor for Sunlight				NOT RECOMMENDED					

Recommended control gamma: Use Process ME-4 only.

Base: Clear safety (acetate)

Identification: None

KODAK EKTACHROME MS FILM 5256 (35mm) AND 7256 (16mm)

Exposure Index: *Daylight: 64* *Tungsten: 16 (3200K lamps with 80A filter)*
20 (3400K lamps with 80B filter)

These settings are recommended for meters marked for American Standard Exposure Indexes. Because of differences in individual meters and methods of use, higher or lower values than those given above may be desirable. The effective speed of this film, as with other films, is also influenced by the particular formulas and manner of processing employed. The values given should be considered only as preliminary guides subject to revision on the basis of tests processed with the actual formulas to be used.

Color Sensitivity: Color reversal film balanced for daylight.

Safelight: Total darkness required. A series 3 (dark green) safelight filter, in a suitable safelight lamp with a 15-watt bulb can be used for a few seconds only, at 4 feet, after development is half completed.

Illumination (Incident Light) Table for Daylight
Shutter speed approximately 1/50 sec. (24 frames per sec., 170° shutter)

Lens Apertures	f/1.4	f/2.0	f/2.8	f/4.0	f/5.6	f/8.0
Foot-candles required	40	80	160	320	640	1250

Filter Factors

Kodak Wratten Filter No.	No. 3 Aero-1	No. 6 K-2	No. 12 Minus Blue	No. 15 G	No. 21	No. 23A	8N5	No. 25 A	No. 29 F
Factor for Sunlight				NOT RECOMMENDED					

Recommended control gamma: Processed only by Ektachrome Process ME-4.

Base: Clear safety (acetate).

Identification: None.

EASTMAN DOUBLE-X NEGATIVE FILM TYPES 5222 (35mm) AND 7222 (16mm)

Exposure Index: *Daylight: 250 Tungsten: 200*

These settings are recommended for meters marked for American Standard Exposure Indexes. Because of differences in individual meters and methods of use, higher or lower values than those given above may be desirable. The effective speed of this film, as with other films, is also influenced by the particular formulas and manner of processing employed. The values given should be considered only as preliminary guides subject to revision on the basis of tests processed with the actual formulas to be used.

Color Sensitivity: Panchromatic.

Safelight: Total darkness required. A Series 3 (dark green) safelight filter, in a suitable safelight lamp with a 15-watt bulb can be used for a few seconds only, at 4 feet, after development is half completed.

Illumination (Incident Light) Table for Tungsten Light

Shutter speed approximately 1/50 sec. (24 frames per sec., 170° shutter)

Lens Apertures	f/1.4	f/2.0	f/2.8	f/4.0	f/5.6	f/8.0
Foot-candles required	13	25	50	100	200	400

Filter Factors

Kodak Wratten Filter No.	No. 3 Aero-1	No. 6 K-2	No. 12 Minus Blue	No. 15 G	No. 21	No. 23A	8N5	No. 25 A	No. 29 F
Factor for Sunlight	1.5	1.5	2.0	3.0	3.0	5.0	5.0	8.0	20.0

Recommended control gamma: 0.65 to 0.70.

Base: Gray safety.

Identification: The letter C is printed just before the footage number on 35mm only. The designation DXN is perforated on the end of 16mm x 100 and 200 ft. rolls.

EASTMAN 4-X NEGATIVE FILM, TYPE 5224 (35mm) AND 7224 (16mm)

Exposure Index: *Daylight: 500* *Tungsten: 400*

These settings are recommended for meters marked for American Standard Exposure Indexes. Because of differences in individual meters and methods of use, higher or lower values than those given above may be desirable. The effective speed of this film, as with other films, is also influenced by the particular formulas and manner of processing employed. The values given should be considered only as preliminary guides subject to revision on the basis of tests processed with the actual formulas to be used.

Color Sensitivity: Panchromatic.

Safelight: Total darkness required. A Series 3 (dark green) safelight filter, in a suitable safelight lamp with a 15-watt bulb can be used for a few seconds only, at 4 feet, after development is half completed.

Illumination (Incident Light) Table for Tungsten Light

Shutter speed approximately 1/50 sec. (24 frames per sec., 170° shutter)

Lens Apertures	f/1.4	f/2.0	f/2.8	f/4.0	f/5.6	f/8.0
Foot-candles required	6	13	25	50	100	200

Filter Factors

Kodak Wratten Filter No.	No. 3 Aero-1	No. 6 K-2	No. 12 Minus Blue	No. 15 G	No. 21	No. 23A	8N5	No. 25 A	No. 29 F
Factor for Sunlight	1.5	2.0	2.5	3.0	3.5	5.0	5.0	8.0	25.0

Recommended control gamma: 0.65 to 0.70.

Base: Gray safety.

Identification: The letter G is printed just before the footage number on 35mm only. The designation 4 x N is perforated on the end of 16mm x 100 and 200 ft. rolls.

KODAK 4-X REVERSAL FILM 7277 (16mm)

Exposure Index: *Daylight: 400 Tungsten: 320*

These settings are recommended for meters marked for American Standard Exposure Indexes. Because of differences in individual meters and methods of use, higher or lower values than those given above may be desirable. The effective speed of this film, as with other films, is also influenced by the particular formulas and manner of processing employed. The values given should be considered only as preliminary guides subject to revision on the basis of tests processed with the actual formulas to be used.

Color Sensitivity: Panchromatic.

Safelight: Total darkness required. A series 3 (dark green) safelight filter, in a suitable safelight lamp with a 15-watt bulb can be used for a few seconds only, at 4 feet, after development is half completed.

Illumination (Incident Light) Table for Tungsten Light

Shutter speed approximately 1/50 sec. (24 frames per sec., 170° shutter)

Lens Apertures	f/1.4	f/2.0	f/2.8	f/4.0	f/5.6	f/8.0
Foot-candles required	8	15	30	60	125	250

Filter Factors

Kodak Wratten Filter No.	No. 3 Aero-1	No. 6 K-2	No. 12 Minus Blue	No. 15 G	No. 21	No. 23A	8N5	No. 25 A	No. 29 F
Factor for Sunlight	1.5	2.0	2.0	2.5	3.0	5.0	6.0	10.0	40.0

Recommended control gamma: Not recommended for negative processing.

Base: Gray safety.

Identification: None.

EASTMAN PLUS-X NEGATIVE FILM TYPES 4231 (35mm) AND 7231 (16mm)

Exposure Index: *Daylight: 80 Tungsten: 64*

These settings are recommended for meters marked for American Standard Exposure Indexes. Because of differences in individual meters and methods of use, higher or lower values than those given above may be desirable. The effective speed of this film, as with other films, is also influenced by the particular formulas and manner of processing employed. The values given should be considered only as preliminary guides subject to revision on the basis of tests processed with the actual formulas to be used.

Color Sensitivity: Panchromatic.

Safelight: Total darkness required. A Series 3 (dark green) safelight filter, in a suitable safelight lamp with a 15-watt bulb can be used for a few seconds only, at 4 feet, after development is half completed.

Illumination (Incident Light) Table for Tungsten Light

Shutter speed approximately 1/50 sec. (24 frames per sec., 170° shutter)

Lens Apertures	f/1.4	f/2.0	f/2.8	f/4.0	f/5.6	f/8.0
Foot-candles required	40	80	160	320	640	1280

Filter Factors

Kodak Wratten Filter No.	No. 3 Aero-1	No. 6 K-2	No. 12 Minus Blue	No. 15 G	No. 21	No. 23A	8N5	No. 25 A	No. 29 F
Factor for Sunlight	1.5	2.0	2.0	2.5	3.0	5.0	5.0	8.0	16.0

Recommended control gamma: 0.65 to 0.70.

Base: Gray safety.

Identification: The letter H is printed just before the footage number on 35mm only. The designation PXN is perforated on the end of 16mm x 100 and 200 ft. rolls.

KODAK PLUS-X REVERSAL FILM 7276 (16mm) and PXR-464 (Super 8mm)

Exposure Index: *Daylight: 50 Tungsten: 40*

These settings are recommended for meters marked for American Standard Exposure Indexes. Because of differences in individual meters and methods of use, higher or lower values than those given above may be desirable. The effective speed of this film, as with other films, is also influenced by the particular formulas and manner of processing employed. The values given should be considered only as preliminary guides subject to revision on the basis of tests processed with the actual formulas to be used.

Color Sensitivity: Panchromatic.

Safelight: Total darkness required. A series 3 (dark green) safelight filter, in a suitable safelight lamp with a 15-watt bulb can be used for a few seconds only, at 4 feet, after development is half completed.

Illumination (Incident Light) Table for Tungsten Light

Shutter speed approximately 1/50 sec. (24 frames per sec., 170° shutter)

Lens Apertures	f/1.4	f/2.0	f/2.8	f/4.0	f/5.6	f/8.0
Foot-candles required	60	125	250	500	1000	2000

Filter Factors

Kodak Wratten Filter No.	No. 3 Aero-1	No. 6 K-2	No. 12 Minus Blue	No. 15 G	No. 21	No. 23A	8N5	No. 25 A	No. 29 F
Factor for Sunlight	1.5	2.0	2.0	2.5	3.0	5.0	6.0	10.0	40.0

Recommended control gamma: 0.65 to 0.70 when processed as a negative. In this case the effective speed of the film is lowered to Daylight 25, Tungsten 20.

Base: Gray safety.

Identification: None

Note: This film is available in 50-foot cartridges for Super 8mm cameras, code PXR-464. Kodak processing is not available; check commercial laboratories for this service.

EASTMAN RP PANCHROMATIC NEGATIVE FILM TYPE 7229 (16mm)

Exposure Index: *Daylight: 250* *Tungsten: 200*

These settings are recommended for meters marked for American Standard Exposure Indexes. Because of differences in individual meters and methods of use, higher or lower values than those given above may be desirable. The effective speed of this film, as with other films, is also influenced by the particular formulas and manner of processing employed. The values given should be considered only as preliminary guides subject to revision on the basis of tests processed with the actual formulas to be used.

Color Sensitivity: Panchromatic.

Safelight: Total darkness required. A Series 3 (dark green) safelight filter, in a suitable safelight lamp with a 15-watt bulb can be used for a few seconds only, at 4 feet, after development is half completed.

Illumination (Incident Light) Table for Tungsten Light

Shutter speed approximately 1/50 sec. (24 frames per sec., 170° shutter)

Lens Apertures	f/1.4	f/2.0	f/2.8	f/4.0	f/5.6	f/8.0
Foot-candles required	13	25	50	100	200	400

Filter Factors

Kodak Wratten Filter No.	No. 3 Aero-1	No. 6 K-2	No. 12 Minus Blue	No. 15 G	No. 21	No. 23A	8N5	No. 25 A	No. 29 F
Factor for Sunlight	1.5	2.0	2.0	2.5	3.0	5.0	6.0	8.0	16.0

Recommended control gamma: 0.65 to 0.70.

Base: Gray safety.

Identification: None.

KODAK TRI-X REVERSAL FILM 7278 (16mm) and TXR-464 (Super 8mm)

Exposure Index: *Daylight: 200 Tungsten: 160*

These settings are recommended for meters marked for American Standard Exposure Indexes. Because of differences in individual meters and methods of use, higher or lower values than those given above may be desirable. The effective speed of this film, as with other films, is also influenced by the particular formulas and manner of processing employed. The values given should be considered only as preliminary guides subject to revision on the basis of tests processed with the actual formulas to be used.

Color Sensitivity: Panchromatic.

Safelight: Total darkness required. A series 3 (dark green) safelight filter, in a suitable safelight lamp with a 15-watt bulb can be used for a few seconds only, at 4 feet, after development is half completed.

Illumination (Incident Light) Table for Tungsten Light

Shutter speed approximately 1/50 sec. (24 frames per sec., 170° shutter)

Lens Apertures	f/1.4	f/2.0	f/2.8	f/4.0	f/5.6	f/8.0
Foot-candles required	15	30	60	125	250	500

Filter Factors

Kodak Wratten Filter No.	No. 3 Aero-1	No. 6 K-2	No. 12 Minus Blue	No. 15 G	No. 21	No. 23A	8N5	No. 25 A	No. 29 F
Factor for Sunlight	1.5	2.0	2.0	2.5	3.0	5.0	6.0	10.0	40.0

Recommended control gamma: 0.65 to 0.70 if processed as a negative. In this case the effective speed of the film is reduced to Daylight 125, Tungsten 100.

Base: Gray safety.

Identification: None

Note: This film is available in 50-foot cartridges for Super 8mm cameras, code TXR-464. Kodak processing is not available; check commercial laboratories for this service.

EASTMAN XT PANCHROMATIC NEGATIVE FILM TYPE 5220 (35mm) AND 7220 (16mm)

Exposure Index: *Daylight: 25 Tungsten: 20*

These settings are recommended for meters marked for American Standard Exposure Indexes. Because of differences in individual meters and methods of use, higher or lower values than those given above may be desirable. The effective speed of this film, as with other films, is also influenced by the particular formulas and manner of processing employed. The values given should be considered only as preliminary guides subject to revision on the basis of tests processed with the actual formulas to be used.

Color Sensitivity: Panchromatic.

Safelight: Total darkness required. A Series 3 (dark green) safelight filter, in a suitable safelight lamp with a 15-watt bulb can be used for a few seconds only, at 4 feet, after development is half completed.

Illumination (Incident Light) Table for Tungsten Light

Shutter speed approximately 1/50 sec. (24 frames per sec., 170° shutter)

Lens Apertures	f/1.4	f/2.0	f/2.8	f/4.0	f/5.6	f/8.0
Foot-candles required	125	250	500	1000	2000	4000

Filter Factors

Kodak Wratten Filter No.	No. 3 Aero-1	No. 6 K-2	No. 12 Minus Blue	No. 15 G	No. 21	No. 23A	8N5	No. 25 A	No. 29 F
Factor for Sunlight	1.5	2.0	2.5	2.5	3.0	5.0	6.0	8.0	16.0

Recommended control gamma: 0.65 to 0.70.

Base: Gray safety.

Identification: The letter F is printed just before the footage number on 35mm only.

KODAK FINE GRAIN POSITIVE FILM 5302 (35mm), 7302 (16mm) AND SHEET FILM

This film has a low-speed, positive-type emulsion, useful for printing positive transparencies, from continuous-tone or line negatives, for use in miniature slide projectors. It is not recommended for general camera work, but can be used for copying.

Safelight: Use a Kodak Safelight Filter, Wratten Series 1A (light red), in a suitable safe-light lamp with a 15-watt bulb at not less than 4 feet. A Series 0A (greenish yellow) can be used up to 2 minutes at 4 feet from the film with the 15-watt bulb in the lamp.

Relative Printing Speed: Fine Grain Positive has about one-half the speed of Kodabromide Paper No. 2.

The exact printing speed will depend on the development time to be used. Transparencies can be printed by projection or by contact with reduced illumination in the printer.

Development: Develop at 68 F for times given in the following table, to obtain contrasts corresponding approximately to the grade of paper given:

Equivalent Grade of Paper			Development Time With Continuous Agitation at 68 F Kodak Developers: Dektol (1:2); Versatol (1:3); or D-72 (1:2)	
Azo	Kodabromide			
Contact Printed	Contact Printed	Projection Printed	Films Printed by Contact	Films Printed by Projection
0	1	—	1¼ minutes	—
1	2	1	3½ minutes	1¼ minutes
2	3	2	5 minutes	3½ minutes
3	4	3	7 minutes	5 minutes
4	5	4	—	7 minutes

Examples: If a negative is known to yield good prints by contact on Kodak Azo Paper, Grade No. 1, then a transparency properly exposed by contact on Kodak Fine Grain Positive Film should develop to the proper contrast in approximately 3½ minutes (column 4). If the negative is printed by *projection* on Fine Grain Positive Film, development time should be reduced to 1¼ minutes (column 5). Likewise, a negative should produce good transparencies with this film and processing, if it is known to yield good prints by projection on Kodabromide Paper, Grade No. 1 (column 3).

If the exposure and contrast of the negative are judged by tests, it is suggested that the test exposures be made on Kodabromide, even for slides printed by contact, since the intensity of the printing illumination suitable for Kodak Fine Grain Positive Film is too low for regular contact papers such as Azo.

KODAK PROJECTOR SLIDE PLATES, MEDIUM AND CONTRAST

Safelight: Use a Kodak Safelight Filter, Wratten Series 1 (red) in a suitable safelight lamp with a 15-watt bulb at not less than 4 feet.

Exposure: Relative Printing Speed

Projector Slide Plate, Medium—about 2x speed of Kodabromide paper No. 2

Projector Slide Plate, Contrast—about 4x speed of Kodabromide paper No. 4

Exposure For Contact Printing: With a 15-watt frosted lamp at about 7 feet, for an average negative, expose the Medium Projector Slide Plate about 2 seconds.

Meter Setting for Camera Use: For use with meters marked for ASA speeds or Exposure Indexes:

Projector Slide Plate, Medium—10 (Tungsten)

Projector Slide Plate, Contrast—12 (Tungsten)

Processing: Develop at 68 F for times given in the table below to obtain contrasts corresponding approximately to the grades of printing and enlarging papers as indicated.

Equivalent Grade of Paper			Contrast Grade of Plate	Tray Development with Continuous Agitation at 68 F. Kodak Developers: Dektol (1:2), Versatol (1:3), or D-72 (1:2)	
Azo	Kodabromide				
Contact Printed	Contact Printed	Projection Printed		Slides Printed by Contact	Slides Printed by Projection
0	1	—	Medium	1 minute	—
1	2	1	Medium	2 minutes	1 minute
2	3	2	Medium	3 minutes	2 minutes
3	4	3	{ Medium	—	3 minutes
			Contrast	2 minutes	—
4	5	4	Contrast	3½ minutes	2 minutes
5	—	5	Contrast	6 minutes	3½ minutes

Examples: If a negative is known to yield good prints by contact on Kodak Azo Paper, Grade No. 1, then a Kodak Projector Slide Plate—Medium should be used (column 4). When properly exposed by contact, this plate should develop to the proper contrast in approximately 2 minutes (column 5). If the slide is printed by projection, development time should be reduced to one minute (column 6). Likewise, a negative should produce a good slide with this plate and processing if it is known to yield good prints by projection on Kodabromide Paper, Grade No. 1.

If the contrast of the negative is judged by tests, it is suggested that the test exposures be made on Kodabromide Paper, even for slides printed by contact, since the intensity of the printing illumination for lantern slides is too low for regular contact papers such as Kodak Azo Paper.

Special Effects: For maximum density and contrast for line work or half tones on the Contrast Projector Slide Plate, use Kodak D-11 without dilution for 5 minutes in a tray or 6 minutes in a tank at 68 F. For soft results on Medium Projector Slide Plates, use Kodak DK-50 full strength for 2 to 3 minutes in a tray at 68 F.

Rinse in Kodak Indicator Stop Bath, or Kodak Stop Bath SB-5 about 30 seconds with agitation at 65 to 70 F. A running water rinse can be used if an acid rinse bath is not available.

Fix 5 to 10 minutes at 65 to 70 F with Kodak Fixer or Kodak Fixing Bath F-5, or 2 to 4 minutes with Kodak Rapid Fixer. *Agitate plates frequently during fixing.*

In many cases slides of either continuous-tone or line subjects can be improved by short immersion in Kodak Farmer's Reducer or Kodak Reducer R-4a for clearing highlights.

Wash 20 to 30 minutes in running water. To minimize drying marks, treat in Kodak Photo-Flo Solution after washing, or wipe surface carefully with a Kodak Photo Chamois or a soft viscose sponge.

Dry in a dust-free place.

POLAROID TRANSPARENCY FILM, CONTINUOUS TONE, TYPE 46L

Speed: 800 (ASA equivalent.) A roll of Type 46L produces 8 rectangular transparencies with an image area of 2-7/16" x 3¼" for use in standard 3¼" x 4" lantern slide projectors. This image is slightly smaller than the standard lantern slide image, although the plastic mounts for the slides are standard size.

Lantern slide projectors always take the slide in a horizontal position. In order to have the slide properly oriented for projection, the camera/subject relationship should be as follows: the camera must always be horizontal with relation to the subject matter. On the MP-3, place the top of the subject matter next to the supporting column. On the Model 208 Copymaker, place the bottom of the subject matter next to the supporting column.

Exposure: MP-3 Camera. Basic exposure with normal MP-3 illumination is ¼ sec. at f/22 where no exposure compensation for bellows extension is required.

Exposure: 208 Copymaker. Set the camera to the highest shutter number or f/number in order to obtain maximum depth of field and sharpness. Basic trial exposure is 5–8 seconds with the 3-stop filter in place over the lens, or 1 second without the filter. These exposure recommendations are based on low ambient light levels where the main illumination comes from the lights in the Copymaker stand.

Exposure: Daylight. The following chart will serve as an approximate guide. EV numbers are for all camera models except 95, 95A, and 700. If the picture is too light, set the shutter to a higher number or place a filter over the lens; if it is too dark, set the shutter to a lower number.

Subject	Bright	Hazy soft shadows	Cloudy no shadows	Dull
AVERAGE People, pets	EV 17 8	EV 16 7	EV 15 6	EV 14 5
BRIGHT Beach, snow	EV 17* 8*	EV 16* 7*	EV 16 7	EV 15 6
DARK Shady spots	EV 16 7	EV 15 6	EV 14 5	EV 13 4

*With Polaroid orange or polarizing filter over lens.

Flash Lamp Exposures

Distance (feet)	4	5	6	8	10	15	25
AG-1	EV 17 8	EV 16 7	EV 15 6	EV 15 6	EV 14 5	EV 13 4	EV 12 3
No. 5 or Press 25	EV 17* 8*	EV 16* 7*	EV 16* 7*	EV 17 8	EV 16 7	EV 15 6	EV 14 5

*With diffuser over flashgun shield.

Development: Pull the tab slowly but steadily. A fast pull can create small pinholes in the dark areas of the picture. Hesitation during a slow pull can cause streaks across the picture.

Temperature affects development time. At 60 F and above, develop for 2 minutes (not 10 seconds as with other Polaroid transparency films). Below 60 F, develop as follows: at 50 F, 4 minutes; at 40 F, 6 minutes, and at 30 F, 8 minutes. Pictures that are not developed for a long enough time will have a muddy, gray look. In case of doubt, it is better to overdevelop slightly than to underdevelop.

Negative Cut-Off: The negative of this material is on Cronar base, which is an extremely tough plastic, highly resistant to tearing. After pulling the tab, cut the negative away with scissors, or if you prefer, leave it uncut until the end of the roll. The cutter bar teeth accessory, available for color film, will make it easier to tear the negative. See your dealer, or write to Customer Service, Polaroid Corp., Cambridge, Mass. 02139 and enclose 50 cents.

Removing and handling the transparency: When the transparency is removed from the camera, the emulsion is soft and delicate, so care must be exercised. For best results, start removal at the cut-out slot in the upper right-hand corner near the cutter bar. Tear out diagonally, from the upper right-hand corner to lower left. *Do not allow the transparency to fall back against the negative. Do not touch the image side before hardening.*

Hardening in the Dippit: Transparencies should be hardened and stabilized in the Polaroid Dippit #646 within one hour after removal from the camera. For best results, allow the transparency to dry in the air 2 to 3 minutes before dipping, or wave the transparency vigorously for 10 to 15 seconds. Be sure to agitate the transparency in the Dippit for at least 20 seconds. Follow carefully the instructions packed with the Dippit, particularly with regard to insertion and removal of the transparency.

Mounting: If the slides are to be projected within 12 hours after insertion in the Dippit, they should be mounted in Polaroid #633 snap-in plastic slide mounts. Transparencies are aligned in the mount by placing the corner that is cut off diagonally against a corresponding shoulder in the male half of the mount. Use care in inserting the transparency and avoid touching the image, since the emulsion is still slightly soft when removed from the Dippit. For permanent storage, mount the transparency between 3¼" x 4" lantern slide glass plates, using a suitable size standard mask. Be sure to wait 12 hours after dipping to allow for thorough drying. Selected portions of the image may also be cut out and mounted in 35mm and other small mounts.

Cleaning Transparencies: After the image is completely set (12 hours after dipping), the transparency is resistant to moisture and may be cleaned carefully with a damp cloth.

Important: Do not use plastic-mounted Polaroid Land transparencies in projectors that do not have an adequate blower or cooling system. In projectors of this type, glass mounted slides must be used to avoid buckling of the mount.

POLALINE PROJECTION FILM, HIGH CONTRAST, TYPE 146L

Speed: 125 (ASA equivalent.)

Spectral Sensitivity: Blue sensitive; no sensitizers have been added for the green and red portions of the spectrum.

Size: A roll of Type 146 L produces 8 rectangular transparencies with an image area of 2-7/16" x 3¼" for use in standard 3¼" x 4" lantern slide projectors. This image is slightly smaller than the standard lantern slide image, although the plastic mounts for the slides are standard size.

Lantern slide projectors always take the slide in a horizontal position. In order to have pictures properly oriented for projection, the camera/subject relationship should be as follows:

The camera must always be horizontal with relation to the subject matter. On the MP-3 place the top of the subject matter next to the supporting column. On the Model 208 Copymaker, place the bottom of the subject matter next to the supporting column.

Exposure—MP-3: Basic exposure with normal MP-3 illumination is 1 second at f/22 where no exposure compensation for bellows extension is required.

Exposure—#208 Copymaker: Exposure times (below) are based on low ambient light levels where the main illumination comes from the lights on the Copymaker stand. All exposures are time exposures requiring rigid mounting of the camera and the subject matter. The apertures recommended are the smallest available with the camera equipment used in conjunction with the Copymaker, in order to obtain maximum depth of field and sharpness.

Model	Without Filter		With 3-Stop Filter	
110	f/32	2–4 seconds		
110A, 110B, 120	f/45	4–8 seconds		
95, 95A, 700	EV-8	2–5 seconds	EV-6	11–15 seconds
95B, 150, 160, 800	EV-17	2–5 seconds	EV-17	11–15 seconds
850, 900 manual	EV-18	8–13 seconds		

Latitude: Because of the film's high contrast, its exposure latitude is necessarily restricted as compared to films intended for continuous-tone reproduction. Overexposure (approximately ½ stop or more) will result in line reproduction with insufficient blackness. Underexposure (½ stop or more) will cause lack of clarity in transparent areas and uneven screen whiteness in projection. The restricted latitude also requires uniform subject lighting for good results. Uneven lighting of the subject matter will affect the clarity of highlight areas and the blackness of lines. Photography with the MP-3 or the #208 Copymaker should be done in areas of low ambient light so as to avoid affecting the exposure. If this is impossible, the ambient light should be of uniform brightness over the subject matter. Consistent dark smudges in transparent areas indicate uneven lighting. This can be corrected by additional light from a reflector flood clamped to the column of the Copymaker.

Development: *Pull the tab slowly but steadily.* A fast pull can create small pinholes in the dark areas of the picture. Hesitation during a slow pull can cause streaks across the picture.

Temperature affects development time. At 70 F and above, normal development time is 10 seconds (not 2 minutes as in other Polaroid Land transparency films.) Below 70 F, development time is longer, as follows: at 60 F, time is 20 seconds; at 50 F, it is 30 seconds; at 40 F, it is 45 seconds; and at 30 F, it is 60 seconds.

Pictures that are not developed for a long enough time will have a muddy, gray look. In case of doubt, it is better to overdevelop than to underdevelop.

Negative Cut-off: The negative of this material is on Cronar base, which is an extremely tough plastic, highly resistant to tearing. After pulling the tab, cut the negative away with scissors, or, if you prefer, leave it uncut till the end of the roll. The cutter bar teeth accessory, available for color film, will make it easier to tear the negative. See your dealer or write to Customer Service, Polaroid Corp., Cambridge, Mass. 02139, and enclose 50 cents.

Removing and Handling the Transparency: When the transparency is removed from the camera, the emulsion is soft and delicate, so care must be exercised. For best results, start removal at the cut-out slot in the upper right hand corner near the cutter bar. Tear out diagonally, from the upper right hand corner to the lower left. *Do not allow the transparency to fall back against the negative. Do not touch the image side before handling.*

Hardening in the Dippit: Transparencies should be hardened and stabilized in the Polaroid Dippit #646 within 1 hour after removal from the camera. For best results, allow the transparency to dry in the air 2 to 3 minutes before dipping or wave the transparency vigorously for 10 to 15 seconds. Be sure to agitate the transparency in the Dippit for at least 20 seconds. Follow carefully the instructions packed with the Dippit, particularly with regard to insertion and removal of the transparency.

Mounting: If the slides are to be projected within 12 hours after insertion in the Dippit, they should be mounted in Polaroid #633 snap-in plastic slide mounts. Transparencies are aligned in the mount by placing the corner that is cut off diagonally against a corresponding shoulder in the male half of the mount. Use care in inserting the transparency and avoid touching the image since the emulsion is still slightly soft when removed from the Dippit. For permanent storage, mount the transparency between 3¼" x 4" lantern slide cover glasses, using a suitable size standard mask. Be sure to wait 12 hours after dipping to allow for thorough drying. Selected portions of the transparency image may also be cut out and mounted in 35mm or other small size mounts.

Cleaning Transparencies: After the image is completely hard (12 hours after dipping) the transparency is resistant to moisture and may be cleaned carefully with a damp cloth.

Important: Do not use plastic-mounted Polaroid Land transparencies in projectors that do not have an adequate blower or cooling system. In projectors of this type, glass mounted slides must be used to avoid buckling of the mount.

3M PANCHROMATIC REVERSAL FILM CR-64
(16mm and Super 8mm)

Exposure Index: *Reversal: Daylight 64, Tungsten 50*
Negative: Daylight 32, Tungsten 25

These settings are recommended for meters marked for American Standard Exposure Indexes. Because of differences in individual meters and methods of use, higher or lower values than those given above may be desirable. The effective speed of this film, as with other films, is also influenced by the particular formulas and manner of processing employed. The values given should be considered only as preliminary guides subject to revision on the basis of tests processed with the actual formulas to be used.

Color Sensitivity: Panchromatic

Safelight: Total darkness required. A series 3 (dark green) safelight filter, in a suitable safelight lamp with a 15-watt bulb can be used for a few seconds only, at 4 feet, after development is half completed.

Illumination (Incident Light) Table for Tungsten Light.

Shutter speed approximately 1/50 sec. (24 frames per sec., 170° shutter)

Lens Apertures		f/1.4	f/2.0	f/2.8	f/4.0	f/5.6	f/8.0
Foot-candles required	Reversal	50	100	200	400	800	1600
	Negative	100	200	400	800	1600	3200

Filter Factors

Kodak Wratten Filter No.	No. 3 Aero-1	No. 6 K-2	No. 12 Minus Blue	No. 15 G	No. 21	No. 23A	8N5	No. 25 A	No. 29 F
Factor for Sunlight	1.5	2.0	2.0	3.0	3.0	6.0	8.0	8.0	16.0

Recommended control gamma: Reversal process according to manufacturer's instructions.

Base: Antihalation safety (cellulose triacetate)

Identification: None

3M PANCHROMATIC REVERSAL FILM CR-160
(16mm and Super 8mm)

Exposure Index: *Reversal: Daylight 160, Tungsten 125*
Negative: Daylight 80, Tungsten 64

These settings are recommended for meters marked for American Standard Exposure Indexes. Because of differences in individual meters and methods of use, higher or lower values than those given above may be desirable. The effective speed of this film, as with other films, is also influenced by the particular formulas and manner of processing employed. The values given should be considered only as preliminary guides subject to revision on the basis of tests processed with the actual formulas to be used.

Color Sensitivity: Panchromatic

Safelight: Total darkness required. A series 3 (dark green) safelight filter, in a suitable safelight lamp with a 15-watt bulb can be used for a few seconds only, at 4 feet, after development is half completed.

Illumination (Incident Light) Table for Tungsten Light.

Shutter speed approximately 1/50 sec. (24 frames per sec., 170° shutter)

Lens Apertures		f/1.4	f/2.0	f/2.8	f/4.0	f/5.6	f/8.0
Foot-candles required	Reversal	20	40	80	160	320	640
	Negative	40	50	160	320	640	1280

Filter Factors

Kodak Wratten Filter No.	No. 3 Aero-1	No. 6 K-2	No. 12 Minus Blue	No. 15 G	No. 21	No. 23A	8N5	No. 25 A	No. 29 F
Factor for Sunlight	1.5	2.0	2.0	3.0	3.0	6.0	8.0	11.0	32.0

Recommended control gamma: Reversal processing. By extending first development, speed can be increased to 640 Daylight with some loss in picture quality.

Base: Non-halation cellulose triacetate

Identification: None

3M PANCHROMATIC REVERSAL FILM CR-250
(16mm and Super 8mm)

Exposure Index: *Reversal: Daylight 250, Tungsten 160*
Negative: Daylight 125, Tungsten 80

These settings are recommended for meters marked for American Standard Exposure Indexes. Because of differences in individual meters and methods of use, higher or lower values than those given above may be desirable. The effective speed of this film, as with other films, is also influenced by the particular formulas and manner of processing employed. The values given should be considered only as preliminary guides subject to revision on the basis of tests processed with the actual formulas to be used.

Color Sensitivity: Panchromatic

Safelight: Total darkness required. A series 3 (dark green) safelight filter, in a suitable safelight lamp with a 15-watt bulb can be used for a few seconds only, at 4 feet, after development is half completed.

Illumination (Incident Light) Table for Tungsten Light.
Shutter speed approximately 1/50 sec. (24 frames per sec., 170° shutter)

Lens Apertures		f/1.4	f/2.0	f/2.8	f/4.0	f/5.6	f/8.0
Foot-candles	Reversal	10	20	40	80	160	320
required	Negative	20	40	80	160	320	640

Filter Factors

Kodak Wratten Filter No.	No. 3 Aero-1	No. 6 K-2	No. 12 Minus Blue	No. 15 G	No. 21	No. 23A	8N5	No. 25 A	No. 29 F
Factor for Sunlight	1.5	2.0	2.0	3.0	3.0	6.0	8.0	8.0	16.0

Recommended control gamma: Reversal processing. By extending first development, speed can be increased to 1250 Daylight with some loss in picture quality.

Base: Non-halation cellulose triacetate.

Identification: None.

INTRODUCTION TO "PHOTOGRAPHIC OPTICS"

This section contains the essential optical formulas, tables, and data required by the practical photographer. There are not many of these, because few of the calculations that can be made *are* actually made. It is much easier to look through a camera or finder to determine the field covered at a given distance, than it is to sit down and calculate it. Such calculations, however, do sometimes have to be made, as for example, when studios are being planned or movie sets are being built.

Optical Principles

Many elementary texts discuss camera lenses in terms of image formation through a pinhole, or the oversimplified analogy of a lens to two prisms base to base. These concepts are useful for beginners, but they do not have any place in a book of this sort, intended for the professional and advanced amateur photographer. Likewise, many compendia list, at great length, hundreds of different lenses by name, show them in cross-section, and classify them by number of elements and the positive-negative order and arrangement. There may have once been some use for such information, but with the coming of the computer and computer-designed lenses this kind of data is of no real utility. There is a parallel with radio here; once we wanted to know how many tubes a given set had. Today, whether tubes or transistors, we no longer count them. By the same token, a lens may contain 3, 4, 5 or more elements. There is little correlation between number of elements and lens performance, and the counting of glasses should be left to the designer.

What has been sadly lacking in previous discussions of lenses for the photographer is an explanation of lens corrections, how they are made, and most important, how far they can be carried. With this, we can judge whether a given lens will be suitable for a certain purpose; that is, we will know that a lens designed for portraiture will probably not be a good copying lens, while a very highly corrected apochromatic process lens will probably not make good portraits.

Thus the usual question "How good is a given lens?" can only be answered when we have some criteria by which to judge good or bad. This is a special problem in optics because, whereas in other fields a close approach to perfection may be possible, there is no such thing as a perfect lens, and it is mathematically impossible to make one. This is due to certain inexorable physical laws of refraction, not to any lack of knowledge or skill in lens making.

To understand this point better, we need a definition of a "perfect lens." There are actually two such definitions, and they are complementary to each other.

First, we could consider a lens perfect if it produces, of an infinitesimally small object point, an image which is likewise infinitesimally small.

Second, opticians consider as a perfect lens one which will produce a perfect image of an object at any distance. This does *not* imply infinite depth of field; it merely calls for the lens to be capable of focusing upon an object at one distance and producing a perfect image thereof, and then focusing on an object at some other distance, and producing an equally perfect image of that object. That such a lens does not and cannot exist may come as a surprise to photographers who are accustomed to focusing their cameras at any distance from a few feet to infinity.

Nonetheless it has been proved mathematically* that no lens can produce an equally good image of objects at all distances, nor even of objects at merely two different distances. That is, a lens produces the best image of an object at a distance for which the lens was originally designed; focused on any other distance its performance will be inferior.

This situation is not as bad as it appears; because of other problems, no lens ever approaches its theoretical performance anyway. But it does point out why a process lens designed for 1:1 copying is not recommended for general outdoor photography with objects at a great distance. By the same token, an ordinary camera lens is not too satisfactory for extreme close-up work, especially in microfilming and macrophotography; the so-called "macro" lens is one which has been designed specifically to work at close ranges.

The initial question is the more important one; whether any lens can produce infinitely small image points is answered by the fact that light is considered a wave motion, and because it is, we find a phenomenon known as *diffraction*. Diffraction, in its simplest form, is a spreading of light rays passing an edge or a small aperture. In the case of a lens, it results in the image of a point appearing, not as a point, but as a small circle, or sometimes as a group of concentric circles of different colors. The diameter of the innermost circle, which is usually the only one bright enough to matter, depends on the size of the aperture and the wavelength of the light, and on no other factors.

Since no datum of the lens other than its aperture enters into this statement, it is obvious that no lens construction nor any type of lens correction can affect the size of the blur circle produced at any given aperture. Any lens of a given f/stop will have the same diameter of diffraction circle as any other lens of the same f/number, and for that matter, in the case of very small apertures, the same diffraction circle as a pinhole camera of the same aperture.

We refer here, of course, to the *minimum* blur circle; any residual aberrations in the lens will make the blur circle larger, but no degree of correction can make the circle smaller than that dictated by its aperture. This sets a limit to the amount of correction considered worthwhile. A lens that is corrected to the point where its minimum blur circle is equal to the theoretical circle for the same aperture is called *diffraction-limited*.

Diffraction-limited lenses do exist, but not in photography, except in a few very special cases, such as lenses made for micro-image work, reticle-making, miniaturization of printed circuits, and other such work. No ordinary camera lens even approaches the diffraction-limited condition.

It may seem strange that a telescope objective composed of two or at most three glasses, of very simple shapes and gentle curvatures, can be corrected

*Those who are interested in this proof will find it in *Applied Optics and Optical Design* by A. E. Conrady, Dover Publications, New York, Part I, Chapter 9, page 458.

almost perfectly, and camera lenses cannot. The reason for this lies in the different conditions under which the two types of lens work.

A six-inch telescope objective appears enormous compared with most camera lenses. What is not immediately obvious is that the focal length is very long; in a lens of this diameter it will be around 90 inches, or close to eight feet! Thus the actual aperture of this very large lens is about $f/15$, whereas in photography even simple box camera lenses work at between $f/11$ and $f/12.5$.

A second consideration with telescope objectives is that they are not expected to cover a wide angle of view; even at low magnifications such as 40 to 50 power, the angle of view of a telescope is likely to be about *one degree*. A camera lens, following the usual rule of thumb that the focal length is equal to the diagonal of the image format, will have a field of view of about 55°, and wide angle lenses are routinely made with view angles of 90° and upwards.

Thus a telescope objective can be considered fully corrected if it has negligible spherical aberration, coma, and chromatic aberration. In camera lenses, these are not even the most important corrections; elimination of astigmatism is the essential point, both because of the wider angle to be covered and the large aperture ratios demanded by photographers. A telescope is thus capable of producing exquisitely sharp images over a very narrow field; a camera lens produces what an optician would call mediocre definition, but this is uniform over a wide field of view.

Fortunately, perfection is not required of camera lenses. For one thing, we have to tolerate some unsharpness in order to secure a usable depth of field. Depth of field tables are commonly calculated for a circle of confusion* of about 1/40mm (.001″) and this will be adequate for enlargements up to at least 10 times. There is no use making the lens much better than that, then, because to do so would merely emphasize the difference between the plane of sharpest focus and the zone of acceptable focus which encompasses most of the image.

So, in the simplest possible terms, a photographic lens is not corrected to the ultimate degree; its definition is limited by residual aberrations rather than by diffraction. It is unfortunate that most of the literature offered to the photographer by the manufacturers tend to give the impression that all aberrations are fully eliminated; this is not and cannot be the case. It is, in fact, quite impossible to correct all the aberrations of a photographic lens. The problem is that the aberrations are interdependent—one cannot eliminate one without introducing another. The total elimination of spherical aberration would result in an intolerable amount of astigmatism, while total elimination of astigmatism would not only re-introduce spherical aberration, it would also result in a severe curvature of field. One special case is that of coma; reducing the coma in a given lens design often tends to minimize other aberrations. In general, though, it is impossible to eliminate all aberrations completely; what we attempt to do in a well-corrected photographic objective is to secure a satisfactory *balance* of the residual aberrations for optimum performance.

One long-held hope of improvement in lenses has been in the shape of the lens elements, which are almost always spherical. It has been believed that if lenses could be ground to shapes other than spherical—say paraboloidal or

*It is necessary to make a sharp distinction between "blur circle" and "circle of confusion". The former term refers to the minimum image size of a point object which can be produced by a given lens. The latter term refers to the maximum image size of a point object which we will consider acceptable, to secure a given depth of field. Thus, in a sense, "blur circle" indicates the best definition of which a lens is capable, "circle of confusion" is the poorest definition which is acceptable.
Some authorities use the term "minimum circle of confusion" for "blur circle", but this usage is likely to lead to misunderstanding, and we have avoided it.

ellipsoidal—a great improvement in performance would result, hopefully by elimination of the astigmatism and field curvature that limit the performance of large aperture lenses.

Unfortunately, this is not the case. The use of paraboloidal curves in telescope objectives is intended to reduce or eliminate the last traces of spherical aberration. However, it has been known for years that spherical aberration is the only one of the major aberrations which is affected by the shape of the lens. In Volume 2 of *Applied Optics and Optical Design* by A. E. Conrady, we find the following statement:

"... It is still widely believed that the figuring of surfaces, if rendered a commercially practicable operation, would be a means of overcoming certain grave difficulties in the design of well-corrected lens systems, more especially those concerned with the attainment of a flat field, free from astigmatism. Our discussion shows that there is no foundation for this belief ... The only advantages of figured surfaces are that they give us independent control over the spherical aberration and therefore, at times, the possibility of attaining a certain result with fewer constituent lenses or with a more compact system ..."

One or two recent camera lenses include aspheric surfaces in their design; they are extremely costly, and it is unlikely that the use of aspheric surfaces will become general practice in ordinary photographic lenses.

Recent studies in computer lens design indicate that there are some possibilities in figured surfaces of considerably greater complexity than the simple paraboloidal or ellipsoidal surface. Some high order curves have been shown to produce interesting results in catadioptric systems (systems of lenses and mirrors), and one simple example of this sort of thing is the corrector plate used in Schmidt telescopes. Even so, this does not appear to serve any purpose other than the correction of spherical aberration, and for the time being, at least, we may consider Conrady's remark still true.

One other hope of a breakthrough remains current, and that is the demand for ever faster lenses. It is unfortunate but true that the speed of a lens is likewise limited by inexorable optical principles, and we have very nearly reached the limit of maximum aperture in photographic objectives.

To understand this limit, we should think of the f/number of a lens, not as the ratio of diameter to focal length, but in terms of the angle between the axis of the system and the extreme ray from the edge of the aperture to the axial image point. In these terms the f/number is expressed as:

$$f/\text{number} = \frac{1}{2N \sin a}$$

where N is the refractive index of the medium in which the image is formed, and a is the angle between the axis and the extreme ray.

In cameras, the image space is always filled with air, hence $N = 1$, and that leaves sin a as the only variable. The value of the sine of any angle can never exceed 1; that is, the sine of $0° = 0$, the sine increases until at $90°$ it is equal to 1.0, then it diminishes to zero again at $180°$, rises to 1.0 again at $270°$ and back to zero at $360°$. But then, if the maximum value of the sine of a is 1.0 and the refractive index of air is likewise 1.0, then the maximum aperture a lens can have is:

$$f/\text{number} = \frac{1}{2 \times 1 \times 1} = \frac{1}{2} = f/0.5.$$

And since lenses with an aperture ratio of $f/0.7$ have already been made, it is obvious that we are practically at the limit of progress in this direction.

Again, this is not as serious a matter as it would appear; lenses of such enormous aperture would have little or no usable depth of field and would be suitable only for micro-copying where the large aperture is required, not for speed, but for resolving power.

Resolving Power

If all this discussion gives the impression that photographic lenses are pretty poor things and unlikely to get better, this is not the case. The fact is, that for their purposes, today's camera lenses are very good indeed. They are, in most cases, better than the equipment in which they are used, and in many cases, better than the use to be made of them requires them to be. The final image in a photographic print depends on many factors other than the lens. Some of these factors are: how accurately the lens can be focused, how free from vibration the camera and its mounting may be, how good the resolution of the film is, how much enlargement the image is to have, how good an enlarger lens is used, and still more factors. All of these can diminish the quality of the primary image formed by the camera lens; none of them can improve it.

A simple example will make this point clear. The factors that make up the resolution of the final image combine by simple addition, and thus the resolution of a system can never be better than that of the poorest element in it. Take a simple two part system—a lens and a film—and assume that each is capable of resolving 1/50mm (or 50 lines per millimeter in common terms). Then if we add these two resolutions, we get

$$\frac{1}{50} + \frac{1}{50} = \frac{1}{25}.$$

That is, the resolution of the combined lens and film will be 1/25mm or 25 lines per millimeter. Suppose we try a better lens, for example one which can resolve 1/100mm. Then

$$\frac{1}{100} + \frac{1}{50} = \frac{3}{100} = \frac{1}{33}.$$

From which we find that doubling the resolving power of the lens alone has improved resolution only from 25 lines per millimeter to 33 lines per millimeter. Further improvements in lens quality alone will have less and less effect; for example, take a lens of 200 lines per millimeter resolution. Combined with the same film, we have

$$\frac{1}{200} + \frac{1}{50} = \frac{5}{200} = \frac{1}{40}.$$

Thus a second doubling of resolution only increased the total resolving power from 33 to 40 lines per millimeter. Resolution will only tend to *approach* 50 lines per millimeter, it cannot exceed it. It should be clear from the trend of these figures that as long as a film with 1/50mm resolution is being used, even a perfect lens will not produce better resolution than the film itself has.

However, there is another lesson to be learned from these figures. Some photographers believe that if a lens is as good as the film, that is amply good enough, and that no further improvement is possible. It should be clear from the above that this is not true; if the lens is only as good as the film, then

the combined resolution will only be half that of either. A better lens makes a definite improvement, though the improvement diminishes rapidly, and in any case is always less than one might expect. Furthermore, the final resolution is unlikely to be even as good as these figures imply—we are examining only two factors and omitting several others that also influence the resolution of the system: focusing errors, shutter vibration, and others.

These are, of course, hypothetical figures; there is still a question of what actual resolving power we can expect from a lens. Given a lens free from all aberrations, the resolution depends only on the f/number of the lens and the wavelength of the light in use. Various formulas have been offered relating these two factors, but none of them can be very accurate, simply because of the large variation in wavelength between blue and red light—from 400nm to 700nm. Thus an approximation is all that is needed, and a simple rule of thumb gives us

$$R = \frac{f/\text{number}}{2000} \quad (\text{in millimeters}).$$

Thus a lens at $f/4$ should be capable of resolving 1/500mm, and at $f/8$, about 1/250mm. These numbers indicate several things. First of all, since most lenses do not approach the figures attainable at large apertures, the resolution of any lens at large openings is limited by aberrations, not by diffraction. Second, the opposite case is probably true at small apertures; at $f/45$, the formula above gives only 44 lines per millimeter, indicating that in this area, resolution is limited by diffraction rather than by the quality of the lens. Most good lenses will show their maximum resolution somewhere around the middle of their aperture range, but the average value will seldom exceed 100 lines per millimeter.

If such a lens is used in connection with a fine-grained film, also capable of 100 lines per millimeter resolution, the system will resolve 50 lines per millimeter, which is considered good performance by present standards. In inch measure, this is about 1250 lines per inch, and since the eye is thought to resolve about 1/100 inch at normal reading distances, such a lens should produce images good enough for 12X enlargement.

This resolution is, of course, measured in the image plane and is, as has been seen, independent of the focal length of the lens. But since the size of the image in the focal plane increases with the focal length of the lens, this leads to a very important conclusion: the longer the focal length, the better the resolution *in the subject plane*. For example, a 12-inch lens with 1/50mm (1/1250 inch) resolution will just separate the bricks in a wall 2,500 feet— about half a mile—away. The two-inch lens of a 35mm still camera makes an image of these same bricks only 1/6 as big, and they will not be resolved beyond 400 feet. And the half-inch lens of an 8mm movie camera cannot resolve bricks at distances beyond about 100 feet. This is a matter of considerable importance in aerial surveying and "spy-plane" photography, and accounts for the large size of the cameras used in this type of work, where focal lengths range from 12 inches to more than 48 inches. There is a rule, well known among the people who do this type of work, that "there is no substitute for focal length."

Lens Testing

Many curious charts have been designed for the use of amateur photographers who desire to "test" their lenses. They probably have some utility, provided they are not taken too seriously. It is essential for the user to remember that he is not, when using such a chart, measuring lens resolution alone, but

508

the combined resolution of lens, film, camera, and his own ability to focus sharply. Thus the results obtained are usually much lower than expected by the uninitiated beginner. Using a finer-grained film will probably produce slightly higher resolution figures but this has little meaning if we are trying to determine lens performance.

The only way one can test a lens substantially independently of all other factors is to use an optical bench, an artificial star, and a high-powered, large-aperture microscope to examine the aerial image. Such equipment is not available to amateurs.

This is of little importance; such a test means nothing to the user anyway. It is simply impossible in practical photography to separate the influences of the lens, the camera, the film, and other factors. Likewise, in photographing one of the fancier charts that purport to show the various aberrations, the results seldom have any real meaning because it is impossible to separate the effects of the various aberrations. They are all jumbled together in such a test. All that one can learn from such a chart, then, is the *approximate* resolving power of the lens-camera-film combination used, and even this information means little. If one intends to use a lens for making portraits, probably the best test is to try it on portraits; if a lens is to be used for copying, then try it on copy work. This will give a fairly good idea of the utility of a given lens for a given purpose, and that is the purpose of testing.

Aberrations

Since nothing can be done about correcting the aberrations in a finished lens, the following discussion of the various aberrations and their importance is intended mainly for general information; it may help to know which aberrations are important in a given application and which are not. Portrait photographers, for example, like a slightly soft, "plastic" image quality. This is usually accomplished by admitting rather more than the normal residual of spherical aberration in such lenses. Obviously, then, one cannot reject a portrait lens simply because it has more than some arbitrary amount of spherical aberration.

There are seven major aberrations, five of which are geometric and two concerned with color. They are as follows:

1. Spherical aberration
2. Coma
3. Astigmatism
4. Curvature of Field
5. Distortion
6. Chromatic aberration
7. Lateral color.

Spherical Aberration. Spherical aberration is the inability of a lens having spherical surfaces to focus rays passing through the center and edges of the lens at the same point. If rays passing through the edges of the lens focus closer to the lens than those passing near the axis, then the spherical aberration is considered positive; if the marginal ray falls beyond the paraxial focus, it is considered negative.

No single lens can be completely corrected for spherical aberration except by shaping its surfaces to some form other than spherical; usually paraboloidal. However, in systems of several lenses, it is possible to combine lenses having negative and positive spherical aberration in such a way that they cancel each other out. Such a system will not be entirely free from spherical aberration, though; when the marginal and paraxial rays are brought to the same focus, it

is possible that rays from some intermediate zone will still fail to come into the same plane. This condition is known as "zonal spherical" aberration and is sometimes more serious than a simple undercorrection of primary spherical aberration.

Ordinary spherical aberration tends to cause the out-of-focus rays to surround the sharply focused points with a small halo. The effect on the image as a whole is to cover the entire image area with a haze of scattered and out-of-focus light. This tends to reduce the contrast of the image, but because the scattered light is much less bright than the sharply focused rays, it does not tend to damage the image definition very much. The effect is most visible with large aperture lenses on reflex cameras; the residual spherical aberration is seen as a haze that is most severe at full aperture, tending to disappear as the lens is stopped down.

This haze, containing as it does little of the available light, can often be minimized by the simple expedient of underexposing slightly. This is what is done in the case of the ordinary box camera; the single lenses used in these cameras have a considerable amount of spherical aberration, but since most box cameras are used on the verge of underexposure anyway, it has little effect on the image. Obviously, the use of faster-than-usual films in a box camera can seriously degrade the quality of the image.

When a lens is corrected to bring the extreme marginal ray to the same focus as the paraxial one, then the residual error is usually in the form of a zone of spherical aberration at about 0.7 of full aperture. If, though, the 0.7 ray is brought to the same focus as the paraxial ray, then there are two zones of residual spherical aberration, one at the margin, the other about halfway between the axis and the 0.70 point. These zones are opposite in direction and usually are only about half as serious as the single zone of residual spherical aberration resulting from a union of the marginal and paraxial rays. Since the zonal spherical aberration tends to cause a focus shift as the lens is stopped down, it is evidently desirable to reduce its effect to a practical minimum in this manner. This is especially important in the case of single-lens reflexes with automatic diaphragms, where focusing is always done wide open, and the lens is stopped down at the instant of exposure.

The use of paraboloidal curves to eliminate spherical aberration has been tried in a few very expensive lenses. Because of the great cost of grinding these special curves, it is not likely that any great use will be made of them in ordinary camera lenses. Aspheric curves of this type can be used quite easily and inexpensively in projection systems, however, in the condenser lenses, which focus the light on the film or slide. In such projectors, spherical aberration in the condenser system produces a serious unevenness of illumination on the screen. But since the condenser is not expected to produce a sharp image (it is only required to focus the lamp filament in or near the projection lens), high optical quality is not required. Usually, simple molded and fire-polished lenses are used in condenser systems, and it is easy enough to mold such lenses into a roughly paraboloidal shape. Often this reduces a condenser system to a single lens.

Coma. Unlike spherical aberration, coma appears only in off-axis image points. The marginal rays have a different focal length from the paraxial rays, and since focal length determines the size of the image, points near the margins are spread out into a fan-shaped pattern by failure of the marginal and paraxial rays to intersect. This pattern is generally somewhat comet-shaped, from which the aberration takes its name.

Coma differs from spherical aberration in another way; most of the light is scattered into the tail of the patch, rather than into the sharply focused point.

This makes coma very visible even in small amounts. The usual effect of coma is to cause all image points near the edges of the field to blur outward; the effect is exceedingly unpleasant, giving the impression that the image is flying apart. Thus coma must be reduced to the minimum in any lens which is to be considered well-corrected.

Luckily, the correction of coma is not difficult; it is done in much the same way as the correction of spherical aberration, by combining two lenses having opposite coma tendencies. It is quite possible to correct both coma and spherical aberration with the same pair of lenses (though some zonal residuals will necessarily remain), and a lens corrected for both spherical aberration and coma is called "aplanatic."

Astigmatism. This is probably the most serious and most stubborn aberration of large-aperture lenses. Because it cannot be corrected in lenses made of ordinary crown and flint glasses, early landscape lenses, Rapid Rectilinears, and portrait lenses were all limited to apertures of $f/8$ or smaller. Astigmatism is the tendency of a lens to focus off-axis rays to two separate positions; lines radial to the lens axis are focused in one plane, and lines tangent to the field are focused in another plane. This effect grows more serious with larger lens apertures and with wider angles of view, hence it is not much of a problem in telescope objectives, but exceedingly important in camera lenses.

With the new Jena glass types, and a proper choice of curvatures, the astigmatic difference between radial and tangential lines is minimized, but a new aberration appears; the combined images fall upon the surface of a sphere rather than in the flat plane we require. Curvature of field and astigmatism are thus closely tied together, and correction of the two aberrations must be done in one operation.

Curvature of Field. The formation of images on a spherical surface rather than on a flat plane is characteristic of lenses of any aperture; however, stopping down tends to minimize the effect simply because of the increased depth of field (and depth of focus). The effect is most serious when the lens has a large aperture and also an extended field. Therefore, it must be corrected even in simple box-camera lenses; here the flattening is accomplished simply by making the lens of meniscus shape and putting the diaphragm in front of the lens, which has its concave side facing the subject. Unfortunately, this tends to increase the astigmatism and coma of the lens; however, in lenses working at $f/11$ or thereabouts the problem is not serious, and in box cameras, the other aberrations tend to swamp it out.

Another method of handling the box camera problem is to make the lens of meniscus shape, but with its convex side facing the subject, and the diaphragm behind. This construction is mainly used to make the camera more compact; the astigmatism is slightly improved but the field is severely curved. This is compensated by the simple mechanical means of curving the film path to approximately the same degree.

In large-aperture lenses, astigmatism and field curvature are the most serious problems; their corrections are bound up and must be effected together. The exact type of correction used depends upon the intended use of the lens. The most obvious would be to try to get the astigmatism and field curvature in opposite directions so that the plane of best focus would lie between them. Unfortunately, this does not produce a completely flat field, because of zonal residuals, but it is useful where a small aperture and a wide field are required, as in the case of extreme wide-angle lenses. In ordinary camera lenses, some field curvature is tolerated to secure a better correction of astigmatism.

By this time it must be clear that the aberrations are mostly interdependent. Astigmatism and field curvature must be worked on together; however, to eliminate astigmatism completely introduces a large residual of spherical aberration. Which to minimize, then, depends upon which is considered more serious. Generally, spherical aberration does not seriously degrade the definition of the lens; it merely scatters the out-of-focus light into an overall haze, which reduces only the contrast of the image. On the other hand, astigmatism distorts the shape of the image points very seriously; circles of confusion become ellipses and in extreme cases, lines. This is destructive of definition, and it is generally considered best to minimize astigmatism as far as possible, even at the expense of admitting some spherical aberration.

Distortion. Distortion is a lens fault in which the magnification in the outer parts of the field is different from that at the center. If the marginal magnification is too great, the corners of a square object will be extended outward, causing the well-known "pincushion" distortion. The image as a whole will be too large, since the magnification increases with the distance from the axis. If the marginal magnification is too small, then the image will be bent inward, particularly at the corners, causing the equally well-known "barrel" distortion.

Distortion must be eliminated in the design of the lens; it is not affected in any way by stopping down. One way of correcting distortion is to make the lens system symmetrical in form, with the diaphragm in the middle, as in the well known Rapid Rectilinear lens. This has other benefits: it not only corrects distortion, but coma and lateral color as well. This cancellation is only complete for object-image ratios of 1:1 but is very large at other magnifications as well. It is possible to cancel the three aberrations for other object-image ratios by making the lens system *hemi-symmetrical;* that is, the lens *shapes* are symmetrical, but the *sizes* are in the ratio of the desired object-image distance. Again, the correction will be best at the ratio designed for, but usefully large at others.

If the lens is of asymmetrical design, like the Tessar, distortion is corrected in other ways. It cannot always be eliminated completely, and for that matter, it is not always *desirable* to eliminate all traces of distortion. For instance, in lenses of fairly wide angle, used on miniature cameras where subject matter seldom contains any straight lines, some barrel distortion is often designed into the lens. This residual is generally considered to improve lens performance because the lower magnification at the edges of the field increases the corner illumination noticeably.

A large amount of barrel distortion is required in lenses of the "fisheye" type, where the field of view is nearly 180°. With such a field of view, obviously, a lens having a flat field would also have a field of 180° in the image plane, and one would require a plate or film of infinite size to include the entire image. By designing these lenses with *very severe* barrel distortion, the image is caused to take the shape of a circle that contains the entire 180° field of view in a relatively small image area, although objects at the margins of the picture are far smaller than their true geometrical size. It is possible to compensate for the distortion of such a lens by printing negatives from it through the original fisheye lens mounted in an enlarger. The entire negative cannot be printed at one time, but sections of the image not too close to the margins can be printed with nearly rectilinear rendition in this way.

Other cases include telephoto lenses having positive front components and negative rear elements; these almost always have some distortion, though by careful design it can be reduced to a very small amount. Zoom lenses likewise suffer from distortion, which is likely to vary as the focal length is changed.

In one case the distortion went from barrel to pincushion through the normal zoom range; this lens was free from distortion at one focal length setting only.

Process lenses for photomechanical work must not have any appreciable distortion; this applies also to wide-angle lenses for architectural work and lenses for aerial mapping. In all three cases, either symmetrical or hemi-symmetrical construction is used.

Chromatic aberration. Up to this point, it has been tacitly assumed that the characteristics of the lens are the same regardless of the color of the light. This, of course, is not so. The refractive index of glass varies with wavelength; it is greatest for the short wavelengths (blue, violet) and least for the long wavelengths (orange, red). Thus the actual focal length of a simple lens will vary with color—shortest for blue, longest for red. That is, the image of a blue object falls closer to the lens than that of a red object, and it is impossible to focus both at the same time. The effect is extremely important and must be corrected in all but the simplest, most primitive systems. Achromats (lenses designed to bring two colors to the same focus) were even used in box cameras until quite recently.

It is not well known among photographers that it is possible to combine two lenses made of the same type of glass to produce an achromatic combination; this is done by careful choice of the separation between the two lenses. At one particular spacing, the chromatic error of one lens will exactly cancel that of the other, and since the two glasses are alike, their variation in index is the same at every wavelength. Hence cancellation is complete at all wavelengths, and a very high order of chromatic correction can be attained in this manner. Unfortunately, the method does not admit of correction for other aberrations, and so it is used only for special purposes such as microscope and telescope eyepieces.

The more common method of correcting chromatic aberration is to use two different types of glass, having different refractive indexes but fairly similar dispersions (difference in index at different wavelengths). If a combination is made of the two glasses, one positive, the other negative, the chromatic errors will be canceled, but the combination will still have power because of the difference in refractive indexes.

The proper choice of glasses and adjustment of the powers of the two lenses will result in a pair of colors being brought to focus in the same plane. Which pair is chosen depends upon the use to which the lens is put — one pair is used for visual purposes, such as telescopes, microscopes, and projectors; another pair for photographic purposes. There are also special types of achromatism for work in the infrared and ultraviolet.

It must not be assumed, however, that bringing two colors to a focus will automatically bring all other colors to focus in the same plane — if this were the case, there would be no need for the different types of achromatism mentioned. Colors lying between the chosen pair will come to a focus somewhat closer to the lens, and those outside the pair will fall beyond the focus of the chosen colors. This error is called "secondary spectrum" and in the case of camera lenses is usually small enough so that it may be ignored except for very critical work. In fact, in such lenses, the exact type of achromatism is not very critical; any error in correction will merely result in some other pair of colors being brought to a common focus at the prescribed distance. Furthermore, the residual error will not have any great effect on the sharpness of the image. As in the case of spherical aberration, the out-of-focus rays are simply superimposed on the focused ones, causing a colored halo that reduces only the contrast of the image. But for critical work, such as color photography with large cameras,

color separation work in photomechanical processes, and color mapping, the residual color error, or secondary spectrum, must be minimized if it cannot be completely corrected.

One way of diminishing the secondary spectrum is to use certain special types of glass which have better characteristics than the usual ones for this type of correction, and can diminish the secondary spectrum to as little as $1/3$ to $1/5$ its normal value. The special glasses required for this type of color correction tend to be unstable, however, and so they are used only in certain apochromats, where simple symmetrical construction is important.

A material frequently used in place of glass for the correction of high-aperture microscope objectives is fluorite (calcium fluoride). This material has a very high refractive index and a low dispersion, and lenses made from it have very low secondary spectra. However, until recently, the only source of fluorite was certain mines where it was found in the form of natural crystals; these were seldom big enough for anything except microscope objectives. Recently, a method has been found to grow fluorite crystals artificially, and a new lens, the 300mm Canon $f/5.6$, contains two fluorite elements.

There is, however, another way to handle this problem, and that is to make a lens of *three* different types of glass and bring three different colors to a focus in the same plane. This method is employed in the so-called "photovisual" telescope objective, but is seldom used in camera lenses. For one thing, it is very difficult to find three glasses that have a set of dispersion and refraction ratios different enough to make this correction possible. For another, the final result is merely to bring a third color into focus, but colors between and outside the three are still out of focus, and this "tertiary spectrum" is often just about as bad as the secondary spectrum of an ordinary achromat.

In general, though, the problem is simply not that serious; secondary spectrum in camera lenses does not seriously degrade their performance, and a designer, if troubled by other aberrations, may sometimes allow large tolerances in achromatism.

Lateral Color. Lateral color, or chromatic difference of magnification signifies a difference, not of focus, but of image size, in various colors. This aberration is far more serious than simple axial chromatic aberration because it results in serious color fringes surrounding the outlines of objects. In color-separation work, it causes the three negatives to be different in size and impossible to bring into register. Even in black-and-white work, lateral color seriously degrades the sharpness of images, especially where the subject matter contains objects of a variety of colors.

Years ago, when most photography was done on films sensitive only to blue, the error was not considered serious; in essence, all photography was being done with light of a very restricted range of wavelengths. However, this explains why some old lenses that produced very sharp images years ago no longer do so; the lens has not deteriorated, but the use of panchromatic and color films brings to light the lateral color error which was in the lens all the time.

Lateral color must be eliminated in the design of the lens; it is independent of lens aperture and cannot be diminished by stopping down. This makes it just as serious in small lenses as in big ones. Luckily, there are several effective ways of correcting for lateral color.

The simplest method of correction is merely to make the lens symmetrical in form; the lateral color of the two elements is opposite in direction and is totally cancelled. This construction is generally used in process apochromats for photomechanical work.

In unsymmetrical systems of separated components, lateral color is corrected by making each component of the lens separately achromatic, rather than by depending on the color error of one element being corrected by an opposite error in the other. This is not difficult to accomplish, and most high-quality modern lenses are made in this manner. This criterion is important, though, for it explains why the addition of supplementary lenses, which are usually uncorrected, may degrade the definition of a lens quite seriously. Whereas stopping down will eliminate the other faults of lens attachments, such as spherical aberration, it will not affect lateral color. For this reason, some very high-grade close-up lenses are made as two-element achromats, as are many of the "tele-extenders" now being offered.

Nevertheless, it must be remembered that all the corrections of a lens are bound together, and all should be carefully balanced in the original design. Obviously, the better the correction of the prime lens, the more the addition of a partly-corrected attachment will affect it. This is not to say that these attachments are useless; it is only to point out that they are never as suitable as a good prime lens for critical work.

Aberrations and Focal Length. In designing a lens, the various dimensions are taken only as ratios; that is, the designer may begin a lens design with a focal length of "10" and a diameter of "2", producing an aperture of $f/5.0$. All curvatures, thicknesses, and spacings are given the same way, as simple numbers. The unit is not specified; it may be inches, centimeters, millimeters, or in the case of telescope objectives, feet or meters. The unit is decided on at the stage in design where the aberrations are being evaluated; if the lens is measured in centimeters, then the aberrations will come out in centimeters. If we use inches, then all dimensions and aberrations will be in inches and all will be two and one-half times larger.

It follows from this that all units may be used, or for that matter, any arbitrary unit, such as half-inches or quarter-feet. That is, if a good design exists for a three-inch lens, and a six-inch lens is wanted, it is not necessary to make a new design. All that is necessary is to double all the dimensions of the original lens and we have a new lens of the same aperture ratio and double the focal length. But in this case we also double the size of all the aberrations, and this is the key to the usefulness of this fact. If the three-inch lens had aberrations that were just barely tolerable, then the six-inch lens would have aberrations twice as big, and it would not be satisfactory.

On the other hand, if we have a satisfactory lens of three-inch focus and want a lens of one-inch focus, we have only to divide all its dimensions by three to secure the new design. In this case, of course, all the aberrations will also be reduced by a factor of three. In essence, making the lens smaller has actually improved it.

This explains why very good large-aperture lenses can be supplied at moderate cost for 8mm movie cameras, whereas for larger cameras the lenses require much better and more expensive construction. The current popularity of zoom lenses on 8mm movie cameras is based on this simple fact. These same lenses, if enlarged to the required size for a 16mm camera would be considered quite inferior, and with further enlargement for 35mm cameras would be quite worthless. Larger zoom lenses for 35mm cameras are more complex in construction, more highly corrected, and more expensive.

Lens Types

There are literally hundreds of types of lenses on the market, ranging from the simplest single-element box-camera lenses to very complex high-speed anastigmats; in addition, there are numerous specialty lenses such as telephotos,

wide-angle lenses, zoom lenses, and others. It is not possible in the limited space available here to discuss all these types; many lens structures simply defy classification, and anyway, there are many books that tabulate and illustrate the internal construction of camera lenses.

Actually, it is not really important to know the internal structure of a lens; in most cases this gives little clue to the purpose or performance of the objective. If a lens is an unsymmetrical four-element Tessar or a symmetrical four-element Gauss-type anastigmat, it is not likely that the user will find any real difference in performance. The choice of structure is mainly made by the designer for reasons of his own. In most cases, performance depends more on how well the design has been carried out than on what arrangement of elements has been chosen.

In the past, the number and arrangement of elements were used by the designer as starting points, to save a good deal of preliminary design work. He would choose, for example, an existing Tessar design of good performance, and most of his work consisted of attempting to improve its performance by minor changes in the types of glass and shapes of the elements.

Computer lens design has changed all that. In early attempts at computer designing, the computer was used simply to carry out the classical calculations of the various aberrations, just as the designer had done with his pencil and paper. It was soon discovered that this was unnecessary. The use of aberration theory began originally to save the labor of extensive ray-tracing; however, the computer can trace 1,000 rays per surface per second, and at this rate, it appears better to ignore all the classic aberrations and go directly to ray tracing.

The new programs, therefore, merely choose a group of rays and trace them through the lens formula, to determine how small an image spot results. After each pass, curvatures, thicknesses, or spacings are changed, and another set of rays is traced. The computer is programmed so that changes are made only as long as an improvement results; when changing a given surface ceases to produce an improvement, the computer automatically goes on to the next surface. This is repeated until no further improvement happens overall; then the computer stops and prints out the design of the lens as it appears at that point and gives an evaluation of the resolution and other performance factors.

If the design is satisfactory, the designer can accept it; if not, he may change one or more of the glass types and try another run. In any case, because of the huge speed of this system, it is no longer necessary to use any existing lens design as a starting point; the computer can start from nothing more than a number of flat plates of glass and end up with the same design, passing the existing design on the way.

As an example, the computer was given the following set of glass plates, in the order crown-flint-crown. The curve on the last surface gives the necessary power to the system, and decides the final focal length; all other surfaces were

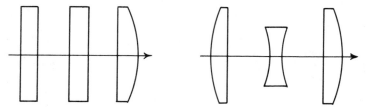

flat. What came out of the computer was in no way unusual; it was a typical triplet anastigmat. What *was* unusual was that the entire design run took just

four minutes; the same lens would have taken weeks or months to design by pencil-and-paper methods.

The example is, of course, trivial; the design which evolved is a well-known one. The reason, of course, is that the problem is a simple one. With only three elements and two glass types involved, the final result would have had to come out the way it did. This type of anastigmat has been studied for years and almost all the useful solutions to the problem are known. Given three elements of two types of glass, however, there are at least four arrangements possible. Two of them are not likely to be useful—crown-crown-flint or flint-flint-crown would tend to a highly unsymmetrical design. The crown-flint-crown combination is the well-known one, used for years. The remaining possibility—flint-crown-flint—opens a question as to why it had never been tried. It appeared that this arrangement had been explored to a limited degree, and it seemed to result in excessive distortion. Thus it did not seem to justify the amount of labor which would go into a thorough study.

In computer design, though, at 1,000 rays per second, one can carry out an extensive study of a lens design in a very short time. Furthermore, new variables can be added, and these may bring up new answers not previously contemplated. One of these is the thickness of the glass elements. In manual designing, thickness was chosen merely to ensure that the desired diameter could be attained with the most extreme curvature likely to be found; in the computer program, thickness was put into the system as an additional variable, and safeguards were provided to prevent an element from coming to a sharp edge at too small a diameter.

With this type of program, a computer run on the combination flint-crown-flint came up with the rather remarkable construction shown here. The thick-

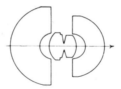

nesses of the elements are quite extreme, especially the center crown element. The result is, however, a wide-angle lens of unusual performance; it has a field of view of 110° and a fixed aperture of $f/8$. Because of its extreme angle of view, it is not possible to put a diaphragm between the elements; the V-shaped groove in the center element acts to stop the lens down to its normal and fixed $f/8$. This lens is now being manufactured as the Zeiss Hologon $f/8$. In a focal length of 15mm it covers a 35mm double frame with excellent definition, it is free from distortion, and because of a special property of its exit pupil, it gives better than normal corner illumination.

Still, this is a simple case. Years ago, designers tried to improve on the simple triplet by splitting the front and rear crown elements into achromatic doublets (below); it was reasoned that with five elements, or ten surfaces, better correction

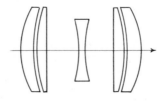

could be attained. Sometimes it was, sometimes the more complicated lens did not perform any better than the simple triplet.

A 15-minute computer run on this set of glasses, with freedom to vary thicknesses as well, resulted in the rather startling design shown below. An old-time designer would not even have tried such a construction; by former standards the curves are excessively deep and would have been expected to lead to excessive astigmatism.

Nothing of the sort has happened; the correction attained with this construction is very high, and the lens is an excellent performer. At an aperture of $f/2.8$, it is currently made as the Zeiss Planar and the Schneider Xenotar; the design has been carried to an aperture of $f/2.0$ in the Wray Unilite.

It is hard to classify this design; it certainly bears little resemblance to the triplet from which it was derived, especially as all semblance of symmetry is gone. The lesson to be learned from this is that cross-sectional diagrams of lenses really convey no useful information to the practical photographer; the only way to judge a lens is by its performance in actual picture-taking.

The Telephoto Lens

If a negative and positive lens of equal power are placed in contact with each other, they neutralize one another and have no more power than a piece of flat glass. If these two lenses are separated, the combination develops a focal length, long at first, gradually shortening as the space increases. When the separation is equal to the focal length of the positive lens, the focal length of the combination is the same as that of the positive lens alone. But, more important, as the components are separated, the principal point moves away from the lens in the direction of the subject. Since, however, focal length is defined as the distance from the principal point to the focal plane, we find that the back focus of the combination is much shorter than its equivalent focal length. Thus we can make a lens of long focus but short extension, and such a combination is called a *telephoto lens*.

Early telephoto lenses were made of a positive combination, similar to a rapid rectilinear lens, and a fairly well corrected negative rear component composed of two or three elements. Many of these were mounted in such a manner that the spacing between the two main components could be varied, and thus the focal length of the combination could be changed to suit the job at hand. This variation of focal length, however, went hand-in-hand with a change in back focus, so the lens had to be refocused for every new adjustment. In addition, its aperture changed with every setting, and complicated tables were needed to determine what $f/$stop was actually in use at any time.

This construction was not very well corrected, and it was taken as an axiom at the time that a telephoto lens could not produce as sharp an image as a normal objective. Still, it had some usefulness. Furthermore, since the front element was usually a more-or-less common camera lens of the Rapid Rectilinear type, many manufacturers offered rear elements only, known as "tele-negative" components, which could be used with whatever camera lens the

518

photographer happened to have. In a way, these tele-negative elements were similar to the "tele-extenders" currently popular with users of 35mm single-lens reflex cameras. However, we know by now that adding any kind of partly-corrected lens system to one that is fully corrected can only upset the corrections of the system as a whole. Thus these devices are useful only for relatively non-critical applications.

It was eventually realized that a telephoto lens had to be designed as a single unit, for a single, fixed magnification if good performance were to be attained. Furthermore, the magnification had to be kept fairly low, simply to avoid ending up with either a very bulky lens, or one of too small an f/number to be of much use. Only by designing the lens as a unit can the distortion be kept to manageable amounts; the combination of a positive front and negative rear combination is subject to a good deal of distortion unless special pains are taken to minimize this particular aberration.

With the general popularity of small cameras, the need for telephoto lenses has diminished; for the magnifications usually used, it is easier and better to use a normal camera lens of the appropriate focal length. Even for very long focal lengths, prime lenses are preferred. For one thing, when a lens of 400 mm focal length is used on a 35mm camera, the field of view is so narrow that a simple two-element achromat will often perform as well as a much more complicated objective. In this way we can make large but lightweight long-focus lenses of moderate aperture and excellent performance.

The small camera has another problem; it is lacking in room for short back-focus lenses of the wide-angle type. Like most optical systems, however, the telephoto lens is reversible; if we put the negative element in front and the positive in the rear, we have what is known as a "retrofocus" lens, which has a short focal length and a long back focus. In this way we can make wide-angle lenses with ample clearance behind them to allow for the mirror and shutter of the single-lens reflex camera. Such lenses are also essential for use with turret-type motion-picture cameras.

Zoom Lenses

Variable focal length telephoto lenses have been known for over half a century, but these earlier lenses could not be considered "zoom" lenses because they did not meet two important criteria. A zoom lens must remain in focus as its focal length is varied, and it must retain the same relative aperture at all focal lengths.

To meet the first criterion, there are, obviously, two possibilities. The first is mechanical compensation—some kind of linkage between the focusing movement and the focal-length movement, such that the distance of the whole lens to the film is changed as the lens is adjusted from one focal length to another. The difficulty with such a system, which was actually used in some early zoom lenses, is that it becomes hopelessly complicated if we also wish to adjust this linkage to focus on objects at different distances. These early lenses, therefore, were fixed focus; they were designed for a single distance, such as 25 feet, and then other distances were focused upon by the use of supplementary lenses placed in front of the whole system.

The second method is that used in all modern zoom lenses: it is known as optical compensation. In these lenses, there are two groups of moving elements, such that one adjusts the focal length and the other maintains a constant focal distance. Such lenses can be focused by the common method of separating the sections of the front element.

This system is only approximate at best. It is actually impossible for such a system to be in focus for more than two settings, and the problem that re-

mains is simply to minimize the error at intermediate positions. If this can be done so that the focusing error is no greater than the normal depth of focus of a lens of similar focal length and aperture, then we can consider it fully corrected for most purposes.

This focusing error is proportionate to the size of the lens as a whole. Thus large zoom lenses for television cameras are exceedingly difficult to make and extremely expensive. Smaller zoom lenses for 35mm motion-picture and still cameras are practical, and not too expensive, but their definition seldom equals that of a good prime lens for the same camera. In the case of 8mm cameras, the errors become small enough so that zoom lenses are commonly provided on all but the least expensive of these cameras, and zoom objectives are commonly provided for the 8mm projector also.

The second criterion, that a zoom lens retain its relative aperture at all focal-length settings is obviously necessary if the lens is to be used on movie cameras, where the focal length is generally changed during the filming of a scene. This is not, however, a difficult problem; since the lens has been designed for a constant back focus, all that is necessary is to maintain a constant diameter of the exit pupil, and the diaphragm markings will be true at any focal length. This is accomplished by placing the diaphragm in the back part of the lens system, behind the moving sections; thus its size as seen through the back element of the lens does not vary in size with a change of focal length setting. If, then, the front elements are made large enough so that the image of their aperture is never smaller than the diaphragm aperture at its largest settings, the diaphragm will control the aperture of the entire lens at any focal length setting, and its aperture will not change regardless of magnification.

Afocal Converters

When a camera has a permanently mounted lens, it is sometimes desirable to have an attachment made that will shorten or lengthen the focus of the main lens without changing its back focus.

If a positive and a negative lens are separated by a distance equal to the difference between their focal lengths, rays that enter parallel (as from an object at infinity) emerge parallel, or apparently still coming from an infinite distance. Thus these combinations can produce an enlarged or reduced image of an object without affecting the focus of the lens over which they are used. Essentially, the combination of a negative eyepiece and positive objective is a Newtonian telescope, and it is well known that reversing such an instrument reduces the size of the image instead of enlarging it. Thus it is possible to make such a device act either as a telephoto or a wide angle lens, and in a few cases it can even be made reversible so it will serve either purpose.

There is a temptation to use ordinary binoculars in this manner, and in fact, attachments are sold to fit a pair of binoculars to a camera lens. While binoculars are fairly well corrected for their intended purpose, the achromatism is visual, not photographic, and definition will suffer.

However, if an afocal converter is made specifically for a given camera lens, with full corrections, it can work very well indeed. Some telephoto attachments are sold for twin-lens reflexes, which perform quite well; also a wide-angle converter for the Kodak Cine-Ektar lens was sold for some time and used by professionals with excellent results.

One point in this construction is that the ratio of diameters of the front and rear elements must be the same as the magnification (or reduction) of the lens attachment. If this is the case, then the exit pupil is as large as the entrance pupil of the camera lens, and there is no change in f/number settings.

The camera diaphragm numbers then retain their value and can be used for exposure control in the normal way. However, the focusing scale on the camera lens can no longer be used when a converter is attached; focusing movements are the same as if the prime lens had the new focal length.

Obviously, to make such an adapter reversible, both front and rear elements must be very large, as either one will have to be used as front element. This makes the whole thing quite bulky and difficult to mount and corrections for focusing distances closer than infinity cannot be the same in both directions. For these reasons, few such attachments are marketed, though there is one available for motion picture projectors. Its magnification is quite low, however; used with a two-inch projection lens, it produces focal lengths of either 1½ or 2½ inches, depending on which way it is turned.

The main reason the afocal converter is not more popular is simply that it is large and bulky, but more important, if it is not to damage the corrections of the prime lens, it must itself be fully corrected, which requires four elements at least. Such a lens will not cost much less than a prime lens of the same size.

Simple Lens Attachments; Diopter Measure

Small changes in focal length can be accomplished by adding a thin lens to an existing combination. If the added element is thin enough, it has little effect on the corrections of the system, and this provides a useful means to extend the usefulness of certain lens systems.

For many years a simple lens of about three-foot focal length was sold as a "portrait attachment"; it was intended for use on box cameras to focus them for the closer distance required for head-and-shoulder pictures. Since a box camera lens is substantially uncorrected to begin with, and since a lens having a focal length of three feet and a diameter of no more than an inch will be very thin and almost flat, such a setup worked quite satisfactorily. However, there is often a requirement to make a similar adjustment in focal length of better-corrected systems, and the usual expedient is to use simple spectacle lenses.

Opticians who work mainly with thin lenses use a special system of measurement. When two thin lenses are placed in contact, the combined focal length (f) is given by the following formula:

$$\frac{1}{f} = \frac{1}{f_1} + \frac{1}{f_2}.$$

This is not an easy formula to evaluate, but if lenses are marked with their "powers," where "power" is defined as

$$D = \frac{1}{f}$$

then the formula reduces to nothing more than

$$D = D_1 + D_2$$

and one can combine lens powers by simple addition or subtraction. The question of units is simple: if the focal length of the lens is given in meters, then the power D is in *diopters*. Thus a lens having a focal length of one meter has a power of one diopter, if its focal length is two meters, the power is 0.5 diopter, if the focal length is ½ meter, then the power is 2 diopters, ¼ meter is 4 diopters, and so on.*

*Because the powers of lenses are given in diopters, some writers in the amateur press have been referring to them as "diopter lenses". This terminology is careless and should be stamped out.

If one places a thin positive lens over the camera lens, and the latter is focused on infinity, then the combination is now focused at a distance equal to the focal length of the thin lens. Knowing the focal length of the attachment (which can be deduced from its power as explained above), we can do closeup copying and portraits by the use of such simple positive attachments.

It must be emphasized that the term "thin lens" means, in theory, a lens which is infinitely thin; any thickness causes the appearance of aberrations. Where the lens is substantially equivalent to a true thin lens, the added aberrations will be small and are easily compensated by simply stopping down the lens; however, the use of strong positive lenses, such as +3, +4 or +5 (or combinations of lower-powered lenses of equivalent strength) will definitely degrade the definition of the main lens except at extremely small apertures.

A few high-quality supplementary lenses of +1, +2 and +3 diopter strength are offered for high grade work; these are doublets, corrected mainly for chromatic aberration, but probably having some spherical and coma correction as well. These are definitely superior to simple spectacle lenses for their intended purposes.

CLOSE-UP LENSES

The formulas for combined focal length, field size, and wide-angle work apply only when the separation between the close-up lens and the camera lens is very small compared with the focal length of the camera lens. For this reason, they do not apply precisely to 35mm cameras and they do not apply at all to movie cameras.

The following quantities, except "s" must all be expressed in meters. The answer will be in meters.

F_s = focal length of closeup lens = $1/D$

D = power in diopters (1+, 2+, 3+) of closeup lens

u = distance from closeup lens to subject

s = focusing scale setting *in feet*

F_c = combined focal length of camera lens and closeup lens

F = focal length of camera lens

W = field width

w = negative width

Subject Distance

Distance for Infinity Setting

$$u = F_s = \frac{1}{D} \ ; \text{for two closeup lenses} = \frac{1}{D_1 + D_2}$$

Distance for focusing scale set at "s" feet

$$u = \frac{1}{\left\{ D + \frac{3.28}{s} \right\}} \quad *$$

*3.28/s is "power of focusing scale." This is equivalent to the power of a closeup lens which would cause the same change of focus. For example, changing the focusing scale setting from infinity to 3 feet is equivalent to adding slightly more than one diopter to the power of the closeup lens used.

522

To find s and D for given u:

$$\frac{1}{u} - D = \frac{3.28}{s}$$

Take highest whole number of D (1, 2, 3) that is not larger than 1/u. Solve for s.

Combined Focal Length

$$Fc = \frac{1}{1 + FD}$$

Field Size

For Infinity Setting:

$$W = \frac{w \, Fs}{F}$$

For Front-Element Focusing† Lens at s feet:

$$W = \frac{w}{F\left\{D + \frac{3.28}{s}\right\}}$$

For Unit Focusing† Lens at s feet:

$$W = \frac{\left\{\dfrac{1}{D + \dfrac{3.28}{s}}\right\} - F}{F} \, w$$

Field height is proportional to negative height.

For Wide-Angle Use — with view-type cameras and lens-to-film distances shorter than when the lens is set on infinity.

$$\textit{Width of Field with close-up lens} = \frac{\textit{Width of field without}}{\textit{close-up lens}} \times (1 + FD)$$

† Open the back of your camera and look at the lens while adjusting the focus. If the rear lens element moves, your lens is unit focusing; if it doesn't move, your lens is front-element focusing.

SUBJECT-IMAGE RELATIONS

To determine the relative sizes of object and image, there are a number of formulas available. All of them require a knowledge of the focal length of the lens.

Most lenses have the focal length printed on the side or end of the mount. The focal length of a normal camera lens (not a telephoto or retrofocus wide angle lens) is equal to the distance from approximately the center of the lens to the image plane, when the lens is focused on infinity. If you do not know the focal length of a given lens, you can measure it from the center of the lens. This is sufficiently precise for the formulas on the following pages.

A more accurate method of determining the focal length of a lens is to focus first on infinity, then on a close subject at a distance that produces a "same-size" image. Measure the lens-to-film distance at each setting, using any convenient point on the lens mount for both measurements (the same point must be used, of course). The difference between the two measurements is equal to the focal length. This method can only be used when you have a camera with groundglass focusing and sufficient extension to produce unit magnification (twice the nominal focal length of the lens).

APPROXIMATE POSITION OF SUBJECT AND IMAGE

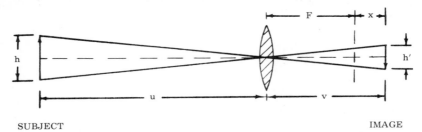

SUBJECT IMAGE

F = focal length u = subject distance h = height of subject*
m = magnification v = image distance h' = height of image*
x = distance of image from focal point, or distance that lens is extended from
 infinity setting.

All dimensions must be expressed in the same unit of measure.

To convert dimension in	divide by
millimeters to meters	1000
centimeters to meters	100
inches to meters	39.4
feet to meters	3.28
millimeters to inches	25.4

The fundamental relationship between focal length, image distance, and subject distance is:

$$\frac{1}{F} = \frac{1}{v} + \frac{1}{u}$$

Formulas that are more directly useful and some examples follow.

* You can use width of the subject for h, then h' becomes width of the image.

Magnification

$$m = \frac{h'}{h} = \frac{v}{u} = \frac{v-F}{F} = \frac{F}{u-F}$$

Lens movement from infinity position

$$x = \frac{F^2}{u - F}$$

Lens to image

$$v = \frac{Fu}{u - F} = mu = (m + 1)F$$

Subject to image

$$u + v = \frac{(m + 1)^2}{m} F$$

Lens to subject

$$u = \frac{Fv}{v - F} = \frac{v}{m} = \left\{ \frac{1}{m} + 1 \right\} F$$

Example 1: What is the shortest length studio you can use for photographing groups, 10 feet wide, with an eight-inch focal-length lens on a 4″ x 5″ camera?

Solution: Allow 4½ inches on horizontal negative for image.

$$\text{Then } m = \frac{4.5}{120} = .038$$

$$\text{and } u = \left\{ \frac{1}{.038} + 1 \right\} F = (26.3 + 1)F = 27.3 \times 8 =$$

$$218 \text{ inches} = 18+ \text{ feet.}$$

This answer gives the lens-to-subject distance. You will also need to add at least seven feet to allow room for the camera, operator, background separation, and other factors. The minimum room length is therefore 25 feet. The room width must be at least 15 feet in order to accommodate the group and lights.

Focal Length

$$F = \frac{u}{\left\{ \frac{1}{m} + 1 \right\}} = \frac{v}{m + 1}$$

Example 2: For a studio 20′ x 32′, and a 2¼″ x 2¼″ camera, what is the longest focal length lens feasible for photographing a scene 10 feet wide?

Solution: Since you need about 7 feet of room length for working space, the maximum lens-to-subject distance available is 25 feet or 300 inches; u = 300. You should allow at least 1/8 inch of space on either side of the negative. The usable width of the negative is then 2 inches. Since the width of the subject is 10 feet, or 120 inches, the magnification (m) equals 2 divided by 120, or .017. The formula now reads:

$$F = \frac{300}{1/.017 + 1} = \frac{300}{59 + 1} = \frac{300}{60} = 5$$

Answer: 5 inches, or 127mm, is the maximum usable focal length.

Field Size (Front-element focusing lenses) :

$$\text{Field width} = \text{negative width} \times \frac{u}{F}$$

With a lens of normal focal length (not telephoto or wide angle), measuring u and v from the center of the lens is accurate enough for practical use. The formulas that do not include v are valid for telephoto lenses and wide-angle lenses when u is large enough so that any inaccuracy in measuring u from the center of the lens is insignificant.

LENS DIAPHRAGM AND ITS MARKINGS — f/NUMBERS

Simple lenses in inexpensive cameras have a fixed lens opening or a series of apertures in a movable slide or disc. More complex lenses have an adjustable lens opening, called a lens diaphragm, that varies the amount of light that passes through the lens. The size of this opening is indicated by a lens-aperture scale marked in f/numbers (sometimes called f/stops). Each f/number is equal to the focal length of the lens divided by the effective diameter of the lens aperture. The f/numbers $f/1.4$, $f/2$, $f/2.8$, $f/4$, $f/5.6$, $f/8$, $f/11$, $f/16$, $f/22$, $f/32$, and $f/45$ are full-stop increments. Each lens opening in the series transmits one-half as much light as the preceding lens opening (for example, $f/5.6$ transmits half as much light as $f/4$). Most lenses do not have a range of apertures this great. Sometimes the largest lens opening on a lens is less than one full f/stop from the next marked lens opening. Examples are $f/3.5$, $f/4.5$, and $f/6.3$. The lens diaphragm is continuously variable so that you can set the lens opening at intermediate f/numbers for small changes in exposure.

Most lenses today are coated during manufacture to increase light transmission and reduce lens flare. At a given f/number there is practically no difference in light transmission between coated complex lenses and coated single-element lenses. Uncoated lenses, however, are not as efficient in light transmission. Different types of uncoated lenses vary in their light-transmission efficiency so that their f/numbers are not necessarily equivalent measurements. An uncoated lens that has eight glass-air surfaces, for example, may transmit only about 60 per cent as much light as a single lens, due to loss of light by reflection. Most coated lenses, on the other hand, have a transmittance of about 95 per cent.

Effective f/Number for Lens Extension. When you use a bellows extension or extension tubes to make extreme close-ups, the lens-to-film distance becomes significantly greater than the focal length. As a result, the effective f/number is higher than indicated on the aperture scale. To correct for this effect, an exposure compensation is necessary when the subject distance is less than eight times the focal length of the camera lens. This is especially important when you take pictures on color-slide film or when you use high-contrast black-and-white film for copying work. Exposure in these instances must be close to optimum for the best pictures. Use the formula for computing effective f/number given below. You can obtain the effective f/number more quickly without calculation by using the Effective Aperture Computer in the *Kodak Master Photoguide* (AR-21).

Effective f/number for Lens Extension is greater than the indicated f/number because of the increased image distance (lens-to-film distance). When the subject distance, u, is less than eight times the focal length of the camera lens, use one of the following formulas to determine the required exposure compensation.

Effective f/number (for any subject distance) $= \dfrac{v \times f}{F} = f(m + 1)$

Exposure time for lens extension = Normally computed exposure time $\times \dfrac{v^2}{F^2}$

Where v = lens-to-film distance, or focal length plus lens extension from infinity focus, $f = f$/number indicated on aperture scale, and F = focal length. For close-up pictures with lens extension, (1) use effective f/number for computing your exposure, or (2) compensate your exposure time directly by using the second formula which includes exposure time.

DEPTH OF FIELD

Depth-of-field computations are made on the basis of a fixed circle of confusion or on a circle of confusion equal to a fraction of the focal length. Lenses of different focal lengths used at the same f/number have the same depth of field for equal image sizes. As a general rule, one-third of the depth of field is in front of the subject and two-thirds is behind the subject. An exception to this rule is extreme close-ups, including those made with close-up lenses, where depth of field is about equal on both sides of the subject.

Method A, fixed circle of confusion:

F = focal length of lens
f = f/number of relative aperture
H = hyperfocal distance
u = distance for which camera is focused
d = diameter of circle of confusion

Camera	Fixed circle of confusion most widely used (in inches)
Regular 8mm movie	.0005
Super 8mm movie	.00065
16mm movie	.001
135 (24 x 36mm)	.002
126 (28 x 28mm)	.002
Roll-film	.005
4″ x 5″ and larger	F/1720 critical use or F/1000 liberal use

Near limit of depth of field (measured from camera lens) $\dfrac{H \times u}{H + (u - F)}$

Far limit of depth of field (measured from camera lens) $\dfrac{H \times u}{H - (u - F)}$

Hyperfocal Distance (near limit of depth of field when lens is set at infinity)

$$H = \frac{F^2}{f \times d}$$

Method B, circle of confusion a fraction of the focal length of the lens:

u = distance focused upon
θ = angular size of circle of confusion. For critical definition, θ is 2 minutes of arc and the linear size of the circle of confusion is approximately F/1720 (tan $2'$ = .00058).
L = effective diameter of lens = $\dfrac{F}{f}$

$$\text{Near limit of depth of field} \atop \text{(measured from plane focused upon)} = \frac{u^2 \tan \theta}{L + u \tan \theta}$$

$$\text{Far limit of depth of field} \atop \text{(measured from plane focused upon)} = \frac{u^2 \tan \theta}{L - u \tan \theta}$$

USING DEPTH OF FIELD

Depth of field is the range of acceptably sharp focus in front of and behind the distance the camera is focused on. Usually by selectively controlling depth of field, you can place the emphasis where you want it in your pictures. For example, you can use a larger lens opening to intentionally throw the foreground or background out of focus. To determine the range of sharp focus, consult the depth-of-field scale on your camera, or the depth-of-field tables in this section.

To get the maximum depth of field for a particular lens opening, focus your camera lens on the hyperfocal distance (defined below). The easiest way to do this with a camera that has a depth-of-field scale is to set the far limit indicator for the lens opening you are using opposite the infinity mark on the focusing scale. Infinity is usually indicated on the focusing scale by "INF" or "∞". The infinity setting focuses the lens for distances beyond the maximum distance in feet (or meters) marked on the focusing scale.

HYPERFOCAL DISTANCE

Hyperfocal distance is just a special application of depth of field. When a lens is focused on infinity, the distance beyond which all objects are in satisfactory sharp focus is the hyperfocal distance.

If you focus a lens on the hyperfocal distance, objects from half of the hyperfocal distance to infinity will appear in sharp focus.

For example, first focus a 35mm focal length lens on infinity. Set the lens opening at $f/11$. The depth-of-field scale shows that all objects from 11 feet to infinity will look sharp. The hyperfocal distance is therefore 11 feet. But when you focus the lens on 11 feet all objects from 6 feet to infinity are sharp. This gives you the greatest depth of field for this lens opening. As you open the lens diaphragm to larger apertures, the hyperfocal distance increases.

Many photographers waste depth of field without realizing it. In the example just described, if you had focused your camera lens on 50 feet (instead of the hyperfocal distance) for a subject 50 feet away, your depth of field would be from 10 feet to infinity. This would result in a four-foot loss in foreground sharpness.

DEPTH OF FIELD TABLES

The following Depth-of-Field Tables are abridged from *Official Depth of Field Tables for 35mm Cameras*, published by Amphoto. This very authoritative work contains two sets of depth of field tables, calculated at 1/40mm and 1/50mm circle of confusion for normal and for critical work. These tables cover lenses from 21mm to 1000mm in focal length, and apertures from $f/0.95$ to $f/45$.

Those photographers who require this much data are, of course, referred to that book for the complete set of tables. Most workers will require only a selected few of the tables, and even then, these can be condensed by the omission of some lens apertures; no lens of 1000mm focal length has yet been made with an aperture of $f/0.95$. If such a lens did exist, it would be a monster, more than three feet in diameter; it would not be of much use on a 35mm camera. We have, in fact, omitted all focal lengths longer than 400mm, and all apertures larger than $f/1.4$.

The tables as originally published were compiled by an IBM 7090 computer and printed just as they came out of the machine, except that a more legible type was used. The condensation herein was done by manual selection and a simple rounding-off procedure. The printing was done on an IBM Model 615 "Selectric" Composer by the compiler to avoid errors of transcription.

The rounding-off procedure followed these rules: distances beyond 500 feet are given as INF. Distances from 100 feet to 500 feet are given to the nearest whole foot, distances from 10 feet to 99 feet are given to the nearest whole inch, and distances less than 10 feet are given to the nearest quarter-inch.

There are two special cases in these tables. One is where the original table gave a depth of field, for example, from 650 feet to infinity. Rather than mark this as INF to INF, we have simply placed a dash in those columns, indicating that there is no useful depth of field. The same dash is also used at close ranges and large apertures where total depth of field is less than one-quarter inch; again, the meaning of the dash is "no useful depth of field."

These tables are calculated for a circle of confusion of 1/40mm (1/1000 inch). This is satisfactory for all but the most critical work with 35mm still and motion-picture cameras and is the value generally used by professionals with 16mm cameras also.

Those using larger cameras may find the value of 1/40mm too critical. Generally, with cameras using #120 roll film, a value of 1/30mm (1/750 inch) is ample, and for bigger cameras, such as 4" x 5" press cameras, 1/20mm (1/500 inch) is satisfactory. Remembering the inevitable vagueness of depth of field figures (one cannot be sure where the zone of sharp focus really ends) it is not necessary to make a new set of tables for each of these situations; the tables herewith can be used with the aid of a simple artifice.

The method is simply to multiply the $f/$stop in use by the ratio of the desired circle of confusion to the one used. If we wanted to use 1/20mm instead of 1/40mm — the ratio of these two figures is 2 to 1 — we would multiply the $f/$stop by 2. That is, if we were to use $f/8$, then we would find the depth of field for this stop in the column corresponding to $f/8$ x $2 = f/16$. This will have the effect of giving us a larger depth of field, which is, of course, exactly what happens when we admit a larger circle of confusion.

We do not have to do even this much arithmetic; we need only remember: if we want the depth of field for 1/750 inch (1/30mm), use the figures one column to the right of the lens stop in use. For 1/20mm (1/500 inch) move

over two columns. For 1/15mm (1/375 inch) move over three columns, and for 1/10mm (1/250 inch), move over four columns.

The tables have been condensed to seven lens stops, and these have been chosen according to the likelihood of their being found on a given lens. Thus, in extreme wide-angle lenses, such as 21mm, the largest aperture likely to be found is $f/2.8$ and the table begins at that aperture. The 50mm and one or two other lenses start at $f/1.4$, go only to $f/11$. Long-focus lenses again start at about $f/2.8$ or $f/4$ and go to fairly small apertures.

If demand develops for additional focal lengths or for extended tables in the focal lengths given, they will be added to the book in future supplements.

Depth of Field: 21mm Lens — Circle of Confusion 1/40mm (.001")

Distance (Feet)	2.0		2.8		4.0		5.6		8		11		16	
	FROM	TO	FROM	TO	FROM	TO	FROM	TO	FROM	TO	FROM	TO	FROM	TO
INF	29'0"	INF	20'9"	INF	14'6"	INF	10'5"	INF	7'3½"	INF	5'4"	INF	3'8¼"	INF
200	25'4"	INF	18'9"	INF	13'7"	INF	9'10¾"	INF	7'0½"	INF	5'2¼"	INF	3'7½"	INF
100	22'6"	INF	17'2"	INF	12'8"	INF	9'5¼"	INF	6'10"	INF	5'0"	INF	3'6¾"	INF
50	18'4"	INF	14'8"	INF	11'3½"	INF	8'7½"	INF	6'4¾"	INF	4'10"	INF	3'5½"	INF
30	14'9"	INF	12'3"	INF	9'10"	INF	7'9"	INF	5'10¾"	INF	4'6½"	INF	3'3½"	INF
20	11'11"	64'0"	10'5"	INF	8'5½"	INF	6'10½"	INF	5'4½"	INF	4'2¼"	INF	3'1½"	INF
15	9'11"	30'11"	8'9"	53'10"	7'5"	INF	6'2"	INF	4'11¼"	INF	3'11½"	INF	2'11¼"	INF
10	7'5½"	15'2"	6'9¼"	19'2"	5'11½"	31'9"	5'1½"	INF	4'3"	INF	3'6"	INF	2'8½"	INF
7	5'8"	9'2¼"	5'3"	10'6"	4'9"	13'5"	4'2½"	21'2"	3'7¼"	166'	3'0½"	INF	2'5¼"	INF
5	4'3½"	6'0¼"	4'0½"	6'6½"	3'9"	7'6½"	3'5"	9'6"	3'0"	15'7"	2'7½"	78'8"	2'2"	INF
3	2'8¾"	3'4"	2'7½"	3'5½"	2'6"	3'9"	2'4¼"	4'2"	2'2"	5'0"	1'11½"	6'8¼"	1'8¼"	15'6"
2	1'10½"	2'1¾"	1'10"	2'2½"	1'9¼"	2'3½"	1'8½"	2'5¼"	1'7"	2'8½"	1'5¾"	3'1½"	1'4"	4'2½"

Depth of Field: 25mm Lens — Circle of Confusion 1/40mm (.001")

Distance (Feet)	1.4 FROM	1.4 TO	2.0 FROM	2.0 TO	2.8 FROM	2.8 TO	4.0 FROM	4.0 TO	5.6 FROM	5.6 TO	8 FROM	8 TO	11 FROM	11 TO
INF	58'8"	INF	41'1"	INF	29'5"	INF	20'7"	INF	14'9"	INF	10'4"	INF	7'6½"	INF
200	45'5"	INF	34'1"	INF	25'8"	INF	18'8"	INF	13'9"	INF	9'10"	INF	7'3"	INF
100	37'0"	INF	29'2"	INF	22'9"	INF	17'1"	INF	12'10"	INF	9'4½"	INF	7'0¼"	INF
50	27'0"	337'	22'7"	INF	18'6"	INF	14'7"	INF	11'5"	INF	8'7"	INF	6'6¾"	INF
30	19'11"	61'3"	17'5"	111'	14'11"	INF	12'3"	INF	9'11"	INF	7'8½"	INF	6'0½"	INF
20	14'11"	30'3"	13'6"	38'10"	11'11"	624"	10'2"	695'	8'6¼"	INF	6'10¼"	INF	5'6"	INF
15	12'0"	20'1"	11'0"	23'6"	9'11½"	30'6"	8'8½"	54'10"	7'5¾"	INF	6'2"	INF	5'0½"	INF
10	8'6¾"	12'0"	8'0¾"	13'2"	7'6"	15'1"	6'9¾"	19'4"	6'0"	30'10"	5'1½"	304'	4'4"	INF
7	6'3¾"	7'11"	6'0"	8'5"	5'8¾"	9'1¾"	5'3"	10'6"	4'9½"	13'3"	4'2½"	21'4"	3'8"	96'0"
5	4'7½"	5'5½"	4'5¾"	5'8"	4'3½"	6'0"	4'0½"	6'6½"	3'9¾"	7'5¾"	3'5"	9'6½"	3'0½"	14'6"
3	2'10½"	3'1½"	2'9¾"	3'2¾"	2'8¾"	3'4"	2'7½"	3'5¾"	2'6¼"	3'8¾"	2'4¼"	4'2"	2'2"	4'10½"
2	1'11½"	2'0¾"	1'11"	2'1"	1'10½"	2'1½"	1'10"	2'2½"	1'9¼"	2'3½"	1'8½"	2'5¼"	1'7¾"	2'8"

Depth of Field: 28mm Lens — Circle of Confusion 1/40mm (.001")

Distance (Feet)	2.0 FROM	2.0 TO	2.8 FROM	2.8 TO	4.0 FROM	4.0 TO	5.6 FROM	5.6 TO	8 FROM	8 TO	11 FROM	11 TO	16 FROM	16 TO
INF	51'6"	INF	36'10"	INF	25'10"	INF	18'6"	INF	12'11"	INF	9'5¼"	INF	6'6¼"	INF
200	41'0"	INF	31'2"	INF	22'11"	INF	16'11"	INF	12'2"	INF	9'0¼"	INF	6'4"	INF
100	34'1"	INF	27'0"	INF	20'7"	INF	15'7"	INF	11'6"	INF	8'7¾"	INF	6'1½"	INF
50	25'5"	INF	21'3"	INF	17'1"	INF	13'6"	INF	10'4"	INF	7'11½"	INF	5'9½"	INF
30	19'0"	71'6"	16'7"	160'	13'11"	INF	11'6"	INF	9'1"	INF	7'2½"	INF	5'4½"	INF
20	14'5"	32'7"	13'0"	43'6"	11'4"	88'2"	9'7¾"	INF	7'11"	INF	6'5½"	INF	4'11½"	INF
15	11'8"	21'1"	10'8"	25'2"	9'6½"	35'7"	8'4"	79'2"	7'0"	INF	5'10"	INF	4'7"	INF
10	8'4¾"	12'4"	7'10¾"	13'8"	7'3"	16'2½"	6'6¼"	21'7"	5'8¼"	43'3"	4'10¾"	INF	4'0"	INF
7	6'2¼"	8'1"	5'11"	8'7¼"	5'6½"	9'6½"	5'1½"	11'2"	4'7"	15'0"	4'0¾"	26'6"	3'5"	INF
5	4'7"	5'6¼"	4'5"	5'9"	4'2½"	6'2"	3'11½"	6'9½"	3'7¾"	8'0¼"	3'3¼"	10'5"	2'10½"	20'10¾"
3	2'10"	3'2"	2'9½"	3'3"	2'8½"	3'4½"	2'7"	3'6½"	2'5½"	3'10¼"	2'3¾"	4'3¾"	2'1"	5'4¾"
2	1'11¼"	2'1"	1'11"	2'1¼"	1'10½"	2'2"	1'10"	2'2¾"	1'9"	2'4"	1'8"	2'6"	1'6¾"	2'9¾"

Depth of Field: 35mm Lens — Circle of Confusion 1/40mm (.001")

Distance (Feet)	1.4 FROM	1.4 TO	2.0 FROM	2.0 TO	2.8 FROM	2.8 TO	4.0 FROM	4.0 TO	5.6 FROM	5.6 TO	8 FROM	8 TO	11 FROM	11 TO
INF	114'	INF	80'6"	INF	57'6"	INF	40'4"	INF	28'10"	INF	20'3"	INF	14'9"	INF
200	73'0"	INF	57'5"	INF	44'9"	INF	33'7"	INF	25'3"	INF	18'5"	INF	13'9"	INF
100	53'6"	INF	44'8"	INF	36'7"	INF	28'9"	INF	22'5"	INF	16'10"	INF	12'10"	INF
50	34'11"	88'4"	30'11"	131'	26'10"	INF	22'5"	INF	18'4"	INF	14'5"	INF	11'5"	INF
30	23'10"	40'6"	21'11"	47'8"	19'9"	62'5"	17'3"	116'	14'9"	INF	12'2"	INF	9'11"	INF
20	17'1"	24'2"	16'1"	26'6"	14'11"	30'6"	13'5"	39'6"	11'10"	64'10"	10'1"	INF	8'6½"	INF
15	13'4½"	17'3"	12'8"	18'5"	11'11"	20'3"	11'0"	23'9"	9'11"	31'0"	8'8"	57'6"	7'6"	INF
10	9'2½"	10'11"	8'11"	11'5"	8'6½"	12'1"	8'0½"	13'3"	7'5½"	15'2"	6'9"	19'7"	6'0"	30'8"
7	6'7¼"	7'5¼"	6'5½"	7'7¾"	6'3¾"	7'11¼"	6'0"	8'5"	5'8"	9'2"	5'3"	10'7"	4'9½"	13'2"
5	4'9½"	5'2½"	4'8½"	5'3¾"	4'7½"	5'5½"	4'5½"	5'8"	4'3½"	6'0"	4'0½"	6'6¾"	3'9¾"	7'5½"
3	2'11"	3'1"	2'10¾"	3'1¼"	2'10¼"	3'1¾"	2'9¾"	3'2¼"	2'8¾"	3'3¾"	2'7½"	3'5½"	2'6¼"	3'8¼"
2	1'11½"	2'0½"	1'11½"	2'0½"	1'11½"	2'0¾"	1'11"	2'1"	1'10½"	2'1½"	1'10"	2'2½"	1'9½"	2'3¾"

Depth of Field: 50mm Lens — Circle of Confusion 1/40mm (.001")

Distance (Feet)	1.4		2.0		2.5		2.8		3.5		4.0		5.6	
	FROM	TO	FROM	TO	FROM	TO	FROM	TO	FROM	TO	FROM	TO	FROM	TO
INF	235'	INF	164'	INF	131'	INF	117'	INF	93'11"	INF	82'2"	INF	58'9"	INF
200	108'	INF	90'3"	INF	79'5"	INF	74'0"	INF	64'0"	INF	58'4"	INF	45'6"	INF
100	70'2"	174'	62'3"	255'	56'10"	417'	54'1"	INF	48'6"	INF	45'2"	INF	37'1"	INF
50	41'3"	63'6"	38'5"	71'9"	36'3"	80'6"	35'2"	86'11"	32'8"	106'	31'2"	127'	27'1"	333'
30	26'8"	34'4"	25'5"	36'8"	24'6"	38'9"	23'11"	40'2"	22'10"	43'11"	22'1"	47'1"	19'11"	61'0"
20	18'5"	21'10"	17'10"	22'9"	17'5"	23'6"	17'2"	24'1"	16'6"	25'4"	16'2"	26'4"	15'0"	30'2"
15	14'1"	16'0"	13'9"	16'6"	13'6"	16'11"	13'4"	17'2"	13'0"	17'10"	12'9"	18'3"	12'0"	20'0"
10	9'7¼"	10'5"	9'5¼"	10'8"	9'3¾"	10'10"	9'3"	10'11"	9'0¾"	11'2"	8'11½"	11'4"	8'7"	12'0"
7	6'9¾"	7'2½"	6'8¾"	7'3½"	6'8"	7'4½"	6'7½"	7'5"	6'6½"	7'6½"	6'5¾"	7'7½"	6'3½"	7'11"
5	4'10¾"	5'1½"	4'10¼"	5'1¾"	4'10"	5'2¼"	4'9¾"	5'2½"	4'9¼"	5'3¾"	4'8¾"	5'3½"	4'7¾"	5'5¼"
3	2'11½"	3'0½"	2'11½"	3'0½"	2'11¼"	3'0¼"	2'11¼"	3'0¾"	2'11"	3'1"	2'10½"	3'1½"	2'10½"	3'1¾"
2	1'11¾"	2'0½"	1'11¾"	2'0½"	1'11¾"	2'0¼"	1'11¾"	2'0½"	1'11½"	2'0½"	1'11½"	2'0½"	1'11½"	2'0¾"

Distance (Feet)	6.3		8		11		16		22		32		45	
	FROM	TO	FROM	TO	FROM	TO	FROM	TO	FROM	TO	FROM	TO	FROM	TO
INF	52'3"	INF	41'2"	INF	30'0"	INF	20'8"	INF	15'1"	INF	10'5"	INF	7'5½"	INF
200	41'6"	INF	34'2"	INF	26'1"	INF	18'9"	INF	14'1"	INF	9'11"	INF	7'2¼"	INF
100	34'5"	INF	29'3"	INF	23'2"	INF	17'2"	INF	13'2"	INF	9'5½"	INF	6'11½"	INF
50	25'8"	INF	22'8"	INF	18'10"	INF	14'8"	INF	11'8"	INF	8'8"	INF	6'6¼"	INF
30	19'2"	70'0"	17'5"	109'	15'1"	INF	12'4"	INF	10'1"	INF	7'9½"	INF	6'0¾"	INF
20	14'6"	32'2"	13'6"	38'7"	12'1"	59'5"	10'3"	INF	8'8"	INF	6'11"	INF	5'6"	INF
15	11'9"	20'11"	11'1"	23'5"	10'1"	29'8"	8'9¾"	53'10"	7'7¾"	INF	6'2¾"	INF	5'0½"	INF
10	8'5½"	12'4"	8'1¼"	13'1"	7'6¾"	14'10"	6'9¾"	19'1"	6'1"	29'8"	5'2¼"	242'	4'4"	INF
7	6'2½"	8'0½"	6'0¼"	8'4½"	5'8¾"	9'0½"	5'3½"	10'5"	4'10¼"	13'1"	4'3¼"	20'8"	3'8¾"	110'
5	4'7"	5'6"	4'6"	5'7¾"	4'4"	5'11¼"	4'1"	6'6"	3'9¾"	7'5¾"	3'5½"	9'3¾"	3'1"	14'6"
3	2'10¼"	3'2"	2'9¾"	3'2½"	2'9"	3'3½"	2'8"	3'5½"	2'6½"	3'9"	2'4½"	4'1"	2'2½"	4'9½"
2	1'11¾"	2'0¾"	1'11"	2'1"	1'10¾"	2'1½"	1'10¾"	2'2¼"	1'9½"	2'3¾"	1'8¾"	2'4¾"	1'7½"	2'7½"

Depth of Field: 75mm Lens — Circle of Confusion 1/40mm (.001")

Distance (Feet)	2.0 FROM	2.0 TO	2.8 FROM	2.8 TO	4.0 FROM	4.0 TO	5.6 FROM	5.6 TO	8 FROM	8 TO	11 FROM	11 TO	16 FROM	16 TO
INF	369'	INF	263'	INF	184'	INF	132'	INF	92'6"	INF	67'4"	INF	46'5"	INF
200	129'	INF	113'	INF	96'2"	INF	79'8"	INF	63'4"	INF	50'6"	INF	37'9"	INF
100	78'9"	136'	72'7"	160'	65'0"	217'	57'0"	INF	48'2"	INF	40'4"	INF	31'10"	INF
50	44'1"	57'9"	42'1"	61'7"	39'5"	68'4"	36'4"	80'2"	32'7"	108'	28'10"	192'	24'2"	INF
30	27'9"	32'7"	27'0"	33'9"	25'10"	35'9"	24'6"	38'8"	22'9"	44'2"	20'10"	53'8"	18'4"	84'1"
20	19'0"	21'1"	18'8"	21'7"	18'1"	22'4"	17'5"	23'6"	16'6"	25'5"	15'6"	28'3"	14'1"	34'10"
15	14'5"	15'7"	14'3"	15'11"	13'11"	16'3"	13'6"	16'10"	13'0"	17'10"	12'4"	19'2"	11'5"	21'11"
10	9'9"	10'3"	9'7¾"	10'5"	9'6"	10'7"	9'4"	10'9"	9'0¾"	11'2"	8'9"	11'8"	8'3½"	12'7"
7	6'10½"	7'1½"	6'10"	7'2"	6'9¼"	7'3"	6'8"	7'4½"	6'6½"	7'6½"	6'4½"	7'9"	6'1¾"	8'2"
5	4'11¼"	5'0¾"	4'11"	5'1"	4'10½"	5'1½"	4'10"	5'2"	4'9¼"	5'3"	4'8¾"	5'4¼"	4'6¾"	5'6½"
3	2'11¾"	3'0¼"	2'11½"	3'0¼"	2'11½"	3'0½"	2'11¾"	3'0¾"	2'11"	3'1"	2'10¾"	3'1½"	2'10"	3'2"
2*	—	—	—	—	1'11¾"	2'0¼"	1'11¾"	2'0¼"	1'11½"	2'0½"	1'11½"	2'0½"	1'11¾"	2'0¾"

* —indicates no useful depth of field

Depth of Field: 80mm Lens — Circle of Confusion 1/40mm (.001")

Distance (Feet)	2.0		2.8		4.0		5.6		8		11		16	
	FROM	TO	FROM	TO	FROM	TO	FROM	TO	FROM	TO	FROM	TO	FROM	TO
INF	420'	INF	300'	INF	210'	INF	150'	INF	105'	INF	76'7"	INF	52'9"	INF
200	135'	381'	120'	INF	102'	INF	85'11"	INF	69'1"	INF	55'6"	INF	41'10"	INF
100	80'10"	131'	75'1"	149'	67'11"	190'	60'2"	297'	51'5"	INF	43'6"	INF	34'8"	INF
50	44'9"	56'8"	42'11"	59'11"	40'6"	65'5"	37'7"	74'8"	34'0"	94'9"	30'5"	142'	25'10"	INF
30	28'0"	32'3"	27'4"	33'3"	26'4"	34'11"	25'1"	37'4"	23'5"	41'9"	21'8"	49'0"	19'3"	68'10"
20	19'1"	21'0"	18'9"	21'5"	18'4"	22'1"	17'9"	23'0"	16'11"	24'7"	15'11"	26'11"	14'7"	31'11"
15	14'6"	15'6"	14'4"	15'9"	14'0"	16'1"	13'8"	16'7"	13'2"	17'5"	12'7"	18'6"	11'9"	20'9"
10	9'9½"	10'3"	9'8¾"	10'4"	9'6¾"	10'6"	9'5"	10'8"	9'2"	11'0"	8'10¾"	11'5"	8'5¾"	12'3"
7	6'10¾"	7'1¾"	6'10¼"	7'2"	6'9½"	7'2¾"	6'8½"	7'3¾"	6'7"	7'5½"	6'5½"	7'7¾"	6'2¾"	8'0"
5	4'11½"	5'0½"	4'11"	5'1"	4'10¾"	5'1¼"	4'10¼"	5'2"	4'9½"	5'2¾"	4'8¾"	5'3¾"	4'7¼"	5'5½"
3	2'11¾"	3'0¼"	2'11¾"	3'0¼"	2'11½"	3'0½"	2'11½"	3'0½"	2'11¼"	3'1"	2'10¾"	3'1¼"	2'10½"	3'1¾"

Depth of Field: 90mm Lens — Circle of Confusion 1/40mm (.001")

Distance (Feet)	2.8		4.0		5.6		8		11		16		22	
	FROM	TO	FROM	TO	FROM	TO	FROM	TO	FROM	TO	FROM	TO	FROM	TO
INF	379'	INF	266'	INF	190'	INF	133'	INF	96'11"	INF	66'9"	INF	48'7"	INF
200	131'	421'	114'	INF	97'7"	INF	80'1"	INF	65'5"	INF	50'2"	INF	39'2"	INF
100	79'3"	135'	72'10"	160'	65'8"	210'	57'3"	400'	49'4"	INF	40'2"	INF	32'10"	INF
50	44'3"	57'6"	42'2"	61'5"	39'8"	67'8"	36'6"	79'9"	33'1"	102'	28'9"	198'	24'10"	INF
30	27'10"	32'6"	27'0"	33'9"	26'0"	35'6"	24'7"	38'7"	23'0"	43'2"	20'10"	54'0"	18'8"	77'5"
20	19'0"	21'1"	18'8"	21'7"	18'2"	22'3"	17'6"	23'5"	16'8"	25'1"	15'6"	28'4"	14'4"	33'7"
15	14'5"	15'7"	14'3"	15'10"	13'11"	16'3"	13'6"	16'10"	13'1"	17'8"	12'4"	19'2"	11'7"	21'5"
10	9'9"	10'3"	9'8"	10'4"	9'6¼"	10'6"	9'4"	10'9"	9'1½"	11'1"	8'9¼"	11'8"	8'4½"	12'5"
7	6'10½"	7'1½"	6'10"	7'2"	6'9¼"	7'3"	6'8"	7'4¼"	6'6¾"	7'6"	6'4½"	7'9"	6'2¼"	8'1"
5	4'11½"	5'0¾"	4'11"	5'1"	4'10½"	5'1½"	4'10"	5'2"	4'9½"	5'3"	4'8½"	5'4¼"	4'7"	5'6"
3	2'11¾"	3'0¼"	2'11¾"	3'0¼"	2'11½"	3'0½"	2'11¼"	3'0¾"	2'11"	3'1"	2'10¾"	3'1½"	2'10½"	3'2"
2*	—	—	—	—	1'11¾"	2'0¼"	1'11¾"	2'0¼"	1'11¾"	2'0½"	1'11½"	2'0½"	1'11¼"	2'0¾"

* —indicates no useful depth of field.

Depth of Field: 100mm Lens — Circle of Confusion 1/40mm (.001")

Distance (Feet)	2.8		4.0		5.6		8		11		16		22	
	FROM	TO	FROM	TO	FROM	TO	FROM	TO	FROM	TO	FROM	TO	FROM	TO
INF	469'	INF	328'	INF	234'	INF	164'	INF	119'	INF	82'4"	INF	60'0"	INF
200	140'	348'	124'	INF	108'	INF	90'5"	INF	75'0"	INF	58'6"	INF	46'3"	INF
100	82'6"	126'	76'9"	143'	70'3"	173'	62'4"	254'	54'8"	INF	45'4"	INF	37'8"	INF
50	45'3"	55'11"	43'6"	58'10"	41'4"	63'4"	38'6"	71'7"	35'5"	85'5"	31'3"	126'	27'5"	297'
30	28'3"	32'0"	27'7"	32'11"	26'8"	34'4"	25'6"	36'7"	24'1"	39'10"	22'1"	46'10"	20'2"	59'4"
20	19'3"	20'10"	18'11"	21'3"	18'6"	21'10"	17'11"	22'8"	17'3"	23'11"	16'2"	26'3"	15'2"	29'8"
15	14'7"	15'6"	14'5"	15'8"	14'2"	16'0"	13'10"	16'5"	13'5"	17'1"	12'9"	18'2"	12'1"	19'9"
10	9'9¾"	10'3"	9'8¾"	10'4"	9'7½"	10'5"	9'5½"	10'7"	9'3¼"	10'10"	8'11¾"	11'4"	8'7¾"	11'11"
7	6'11"	7'1¼"	6'10½"	7'1¾"	6'9¾"	7'2½"	6'9"	7'3½"	6'7¾"	7'4¾"	6'6"	7'7"	6'4"	7'10"
5	4'11½"	5'0½"	4'11¼"	5'0¾"	4'11"	5'1"	4'10½"	5'1½"	4'10"	5'2¼"	4'9"	5'3½"	4'8"	5'4¾"
3	2'11¾"	3'0¼"	2'11¾"	3'0¼"	2'11½"	3'0½"	2'11½"	3'0½"	2'11¼"	3'0¾"	2'11"	3'1"	2'10¾"	3'1½"
2*	—	—	—	—	—	—	1'11¾"	2'0¼"	1'11¾"	2'0¼"	1'11½"	2'0½"	1'11½"	2'0½"

* —indicates no useful depth of field.

539

Depth of Field: 125mm Lens — Circle of Confusion 1/40mm (.001")

Distance (Feet)	2.8 FROM	2.8 TO	4.0 FROM	4.0 TO	5.6 FROM	5.6 TO	8 FROM	8 TO	11 FROM	11 TO	16 FROM	16 TO	22 FROM	22 TO
INF*	—	—	—	—	366'	INF	256'	INF	186'	INF	128'	INF	93'7"	INF
200	157'	274'	144'	327'	129'	439'	112'	INF	96'10"	INF	78'6"	INF	63'11"	INF
100	88'1"	115'	83'9"	124'	78'9"	137'	72'2"	163'	65'4"	214'	56'5"	447'	48'7"	INF
50	46'10"	53'7"	45'8"	55'4"	44'1"	57'9"	41'11"	61'11"	39'7"	68'0"	36'2"	81'4"	32'9"	106'
30	28'10"	31'3"	28'5"	31'10"	27'10"	32'7"	26'11"	33'10"	25'11"	35'7"	24'5"	38'10"	22'10"	43'9"
20	19'6"	20'6"	19'3"	20'9"	19'0"	21'1"	18'7"	21'8"	18'2"	22'4"	17'5"	23'6"	16'7"	25'3"
15	14'9"	15'4"	14'7"	15'5"	14'5"	15'7"	14'3"	15'11"	13'11"	16'3"	13'6"	16'11"	13'0"	17'9"
10	9'10½"	10'2"	9'10"	10'2"	9'9"	10'3"	9'7¾"	10'5"	9'6½"	10'6"	9'4"	10'9"	9'1½"	11'1"
7	6'11¼"	7'0¾"	6'11"	7'1"	6'10½"	7'1½"	6'10½"	7'1¾"	6'10"	7'2"	6'9¼"	7'3"	6'8"	7'4¼"
5	4'11¾"	5'0¼"	4'11½"	5'0½"	4'11¼"	5'0¾"	4'11"	5'1"	4'10¾"	5'1½"	4'10"	5'2"	4'9½"	5'3"
3*	—	—	2'11¾"	3'0¼"	2'11¾"	3'0¼"	2'11¾"	3'0¼"	2'11½"	3'0½"	2'11¾"	3'0½"	2'11"	3'1"
2*	—	—	—	—	—	—	—	—	—	—	1'11¾"	2'0¼"	1'11¾"	2'0¼"

* —indicates no useful depth of field.

540

Depth of Field: 135mm Lens — Circle of Confusion 1/40mm (.001")

Distance (Feet)	2.8 FROM	2.8 TO	4.0 FROM	4.0 TO	5.6 FROM	5.6 TO	8 FROM	8 TO	11 FROM	11 TO	16 FROM	16 TO	22 FROM	22 TO
INF*	—	—	—	—	427'	INF	299'	INF	217'	INF	149'	INF	109'	INF
200	162'	260'	150'	299'	136'	375'	120'	INF	104'	INF	85'11"	INF	70'10"	INF
100	89'7"	113'	85'10"	119'	81'2"	130'	75'2"	149'	68'9"	184'	60'2"	298'	52'5"	INF
50	47'3"	53'1"	46'3"	54'6"	44'10"	56'6"	42'11"	59'10"	40'10"	64'8"	37'8"	74'7"	34'6"	91'6"
30	29'0"	31'1"	28'7"	31'6"	28'1"	32'2"	27'4"	33'3"	26'6"	34'8"	25'1"	37'3"	23'8"	41'0"
20	19'7"	20'6"	19'5"	20'8"	19'2"	20'11"	18'10"	21'4"	18'5"	21'11"	17'9"	22'11"	17'0"	244'
15	14'9"	15'3"	14'8"	15'4"	14'6"	15'6"	14'4"	15'9"	14'1"	16'1"	13'9"	16'7"	13'3"	17'3"
10	9'10¾"	10'1"	9'10¼"	10'2"	9'9½"	10'3"	9'8½"	10'4"	9'7¼"	10'5"	9'5"	10'8"	9'3"	10'11"
7	6'11½"	7'0½"	6'11¼"	7'1"	6'10¾"	7'1¼"	6'10¼"	7'1¼"	6'9¾"	7'2½"	6'8¾"	7'3½"	6'7½"	7'5"
5	4'11¾"	5'0¾"	4'11½"	5'0½"	4'11½"	5'0½"	4'11¾"	5'0¾"	4'11"	5'1¼"	4'10½"	5'1¾"	4'9¾"	5'2½"
3*	—	—	—	—	2'11¾"	3'0¾"	2'11¾"	3'0¾"	2'11½"	3'0¼"	2'11¾"	3'0½"	2'11¼"	3'0¾"
2*	—	—	—	—	—	—	—	—	—	—	1'11¾"	2'0¼"	1'11¾"	2'0¼"

* —indicates no useful depth of field.

Depth of Field: 150mm Lens — Circle of Confusion 1/40mm (.001")

Distance (Feet)	2.8 FROM	2.8 TO	4.0 FROM	4.0 TO	5.6 FROM	5.6 TO	8 FROM	8 TO	11 FROM	11 TO	16 FROM	16 TO	22 FROM	22 TO
INF*	—	—	—	—	—	—	369'	INF	268'	INF	185'	INF	134'	INF
200	168'	246'	157'	273'	145'	321'	129'	434'	114'	INF	96'4"	INF	80'8"	INF
100	91'5"	110'	88'2"	115'	84'2"	123'	78'10"	136'	73'1"	158'	65'2"	216'	57'8"	385'
50	47'9"	52'5"	46'11"	53'7"	45'9"	55'2"	44'2"	57'8"	42'4"	61'2"	39'6"	68'2"	36'8"	78'11"
30	29'2"	30'10"	28'10"	31'3"	28'5"	31'9"	27'10"	32'7"	27'1"	33'8"	25'11"	35'7"	24'8"	38'4"
20	19'8"	20'4"	19'6"	20'6"	19'4"	20'9"	19'0"	21'1"	18'8"	21'6"	18'2"	22'4"	17'6"	23'4"
15	14'10"	15'2"	14'9"	15'4"	14'7"	15'5"	14'5"	15'7"	14'3"	15'10"	13'11"	16'3"	13'7"	16'9"
10	9'11"	10'1"	9'10½"	10'2"	9'10"	10'2"	9'9"	10'3"	9'8"	10'4¼"	9'6½"	10'6¼"	9'4½"	10'8¾"
7	6'11½"	7'0½"	6'11¼"	7'0¾"	6'11"	7'1"	6'10¾"	7'1½"	6'10½"	7'2"	6'9½"	7'3"	6'8½"	7'4"
5	4'11¾"	5'0¼"	4'11¾"	5'0¾"	4'11½"	5'0½"	4'11¼"	5'0¾"	4'11"	5'1"	4'10¾"	5'1½"	4'10¼"	5'2"
3*	—	—	—	—	2'11¾"	3'0¼"	2'11¾"	3'0¾"	2'11¾"	3'0¾"	2'11½"	3'0½"	2'11¾"	3'0½"
2*	—	—	—	—	—	—	—	—	—	—	—	—	1'11¾"	2'0¼"

* —indicates no useful depth of field.

542

Depth of Field: 200mm Lens — Circle of Confusion 1/40mm (.001")

Distance (Feet)	4.0		5.6		8		11		16		22		32	
	FROM	TO	FROM	TO	FROM	TO	FROM	TO	FROM	TO	FROM	TO	FROM	TO
INF*	—	—			—	—	477'	INF	328'	INF	239'	INF	164'	INF
200	173'	235'	165'	253'	153'	286'	141'	343'	124'	INF	109'	INF	90'7"	INF
100	93'0"	108'	90'6"	111'	86'11"	117'	82'11"	126'	76'11"	143'	70'10"	170'	62'6"	252'
50	48'3"	51'11"	47'6"	52'9"	46'7"	54'0"	45'5"	55'8"	43'7"	58'9"	41'7"	62'11"	38'7"	71'3"
30	29'4"	30'8"	29'1"	30'11"	28'9"	31'5"	28'4"	31'11"	27'7"	32'11"	26'9"	34'1"	25'7"	36'5"
20	19'9"	20'4"	19'7"	20'5"	19'5"	20'7"	19'3"	20'10"	18'11"	21'3"	18'7"	21'9"	18'0"	22'7"
15	14'10"	15'2"	14'9"	15'3"	14'8"	15'4"	14'7"	15'5"	14'5"	15'8"	14'2"	15'11"	13'10"	16'5"
10	9'11¾"	10'1"	9'11"	10'1"	9'10½"	10'2"	9'9¾"	10'2"	9'9"	10'3"	9'7¾"	10'5"	9'6"	10'7"
7	6'11½"	7'0½"	6'11½"	7'0½"	6'11¼"	7'0¾"	6'11"	7'1"	6'10¾"	7'1½"	6'10"	7'2"	6'9¾"	7'3"
5	4'11¾"	5'0¼"	4'11¾"	5'0¼"	4'11¾"	5'0¼"	4'11½"	5'0½"	4'11¼"	5'0¾"	4'11"	5'1"	4'10¾"	5'1½"
3*	—	—			—	—	2'11¾"	3'0"	2'11¾"	3'0¼"	2'11¾"	3'0¼"	2'11½"	3'0½"

* —indicates no useful depth of field.

543

Depth of Field: 300mm Lens — Circle of Confusion 1/40mm (.001")

Distance (Feet)	4.0 FROM	4.0 TO	5.6 FROM	5.6 TO	8 FROM	8 TO	11 FROM	11 TO	16 FROM	16 TO	22 FROM	22 TO	32 FROM	32 TO
INF*	—	—	—	—	—	—	—	—	—	—	—	—	370'	INF
200	187'	214'	182'	220'	176'	231'	168'	245'	157'	273'	146'	317'	130'	432'
100	96'9"	103'	95'7"	104'	93'9"	107'	91'7"	110'	88'4"	115'	84'7"	122'	79'1"	136'
50	49'2"	50'10"	48'11"	51'2"	48'5"	51'8"	47'10"	52'4"	46'11"	53'6"	45'11"	54'11"	44'3"	57'6"
30	29'9"	30'4"	29'7"	30'5"	29'5"	30'7"	29'2"	30'10"	28'11"	31'2"	28'6"	31'8"	27'11"	32'6"
20	19'11"	20'2"	19'10"	20'2"	19'9"	20'3"	19'8"	20'4"	19'6"	20'6"	19'4"	20'8"	19'1"	21'0"
15	14'11"	15'1"	14'11"	15'1"	14'11"	15'2"	14'10"	15'2"	14'9"	15'3"	14'8"	15'5"	14'6"	15'7"
10	9'11¾"	10'0"	9'11½"	10'1"	9'11¼"	10'1"	9'11"	10'1"	9'10¾"	10'1"	9'10½"	10'2"	9'9½"	10'3"
7*	—	—	—	—	6'11¾"	7'0¼"	6'11½"	7'0½"	6'11½"	7'0½"	6'11¼"	7'0¾"	6'11"	7'1¼"
5*	—	—	—	—	—	—	4'11¾"	5'0¼"	4'11¾"	5'0¼"	4'11½"	5'0½"	4'11½"	5'0½"

* —indicates no useful depth of field.

544

Depth of Field: 400mm Lens — Circle of Confusion 1/40mm (.001")

Distance (Feet)	5.6 FROM	5.6 TO	8 FROM	8 TO	11 FROM	11 TO	16 FROM	16 TO	22 FROM	22 TO	32 FROM	32 TO	45 FROM	45 TO
INF*	—	—	—	—	—	—	—	—	—	—	—	—	467'	INF
200	190'	211'	186'	216'	181'	223'	173'	235'	165'	252'	153'	286'	140'	347'
100	97'6"	102'	96'5"	104'	95'2"	105'	93'1"	108'	90'10"	111'	87'1"	117'	82'9"	126'
50	49'5"	50'8"	49'1"	50'11"	48'9"	51'3"	48'3"	51'11"	47'8"	52'7"	46'8"	53'11"	45'5"	55'8"
30	29'9"	30'3"	29'8"	30'4"	29'7"	30'5"	29'5"	30'8"	29'2"	30'11"	28'10"	31'4"	28'4"	31'11"
20	19'11"	20'1"	19'10"	20'2"	19'10"	20'2"	19'9"	20'3"	19'8"	20'5"	19'6"	20'7"	19'3"	20'9"
15	14'11"	15'1"	14'11"	15'1"	14'11"	15'1"	14'10"	15'2"	14'10"	15'2"	14'9"	15'4"	14'7"	15'5"
10	9'11¾"	10'0¼"	9'11¾"	10'0¾"	9'11½"	10'0½"	9'11¼"	10'0¾"	9'11"	10'1"	9'10½"	10'1½"	9'10"	10'2"
7*	—	—	—	—	6'11¾"	7'0¼"	6'11¾"	7'0¼"	6'11½"	7'0½"	6'11½"	7'0½"	6'11¼"	7'1"
5*	—	—	—	—	—	—	—	—	4'11¾"	5'0¼"	4'11¾"	5'0¼"	4'11¾"	5'0½"

* —indicates no useful depth of field.

545

This page is being reserved
for future expansion.

INTRODUCTION TO MISCELLANEOUS DATA

In the preceding sections, data have been given for a large number of individual products, and these data were specifically for the products in question. In this section we depart from this treatment and consider certain photographic data in a more general manner. We discuss film speeds in terms of how speeds are derived, the meaning of speed numbers and meter settings, and the relationship between speed numbers, scene brightness, and exposure.

The same approach is taken here to matters of illumination. Whereas in the data pages, guide numbers were given for specific film and lamp combinations, in this section we offer general tables of flash data applicable to any film of a given speed in connection with a wide variety of lamps.

Filters and factors are dealt with in theoretical terms, and we examine filter equivalents, the need for filters in black-and-white photography, and some additional factors for filters not covered in the film data pages. Further, a discussion is included of filters for color photography and color temperatures in kelvin versus the mired, or micro-reciprocal degree.

The remainder of this section is composed of general information, conversion factors, weights and measures, and dimensions and temperatures in different systems. These are not likely to be needed in using this book since all data herein are given in both metric and American Customary measure and in both Fahrenheit and Celsius temperatures. But there are times when one may wish to make comparisons with material published in the amateur press, trade journals, or scientific publications where only a single system, which may require translation, is used.

In this connection, we would like to repeat our long-held conviction that it is not necessary to wait for the metric system to be introduced into the United States on a universal basis. The photographer can set up his own studio or darkroom with metric weights and measures. Not only will this simplify the work a great deal, more importantly, it will eliminate a potential source of error when using formulas and data from other sources. Too often, we find a formula taken from an English magazine and stated to make a "pint" of developer. If the user does not realize that the English pint is 20 ounces, whereas the American pint is only 16 ounces, a very large error can be introduced. But metric measure remains the same, regardless of its source; hence in any published formula, with few exceptions, the metric formula may be taken as the most reliable.

FILM SPEED SYSTEMS AND EXPOSURE MEASUREMENT

We do not have the space here to go into the elements of sensitometry and the derivation of the various film speed systems; all of this material can be found in various photographic textbooks. We assume that the reader is familiar with the characteristic curve of the film and its implications. We must point out though, that some of the basic concepts of sensitometry have had to be modified in recent years, to bring them into accord with the way films are actually made and used.

The scientist is always seeking linear relationships between quantities; this simplifies the problem of measuring and specifying the relationships in question. Thus, when Hurter and Driffield first studied the characteristic curve of the film, they immediately noted that whereas it was, indeed, a curve at bottom and top, it had a long straight line portion where density was proportional to the logarithm of the exposure. It appeared to them that this linear portion would correspond to what they conceived to be the "correct exposure", thus they named it the *correct exposure* part of the curve.

If the negative were the end result of the photographic process, there would have been ample justification for this view; furthermore, where measurements are to be taken from the negative, as in certain instrumentation procedures, the straight line portion of the curve can give a good deal of useful, reliable information. In practical photography, though, the negative is merely an intermediate stage with the end result a print on paper. This complicates matters. We must take into account the curves of both the film and the paper and how they relate to each other.

Extended study has shown that what is considered a good print is one that utilizes the entire tonal range of the paper. It is simply blank in the highest lights and the deepest black of which the emulsion is capable in the shadows. To attain such a result, the entire exposure scale of the paper emulsion must be used. Paper emulsions have characteristic curves similar to those of films; they have a toe or underexposure period, a straight line, and a shoulder or overexposure period.

If the negative is linear and all of its tones are on the straight line portion of its characteristic, printing it on paper in such a way as to utilize the total scale of the paper will necessarily result in distortion of the tonal scale. Rendition will be normal in the middle of the scale only; both highlights and shadows will be compressed and flattened. This was not very noticeable in Hurter and Driffield's time, because then most prints were made on printing-out papers, which had a limited range of tones. This distortion is, however, quite evident when one attempts to print a negative of that period on today's bromide or chlorobromide papers.

Careful analysis of the problem has revealed that this was a situation where equal and opposite errors could be combined for a correct result. If the negative were given a minimum exposure so that most of its shadow detail would be recorded on the toe of the negative curve, then printed on paper where the highlights would now fall on the toe of the paper curve, the end result would be a print whose tones would be almost linearly related to those of the original subject throughout, although neither the negative nor the print are, in themselves, tonally correct.

Modern negatives are exposed at lower levels than in former days and are much less dense. This confers an added benefit: it is well known that graininess in negative materials is related to overall density and is least in the thinnest useful negative.

Obviously, both the film speed system and the calibration of the exposure meter must be chosen to produce a negative that has the minimum useful exposure without loss of shadow detail. In the original H & D system, a point on the base of the curve was chosen, called the *inertia,* and speed measurements were made from this point as a basis. It was not immediately evident that the inertia point is not really related to the toe of the curve but to the straight line, and exposures based on inertia measurements were, in effect, straight-line exposures. The early Weston exposure system, which used a different criterion, took its measurements from a point well up on the curve and was also a "straight-line system."

The first ASA system was based on studies that showed that a good deal of the negative toe was used in practical photography, and a rather complicated system of measurement based on "minimum useful gradient" was devised. The framers of this system, however, negated most of the value of the method by including a rather large safety factor to prevent the danger of underexposure. This safety factor had the effect of putting the exposure well up on the straight line again. More recently, most of the safety factor was eliminated, practically doubling all film speed ratings published up to that time. In addition, a simpler system of measurement was adopted, based on locating a point on the toe of the curve chosen according to a method to be explained below. Negatives made using these new ratings correctly will produce the optimum print quality on present day papers.

Other Film Speed Systems. The ASA system was adopted in essentially the same form by the British Standards Institute (BSI), but two different numerical scales are used for meter settings. The linear scale, identical to the ASA number scale, is known as *BSI Arithmetic.* A second scale, logarithmic in form, is also used; it is known as *BSI Log,* and the magnitude of the numbers was chosen so that they could be used on many older meters scaled in Scheiner numbers. For this reason, it is often referred to as "British Scheiner", but it actually bears no real relation to the obsolete Scheiner system.

The original Scheiner system was based on an exceedingly simple concept. A film was given a graded series of exposures and developed. The exposure that produced the first visible trace of an image was taken as the speed point and multiplied by an appropriate constant to produce a speed number usable on existing meters.

The difficulties with this so-called "threshold system" are at least two. First of all, the appearance of a mere trace of visible image has no real correlation with the exposure required to make a useful photograph. Shadow detail demands a definite differentiation of tone, not the mere ghost of an image. With a system of this kind, two films of different curve shapes might have the same nominal speed simply because each produces a trace of an image at a certain minimal exposure, yet on a practical basis, one might be several times as fast as the other in terms of useful shadow gradient.

The second difficulty with the threshold system is its inherent vagueness: one observer may detect an image where a second might not. When one cannot be sure whether an image exists or not, the value of the measurement is likely to be exceedingly dubious. There is the added danger that advertising exigencies might call for stretching the system constants to the limit, to make "Brand X" film "faster" than "Brand Y."

The original DIN (Deutsche Industrie Norm) system was also based on a threshold system, but the difficulties were recognized very early, and a more exact definition was established for the minimum visible image. Under the DIN system, the measuring point was taken at a density 0.1 above the combined

density of the film base and any fog that might be present. To make this measurement, the film was given a graded series of exposures as in the Scheiner system; however, a small area was left entirely unexposed. The density of the unexposed area was measured first, and this, of course, is the density of the film base plus any fog resulting from the developer or inherent in the emulsion. Then the exposed steps were measured to find one that was exactly 0.1 density unit above the reading on the unexposed patch. For example, assuming that the unexposed area measured 0.25 density, then the exposed step whose density was 0.25 + 0.1 = 0.35 was taken, and the exposure that produced this density was multiplied by the necessary constant to fit it to the meter. This criterion is practical on several grounds; first, because it is definite and easily measured; second, because it indicates a point on the toe of the curve where density is rising and thus there is useful tone differentiation; and third, because the measurement is made low on the toe and thus correlates with the printing medium to produce a substantially correct tone rendition.

As mentioned above, the original ASA system was based on a complex measurement known as *fractional gradient* or *minimum useful gradient*. This proved difficult to measure, and it was realized after a time that the fixed density above base plus fog specified in the DIN system would give about the same degree of precision, provided all films were developed to the same contrast.

Hence the current ASA standard, which is the same as the BSI and DIN standards, calls for a measurement of exposure required to produce a density of 0.1 above base plus fog, subject to the condition that the film be developed according to a prescribed system. This system is specified in the American Standard, ASA PH 2.5-1960. If this be done, then the numerical speed will be $0.8/E$ where E is the exposure required to produce the specified density of 0.1 above base plus fog.

The factor $0.8/E$ is merely a constant designed to produce numbers in an arithmetic scale which correlate with the calibration of most American-made and many English exposure meters. Both BSI and DIN, however, use a different set of factors, designed to produce a series of numbers on logarithmic scales, to fit the meters of their respective countries.

Now only one other system of film speed ratings is employed in practical photography, and that is GOST, used in the U.S.S.R. and certain other European countries. The system is quite similar to the ASA/BSI/DIN system except that the measurement is made at a point where the density is 0.2 above base plus fog, and a different constant is used to derive the meter setting. The result is a scale of numbers so close to the ASA/BSI Arithmetic scale that it can be used unchanged on most meters. This will work for another reason—the numbers used in the GOST scale differ from those used in ASA and BSI scales and will not be found on American and British meters. If the nearest number is used, then it will be found that one has practically converted one system to the other, and the error will be trifling.

One other logarithmic scale, based on ASA measurements, was used in the United States for a short time. Designed to fit into the EVS (Exposure Value System) number scale, it was known as the *ASA Additive Speed Value System*. The numbers, however, were too widely spaced and did not provide sufficient precision, especially for use with color films. The system has now been entirely abandoned.

Converting Film Speed Ratings

In earlier publications it was duly pointed out that one could not translate Hurter and Driffield speeds into Weston or Weston into ASA because the bases

COMPARISON TABLE OF FILM SPEED RATINGS

ASA Speed BSI Arithmetic	Weston	BSI Log (Scheiner)	DIN	GOST *
3	2.5	16°	6	2.8
4	3	17°	7	3.6
5	4	18°	8	4.5
6	5	19°	9	5.8
8	6	20°	10	7.2
10	8	21°	11	9
12	10	22°	12	11
16	12	23°	13	14
20	16	24°	14	18
25	20	25°	15	23
32	24	26°	16	29
40	32	27°	17	36
50	40	28°	18	45
64	50	29°	19	58
80	64	30°	20	72
100	80	31°	21	90
125	100	32°	22	112
160	125	33°	23	144
200	160	34°	24	180
250	200	35°	25	225
320	250	36°	26	288
400	320	37°	27	360
500	400	38°	28	450
640	500	39°	29	576
800	640	40°	30	720
1000	800	41°	31	900
1250	1000	42°	32	1125
1600	1250	43°	33	1440
2000	1600	44°	34	1800
2500	2000	45°	35	2250
3200	2500	46°	36	2880

*The numbers in this column may not correspond to those on some meters calibrated in GOST units; they have been chosen to be in the proper 9/10 relationship to ASA.

(Continued from page 614)

of the different systems did not correspond mathematically. Today, H & D, Weston, G-E, Scheiner, Watkins, Wynne, and Chapman-Jones are all obsolete; some have been obsolete for so many years that many of today's photographers have never even heard of them, and it serves no useful purpose to discuss any of them.

The systems currently in use—ASA, BSI, DIN, and GOST—are all based on fundamentally the same principles and can be freely converted from one to the other. The old limitation on conversions, therefore, no longer exists.

It should be pointed out that although the old Weston system theoretically could not be converted to ASA and vice versa, what actually happened when the Weston system was abandoned was simply that the makers of the Weston meter made just one small change in the meter itself. They replaced the meter calculator dial with a new one marked in ASA numbers, which was simply the old dial with the numbers changed in a 5:4 ratio. Thus, in essence, it is legitimate to multiply an ASA setting by 4/5 to secure a setting for an old Weston meter having the original calculator dial. This is in no sense converting one

film speed system to another; it is merely shifting the light measurement scale of the meter to bring it into accord with the American Standard. To be precise about it, we are not converting the Weston *speed* to an ASA *speed;* we are merely devising a Weston *meter setting* that will give satisfactory exposures.

It will be noticed that there is a definite relationship between the numbers used in the arithmetic series. The Weston scale is the ASA/BSI scale multiplied by 0.8, and the GOST scale is the ASA/BSI scale multiplied by 0.9, thus the latter falls midway between the Weston and ASA values.

The derivation of the BSI Logarithmic and the DIN numbers is less clear, but simple enough. It is based on the following relationship:

$$\text{BSI Logarithmic speed} = 10 \log_{10} \text{ASA} + 11$$

Thus, for example, an ASA speed of 20 would be converted to BSI Log as follows: $\log_{10} 20 = 1.3$

$$\text{Then } 10 \times 1.3 = 13 + 11 = 24 \text{ BSI Log.}$$

A similar system is used to derive DIN from ASA except that the constant factor is 1 instead of 11. That is:

$$\text{DIN speed} = 10 \log_{10} \text{ASA} + 1$$

And therefore a speed of ASA 20 would be

$$10 \times 1.3 = 13 + 1 = 14 \text{ DIN.}$$

It should be obvious that one can convert BSI Log speeds to DIN by simply subtracting 10 from the BSI number, and conversely, one can translate DIN speeds to BSI Log by adding 10 to the DIN number.

Exposure Meters and Measurement

The earliest system of exposure measurement consisted of a piece of sensitive paper of the printing-out variety, held in a small case about the size of a pocket watch. A semicircular area of the paper was exposed to light, alongside a "standard tint." When the paper had darkened to match the standard tint, the time required was a measure of the exposure that would be needed for the actual picture. Usually, a table of exposures for the various films and plates available at the time was printed right on the face of the meter.

Obviously, this was a kind of incident-light measurement system, quite valid for several reasons. One was that a reading could be obtained regardless of light conditions; it was only a matter of time. In any case, the slow films of the period could only be exposed in skylighted studios or outdoors, where ample light was available to produce a visible color on the paper in a reasonable amount of time. More important was the fact that the paper was sensitive only to blue and ultraviolet light, corresponding almost exactly to the sensitivity of the films and plates of the time. Thus the system was theoretically correct in that it was measuring the same component of the light as would be used for the actual exposure.

When the barrier-layer photoelectric cell was introduced in the late 1920's, one of its first uses was for the construction of illumination meters, used mainly by engineers. Motion-picture cameramen, however, were quick to see the utility of such meters for the measurement of light in the studio. The method, again, was to measure the incident light on the subject. No film speed values were available at the time, but since only one or two types of film were being used in motion pictures, it was simply a matter of running a few tests to determine the

proper exposures for various light levels. In skilled hands, the system produced a very high percentage of correct exposures.

For general photography, though, many people believed that a better system would be one that measured the light reflected directly from the subject, rather than merely measuring the light falling upon it. They reasoned that this would automatically compensate for subject matter of differing reflectances and thus produce more uniform negatives.

Converting an illumination meter to read reflected light is simple enough; all that is necessary is to restrict the angle of view, or collection angle, of the photocell to some angle roughly equal to that of the camera lens. When this is done, the distance of the meter from the subject no longer affects the reading obtained. Provided that the subject is uniformly illuminated, the same reading will be obtained at any distance as long as the subject fills the entire field of the meter.

The reason for this is quite simple. The inverse square law continues to function, and as the meter is moved away from the subject, the intensity of the light falls off as the square of the distance. Since the meter views a constant angle, however, as it moves away from the subject, it scans a larger area, and the increasing area of coverage exactly balances the decrease in intensity due to distance.

It would appear, then, that all one has to do is to point the meter at the subject and get an accurate exposure setting. Although this is true in the majority of cases, it is not true in all. Misleading results can be obtained with the reflected-light meter simply because it is a mechanical device and cannot distinguish between, for example, a light-colored object in dim light or a dark-colored object in bright light. Both may reflect the same amount of light to the meter cell, and thus both will secure the same exposure. It should be obvious, however, that a different rendition of two such objects must be obtained, and this cannot be the case if both get the same exposure.

Uncompensated, the meter will tend to overexpose the dark object in bright light, making it appear light gray rather than dark gray or black. Since it is giving the same exposure in both cases, it will underexpose the light-colored object in dim light, so that we will, again, secure a gray object rather than a white one.

Evidently, the tendency of the reflected-light meter is to bring all negatives to a uniform exposure level, producing substantially equal image densities. But such uniform negatives do not print uniformly; as we have just learned, to get a dark object to appear dark in the print, we may have to give considerably more exposure in printing.

The reflected-light meter has a calculator system that is calibrated to produce a "normal" exposure on "average" subject matter. Average subject matter is defined as a scene that reflects about 18 per cent of the light falling upon it overall. When a scene contains mostly dark objects and reflects less than this 18 per cent figure, the meter will tend to overexpose it, and when the scene is mostly made up of light objects, the meter will tend to underexpose it.

Therefore, some photographers found it desirable to return to the incident-light system of measurement. They reasoned that as long as the scene illumination remained constant, light objects would reproduce light, and dark objects would reproduce dark. The densities of the negatives would vary considerably, but interestingly, all would require substantially the same exposure in printing.

The incident-light system is, therefore, very popular in motion-picture photography, where an entire reel of negatives made at different times and

places must be printed onto a single roll of positive film. It is true that the printing machines used in this work have some facility for scene-to-scene exposure compensation, but the range of light intensities is limited, and the more consistently a single exposure can be used in printing, the more uniform the print quality will be.

Within limits, the incident-light system works as described; in the motion-picture studio, where light levels are strictly controlled, a very large proportion of excellent negatives is obtained. The incident-light system, however, is not entirely immune to subject errors; in extreme cases, these errors still occur, but the direction of these errors is opposite to that of the reflected-light system. That is, in the example given above, of a light-colored object in dim light and a dark-colored object in bright light, the meter will read the dim light much lower than the bright one. Thus the calculator will call for additional exposure on the light object in dim light and less exposure on the dark subject in bright light. The tendency, then, will be to overexpose the light object and underexpose the dark one, just the opposite of the case of the reflected-light meter.

Thus, either meter will produce correct exposures when the subject matter is "normal," containing about 18 per cent overall light reflectance. Either type will produce an error with subject matter that is not "normal." Obviously, both types must be used with judgment.

Built-in Exposure Meters. When a meter is built into a camera, regardless of whether it is coupled to the lens and shutter or not, it must, obviously, be a reflected-light type of meter, and it will be subject to error from "abnormal" subject matter.

Thus, the built-in meter cannot be expected to produce perfect exposures all the time. In the case of the off-standard subject, one has two alternatives. For the professional, there is always the option of overriding the meter and making an exposure adjustment for subject matter based on personal experience and judgment. But the majority of users of built-in exposure meters are not professionals, and they neither wish to nor know how to make the necessary corrections for subject error. They want the camera to be as nearly automatic as possible—that is why they bought it in the first place.

The other alternative is to make the meter more effective; this is done in one of several ways. One way is to "weight" the response of the meter; instead of having it read the scene as a whole, it responds selectively so that objects near the center of the field have more influence on the reading than those at the edges. The theory is simply that the photographer usually puts the important subject matter in the center of the picture. Thus such a meter will tend to read the most important part of the subject rather than the picture as a whole.

Another approach is to make the meter quite selective so that it reads only a small spot. The user then takes his reading on important subject detail, rather than on any particular area of the scene. Although the idea appears attractive, it does not produce a noticeably larger percentage of good exposures than the overall meter reading.

The ultimate solution to the problem of the built-in meter is statistical. By and large, the built-in meter will produce good results in the overwhelming majority of cases, as high as 85 per cent in many instances. Of the remaining 15 per cent, nearly two-thirds are in error by no more than one lens stop. The obvious answer, in this case, is a simple improvement in the film, to increase its latitude so that a \pm 1 stop error will be negligible. If this is done, the built-in meter will produce 95 per cent "good" pictures. The remaining 5 per cent will vary from acceptable to useless, but the average amateur is likely to be more

than satisfied with a 95 per cent satisfactory picture production; this percentage is far higher than any he is likely to get by any other simple method.

The required latitude was already available in black-and-white films, and for that matter, in color negative films. To extend the latitude of color transparency films, all that is necessary is to reduce the contrast somewhat. This will, necessarily, also reduce color saturation to some extent; many users actually prefer the "softer" color that results. As an example, Kodachrome II has noticeably lower contrast and color saturation than Kodak Ektachrome-X, and it will usually produce a higher percentage of satisfactory pictures in automated cameras.

Spot Meters. It has been pointed out above that the reflected-light meter does not change its reading with distance from the subject; this presumes that the subject subtends the entire angle of view of the meter. Beyond that point, of course, the meter reading will change, as extraneous objects send their light to the meter cell.

Obviously, if a reflected-light meter is made with a very narrow angle of view, it can be used at great distances from the subject and still produce accurate readings. This is the principle of the "spot" meter, which may have an angle as narrow as one or two degrees. It can be used in cases where the subject simply cannot be approached closely enough to take a reading with the normal reflected-light meter.

Aside from its convenience, the spot meter is in no way different from any other reflected-light meter. Its readings are subject to the same subject errors, and one could secure exactly the same results by taking individual close-up readings of each object in a scene and averaging them to produce the final exposure reading, as motion-picture cameramen do. Evidently, the spot meter merely saves a good deal of walking.

Substitution Methods. Incident-light readings can be made with a reflected-light meter. Two factors must be considered. The first is that for a correct incident-light reading, the meter acceptance angle must be increased to a full 180°; the second is that since the calculator dial is calibrated for average subject matter reflecting about 18 per cent of the incident light, whatever system is used to increase the acceptance angle must maintain the calibration, or else it must be allowed for.

Some meters are convertible; they have a diffusing device that fits over the meter cell and gathers light through the required 180° angle. Such devices include the Photosphere of the Norwood meter and the attachable Invercone for the Weston meter. Both these devices have their transmissions adjusted to produce correct exposure readings with the calculators of their respective meters, without need to compensate for the 18 per cent reflectance calibration.

By using a simple matte-surfaced reflector, however, any reflected-light meter can be used to make incident-light readings. The matte surface automatically integrates the light arriving through a 180° angle, thus serving the same purpose as the sphere or cone attachments. One good form of such a reflector is the Kodak Gray Card, which has a reflectance of about 18 per cent. Thus the readings made on this card can be transferred directly to the calculator of the meter.

Some photographers simply take a reading from the palm of their hand, in the same manner as the gray card is used. Although this works reasonably well, one must take into account the fact that average Caucasian skin reflects about 35 per cent of the light falling upon it. Thus the meter will read twice the light level obtainable from a gray card and will indicate an exposure about one

stop too low. The solution is obvious: either use half the reading obtained from the hand, or set the meter to half the film speed actually in use, or set the camera lens one stop larger than the aperture indicated by the meter.

This suggests a method for getting exposure meter readings in very dim light, where the meter is normally not sensitive enough. A reading can be taken from a sheet of plain white paper or from the white side of the Kodak Gray Card. Since white paper reflects about 90 per cent of the light falling upon it, the effect will be to produce a reading about 5 times as large as one which would be obtained from either a gray card or from the scene itself. This makes it easier to read, and it is only necessary to increase the exposure 5 times. One may either use a film speed setting one-fifth of that actually in use or multiply the indicated exposure by 5. In the latter case, the easiest way to make the correction is with the shutter speed; if it calls for 1/10 sec., use 1/2 sec. instead.

EXPOSURE WITH FLASH LAMPS

It has been many years since the concept of the Flash Guide Number was introduced to photographers. The guide number is, of course, the product of the f/stop and the distance in feet between lamp and subject; it has a given value for each combination of lamp, reflector, shutter speed, and film sensitivity.

The use of guide numbers is by now well known. In short, one simply chooses the guide number for the lamp in use at the shutter speed setting intended. Then this number is divided by the lamp-to-subject distance in feet, and the result is the f/stop to be used. A simple example: if the guide number is 220 and the lamp-to-subject distance 10 feet, then $220 \div 10 = 22$ and the lens is set to $f/22$.

The guide number system works because it is actually the ratio of two squares. The light admitted by any lens aperture is proportional to the square of the aperture, whereas the light reaching the subject varies inversely as the square of the distance. Doubling the diameter of the lens aperture increases the light admitted by $(2)^2$ times the light, or 4 times. And doubling the distance from lamp to subject diminishes the light by $(2)^2$, or 4 times

It is not necessary to do a great deal of memorizing of tables of squares to use this fact. All one need remember is that the square root of $2 = 1.4$, nearly enough. Thus to get a guide number for doubling of the film speed, one does not double the guide number but merely multiplies it by 1.4. Thus if the guide number for a given film is 50, the guide number for another film with twice the ASA rating is $50 \times 1.4 = 70$.

Even this simple calculation is usually unnecessary; tables are available for films of almost all useful speeds, and these tables will be found on the following pages. Thus the question of exposure for a single lamp is solved by remembering one guide number and performing one simple mental division.

Multiple Flash

The use of guide numbers for single lamps needs no further discussion. However, some photographers are still confused by the problem of determining the exposure for more than one lamp and find it especially difficult to decide what guide numbers to use for several lamps.

The problem is much simpler than it appears at first; it boils down to deciding upon the exposure for a single lamp and then making corrections for the light of the additional lamps. The questions then are how much additional light is obtained and how much allowance must be made for the additional light?

Here is the surprising fact; the change in exposure for additional lamps is quite small, much smaller than one would expect. To clarify this situation, the following discussion covers the matter in general terms.

Given a single lamp, the guide number formula directly determines the exposure. Now, let us assume that a second lamp is employed. If it is placed at the camera position, right alongside the first lamp, its light merely adds to that of the first lamp, and the result is to double the light. But as we have already seen, if the light is doubled, the guide number is multiplied by 1.4, which is equivalent to a single lens stop.

This is the maximum effect that a second lamp can have. If the lamp is placed anywhere else than right next to the first lamp, it will illuminate only part of the subject. Going to the opposite extreme, if the second lamp is placed behind the subject, either to illuminate the hair or to brighten the background, its effect on the exposure of the subject itself will be *zero*. In this case, we use the guide number for the lamp at the camera position and ignore the added lamp altogether.

These are the two extremes; all other cases must lie between them. If a lamp is placed to the side, it will add only to the light on the highlight side of the face but will put no light on the other half of the subject. Since the exposure must fall between that for two lamps and that for a single lamp and since it is seldom possible to split lens stops in smaller parts than halves, we can simply make a half-stop reduction in lens aperture for the added lamp, and the results will be well within the practical latitude of the process.

In the case of black-and-white films, one seldom bothers to make any compensation for a second lamp unless it is doubling the power of the main lamp. Otherwise, the latitude of the film will handle the matter nicely. With color films, most photographers make several exposures, "bracketing" a half stop above and below the estimated correct exposure. If the same thing is done, after allowing a half stop for the extra lamp, one of the three exposures will almost certainly be correct.

For more than two lamps, the same method is used, but additional lamps have even less effect on the exposure. Returning to the first example, where two lamps are placed at the camera, the exposure required is cut by a single lens stop. Placing another lamp there will not double the light again (2 + 1 = 3) and the added illumination will be only about a half stop.

Again, if the added lamp or lamps are not exactly coincident with the main light, the effect will be less. As an example, if we use three lamps, one for a main light, one for a side light, and one for a hair light, we may ignore the hair light completely, allow a half stop for the side light, and our exposure will be that for the front lamp, reduced by about a half stop. Or we may multiply the guide number for the front lamp by 1.2, and the result will be the f/stop for the combination.

In short, the whole problem of multiple flash comes down to deciding which is the main lamp and making a small adjustment for additional units, seldom exceeding a half stop overall.

This leaves a single problem—what occurs when the lamps are at different distances from the subject? Although this seems at first consideration to be more complicated, it actually is not. We must again assume that both lamps are at the camera position, but that one is nearer the subject than the other. If we use the guide number for the nearer of the two lamps, it is evident that the other lamp will not even double the light, and the compensation will necessarily be less than one lens stop for the second lamp. In short, the added light will always be less than double, and the compensation for two lamps will be less than a full stop at most, again diminishing as the second lamp is moved away from the camera position.

Thus in a seemingly complicated situation with several lamps all at different distances, all that is necessary is to take the lamp most nearly frontal to the subject (and nearest the subject as well) and calculate the exposure for this lamp. Then the others, being farther from the subject and at angles to it, will contribute little additional light, and a reduction in exposure will usually be no more than a half stop for adequate compensation.

Guide Number Tables

The guide number tables on the following pages are those supplied by the two principal manufacturers of flash lamps, General Electric and Sylvania. These tables will not necessarily give the same numbers as those provided on the film data pages. This does not mean that one or the other is wrong; it merely indicates that there are different ways of deriving these guide numbers and that different sources use different methods.

The major source of difference is the type of reflector used with a given lamp. The relatively flat reflectors used with large lamps have a light gain factor of barely 2X, whereas the deep reflectors used with the smaller lamps may have a gain of as much as 10X. Obviously, the guide number for a lamp can vary widely, depending upon what kind of reflector it is used with.

A second source of error causes even the guide numbers for flashcubes with built-in reflectors to vary. This is variation in synchronization depending upon the contact system used in the camera shutter and the efficiency of the shutter itself.

Finally, there will be changes in exposure for individuals, who will find that they must modify the guides given in the tables to allow for variations in actual equipment and for changes in film speed due to processing methods.

For all these reasons, we emphasize that the guide numbers given are just that: *guides.* The user should not hesitate to change them if they do not produce the optimum results with his equipment and methods of working or if the negatives produced do not meet his preference for thin or dense negatives. These tables are a starting point only.

GUIDE NUMBERS FOR GENERAL ELECTRIC CLEAR FLASHLAMPS

Tungsten film speed:		16	20	25	32 40 50	64 80 100	125 160 200	250 320 400	500 640 800	1000 1250 1600
AG-1	1/30 & slower	55	60	70	90	120	180	240	360	480
	1/50 & 1/60	44	50	55	70	100	140	200	280	400
	1/100 & 1/125	38	42	48	60	85	120	170	240	340
	1/200 & 1/250	28	32	34	44	60	90	120	180	240
	1/400 & 1/500	22	26	28	36	50	70	100	140	200
M-3	1/30 & slower	110	120	130	170	240	340	480	700	950
	1/50 & 1/60	95	100	120	150	200	300	420	600	850
	1/100 & 1/125	80	90	100	130	180	260	360	500	750
	1/200 & 1/250	70	80	90	110	160	220	320	440	600
	1/400 & 1/500	55	60	70	90	120	180	240	360	480
5	1/30 & slower	110	120	130	170	240	340	480	700	950
	1/50 & 1/60	95	100	120	150	200	300	420	600	850
	1/100 & 1/125	80	90	100	130	180	260	360	500	750
	1/200 & 1/250	70	80	90	110	160	220	320	440	600
	1/400 & 1/500	55	60	70	90	120	180	240	360	480
6 Focal Plane Shutter	1/30 & slower	110	120	130	170	240	340	480	700	950
	1/100 & 1/125	55	60	70	90	120	180	240	360	480
	1/200 & 1/250	40	46	50	65	90	130	180	260	360
	1/400 & 1/500	28	32	34	44	60	90	120	180	240
	1/1000 & 1/1250	20	22	26	32	44	65	90	130	180
11	1/30 & slower	130	140	160	200	280	400	550	800	1100
	1/50 & 1/60	110	120	130	170	240	340	480	700	950
	1/100 & 1/125	95	100	120	150	200	300	420	600	850
	1/200 & 1/250	65	70	80	100	140	200	280	400	550
	1/400 & 1/500	50	55	65	80	110	160	220	320	440
22	1/30 & slower	180	200	220	280	400	550	800	1100	1600
	1/50 & 1/60	140	160	170	220	320	440	600	900	1200
	1/100 & 1/125	130	140	160	200	280	400	550	800	1100
	1/200 & 1/250	100	110	130	160	220	320	460	650	850
	1/400 & 1/500	80	90	100	130	180	260	360	500	750
50	1/30 & slower	220	260	280	360	500	700	1000	1400	2000

Daylight film speed		16	20	25	32 40 50	64 80 100	125 160 200	250 320 400	500 640 800	1000 1250 1600
AG-1B	1/30 & slower	50	55	65	80	110	160	220	320	440
	1/50 & 1/60	40	45	55	65	90	125	160	250	360
Super Cube and Magi-Cube	1/30 & slower			55	75	100	130	200		
	1/50 & 1/60			36	50	75	90	130		
	1/100 & 1/125			30	42	60	75	110		
	1/200 & 1/250			24	34	48	60	90		
	1/400 & 1/500			19	28	38	48	70		
Hi-Power Cube	1/30 & slower			90	125	160	220			
	1/50 & 1/60			55	80	100	140			
	1/100 & 1/125			48	70	90	125			
M-3B	1/30 & slower	90	100	110	140	200	280	400	560	800
	1/50 & 1/60	75	90	95	120	180	240	360	480	700
	1/100 & 1/125	70	80	90	115	160	230	320	460	640
	1/200 & 1/250	55	70	75	100	140	200	280	400	550
	1/400 & 1/500	45	55	60	80	110	180	220	320	450
5-B	1/30 & slower	90	100	110	140	200	280	400	560	800
	1/50 & 1/60	75	90	95	120	180	240	360	480	700
	1/100 & 1/125	70	80	90	115	160	230	320	460	640
	1/200 & 1/250	55	70	75	100	140	200	280	400	550
	1/400 & 1/500	45	55	60	80	110	180	220	320	450
6-B Focal Plane Shutter	1/30 & slower	85	100	110	140	200	280	400	550	800
	1/100 & 1/125	40	50	55	70	100	140	200	280	400
	1/200 & 1/250	30	35	40	50	70	100	140	200	280
	1/400 & 1/500	22	25	28	35	50	70	100	140	200
	1/1000 & 1/1250	15	18	20	25	35	50	70	100	140
22-B	1/30 & slower	125	140	160	200	280	400	560	800	1100
	1/50 & 1/60	115	120	135	180	240	360	480	700	950
	1/100 & 1/125	110	115	120	160	230	320	460	640	900
	1/200 & 1/250	90	100	110	140	200	280	400	550	800
	1/400 & 1/500	75	80	90	110	160	220	320	450	650
50-B	1/30 & slower	150	170	190	240	340	480	700	1000	1500
M-2B	1/30 & slower	60	65	70	90	125	180	250	360	500

GUIDE NUMBERS FOR SYLVANIA CLEAR FLASH BULBS

Lamp Type		Shutter Speed	Film speeds (Tungsten)					
			10 to 16	20 to 32	40 to 64	80 to 125	160 to 250	320 to 500
AG-1	"X" Sync	Up to 1/30	65	90	130	180	260	360
Zirconium	"M" Sync only	Up to 1/60	40	60	85	120	170	240
Filled	"	1/125	34	50	70	100	140	200
(Class MF)	"	1/250	28	42	60	85	120	170
Note 5	"	1/500	24	34	48	70	95	140
M-2								
(Class MF)	"X" Sync	Up to 1/30	60	90	120	180	240	360
Note 4								
M-3	"X" or "M"	Up to 1/30	90	130	180	260	360	500
Zirconium	"M" Sync only	Up to 1/60	75	110	150	220	300	440
Filled	"	1/125	65	90	130	180	260	360
(Class M)	"	1/250	50	75	100	150	200	300
Note 4	"	1/250	40	60	85	120	170	240
	"X" Sync	Up to 1/30	95	130	190	260	380	550
Focal	"FP" Sync only	1/125	55	80	120	170	240	340
Plane	"	1/250	40	60	85	120	170	240
Shutters	"	1/500	28	42	60	85	120	170
	"	1/1000	20	30	42	60	85	120
Press-25	"X" or "M"	Up to 1/30	95	140	200	280	400	550
(Class M)	"M" Sync only	1/60	90	130	180	260	360	500
Note 1	"	1/125	75	110	160	220	320	440
	"	1/250	60	85	120	180	240	360
	"	1/500	46	65	95	130	190	260
	"	1/750	34	50	70	100	140	200
Press-40		Up to 1/30	100	150	200	300	420	600
(Class M)		1/60	90	130	180	260	360	500
Note 2		1/125	75	110	160	220	320	440
		1/250	60	85	120	170	240	340
		1/500	46	65	95	130	190	260
FP-26	"FP" Sync only	Up to 1/30	100	140	200	280	400	550
(Class FP)	"	1/125	48	70	95	140	190	280
(Note 1)	"	1/250	34	48	70	95	140	190
	"	1/500	24	34	48	70	95	140
	"	1/1000	17	24	34	48	70	95
Type 2		Up to 1/30	150	220	300	420	600	850
(Class M)		1/60	130	190	260	380	550	750
Note 2		1/125	110	160	220	320	460	650
		1/250	85	130	180	260	360	500
		1/500	70	100	140	200	280	400
Type 3								
(Class S)		Up to 1/30	200	280	400	550	800	1150
Note 3								

Note 1: 4—5-inch polished reflector
Note 2: 6½—7½-inch polished reflector
Note 3: Studio reflector
Note 4: 3-inch polished reflector
Note 5: 2-inch polished reflector

When using satin-finish reflectors of same size, open lens one-half f/stop.
When using fan-type reflectors, open lens one full stop.

GUIDE NUMBERS FOR SYLVANIA BLUE FLASH BULBS

Lamp Type	Shutter Speed	Film Speeds (Daylight)						
		10 to 12	16 to 20	25 to 32	40 to 64	100 to 125	160 to 200	320 to 500
Flashcube and **Magicube** Type X	"X" Sync Up to 1/30	32	42	55	75	100	130	200
	"M" Sync only Up to 1/60	22	28	36	50	70	90	130
	" 1/125	18	24	30	42	60	75	110
	" 1/250	15	19	24	34	48	60	90
	" 1/500	12	16	19	28	38	48	70
Hi-Power **Cube**	"X" Sync Up to 1/30			80	110	140	180	
	"M" Sync only Up to 1/60			50	70	100	125	
	" 1/125			42	60	80	100	
AG-1B Zirconium Filled (Class MF) Note 5	"X" Sync Up to 1/30	46	60	75	100	150	190	280
	"M" Sync only Up to 1/60	30	38	48	65	95	120	170
	" 1/125	26	32	42	60	80	100	150
	" 1/250	22	28	34	48	70	85	130
	" 1/500	18	22	28	40	55	70	110
M-2B (Class MF) Note 4	"X" Sync Up to 1/30	42	55	70	95	140	170	250
M-3B Zirconium Filled (Class M) Note 4	"X" or "M" Up to 1/30	65	80	100	140	200	260	400
	"M" Sync only 1/60	55	70	85	120	170	220	320
	" 1/125	46	60	75	100	140	180	280
	" 1/250	36	46	60	80	120	150	220
	" 1/500	30	38	48	65	95	120	180
Focal Plane Shutter	"X" Sync Up to 1/30	65	85	110	150	220	280	400
	"FP" Sync only 1/125	42	50	65	95	130	170	240
	" 1/250	30	38	48	65	95	120	170
	" 1/500	20	26	34	46	65	85	120
	" 1/1000	15	19	24	34	46	60	90
Press 25B (Class M) Note 1	"X" or "M" Up to 1/30	65	80	100	150	200	260	380
	"M" Sync only 1/60	60	75	95	130	190	240	360
	" 1/125	50	65	85	120	160	200	300
	" 1/250	40	50	65	90	130	160	240
	" 1/500	30	40	50	70	100	120	180
FP-26B (Class FP) Note 1	"FP" Sync only Up to 1/30	65	85	110	150	220	260	400
	" 1/125	32	40	50	75	100	130	190
	" 1/250	22	28	36	50	70	90	140
	" 1/500	16	20	26	36	50	65	100
	" 1/1000	11	14	18	26	36	46	70
Type 2B (Class M) Note 2	Up to 1/30	100	130	160	220	320	400	600
	1/60	85	110	140	200	280	360	520
	1/125	75	95	120	170	240	300	440
	1/250	60	75	95	130	190	240	340
	1/500	44	55	75	100	140	180	260
Type 3B (Class S) Note 3	Up to 1/30	130	170	220	300	420	550	800

Note 1: 4—5-inch polished reflector
Note 2: 6½—7½-inch polished reflector
Note 3: Studio reflector
Note 4: 3-inch polished reflector
Note 5: 2-inch polished reflector

When using satin-finish reflectors of same size, open lens one-half stop.
When using fan-type reflectors, open lens one full stop.

Electronic Flash Exposure. Electronic flash units are used in the same way as flashlamps, with one difference. Since the exposure time is usually shorter than 1/1000 sec., the shutter speed of the camera has no influence on the guide number. Thus the electronic flash has a single guide number for each film speed, and this guide number is used regardless of shutter speed setting.

The problem of assigning a guide number to a flash unit is rather more complex, although it can, of course, be done by simple trial and error for any one unit. Two units of different makes, however, having essentially the same power loading in watt-seconds will not necessarily have the same guide number. Calculating the guide number for a given electronic flash unit requires the evaluation of the following rather complicated expression:

$$DF = K\sqrt{\frac{nCE^2M}{2}}$$

Where DF = the guide number for the unit.
 K = a constant based on the film speed and development.
 n = flashtube efficiency in lumens per watt.
 C = capacitance in microfarads.
 E = voltage in kilovolts.
 M = efficiency of the reflector.

Obviously, the solution of this equation requires the knowledge of some factors not generally possessed except by the manufacturer of the unit. We shall therefore not try to solve it, but we can draw some useful conclusions from an analysis of its form.

To begin with, we have the factor "K" for film speed and development. This is not the ASA film speed, but is a rather small factor varying from about 0.5 to perhaps 2.0 or a bit more and depending not only upon the speed of the film but whether it was given normal or extended development. A table of K-factors was given by Dr. Harold Edgerton for films available at the time this formula was proposed, but these factors are probably obsolete for modern films and flash units. The K-factor took into account that early high-speed flash units produced considerable reciprocity failure in the films used at that time. Today's units working between 1/500 sec. and 1/2000 sec. cause little or no reciprocity loss.

The factor "n" poses a more serious problem yet; the efficiency of the flashtube may vary from 20 to 40 lumens per watt, depending upon gas pressure, voltage, and other factors. This variation can produce an error of 100 per cent in light output of a given unit. The actual value of "n" is not obtainable from any source and can only be found by measuring the light output of the tube in the actual equipment in which it is used.

$CE^2/2$ is the power of the unit in watt-seconds and is often the only thing that is known about a given commercial flash unit. It has a direct bearing on the light output and guide number, but unless the other factors are known, we cannot determine a guide number from the watt-second loading of the unit.

The factor "M" is the reflector efficiency and may vary as widely as the reflectors used with flash lamps. Large, flat reflectors will have low efficiencies, whereas deeply curved ones may have light gains upwards of 10X.

Thus it is not possible to publish a guide number table based on the watt-second rating of the flash unit. With a 2:1 variation in flash lamp efficiency and a 5:1 possible variation in light gain due to the reflector, a guide number

from such a table could be in error by as much as ten times; any such table is quite useless.

Some manufacturers specify the output of their units in either Beam Candlepower Seconds (BCPS) or Effective Candlepower Seconds (ECPS). Since these ratings correlate exactly with the light output of the unit, it is possible to use them to determine guide numbers for any unit and any film. The formula for this is:

$$\text{Guide Number} = \sqrt{0.05 \times \text{BCPS} \times \text{ASA Speed for daylight}}$$

To save the trouble of calculating this formula for each film, the table on the facing page gives guide numbers for units having outputs from 350 to 8000 BCPS and for films from 10 to 1600 ASA.

Determining Guide Numbers for Units of Unknown Output

When the effective beam candlepower second rating of the flash unit is not known, the only reliable way to determine a guide number is by an actual photographic test.

For such a test, the best material to use is a color reversal film; since they are not subject to correction in processing, the results obtained clearly show whether the exposure is high or low.

Set up the camera in surroundings typical of the ones in which you expect to be taking pictures. Set flash synchronization of the camera to "X" and shutter to 1/50 or 1/60 sec. Then take a series of pictures varying the camera lens opening by ½ stop for each shot. Take a picture at $f/5.6$, $f/6.7$, $f/8$, $f/9.5$, $f/11$, and $f/13$ (the half stops $f/6.7$, $f/9.5$, and $f/13$ are not marked on cameras but are approximately halfway between the full stop markings.) Allow at least 30 seconds between pictures to make sure the flash unit is fully recharged; this gives you full light output for each shot. Include a card identifying the f/stop used for each picture so that you will be sure of the exposure on each image when they are processed and mounted as slides.

When the pictures have been processed, project them all and choose the one having the best exposure. Mustiply the f/stop used to make this slide by the flash-to-subject distance in feet. For example, assume the camera was 10 feet from the subject, and the best exposure was $f/9.5$. Then $10 \times 9.5 = 95$ and you can use 95 as the guide number for that flash unit with the particular film used.

It is necessary to do this test only once, for any given flash unit; once you have found a guide number for any given film with that unit, guide numbers for other films can be found from the table on the facing page. For example, if you made a test with a film having a daylight rating of ASA 64, locate 64 in the first column, under "Film Speed (ASA) for Daylight." Then follow the line across until you come to a number as close as possible to the one determined in your test. In this case, the value 95 will be found under the 2800 column. Then you can consider that for practical purposes, your flash unit has an output of 2800 BCPS and you can use the guide numbers in that column (or in the 2800 BCPS column in the film data pages in Sections BWF and CF) for films of other ASA ratings.

Another way of determining the guide number for films of other speeds where your trial guide number does not come out even with one in the table is by using the following formula:

$$\text{Guide no. for film "a"} = \text{Guide no. for film "b"} \times \sqrt{\frac{\text{ASA speed of film "a"}}{\text{ASA speed of film "b"}}}$$

(Continued on page 566)

GUIDE NUMBERS FOR ELECTRONIC FLASH

FILM SPEED (ASA) FOR DAYLIGHT	BCPS OUTPUT OF ELECTRONIC FLASH									
	350	500	700	1000	1400	2000	2800	4000	5600	8000
10	13	16	18	22	26	32	35	45	55	65
12	14	18	20	24	28	35	40	50	60	70
16	17	20	24	28	32	40	50	55	65	80
20	18	22	26	32	35	45	55	65	75	90
25	20	24	30	35	40	50	60	70	85	100
32	24	28	32	40	50	55	65	80	95	110
40	26	32	35	45	55	65	75	90	110	130
50	30	35	40	50	60	70	85	100	120	140
64	32	40	45	55	65	80	95	110	130	160
80	35	45	55	65	75	90	110	130	150	180
100	40	50	60	70	85	100	120	140	170	200
125	45	55	65	80	95	110	130	160	190	220
160	55	65	75	90	110	130	150	180	210	250
200	60	70	85	100	120	140	170	200	240	280
250	65	80	95	110	130	160	190	220	260	320
320	75	90	110	130	150	180	210	250	300	360
400	85	100	120	140	170	200	240	280	340	400
500	95	110	130	160	190	220	260	320	370	450
650	110	130	150	180	210	260	300	360	430	510
800	120	140	170	200	240	280	330	400	470	560
1000	130	160	190	220	260	320	380	450	530	630
1250	150	180	210	250	300	350	420	500	600	700
1600	170	200	240	280	340	400	480	560	670	800

(Continued from page 564)

Because of the short duration of the flash, some black-and-white films are subject to reciprocity failure with electronic flash exposures. This is best compensated by an increase in developing time, because the effect is a loss in both density and contrast. With Kodak films, increase processing times according to the figures below.

Kodak Tri-X Pan Film, roll and 135 5% longer development
Kodak Super Panchro Press 6146 Type B, sheet film. . 20% longer development
Kodak Commercial 6127 and 4127 sheet film 50% longer development

Synchro-Sunlight Flash

The use of flash lamps or electronic flash to provide shadow fill-in illumination in outdoor photography is a well-established procedure. A simple and practical discussion of the use of fill-in flash with color films will be found in the Introduction to Section 3: Color Films.

Although the flash lamp is very bright, as artificial sources go, it is not anywhere near as bright as direct sunlight, so that the major effect of flashing a lamp for an outdoor picture is to raise the level of shadow illumination to a useful degree, without much effect on the illumination of the highlights. For this reason, the fill-in flash has little effect on the overall exposure of the picture, and exact exposure recommendations are neither possible nor necessary.

For those who wish to understand the technique more thoroughly, however, we can point out that the determination of exposure for fill-in flash with flash lamps is merely a matter of working the normal exposure calculation backward. That is, we first determine the exposure required for the daylight part of the scene. Having arrived at a shutter speed and f/stop combination or a set of combinations from the exposure meter, we choose one of the combinations in the normal way, depending upon whether we wish action-stopping or depth-of-field.

Now, from the guide-number table, we find the proper guide number for the lamp in question for the given film speed. This guide number is divided by the f/stop already chosen for the daylight exposure, and the result will be the distance from flash lamp to subject. If camera to subject distance is not important, we move the camera to this distance and make the exposure; if distance is critical for correct composition and is different from that determined for the flash, we remove the lamp from the camera, connect it with an extension cord, and place it at the correct distance from the subject for the exposure.

We have some opportunity to use different distances even with flash on camera because we can use different shutter speeds. That will require different f/stops and correspondingly different distances for the flash-to-subject placement. In so doing, though, we must note that the guide number must be chosen according to the shutter speed in use.

The same system can be used with electronic flash and in fact is somewhat simpler in this case. The reason is that the electronic flash is faster than any ordinary shutter speed; thus only a single guide number is used regardless of the shutter setting. We can choose any f/stop to secure the amount of fill-in light at the distance chosen, then find the shutter setting that will give the correct daylight exposure at the previously chosen f/stop .

FILTERS AND FILTER FACTORS

Early films were sensitive only to blue light; objects of other colors were reproduced as dark gray or black. This distortion could not be corrected in any way since it was inherent in the film sensitivity.

The first color-sensitized films were called *orthochromatic,* which means "true color." This claim was somewhat exaggerated; although these films had some added sensitivity in the green and yellow-green areas, they still had neither orange nor red sensitivity, and objects of these latter two colors were still rendered much too dark.

Nonetheless, there was a very noticeable improvement in rendition, especially of landscape scenes, where the added green sensitivity aided in the proper reproduction of foliage. The additional color sensitivity was rather low, though, and the film was still much too sensitive to blue, violet, and ultraviolet. The sky in most pictures washed out to pure white, and clouds were invisible. Photographers soon discovered the "ray screen," or filter; made of yellow glass, it held back some of the excess blue and allowed green and yellow areas to reproduce more naturally. Obviously, the loss of some blue light made it necessary to increase the exposure to compensate, and filters were soon marked with a "factor" such as 2X, 3X and so on. As long as only the one kind of film was available, this simple system of marking was adequate.

About 1930, *panchromatic* films became available. The term "panchromatic" means "all colors," and this was substantially true, although it could not be taken to mean that the film was *equally* sensitive to all colors. In fact, there was still a great excess of blue and violet sensitivity.

Thus for best rendition, it was (and is) still necessary to use filters, although the necessity is not as great with the most recent types of panchromatic film. Many of these have sensitivities corresponding closely to that of the eye, with the exception of some small excess of sensitivity to blue, violet, and ultraviolet.

A few panchromatic films have, in addition to the excess blue sensitivity, an unnecessarily high sensitivity to red; these are mainly the extra-fast types of film for available-light photography. When the extra speed is not needed and better rendition is desired in artificial light, the Wratten No. 13 filter can be used. This medium-green filter produces better rendition of skin tones and lips in studio portraits but has no real use outdoors. A few photographers use the somewhat lighter Wratten No. 11 filter for a moderate darkening of skies and lightening of green foliage. The same effect can be produced in daylight by the medium-yellow Wratten No. 8 filter, which has a smaller factor.

Thus for "correct" rendition of colors in black and white, one can get along with one or two filters—the No. 8 for outdoor photography and the No. 11 or No. 13 for studio work by incandescent light. Except for critical work or for a slight emphasis on sky tones in outdoor work, even these filters are not always required. Modern panchromatic films produce a remarkably natural rendition of tones when used without any filter whatever.

For specialized work, however, where it is often necessary to distort tonal rendition deliberately for emphasis, a variety of filters is available. Consider for example, the classic case of the red apple in green foliage. The eye separates these by color contrast; in black and white, they are almost equal in tone, and both appear about the same shade of gray in an uncorrected negative. Since most people think of red as brighter than green, we might wish to emphasize the apple by making it appear lighter than the leaves. With panchromatic film this can be accomplished by a deep orange or light red filter. For technical

reasons, however, we might want a dark apple on light foliage (perhaps we wish to indicate that the species is a Red Delicious, not a Yellow Delicious). In this case, we can use a deep green filter such as the Wratten No. 58, which will darken the apple and lighten the foliage.

Usually quite deep in color, these "contrast" filters require considerable exposure compensation, which will, of course, vary with the color sensitivity of the film. Therefore, it is not possible to specify a red filter as being a 4X or a 6X red—a given red filter may have factors varying from 4X to 10X depending upon the film with which it is used.

Luckily, most films sold today are panchromatic, and the varieties of such films fall into a few classes, depending upon the type of sensitizer used in their manufacture. With most panchromatic films, the average light yellow filter will require only about a half-stop compensation outdoors and practically none at all in tungsten light. Usually, this compensation is within the latitude of the film and can be ignored. In fact, it is sometimes preferable with light-colored filters not to make any compensation for exposure factors; this will produce a more marked contrast effect. Overexposure with filters tends to cancel the filtering effect to a considerable extent. This occurs because very few filters have an absolutely sharp cutoff at a given color. This can be considered a sort of "leakage"; nearly all filters transmit some of the light that they are supposed to absorb. Overexposure, then, increases the transmission of the light intended to be held back and reduces the effect of the filter. Slight underexposure will tend to exaggerate the effect of the filter: using a light yellow filter without additional exposure will produce a more definite effect than if we meticulously attempt to compensate for it.

Where more exaggerated effects are desired, deeper colored filters can be used—in the case of the red filters, we have the light red 23A, the medium red 25, and the deep red 29. The denser filters have greater exposure factors and additional exposure must be given. Sometimes the amount turns out to be greater than is convenient either because of the danger of subject movement or because we wish to use a small aperture for greater depth of field. In such a case, the effect of a deeper filter can be approximated with a lighter one, with controlled underexposure.

The filter colors most used are yellows, oranges, and reds. Green filters, other than the No. 11, have little use except in specific cases where a green object must be photographed with lightened rendition. The same applies to deep blue filters, which are used only to achieve color contrast or occasionally to simulate a "color-blind" rendition. The pale blue filters found in some filter kits are useless in black-and-white photography.

Filter Factors. Factors for all commonly used films of American make are found in the data pages for these films in Sections 2 and 6. We have been unable, however, to secure factors for the use of Wratten filters with the Agfa-Gevaert and Ilford films. This is not to say that these filters cannot be used with these films. They can, of course, but it will be necessary to determine the factors for these combinations by test. One can use as a starting point, the factor given for an American made film of similar characteristics, and a small final adjustment will usually provide a workable filter factor.

Of course, other makes of filter are sold in the United States. Some domestic manufacturers of filters have simply adopted the Wratten terminology for their filters—these include Accura, Enteco, Gallinger, and probably some others. Other makers offer filters of similar characteristics, but use a different name or number system. For the convenience of those who wish to use these with published data, we give a substitution table below.

568

FILTER SUBSTITUTION TABLE

	Light Yell.	Med. Yell.	Dark Yell.	Or'g	Light Gr'n.	Med. Gr'n.	Light Red	Med. Red	Dark Red	Blue
Ednalite	Y-1	Y-2	Y-3	O-2	G-1	G-2	R-1	R-2	R-3	——
Harrison	YL-1	YL-3	YL-4	YL-6	GR-4	GR-5	RD-4	RD-5	RD-8	——
Ilford	——	108	109	110	402	——	——	204	——	304
Leitz	YO	Y1	——	O	YG	——	——	Red	——	——
Lifa	G0 G1	G2	G3	G4	P0 P1	P2	RO	R1	R2	——
Mico	Lt Y	Md Y	Dk Y	Org	LtGr	MdGr	——	Red	DkRd	Blue
Rollei	Lt Y	MdY	——	Org	LtGr	Gr	——	LtRd	——	——
Tiffen	Y1	Y2	Y3	Or	Gr 1	Gr 2	23A	R1	29	47
Wratten	6	8	9	15	11	13	23A	25	29	47
Zeiss	——	Yel	——	Org	Grn	——	——	Red	——	——

FACTORS FOR ILFORD FILTERS AND FILMS

Filter Number and Name	Wratten Number	FACTORS Daylight	FACTORS Tungsten
102—Aviol	—	1.5	1.2
103—Chromatic-1	—	1.5	1.2
104—Alpha, Micro-8, Chromatic-2	86B	1.5	1.2
105—Iso	—	1.5	1.2
108—Micro-9	8	1.5	1.2
109—Delta, Chromatic-3	9	2.0	1.5
110—Micro-4, Minus Blue	15	2.5	1.5
111—	—	3.0	1.8
ORANGE & RED FILTERS			
201—	—	4.0	2.0
202—Micro-5	22	5.0	2.2
203—	—	6.0	4.0
204—Tricolor Red	25	6.0	4.0
205—Narrow Cut Tricolor Red	—	18.0	14.0
206—	—	—	—
BLUE FILTERS			
301—	—	—	1.5
302—Minus Red	—	3.0	5.0
303—Micro-2	—	5.0	10.0
304—Tricolor Blue	47B	7.0	13.0
305—Micro-1	—	9.0	18.0
306—	—	18.0	30.0
GREEN FILTERS			
401—Beta	—	2.0	1.5
402—Gamma	11	3.5	4.0
404—Tricolor Green, Micro-3	58	6.0	6.0
406—Astra	—	3.5	4.0
408—	—	9.0	9.0
PURPLE & MAGENTA FILTERS			
501—Micro-6	—	15.0	30.0
502—Micro-7	—	4.0	4.0
503—Minus Green	—	6.0	7.0
MISCELLANEOUS			
808—Q filter	—	1.2	1.2

NOTE: All Ilford films currently available in the United States fall in Ilford Sensitivity Class 3, and the above table is therefore correct for all these films.

COLOR TEMPERATURE

One way of comparing the color quality of light sources is by the use of "color temperature" values. These are based on the well-known fact that when certain objects, such as an iron bar, are heated, they will emit light of various colors at various temperatures. Thus an iron bar as it is heated will glow first dull red, then orange, yellow, white, and finally blue-white (though it will very likely melt before reaching this latter color). For this reason, we generally specify color temperatures, not by reference to any material object but by comparison with a theoretical "black body."

The "black body," or perfect radiator, is defined as an object that absorbs all radiation falling upon it and reflects none. Although such an object does not actually exist, an approximation may be made of some highly refractory black material in the form of a hollow cube with a hole in one side. The radiation from the hole may be considered a close approximation to black-body radiation.

When an actual object *has* some reflectance but reflects equally at all wavelengths, it is called a "gray-body" reflector, and its characteristics are much the same as a black body, except that its actual temperature and the color temperature of its radiation will differ somewhat. The filament of an incandescent lamp is a form of "gray-body" radiator, and it is for this reason that color temperature measurements are valid with incandescent lamps.

The use of the theoretical black body allows the specification of the color quality of a light source in terms of a single number. This number is the temperature to which the black body must be raised, in order for its radiation to match in color that of the source being measured. Any convenient temperature scale can be used; for reasons not pertinent here, the "absolute" thermometer is used, and its readings are specified in Kelvin numbers (abbreviation K), Temperatures on the absolute thermometer scale are approximately 273 units larger, numerically, than the degrees on a Celsius thermometer; the size of the unit is the same. Thus, on the absolute thermometer, the freezing point of water is 273 K, and the boiling point of water is 373 K. (The precise values are 273.16 and 373.16, respectively.)

Since there are some basic limitations to this system as applied to photography its use is diminishing. The major problem is in the fundamental definition of the term color temperature—it is the temperature to which the black body must be raised for the color of its light to match that of the sample. The color match specified here is a visual one; it defines only the appearance of the light, not its energy distribution. Therefore, although a gray-body radiator, such as an incandescent lamp, can be specified in terms of black-body color temperature, we cannot use color temperature figures for light sources that do not have black-body or gray-body radiation. Thus daylight, which is a mixture of sunlight and scattered skylight, cannot be given a valid color temperature value.

At one time, manufacturers of fluorescent lamps specified the color quality of these units by their equivalent visual color temperature; however, these lamps have large gaps in their spectra and cannot be accurately specified in this manner. Color temperature measurement is of some use in the studio for incandescent lamps, flash lamps, and electronic flash units, which happen to have fairly similar energy distributions. It is of no value in connection with fluorescent lamps or daylight.

*Note that the unit is *not* Kelvin *degrees* (nor "degrees Kelvin" nor °K). The new international unit is the kelvin (lower case k), and its abbreviation is K (capital K). The degree mark is not used; thus a color temperature is simply written 3200 K.

The measurement of color temperature is usually done in an indirect manner, since no convenient black-body radiator is available for comparison. Most color temperature meters make the assumption that a black body is being measured and actually determine the ratio between red and blue light in the output. This system is adequate for studio use with incandescent lamps only; such meters should not be used outdoors or with other light sources.

The high-efficiency incandescent lamp used in studio photography changes color temperature by about 10 K for each volt of change at its terminals; thus it is possible to make small adjustments of color temperature with a rheostat or a transformer. Larger changes, especially in an upward direction, must be made with filters, because an increase in voltage tends to shorten the life of lamps drastically.

Filters present a new problem. A filter that raises or lowers color temperature by a given amount at one temperature will not make the same change at any other temperature. That is, a filter that will raise a 3200 K source to 3400 K will not have the same effect on a source at 3800 K.

Another way of specifying color temperature is with a unit called the *Micro-reciprocal degree,* or *Mired* (pronounced my-red). A larger unit, the *Decamired,* equal to ten Mireds, is sometimes used. A filter may be given a "Mired shift value" whose utility is that it is constant, regardless of the color temperature of the source. One must not forget, though, that these values only apply when the filter is used with a light source having the standard energy distribution; Mired shift values are meaningless when used in daylight or fluorescent light. The mired is one million times the reciprocal of the temperature in kelvin, thus:

$$\text{Mired} = \frac{1,000,000}{\text{color temperature}}$$

The Mired shift value for a filter is determined by the use of the following relationship:

$$\frac{1,000,000}{T_2} - \frac{1,000,000}{T_1}$$

Where T_1 = the color temperature of the source.
 T_2 = the color temperature of the light transmitted by the filter.

Depending upon the color of the filter, this value can be either negative or positive; it is important to notice that the sign is opposite to that of the change in color temperature. Thus, a yellowish filter that lowers the color temperature will have a positive (+) Mired shift value, whereas a bluish filter that raises the color temperature will have a negative (−) Mired shift value.

The Eastman Kodak Company manufactures a variety of filters that can be used for light source correction. Those made primarily for this purpose in color photography are known as Kodak Light Balancing Filters and Kodak Conversion Filters. Another series of Kodak Wratten Filters is made primarily for visual use in photometry. These filters can be assigned mired shift values and can be used in color photography when desired.

Other filters, not listed here, are made by other manufacturers. Many of these are marked in Decamireds (pronounced dekka-my-red) and can be used in exactly the same way, but one must remember that the Decamireds is ten times larger than the Mired. Thus a filter marked 3.0 Decamireds is the same as one having a Mired shift value of 30. The purposes and uses are exactly the

same, and the use of the + sign for a raising of Mired shift, or lowering of color temperature, and the − sign for reduction of Mired shift, or raising of color temperature, remains the same.

KODAK LIGHT BALANCING AND CONVERSION FILTERS

	Filter Color	WRATTEN Number	Exposure Increase in Stops°	To obtain 3200 K from:	To obtain 3400 K from:	Mired Shift Value
Light Balancing Filters	Bluish	82C + 82C	1⅓	2490 K	2610 K	−89
		82C + 82B	1⅓	2570 K	2700 K	−77
		82C + 82A	1	2650 K	2780 K	−65
		82C + 82	1	2720 K	2870 K	−55
		82C	⅔	2800 K	2950 K	−45
		82B	⅔	2900 K	3060 K	−32
		82A	⅓	3000 K	3180 K	−21
		82	⅓	3100 K	3290 K	−10
		No Filter Necessary		3200 K	3400 K	—
	Yellowish	81	⅓	3300 K	3510 K	9
		81A	⅓	3400 K	3630 K	18
		81B	⅓	3500 K	3740 K	27
		81C	⅓	3600 K	3850 K	35
		81D	⅔	3700 K	3970 K	42
		81EF	⅔	3850 K	4140 K	52
Conversion Filters	Blue	80A	2	3200 to 5500		−131
		80B	1⅔	3400 to 5500		−112
		80C	1	3800 to 5500		−81
		80D	⅓	4200 to 5500		−56
	Orange	85C	⅓	5500 to 3800		81
		85	⅔	5500 to 3400		112
		85B	⅔	5500 to 3200		131

°These values are approximate. For critical work, they should be checked by practical test, especially if more than one filter is used.

KODAK WRATTEN PHOTOMETRIC FILTERS

THE NO. 78 SERIES			THE NO. 86 SERIES		
Filter No.	Description	Mired Shift Value	Filter No.	Description	Mired Shift Value
78	2360 K to 5500 K	−242	86	5500 K to 2360 K	242
78AA	2360 K to 4400 K	−196	86A	3200 K to 2360 K	111
78A	2360 K to 3200 K	−111	86B	2800 K to 2360 K	67
78B	2360 K to 2800 K	−67	86C	2500 K to 2360 K	24
78C	2360 K to 2500 K	−24	Dummy	For Setting 0°	

Note: See next page for color temperatures of practical light sources.

COLOR TEMPERATURES OF VARIOUS LIGHT SOURCES

The following table gives the approximate visual color temperatures of various standard and practical light sources. It must be emphasized that a visual match does not necessarily imply identical energy distributions, and in the case of color films, visual corrections will not necessarily produce the same effect on the film. The following table, therefore, is for information only, and some of the values given can be corrected for color photography with the appropriate filters, others cannot.

Standards of Luminous Intensity and Their Color Temperatures

Source	Color Temperature (in K)
Standard British candle	1930
Hefner	1880
Harcourt pentane	1920
Acetylene	2415
Incandescent carbon (4 watts/candle)	2080
Incandescent tungsten (1.25 watts/candle)	2400
Freezing point of platinum	2042

Practical Sources of Illumination and Their Color Temperatures

Source	Color Temperature (in K)
Sunlight (mean noon)	5400
Skylight	12,000 to 18,000
Photographic Daylight *	5500
Crater of carbon arc (ordinary hard-cored)	4000
White-flame carbon arc	5000
High-intensity carbon arc (sun arc)	5500
Clear zirconium foil-filled flash	4200
Clear aluminum foil-filled flash	3800
500-watt (photoflood) approx. 34.0 lumens/watt	3400
500-watt (3200 K photographic) approx. 27.0 lumens/watt	3200
200-watt (general service) approx. 20.0 lumens/watt	2980
100-watt (general service) approx. 17.5 lumens/watt	2900
75-watt (general service) approx. 15.4 lumens/watt	2820
40-watt (general service) approx. 11.8 lumens/watt	2650

*Condition of daylight which best represents that encountered in typical photographic situations.
Literature reference: "Spectral Distribution of Typical Daylight as a Function of Correlated Color Temperature," D. B. Judd, D. L. MacAdam, G. Wyszecki, **Journal of the Optical Society of America,** Vol. 54, No. 8, (August 1964), pp 1031-1041.

SAFELIGHT FILTERS

A wide variety of sensitized materials is available today, and matching safelights are marketed for the convenient handling of most of them. It must be remembered, though, that no light is totally safe; safelight filters, like camera filters, have some "leakage," and extended exposure to any kind of "safe" light will eventually cause fog. It is essential to use each safelight filter with its recommended bulb and at the recommended distance from the material being handled.

Some special safelights are employed in commercial and photomechanical darkrooms; these are usually some kind of colored fluorescent tube in connection with a filter, and they are intended mainly for use with slow films and papers used in phototypesetting, photostatting, and similar work.

Most photographers, though, use the conventional incandescent fixture with the appropriate filter. The use of orange or red filters with enlarging papers was abandoned years ago in favor of the Kodak Wratten Series OA (greenish-yellow) safelight, which provides much more light and in addition is of a color that makes judging print density easier. This filter cannot be used with variable-contrast papers, though; they have considerable green sensitivity and will be fogged. For such papers, the Wratten Series OC (deep amber) is recommended, as is the DuPont S55-X or Ilford 902.

The green safelight, Wratten Series 3, is a special case. It is intended for use with panchromatic films, which are sensitive to light of all colors, and no safelight is really safe for these. The Series 3 Safelight Filter works on the principle of utilizing a color of light to which the eye is most sensitive; thus the light can be made so dim that there is little danger of fog. Even so, it is really safe only for the slower panchromatic films; high-speed panchromatic films may be fogged. In any case, the safelight should be turned on only after the film has been in the developer for a few minutes; the film loses some sensitivity in the developer. It is doubtful that this filter can be used for development by inspection, and one is best advised to develop all panchromatic films in total darkness, using the green safelight only to illuminate the face of a darkroom clock or timer.

Infrared materials are a special case, too. They are usually sensitive only to blue, violet, and to the far red and infrared. Since there is a large gap in their sensitivity, they can be safely handled with a green safelight of fairly high brightness, such as the Wratten Series 7.

Color negative and reversal materials must be handled in total darkness; however, color print and color duplicating films also have gaps in their sensitivity, which allow the use of a deep yellow filter (Wratten Series 8) for Eastman Color Print Film and a dark amber filter (Wratten Series 10) for most other Kodak Color Print materials.

There are corresponding types of safelight filter made by Ilford. The following tables show that one can easily substitute filters from each for the other, where that is convenient.

574

KODAK WRATTEN SAFELIGHT FILTERS

Filter	Color	For Use With
Series OA	Greenish Yellow	Kodak Contact Papers, Kodalith Contact and Duplicating Materials, Kodagraph Contact and Projection Films, Kodak Opalure Print Film.
Series OC	Light Amber	Kodak Black-and-white Contact and Enlarging Papers, Kodak High Resolution Plate.
Series OO	Light Yellow	For flash exposure technique with Kodak Contact Screens.
Series 1	Red	Blue-sensitive films and plates, Kodagraph Projection Positive, and Kodagraph Projection Papers (Standard and Extra Thin)
Series 1A	Light Red	Kodalith ortho-sensitive films, plates, and paper, Kodagraph Contact, Kodagraph Projection (Translucent) and Kodagraph Ortho Papers.
Series 2	Dark Red	Orthochromatic films and plates, Kodagraph Fast Projection Paper, Kodak Linagraph Papers.
Series 3*	Dark Green	Panchromatic Films and Plates.
Series 6B†	Brown	X-ray film (except dental), blue-sensitive film for photoradiography, Kodak Electrocardiograph 553 Paper.
Series 7	Green	Infrared materials (except Kodak High Speed Infrared Film)
Series 8‡	Dark Yellow	Eastman Color Print Film, Types 5385 and 7385.
Series 10 §	Dark Amber	Kodak Ektacolor Slide Film, Kodak Ektacolor Print Film, Kodak Resisto Rapid Pan Paper, Kodak Panalure Paper.
Series 11¶	-------	Transmits infrared only, for use with the Kodak Infrared Scope.
Series 13	Amber	Kodak Ektacolor 30 RC Paper and Kodak Ektacolor 37 RC Paper.

*Fast panchromatic materials require that development be started in total darkness. After the material has been in the developer for half the total development time, or longer, it can be inspected for a few seconds by the light of a Series 3 Filter, provided the lamp is kept at a distance of at least four feet.

†With Kodak Royal Blue Medical X-ray film and Kodak Single-Coated Medical X-ray Film, Blue-Sensitive, use a 7½-watt bulb instead of a 15-watt bulb.

‡See instructions in specification sheet for Types 5385 and 7385 Films.

§With Kodak Ektacolor Print Film and Kodak Ektacolor Slide Film, use no longer than 30 seconds.

¶This filter is not intended for infrared films; it transmits infrared freely and will fog them. Its purpose is for monitoring the processing or handling of films which are not sensitive to infrared, through the use of the Kodak Infrared Scope or other viewing device using infrared radiation and an image converter tube.

ILFORD DARKROOM SAFELIGHT FILTERS

Safelight Number	Name	Color	For use with
900	BR	Bright red	Slow orthochromatic materials
902	S	Light brown	Slow, blue-sensitive materials including Ilfoprint Projection and Ilfoprint Projection Document papers.
903	Infrared	Yellow-green	Infrared plates which are not sensitive to green.
904	F	Dark brown	Process Films, Process Plates, Special Lantern Plates and other fast blue-sensitive materials.
906	Iso	Dark red	Orthochromatic materials.
907	G	Dark green	Very slow panchromatic plates and films.
908	GB	Very dark green	All panchromatic plates and films except the very slowest. Although designed for the maximum possible efficiency, this safelight must be used with extreme care. Hypersensitive materials must not be exposed to its direct light for any appreciable length of time.
909	Bright green	Green	Desensitized panchromatic films and plates.
910	VS 2	Orange	Contact paper, Reflex Contact Document Paper, Contact Lantern Plates, Contact Film and other very slow blue-sensitive materials.
914	NX	Sepia	X-ray films. Not suitable for use with color-sensitive materials.

WEIGHTS, MEASURES, AND MISCELLANEOUS FORMULAS

For many years the people of the United States have worked with a hodgepodge system of weights and measures; commonly thought of as "avoirdupois", it is actually a mélange of several systems, mostly of British ancestry, although our pint, quart, and gallon differ from the English measures of the same name. The system is best called *American Customary,* rather than avoirdupois. Adding to the confusion, certain trades have other systems: pharmacists use Apothecaries' measures; jewelers use Troy weights; and farmers measure their lands in rods and acres, their crops in bushels, pecks, and quarts.

Most of Europe has long since adopted the Metric system, which is distinguished from the others not only by its basic units but also by the simple decimal system by which all the different measures are related. It is certainly easier to remember that 10 millimeters make a centimeter, and 100 centimeters make a meter, than to remember that 12 inches make a foot, 3 feet make a yard, and 1,760 yards (or 5,280 feet) make a mile.

There has been considerable resistance to repeated efforts to change the American system to the Metric. Some of the resistance is economic—it will, of course, involve changing almost every measuring tool used in the country, including rulers, micrometers, scales, weights, gauge blocks, and many other devices. There will also be important secondary changes to be made; one of them is the system of threads used in nuts, bolts, all parts that screw into one another, and all the tools used to make them.

This resistance can be understood; it will involve a vast expenditure of both time and money. But there is also resistance from people who have no economic stake in the matter, and much of this stems from simple inertia. People are accustomed to the current system and see no reason to change it. Then, too, some actively oppose the change because of a fancied difficulty; they are concerned over various complicated tables of conversion, wherein a meter is equal to 39.37 inches, a kilogram 2.2 pounds, and a liter about 33 ounces.

The American people, when and if they change to Metric measure, will find that the huge bugaboo of conversions will cease to exist. Since no one will need to use pounds, ounces, gills, gallons, or yards any more, there will be no need to refer to tables of conversions. One will simply use the Metric weights and measures, remember a few factors of 10, and that is all.

Meanwhile, it is not necessary to wait until that far-distant day when the American Customary System is finally abandoned. The photographer can make the change immediately. It will cost him little—a couple of graduates and a new set of weights for his balance. Since all the formulas given in this book are in both American Customary and Metric measure, no conversions are necessary. Once the reader has provided a set of Metric weights and measures, he will find his chemical mixing vastly simplified.

This may not be quite self-evident. But consider a simple and very common occurrence. Many formulas call for amounts like "1 ounce 145 grains." Most darkroom scales do not have weights for the smaller grain quantities; they use a sliding beam which goes up to 50 or 100 grains, seldom more. The first problem with this amount is deciding how to set up the scale for 145 grains. Since one-quarter ounce is roughly 109 grains, one has to take a one-ounce weight, a quarter-ounce weight, and after a bit of mental arithmetic (where one can easily make a mistake), set 36 grains on the sliding beam.

The same quantity in the Metric formula is 50.0 grams. Usually the photographer has a 50-gram weight, but if not, he can use two 25-gram weights or two

20-gram weights plus a 10-gram weight. In any case, no intricate arithmetic is required, and much less chance of error exists.

It is important to point out here that 1 ounce 145 grains does *not* equal 50 grams. They appear in parallel columns in the formulas, but the two columns make different quantities of solution; a quart in one case, a liter in the other. Although the *quantities* of solids are different, the final *concentration* of chemical in solution is the same, and this is what matters.

Generally, when the Metric system is adopted, the Metric thermometer (Celsius or Centigrade) is used. The advantage is not great, although it is probably easier to set 20 C than 68 F. That Celsius thermometers are decimally graduated is advantageous only in the case of the better and larger ones, where the scale will be in degrees and tenths of degrees. Such thermometers are both more accurate and easier to read than the conventional Fahrenheit thermometers, which are seldom marked in units smaller than a whole degree.

It is not expected that photographers will for the time being give up inches and feet in favor of meters. For one thing, all domestic cameras are scaled in feet, which would only lead to troublesome conversions. Likewise, with a few exceptions, film and paper sizes are all in inches; one odd situation is motion-picture film, with width measured in millimeters and length in feet.

If the photographer should encounter Metric measures, however, the easiest way to solve the conversion problem is simply to ignore it. All one need do is buy a couple of Metric rules, such as a 15-centimeter steel rule, graduated in millimeters, and a meter stick, graduated in centimeters. It is easier to take the measurement with one of these than to take it in inches and laboriously convert it with pencil and paper.

Thus we intend to do our part to speed the conversion to the Metric system by deliberately *not* providing extended tables of conversions. We think it preferable that the photographer provide himself with some Metric measures and get used to them. We do list the conversion factors between the various systems for the odd occasion when it is necessary to make the conversion. But we do not wish to clutter pages with long tables of every possible fraction of an inch and its corresponding millimeter measure.

A few minor problems come up now and then. One of these is the occasional formula in British measure. In these, the grain and ounce weights are the same as the American, but the British (or Imperial) pint is 20 ounces, the British quart is 40 ounces, and the Imperial gallon is 160 ounces. Most modern British publications give formulas in both Imperial and Metric system measure, and our advice stands—use the Metric form in all cases and avoid all possibility of confusion.

One other problem with foreign formulas is that they often specify certain chemicals in different forms from those used in the United States. British formulas frequently call for sodium sulfite and sodium carbonate in crystal form; American formulas almost always use anhydrous (desiccated) sodium sulfite and monohydrated sodium carbonate.

Where a formula calls for crystalline sodium sulfite, we may use half the amount of anhydrous or desiccated sulfite. Where the formula calls for crystalline sodium carbonate, the solution is less simple; one has to use 0.433 times the amount of monohydrated carbonate. In many formulas, no great precision is required, and if we simply use half the quantity, just as with sodium sulfite, the difference in results will be nearly unnoticeable.

The tables of weights, measures, and conversions that appear in the following pages are all taken from *Photographic Facts and Formulas* by Wall and

578

Jordan (Amphoto, 1947); they have been checked and rechecked over the years and may be considered reliable.

Avoirdupois Weight

$$
\begin{aligned}
1 \text{ dram} &= 27.343 \text{ grains} \\
16 \text{ drams} &= 1 \text{ ounce} &= 437\frac{1}{2} \text{ grains} \\
16 \text{ ounces} &= 1 \text{ pound} &= 7000 \text{ grains}
\end{aligned}
$$

Ounces and Equivalents in Grains

Ounces	Grains	Ounces	Grains	Ounces	Grains	Ounces	Grains
1/8	54.7	1	437.5	2¾	1203	4½	1969
1/4	109	1¼	546	3	1312	4¾	2078
3/8	164	1½	656	3¼	1421	5¼	2296
1/2	219	1¾	765	3½	1531	5½	2406
5/8	273½	2	875	3¾	1640	6	2625
3/4	328	2¼	984	4	1750	6¼	2734
7/8	383	2½	1094	4¼	1859	6½	2844

Fluid Measure

$$
\begin{aligned}
60 \text{ minims} &= 1 \text{ dram} \\
8 \text{ drams} &= 1 \text{ ounce} &= 480 \text{ minims} \\
4 \text{ ounces} &= 1 \text{ gill} \\
16 \text{ ounces} &= 1 \text{ pint} \\
32 \text{ ounces} &= 1 \text{ quart} \\
128 \text{ ounces} &= 1 \text{ gallon}
\end{aligned}
$$

Note that the above are U. S. measures and that the British or Imperial pint contains 20 ounces, an Imperial quart 40 ounces, and an Imperial gallon 160 ounces. Due allowances must always be made when handling these quantities in English formulas if the terms pint, quart, and gallon are used instead of the quantity being expressed in ounces.

The Metric System. The prefixes used in Metric terminology are:

deci	= 0.1 (one-tenth)	deka	= 10 times	
centi	= 0.01 (one-hundredth)	hecto	= 100 times	
milli	= 0.001 (one-thousandth)	kilo	= 1000 times	
micro	= 0.000 001 (one-millionth)	mega	= 1,000,000 times	
nano	= 0.000 000 001	giga	= 1,000,000,000 times	
pico	= 0.000 000 000 001	tera	= 1,000,000,000,000 times	
femto	= 0.000 000 000 000 001			

Compound prefixes (*e. g.,* millimicro) are not to be used.

The unit of length is the meter, and the unit of weight (mass) is the gram. A decimeter is one-tenth meter, a decigram is one-tenth gram. A centimeter is one-hundredth meter, and a centigram is one-hundredth of a gram. A dekagram is 10 grams, a hectogram is 100 grams, and a kilogram is 1000 grams.

In photography, only a few of these prefixes are ever used, the general practice being to write the multiples in full and the subdivisions decimally, as: 50.0 grams, 2.5 grams, and so on. Plate and film sizes are often expressed in centimeters or millimeters and the focal length of lenses may be stated either in centimeters or millimeters. Because the liter is not exactly a cubic decimeter (or 1000 cubic centimeters), the use of the term *cubic centimeter (cc)* is not exactly correct and in scientific work has been abandoned in favor of the term *milliliter (ml).* The difference is so trifling in all but very large quantities that photographers may safely ignore it.

Weights are based on the international kilogram in which 1 pound or 7,000 grains = 453.5924277 grams. A troy pound is 5760 ÷ 7000 avoirdupois pounds.

A change in temperature affects the standards of length, capacity, and so on, although the units themselves may be fixed ones. A definite temperature must be established if accurate comparisons are to be made, on account of the shrinkage or expansion in length or volume. The capacity standards of the United States are fixed at a temperature of 4 C, at which water reaches its maximum density. If extreme accuracy is needed at other temperatures, the exact equivalents can be found by means of tables.

Useful Equivalents: Linear

1 inch	=	25.4 millimeters
1 foot	=	0.3048 meter
1 yard	=	0.9144 meter
1 mile	=	1.6093 kilometers
1 millimeter	=	0.03937 inch
millimeters ÷ 25.4	=	inches
1 centimeter	=	0.3937 inch
1 meter	=	39.3704 inches
1 meter	=	3.2808 feet
1 meter	=	1.0936 yards
1 kilometer	=	0.6213 mile
kilometers ÷ 1.6093	=	miles
1 kilometer	=	3280.833 feet

Useful Equivalents: Volume

1 minim (water)	=	0.06161 cubic centimeter
1 fluid dram	=	3.6966 cubic centimeters
1 fluid ounce	=	29.5729 cubic centimeters
1 ounce apothecary (water)	=	31.1035 cubic centimeters
1 pint (16 ounces)	=	0.4732 liter
1 quart (32 ounces)	=	0.9463 liter
1 gallon (128 ounces)	=	3.7853 liters
1 cubic inch	=	16.3871 cubic centimeters
1 cubic foot	=	0.0283 cubic meter
1 cubic yard	=	0.765 cubic meter
1 cubic centimeter	=	16.23 minims
1 cubic centimeter	=	0.2705 fluid dram
1 cubic centimeter	=	0.0338 fluid ounce
1 liter	=	1.0567 quarts
1 liter	=	0.26418 gallon
1 liter	=	33.8147 fluid ounces
liters ÷ 3.7853	=	gallons (231 cubic inches)
1 cubic centimeter	=	0.061 cubic inch
cubic centimeters ÷ 16.387	=	cubic inches
cubic centimeters ÷ 3.6966	=	fluid drams
cubic centimeters ÷ 29.5729	=	fluid ounces
1 cubic meter	=	35.3357 cubic feet
1 cubic meter	=	1.3079 cubic yards
1 cubic meter	=	264.15 gallons
1 liter	=	61.0232 cubic inches
liters ÷ 3.7853	=	gallons
liters ÷ 28.3170	=	cubic feet

Useful Equivalents: Weight

1 grain	=	64.7989 milligrams
1 ounce avoirdupois	=	28.3495 grams
1 pound avoirdupois	=	0.4536 kilogram
1 pound avoirdupois	=	453.5924 grams
1 milligram	=	0.01543 grain
1 gram	=	15.4323 grains
1 kilogram	=	2.2046 pounds avoirdupois
1 kilogram	=	35.2739 ounces avoirdupois

Useful Equivalents: Miscellaneous

1 gallon (United States)	=	231 cubic inches
1 gallon (U. S.) of water	=	8.313 pounds avoirdupois
1 gallon (U. S.) of water	=	58418.144 grains
1 pound avoirdupois (water)	=	0.1203 gallon
1 fluid ounce (water)	=	456.392 grains
1 fluid ounce (water)	=	1.0391 ounces avoirdupois
1 ounce avoirdupois (water)	=	0.9623 fluid ounce
1 cubic inch (water)	=	252.892 grains
1 liter (water)	=	1 kilogram
1 liter of water × specific gravity of liquid	=	weight in grams of liquid
1 United States gallon	=	0.83267 Imperial gallon
1 Imperial gallon	=	1.201 United States gallons

Compound Conversion Factors

Grains per 32 fluid ounces multiplied by 0.06847	=	grams per liter
Ounces per 32 fluid ounces multiplied by 29.96	=	grams per liter
Pounds per 32 fluid ounces multiplied by 479.3	=	grams per liter
Grams per liter multiplied by 14.60	=	grains per 32 fluid oz.
Grams per liter multiplied by 0.03338	=	ounces per 32 fluid oz.
Grams per liter multiplied by 0.002086	=	pounds per 32 fluid oz.
Ounces (fluid) per 32 oz. multiplied by 31.25	=	cubic centimeters per liter
Cubic centimeters per liter multiplied by 0.032	=	ounces (fluid) per 32 oz.

Metric/English Equivalents: Lengths

Centimeters		Inches		Inches		Centimeters
1	=	0.3937		1	=	2.54
2	=	0.7874		2	=	5.08
3	=	1.1811		3	=	7.62
4	=	1.5748		4	=	10.16
5	=	1.9685		5	=	12.70
6	=	2.3622		6	=	15.24
7	=	2.7559		7	=	17.78
8	=	3.1496		8	=	20.32
9	=	3.5433		9	=	22.86

Note that the names of the metric units all end in *meter* and are pronounced as separate syllables—thus kilo-meter, not ki-LOM-eter. The latter pronunciation is by a false analogy with words like thermometer, micrometer, and so on. Thus the unit for a millionth of a meter (formerly the *micron*) is now the *micrometer*, pronounced micro-meter, and not to be confused with the measuring device pronounced mic-ROM-eter.

Metric/English Equivalents: Masses

Grains		Grams		Grams		Grains
1	=	0.0648		1	=	15.4324
2	=	0.1296		2	=	30.8647
3	=	0.1944		3	=	46.2971
4	=	0.2592		4	=	61.7294
5	=	0.3240		5	=	77.1618
6	=	0.3888		6	=	92.5941
7	=	0.4536		7	=	108.0265
8	=	0.5184		8	=	123.4589
9	=	0.5832		9	=	138.8912

Metric/English Equivalents: Liquid Measure

Cubic Centimeters		Minims		Fluid Ounces		Cubic Centimeters
1	=	16.23		1	=	29.574
2	=	32.46		2	=	59.147
3	=	48.69		3	=	88.721
4	=	64.92		4	=	118.295
5	=	81.15		5	=	147.869
6	=	97.38		6	=	177.442
7	=	113.61		7	=	207.016
8	=	129.84		8	=	236.590
9	=	146.07		9	=	266.163

The above tables also apply to the British weights and measures with the exception of the liquid measures: the British or Imperial gallon measures 160 fluid ounces = 4545.96cc = 277.418 cubic inches (Br.) or 277.420 (U. S.). One liter = 1000cc or ml = 35 fluid ounces, 94 minims (Br.) = 16894.1 minims. A fluid ounce of water weighs 437.5 grains and a minim is 437.5 ÷ 480 = 0.91 grain. The following table must therefore be used for the conversion of the British liquid measure:

Conversion of Metric to British (Imperial) Liquid Measure

Cubic Centimeters		Minims		Fluid Ounces		Cubic Centimeters
1	=	16.894		1	=	28.4123
2	=	33.788		2	=	56.8245
3	=	50.682		3	=	85.2368
4	=	67.576		4	=	113.6490
5	=	84.470		5	=	142.0613
6	=	101.364		6	=	170.4735
7	=	118.258		7	=	198.8858
8	=	135.152		8	=	227.2980
9	=	153.046		9	=	255.7103

Percentage Solutions

Chemicals are sometimes kept in stock solutions. Some dispute has prevailed as to the exact meaning of "x per cent solution," but in photographic practice it means x parts in 100 parts of the total bulk of the solution. As most chemicals are sold by the avoirdupois ounce of 437.5 grains, and liquids are measured by the ounce of 480 minims, some confusion has arisen. The following tables show: (a) the accurate quantities of solids to be dissolved in sufficient liquid to make a total bulk of 100 parts for the various percentages; (b) the number of grains to be dissolved in sufficient solvent to make one ounce of any given percentage.

Per cent		Grains	Per cent		Grains
1	=	4.375	6	=	26.25
2	=	8.75	7	=	30.625
3	=	13.125	8	=	35.0
4	=	17.50	9	=	39.375
5	=	21.875	10	=	43.75

The number of grains of a solid which must be dissolved in sufficient liquid to make one fluid ounce for the various percentages:

Per cent		Grains	Per cent		Grains
1	=	4.8	6	=	28.8
2	=	9.6	7	=	33.6
3	=	14.4	8	=	38.4
4	=	19.2	9	=	43.2
5	=	24.0	10	=	48.0

These tables are sufficient to calculate any percentage or volume, by merely multiplying or adding. Example: to make a 15% solution, how many grains are required?

$$10 \text{ per cent} = 43.75$$
$$5 \text{ per cent} = \underline{21.875}$$
$$65.625 \text{ grains}$$

To make 16 ounces of 10% solution, how many grains required?

$$48 \times 16 = 568 \text{ grains}$$

A table listing the factors to use in making up an aqueous solution of any percentage strength, weight to volume, is published by Merck & Co. These factors are based on the value: 1 fluid ounce = 480 minims, the weight of which is 455 grains. Thus for 10 ounces (of 10% solution) the figure to use is 455 grains. For 16 ounces, 455 x 16 = 728 grains. For one ounce, 45.5 grains of solid make a 10% solution, for a 5% solution, take half of the 10 per cent values, for 30% take three times the 10 per cent values, and so on.

The foregoing provides one of the most powerful arguments for adopting the Metric system. All the confusion and ambiguity disappear when a percentage solution is made in Metric measure. For instance, to make a 10% solution, one need merely dissolve 10 grams of chemical in enough water to make a final volume of 100.0ml. Since the chemical takes up some room in solution, the procedure is simply to dissolve 10.0 grams of chemical in about 90.0ml of water and after it is fully dissolved, add enough water to bring the total volume up to 100.0ml. Obviously, if 100.0ml of solution are to be made, the number of grams of chemical is exactly the same as the percentage desired, and no calculations are necessary.

When a percentage solution is to be made of a liquid, the problem is a bit different; of course, if the liquid is 100% in strength or substantially so, then it is merely necessary to dilute it with the required amount of water. But many liquids used in photography are already diluted, such as, for example, Formalin, which is a 40% solution of formaldehyde. If it is to be further diluted, a special method is required to determine the quantities required to produce a final solution of a given strength. The "criss-cross" method given below is probably the most convenient and has been used for many years. It is reproduced from *Photographic Facts and Formulas* by Wall and Jordan (Amphoto, 1947).

*Percentage strength
that is to be diluted*

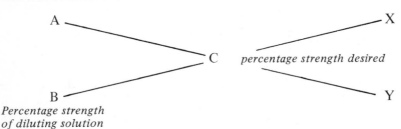

*Percentage strength
of diluting solution*

At A write the percentage strength of the solution that is to be diluted.

At B write the percentage strength of the diluting solution. Use 0 for water.

At C write the percentage strength desired.

Subtract C from A and write the result at Y.

Subtract B from C and write the result at X.

Then if X parts of A are diluted with Y parts of B, the result will be a solution of C percentage.

For example, if it is desired to make a 30% solution of hypo from a 50% stock solution, write 50 at A, 0 at B, and 30 at C. Subtracting 30 from 50,

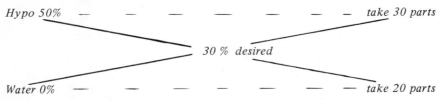

write 20 at Y. Subtracting 0 from 30, write 30 at X. Reading the result, if 30 parts of 50% hypo is diluted with 20 parts of water, the result will be a 30% solution of hypo.

Comparison of Thermometer Scales

The thermometer is an instrument for measuring temperatures. Three systems are used. Celsius (formerly called Centigrade) fixes 0 at the freezing point of water and 100 at the boiling point. The absolute, or Kelvin scale starts at "absolute zero" and uses degrees the same size as Celsius, thus placing the freezing point of water at 273 K and its boiling point at 373 K. On the Fahrenheit scale, 0 represents the temperature of equal parts of ice and salt, 32 the freezing point of water, and 212 the boiling point of water.

Formulas for conversion: $(C \times \frac{9}{5}) + 32 = F$
$(F - 32) \times \frac{5}{9} = C$
$C + 273 = K$
$K - 273 = C$

C	F	C	F	C	F	C	F
+120	+248	+80	+176	+40	+104	±0	+32
119	246.2	79	174.2	39	102.2	−1	30.2
118	244.4	78	172.4	38	100.4	−2	28.4
117	242.6	77	170.6	37	98.6	−3	26.6
116	240.8	76	168.8	36	96.8	−4	24.8
115	239	75	167	35	95	−5	23
114	237.2	74	165.2	34	93.2	−6	21.2
113	235.4	73	163.4	33	91.4	−7	19.4
112	233.6	72	161.6	32	89.6	−8	17.6
111	231.8	71	159.8	31	87.8	−9	15.8
110	230	70	158	30	86	−10	14
109	228.2	69	156.2	29	84.2	−11	12.2
108	226.4	68	154.4	28	82.4	−12	10.4
107	224.6	67	152.6	27	80.6	−13	8.6
106	222.8	66	150.8	26	78.8	−14	6.8
105	221	65	149	25	77	−15	5
104	219.2	64	147.2	24	75.2	−16	3.2
103	217.4	63	145.4	23	73.4	−17	1.4
102	215.6	62	143.6	22	71.6	−18	− 0.4
101	213.8	61	141.8	21	69.8	−19	− 2.2
100	212	60	140	20	68	−20	− 4
99	210.2	59	138.2	19	66.2	−21	− 5.8
98	208.4	58	136.4	18	64.4	−22	− 7.6
97	206.6	57	134.6	17	62.6	−23	− 9.4
96	204.8	56	132.8	16	60.8	−24	−11.2
95	203	55	131	15	59	−25	−13
94	201.2	54	129.2	14	57.2	−26	−14.8
93	199.4	53	127.4	13	55.4	−27	−16.6
92	197.6	52	125.6	12	53.6	−28	−18.4
91	195.8	51	123.8	11	51.8	−29	−20.2
90	194	50	122	10	50	−30	−22
89	192.2	49	120.2	9	48.2	−31	−23.8
88	190.4	48	118.4	8	46.4	−32	−25.6
87	188.6	47	116.6	7	44.6	−33	−27.4
86	186.8	46	114.8	6	42.8	−34	−29.2
85	185	45	113	5	41	−35	−31
84	183.2	44	111.2	4	39.2	−36	−32.8
83	181.4	43	109.4	3	37.4	−37	−34.6
82	179.6	42	107.6	2	35.6	−38	−36.4
81	177.8	41	105.8	1	33.8	−39	−38.2

Specific Gravity, which is the ratio of the mass of a body to the mass of an equal volume of water at 4 C, is measured by an instrument called a *hydrometer*. In the Baumé type, which is the one most commonly used, there are separate instruments for measuring liquids heavier than water and liquids lighter than water. Specific gravity taken by means of these hydrometers is termed in degrees Baumé (Bé.). In the system for liquids heavier than water, 0° equals a specific gravity of 1; 1° equals specific gravity 1.007; 2° equals specific gravity 1.013; 3° equals specific gravity 1.02, and so on. For liquids lighter than water, 10° equals a specific gravity of 1, and for every rise of one degree on the scale, there is a drop in the specific gravity of about 0.005.

In photography, the temperature affects the volume of liquids so that hydrometers are notoriously inaccurate when tested at temperatures other than those for which the readings are given, which are not often stated. The practice of buying liquids by weight instead of volume is the only logical one. Acids are sold in this way, by weight, and a heavy acid, like sulphuric acid, which has a specific gravity of 1.8, takes up less space. Although most photographic formulas do not need to be compounded with extreme accuracy, it is just as well to work with the solutions at an average room temperature of about 68 F (20 C.)

INTRODUCTION TO "GRAPHIC ARTS MATERIALS"

A number of special materials are in use in the photomechanical industries that differ quite sharply in characteristics from those films ordinarily used in photography. It was inevitable that creative photographers would eventually discover these materials and put them to uses never contemplated by their manufacturers. This section will concern itself mainly with those materials that have found use in photography, and it is not intended as a primer of the photomechanical trades. We shall not, at this time at least, discuss the making of line or halftone etchings, nor of lithographic or offset plates. Instead, we shall cover the use and handling of those materials currently used in the photomechanical crafts, which have found use in photography, for whatever purpose.

Thus, the greater part of this section consists of data pages, much like those found in the sections on black-and-white and color films. Wherever possible, we try to offer such information as ASA speeds for these materials; these speeds are not usually given, since they serve no purpose in the photomechanical shop. The fact is that with materials of ultra-high contrast, these speeds are not too useful; their main function will merely be to indicate the approximate exposure level at which to begin testing.

Photomechanical Materials

All photographic films have a characteristic known as *gamma infinity,* which is merely the maximum gamma to which they can be developed. This may not be clear at first; one would assume that the longer a film is developed, the higher the gamma, and so any desired gamma could be attained simply by developing for a sufficient length of time. In practical cases, though, this is not true. As development continues, the growth of image density is accompanied by a slow but increasing rate of development of unwanted density or fog. At some point, the fog rate overtakes the growth of image density, and thus contrast ceases to increase; this point is the gamma-infinity point for that film. It may be quite low, as in the case of portrait films, which can seldom be developed to gammas much above 1.5. Or it can be fairly high, as with positive or lantern-slide emulsions, which can be developed to gammas of 3.0 and higher.

Photomechanical processes differ from the usual photographic systems in that they are basically "go/no-go" devices. A piece of printer's type accepts ink on its high spots only and transfers it to the paper on impression; the resulting

print is either fully inked or not at all. It is not possible in normal printing procedures to secure a scale of grays by transferring different amounts of ink; the surface either touches the paper or it does not (or in lithography, it either accepts ink or it does not). Various devices are used to simulate continuous-tone reproduction; the ordinary halftone plate that produces visual grays by breaking the image into dots of various sizes is the best known, but again, each dot transfers ink to paper totally or not at all.

Thus in photomechanical processes, we need materials that are quite different from the usual photographic emulsions; what we require is an emulsion that is, as nearly as possible, totally insensitive to light up to a certain level. Above this level the emulsion should produce its maximum black regardless of the amount of additional exposure given. Such an emulsion must have a very high gamma infinity attainable in a fairly short processing time, and in addition, must have a very low fog level.

As a simple comparison, let us consider the characteristic curve of a normal negative film. As is evident from the diagram below, the curve has a gentle slope corresponding to a low gamma; it is capable of reproducing a scale of grays as a corresponding scale of grays, differing only slightly in gradation from one step to the next.

NEGATIVE

ORIGINAL SUBJECT

Figure 1: Film of normal contrast

Thus if exposed to a subject with a wide scale of tones or brightnesses, it will produce a negative having nearly as wide a scale of densities.

The litho-type film, on the other hand, has a very steep curve, with a short toe. As can be seen from the following diagram, if it is exposed to a scale of grays, the first few steps are not bright enough to produce any result at all; it is possible that one step will fall right on the bend of the curve and produce some kind of deep gray, and all tones brighter than this are reproduced as solid black—our scale of grays is reduced to three tones and sometimes to only two.

588

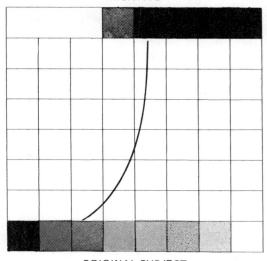

ORIGINAL SUBJECT

Figure 2: High contrast litho film

In the photomechanical trades, the negative is merely a step to a printing plate of some kind; whether letterpress or lithographic, the method of production is much the same. A metal (or in some cases, plastic) plate is coated with a material called a *resist* and this, in turn, is exposed to light under the negative. After exposure, the plate is treated with a solvent that removes the unexposed resist, leaving the image in the form of resist-covered areas, which serve to protect the metal plate from the acid used in etching (in the case of letterpress) or from the various hydrophilic coatings used in lithography.

For this purpose, the negative must be of the highest possible contrast—it must be a completely opaque black in the image areas, and completely free from fog in the unexposed parts. For such negatives, a film known as "litho" film (or various proprietary names containing *lith*) is used. Generally, this film is developed in a developer containing paraformaldehyde, which has a special property; aside from its ability to produce dense blacks in a very short time, it has a solvent action on the unexposed and only slightly exposed areas of the film. Thus it actually clears the unexposed areas of any vestiges of fog, while developing the exposed areas.

There are some applications in the graphic arts where such extremely high contrast is not needed, either because the original material is already of amply high contrast, such as in making duplicate negatives or reverses, or because the negative in question will not be printed to metal. For this purpose, various "line" films are offered; they are still capable of reaching very high gammas, but have the advantage that they can be processed in ordinary developers such as D-11, D-19, and other moderately high-contrast formulas.

Some continuous-tone photography is done even in graphic-arts plants. As an example, it is often desirable to make separation negatives from colored originals at normal contrast levels, and then to make halftone negatives from these separations, or from positive prints made from them. Special films are offered for these purposes, and have other uses in general photography.

Special Purpose Materials

In recent years, practical use has been made of certain obscure effects in photographic materials. It has been known, for instance, that a phenomenon called *pressure desensitization* occurred in certain materials—that is, if local pressure were applied to the emulsion, that spot would no longer be developable, even though fully exposed. This effect is used in the Kodak Autoscreen film, which has been impressed with a dot pattern, and when exposed in an ordinary camera, or by contact under a positive transparency, will produce a halftone negative with the usual pattern of large and small dots required for printing. This makes it possible for the photographer to make halftone negatives for offset printing, silk-screen printing, and other processes, without any special equipment. The film is merely exposed in any camera, given a short flash exposure to a dim light to produce the necessary dots in the unexposed (shadow) areas, and then developed. This film comes in only one screen ruling, but it is a simple matter, if a coarser screen is required for silk-screen or newspaper work, to make the image smaller than needed, and then to make an enlargement to the required scale, which will also enlarge the spacing of the dots.

Another useful effect is that which is correctly known as *solarization;* in certain emulsions, after a maximum exposure level is reached, further exposure will result in a *decrease* in density. If such an emulsion is made and pre-exposed to a maximum black, then a sheet of film taken from the package will develop to a full black without further exposure. If exposed to a positive image, the result, after development, will be a duplicate positive.

Such autopositive emulsions can be made in almost any desired contrast level; one such emulsion, Kodak Autopositive Film, also has the ability to work either as a negative or as a positive material depending on the color of light to which it is exposed. This is a high-contrast material for line work; as normally supplied it will come out fully black if developed without exposure. Exposure to yellow light through a negative will produce another negative; if, though, the the emulsion is first flashed to yellow light, then exposure through a negative to white light will produce a positive. Obviously, many very interesting results can be produced with such a film by successive exposures to negative and positive images, by yellow and white light.

Other autopositive films of lower contrast can be used for the duplication of continuous-tone images; for example, Kodak High Speed Duplicating Film 2575 has become quite popular among pictorialists for the making of enlarged negatives from 35mm originals, for use in carbon, gum-bichromate, platinum, and other processes that can only be done by contact printing.

A very unusual film known as Agfacontour Film uses the solarization effect in a special way. The emulsion of this material is only partly solarized, thus resulting in a film that produces a full black either when unexposed or when fully exposed to light. At some intermediate exposure the emulsion produces light grays, and thus has a characteristic curve something like Figure 3, next page.

Exposure to a normal subject will produce outline effects at one particular density; the film was originally designed for certain scientific purposes requiring the outlining of areas of equal density (isohely). If exposed to a continuous-tone subject, the result will be a negative in which the image will be transformed into an outline, and a print from this negative will show the outline to be a line version of the original image. This line will not be entirely sharp—it will be a band of densities diminishing on both sides. This leads to further interesting possibilities; if this line image is used as a master to expose another sheet of the same film, the resulting image will be produced by the mid-density on each side of the original line; thus the line-contour image now becomes a double-line image. Obviously,

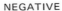

NEGATIVE

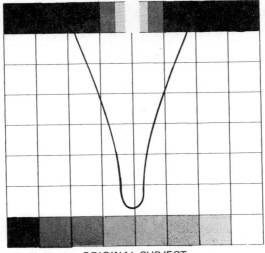

ORIGINAL SUBJECT
Figure 3: Agfacontour Film

repetition of this procedure will produce four lines, and so on. Some highly interesting results can be produced from fairly simple subject matter by this procedure, and it is finding use in the textile-decorating industry.

Proofing Materials

In the photomechanical industries, there is need for quick visual proofs for checking the results of color separations, and for customer approval. Several materials are available for such purposes, among them Gevaproof, which utilizes transfer layers to produce a colored image in several colors on a single base. Another, even simpler product is 3M Color Key, which consists of a variety of colored coatings on plastic sheets. For a three-color proof, one sheet each of magenta, cyan, and yellow is exposed to its respective negative. Development is done in full room light, and the finished images are merely superimposed to form the color proof.

Both processes are high-contrast, intended for either line work, or for screened halftones. 3M Color Key comes in a wide range of colors other than the three process colors, and can be used for making proofs of multicolor type layouts and line art in many colors. As a guide for subsequent printing, 3M Color Key provides colors that are matched to the standard Pantone printing inks.

Color Key comes in two types, one negative-working, the other direct-positive. The development procedure for both is essentially the same, with a minor change in the last step. The colors in the Pantone series are transparent, and can be used for preparing positives for projection in classroom overhead projectors, or in smaller sizes, for lantern slides.

The opaque Color Key materials are suitable not only for proofing, but, since they are of very high contrast, equivalent to the usual litho film, they may be used for such processes as posterization.

Special Effects

Because of the great contrast of litho-type films, it is generally believed that variations in exposure above a given minimum have no effect on the image—it is

591

either unexposed, or it attains maximum black depending on the exposure level. This, in fact, is true on a large scale; it is most emphatically not true when it comes to fine detail in an image.

We have already pointed out that photographing a gray scale on high-contrast film results in a number of white steps and a number of black steps. The exact step at which transition from white to black takes place is determined by the overall exposure level. Thus, a given exposure might cause steps one to three to be white, all the rest black. Increasing the exposure will move the transition one or more steps to the white end; decreasing it will move it one or more steps to the dark end. That is, if the exposure is much reduced we will now have steps one to five white, the rest black. If the exposure is increased, then we might find that step three is now black instead of white, and we have only two white steps.

Thus we can move the transition from white to black along the length of a gray scale by changing the exposure level. Now, no photographic image has a completely sharp transition from white to black; because of diffraction, residual lens aberrations, and other causes, the edge of a black object will appear on the focusing screen as a measurable blur. That is, the sharp edge has been transformed into a miniature gray scale.

Then, if the exposure is changed, the point at which the image changes from white to black is moved within this gray zone forming the edge of the image. The result is obvious—if, for instance, the subject is a narrow black line, underexposure will cause this line to be rendered wider than it should be, and overexposure will, to some extent, narrow its image.

The ability to control the width of lines by varying exposure finds uses in photomechanical work, and the creative photographer can also utilize the effect to his own ends. Take, for example, a circle, solid black inside, on a white ground. If this is photographed on litho film with minimum exposure, we will find a negative which in this case will be a white circle on a black ground; because of the minimal exposure, the black area will be a bit small, or, in turn, the white circle will be slightly larger than it should be. Now, suppose we make a contact print from this negative on another piece of litho film, and again, give a minimum exposure. The result now will be a black circle on a white ground, and the black area will be a bit small, again. Then, if we superimpose the negative and the positive, we will find the black circle is just a little smaller than the white one; we have, in the combination, a black disc surrounded by a thin white line, in turn surrounded by a black background. If this sandwich is printed on paper, we get a thin line circle on a white ground.

This method is used to a great extent in photolettering to transform solid letters into outline letters; its use in creative photography is limited only by the imagination of the photographer.

Obviously, there are ways of exaggerating this effect. One thinks of the old bas-relief process, which involved making a somewhat out-of-focus negative and positive on continuous-tone film, and superimposing them, in or out of register. The same thing can be done with litho films, either by putting the camera lens out of focus, or by contact printing with a broad light source and a separator between the films. If the original subject is a continuous-tone negative, the result of making a line positive and a line negative from that, and superimposing the two will be a very interesting "line-drawing" from the continuous-tone subject, without need for any handwork at all. This process is known as the *tone-line process,* and further information on it will be found in this section.

Another use can be found for the extreme contrast attainable with litho films. As we have already pointed out, it is possible by choice of exposure level to determine just what tone of gray will be the first black tone in a gray scale. Obviously this applies equally well to any continuous-tone subject matter. Given

a continuous-tone positive, a minimum exposure in contact printing to a negative on litho film will result in a negative that is completely transparent except for a few black areas that are the extreme highlights. If another such negative is made at a greater exposure, it will, in turn, represent the upper middle tones. Still another negative, made with still more exposure, will be mostly black with only some few large areas representing the deeper middle tones. And one more negative with maximum exposure will be entirely black, except that a few spots representing the deepest shadows remain clear.

Now, these four negatives can be printed in succession on any black-and-white paper, the first, representing the highlights, being given only a very short exposure, then each succeeding negative being printed on the same paper with more exposure. The result will be a rendition of the original subject in which the wide range of tones has been reduced to just four flat tints.

This is by no means a new process; it is discussed at some length in old books under the name of its discoverer as the *Person Process*. Its use has been much increased in modern photography because of the availability of materials in which the final print can be made, not merely in tones of gray, but as various colors. The general process is called *posterization,* and it can be done, not only with litho films, but with such materials as 3M Color Key as well.

Obviously, once these basic ideas are mastered, it is quite possible for the imaginative photographer to discover ways of combining them for new effects— one could make a line image and a series of flat tones from a single continuous-tone original, then print the line image in black, and the flat tones in various colors. Other ideas will suggest themselves.

Processing

As in other parts of this book, the data pages for the various high-contrast films give the manufacturer's recommendations for processing. In general, since nearly all these films are either orthochromatic or blue-sensitive, fairly bright safelights are permissible, and processing is done more by inspection than by time. This is especially the case because most high-contrast films process very rapidly, developing times being on the order of 1½ to 3 minutes, and it is not possible to control the process very well in trays with a timer. Commercial graphic-arts plants, of course, are now using automatic processing machines in which time, temperature, and replenishment are all automatically controlled for uniform density and contrast.

The creative photographer who uses these films for purposes other than those for which they were designed will find that they react fairly well to a wide variety of developers; the usual litho film will produce remarkably high contrast in D-11, D-19, and even D-72 or Dektol, used undiluted. It is only for certain specialized purposes where the absolute maximum contrast is desired that one must use the true litho-type developer, and most shops, today, buy this type of developer ready-mixed under various trade names.

There is not really much difference between litho films of various brands, and all work pretty well with a standard litho-type developer, with possibly minor adjustments of exposure and processing time. For those who do not have a graphic-arts supplier near at hand, and for those who prefer to mix their own chemicals, there is a more or less standard developer formula that utilizes hydroquinone and paraformaldehyde, and has the desirable property of cutting off development sharply in the low densities, thus producing a negative that is free from fog and of the highest possible contrast. This developer was known variously as Kodak D-85, Dupont 7-D, Ansco 79, Haloid D-3, and others (the Dupont version was double strength and required dilution with water before use.) It may

be used with litho films of any make, and will produce much the same results as the packaged formulas offered for use with these films.

LITHO FILM DEVELOPER

Water (not over 90 F or 32 C)	16 ounces	500.0 cc
Sodium Sulfite, desiccated	1 ounce	30.0 grams
Paraformaldehyde	¼ ounce	7.5 grams
Sodium Bisulfite.	32 grains	2.2 grams
*Boric acid, crystalline	¼ ounce	7.5 grams
Hydroquinone .	¾ ounce	22.5 grams
Potassium Bromide	22½ grains	1.6 grams
Add water to make	32 ounces	1.0 liter

*Use crystalline boric acid as specified. Powdered boric acid dissolves with great difficulty and its use should be avoided.

Develop line negatives for 1½ to 2 minutes at 68 F (20 C). Halftone negatives should be developed for not over 2½ minutes at 68 F (20 C). With a correctly exposed film, the image should appear in 30 to 45 seconds at normal temperature,

The remainder of the process is much the same as for any other film. A stop bath such as Kodak Stop Bath SB-1a or the Kodak Indicator Stop Bath may be used after development, or a simple running-water rinse can be used. Fixing is done in any standard acid hardening fix bath such as Kodak F-5 or the equivalent of other makers.

Litho films have a very thin emulsion and extended washing is not necessary. Ten minutes in running water is ample for good permanence in most cases, and even shorter washing times will be adequate if the negative is needed only as an intermediate stage and will not be preserved for future use.

Because litho films develop to maximum contrast, the only effect of extended development is to change the point at which the transition from white to black occurs. This is equivalent to a change of exposure, and so minor errors in exposure can be corrected in the development; it is for this reason that development by inspection is recommended where possible. Only a limited amount of control is possible in this way; development in a litho-type developer for more than three minutes produces little further change in either contrast or density.

Filters

Filters can be used in much the same way and for the same purposes as in any other type of photography. Obviously, only those films having some color sensitivity can be used with filters. The ortho-type films can be used only with yellow and green filters; a red filter will eliminate all useful light, and no exposure can be made. Thus if a high-contrast copy is required from a weak blue image, such as an old blueprint, it will be necessary to use a panchromatic litho film, with a red filter. The combination of the very high-contrast film and the filter can produce usable copies from faint images of this type.

Again, most litho films are pretty much alike, and where the manufacturer has not given filter factors, one can try the factor for a film of another make of the same general class. This will be, of course, only an approximation, but it is useful as a starting point, and one or two tests should result in a factor that will be valid for future work with that film under the same conditions.

AGFA-GEVAERT GEVALITH PAN FILM P 81 p

Safelight: *Total darkness required.* A safelight filter Series 3 (dark green), in a suitable safelight lamp with a 15-watt bulb can be used for a few seconds *only,* at 4 feet, after development is half completed.

Color Sensitivity: Panchromatic.

Meter Settings

White Flame Arc	Tungsten or Quartz-Iodine	Pulsed Xenon
	FIND BY TRIAL	

*Recommended for meters marked for ASA speeds and are for trial exposures in copying. They apply to incident-light meters directly and to reflected-light meters used with the Kodak Neutral Test Card (18% gray side) at the copyboard. A matte white card will serve, in which case expose for five times the calculated exposure time.
†This value indicates the relative speed of this material to pulsed-xenon illumination as measured by light integrator.

Indexes are for lenses focused at infinity. For same-size reproduction, give four times the indicated exposure. Use the Kodak Graphic Arts Exposure Computer or equivalent to determine exposure for enlargement or reduction.

Example of Exposure: For a same-size (1:1) line reproduction, with two 1500-watt pulsed-xenon arc lamps in reflectors about 3 feet from the center of the copyboard, find exposure by trial.

Screen Exposures: With Kodak Contact Screens (Estar Base) the exposures will be four to five times longer than for linework. For glass cross-line screens, the factor is much higher and varies with the method of use.

Filter Factors: When a filter is used, multiply the unfiltered exposure by the factor for the filter shown below. Since lighting conditions vary, these factors are only approximate.

Light Source	8	15	23A	25	30	33	47	47B	58
Pulsed Xenon *White-flame arc †Tungsten Quartz-Iodine				NOT GIVEN					

*For ac or dc. With direct-current arc lamps, the positive carbon should be in the lower position.
†Photoflood or other high-efficiency tungsten.

Develop at 68 F (20 C) for approximate times given below:

Developer*	Development Times (minutes)			
	Halftone Negative	Agitation	Line Negative	Development Range† (minutes)
Gevalith 865	2¾	Continuous	—	2¼ to 3¼
Gevaline G7c	3	Continuous	—	2 to 4
Gevatone G5c	3	Continuous	—	2 to 4

*Available in ready-to-mix form in several package sizes.
†Within this range of development times, satisfactory results can usually be obtained.

AGFA-GEVAERT GEVALITH ORTHO FILMS

Safelight: Use a safelight filter No. 1A (light red) in a suitable safelight lamp, with a 15-watt bulb at not less than 4 feet.

Color Sensitivity: Orthochromatic.

Meter Settings

White Flame Arc	Tungsten or Quartz-Iodine	Pulsed Xenon
	FIND BY TRIAL	

*Recommended for meters marked for ASA speeds and are for trial exposures in copying. They apply to incident-light meters directly and to reflected-light meters used with the Kodak Neutral Test Card (18% gray side) at the copyboard. A matte white card will serve, in which case expose for five times the calculated exposure time.
†This value indicates the relative speed of this material to pulsed-xenon illumination as measured by light integrator.

Indexes are for lenses focused at infinity. For same-size reproduction, give four times the indicated exposure. Use the Kodak Graphic Arts Exposure Computer or equivalent to determine exposure for enlargement or reduction.

Example of Exposure: For a same-size (1:1) line reproduction, with two 1500-watt pulsed-xenon arc lamps in reflectors about 3 feet from the center of the copyboard, expose for about 4 seconds at $f/22$.

Screen Exposures: With Kodak Contact Screens (Estar Base) the exposures will be four to five times longer than for linework. For glass cross-line screens, the factor is much higher and varies with the method of use.

Filter Factors: When a filter is used, multiply the unfiltered exposure by the factor for the filter shown below. Since lighting conditions vary, these factors are only approximate.

Light Source	8	15	23A	25	30	33	47	47B	58
Pulsed Xenon *White-flame arc †Tungsten Quartz-Iodine					NOT GIVEN				

*For ac or dc. With direct-current arc lamps, the positive carbon should be in the lower position.
†Photoflood or other high-efficiency tungsten.

Develop at 68 F (20 C) for approximate times given below:

Developer*	Development Times (minutes)			Development Range† (minutes)
	Halftone Negative	Agitation	Line Negative	
Gevalith 865	2½	Continuous	—	2 to 3
Gevaline G7c	—	Continuous	3	2 to 4
Gevatone G5c	—	Continuous	3	2 to 4

*Available in ready-to-mix form in several package sizes.
†Within this range of development times, satisfactory results can usually be obtained.

AGFA-GEVAERT GEVALITH ORTHO RO 81 p

Safelight: Use a safelight filter No. 1A (light red) in a suitable safelight lamp, with a 15-watt bulb at not less than 4 feet.

Color Sensitivity: Orthochromatic.

Meter Settings

White Flame Arc	Tungsten or Quartz-Iodine	Pulsed Xenon
	FIND BY TRIAL	

*Recommended for meters marked for ASA speeds and are for trial exposures in copying. They apply to incident-light meters directly and to reflected-light meters used with the Kodak Neutral Test Card (18% gray side) at the copyboard. A matte white card will serve, in which case expose for five times the calculated exposure time.
†This value indicates the relative speed of this material to pulsed-xenon illumination as measured by light integrator.

Indexes are for lenses focused at infinity. For same-size reproduction, give four times the indicated exposure. Use the Kodak Graphic Arts Exposure Computer or equivalent to determine exposure for enlargement or reduction.

Example of Exposure: For a same-size (1:1) line reproduction, with two 1500-watt pulsed-xenon arc lamps in reflectors about 3 feet from the center of the copyboard, expose for about 5 seconds at $f/45$.

Screen Exposures: With Kodak Contact Screens (Estar Base) the exposures will be four to five times longer than for linework. For glass cross-line screens, the factor is much higher and varies with the method of use.

Filter Factors: When a filter is used, multiply the unfiltered exposure by the factor for the filter shown below. Since lighting conditions vary, these factors are only approximate.

Light Source	8	15	23A	25	30	33	47	47B	58
Pulsed Xenon *White-flame arc †Tungsten Quartz-Iodine				NOT GIVEN					

*For ac or dc. With direct-current arc lamps, the positive carbon should be in the lower position.
†Photoflood or other high-efficiency tungsten.

Develop at 68 F (20 C) for approximate times given below:

Developer*	Development Times (minutes)			
	Halftone Negative	Agitation	Line Negative	Development Range† (minutes)
Gevalith 865	3¼	Continuous	—	2½ to 4
Gevaline G7c	—	Continuous	3	2 to 4
Gevatone G5c	—	Continuous	3	2 to 4

*Available in ready-to-mix form in several package sizes.
†Within this range of development times, satisfactory results can usually be obtained.

AGFA-GEVAERT GEVALITH DUPLICATING FILM DN 81 p

Safelight: Use a safelight filter No. 1A (light red) in a suitable safelight lamp, with a 15-watt bulb at not less than 4 feet.

Color Sensitivity: Blue sensitive.

Meter Settings

White Flame Arc	Tungsten or Quartz-Iodine	Pulsed Xenon
	FOR CONTACT PRINTING	

*Recommended for meters marked for ASA speeds and are for trial exposures in copying. They apply to incident-light meters directly and to reflected-light meters used with the Kodak Neutral Test Card (18% gray side) at the copyboard. A matte white card will serve, in which case expose for five times the calculated exposure time.
†This value indicates the relative speed of this material to pulsed-xenon illumination as measured by light integrator.

Indexes are for lenses focused at infinity. For same-size reproduction, give four times the indicated exposure. Use the Kodak Graphic Arts Exposure Computer or equivalent to determine exposure for enlargement or reduction.

Example of Exposure: For a same-size (1:1) line reproduction, with two 1500-watt pulsed-xenon arc lamps in reflectors about 3 feet from the center of the copyboard. (Not for camera use.)

Screen Exposures: With Kodak Contact Screens (Estar Base) the exposures will be four to five times longer than for linework. For glass cross-line screens, the factor is much higher and varies with the method of use.

Filter Factors: When a filter is used, multiply the unfiltered exposure by the factor for the filter shown below. Since lighting conditions vary, these factors are only approximate.

Light Source	8	15	23A	25	30	33	47	47B	58
Pulsed Xenon *White-flame arc †Tungsten Quartz-Iodine					NOT USED				

*For ac or dc. With direct-current arc lamps, the positive carbon should be in the lower position.
†Photoflood or other high-efficiency tungsten.

Develop at 68 F (20 C) for approximate times given below:

Developer*	Development Times (minutes)			Development Range† (minutes)
	Halftone Negative	Agitation	Line Negative	
Gevalith 865	—	Continuous	2½	2 to 3
Gevaline G7c	—	Continuous	3	2 to 4
Gevatone G5c	—	Continuous	3	2 to 4

*Available in ready-to-mix form in several package sizes.
†Within this range of development times, satisfactory results can usually be obtained.

AGFA-GEVAERT GEVALITH CONTACT FILM N 81 p

Safelight: Use a safelight filter No. 1A (light red) in a suitable safelight lamp, with a 15-watt bulb at not less than 4 feet.

Color Sensitivity: Blue sensitive.

Meter Settings

White Flame Arc	Tungsten or Quartz-Iodine	Pulsed Xenon

FOR CONTACT PRINTING ONLY

*Recommended for meters marked for ASA speeds and are for trial exposures in copying. They apply to incident-light meters directly and to reflected-light meters used with the Kodak Neutral Test Card (18% gray side) at the copyboard. A matte white card will serve, in which case expose for five times the calculated exposure time.
†This value indicates the relative speed of this material to pulsed-xenon illumination as measured by light integrator.

Indexes are for lenses focused at infinity. For same-size reproduction, give four times the indicated exposure. Use the Kodak Graphic Arts Exposure Computer or equivalent to determine exposure for enlargement or reduction.

Example of Exposure: For a same-size (1:1) line reproduction, with two 1500-watt pulsed-xenon arc lamps in reflectors about 3 feet from the center of the copyboard. (Not for camera use.)

Screen Exposures: With Kodak Contact Screens (Estar Base) the exposures will be four to five times longer than for linework. For glass cross-line screens, the factor is much higher and varies with the method of use.

Filter Factors: When a filter is used, multiply the unfiltered exposure by the factor for the filter shown below. Since lighting conditions vary, these factors are only approximate.

Light Source	8	15	23A	25	30	33	47	47B	58
Pulsed Xenon *White-flame arc †Tungsten ⎱ Quartz-Iodine ⎰					NOT USED				

*For ac or dc. With direct-current arc lamps, the positive carbon should be in the lower position.
†Photoflood or other high-efficiency tungsten.

Develop at 68 F (20 C) for approximate times given below:

Developer*	Development Times (minutes)			Development Range† (minutes)
	Halftone Negative	Agitation	Line Negative	
Gevalith 865	2	Continuous	2	2 to 3
Gevaline G7c	2½	Continuous	2½	1 to 4
Gevatone G5c	2½	Continuous	2½	1 to 4

*Available in ready-to-mix form in several package sizes.
†Within this range of development times, satisfactory results can usually be obtained.

AGFA-GEVAERT GEVALINE ORTHO FILMS

Safelight: Use a safelight filter No. 1A (light red) in a suitable safelight lamp, with a 15-watt bulb at not less than 4 feet.

Color Sensitivity: Orthochromatic.

Meter Settings

White Flame Arc	Tungsten or Quartz-Iodine	Pulsed Xenon
	FIND BY TRIAL	

*Recommended for meters marked for ASA speeds and are for trial exposures in copying. They apply to incident-light meters directly and to reflected-light meters used with the Kodak Neutral Test Card (18% gray side) at the copyboard. A matte white card will serve, in which case expose for five times the calculated exposure time.
†This value indicates the relative speed of this material to pulsed-xenon illumination as measured by light integrator.

Indexes are for lenses focused at infinity. For same-size reproduction, give four times the indicated exposure. Use the Kodak Graphic Arts Exposure Computer or equivalent to determine exposure for enlargement or reduction.

Example of Exposure: For a same-size (1:1) line reproduction, with two 1500-watt pulsed-xenon arc lamps in reflectors about 3 feet from the center of the copyboard, expose for about 5 seconds at $f/22$.

Screen Exposures: With Kodak Contact Screens (Estar Base) the exposures will be four to five times longer than for linework. For glass cross-line screens, the factor is much higher and varies with the method of use.

Filter Factors: When a filter is used, multiply the unfiltered exposure by the factor for the filter shown below. Since lighting conditions vary, these factors are only approximate.

Light Source	8	15	23A	25	30	33	47	47B	58
Pulsed Xenon *White-flame arc †Tungsten Quartz-Iodine					NOT USED				

*For ac or dc. With direct-current arc lamps, the positive carbon should be in the lower position.
†Photoflood or other high-efficiency tungsten.

Develop at 68 F (20 C) for approximate times given below:

Developer*	Development Times (minutes)			Development Range† (minutes)
	Halftone Negative	Agitation	Line Negative	
Gevalith 865	3	Continuous	3	2¼ to 3½
Gevaline G7c	3	Continuous	3	2 to 4

*Available in ready-to-mix form in several package sizes.
†Within this range of development times, satisfactory results can usually be obtained.

3M CONTACT FILM

Safelight: Use a safelight filter No. 1A (light red) in a suitable safelight lamp, with a 15-watt bulb at not less than 4 feet.

Color Sensitivity: Blue sensitive.

Meter Settings

White Flame Arc	Tungsten or Quartz-Iodine	Pulsed Xenon

FOR CONTACT PRINTING

*Recommended for meters marked for ASA speeds and are for trial exposures in copying. They apply to incident-light meters directly and to reflected-light meters used with the Kodak Neutral Test Card (18% gray side) at the copyboard. A matte white card will serve, in which case expose for five times the calculated exposure time.
†This value indicates the relative speed of this material to pulsed-xenon illumination as measured by light integrator.

Indexes are for lenses focused at infinity. For same-size reproduction, give four times the indicated exposure. Use the Kodak Graphic Arts Exposure Computer or equivalent to determine exposure for enlargement or reduction.

Example of Exposure: For a same-size (1:1) line reproduction, with two 1500-watt pulsed-xenon arc lamps in reflectors about 3 feet from the center of the copyboard (for contact printing only).

Screen Exposures: With Kodak Contact Screens (Estar Base) the exposures will be four to five times longer than for linework. For glass cross-line screens, the factor is much higher and varies with the method of use.

Filter Factors: When a filter is used, multiply the unfiltered exposure by the factor for the filter shown below. Since lighting conditions vary, these factors are only approximate.

Light Source	8	15	23A	25	30	33	47	47B	58
Pulsed Xenon *White-flame arc †Tungsten Quartz-Iodine					NOT USED				

*For ac or dc. With direct-current arc lamps, the positive carbon should be in the lower position.
†Photoflood or other high-efficiency tungsten.

Develop at 68 F (20 C) for approximate times given below:

Developer*	Development Times (minutes)			
	Halftone Negative	Agitation	Line Negative	Development Range† (minutes)
3M Liquid Lith	2½	Continuous	2½	2¼ to 3¼
‡D-11	2	Continuous	2	1¾ to 3½

*Available in ready-to-mix form in several package sizes.
†Within this range of development times, satisfactory results can usually be obtained.
‡Developer D-11 is preferred if negatives are to be dot-etched.

3M LINE ORTHO FILM

Safelight: Use a safelight filter No. 1A (light red) in a suitable safelight lamp, with a 15-watt bulb at not less than 4 feet.

Color Sensitivity: Orthochromatic.

Meter Settings

White Flame Arc	Tungsten or Quartz-Iodine	Pulsed Xenon
	FIND BY TRIAL	

*Recommended for meters marked for ASA speeds and are for trial exposures in copying. They apply to incident-light meters directly and to reflected-light meters used with the Kodak Neutral Test Card (18% gray side) at the copyboard. A matte white card will serve, in which case expose for five times the calculated exposure time.
†This value indicates the relative speed of this material to pulsed-xenon illumination as measured by light integrator.

Indexes are for lenses focused at infinity. For same-size reproduction, give four times the indicated exposure. Use the Kodak Graphic Arts Exposure Computer or equivalent to determine exposure for enlargement or reduction.

Example of Exposure: For a same-size (1:1) line reproduction, with two 1500-watt pulsed-xenon arc lamps in reflectors about 3 feet from the center of the copyboard, expose for about 6 seconds at $f/22$.

Screen Exposures: With Kodak Contact Screens (Estar Base) the exposures will be four to five times longer than for linework. For glass cross-line screens, the factor is much higher and varies with the method of use.

Filter Factors: When a filter is used, multiply the unfiltered exposure by the factor for the filter shown below. Since lighting conditions vary, these factors are only approximate.

Light Source	8	15	23A	25	30	33	47	47B	58
Pulsed Xenon	3	7.5	—	—	7.5	—	17	—	6.6
*White-flame arc	3	7.5	—	—	4	—	11.6	—	6.6
†Tungsten Quartz-Iodine	1.6	3	—	—	11	—	20	—	3

*For ac or dc. With direct-current arc lamps, the positive carbon should be in the lower position.
†Photoflood or other high-efficiency tungsten.

Develop at 68 F (20 C) for approximate times given below:

Developer*	Development Times (minutes)			Development Range† (minutes)
	Halftone Negative	Agitation	Line Negative	
3M Liquid Lith	—	Continuous	2½	2 to 3

*Available in ready-to-mix form in several package sizes.
†Within this range of development times, satisfactory results can usually be obtained.

DUPONT ACETATE L LITHO FILMS (AHL-3, AHL-5)

Safelight: Use a safelight filter No. 1A (light red) in a suitable safelight lamp, with a 15-watt bulb at not less than 4 feet.

Color Sensitivity: Orthochromatic

Meter Settings

White Flame Arc	Tungsten or Quartz-Iodine	Pulsed Xenon
20*	12†	20*

*Recommended for meters marked for ASA speeds and are for trial exposures in copying. They apply to incident-light meters directly and to reflected-light meters used with the Kodak Neutral Test Card (18% gray side) at the copyboard. A matte white card will serve, in which case expose for five times the calculated exposure time.
†This value indicates the relative speed of this material to pulsed-xenon illumination as measured by light integrator.

Indexes are for lenses focused at infinity. For same-size reproduction, give four times the indicated exposure. Use the Kodak Graphic Arts Exposure Computer or equivalent to determine exposure for enlargement or reduction.

Example of Exposure: For a same-size (1:1) line reproduction, with four 1500-watt pulsed-xenon arc lamps in reflectors about 3 feet from the center of the copyboard, expose for about 6 seconds to the emulsion or 8 seconds through the base, at $f/32$.

Screen Exposures: With Kodak Contact Screens (Estar Base) the exposures will be four to five times longer than for linework. For glass cross-line screens, the factor is much higher and varies with the method of use.

Filter Factors: When a filter is used, multiply the unfiltered exposure by the factor for the filter shown below. Since lighting conditions vary, these factors are only approximate.

Light Source	8	15	23A	25	30	33	47	47B	58
Pulsed Xenon	2.8	5.7	—	—	—	—	—	11	—
*White-flame arc	2.5	5.8	—	—	—	—	—	14	—
†Tungsten Quartz-Iodine	1.5	2.8	—	—	—	—	—	25	—

*For ac or dc. With direct-current arc lamps, the positive carbon should be in the lower position.
†Photoflood or other high-efficiency tungsten.

Develop at 68 F (20 C) for approximate times given below:

Developer*	Development Times (minutes)			Development Range† (minutes)
	Halftone Negative	Agitation	Line Negative	
Dupont CLLD	2	Continuous	2	2-2½

*Available in ready-to-mix form in several package sizes.
†Within this range of development times, satisfactory results can usually be obtained.

DUPONT ACETATE S LITHO FILMS (AOS and AOT)

Safelight: Use a safelight filter No. 1A (light red) in a suitable safelight lamp, with a 15-watt bulb at not less than 4 feet.

Color Sensitivity: Orthochromatic

Meter Settings

White Flame Arc	Tungsten or Quartz-Iodine	Pulsed Xenon
10*	6†	10*

*Recommended for meters marked for ASA speeds and are for trial exposures in copying. They apply to incident-light meters directly and to reflected-light meters used with the Kodak Neutral Test Card (18% gray side) at the copyboard. A matte white card will serve, in which case expose for five times the calculated exposure time.
†This value indicates the relative speed of this material to pulsed-xenon illumination as measured by light integrator.

Indexes are for lenses focused at infinity. For same-size reproduction, give four times the indicated exposure. Use the Kodak Graphic Arts Exposure Computer or equivalent to determine exposure for enlargement or reduction.

Example of Exposure: For a same-size (1:1) line reproduction, with two 1500-watt pulsed-xenon arc lamps in reflectors about 3 feet from the center of the copyboard, expose for about 9 seconds on emulsion side, or 12 seconds through base, at $f/22$.

Screen Exposures: With Kodak Contact Screens (Estar Base) the exposures will be four to five times longer than for linework. For glass cross-line screens, the factor is much higher and varies with the method of use.

Filter Factors: When a filter is used, multiply the unfiltered exposure by the factor for the filter shown below. Since lighting conditions vary, these factors are only approximate.

Light Source	8	15	23A	25	30	33	47	47B	58
Pulsed Xenon	3	8	—	—	—	—	—	18	8
*White-flame arc	4	9	—	—	—	—	—	15	8
†Tungsten Quartz-Iodine	2	4	—	—	—	—	—	30	5

*For ac or dc. With direct-current arc lamps, the positive carbon should be in the lower position.
†Photoflood or other high-efficiency tungsten.

Develop at 68 F (20 C) for approximate times given below:

Developer*	Halftone Negative	Agitation	Line Negative	Development Range† (minutes)
Dupont CLLD	2	Continuous	2	1½ to 2½
Dupont 21-D	2½	Continuous	2½	2 to 3
Dupont 24-D	2	Continuous	2	1½ to 2½

*Available in ready-to-mix form in several package sizes.
†Within this range of development times, satisfactory results can usually be obtained.

DUPONT CRONAR BLUE-SENSITIVE CONTACT FILM
CBS-4 (.004" Base) and CBS-7 (.007" Base)

Safelight: Use a safelight filter No. OA or S55X in a suitable safelight lamp, with a 15-watt bulb at not less than 4 feet.

Color Sensitivity: Blue only

Meter Settings

This film is not intended for camera use and so no ASA speed or Exposure Index has been assigned; since it is used only for duplicating black-and-white material, filters are not used, and in any case, since the film is sensitive to blue only, no filter would produce any useful result. The working speed of this film is such that it allows exposures of convenient length in conventional contact printing equipment; a few tests will quickly show the normal exposure required in any particular shop.

Develop at 68 F (20 C) for approximate times given below:

| Developer* | Development Times (minutes) | | | |
	Halftone Negative	Agitation	Line Negative	Development Range† (minutes)
Dupont 21-D	2½	Continuous	2½	1¾ to 3½
Dupont 24-D	2	Continuous	2	1½ to 2½
Dupont CLLD	2	Continuous	2	1¾ to 3½

*Available in ready-to-mix form in several package sizes.
†Within this range of development times, satisfactory results can usually be obtained.

DUPONT CRONAR CONTACT REVERSAL W FILM
CRW-4 (.004" Base), CRW-7 (.007" Base), MRK-471-4 (.004" Base for automatic processing), and MRK-471-7 (.007" Base for automatic processing)

Safelight: Use a safelight filter No. OA or S55X in a suitable safelight lamp, with a 15-watt bulb at not less than 4 feet.

Color Sensitivity: Blue only

Meter Settings

This film is not intended for camera use and so no ASA speed or Exposure Index has been assigned; since it is used only for duplicating black-and-white material, filters are not used, and in any case, since the film is sensitive to blue only, no filter would produce any useful result. The working speed of this film is such that it allows exposures of convenient length in conventional contact printing equipment; a few tests will quickly show the normal exposure required in any particular shop.

Develop at 68 F (20 C) for approximate times given below:

Developer*	Development Times (minutes)			Development Range† (minutes)
	Halftone Negative	Agitation	Line Negative	
Dupont 24-D (or 24-DL)	2	Continuous	2	1½ to 2½
Dupont CLLD	2	Continuous	2	1¾ to 3½

*Available in ready-to-mix form in several package sizes.
†Within this range of development times, satisfactory results can usually be obtained.

DUPONT CRONAR L LITHO FILMS (CHL-4, CHL-7, CLL-4, CDL-4)

Safelight: Use a safelight filter No. 1A (light red) in a suitable safelight lamp, with a 15-watt bulb at not less than 4 feet.

Color Sensitivity: Orthochromatic

Meter Settings

White Flame Arc	Tungsten or Quartz-Iodine	Pulsed Xenon
20*	12†	20*

*Recommended for meters marked for ASA speeds and are for trial exposures in copying. They apply to incident-light meters directly and to reflected-light meters used with the Kodak Neutral Test Card (18% gray side) at the copyboard. A matte white card will serve, in which case expose for five times the calculated exposure time.
†This value indicates the relative speed of this material to pulsed-xenon illumination as measured by light integrator.

Indexes are for lenses focused at infinity. For same-size reproduction, give four times the indicated exposure. Use the Kodak Graphic Arts Exposure Computer or equivalent to determine exposure for enlargement or reduction.

Example of Exposure: For a same-size (1:1) line reproduction, with four 1500-watt pulsed-xenon arc lamps in reflectors about 3 feet from the center of the copyboard, expose for about 6 seconds to the emulsion or 8 seconds through the base, at $f/32$.

Screen Exposures: With Kodak Contact Screens (Estar Base) the exposures will be four to five times longer than for linework. For glass cross-line screens, the factor is much higher and varies with the method of use.

Filter Factors: When a filter is used, multiply the unfiltered exposure by the factor for the filter shown below. Since lighting conditions vary, these factors are only approximate.

Light Source	8	15	23A	25	30	33	47	47B	58
Pulsed Xenon	2.8	5.7	—	—	—	—	—	11	—
*White-flame arc	2.5	5.8	—	—	—	—	—	14	—
†Tungsten ⎫ Quartz-Iodine ⎭	1.5	2.8	—	—	—	—	—	25	—

*For ac or dc. With direct-current arc lamps, the positive carbon should be in the lower position.
†Photoflood or other high-efficiency tungsten.

Develop at 68 F (20 C) for approximate times given below:

Developer*	Development Times (minutes)			Development Range† (minutes)
	Halftone Negative	Agitation	Line Negative	
Dupont CLLD	2	Continuous	2	2-2½

*Available in ready-to-mix form in several package sizes.
†Within this range of development times, satisfactory results can usually be obtained.

DUPONT CRONAR S LITHO FILMS (COS-4, COS-7, COD-4, COH-4)

Safelight: Use a safelight filter No. 1A (light red) in a suitable safelight lamp, with a 15-watt bulb at not less than 4 feet.

Color Sensitivity: Orthochromatic

Meter Settings

White Flame Arc	Tungsten or Quartz-Iodine	Pulsed Xenon
10*	6†	10*

*Recommended for meters marked for ASA speeds and are for trial exposures in copying. They apply to incident-light meters directly and to reflected-light meters used with the Kodak Neutral Test Card (18% gray side) at the copyboard. A matte white card will serve, in which case expose for five times the calculated exposure time.
†This value indicates the relative speed of this material to pulsed-xenon illumination as measured by light integrator.

Indexes are for lenses focused at infinity. For same-size reproduction, give four times the indicated exposure. Use the Kodak Graphic Arts Exposure Computer or equivalent to determine exposure for enlargement or reduction.

Example of Exposure: For a same-size (1:1) line reproduction, with two 1500-watt pulsed-xenon arc lamps in reflectors about 4 feet from the center of the copyboard, expose for about 9 seconds on emulsion side, or 12 seconds through base, at $f/22$.

Screen Exposures: With Kodak Contact Screens (Estar Base) the exposures will be four to five times longer than for linework. For glass cross-line screens, the factor is much higher and varies with the method of use.

Filter Factors: When a filter is used, multiply the unfiltered exposure by the factor for the filter shown below. Since lighting conditions vary, these factors are only approximate.

Light Source	8	15	23A	25	30	33	47	47B	58
Pulsed Xenon	3	8	—	—	—	—	—	18	8
*White-flame arc	4	9	—	—	—	—	—	15	8
†Tungsten } Quartz-Iodine {	2	4	—	—	—	—	—	30	5

*For ac or dc. With direct-current arc lamps, the positive carbon should be in the lower position.
†Photoflood or other high-efficiency tungsten.

Develop at 68 F (20 C) for approximate times given below:

Developer*	Development Times (minutes)			
	Halftone Negative	Agitation	Line Negative	Development Range† (minutes)
Dupont CLLD	2	Continuous	2	1½ to 2½
Dupont 21-D	2½	Continuous	2½	2 to 3
Dupont 24-D	2	Continuous	2	1½ to 2½

*Available in ready-to-mix form in several package sizes.
†Within this range of development times, satisfactory results can usually be obtained.

DUPONT CRONAR MASKING FILM CMF-4

Safelight: Use a safelight filter No. 1A (light red) in a suitable safelight lamp, with a 15-watt bulb at not less than 4 feet.

Color Sensitivity: Blue and ultraviolet.

Meter Settings

White Flame Arc	Tungsten or Quartz-Iodine	Pulsed Xenon
64	25	50

*Recommended for meters marked for ASA speeds and are for trial exposures in copying. They apply to incident-light meters directly and to reflected-light meters used with the Kodak Neutral Test Card (18% gray side) at the copyboard. A matte white card will serve, in which case expose for five times the calculated exposure time.
†This value indicates the relative speed of this material to pulsed-xenon illumination as measured by light integrator.

Indexes are for lenses focused at infinity. For same-size reproduction, give four times the indicated exposure. Use the Kodak Graphic Arts Exposure Computer or equivalent to determine exposure for enlargement or reduction.

Example of Exposure: For a same-size (1:1) line reproduction, with two 1500-watt pulsed-xenon arc lamps in reflectors at 100 footcandles, 50 seconds at $f/22$.

Screen Exposures: With Kodak Contact Screens (Estar Base) the exposures will be four to five times longer than for linework. For glass cross-line screens, the factor is much higher and varies with the method of use.

Filter Factors: When a filter is used, multiply the unfiltered exposure by the factor for the filter shown below. Since lighting conditions vary, these factors are only approximate.

Light Source	8	15	23A	25	30	33	47	47B	58
Pulsed Xenon *White-flame arc †Tungsten Quartz-Iodine				NOT USED					

*For ac or dc. With direct-current arc lamps, the positive carbon should be in the lower position.
†Photoflood or other high-efficiency tungsten.

Develop at 68 F (20 C) for approximate times given below:

Developer*	Development Times (minutes)			Development Range† (minutes)
	Halftone Negative	Agitation	Line Negative	
Dupont 16-D, 1:1	Find by test for desired density range			2-8
Dupont 16-D, 1:2	Find by test for desired density range			1-6

*Available in ready-to-mix form in several package sizes.
†Within this range of development times, satisfactory results can usually be obtained.

GAF ECONOLINE FILMS

Safelight: Use a safelight filter No. 1A (light red) in a suitable safelight lamp, with a 15-watt bulb at not less than 4 feet.

Color Sensitivity: Orthochromatic

Meter Settings

White Flame Arc	Tungsten or Quartz-Iodine	Pulsed Xenon
16*	8†	16*

*Recommended for meters marked for ASA speeds and are for trial exposures in copying. They apply to incident-light meters directly and to reflected-light meters used with the Kodak Neutral Test Card (18% gray side) at the copyboard. A matte white card will serve, in which case expose for five times the calculated exposure time.
†This value indicates the relative speed of this material to pulsed-xenon illumination as measured by light integrator.

Indexes are for lenses focused at infinity. For same-size reproduction, give four times the indicated exposure. Use the Kodak Graphic Arts Exposure Computer or equivalent to determine exposure for enlargement or reduction.

Example of Exposure: For a same-size (1:1) line reproduction, with four 1500-watt pulsed-xenon arc lamps in reflectors about 3 feet from the center of the copyboard, expose for about 13 seconds at $f/45$.

Screen Exposures: With Kodak Contact Screens (Estar Base) the exposures will be four to five times longer than for linework. For glass cross-line screens, the factor is much higher and varies with the method of use.

Filter Factors: When a filter is used, multiply the unfiltered exposure by the factor for the filter shown below. Since lighting conditions vary, these factors are only approximate.

Light Source	8	15	23A	25	30	33	47	47B	58
Pulsed Xenon	2	4	—	—	—	—	—	9	3.5
*White-flame arc	2	6	—	—	—	—	—	9	4
†Tungsten Quartz-Iodine	1.5	3	—	—	—	—	—	20	2.5

*For ac or dc. With direct-current arc lamps, the positive carbon should be in the lower position.
†Photoflood or other high-efficiency tungsten.

Develop at 68 F (20 C) for approximate times given below:

Developer*	Development Times (minutes)			
	Halftone Negative	Agitation	Line Negative	Development Range† (minutes)
Reprodol L Developer Type II	3	Intermittent	3	2 to 4
Reprodol P	2½	Intermittent	2½	1½ to 3½

*Available in ready-to-mix form in several package sizes.
†Within this range of development times, satisfactory results can usually be obtained.

GAF LITHO FILMS

Safelight: Use a safelight filter No. 1A (light red) in a suitable safelight lamp, with a 15-watt bulb at not less than 4 feet.

Color Sensitivity: Orthochromatic

Meter Settings

White Flame Arc	Tungsten or Quartz-Iodine	Pulsed Xenon
16*	8†	16*

*Recommended for meters marked for ASA speeds and are for trial exposures in copying. They apply to incident-light meters directly and to reflected-light meters used with the Kodak Neutral Test Card (18% gray side) at the copyboard. A matte white card will serve, in which case expose for five times the calculated exposure time.
†This value indicates the relative speed of this material to pulsed-xenon illumination as measured by light integrator.

Indexes are for lenses focused at infinity. For same-size reproduction, give four times the indicated exposure. Use the Kodak Graphic Arts Exposure Computer or equivalent to determine exposure for enlargement or reduction.

Example of Exposure: For a same-size (1:1) line reproduction, with four 1500-watt pulsed-xenon arc lamps in reflectors about 3 feet from the center of the copyboard, expose for about 13 seconds at $f/45$.

Screen Exposures: With Kodak Contact Screens (Estar Base) the exposures will be four to five times longer than for linework. For glass cross-line screens, the factor is much higher and varies with the method of use.

Filter Factors: When a filter is used, multiply the unfiltered exposure by the factor for the filter shown below. Since lighting conditions vary, these factors are only approximate.

Light Source	8	15	23A	25	30	33	47	47B	58
Pulsed Xenon	2	4	—	—	—	—	—	9	3.5
*White-flame arc	2	6	—	—	—	—	—	9	4
†Tungsten } Quartz-Iodine {	1.5	3	—	—	—	—	—	20	2.5

*For ac or dc. With direct-current arc lamps, the positive carbon should be in the lower position.
†Photoflood or other high-efficiency tungsten.

Develop at 68 F (20 C) for approximate times given below:

Developer*	Development Times (minutes)			
	Halftone Negative	Agitation	Line Negative	Development Range† (minutes)
GAF Reprodol L Developer Type II	3	Intermittent	3	2 to 4
GAF Reproflo P	3½	Intermittent	3½	2½ to 4
GAF Reprodol P	2½	Intermittent	2½	1½ to 3½
GAF Phototypesetting Developer (1:6)		Intermittent	2½	1½ to 3

*Available in ready-to-mix form in several package sizes.
†Within this range of development times, satisfactory results can usually be obtained.

ILFORD ILFOLINE IN-3 (.003 ACETATE BASE) AND IN-5 (.005 ACETATE BASE)

Safelight: Use a safelight filter No. 1A (light red) in a suitable safelight lamp, with a 15-watt bulb at not less than 4 feet.

Color Sensitivity: Orthochromatic

Meter Settings

White Flame Arc	Tungsten or Quartz-Iodine	Pulsed Xenon
ASA 32*	ASA 12*	ASA 40†

*Recommended for meters marked for ASA speeds and are for trial exposures in copying. They apply to incident-light meters directly and to reflected-light meters used with the Kodak Neutral Test Card (18% gray side) at the copyboard. A matte white card will serve, in which case expose for five times the calculated exposure time.
†This value indicates the relative speed of this material to pulsed-xenon illumination as measured by light integrator.

Indexes are for lenses focused at infinity. For same-size reproduction, give four times the indicated exposure. Use the Kodak Graphic Arts Exposure Computer or equivalent to determine exposure for enlargement or reduction.

Example of Exposure: For a same-size (1:1) line reproduction, with two 1500-watt pulsed-xenon arc lamps in reflectors about 4 feet from the center of the copyboard, expose for about 10 seconds at $f/32$.

Screen Exposures: With Kodak Contact Screens (Estar Base) the exposures will be four to five times longer than for linework. For glass cross-line screens, the factor is much higher and varies with the method of use.

Filter Factors: When a filter is used, multiply the unfiltered exposure by the factor for the filter shown below. Since lighting conditions vary, these factors are only approximate.

Light Source	8	15	23A	25	30	33	47	47B	58
Pulsed Xenon	1½	3	—	—	—	—	—	16	3
*White-flame arc	2	3½	—	—	—	—	—	10	4
†Tungsten ⎱ Quartz-Iodine ⎰	1¼	2	—	—	—	—	—	20	2

*For ac or dc. With direct-current arc lamps, the positive carbon should be in the lower position.
†Photoflood or other high-efficiency tungsten.

Develop at 68 F (20 C) for approximate times given below:

Developer*	Development Times (minutes)			
	Halftone Negative	Agitation	Line Negative	Development Range† (minutes)
Ilford SX200	—	Continuous	2½	2¼ to 3

*Available in ready-to-mix form in several package sizes.
†Within this range of development times, satisfactory results can usually be obtained.

ILFORD ILFOREP IT-4 (.004″ POLYESTER BASE) AND IT-7 (.007″ POLYESTER BASE)

Safelight: Use a safelight filter No. 1A (light red) in a suitable safelight lamp, with a 15-watt bulb at not less than 4 feet.

Color Sensitivity: Ultraviolet and blue

Meter Settings

White Flame Arc	Tungsten or Quartz-Iodine	Pulsed Xenon
ASA 8*	ASA 3*	ASA 10†

*Recommended for meters marked for ASA speeds and are for trial exposures in copying. They apply to incident-light meters directly and to reflected-light meters used with the Kodak Neutral Test Card (18% gray side) at the copyboard. A matte white card will serve, in which case expose for five times the calculated exposure time.
†This value indicates the relative speed of this material to pulsed-xenon illumination as measured by light integrator.

Indexes are for lenses focused at infinity. For same-size reproduction, give four times the indicated exposure. Use the Kodak Graphic Arts Exposure Computer or equivalent to determine exposure for enlargement or reduction.

Example of Exposure: For contact printing, expose about 10 seconds with a 15-watt lamp, 3 feet from the printing frame.

Filter Factors: When a filter is used, multiply the unfiltered exposure by the factor for the filter shown below. Since lighting conditions vary, these factors are only approximate.

Light Source	8	15	23A	25	30	33	47	47B	58
Pulsed Xenon *White-flame arc †Tungsten Quartz-Iodine					NOT USED				

*For ac or dc. With direct-current arc lamps, the positive carbon should be in the lower position.
†Photoflood or other high-efficiency tungsten.

Develop at 68 F (20 C) for approximate times given below:

Developer*	Development Times (minutes)			Development Range† (minutes)
	Halftone Negative	Agitation	Line Negative	
Ilford SX200	2½	Continuous	2½	2¼ to 3

*Available in ready-to-mix form in several package sizes.
†Within this range of development times, satisfactory results can usually be obtained.

ILFORD ILFOSTAR IS-4 AND IS-4D FILM

Safelight: Use a safelight filter No. 1A (light red) in a suitable safelight lamp, with a 15-watt bulb at not less than 4 feet.

Color Sensitivity: Orthochromatic

Meter Settings

White Flame Arc	Tungsten or Quartz-Iodine	Pulsed Xenon
ASA 32*	ASA 12*	ASA 40†

*Recommended for meters marked for ASA speeds and are for trial exposures in copying. They apply to incident-light meters directly and to reflected-light meters used with the Kodak Neutral Test Card (18% gray side) at the copyboard. A matte white card will serve, in which case expose for five times the calculated exposure time.
†This value indicates the relative speed of this material to pulsed-xenon illumination as measured by light integrator.

Indexes are for lenses focused at infinity. For same-size reproduction, give four times the indicated exposure. Use the Kodak Graphic Arts Exposure Computer or equivalent to determine exposure for enlargement or reduction.

Example of Exposure: For a same-size (1:1) line reproduction, with two 1500-watt pulsed-xenon arc lamps in reflectors about 4 feet from the center of the copyboard, expose for about 10 sec. at $f/32$.

Screen Exposures: With Kodak Contact Screens (Estar Base) the exposures will be four to five times longer than for linework. For glass cross-line screens, the factor is much higher and varies with the method of use.

Filter Factors: When a filter is used, multiply the unfiltered exposure by the factor for the filter shown below. Since lighting conditions vary, these factors are only approximate.

Light Source	8	15	23A	25	30	33	47	47B	58
Pulsed Xenon	1½	3	—	—	—	—	—	16	3
*White-flame arc	2	3½	—	—	—	—	—	10	4
†Tungsten Quartz-Iodine	1¼	2	—	—	—	—	—	20	2

*For ac or dc. With direct-current arc lamps, the positive carbon should be in the lower position.
†Photoflood or other high-efficiency tungsten.

Develop at 68 F (20 C) for approximate times given below:

Developer*	Development Times (minutes)			Development Range† (minutes)
	Halftone Negative	Agitation	Line Negative	
Ilford SX201-205	2½	Continuous	2½	2¼ to 3

*Available in ready-to-mix form in several package sizes.
†Within this range of development times, satisfactory results can usually be obtained.

KODALITH ORTHO FILMS 2556, 3556, 4556, 6556
AND 8556, TYPE 3 (ESTAR BASE)
KODALITH ORTHO MATTE FILM 2550, TYPE 3 (ESTAR BASE)
KODALITH TRANSPARENT STRIPPING FILM 6554, TYPE 3

Safelight: Use a safelight filter No. 1A (light red) in a suitable safelight lamp, with a 15-watt bulb at not less than 4 feet.

Color Sensitivity: Orthochromatic.

Meter Settings

White Flame Arc	Tungsten or Quartz-Iodine	Pulsed Xenon
ASA 10*	ASA 6*	ASA 10†

*Recommended for meters marked for ASA speeds and are for trial exposures in copying. They apply to incident-light meters directly and to reflected-light meters used with the Kodak Neutral Test Card (18% gray side) at the copyboard. A matte white card will serve, in which case expose for five times the calculated exposure time.
†This value indicates the relative speed of this material to pulsed-xenon illumination as measured by light integrator.

Indexes are for lenses focused at infinity. For same-size reproduction, give four times the indicated exposure. Use the Kodak Graphic Arts Exposure Computer or equivalent to determine exposure for enlargement or reduction.

Example of Exposure: For a same-size (1:1) line reproduction, with two 1500-watt pulsed-xenon arc lamps in reflectors about 3 feet from the center of the copyboard, expose for about 10 seconds at $f/22$.

Screen Exposures: With Kodak Contact Screens (Estar Base) the exposures will be four to five times longer than for linework. For glass cross-line screens, the factor is much higher and varies with the method of use.

Filter Factors: When a filter is used, multiply the unfiltered exposure by the factor for the filter shown below. Since lighting conditions vary, these factors are only approximate.

Light Source	8	15	23A	25	30	33	47	47B	58
Pulsed Xenon	2.0	5.0	—	—	5.0	60.0	—	16.0	3.0
*White-flame arc	2.5	5.0	—	—	5.0	60.0	—	12.0	4.0
†Tungsten / Quartz-Iodine	1.5	2.5	—	—	10.0	120.0	—	25.0	2.5

*For ac or dc. With direct-current arc lamps, the positive carbon should be in the lower position.
†Photoflood or other high-efficiency tungsten.

Develop at 68 F (20 C) for approximate times given below:

Developer*	Development Times (minutes)			Development Range† (minutes)
	Halftone Negative	Agitation	Line Negative	
Kodalith Super	2¾	Continuous	2¾	2½ to 4½
Kodalith	2¼	Continuous	2½	2 to 3½
§Kodalith Fine-Line	—	‡See note below	2¼	—
Kodalith Liquid (1:3)	2¾	Continuous	2¾	2 to 4
¶Kodalith Liquid (1:4)	2¾	Continuous	2¾	2½ to 3½

*Available in ready-to-mix form in several package sizes.
†Within this range of development times, satisfactory results can usually be obtained.
‡2¼ minutes total time (about 30 seconds continuous agitation plus 1¾ minutes with no agitation). Full instructions wih developer.
§ Not recommended for use with Kodalith Transparent Stripping Film 6554 (Type 3).
¶This recommendation for Kodalith Transparent Stripping Film 6554 (Type 3) only.

KODALITH PAN FILM 2568 (ESTAR BASE)

Safelight: *Total darkness required.* A safelight filter Series 3 (dark green), in a suitable safelight lamp with a 15-watt bulb can be used for a few seconds *only,* at 4 feet, after development is half completed.

Color Sensitivity: Panchromatic

Meter Settings

White Flame Arc	Tungsten or Quartz-Iodine	Pulsed Xenon
ASA 40*	ASA 32*	ASA 40†

*Recommended for meters marked for ASA speeds and are for trial exposures in copying. They apply to incident-light meters directly and to reflected-light meters used with the Kodak Neutral Test Card (18% gray side) at the copyboard. A matte white card will serve, in which case expose for five times the calculated exposure time.
†This value indicates the relative speed of this material to pulsed-xenon illumination as measured by light integrator.

Indexes are for lenses focused at infinity. For same-size reproduction, give four times the indicated exposure. Use the Kodak Graphic Arts Exposure Computer or equivalent to determine exposure for enlargement or reduction.

Example of Exposure: For a same-size (1:1) line reproduction, with two 1500-watt pulsed-xenon arc lamps in reflectors about 3 feet from the center of the copyboard, expose for about 10 seconds at $f/22$ through the Kodak Wratten Filter No. 25.

Screen Exposures: With Kodak Contact Screens (Estar Base) the exposures will be four to five times longer than for linework. For glass cross-line screens, the factor is much higher and varies with the method of use.

Filter Factors: When a filter is used, multiply the unfiltered exposure by the factor for the filter shown below. Since lighting conditions vary, these factors are only approximate.

Light Source	8	15	23A	25	30	33	47	47B	58
Pulsed Xenon	2.5	—	4	5	—	—	15	20	10
*White-flame arc	2.5	—	4	5	—	—	12	15	15
†Tungsten } Quartz-Iodine }	2.5	—	3.2	4	—	—	40	48	16

*For ac or dc. With direct-current arc lamps, the positive carbon should be in the lower position.
†Photoflood or other high-efficiency tungsten.

Develop at 68 F (20 C) for approximate times given below:

Developer*	Development Times (minutes)			Development Range† (minutes)
	Halftone Negative	Agitation	Line Negative	
Kodalith Super	2¾	Continuous	2¾	2¼ to 3¼
Kodalith	2½	Continuous	2½	2 to 3

*Available in ready-to-mix form in several package sizes.
†Within this range of development times, satisfactory results can usually be obtained.
Note: Kodalith Liquid Developer is *not* recommended for use with this film.

KODALITH SUPER ORTHO FILM 6555

Safelight: Use a safelight filter No. 1A (light red) in a suitable safelight lamp, with a 15-watt bulb at not less than 4 feet.

Color Sensitivity: Orthochromatic.

Meter Settings

White Flame Arc	Tungsten or Quartz-Iodine	Pulsed Xenon
ASA 6*	ASA 4*	ASA 6†

*Recommended for meters marked for ASA speeds and are for trial exposures in copying. They apply to incident-light meters directly and to reflected-light meters used with the Kodak Neutral Test Card (18% gray side) at the copyboard. A matte white card will serve, in which case expose for five times the calculated exposure time.
†This value indicates the relative speed of this material to pulsed-xenon illumination as measured by light integrator.

Indexes are for lenses focused at infinity. For same-size reproduction, give four times the indicated exposure. Use the Kodak Graphic Arts Exposure Computer or equivalent to determine exposure for enlargement or reduction.

Example of Exposure: For a same-size (1:1) line reproduction, with two 1500-watt pulsed-xenon arc lamps in reflectors about 3 feet from the center of the copyboard, expose for about 15 seconds at $f/22$.

Screen Exposures: With Kodak Contact Screens (Estar Base) the exposures will be four to five times longer than for linework. For glass cross-line screens, the factor is much higher and varies with the method of use.

Filter Factors: When a filter is used, multiply the unfiltered exposure by the factor for the filter shown below. Since lighting conditions vary, these factors are only approximate.

Light Source	8	15	23A	25	30	33	47	47B	58
Pulsed Xenon	2.0	5.0	—	—	—	—	8	16	—
*White-flame arc	2.5	5.0	—	—	—	—	10	12	—
†Tungsten / Quartz-Iodine	1.5	2.5	—	—	—	—	12	25	—

*For ac or dc. With direct-current arc lamps, the positive carbon should be in the lower position.
†Photoflood or other high-efficiency tungsten.

Develop at 68 F (20 C) for approximate times given below:

Developer*	Development Times (minutes)			
	Halftone Negative	Agitation	Line Negative	Development Range† (minutes)
Kodalith	2¼	Continuous	2¾	2 to 3½
Kodalith Super	—	Continuous	2¾	2½ to 4½

*Available in ready-to-mix form in several package sizes.
†Within this range of development times, satisfactory results can usually be obtained.
Note: Kodalith Liquid Developer is *not* recommended for use with this film.

KODALITH ROYAL ORTHO FILM 2569 (ESTAR BASE)

Safelight: Use a safelight filter No. 1A (light red) in a suitable safelight lamp. with a 15-watt bulb at not less than 4 feet.

Color Sensitivity: Orthochromatic.

Meter Settings

White Flame Arc	Tungsten or Quartz-Iodine	Pulsed Xenon
ASA 32*	ASA 12*	ASA 40†

*Recommended for meters marked for ASA speeds and are for trial exposures in copying. They apply to incident-light meters directly and to reflected-light meters used with the Kodak Neutral Test Card (18% gray side) at the copyboard. A matte white card will serve, in which case expose for five times the calculated exposure time.
†This value indicates the relative speed of this material to pulsed-xenon illumination as measured by light integrator.

Indexes are for lenses focused at infinity. For same-size reproduction, give four times the indicated exposure. Use the Kodak Graphic Arts Exposure Computer or equivalent to determine exposure for enlargement or reduction.

Example of Exposure: For a same-size (1:1) line reproduction, with two 1500-watt pulsed-xenon arc lamps in reflectors about 3 feet from the center of the copyboard, expose for about 3 seconds at $f/22$.

Screen Exposures: With Kodak Contact Screens (Estar Base) the exposures will be four to five times longer than for linework. For glass cross-line screens, the factor is much higher and varies with the method of use.

Filter Factors: When a filter is used, multiply the unfiltered exposure by the factor for the filter shown below. Since lighting conditions vary, these factors are only approximate.

Light Source	8	15	23A	25	30	33	47	47B	58
Pulsed Xenon	1.5	10	—	—	—	—	5	8	—
*White-flame arc	5.0	16	—	—	—	—	5	8	—
†Tungsten Quartz-Iodine	2.0	5	—	—	—	—	6	10	—

*For ac or dc. With direct-current arc lamps, the positive carbon should be in the lower position.
†Photoflood or other high-efficiency tungsten.

Develop at 68 F (20 C) for approximate times given below:

Developer*	Development Times (minutes)			
	Halftone Negative	Agitation	Line Negative	Development Range† (minutes)
Kodalith Super	2¾	Continuous	2¾	2¼ to 3¾
Kodalith	2¼	Continuous	2¼	2 to 3
‡D-11 (for maximum speed)	2	Continuous	2	—

Note: Kodalith Liquid Developer is *not* recommended for use with this film.
*Available in ready-to-mix form in several package sizes.
†Within this range of development times, satisfactory results can usually be obtained.
‡The use of Kodak Developer D-11 with this film will enable it to be used in some applications which previously required the use of Kodak Contrast Process Ortho Film. Under these conditions, the speed of this film is considerably higher, and the above exposure indexes do not apply.

KODALITH CONTACT FILM 2571 (ESTAR BASE)
KODALITH CONTACT FILM 4571 (ESTAR THICK BASE)

Safelight: Use a safelight filter No. 0A (greenish-yellow) in a suitable safe-light lamp, with a 15-watt bulb at not less than 4 feet.

Color Sensitivity: Blue only.

Meter Settings

White Flame Arc	Tungsten or Quartz-Iodine	Pulsed Xenon
FOR CONTACT PRINTING — FIND EXPOSURE BY TRIAL		

*Recommended for meters marked for ASA speeds and are for trial exposures in copying. They apply to incident-light meters directly and to reflected-light meters used with the Kodak Neutral Test Card (18% gray side) at the copyboard. A matte white card will serve, in which case expose for five times the calculated exposure time.
†This value indicates the relative speed of this material to pulsed-xenon illumination as measured by light integrator.

Indexes are for lenses focused at infinity. For same-size reproduction, give four times the indicated exposure. Use the Kodak Graphic Arts Exposure Computer or equivalent to determine exposure for enlargement or reduction.

Example of Exposure: For a same-size (1:1) line reproduction, with two 1500-watt pulsed-xenon arc lamps in reflectors about 3 feet from the center of the copyboard, expose for about — (not used).

Screen Exposures: With Kodak Contact Screens (Estar Base) the exposures will be four to five times longer than for linework. For glass cross-line screens, the factor is much higher and varies with the method of use.

Filter Factors: When a filter is used, multiply the unfiltered exposure by the factor for the filter shown below. Since lighting conditions vary, these factors are only approximate.

Light Source	8	15	23A	25	30	33	47	47B	58
Pulsed Xenon *White-flame arc †Tungsten Quartz-Iodine					NOT USED				

*For ac or dc. With direct-current arc lamps, the positive carbon should be in the lower position.
†Photoflood or other high-efficiency tungsten.

Develop at 68 F (20 C) for approximate times given below:

Developer*	Development Times (minutes)			
	Halftone Negative	Agitation	Line Negative	Development Range† (minutes)
D-11	2	Continuous	2	1½ to 4
Kodalith Super	2¾	Continuous	2¾	2¼ to 3¾
Kodalith Liquid	2¾	Continuous	2¾	2¼ to 3¾

*Available in ready-to-mix form in several package sizes.
†Within this range of development times, satisfactory results can usually be obtained.

KODALITH AUTO SCREEN ORTHO FILM 2563 (ESTAR BASE)

Safelight: Use a safelight filter No. 1A (light red) in a suitable safelight lamp, with a 15-watt bulb at not less than 4 feet.

Color Sensitivity: Orthochromatic.

Meter Settings

White Flame Arc	Tungsten or Quartz-Iodine	Pulsed Xenon
ASA 4.0*	ASA 2.5*	ASA 4.0†

(This material may be used for Daylight Exposure at ASA 3.0)

*Recommended for meters marked for ASA speeds and are for trial exposures in copying. They apply to incident-light meters directly and to reflected-light meters used with the Kodak Neutral Test Card (18% gray side) at the copyboard. A matte white card will serve, in which case expose for five times the calculated exposure time.
†This value indicates the relative speed of this material to pulsed-xenon illumination as measured by light integrator.

Indexes are for lenses focused at infinity. For same-size reproduction, give four times the indicated exposure. Use the Kodak Graphic Arts Exposure Computer or equivalent to determine exposure for enlargement or reduction.

This film may be exposed in any sheet-film camera with either arc lights or tungsten lights. Two exposures are given: (1) a main exposure to the original based on the highlight density of the subject, and (2) a flash exposure to control contrast.

Main Exposure: For a same-size reproduction (1:1) expose for about 35 seconds at $f/22$, with two 500-watt 3200 K lamps or #2 Photoflood lamps, in reflectors, at 3 feet. If pulsed-xenon lamps are used, expose for about 25 seconds at $f/22$, with two 1500-watt lamps in reflectors at 3 feet.

Flash Exposure: With a Kodak Adjustable Safelight Lamp at 4 feet with a 15-watt bulb and a Kodak Safelight Filter OA (greenish-yellow), use a flash exposure of about 30 seconds.

Filter Factors: When a filter is used, multiply the unfiltered exposure by the factor for the filter shown below. Since lighting conditions vary, these factors are only approximate.

Light Source	8	15	23A	25	30	33	47	47B	58
Pulsed Xenon	1.5	3.0	—	—	—	—	—	12	—
*White-flame arc	2.0	4.0	—	—	—	—	—	10	—
†Tungsten } Quartz-Iodine }	1.5	2.5	—	—	—	—	—	20	—

*For ac or dc. With direct-current arc lamps, the positive carbon should be in the lower position.
†Photoflood or other high-efficiency tungsten.

Develop at 68 F (20 C) for approximate times given below:

Developer*	Development Times (minutes)			Development Range† (minutes)
	Halftone Negative	Agitation	Line Negative	
Kodalith Super	2¾	Continuous	—	—
Kodalith Liquid	2½	Continuous	—	—

*Available in ready-to-mix form in several package sizes.
†Within this range of development times, satisfactory results can usually be obtained.

KODALITH DUPLICATING FILM 2574 (ESTAR BASE)

Safelight: Use a safelight filter No. 1A (light red) in a suitable safelight lamp, with a 15-watt bulb at not less than 4 feet.

Color Sensitivity: Blue sensitive.

Meter Settings

White Flame Arc	Tungsten or Quartz-Iodine	Pulsed Xenon
	NOT USED — CONTACT PRINTING ONLY	

*Recommended for meters marked for ASA speeds and are for trial exposures in copying. They apply to incident-light meters directly and to reflected-light meters used with the Kodak Neutral Test Card (18% gray side) at the copyboard. A matte white card will serve, in which case expose for five times the calculated exposure time.
†This value indicates the relative speed of this material to pulsed-xenon illumination as measured by light integrator.

Indexes are for lenses focused at infinity. For same-size reproduction, give four times the indicated exposure. Use the Kodak Graphic Arts Exposure Computer or equivalent to determine exposure for enlargement or reduction.

Example of Exposure: For contact printing, expose for 15 to 30 sec. at 4 feet from a 650-watt quartz-iodine printing lamp.

Screen Exposures: With Kodak Contact Screens (Estar Base) the exposures will be four to five times longer than for linework. For glass cross-line screens, the factor is much higher and varies with the method of use.

Filter Factors: When a filter is used, multiply the unfiltered exposure by the factor for the filter shown below. Since lighting conditions vary, these factors are only approximate.

Light Source	8	15	23A	25	30	33	47	47B	58
Pulsed Xenon *White-flame arc †Tungsten Quartz-Iodine					NOT USED				

*For ac or dc. With direct-current arc lamps, the positive carbon should be in the lower position.
†Photoflood or other high-efficiency tungsten.

Develop at 68 F (20 C) for approximate times given below:

	Development Times (minutes)			
Developer*	Halftone Negative	Agitation	Line Negative	Development Range† (minutes)
Kodalith Super	2¾	Continuous	—	2 to 4
Kodalith	2½	Continuous	—	2 to 4
Kodalith Liquid (1:3)	2½	Continuous	—	2 to 4
Kodak D-11	2	Continuous	—	1½ to 3½
Kodak Dektol	2	Continuous	—	1½ to 3½
Kodagraph Liquid	2	Continuous	—	1½ to 4

*Available in ready-to-mix form in several package sizes.
†Within this range of development times, satisfactory results can usually be obtained.

KODAK HIGH SPEED DUPLICATING FILM 2575 (ESTAR BASE)
KODAK HIGH SPEED DUPLICATING FILM 4575
(ESTAR THICK BASE)

Safelight: Use a safelight filter No. 1A (light red) in a suitable safelight lamp, with a 15-watt bulb at not less than 4 feet.

Color Sensitivity: Blue sensitive.

Meter Settings

White Flame Arc	Tungsten or Quartz-Iodine	Pulsed Xenon

FOR CONTACT PRINTING

*Recommended for meters marked for ASA speeds and are for trial exposures in copying. They apply to incident-light meters directly and to reflected-light meters used with the Kodak Neutral Test Card (18% gray side) at the copyboard. A matte white card will serve, in which case expose for five times the calculated exposure time.
†This value indicates the relative speed of this material to pulsed-xenon illumination as measured by light integrator.

Indexes are for lenses focused at infinity. For same-size reproduction, give four times the indicated exposure. Use the Kodak Graphic Arts Exposure Computer or equivalent to determine exposure for enlargement or reduction.

Example of Exposure: For a same-size (1:1) line reproduction, with two 1500-watt pulsed-xenon arc lamps in reflectors about 3 feet from the center of the copyboard, expose for about 30 to 50 seconds at $f/16$.

Screen Exposures: With Kodak Contact Screens (Estar Base) the exposures will be four to five times longer than for linework. For glass cross-line screens, the factor is much higher and varies with the method of use.

Filter Factors: When a filter is used, multiply the unfiltered exposure by the factor for the filter shown below. Since lighting conditions vary, these factors are only approximate.

Light Source	8	15	23A	25	30	33	47	47B	58
Pulsed Xenon *White-flame arc †Tungsten Quartz-Iodine					NOT USED				

*For ac or dc. With direct-current arc lamps, the positive carbon should be in the lower position.
†Photoflood or other high-efficiency tungsten.

Develop at 68 F (20 C) for approximate times given below:

Developer*	Development Times (minutes)			Development Range† (minutes)
	Halftone Negative	Agitation	Line Negative	
Kodalith Super	2¾	Continuous	—	2¼ to 5
Kodalith	2¾	Continuous	—	2¼ to 5
Kodalith Liquid (1:3)	2¼	Continuous	—	2 to 5
Kodak D-11	3	Continuous	—	2¾ to 4
Kodak Dektol (1:1)	1½	Continuous	—	1 to 4

*Available in ready-to-mix form in several package sizes.
†Within this range of development times, satisfactory results can usually be obtained.

KODALITH LR FILM 2572 (ESTAR BASE)

Safelight: Use a safelight filter No. 1A (light red) in a suitable safelight lamp, with a 15-watt bulb at not less than 4 feet.

Color Sensitivity: Orthochromatic.

Meter Settings

White Flame Arc	Tungsten or Quartz-Iodine	Pulsed Xenon
10*	4*	10†

For exposure through the base. When you expose the emulsion side, use double the above values.

*Recommended for meters marked for ASA speeds and are for trial exposures in copying. They apply to incident-light meters directly and to reflected-light meters used with the Kodak Neutral Test Card (18% gray side) at the copyboard. A matte white card will serve, in which case expose for five times the calculated exposure time.
†This value indicates the relative speed of this material to pulsed-xenon illumination as measured by light integrator.

Indexes are for lenses focused at infinity. For same-size reproduction, give four times the indicated exposure. Use the Kodak Graphic Arts Exposure Computer or equivalent to determine exposure for enlargement or reduction.

Example of Exposure: For a same-size (1:1) line reproduction, with two 1500-watt pulsed-xenon arc lamps in reflectors about 3 feet from the center of the copyboard, expose for about 10 seconds at $f/22$ (through the base).

Screen Exposures: With Kodak Contact Screens (Estar Base) the exposures will be four to five times longer than for linework. For glass cross-line screens, the factor is much higher and varies with the method of use.

Filter Factors: When a filter is used, multiply the unfiltered exposure by the factor for the filter shown below. Since lighting conditions vary, these factors are only approximate.

Light Source	8	15	23A	25	30	33	47	47B	58
Pulsed Xenon	2.5	8.0	—	—	—	—	—	6.0	—
*White-flame arc	6.0	10.0	—	—	—	—	—	8.0	—
†Tungsten Quartz-Iodine	3.0	8.0	—	—	—	—	—	16.0	—

*For ac or dc. With direct-current arc lamps, the positive carbon should be in the lower position.
†Photoflood or other high-efficiency tungsten.

Develop at 68 F (20 C) for approximate times given below:

Developer*	Development Times (minutes)			
	Halftone Negative	Agitation	Line Negative	Development Range† (minutes)
Kodalith Super	—	Continuous	2¾	2¼ to 3½
Kodalith	—	Continuous	2¼	2 to 3
Kodalith Liquid (1:3)	—	Continuous	2¼	2 to 3

*Available in ready-to-mix form in several package sizes.
†Within this range of development times, satisfactory results can usually be obtained.

KODALITH TRANSLUCENT MATERIAL

Safelight: Use a safelight filter No. 1A (light red) in a suitable safelight lamp, with a 15-watt bulb at not less than 4 feet.

Color Sensitivity: Orthochromatic.

Meter Settings

White Flame Arc	Tungsten or Quartz-Iodine	Pulsed Xenon
12*	6*	12†

*Recommended for meters marked for ASA speeds and are for trial exposures in copying. They apply to incident-light meters directly and to reflected-light meters used with the Kodak Neutral Test Card (18% gray side) at the copyboard. A matte white card will serve, in which case expose for five times the calculated exposure time.
†This value indicates the relative speed of this material to pulsed-xenon illumination as measured by light integrator.

Indexes are for lenses focused at infinity. For same-size reproduction, give four times the indicated exposure. Use the Kodak Graphic Arts Exposure Computer or equivalent to determine exposure for enlargement or reduction.

Example of Exposure: For a same-size (1:1) line reproduction, with two 1500-watt pulsed-xenon arc lamps in reflectors about 3 feet from the center of the copyboard, expose for about 12 seconds at $f/22$.

Screen Exposures: With Kodak Contact Screens (Estar Base) the exposures will be four to five times longer than for linework. For glass cross-line screens, the factor is much higher and varies with the method of use.

Filter Factors: When a filter is used, multiply the unfiltered exposure by the factor for the filter shown below. Since lighting conditions vary, these factors are only approximate.

Light Source	8	15	23A	25	30	33	47	47B	58
Pulsed Xenon *White-flame arc †Tungsten } Quartz-Iodine }				NOT GIVEN					

*For ac or dc. With direct-current arc lamps, the positive carbon should be in the lower position.
†Photoflood or other high-efficiency tungsten.

Develop at 68 F (20 C) for approximate times given below:

Developer*	Development Times (minutes)			Development Range† (minutes)
	Halftone Negative	Agitation	Line Negative	
Kodalith Super	—	Continuous	2¾	2 to 4
Kodalith	—	Continuous	2¾	2 to 4
Kodalith Liquid (1:3)	—	Continuous	2¾	2 to 4

*Available in ready-to-mix form in several package sizes.
†Within this range of development times, satisfactory results can usually be obtained.

KODALITH ORTHO PAPER (STANDARD AND THIN)

Safelight: Use a safelight filter No. 1A (light red) in a suitable safelight lamp, with a 15-watt bulb at not less than 4 feet.

Color Sensitivity: Orthochromatic.

Meter Settings

White Flame Arc	Tungsten or Quartz-Iodine	Pulsed Xenon
8*	5*	8†

*Recommended for meters marked for ASA speeds and are for trial exposures in copying. They apply to incident-light meters directly and to reflected-light meters used with the Kodak Neutral Test Card (18% gray side) at the copyboard. A matte white card will serve, in which case expose for five times the calculated exposure time.
†This value indicates the relative speed of this material to pulsed-xenon illumination as measured by light integrator.

Indexes are for lenses focused at infinity. For same-size reproduction, give four times the indicated exposure. Use the Kodak Graphic Arts Exposure Computer or equivalent to determine exposure for enlargement or reduction.

Example of Exposure: For a same-size (1:1) line reproduction, with two 1500-watt pulsed-xenon arc lamps in reflectors about 3 feet from the center of the copyboard, expose for about 30 seconds at $f/22$.

Screen Exposures: With Kodak Contact Screens (Estar Base) the exposures will be four to five times longer than for linework. For glass cross-line screens, the factor is much higher and varies with the method of use.

Filter Factors: When a filter is used, multiply the unfiltered exposure by the factor for the filter shown below. Since lighting conditions vary, these factors are only approximate.

Light Source	8	15	23A	25	30	33	47	47B	58
Pulsed Xenon *White-flame arc †Tungsten } Quartz-Iodine }					NOT USED				

*For ac or dc. With direct-current arc lamps, the positive carbon should be in the lower position.
†Photoflood or other high-efficiency tungsten.

Develop at 68 F (20 C) for approximate times given below:

Developer*	Development Times (minutes)			Development Range† (minutes)
	Halftone Negative	Agitation	Line Negative	
Kodalith	—	Continuous	1¾	1½ to 2
Kodalith Super	—	Continuous	1¾	1½ to 2

*Available in ready-to-mix form in several package sizes.
†Within this range of development times, satisfactory results can usually be obtained.

KODALINE ORTHO FILM 2567 (ESTAR BASE)
KODALINE ORTHO FILM 4567 (ESTAR THICK BASE)

Safelight: Use a safelight filter No. 1A (light red) in a suitable safelight lamp, with a 15-watt bulb at not less than 4 feet.

Color Sensitivity: Orthochromatic.

Meter Settings

White Flame Arc	Tungsten or Quartz-Iodine	Pulsed Xenon
10*	4*	10†

These exposure indexes will vary with processing, and should be checked by test.

*Recommended for meters marked for ASA speeds and are for trial exposures in copying. They apply to incident-light meters directly and to reflected-light meters used with the Kodak Neutral Test Card (18% gray side) at the copyboard. A matte white card will serve, in which case expose for five times the calculated exposure time.
†This value indicates the relative speed of this material to pulsed-xenon illumination as measured by light integrator.

Indexes are for lenses focused at infinity. For same-size reproduction, give four times the indicated exposure. Use the Kodak Graphic Arts Exposure Computer or equivalent to determine exposure for enlargement or reduction.

Example of Exposure: For a same-size (1:1) line reproduction, with two 1500-watt pulsed-xenon arc lamps in reflectors about 3 feet from the center of the copyboard, expose about 10 seconds at $f/22$.

Screen Exposures: With Kodak Contact Screens (Estar Base) the exposures will be four to five times longer than for linework. For glass cross-line screens, the factor is much higher and varies with the method of use.

Filter Factors: When a filter is used, multiply the unfiltered exposure by the factor for the filter shown below. Since lighting conditions vary, these factors are only approximate.

Light Source	8	15	23A	25	30	33	47	47B	58
Pulsed Xenon *White-flame arc †Tungsten Quartz-Iodine				NOT USED					

*For ac or dc. With direct-current arc lamps, the positive carbon should be in the lower position.
†Photoflood or other high-efficiency tungsten.

Develop at 68 F (20 C) for approximate times given below:

Developer*	Development Times (minutes)			Development Range† (minutes)
	Halftone Negative	Agitation	Line Negative	
Machine processing				
Kodak Versamat Processor Model 317 with Kodalith RT Developer				
Kodalith Film Processor Model 324 with Kodalith RT Developer				
Kodak Supermatic Processor Model 242 with Kodak Supermatic 55 Developer				
Tray processing				
Kodalith Super Developer	—	Continuous	2¾	2¼ to 3¼

*Available in ready-to-mix form in several package sizes.
†Within this range of development times, satisfactory results can usually be obtained.

KODAK BLUE-SENSITIVE MASKING FILM 2136 (ESTAR BASE)

Safelight: Use a safelight filter No. 1A (light red) in a suitable safelight lamp, with a 15-watt bulb at not less than 4 feet.

Color Sensitivity: Blue sensitive .

Meter Settings

White Flame Arc	Tungsten or Quartz-Iodine	Pulsed Xenon
—	25*	—

*Recommended for meters marked for ASA speeds and are for trial exposures in copying. They apply to incident-light meters directly and to reflected-light meters used with the Kodak Neutral Test Card (18% gray side) at the copyboard. A matte white card will serve, in which case expose for five times the calculated exposure time.
†This value indicates the relative speed of this material to pulsed-xenon illumination as measured by light integrator.

Indexes are for lenses focused at infinity. For same-size reproduction, give four times the indicated exposure. Use the Kodak Graphic Arts Exposure Computer or equivalent to determine exposure for enlargement or reduction.

Example of Exposure: For a same-size (1:1) line reproduction, with two 1500-watt pulsed-xenon arc lamps in reflectors about 3 feet from the center of the copyboard, not recommended.

Screen Exposures: With Kodak Contact Screens (Estar Base) the exposures will be four to five times longer than for linework. For glass cross-line screens, the factor is much higher and varies with the method of use.

Filter Factors: When a filter is used, multiply the unfiltered exposure by the factor for the filter shown below. Since lighting conditions vary, these factors are only approximate.

Light Source	8	15	23A	25	30	33	47	47B	58
Pulsed Xenon *White-flame arc †Tungsten } Quartz-Iodine }				NOT RECOMMENDED					

*For ac or dc. With direct-current arc lamps, the positive carbon should be in the lower position.
†Photoflood or other high-efficiency tungsten.

Develop at 68 F (20 C) for approximate times given below:

Developer*	Development Times (minutes)			Development Range† (minutes)
	Halftone Negative	Agitation	Line Negative	
Positive Masks DK-50 (1:2) HC-110 (dilution E)	—	Continuous	2½	—
Continuous-tone Positives DK-50 (full strength) HC-110 (dilution C)	—	Continuous	4	—

*Available in ready-to-mix form in several package sizes.
†Within this range of development times, satisfactory results can usually be obtained.

KODAK SEPARATION NEGATIVE FILM 4131 TYPE 1
(ESTAR THICK BASE)

Safelight: *Total darkness required.* A safelight filter Series 3 (dark green), in a suitable safelight lamp with a 15-watt bulb can be used for a few seconds *only,* at 4 feet, after development is half completed.

Color Sensitivity: Panchromatic.

Meter Settings

White Flame Arc	Tungsten or Quartz-Iodine	Pulsed Xenon
125*	100*	125†

*Recommended for meters marked for ASA speeds and are for trial exposures in copying. They apply to incident-light meters directly and to reflected-light meters used with the Kodak Neutral Test Card (18% gray side) at the copyboard. A matte white card will serve, in which case expose for five times the calculated exposure time.
†This value indicates the relative speed of this material to pulsed-xenon illumination as measured by light integrator.

Indexes are for lenses focused at infinity. For same-size reproduction, give four times the indicated exposure. Use the Kodak Graphic Arts Exposure Computer or equivalent to determine exposure for enlargement or reduction.

Example of Exposure: For a same-size (1:1) line reproduction, with two 1500-watt pulsed-xenon arc lamps in reflectors about 3 feet from the center of the copyboard, expose for about 8 seconds at $f/22$ with Kodak filter No. 23A and 0.6 neutral density.

Screen Exposures: With Kodak Contact Screens (Estar Base) the exposures will be four to five times longer than for linework. For glass cross-line screens, the factor is much higher and varies with the method of use.

Filter Factors: When a filter is used, multiply the unfiltered exposure by the factor for the filter shown below. Since lighting conditions vary, these factors are only approximate.

Light Source	23A	25	29	33	47	47B	49	58	61
Pulsed Xenon	6	10	20	20	15	20	25	12	20
*White-flame arc	6	10	25	20	6	8	20	10	15
†Tungsten Quartz-Iodine }	3.6	6	12	15	30	36	72	12	18

*For ac or dc. With direct-current arc lamps, the positive carbon should be in the lower position.
†Photoflood or other high-efficiency tungsten.

Develop at 68 F (20 C) for approximate times given below:

Developer*	Development Times (minutes)			
	Halftone Negative	Agitation	Line Negative	Development Range† (minutes)
‡ DK-50 (1:1) or HC-110 (dilution B)	{ red 4 green 3½ blue 4	Cont. Cont. Cont.	— — —	— — —
§ DK-50 (1:2) or HC-110 (dilution E)	{ red 4 green 4 blue 5	Cont. Cont. Cont.	— — —	— — —

*Available in ready-to-mix form in several package sizes.
†Within this range of development times, satisfactory results can usually be obtained.
‡Color separation negatives from reflection copy.
§Color separation negatives from original subjects or from masked color transparencies.

KODAK SEPARATION NEGATIVE FILM 4133, TYPE 2
(ESTAR THICK BASE)

Safelight: *Total darkness required.* A safelight filter Series 3 (dark green), in a suitable safelight lamp with a 15-watt bulb can be used for a few seconds *only*, at 4 feet, after development is half completed.

Color Sensitivity: Panchromatic.

Meter Settings

White Flame Arc	Tungsten or Quartz-Iodine	Pulsed Xenon
50*	25*	40†

*Recommended for meters marked for ASA speeds and are for trial exposures in copying. They apply to incident-light meters directly and to reflected-light meters used with the Kodak Neutral Test Card (18% gray side) at the copyboard. A matte white card will serve, in which case expose for five times the calculated exposure time.
†This value indicates the relative speed of this material to pulsed-xenon illumination as measured by light integrator.

Indexes are for lenses focused at infinity. For same-size reproduction, give four times the indicated exposure. Use the Kodak Graphic Arts Exposure Computer or equivalent to determine exposure for enlargement or reduction.

Example of Exposure: For a same-size (1:1) line reproduction, with two 1500-watt pulsed-xenon arc lamps in reflectors about 3 feet from the center of the copyboard, expose for about 20 seconds at $f/22$ with Kodak Filter 23A and 0.6 neutral density.

Screen Exposures: With Kodak Contact Screens (Estar Base) the exposures will be four to five times longer than for linework. For glass cross-line screens, the factor is much higher and varies with the method of use.

Filter Factors: When a filter is used, multiply the unfiltered exposure by the factor for the filter shown below. Since lighting conditions vary, these factors are only approximate.

Light Source	23A	25	29	33	47	47B	49	58	61
Pulsed Xenon	5	6	10	10	7.5	10	20	15	25
*White-flame arc	6	7.2	15	15	9	12	24	18	30
†Tungsten / Quartz-Iodine	2.5	3	5	7	12.5	20	30	12.5	20

*For ac or dc. With direct-current arc lamps, the positive carbon should be in the lower position.
†Photoflood or other high-efficiency tungsten.

Develop at 68 F (20 C) for approximate times given below:

Developer*		Development Times (minutes)			Development Range† (minutes)
		Halftone Negative	Agitation	Line Negative	
‡DK-50 (1:1)		4½	Continuous	—	—
§DK-50 (1:1)	red	3¼	Continuous	—	—
	green	2¾	Continuous	—	—
	blue	2¾	Continuous	—	—
¶D-11		—	Continuous	4	—

*Available in ready-to-mix form in several package sizes.
†Within this range of development times, satisfactory results can usually be obtained.
‡Continuous tone copying, no filter.
§Color separation from masked transparencies.
¶Maximum contrast.

DUPONT DYLUX INSTANT-IMAGE PROOF PAPER

Dupont Dylux Paper is an instant-access photosensitive proofing medium that images immediately when exposed to ultraviolet light through a negative or positive. No processing is required; the ultraviolet exposure produces an immediately visible image. Exposure to white light after the image exposure desensitizes the remaining coating. It is possible to make positive proofs from negatives, or positive proofs from positives, by varying the order of exposure.

Types Available: Dylux 503-1 is coated on one side only, for normal proofing. Dylux 503-2 is coated on both sides and is used where two-sided proofs are needed, as for dummies.

Exposure: Dylux can be exposed in any ordinary vacuum frame, using a bank of ultraviolet lamps. The usual light source is Sylvania BLB fluorescent lamps; other lamps of different manufacture should not be substituted. Twelve 48″ Sylvania BLB lamps (F40T12) mounted one inch apart (on 2½″ centers) produce a bank that will cover a 30″ × 45″ printing frame; the bank of lamps is used within two to four inches from the frame. With this arrangement, exposures will run from 15 to 20 seconds.

Deactivation: After exposure the paper can be deactivated by exposure to a strong white light (not daylight, because of its ultraviolet content). One method is to use a bank of Sylvania Super Diazo (SDZ) lamps; one or two minutes exposure to these lamps will clear the pale yellow background color of the Dylux proof. Pulsed xenon or carbon arc lamps can also be used for deactivation, provided the lamps are screened with a sheet of W-2 Mylar or similar ultraviolet-blocking filter material.

If the proofs are needed immediately, and will not be taken outdoors at once they can be delivered to the customer as they come from the exposure frame. The pale yellow background color will not interfere with normal use of the proof, and will clear itself within an hour in ordinary room light.

Direct Positive Proofs: Since the paper is desensitized by exposure to white light, a direct positive proof can be made by exposing through a positive original to white light. This light can be a bank of photofloods, an arc lamp screened with W-2 Mylar sheeting, or a bank of Sylvania Super Diazo lamps Type SDZ. This exposure desensitizes the paper in the areas corresponding to the clear parts of the original. After this exposure, the positive is removed and the paper is exposed to ultraviolet light (Sylvania BLB) to bring out the positive image.

Other Light Sources: Where a great deal of Dylux proofing is being done, the bank of BLB lamps is the best light source. For occasional proofs, other ultraviolet sources can be substituted; these may be either mercury or pulsed-xenon lamps, but they must be screened with a filter such as the Kokomo Type 400, to remove all visible light that would cause image bleaching.

Commercial printing units are available for Dylux proofing; these mostly contain the Sylvania BLB lamps except the Berkey-Ascor Vacuum Printer, which utilizes the high-intensity mercury lamp and the Kokomo filter.

AGFACONTOUR FILM

Agfacontour is a black-and-white equidensity film which greatly differs in structure and application from the usual photographic emulsions.

In photography equidensities are understood as being places of equal density in an original.

Equidensities are obtained as areas or lines of equal density in a direct procedure with any original negative or positive.

After exposure and development in accordance with instructions, a positive and a negative characteristic curve are obtained alongside each other with a trough in between. As a result of special sensitization the width of equidensities can be varied by exposing through yellow filters. The greater the density of the filter, the narrower will the equidensity be. Positive gradation is built up by physical development, negative gradation by chemical development.

The part of the emulsion for the positive gradation is sensitive to blue, the part for the negative gradation is mainly sensitive to green.

Sensitivity

Between contact and enlarging papers. In general the exposure required will depend on the density of the original to be reproduced as an equidensity.

Gradation

Extremely hard (gamma greater than 7.0). The positive gradation is usually rather harder than the negative gradation. Straight-line characteristic curve.

Resolving Power

40 pairs of lines per millimeter (for narrow equidensity).

Base

Polyester film. Thickness: 180 μm (approximately .007″)

Emulsion Structure

Single coat with supercoat. Emulsion thickness 19μm. The emulsion consists of a mixture of chloride and bromide emulsions with special additives.

Antihalation Protection

Dark blue gelatin backing, which loses its color in the developer.

Exposure

The original negative is contact-printed onto Agfacontour film, or by using an enlarger. Direct camera exposures are only possible with motionless objects, due to the low sensitivity.

A single exposure gives only the equidensity of a single density value in the object photographed. Several exposures of different lengths on a number of sheets of Agfacontour film will therefore be used quite often in practice.

The equidensity can be narrowed by yellow filters of increasing densities. On the other hand, the equidensity can be widened by magenta filters. The filter density necessary in each case will depend on the color temperature of the light source. Light sources resembling daylight require double the filter density needed for incandescent light. For a starting point, a Wratten CC40Y filter is suggested.

A step wedge can be used for your initial exposures. This will allow you to see the characteristic results of the film. Also, from these tests, you can ascertain

the usable exposure range for your particular equipment. These test results can then be translated to full-scale originals.

If your result is a high-contrast, multi-density image, you are most likely overexposing the film, and should decrease your exposure.

The areas or lines obtained with the first copy are referred to as first-order equidensities. If a first-order equidensity is copied again on Agfacontour, each of the two flanks of the first-order equidensity yields a very narrow equidensity, or a total of two second-order equidensities. Further recopying yields four even narrower third-order equidensities, and so on.

Processing

Safelight: A red safelight such as a Wratten No. 1 can be used.

Development in Agfacontour Developer

Development time: 2 minutes at 68 F (20 C) with continuous and thorough agitation in a tray or small tank.

If normal black-and-white developers are used only negative gradation results and therefore no equidensity.

Used developer should not be poured back into the stock bottle. We suggest for consistent results that you divide the developer after mixing for storage purposes, and use the developer on a one-shot basis. One gallon of Agfacontour developer is sufficient to process 25 sheets of 4" X 5" film.

Stop Bath: 30 seconds in 3 per cent acetic acid bath. The use of a stop bath is absolutely necessary for Agfacontour to avoid staining.

Fixing: 5 minutes in an acid fixing bath.

Washing: 15—20 minutes in running water.

Drying: A one-minute treatment in a wetting agent can be used followed by natural or heat drying.

Retouching: Retouching dyes can be applied to the emulsion side and back.

Procedure

1. Black-and-white equidensity images: First or second-order equidensities of one or more densities can be produced as required from a negative or positive original. Black areas or lines on a white background are obtained by recopying onto normal black-and-white materials.

2. Color equidensity images: There are several ways of making multicolored equidensity images with Agfacontour film. The first of these is to make several exposures at different levels on sheets of Agfacontour film, and then to print these on separate sheets of color material, either directly or via a contact positive from each contour negative. Transparex, Color-Key, and similar materials may be used, processed, and then assembled in register.

The second method is to print the separate equicontour negatives onto a color printing paper by a series of separate exposures, one through each negative using a different color filter for each. Pin registration or some similar means of establishing register will be needed, but a wide variety of colors is possible on a single sheet of color paper, merely by the use of a number of different color filters.

GEVAPROOF COLOR PROOFING SYSTEM

General Characteristics

The Gevaproof color proofing system starts from the screened halftone negatives and produces good-quality color proofs, which can be used as references by both graphic-arts photographers and retouchers.

The base (Gevaproof S) is a dimensionally stable .007″ polyester film coated on both sides with a smooth, white, opaque layer, which gives it the appearance of good quality paper.

The various colors are supplied as separate sheets:

cyan (light)	Gevaproof C 1
cyan (heavy)	Gevaproof C 2
yellow	Gevaproof J
magenta (light)	Gevaproof M 1
magenta (heavy)	Gevaproof M 2
black (light)	Gevaproof B 1
black (heavy)	Gevaproof B 2

The light-sensitive emulsion containing the color pigments is coated on a temporary base, which, after transfer of the color onto the sheet of Gevaproof S, is stripped off. The colors used in the Gevaproof system correspond to those of average process color inks, because the pigments selected for making the Gevaproof colors are the same as those used in the manufacture of printing inks.

Two solutions are required: an ethyl alcohol–water solution and an activator. The former is a mixture of two parts of alcohol with one part of water. The activator is supplied in powder form (Gevaproof G 650 p) and is to be dissolved in water.

Four simple and inexpensive machines are available for the Gevaproof system, namely a tray with a built-in timer as well as an indicator to check the alcohol-water balance (Gevaproof 100), a transfer unit (Gevaproof 200), a drying unit (Gevaproof 300), and a unit for activation and washing (Gevaproof 400), which, apart from providing rapid treatment of the Gevaproof material, also saves a considerable amount of space.

A lacquer (Gevaproof L) is also supplied in a spray can to make high-gloss color proofs if necessary.

Use

Color proofs can be made for both offset and letterpress (powderless etching process and photopolymer plates) starting from the screened separation negatives. These color proofs can replace the initial conventional printing proofs for use as a guide for any further retouching, as well as for making paste-ups and layouts.

Particularly in the case of direct screening, the Gevaproof color proofing system represents a rapid means for controlling the results in an efficient manner during the photographic phase of the work.

Treatment

The following working instructions should be followed:

A sheet of Gevaproof S (white base) is immersed for at least 90 seconds in the alcohol-water solution at room temperature in the Gevaproof 100 tray. The latter is provided with a time switch, which is energized by pressing the black button until the buzz tone ceases. As soon as the black button is released, the red

indicator lamp lights up for the time required to moisten the sheet of Gevaproof S (90 seconds).

The moist sheet of Gevaproof S is placed on the lower feeding table of the Gevaproof 200 transfer unit and aligned against the rollers. The handle is then pulled back until the sheet is engaged by the rollers to a length of approximately ½ inch. This is followed by placing a color sheet (Gevaproof C) with the matte side (emulsion) down on the upper feeding table and pushing it against the rollers. The unit is then brought into operation by means of the electric foot switch and the color sheet is transferred onto the sheet of Gevaproof S. (Caution: do not interrupt the transfer!)

By bending one of the corners over the back of the Gevaproof S sheet, one can check when the temporary base detaches itself from the color layer. This happens after about 30 seconds. The temporary base is then completely stripped off and only the color layer remains on the Gevaproof S sheet.

The sheet is placed in the Gevaproof 300 drying unit, which is then switched on. After approximately one minute, the drying unit is switched off.

The dry sheet (which now carries a cyan layer) is then exposed through the corresponding (cyan) halftone separation negative. Register difficulties are avoided by using a pre-register system such as the Agfa-Gevaert register strip, or a punch and peg register system.

Exposure Examples

Light Source	Distance	Exposure	
		C, J, M, B1	B2
Single open arc lamp (2 phase, 45A)	20 in.	100 sec.	300 sec.
Mercury vapor lamp (1 kW)	20 in.	180 sec.	540 sec.
Xenon lamp (5 kW)	20 in.	75 sec.	225 sec.

Note: Incandescent lamps (such as halogen lamps) are not suitable because of their lack of ultraviolet radiation content.

Test Exposure

When using Gevaproof material for the first time, an initial test exposure is recommended. A sheet of Gevaproof C or M is transferred onto a sheet of Gevaproof S, followed by exposure through a continuous-tone step wedge. The correct exposure level will be indicated when all steps up to D = 1.0 are printed as solids.

Relatively large variations in the exposure (50 per cent over- or under-exposure) do not noticeably affect tone rendering, because the dot images on the individual color layers are particularly sharp.

The exposed sheet is immersed for at least 30 seconds in Gevaproof G 650 p activator at room temperature.

When the sheet is removed from the activator, the excess (unexposed) color areas are washed away in the washing tank with luke-warm water (85−105 F).

After washing, the sheet of Gevaproof S, which now carries a cyan image, is again immersed for at least 90 seconds in the alcohol-water solution (repeat step 1). The next color is then transferred (repeat step 2). This is followed by the same treatment as for the first color sheet (steps 3−7).

Finally, the same treatment is followed for the third color and, if necessary, for the black.

After the sheet has been washed for the last time, it is once more immersed for at least 90 seconds in the alcohol-water solution. All excess water is then removed by placing the sheet between the rollers of the transfer unit (image side up), thus preventing the formation of drying marks in the Gevaproof 300 drying unit.

Note

Making Gevaproof color images is very simple. There are no special climatic requirements (the relative humidity of the workroom may be between 30 and 75 per cent). If the air is very dry, stripping the base from the color sheet may prove difficult. In that case, it is sufficient to add water to the alcohol-water solution (up to 10 per cent).

Gevaproof can be handled in subdued daylight, tungsten light, or the light from fluorescent tubes. However, material that has not yet been treated should not be exposed unnecessarily to light.

The sequence of transferring the color sheets can be chosen in conformity with the standards applied in a particular plant.

Preparing The Solutions

a. Alcohol-water solution. The mixture consists of two parts of ethyl alcohol with one part of water. If more than two parts of alcohol are present in the mixture, difficulties may be encountered during transfer, because the gelatin will then not swell sufficiently. Note however that the quantity of water in the mixture increases steadily throughout treatment by transfer of surplus water adhering to the sheet from the washing stage (step 7); the alcohol also evaporates slowly. When the mixture contains too much water, the screen dots may enlarge.

The Gevaproof 100 tray is provided with a simple means for continuously checking the specific gravity of the liquid in order to ensure reproducibility. There are two rings (one black and one white) in the liquid. When both rings come to the surface, the mixture contains insufficient alcohol. When both rings are at the bottom, the mixture contains insufficient water. When the white ring is at the surface and the black ring is at the bottom, the mixture is correct.

The alcohol-water solution is prepared by mixing in a bottle two parts of alcohol with one part of water. The mixture is then poured through a paper filter into the Gevaproof 100 tray and allowed to cool to room temperature.

Always use denatured ethyl alcohol (ethanol) without dyes and with an aqueous content of 4—6 per cent, which has a purity of better than 90 per cent and which does not contain non-volatile denaturization products.

In case ethanol is difficult to obtain, isopropanol may be used. The concentration remains unchanged (2 parts of isopropanol to 1 part of water).

When isopropanol is used, no account should be taken of the white control ring of the Gevaproof 100 tray. The black ring must lie on the bottom; if it rises to the surface, a fresh mixture should be prepared.

There is a difference in treatment when using isopropanol. The first color sheet must be transferred to the Gevaproof S sheet after the latter has been wetted in water for 1 minute. The subsequent color sheets are transferred in the usual manner; that is, after wetting for at least 1½ minutes in the isopropanol-water solution.

The use of an isopropanol-water solution is especially recommended for line work and coarse screen work (as used for silk screen printing for example).

b. Activator (Gevaproof G 650 p): Gevaproof G 650 p activator is supplied in two packets containing chemicals that are dissolved together in 1 or 2 liters (2 or 4 pints) of water. Water is then added to make 5 liters (9 pints) of solution.

The activator must be protected against very strong light and must be replaced daily. It is not recommended to store the activator, because a gas is formed which may cause excessive pressure in the storage vessels.

c. Wash water. For washing out the colors in the Gevaproof 400 unit, water at a temperature of 85−105 F should be used.

Impurities in the wash water can cause local blistering when transferring the following color sheet. Therefore it is recommended to use only filtered water.

The wash water should not be too hard. If the water is very hard, crystallization can occur in the alcohol-water mixture, which would cause faulty contact during the transfer of the next color layer. Should this happen, the sheet must be rinsed in distilled water. Complex-forming additives (such as polyphosphates) for softening the water must never be used, as this reduces the adhesion of the color layers.

KODAK AUTOPOSITIVE MATERIALS

If Kodak Autopositive materials are developed without exposure, a high, even density will result. If, however, the material is exposed to strong yellow light before development, this density will be removed. Furthermore, the density removed by the yellow light can be restored by re-exposing to strong white light—and again removed by strong yellow light. All these exposures must, of course, be made before the film is developed.

Remember, the basic principle in using Kodak Autopositive material is: yellow light removes density, white light adds density.

How To Make a Laterally Reversed Duplicate Negative (or Positive) on Kodak Autopositive Film

1. Working in subdued room illumination, place a sheet of Kodak Autopositive Film (Estar Base) in a printing frame with the negative to be reproduced, just as is done when making any photographic contact print.

2. Between the printing frame and the light source, hang a piece of Kodagraph Sheeting, Yellow, arranged so that no stray white light reaches the printing frame. For convenience in handling, the sheeting can be mounted on a light wooden frame equipped with hooks for suspending it in position. If the yellow sheeting is hung an inch or more from the glass of the printing frame, accumulated dirt specks or scratches will not image on the film.

3. Expose for about 2 minutes to white-flame carbon-arc light (3000 footcandles), such as that from a 35-ampere arc at about 3 feet or a high-intensity, 90-ampere carbon arc at 4 to 5 feet. The exposure can be made to tungsten light of about 3000 footcandles for 1 minute. Four No. 2 reflector-type photofloods, mounted so that their bases are at the corners of a 6-inch square, give adequate exposure at a distance of about 2 feet. With one lamp, the exposure is about 4 minutes. Evenness can be improved by having the lamp suspended above the printing frame and allowing it to swing slightly during exposure.

4. For all general work, develop the film at 68 F (20 C) for 2 minutes, with continuous agitation, in a tray of Kodalith Developer (undiluted) or Kodalith Super Developer (undiluted).

5. Rinse in Kodak Indicator Stop Bath or Kodak Stop Bath SB-1a at 65 to 70 F (18 to 21 C) for about 10 seconds. These baths check development instantly, provided the acid has not been neutralized. They also tend to prevent stains and streaks in the film when it is immersed in the fixing bath.

6. Fix at 65 to 70 F (18 to 21 C) for 1 to 2 minutes in Kodak Rapid Fixer, or for 2 to 4 minutes in Kodak Fixer or Kodak Fixing Bath F-5.

7. Wash for about 10 minutes in an adequate supply of running water. Wipe the surface carefully with a Kodak Photo Chamois or a viscose sponge before drying.

Normal Negative-Positive Work

Kodak Autopositive materials are the right choice when it is desirable to use a film or plate that can be handled in normal room illumination for making a negative from a positive or a positive from a negative. The following procedure can be used: First, flash the Kodak Autopositive Film with an all-over yellow-light exposure for 2 minutes with a 35-ampere arc at 3 feet and then give a white-light image exposure for 5 seconds, using contact-printing methods.*

*White-light exposures that vary from one piece of copy to the next indicate that the yellow-light exposures may be insufficient. In such cases, increase the yellow-light exposures slightly until you are able to standardize the white-light exposures.

The laterally reversed duplicating technique and the normal positive-negative procedure can both be used when exposing from the same original to give a combination result.

Negative And Positive On The Same Film

By a simple masking operation, part of a negative can be printed as a negative and other parts as a positive. For example: (1) Place an opaque film mask over those parts of the negative which are to be printed as a positive. (2) Print the remainder of the negative with yellow light as described above. (3) Remove the negative, cover the areas just exposed, and uncover the area to be printed as a positive. (4) Give this "positive area" a 2-minute flash exposure to yellow light. (5) Replace the negative and expose this same area for 5 seconds to white light. (6) Process as usual.

This entire operation can be carried out easily if the Autopositive Film is fastened to a base, such as a piece of pressboard or acetate sheet, by means of a few pieces of cellulose tape. Each mask is then placed in register and taped on one edge to serve as a hinge. By hinging these masks and the negative along different edges of the Autopositive Film, any of them can be positioned immediately. The Kodak Register Printing Frame or other suitable pin-register systems can also be used to maintain register between the various masks and negatives.

The masks may, of course, be lettering or line images on Kodalith film. By this means, clear or black lettering or other linework can be superimposed on a previously exposed area. Just remember that a 2-minute yellow-light exposure will remove density and a 5-second white-light exposure will restore the density if a single 35-ampere arc is used at 3 feet. (Note: When a white-light exposure has been added to the original density, an increased amount of yellow exposure is necessary to remove the density.)

Outline Effects

From a line negative containing lettering, for example, a negative that has a fine clear line or a dark line at the edges of the letters can be made on Autopositive Film. A line negative will produce lines on the outside of the edges, and a line positive will produce lines on the inside of the edges. Negatives with clear lines can be produced by placing a thin spacer, such as a piece of clear acetate sheeting or fixed-out film, between the negative and the sheet of Autopositive Film and then proceeding as follows: (1) Expose to yellow light through the line negative; (2) remove spacer; and (3) expose to white light through the line negative.

A dark outline on a clear background can be made as follows: (1) Expose film to yellow light without negative; (2) place spacer between negative and film; (3) remove spacer; and (4) expose film to yellow light through negative.

Reflex Copying

Linework or type matter on paper can be copied by the reflex method. Place the Autopositive Film face down on the image side of the original and give a yellow-light exposure through the base side of the film. A piece of clear glass can be used to maintain contact. Expose through Kodagraph Sheeting, Yellow, for 90 seconds with one 35-ampere arc at 3 feet or for 45 seconds with four No. 2 reflector-type photofloods at 2 feet. Process as described above.

THE KODAK TONE-LINE PROCESS

The tone-line process is a method of converting a continuous-tone image to a line drawing by photographic operations. This line conversion will produce an effect similar to that of a pen-and-ink drawing. For pictures where a general line drawing effect is desired, no additional art work is necessary. In cases where important characteristics or details must be clearly reproduced, these may be added by the artist to a tone-line print. The tone-line process, when used as a base for further art work, will enable the production of a pen-and-ink type of picture in much less time than is normally required to make such drawings. This process makes possible the photomechanical reproduction of illustrations without the use of a halftone screen. The tone-line process involves combining a negative with a positive of nearly equal contrast, the positive being used as a mask. This method should not be confused with solarization methods of producing outlines or with the pseudo-relief effect obtained by using a negative and a positive slightly out of register with each other.

A positive and a negative transparency which exactly match each other in contrast are taped together, back to back, in exact register. Except at the boundaries of images, the positive and negative neutralize each other's tone values. A little light leaks around the boundaries of images, and if a print is made from the combined transparencies on a high-contrast material, such as Kodalith Ortho Films, Type 3, or Kodaline Ortho Film 2567 (Estar Base), a line positive is produced.

If desired, a line negative may be made from this line positive by contact printing. If art work or lettering is to be combined with the line positive, the line positive may be produced directly on Kodaline Paper or on Kodak Ektamatic Photomechanical Paper, Grade T.

A tone-line reproduction can be made from either an original negative or a photographic print. In the latter case, of course, it is necessary to make a copy negative.

Not every subject will give a pleasing result by this method, and experience is necessary for judging whether the method will be useful in a given case.

The Continuous-Tone Negative

Any good film negative with sharp detail may be used for the tone-line process. If the negative is made specially for this process, however, the following factors should be considered:

A large-size film should be used, and the negative should be given full exposure. The lighting should be such as to accentuate the outlines of the subject without producing sharp-edged shadows. The use of large light sources will produce the necessary softening of the edges of the shadows. The utmost care should be taken to make the negative as sharp as possible.

For pictorial purposes, it is desirable to have more and thicker outlines in the shadows than in the highlights. This may be achieved by using continuous-tone negatives in which the shadows have more contrast than the highlights—that is, negatives which would normally be considered overexposed. The contrast in the highlights should not be so low, however, as to cause too much loss of highlight detail.

The greater the density range of the transparencies, the easier it will be to make a satisfactory outline print, provided that the positive mask and the negative are matched over the whole range. The density range over which they can be matched is limited, however, by the length of the straight-line portion of the

sensitometric curve of the mask emulsion. A range of about 1.5 is usually satisfactory.

The Positive Mask

The positive mask can be made on either Kodak Blue Sensitive Masking Film 2136 (Estar Base) or Kodak Gravure Positive Film 4135 (Estar Thick Base), using a point source of light or one as small as possible. The procedure described is actually a form of unsharp masking. Although the positive mask has a sharp image, the shadow of the mask image which falls on the high-contrast film is blurred so that the positive acts as an unsharp mask.

Lighting Equipment

The exposure information, given below under "Procedure," is based on the use of an incandescent lamp with no reflector—in this case, a 7-watt, white-enamel lamp, such as the Westinghouse 7C7/W, used with a reducer (medium screw base to candelabra base, Eagle Electric Mfg. Co. Cat. No. 313). This type of lamp is often sold in hardware stores as a "night light."* The lamp should be mounted on a suitable support about six feet above the printing frame.

Registering Equipment and Methods

The printing frame may be modified to permit pinhole pre-register of the positive mask with the negative. By positioning the film prior to exposure, the finished mask may be quickly and accurately registered with the original after processing. This may be accomplished by cutting the diagonally opposite corners of the glass plate used in the printing frame. (Measure about 1 inch from the corner along both edges of the glass and make a diagonal cut connecting these two points.) The printing frame should be the same size as the negative. When the negative and film are placed in the printing frame as described below, a small hole is punched in each of the uncovered corners through both the negative and the film. For this purpose, a punch is made by grinding off the end of a pushpin so that it is absolutely flat, that is, so that the edges are not rounded. A punch of this type makes cleaner holes than a pin with a sharp end. These pinholes serve as guides in registering the mask and negative.

A preferred method of register is provided by the Kodak Register Printing Frame and the Kodak Register Punch. Register of the film is accomplished by means of two register pins located at the end of the printing frame. The Register Punch is designed to perforate the film to fit over these register pins. If there is sufficient room beyond the picture, register holes may be punched directly in the negative and film to be used as a mask. When it is desirable to avoid punching holes in the negative, a narrow strip of film of the same thickness may be fastened with cellulose tape to the edge of the negative, and the holes punched in this strip.

Procedure

1. Place in the printing frame the negative and a sheet of either Kodak Blue Sensitive Masking Film 2136 (Estar Base) or Kodak Gravure Positive Film 4135 (Estar Thick Base), emulsion to emulsion, and close the frame. The base side of the negative should face the exposing light.

2. If the pinhole system is being used, punch a small hole through the negative and film in each of the uncovered corners.

3. Expose for 5 seconds when using Kodak Blue Sensitive Masking Film 2136 (Estar Base). If Kodak Gravure Positive Film 4135 (Estar Thick Base) is used, the

*When bare lamps with no reflectors or lamp houses are used, excessive reflection from light-colored walls and ceilings should be avoided.

exposure time should be increased to 1 minute. These are average exposures using the light source described above, and a negative having a highlight density of about 1.4.

Processing

Develop in a tray at 68 F (20 C), with continuous agitation, as recommended below.

Film	Kodak DK-50 Time in minutes	Kodak D-11 Time in minutes
Kodak Blue Sensitive Masking Film 2136 (Estar Base)	2½	—
Kodak Gravure Positive Film 4135 (Estar Base)	3	3

Fixing, rinsing, and washing instructions are packaged with the above-mentioned films.

The minimum density of the film positive should be between 0.5 and 0.7, and the density range should equal that of the negative.

If a densitometer is not available,* the following method may be used for judging the exposure: Make a test strip so that it has several different exposure steps. Develop it with continuous agitation as recommended. Register the test strip with the negative on an illuminator, and compare the highlights with the shadows in each exposure step. In the steps which received the shorter exposures, the highlights will be lighter than the shadows. In the steps which were exposed longer, the highlights will be darker in comparison with the shadows. Beyond a certain exposure, however, no further darkening of the highlights will occur with respect to the shadows. This is the correct exposure.

If the film positive has been made correctly, there should be almost complete cancellation when it is superimposed on the negative. The combination should appear uniformly dense. If the exposure is correct, but cancellation has not been obtained, a new mask should be made and the development time adjusted to obtain a proper mask.

The 100 per cent positive mask recommended above will exactly cancel the negative, and a print made from the combination will be a true outline picture of the original. In some cases, however, it may be desirable for the shadow areas to be black. If this effect is desired, it can be obtained by using a positive mask that gives less than complete cancellation in the shadow areas. For example, an 80 per cent positive mask has been found to give very pleasing results with architectural subjects. Similarly, other effects can be obtained by using masks of different percentages or positive masks made on sensitized materials which do not have a straight-line characteristic curve.

*If a densitometer is available, the density range of the original negative may be determined by subtracting the minimum density on the negative from the maximum density. The same procedure applied to the mask will give the density range of the mask. If the density ranges of the negative and mask are equal, the mask is designated as a "100 per cent mask." Similarly, an 80 per cent mask would have 80 per cent of the density range of the original. An 80 per cent mask would appear visually to be "flatter," that is, have a little less density range than the original negative.

Line Positives

The line positive is made on either Kodalith Ortho Film 2556, Type 3 (Estar Base), or Kodaline Ortho Film 2567 (Estar Base) from the registered negative-and-positive combination.

The width of the outlines is controlled by the angle of the light source. It also depends on the thickness of the supports of the films, and on the exposure and development of the line positive or negative. However, any attempt to get thin outlines by control of exposure or development time will result in the complete loss of weaker outlines. The angle of the light source may be varied according to the type of result desired, but generally the most pleasing and satisfactory results are obtained with the light source at a 45-degree angle.

Equipment

The Rotation Method of Exposure (Turntable)—A 100-watt frosted lamp, used three feet from the exposure plane and at an angle of about 45 degrees, will generally provide ample illumination. This light will give a reading of about 5 footcandles at the exposure plane.

When a single light source and printing frame are used, the printing frame must be rotated during exposure at a minimum rate of one revolution per second to enable the light to pass through the openings from all sides. This can be accomplished most easily and simply by the use of a turntable. A simple ball-bearing turntable is easily constructed, or an ordinary record-player turntable can be used.

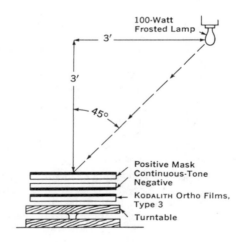

FIGURE 4
The rotation method of exposure (turntable)

The Vacuum-Frame Method (Nonrotating)—If a vacuum frame, which usually cannot be rotated conveniently, is used for making the line positive, a different light source is required. This light source, yielding about 10 footcandles at the exposure plane, consists of six 25-watt lamps, mounted on a framework so that they lie on the circumference of a circle four feet in diameter. The framework is

mounted two feet above the vacuum printing frame and allowed to rotate during exposure.

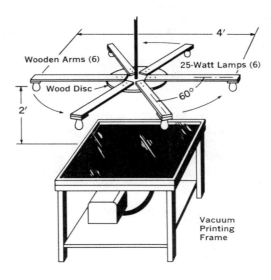

FIGURE 5
The vacuum-frame method of exposure (non-rotating)

Procedure

1. Register the positive mask with the negative, back to back. To do this, remove any dust from the base sides of the two transparencies and place them back to back on a board. If the pinhole system is being used, pin them to the board with two pushpins which pass through the holes in the transparencies, and tape them together securely on all four sides. Remove the pins, and check the register by examining the picture over a strong light. If the Kodak Register Printing Frame and the Kodak Register Punch are being used, the negative and mask may be registered by placing them back to back on the pins in the printing frame.

2. Make a line positive on Kodalith Ortho Film 2556, Type 3 (Estar Base), or Kodaline Ortho Film 2567 (Estar Base) from the registered negative-and-positive combination. The film should be in contact with the negative side of the combined transparencies.

The highlight density of the combined transparencies will generally be about 2.0; and with the intensity of illumination described above, the exposure time will be 30 seconds for the rotation method, 15 seconds for the vacuum-frame method. If the density of the combination differs from 2.0, the exposure time can be estimated by means of the Kodak Graphic Arts Exposure Computer or the Kodak Halftone Negative Computer. Development should be carried out by inspection until strong outlines are produced and the clear areas show a faint tone. *Watch the development carefully since it is quite critical!* After fixing, the tone in the background may be removed by a brief treatment in Kodak Non-Staining Reducer R-14 or Kodak Farmer's Reducer.

It should be emphasized that good contact is essential in making the line positive. Imperfect contact will cause blurring of detail and loss of outlines. Loss

of detail in the line image may also be due to:

 a. Lack of sharpness in the continuous-tone image.

 b. Insufficient contrast in the negative and positive, either over-all or in part of the scale.

 c. Unsatisfactory matching of the contrasts of the negative and positive which are to be combined.

 d. Incorrect exposure or development of the line positive.

If the line positive is accidentally printed from the positive, instead of the negative, side of the transparencies (see Step 2 above) the outlines will be formed on the wrong side of the images. For instance, a fine black line in the original subject will be rendered by a double line outside the original line. Similarly, a white spot will be rendered as a black spot in the line positive, instead of being outlined. Sometimes interesting effects can be obtained in this way. If the subject includes type matter, outline letters will result.

If the line positive has a higher contrast than that of the line negative, a very unsatisfactory result will be produced—the shadows will be completely clear and lacking in detail.

The subsequent steps for tone-line positives on either film or paper are quite straightforward, and the usual methods of reproducing line copy may be followed.

3M COLOR KEY MATERIAL

3M Color Key is a stable, polyester-based film, coated with a pigmented material that is sensitive to ultraviolet radiation. Color Key is processed with a single pre-mixed chemical developer and cotton wipes, then rinsed with water and blotted dry, ready for immediate use. No darkroom is required for exposing or developing.

Color Key is a very high-contrast material, suitable for proofing screened halftones in color; it is also useful for making color slides, TV cells, posterization, transparencies for overhead projection machines, and many other purposes.

Color Key is available in two forms—negative-working and direct-positive. The negative type is available in both opaque and transparent colors; positive colors are transparent only. There is also a Transfer Key material, available only in process colors.

Exposure Source

A high-intensity source with ample ultraviolet output is required for exposure of Color Key material. Carbon arcs require minimum exposure time and produce sharp, uniform images. Pulsed xenon and mercury-vapor sources are also useful. Incandescent and quartz-iodine sources are satisfactory for non-critical line work; exposure times will be much longer.

Exposure Procedure

A quality vacuum frame is required to retain fine definition. Mechanical pressure frames are satisfactory for non-critical line work.

Place the coated side of the Color Key material down on black or goldenrod paper; this backing eliminates destructive light reflections. Then lay the original or negative, image side (emulsion side) down onto the Color Key. See diagram below.

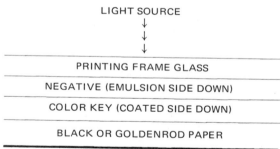

LIGHT SOURCE

PRINTING FRAME GLASS

NEGATIVE (EMULSION SIDE DOWN)

COLOR KEY (COATED SIDE DOWN)

BLACK OR GOLDENROD PAPER

Note that exposure requirements will be greatly increased if the material is not positioned with respect to the light source as shown.

Close frame and draw down full vacuum or lock mechanical frame securely. Expose to produce most accurate reproduction of original. Try a few test exposures, doubling exposure each time to establish approximate exposure. For example, try 30 seconds, one minute, two minutes, four minutes. Originals with greater density will require greater exposure. Note that changes in exposure do not change the color density of the image.

Processing Color Key

A smooth, level surface is required on which to develop Color Key. A suitable device can be made by placing a sheet of heavy plate glass in a photographic

processing tray. Place wood blocks in the tray to raise the glass about one inch from the bottom.

Development is done with a rubber developing block and Webril proof pads. A soft squeegee is required for fast drying of the Color Key image after processing. The Smoothee squeegee manufactured by the T. K. Gray Co. of Minneapolis (or one of equivalent quality) is needed.

Expose positive Color Key to open Step 2-3 gray scale reading. Tests for this exposure can be made on negative Color Key by exposing magenta negative with a gray scale to find the time that will produce a solid 4-5 on the negative magenta. This is the correct exposure time for *all* types of Color Key, positive or negative, including the Pantone colors.

Place exposed Color Key on level glass. Wrap Webril proof pad around special Color Key developing block. Pour Color Key developer smoothly onto the film, and spread immediately with a light, sweeping motion. As development begins, most of the background coating will be removed by a light figure-8 motion of the developing pad. After most of the background has been removed, turn the fresh side of the pad out, and finish development, using moderate pressure and a tight circular motion.

Rinse both sides of the film with clean water at 70—80 F. Firmly squeegee the uncoated side.

With positive Color Key, the image must be fixed. Place the film on the glass, pour fixer on the coated side and spread with a fresh Webril pad; keep the film wet with fixer for 45 seconds, using no pressure.

Negative Color Key does not require fixing and this step may be omitted.

Following fixing, the film is again rinsed in water at 70—80 F. Firmly squeegee the uncoated side, then blot the image side dry with newsprint or other absorbent paper.

Image sharpening indicates possible overexposure of positive Color Key (or underexposure of negative Color Key). Image enlargement indicates possible underexposure of positive Color Key (or overexposure of negative Color Key).

GENERAL ALPHABETIC INDEX

This page is being reserved
for future expansion.